W9-BTD-931

MODERN ART

SAM HUNTER
JOHN JACOBUS

MODERN ART

FROM
POST IMPRESSIONISM
TO THE PRESENT

PAINTING
SCULPTURE
ARCHITECTURE

HARRY N. ABRAMS, INC.,
Publishers
NEW YORK
In association with Alexis Gregory

For Jaye and for Carol

FIRST EDITION
ISBN NO. 8109-1616-9
LIBRARY OF CONGRESS CATALOGUE NO. 76-14611

PRINTED AND BOUND IN ITALY

CONTENTS

INTRODUCTION

Before considering in detail the evolution of modern painting, sculpture, and architecture both as a history of individuals of genius and as social or cultural history, it might be well to examine some general features of the modern movement. Our narrative begins in 1886 after the last Impressionist exhibition in Paris and with the birth of the Independents Salon. The period of Post-Impressionism brought radical changes in the theory and practice of art. Impressionist painting experienced a crisis in the early 1880s as artists participating in the great cycle of exhibitions began to react negatively to its formlessness and exclusively perceptual emphasis. A rising new generation restored pictorial structure and ideational content to a dominant position in art.

Two of the main tendencies of the anti-Naturalistic reaction crystallized in paintings based on a new sympathy for the ordering data of experimental science, exemplified by Georges Seurat and the rational and conceptualized structural style of Paul Cézanne. The effort to give Impressionism more universal meaning by stressing formal design and thus make it "worthy of the museums" was Cézanne's declared goal. Concurrent developments of equal significance, which led directly to Expressionist, abstract, and Symbolist art, were stimulated by Vincent van Gogh, Paul Gauguin, and the many different artists who felt their influence.

The varied pictorial solutions to the problems posed by the crisis in Impressionism shared one important feature—their abstractness of form. Gauguin's emphasis on emotional content, decorative or "synthetic" methods, and use of the arabesque and flat color masses became the basis of the free forms of twentieth-century biomorphic abstraction, the art of Wassily Kandinsky, and that of automatic Surrealism. Cézanne's geometric structures anticipated the more rational and intellectual styles of the century, beginning with Cubism. The gradual transition to an unprecedented nonobjective art, in fact, may justly be described as perhaps the most radical patrimony of Post-Impressionist art. The traditional expressions of the Academy in the late nineteenth century had been based on a Renaissance concept of art as the presentation of the natural world, a realistic art infused with human content. In the twentieth century, with Cubism and the succession of abstract movements derived from its premises, the work of art was no longer considered descriptive or even an attempted illusion of the world of sight. It became, instead, an autonomous structure sustained by the artist's subjective vision and its own internal style. This represented a revolution in both form and content whose seeds were planted in the experimental decade of the 1890s in Europe.

The phenomenon of abstract and nonobjective art, released from the familiar world of appearances, depends, in turn, on a number of unprecedented cultural, historical, and artistic conditions that give definition to the moot and still evolving concept of modernist art. To put these as succinctly as possible: they have to do with changed conceptions of the nature of physical reality, a new understanding of artistic tradition, the development of an avant-garde culture, and significant changes in the expressive physiognomy and content of the art object itself.

With the Impressionists a vast change in the artist's response to material reality took place. During the waning years of the nineteenth century, and in the opening years of the twentieth, a series of discoveries in science revolutionized the conception of the structure of the universe that had prevailed since about the time of the Renaissance. Atomic physics and chemistry revealed the new and insubstantial nature of previously accepted assumptions about objects and the universe. When Kandinsky first read, with great astonishment, of the atom and particle physics, he felt his sense of reality slipping and declared: "All things become flimsy, with no strength or certainty." Even making allowances for romantic exaggeration, we must grant modern science and its revolutionary technology a decisive influence on

artistic sensibilities. These changes were reflected equally in the technology-oriented art of the Constructivists—whose principles of beauty were analogous to those of modern engineering—and in Kandinsky's reaffirmation of emotional responses in an art based on intuition and expressive gesture.

There were further revelations of great importance awaiting twentieth-century man in experimental psychology regarding the operations of the subconscious mind. The machine and motion pictures also had an incalculable impact on modern art forms. In relation to Cubism, science and philosophy added entirely new conceptions of relativity and simultaneity that found their visual embodiments in dynamic and perplexing new art forms. The machine became the source of both a new imagery and an idealistic vision of a Utopian society. In the geometric art of Piet Mondrian and his followers, it provided a model of impersonal order and collective discipline, but contrarily, it also managed to serve an anticlassical taste for disorder and the wildly romantic impulses of the Futurist and Dada movements.

All of these radical new expressions and movements represent a fundamental break with past traditions, and the result has been an immense destruction of received art forms. While this has meant a downgrading of classical tradition, on the positive side it has invited an almost greedy acquisition of new forms from all over the globe, from non-Western, oriental, and primitive cultures, and from folk art, the art of children and the insane, and other aspects of *L'Art Brut*. The outcome of these vast changes has not merely been a spirit of assimilative eclecticism but, instead, the birth of a new tradition more subjective in spirit.

Pablo Picasso's great watershed painting of 1907, *Les Demoiselles d'Avignon*, is perhaps the most famous in the new century for establishing vital connections with primitive cultures. The revolutionary influence of African sculpture created a new cultural atmosphere, which permitted first artists and then a more general audience to perceive the qualities in them that made them art objects. These were a matter of formal structure and psychological expressiveness, and today they are seen as equal to any works of art produced by so-called civilized peoples.

When we come to the historical meaning of the avant-garde phenomenon we must go back to the middle of the nineteenth century for its beginnings. Fine art has always been the product of a creative elite, directed to a comparatively small, specialized audience of like-minded spirits. For the past hundred years, however, since the novels of Flaubert, the realism of Edouard Manet, and the poetry of Baudelaire and Rimbaud, modern art has even further limited its audience. The intransigence of the avant-garde, the flow of polemics, manifestoes, and attacks on middle-class ideology that they generated have been linked to a rapid succession of revolutionary technical and artistic innovations. These never gained wide popular acceptance, which created a divisive confusion in standards of tastes. The sincerity of art forms in the more remote past was never challenged; art was supported and encouraged by a cultural elite, and its quality, honesty, and meaning were not subject to serious doubt. Only in the modern period of mass culture have questions been raised that the artist may, in fact, be a fraud, deceiving the public with unintelligible riddles.

Until 1800 or thereabouts, important artists, writers, and thinkers were usually recognized as such during their lifetimes, since their audiences were limited to an elite group of amateurs who had some expertise in the field. Since the industrial revolution and the Romantics, however, public taste and judgment of quality have become less certain and contemporary responses erratic. And so it has been from the Impressionists right up to the famous pioneering exhibitions of modern art in the twentieth century in Europe such as the

Grafton Gallery shows of Post-Impressionism organized by Roger Fry in London and the 1913 Armory Show in America, which scandalized the critics and public by presenting such artists as Cézanne, Henri Matisse, and Picasso as if they were serious.

In the twentieth century, the neglected artist learned to view his art as a potential esthetic and social weapon of subversion directed at middle-class philistinism. The alienation of the progressive artist and the scandal with which traditional authority identified the innovations of modern art were linked to the absence of familiar realism in the art object and a justified Bohemian mistrust of any credible system of patronage or support. The resulting confusion in standards of taste coincides with the rise of popular culture in the mass media and the phenomenon of kitsch. One dramatic result has been to compel the avant-garde to develop its own community with a set of social ideals based on protest and internal standards of taste and judgment. Because of their precarious social situation as dissenters, avant-garde artists, at least in the early years of the century, often embraced a revolutionary political outlook as well as revolutionary esthetic attitudes. One of the contradictions of the modern movement, however, has been the frequent conflict between progressive esthetic beliefs and the direct expression and implementation of reformist social ideals in art forms readily comprehensible to the common man.

This, then, brings us to our final point, the actual changes in artistic methods and forms. Why has the modern artist been so preoccupied with medium and pure pictorial or sculptural values? Even Manet and the Impressionists, while their delineation of city and country life was surely one of the most touching and charming in history, found themselves moving further and further away from descriptive subject matter. The process of abstraction was clearly hastened in our century.

Many writers have seen in this attrition of recognizable content the decay of humanism. In fact, it seems to be a development entirely understandable in terms of the nature of modern art itself. Beginning with the Impressionists, the artist rejected traditional illusionism because it no longer seemed capable of expressing his most profound feelings, or sensations, in relation to modern existence. "Art for art's sake," and even life for art's sake made their appearance, a refined estheticism that seemed to contradict the more Utopian social aspects of other forms of abstraction.

Whatever the social or historical motivation—whose origins and meanings are quite complex—it became clear with Cubism and abstract art that a profound change in the nature of the art object had taken place. The disciplines once supplied by an illusionistic art based on imitations of the familiar world of sight were supplanted by the internal processes, structures, and stylistic disciplines of the language of art itself, as in so much of modern literature. These in themselves became a new subject matter for art. The excitement of the art of Cézanne and of Picasso, Georges Braque, and Mondrian in the new century lay in the artist's preoccupation with the invention and arrangement of shapes, surfaces, and colors for their own sakes, often at the expense of the representational features of art of the past.

The modern work of art, then, can best be understood on two levels, as a model of a world that is utterly real since it is the product of artistic intelligence responding to medium and, at the same time, as a wholly imaginary creation, since it is also invented and, in that sense, entirely surrounded by the mind of its creator. The complex tension between objective and subjective realities and the rich spectrum of motives that gives depth, quality, and meaning to modern art forms in their full expressive range and variety are the focus of this study of the masters and movements of modern art.

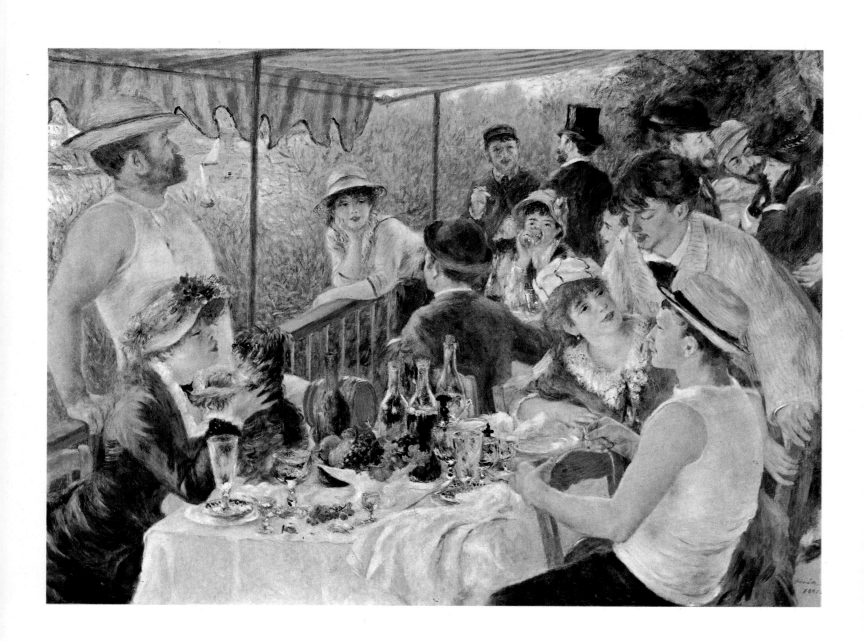

POST-IMPRESSIONISM
THE LANGUAGE OF STRUCTURE

In his book *Modern French Painters*, R. H. Wilenski rather simplistically describes the reaction against Impressionism in French painting during the 1880s as a general classical revival. According to this recipe, Renoir, Seurat, and Cézanne in particular expressed their dissatisfactions with the mere transcription of a corner of nature, or with naturalistic accuracy, which was basic to the Impressionist program, by reverting to classical French tradition and stressing the more enduring architectonic elements of pictorial structure. While this interpretation of the so-called crisis of Impressionism is meaningful to an extent, it is not sufficiently illuminating, for some of the Post-Impressionist styles also represented an effort to preserve Naturalism while re-establishing the fundamentals of traditional pictorial design and structure. Pierre-Auguste Renoir (1841—1919) did so by enlarging his style and idealizing his figures, but without sacrificing his expressive delight in the substance and texture of things, in

pl. 1 such capital works of the early 1880s as *The Luncheon of the Boating Party*. Georges Seurat paid homage to the spirit of Naturalism under the aegis of "science," and even Paul Cézanne's most arbitrary formal inventions were built around the prismatic colors of Impressionism and depended on his fresh, sensory perceptions of nature for their vivacity. While these artists rejected the spontaneity and formlessness of the conventional Impressionist painting, they nonetheless absorbed and extended the movement's basic values and especially its pragmatic, scientific spirit. The artist's sensations before observed nature, his mistrust of all but the immediately given qualities of visual experience, were considered indispensable. But now they made themselves felt within a more carefully articulated pictorial structure—one which took account of conceptual program and analytical intellect. The vital, new traditions of observation and direct painting methods were respected but a more universal application of the old principles was sought.

By the middle of the 1880s the Impressionist

vision had been found wanting not only by younger artists but by its old adherents, who either replaced it with an art of more rigorous formal design, linked in some cases to an interest in the new findings of science, or with an art of emotional impact. Only Claude Monet (1840—1926) carried on the preoccupation with optical experience, pushing it, at the end of his life, to a point of near abstraction. His late mystique of light, as evinced in his serial paintings of Poplars, Haystacks, the facade of Rouen Cathedral, or the Water Landscapes at Giverny curiously combines pl. 2 an almost myopic obsession with magnified visual detail and a radical new form of abstraction. In their marginal recognizability, the emergent new forms countered Impressionist practice, and seem most closely linked to the art of our own postwar period, that of the Abstract Expressionists, and to its fluent, coloristic "writing" and environmental expansiveness. Perhaps the most startling innovation, from our vantage point, was Monet's series pictures, beginning with the fifteen similar Haystacks of 1891. This group of paintings and related series motifs were conceived as durations, representations of the passage of time; Monet fragmented his object into a succession of moments of observation. However, the intensity of his vision reversed the Impressionist program of scientific objectivity and greatly increased the element of subjectivity.

One of the most devoted among the Impressionists, who had exhibited at many of the independent group exhibitions between 1874 and 1882, Renoir also found himself dissatisfied, and told the dealer Ambroise Vollard: "A short break ... came in my work about 1883. I had wrung Impressionism dry and I finally came to the conclusion that I knew neither how to paint nor draw. In a word, Impressionism was a blind alley."[1] Feeling increasingly out of sympathy with the younger generation of artists in Paris, he rejected contemporary subject matter. Perhaps the climactic work of this period of transition was the large *Bathers*—a deliberate rejection of the so- pl. 4 called advanced art of his time in favor of a hard, dry technique and a carefully composed articulation of near-sculptural forms, emphasizing contour rather than color. The idea of painting

1

11

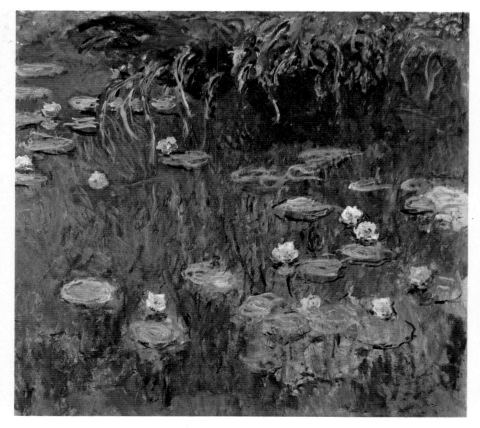

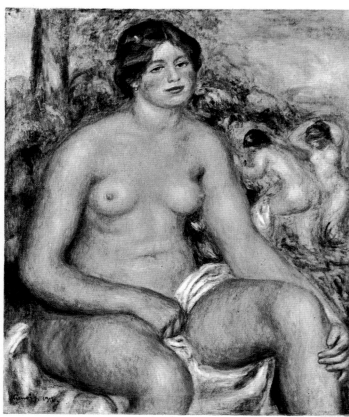

Claude Monet. *Water Lilies (Nymphéas)*. c. 1916—22. Oil on canvas, 78¾ × 83⅞". Collection Mᵐᵉ C. Emil Bührle, Zurich.　2

Pierre-Auguste Renoir. *Seated Nude*. 1916. Oil on canvas, 38⅛ × 26⅝". The Art Institute of Chicago.　3

nymphs bathing around a pool, rather than scenes from contemporary life, seemed a provocative reversion to timeless, classical subject matter just at the moment when such painting appeared to the Impressionists academic and outmoded.

Renoir rode out the esthetic storms of the 1880s by withdrawing to the south of France with his growing family, and settled down to paint whatever he enjoyed painting, with a classical balance between observation and an ideal conception of beauty. He began to soften the harsh, explicit forms of his more synthetic compositions of the early 1880s and allowed his naturally delicate brushwork and luminous color to dominate his canvases once again. Most of his works were of pl. 3　women, whom he celebrated as the most beautiful of all created beings, whether in actual life or in imaginary mythic situations.

Edgar Degas (1834—1917) was another of the pioneer Impressionists, but his late work, after 1880, shows the same simplification and concentration, and universality rather than specific observation of time and place, that we find in pl. 107　Monet, Renoir, and others. After the 1870s, he had progressively limited his subject matter until finally his concerns were exclusively with his female model, whom he painted or sculpted performing certain basic, and usually intimate, actions—washing and drying herself, stepping in or out of tubs. Even the actual movement seemed to matter less and less, and, though the presence of his figure was essential, Degas had become so 12　emotionally detached that the woman's only func-

tion seemed to be that of making the creation of a picture possible. After 1886, he worked more broadly, even abstractly, with a direct and more powerful apprehension of bodily movement and the essential structure of the human figure.

His expressive studies of the female form in these monumental recapitulations of his favorite nudes and dancers show a new freedom and dynamism. His late pastels are violent chromatically, worthy of the Fauves, and his massive nude　pl. 5 forms achieve a prophetic lyrical freedom. There had always been a subversive taste for luxurious sensation in Degas's art, which played against a strict, classical discipline and a vivid sense of actual life. But now, at the end of his career, a conflict between Naturalism and Symbolism became apparent, as it did in so much of the painting and literature of the period.

Opposed to the magnificent later work of these reconstituted Impressionists, who had admittedly changed and enlarged their styles but nonetheless retained elements of their earlier attachment to Naturalism, was a profoundly anti-Naturalistic reaction. But the common denominator among French painters in the Post-Impressionist period was the search for new types of subject and new forms of representation, and they all shared a decisive, negative reaction to purely optical sensation, and the imagery of light phenomena of the kind exemplified by Monet's lifelong obsession with perceptual experience. Whether in the form of allegory, modified realism, Symbolism, or Expressionism, there was evident, on all sides, an

effort to deepen the meaning of art by a conceptual, rather than perceptual, approach.

Both Georges Seurat (1859—1891) and Paul Cézane (1839—1906) transcended their "sensations" of nature by creating more abstract and impersonal styles in a radical new structural language of color form. In their paintings they treated the sensuous, palpable things of nature but reorganized them according to the dictates of a lofty intellectual ideal. Seurat's resolute "scientific" objectivity and Cézanne's structuralism were opposed, on the other hand, by the essentially Symbolist approach of Gauguin, van Gogh, Redon, Moreau, Puvis, Munch, and others who tried to synthesize expressive design and subjective emotion. It is a measure of the universality of the search for new expressive content that even so circumspect a formalist as Seurat, for all his devotion to science, tried to inject a new emotional resonance into his painting. Speaking of his artistic method, he explained that "gaiety of *tone* is given by the luminous dominant; of *tint*, by the warm dominant; of *line*, by lines above the horizontal." [2] Whether drawn to scientific explanations of artistic method like Seurat, or to symbols of human suffering and spirituality like van Gogh, the Post-Impressionists shared a common impulse in establishing an art that went beyond realism.

The first public evidence of defection from Impressionism came with Seurat's exhibition of his
pl. 6 *Bathers (Une Baignade)* at the newly formed Independents Salon in 1884. (Like the Impressionist exhibitions, the new salon was founded by progressive artists to combat the reactionary policy of the official salon; Seurat, Redon, Henri-Edmond Cross, and Paul Signac took the lead in organizing the first exhibition.) Seurat divided his tones in this painting as the Impressionists had done,

setting contrasting dabs of pure color side by side, and his canvas, similarly, presented a speckled, multicolored surface. His color dots were tinier, however, more systematically distributed, with an almost parsimonious rigor, and built up concentrated, dense clusters in assertive texture and relief that gave a more solid definition to form. Impressionist forms tended to vanish in a chromatic exhalation, lost in an amorphous, flowing mass of light and colored air. By using more sharply defined dark and light contrasts, Seurat dislodged his forms from their surrounding atmosphere, established them in space, and created a tension between them and the space they inhabited.

In the *Bathers* a group of clothed and half-clothed gentlemen relax on the banks of the Seine before a broad river view, with sails and a bridge glinting with sunlight in the distance. Each human figure is given a sculptural roundness, though contours are softened so that they merge hazily with a living sun-drenched atmosphere. One boy, waist-deep in water, cups his hands to his mouth; another young man sits in profile, his feet dangling over the bank; still another is outstretched on his stomach. All these poses are carefully weighed and balanced against each other in a cunningly choreographed tableau that summons up the stately, measured movements of Poussin. The varied play of vertical accents (sails, bridge, piers, and trees) and horizontals (the wide, grassy river bank, the reclining figure) gives the composition a carefully thought-out architectural organization, and also conveys a sense of virtually inexhaustible variety within the otherwise strictly planned formal scheme.

Just as Seurat has carefully controlled his space and volume, so has he also calculated the character of the scene. Each figure is sharply typed as a

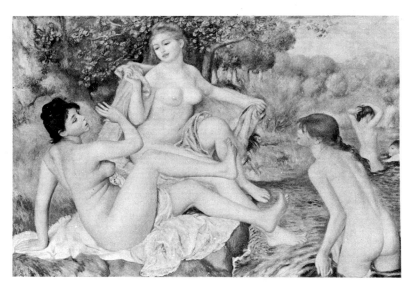

Pierre-Auguste Renoir. *Bathers*. 1887. Oil on canvas, 46⅜ × 67¼". Philadelphia Museum of Art. The Mr. and Mr. Carroll S. Tyson Collection. 4

Edgar Degas. *After the Bath: Woman Drying Her Neck*. c. 1898. Oil on canvas, 24½ × 25½". The Louvre, Paris. 5

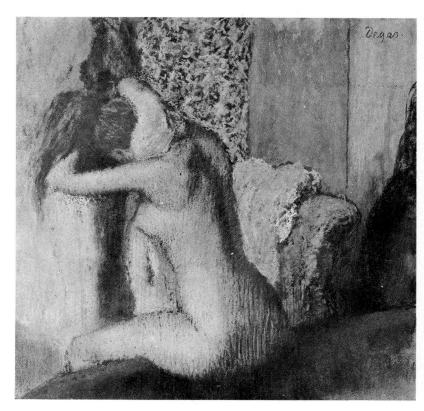

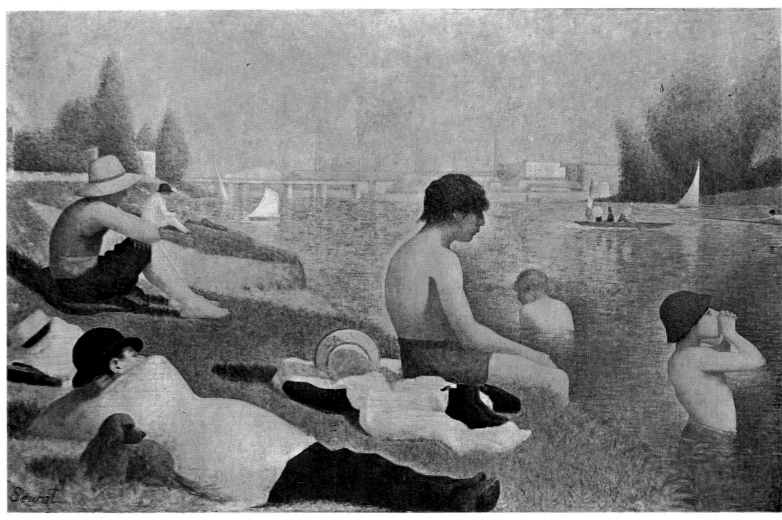

Georges Seurat. *Bathers (Une Baignade)*. 1883—84. Oil on canvas, 79″ × 9′ 10½″. Tate Gallery, London. 6

personality by some expressive detail of dress or gesture. With his first major painting, Seurat summed up and, in a sense, abstracted a common human activity. His elegantly selective vision, formal invention, and wittily stylized figuration fix the scene with the power of myth. Descriptive detail is particular and exact within a visual formula as severe as an Egyptian wall relief. Seurat's remarkable powers of generalization extended the Impressionists' swift glimpse of a "moment in time" and made an episode stand for something customary and permanent in human activity. And he found a form that could withstand patient and studied contemplation.

Seurat painted and drew countless preliminary sketches on the spot for this large painting, which he completed in his studio. He saturated himself in the atmosphere at Asnières and faithfully observed and recorded pertinent incidents. His conté crayon drawings of a number of the main figures are themselves extraordinarily complete and sensitive to character, and he incorporated some of these directly into the final work. He also did many oil studies for color and for light-and-dark distribution. The final painting was the result of a process of accumulating and distilling innumerable impressions and visual notes made at the site. As a manner of working, this in itself was contrary

to the Impressionists' method of seizing the immediate fragment of vision before nature, and setting it down with a minimum of ratiocination.

Monet, Pissarro, and Renoir, in their boulevard scenes, spontaneously recorded random, visual data, and by doing so expressed a kind of first principle of artistic freedom. Their Paris street scenes show building facades, trees, moving figures, and other incidents that are related to each other pictorially only insofar as they have the blurred, psychological rightness of a vision assimilated by the eye at high speed, unified by the moment of perception. In fact, the Impressionists wished precisely to give the impression of something entirely natural and unarranged, and to capture the momentary quality of an arrested action on which they imposed no particular order other than that supplied by the individual artist's sensibility or his personal "handwriting." Seurat, on the contrary, *composed* with unashamed deliberateness and scrupulous care for characteristic detail, leaving nothing to chance. His forms take their place in a preordained, conceptual scheme of things that obeys certain immutable pictorial conventions. Seurat's methods initiated a whole new expression of artistic will.

Seurat's natural love of orderliness had been encouraged and classically disciplined for four

years in Paris, first at the Municipal Art School and later at the École des Beaux-Arts studio of Henri Lehmann, a pupil of Ingres's. The young artist rebelled against the narrow and parochial academic training, but he continued to express his sympathy for classicism in masterful drawings after Raphael, Holbein, and Ingres. In 1879, he left the studio to do military service at Brest, where he lived facing the sea, and he soon came to feel a special affection for the broad skies, crystalline air, and wide distances. He later frequently painted along the Normandy coast, and there is always in his art a quality that recalls the trancelike stillness of coastal regions and that feeling of suspension in an eternity of space which the seaside induces.

In 1880, Seurat returned to Paris and began to draw intensively. He blocked out his figures freely and massed darks and lights to give the broadest expression to his forms. He also painted with "broomswept" strokes and in broad hatchings, building up flat color masses, which gave more distinct definition to his forms. His subjects were of peasant or working-class origin and showed a strong moralizing bent. He was soon using conté crayon in a new way, in his associated drawings, building a velvety depth and richness in his blacks, and exquisite nuances of gray and white.

He discovered that by lightly graying the roughened surface of his paper he could create an interesting texture grain, an effect comparable to the pointillism which he later adopted in his oils. His drawing of an artist and friend, Aman-Jean, drew favorable comment from the respected critic Roger Marx when it was exhibited at the Salon of 1883. Seurat's drawings are a rare genre in nineteenth-century art, as rich in tone as they are remarkably sensitive to character, informal and yet full of aristocratic grace.

Through the Independents Salon of 1884, Seurat met Paul Signac (1863—1935). In the following years these artists together formulated the theoretical basis of a new style which had begun to emerge in the *Bathers* and which the young critic Félix Fénéon later called Neo-Impressionism, thus seeming to imply that this new approach had eclipsed the old Impressionist manner. Camille Pissarro was the only artist of the older generation who did not view Seurat's innovations with suspicion, and he soon, in fact, adopted his apparently scientific systematization of Impressionist technique. Though there was more poetry than science in Seurat's methods, the artist had investigated, since his student days, numerous relevant studies on color theory and the phenomena of

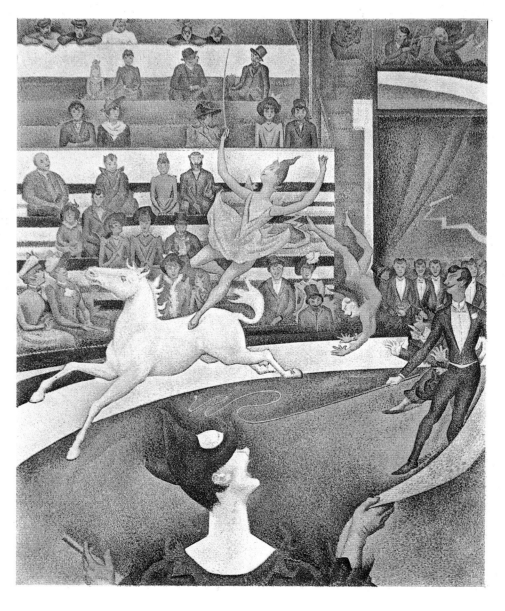

Georges Seurat. *The Circus.* 1890—91. Oil on canvas, 73×59⅛". The Louvre, Paris. 7

perception, written by Eugène Chevreul, Ogden N. Rood, Charles Henry, and James Clerk Maxwell among others. Some of the important discoveries that stimulated Seurat and the Neo-Impressionists were Chevreul's color wheel of the primary and intermediate colors which represented the component rainbow colors of white light when broken down by a prism, Chevreul's "law of simultaneous contrast of colors," and Rood's discovery that optical mixtures of color were more intense than premixed color. Actually, Seurat and his friends rationalized discoveries which the Impressionists, for the most part, already knew intuitively and applied in their painting without conscious research or pedagogy. Seurat apparently first drew inferences about the possibilities of optical mixtures not from Rood's Studies but from the example of Eugène Delacroix's frescoes, which he was able to study in the chapel of Saint-Sulpice. He and his youthful follower Signac, in fact, developed an absolute cult for Delacroix. Delacroix's expressive palette also suggested to Seurat the possibility of the use of color to create certain emotions and states of mind.

Seurat's intense interest in color theory may be understood as part of the scientific preoccupation of his historical period, which was sustained by the belief that everything could be formulated and explained in terms of natural law, even the life of the emotions. (Gauguin, for his part, found the artist's scientism distasteful and referred to Seurat as "the little green chemist.")

From Chevreul's research, Seurat deduced that local color was simply one convention among others. In terms of the laws of optics, it can be demonstrated that any hue modifies its neighboring color since it must induce an aureole of a tone that is its own complementary. Rood's experiments, in turn, proved that the juxtaposition of neighboring primary hues creates a more intense intermediate in the optical mixture, blended by the eye, than the actual corresponding tube color.

In the mid-1880s, the mathematician Charles Henry was holding audiences spellbound at the Sorbonne in lectures on the emotional values and symbolism of lines and colors, and his ideas were soon reflected in Seurat's major compositions. Seurat met Henry at this time, and became convinced that elementary rules of harmony could be established in painting, as they had been in music; for painting, the rules would be based on the new knowledge of perception and on optical laws. He set forth his theory that optical harmonies and contraries produce certain moods and influence feeling in a well-known letter to Maurice Beaubourg, published posthumously.[3] The manifold elements of painting could be simplified and codified, he declared, in "tone, tint, and line"; they were found to inspire "gay, calm, or sad" emotions according to their character, with descending lines, dark tone, and cold tints producing sadness; rising lines, luminous tone, and warm color, gaiety. Curiously enough, Gauguin, whose approach was so different, later suggested that his own painting could similarly be understood as a kind of visual music, and he was profoundly concerned with the affective potential of colors.

In 1884, at the age of twenty-five, Seurat had begun the methodical application of his theories in an immense painting project of a magnitude almost unknown since the days of David and Ingres. On the Seine island of La Grande Jatte, he began making preparatory oil sketches and drawings, just as he had done for the *Bathers*. Completed two years later, the final painting measured approximately seven by ten feet and had been preceded by some twenty drawings and two hundred oil sketches. *A Sunday Afternoon on the Island of La Grande Jatte* was shown at the eighth and last Impressionist exhibition, and again in the Independents Salon of 1886. Degas detested the painting and said so, and Seurat's "Scientific Impressionism" was belabored by the older "Romantic Impressionists," as Monet, Renoir, and Sisley were now called. So challenging was this great new work that the last three artists withdrew from the Impressionist exhibition, at least in part, because they objected to the inclusion of the Neo-Impressionists.

La Grande Jatte was Seurat's out-of-doors masterpiece. It showed a holiday crowd of Parisians on an outing, relaxing on the grass, promenading, fishing and frolicking in a park that is framed by a background of trees and water. The atmosphere is brilliant, and contrasting dots of pigment create the effect of golden light, in fact, sun glare. Seurat's color here is much brighter than formerly; characterizations of the various personages are also intensified, more sharp and witty. As in the *Bathers*, a common human activity has been distilled and charmingly stylized. He wished to leave nothing to chance in the construction of his painting, and he carefully planned every step of the composition. Despite his passion for scientific method, however, Seurat remained an artist of exquisite sensibility. Even his mannered style is turned into a positive emotional element, designed to enhance a seriocomic mood. The general patterning and the immobile, geometric character of his figures add a note of pomp to the Sunday promenade and give it the formality of a stately ritual. There is something wonderfully mechanical and droll about some of these characters, particularly the foreground couple at the right. Their figures are the expression of propriety and dignity, yet they seem to glide along automatically, pulled by invisible wires. If their solemnity were a trifle more exaggerated, the effect would be ludicrous.

Exaggerating, or contrasting with, the more ceremonial figures are such fanciful touches as the monkey, whose curled tail echoes his mistress's bustle; the lyrical relief of the child skipping in the middle distance and of the sails on the river; the relaxed pose of the gentleman leaning on his elbow. Quite properly this man, so natural and in harmony with nature, has behind him a mongrel dog of a relaxed and friendly character. The more formal couple, on the other hand, is accompanied

pl. 8

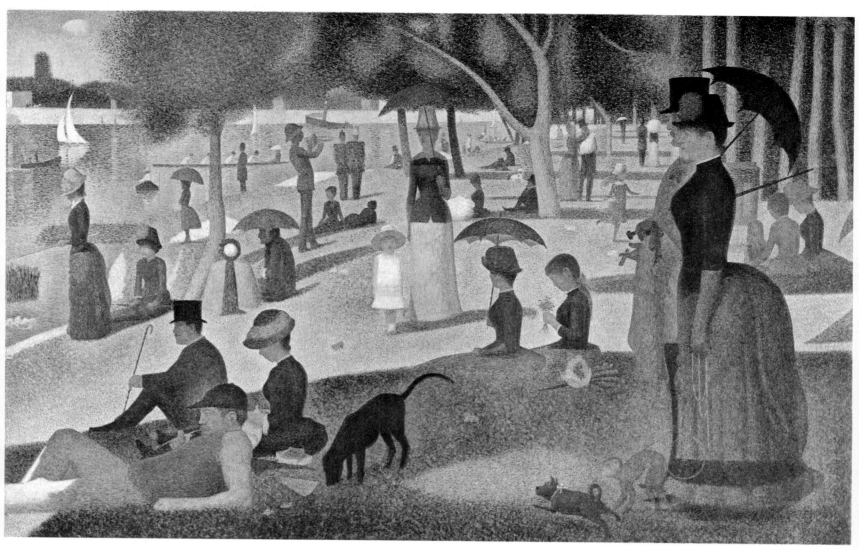

Georges Seurat. *A Sunday Afternoon on the Island of La Grand Jatte.* 1884—86. Oil on canvas, 81¼" × 10'¼". The Art Institute of Chicago. Helen Birch Bartlett Memorial Collection.

8

by a monkey and a dainty little beribboned toy dog of obvious pedigree. Throughout the painting, the artificial and the natural compete, as they had begun to do in so many of the significant works of the Symbolist period, whether in art or literature.

Seurat's unfolding panorama of the middle class at play is an eloquent commentary on contemporary life and manners much like Renoir's great lyrical paintings *Dancing at the Moulin de la Galette* pl. 1 and *The Luncheon of the Boating Party.* Whereas Renoir's figures are larger than life, with vitality and energy that spill over and animate nature, Seurat's lyricism is more tightly contained. His people have been reduced to delightful little statuettes arranged deftly and with good humor in obedience to the artist's will. They take their places almost ritualistically in the compositional scheme, swelling an arabesque, relieving a splash of sunlight or a mass of shade. Much of the curious charm of the work comes from the artist's insistent, exhibited control of forms. Yet, out of a tension between the natural and the artificial, between sensations based on living atmosphere in nature and a contrary, nearly religious dedication to formal problems, Seurat constructed a vital contemporary creation. In its time, however, it

was generally thought rather frivolous and fanciful; the novelist George Moore reported that the canvas aroused great curiosity, but mainly for its size, its peculiar color scheme, and "a ring-tailed monkey" whose "tail [is said to be] three yards long." [4] The famous critic Joris-Karl Huysmans wrote, "Strip his figures of the colored fleas that cover them; underneath you will find nothing, no thought, no soul." [5]

After *La Grande Jatte*, Seurat painted a number of works which again brilliantly caught the essential character and movement of some aspect of contemporary life: *The Models*, a group of models in a room with *La Grande Jatte* in the background; *Invitation to the Sideshow*, a row of musicians at a fair on a proscenium under flickering gaslight; *Le Chahut*, a cabaret scene; many marine paintings of the Normandy coast; and *The Circus*, a bareback pl. 7 equestrian and a ringmaster performing at the circus. In his last works, Seurat's rhythms are more emphatic and flat; decorative accents are played up in a curvilinear style anticipating the flourishes and ornamental embellishments of Art Nouveau. The new artistic focus on popular entertainments, especially fairs, cabarets, and circuses, also anticipates subject matter of the 1890s. His quiet humor became rather more pointed as his 17

compositions became more flat and posterlike. *The Circus*, for example, burlesques the action portrayed, and the figures verge on cartoonlike grotesques of a fantastic character, predicting the more self-conscious design of his follower, Signac, in his extraordinary portrait of the critic Félix Fénéon, a noteworthy attempt to reconcile the conflicting claims of Symbolism and abstraction in the century's waning years.

Seurat died at the age of thirty-one. He left behind only six major paintings, a number of charming marines, innumerable informal oil studies, and a sizable body of exquisite drawings. His achievement cannot be measured by the relatively small corpus of oils he produced; if he had painted only *La Grande Jatte*, he would take his place as one of the finest artists of the modern period. After his death, Pissarro, who had joined, and then in 1890 withdrawn from, the Neo-Impressionist group, wrote to his son Lucien: "I believe you are right, pointillism is finished, but I think it will have consequences which later on will be of the utmost importance for art. Seurat really added something."[6] What he brought was, above all, a renewed interest in pictorial structure and design, those major formal considerations that Impressionism ignored. He began, tentatively, to use color for plastic definition as well as for description, and his art thereby forms a bridge between Impressionism and the great innovations of Cézanne. Seurat's feeling for flat decorative form, his comic exaggeration, and some of his music-hall and circus subject matter also link him to Toulouse-Lautrec, of whom we shall hear more in the next chapter.

The new interest in the solid presence of objects and a deeper concern with the more permanent and formal aspects of nature are even more dramatically illustrated by the influential paintings of Paul Cézanne. Because of the impact of Cézanne's innovations on the twentieth century, he has been called, with justice, "the father of modern art." For continuous creative impulse, Cézanne is one of the major figures of nineteenth-century painting, a prodigy of creative innovation, ranking—in the period after 1850—with Manet, Monet, Gauguin, and very few others. If a comparison is valid, or illuminating at all, even Seurat must take his place as a somewhat lesser figure—an incomparable sensibility and formalist, and yet perhaps a narrower, and certainly a less influential, talent than Cézanne. However, Seurat's paintings, despite their decorative flatness, contrast less sharply with traditional illusionist systems, and therefore make a useful introduction and transition to Cézanne's more radical pictorial solutions.

Although it is reckless to summarize Cézanne's revolutionary achievement in a facile formula, Roger Fry's apt phrase characterizing his innovation as the development of a system of "plastic color" is helpful and illuminating. Not unlike Seurat, but by different pictorial means, Cézanne tried to penetrate the world of appearances, which the Impressionists so carelessly celebrated, in order to reach a more fundamental level of reality. He used color accents and color "planes" in place of distinctively outlined forms to give sensations of three-dimensionality. He spoke of making something solid and enduring of the ephemeral Impressionist vision by recasting art in the image of historical classicism. While the same impulse to re-establish order in a world of rapid social change and dissolving values seems to have been operative in other spheres, Cézanne's method was without precedent. Unlike the Neo-Impressionists, he abandoned both the dot-and-dash system of color application and atmospheric perspective. Each dab of color became for him a living paint cell, a significant plane defining the position of an object and all the intermediate layers of space between objects. He was conscious of a discrepancy between forms as one felt them in natural space, and forms as they were transposed onto the flat surface of the canvas. This, in fact, became the crux of his pictorial problem: finding a new solution that could reconcile his "sensations" of depth in the three-dimensional space of external reality with an acute awareness of the two-dimensional limits of the painting surface.

Seurat had never quite resolved this problem satisfactorily. At one time he spoke of painting as the art of "hollowing out a surface," and he sought to preserve the "illusion" of deep space and traditional Renaissance perspective. At the end of his career, however, he was more aware of a conflict between maintaining the unity of the picture plane and creating the illusion of distance. But he settled the conflict rather arbitrarily, *not* in

Paul Cézanne. *Still Life with Basket of Apples.* 1890—94. Oil on canvas, 25⅝ × 31⅞". The Art Institute of Chicago. Helen Birch Bartlett Memorial Collection. 9

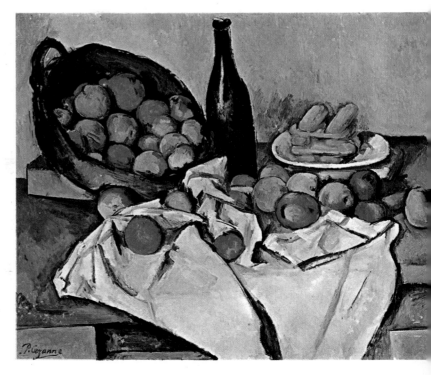

terms of his articulated sensations before nature but by emphasizing a flat, posterlike decoration.

Cézanne, instead, found an abbreviatory pictorial form that was plastic rather than decorative. He at once conveyed a vital impression of the solid physical presence of objects of spatiality in depth, and still accepted the limitations imposed by the flat picture plane. In *Still Life with Basket of Apples*, he stresses certain geometric shapes: the ovals of the fruit and basket and plate, the rectangle of the table, the generous curvature of the tablecloth, and the cylindrical wine bottle. These forms are related to each other in a compositional scheme that is all traction and tension. And yet the composition has a serene poise in which we feel the measured rhythms and solidity of pictorial substance that all great classical paintings have.

In order to emphasize the decorative unity of his painting, Cézanne had also begun, as early as 1873, to flatten his picture space by means of distortion and arbitrary color accents, but his formal resolution of this pictorial problem was less illusionistic than the Impressionists'. As he proceeded, the dynamism evident in his painting betrayed continuous, almost insatiable mental effort that makes his greatest works an almost musical delectation of shifting relationships. He stresses flatness by juggling perspective: by tilting the horizontal plane of a table or sideboard up, thus thrusting the background closer to the foreground; by widening the curved mouth of a bottle or an elliptical bowl; and by modulating the color. We find ourselves looking at apples in the foreground of his still life at eye level, but the objects behind them—the stacked biscuits, for example—are seen from above. Cézanne has thus taken the liberty of "abstracting" certain aspects of form and color from nature and achieving a new synthesis, all to the end of inventing unexpected formal relationships which are satisfying in themselves. He uses color—notably in his previously discussed apples—in flat, palpable planes to stress the plastic structure of the painting as a whole and to define the position of the fruit in the general compositional scheme. The unification in one frontal plane of different visual points of view and the construction of form by means of color were to become the direct inspiration of twentieth-century Cubism. Cézanne's innovations shattered, with one blow, all painting formulas based on traditional Renaissance perspective.

To disengage from traditional illusionism, Cézanne divorced line from color, discarding the pictorial conventions of drawing an outline and coloring it in afterwards or of making tonal gradations at the edge of form to establish contour. He used tentative markings to indicate form, identify line and color, and give shapes a tentative spatial location. What may have seemed an arbitrary formal system was, in fact, based on the artist's acuity of perception. To Émile Bernard he wrote: "To achieve progress nature alone counts, and the eye is trained through contact with her. It becomes concentric by looking and working. I

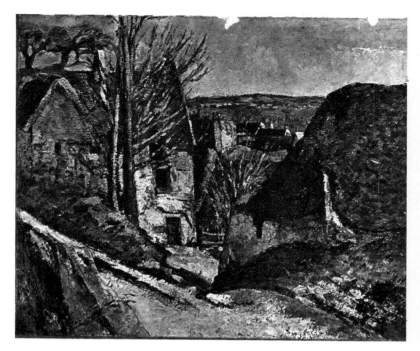

Paul Cézanne. *The House of the Hanged Man (Maison du Pendu, Auvers)*. 1873—74. Oil on canvas, 22¼ × 26¾". The Louvre, Paris.

mean to say that in an orange, an apple, a bowl, a head, there is a culminating point; and this point is always—in spite of the tremendous effect of light and shade and colorful sensations—closest to our eye; the edges of objects recede to a center on our horizon."[7] In developing his personal, expressive system and the newly ordered constructions of color forms, Cézanne remained keenly aware of the distinction between his own and the less challenging pictorial solutions of his contemporaries, among them the Neo-Impressionists. In another letter to Bernard, he commented on the abstractness and apparent incomplete state of his late paintings: "Now, being old, nearly seventy years, the sensations of color, which give light, are the reason for the abstractions which prevent me from either covering my canvas or continuing the delimitation of the objects where their points of contact are fine and delicate; from which it results that my image or picture is incomplete. On the other hand, the planes are placed one on top of the other from whence Neo-Impressionism emerged, which outlines the contours with a black stroke, a failing which must be fought at all costs."[8]

With little curved strokes of color he was able to create a richness of form which has justifiably been compared to the great Venetians of the sixteenth century. Why these forms penetrate to the deeper levels of our feelings, no one has ever entirely, or clearly, understood. Cézanne's apples, Provençal mountains, and human figures appear disguised as the most rudimentary geometries, reduced to the "cylinder, the sphere, the cone," which he advised Bernard to "seek in nature." Nature is thus reduced to a tense skeleton of form and sinks into a homogeneous color structure, every inch of which is in dynamic formal operation. His grave and

pl. 9

pl. 10

pl. 9

19

intellectually controlled art is at the farthest pole from Degas's psychological realism or Renoir's feeling for sensuous texture. But in his painting we do feel a restrained opulence, one that impresses us through the richness of pictorial means. We have learned to read in his formally complex and sensuously austere surfaces a plenitude of sensation extracted from visible nature. His schematic forms look like the merest ciphers, but they exert force just as solid, material objects do; and they are saturated in a natural atmosphere, even though that atmosphere sometimes seems dense enough to cut with a knife.

In order to achieve a balance between external nature and the exigencies of the painting on a flat surface, Cézanne had to be a master juggler. He painfully adjusted and readjusted his color dabs and rhythmic contour lines, insisting on sitting after sitting from his models, which nearly drove them to distraction. The explicit definition of the edges of forms was always just avoided lest line harden into flat decoration. He also reversed per-

spective, training his eye to the habit of concentric vision and placing the culminating point of objects in the foreground; at that point he made color richest, to use his own apt phrase. He distorted the normal pattern of optical perspective by tilting the horizontal plane of a retreating road or the mouth of a jug so that it came forward, or by bending the side of a house toward the spectator. Or he might paint a landscape from several different points of view and positions to reveal more of its surface than is normally seen. In short, he painted *conceptually* even while he faithfully included the perceptual and sensuous truth of nature.

Because the life or death of his canvas hinged on an aggregate of minute adjustments of color, Cézanne's paintings can sometimes seem either overdeveloped or too summary. An arabesque freezes, the dynamic operation of the many-faceted surface begins to exhaust the eye, or the iron rule of form and structure becomes oppressive. His towering humility before nature and a chance

Paul Cézanne. *Mont Sainte-Victoire*. 1904. Oil on canvas, 27⅞ × 36⅛". Philadelphia Museum of Art. George W. Elkins Collection. 11

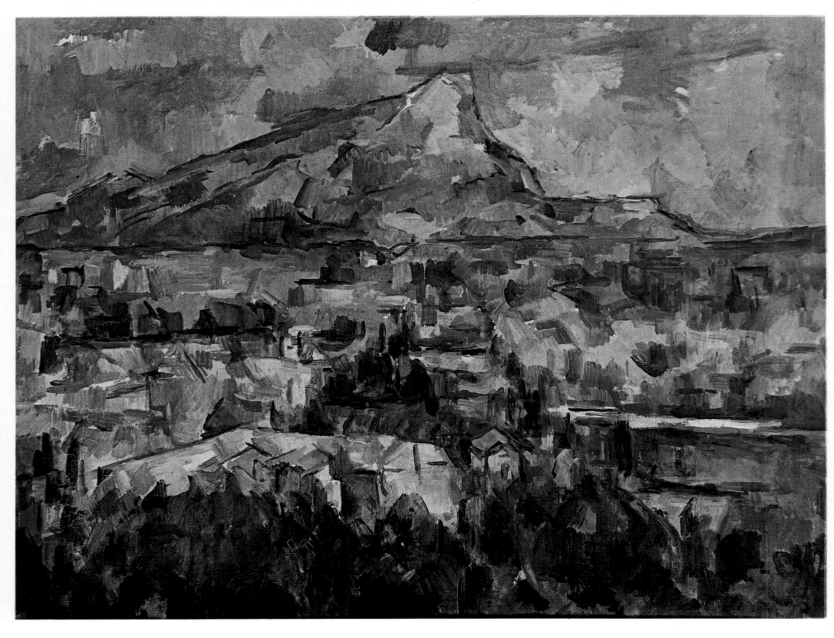

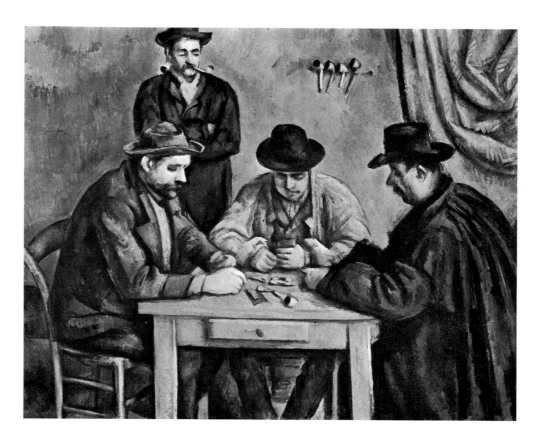

phrase in a letter to the dealer Vollard, confessing an inability to "realize," have unfortunately exaggerated these apparent failures to meet his own demanding and elevated standards. There are certain key canvases—several versions of Card Players, Bathers, Still Lifes, views of Mont Sainte-Victoire—that sum up his methods. And their meaning is enlarged if we think of even these masterpieces as thematic variations in one great fugue on nature's grandeur, and as part of an inexhaustible plastic invention.

pl. 11

The *Card Players* is a superb example of Cézanne's mature style at its most profound. The models are peasants, and the artist has characterized them with a dignity and strength that show profound respect and understanding. They give an impression of stern impassivity and durability characteristic of those who traditionally work the land. Cézanne did a number of versions of this subject, the two best known being in the Louvre and in the Metropolitan Museum of Art.

pl. 12

As a supreme example of Cézanne's formal invention, the interplay of varied pictorial elements in the Metropolitan Museum's astonishing composition is virtually inexhaustible. A cluster of repeated rosy color accents on the peasants' hands forms the vital hub of the composition. Such particularized detail at the center is in contrast to the voluminous folds of the blue cloak of the card player seated to the right and the broad sweep of the hanging drapery. One of the most remarkable inventions is the narrow, cylindrical figure of the standing peasant. With his slim torso and tiny head, he appears a relatively indistinct form, standing at some distance from the central figures; yet we *know* that he is close by, in terms of the

grouping. The illusion of his remoteness is contradicted by the fact that his dark cloak is firmly connected at the base with the shadowed areas of the peasant in brown. Like the chair, which is tilted diagonally, the standing figure relieves the compact ensemble at the table and opens up an otherwise tight composition.

Cézanne clearly felt impelled to reverse traditional perspective and spatial readings in order to bring the spectator into a more immediate relation with his own sensation. As the standing figure pushes into the front plane of the picture, while simultaneously creating distance, so the background merges with the foreground, and all the figures in the painting are projected *toward* the spectator rather than away from him, in a very "modern" effect of reverse illusionism. The front-to-back movement of traditional perspective has thus been contradicted and challenged. All the forms are rather tensely related to the rectangular frame of the painting, as well as to the frontal plane. By exercising such formal strategies, Cézanne virtually remade painting.

Despite his concentration on structure and pure pictorial values, Cézanne never relinquished the feeling for light and air that he acquired from the landscape paintings of Pissarro and the Impressionists, whom he so extravagantly lauded in his emotional letters. As his art progressed, he thinned his pigment so that the white surface lightened tones, as it may do in watercolors. During his later years he very often worked in thinned oils or watercolor in a manner that was both suggestive and abstract. In these tenuous impressions Cézanne sought to express not the accidental, shifting iridescence of nature, as the

Maurice Denis. *Homage to Cézanne*. 1900. Oil on canvas, 71 × 94½". Musée National d'Art Moderne, Paris. 13

The violent forces raging within him created many emotional crises in his life and brought on considerable personal suffering. Yet the same tremendous drive that made him exaggerate his youthful defiance and, in maturity, a certain defensiveness, also gave him the resolute strength to put his painting world in order.

Even in his early work, a refinement in color and a way with *la belle matière* made themselves felt despite the often slapdash handling and an extremely melodramatic subject matter. Influenced, in turn, by Daumier, Delacroix, Courbet, and Manet, his style went through many mutations in the 1860s. As early as 1866, he painted portraits of his father, and of an uncle dressed as a monk, with the most expressive and original color harmonies. Then, under Pissarro's guidance, he adopted Impressionist methods for a time in the 1870s and worked "violently and with all his might to regulate his temperament and to impose upon it the control of cold science."[9] A typical painting of the Impressionist period, *The House of the Hanged Man*, employs divided tones, is much less gloomy in color than the "black idyls" of the 1860s, and is thinner in paint paste. But the impasto is still more substantial than Pissarro's and already gives more solid definition to form.

pl. 10

By the end of the 1870s, Cézanne's interest in form, especially as derived from still-life objects, became all-absorbing. In the midst of the Impressionists' *succès d'estime*, he turned his back on their first principles. After 1877, he never again exhibited with them, and between that date and 1895, his paintings were unknown in Paris except to the few curious artists who sought them out at *père* Tanguy's paint supplies shop. His exhibition at Vollard's in 1895 came as a revelation to his fellow artists; it had been arranged, perhaps, as an answer to the Luxembourg Museum, which had turned down some Cézannes, among others, in the superb Caillebotte bequest of Impressionist work just offered the state. Pissarro wrote to his son: "But my enthusiasm was nothing compared to Renoir's. Degas himself is seduced by the charm of this refined savage, Monet, all of us As Renoir said so well, these paintings have I do not know what quality like the things of Pompeii, so crude and so admirable!"[10]

But the impact of Cézanne's work on the new generation was even stronger. Émile Bernard, Maurice Denis, Pierre Bonnard, Édouard Vuillard, young artists who had been painting under the influence of Gauguin's Synthetism, saw in Cézanne the ultimate repudiation of Impressionism. Maurice Denis (1870—1943) later painted a large *Homage to Cézanne*, showing several artists, Redon, Vuillard, Bonnard, and Denis among them, standing before a Cézanne still life. Denis was to describe Cézanne's work as the resolution of classical tradition and the Impressionists' spectrum palette with all it promised for individual, expressive freedom.

pl. 13

It is curious that, in his own time, Cézanne was perceived by Denis and other artists who had

Impressionists had done, but its intrinsic color in all its intensity. He settled upon Provence as his favored painting locale, at least in part because the even Mediterranean light gave a sharp, unchanging exposure to his motifs; the placid skies of Provence allowed color to burn with an undiffused brightness. And in the clarity of a southern atmosphere, Cézanne felt the sympathetic presence of the great classical masters, of Poussin and the Italians. In his own phrase, he wished to "redo Poussin after nature."

The rational and classical quality of his art is all the more remarkable in view of Cézanne's early struggles with his own exuberant and undisciplined nature. It took an enormous exercise of will to master his turbulent emotional life. The general picture of the artist, based on his mature personality, has been that of a "hyper-bourgeois" of fanatical conservatism—a solitary, entrenched in home and church and darkly suspicious of new ideas. Yet, in his youth, Cézanne was the most defiant of rebels and the prototype of the romantic Bohemian.

After an initial trip to Paris in 1861, he returned the following year in full flight from his father's banking business. His early paintings were characterized by violent fantasy and melodrama, and became the butt of much ridicule. A friend of Pissarro's, he soon met Manet and his café circle, but his uncouth meridional manners kept most of them at a respectful distance. Cézanne was also something of a *farceur* and played up his crudeness and romantic defiance of authority; he wrote stinging letters to the officials of the salons who repeatedly rejected his paintings, and once, because he hadn't bathed for a week, refused to offer his hand to Manet. At another time, he went down on his knees before Rodin and half-mockingly, half-hysterically thanked him for the privilege of allowing him, Cézanne, to shake his hand.

22

rejected the realist conception of art that prevailed for the preceding generation, as a Symbolist belonging to much the same expressive category as Gauguin and van Gogh. Denis speaks admiringly of the elements of "objective and subjective deformation" in Cézanne's art as dominant features and cites the artist's discovery of his inability to "copy nature" and his replacement of that goal with a more personal kind of statement based on "something else than that which [he] was seeing by color." For Denis and the Nabis, who were immersed in Gauguin's new esthetic theories, Cézanne became a kindred creative personality, seeking to produce representations of his own interior states through visual equivalents. In the light of dominant turn-of-the-century esthetic ideology, Cézanne was viewed as an artist striving after some kind of symbolic union between nature and thought, between observed reality and ideal life.

To the later generation of Picasso and Braque, these paintings took on yet another meaning and became the point of departure for a more arbitrary, purely formal art which almost entirely dispensed with recognizable subject matter. Cézanne's magnificent *Boy in a Red Vest* can be compared to the Cubist paintings in its abstract design, complex interplay of geometric forms, and structural felicities. And the Great Bathers compositions were a direct inspiration of Picasso's watershed painting, *Les Demoiselles d'Avignon*, which announced the radical new pictorial strategies of Cubism.

Shortly before his death, Cézanne had declared, "I am the primitive of a new art." The character of that new art became clear, however, only in the early decades of the twentieth century. Cézanne's profound revolution hung in abeyance for a period of some twenty years between 1886 and his death. In that interval, the destiny of painting was in the hands of other personalities, and the art scene was dominated by other forces.

pl. 14

Paul Cézanne. *The Great Bathers*. 1898—1905. Oil on canvas, 82 × 99″. Philadelphia Museum of Art. The Wilstach Collection. 14

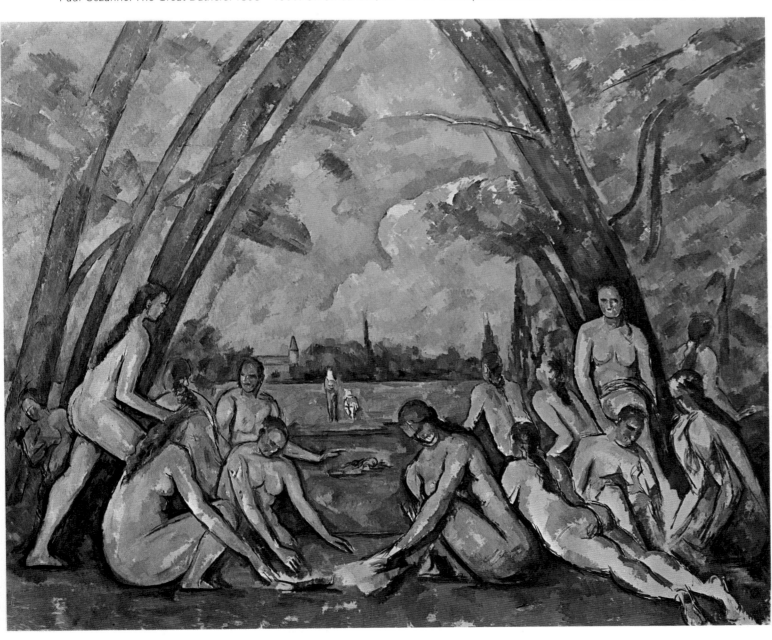

SYMBOLIST PAINTING AND ART NOUVEAU

The climate of art began to change noticeably in the 1880s with the crisis in Impressionism, and with the emergence of the new literary and artistic doctrine of Symbolism. Many of the Impressionists openly acknowledged their dissatisfaction with the informal character of their own painting and its passive registration of mere optical sensation. The need for a more spiritual or emotional approach in art was as evident in the expressive theories underlying Cézanne's premeditated structures and Seurat's science-oriented Neo-Impressionism as in the more subjective attitudes of the work of van Gogh and Gauguin after 1888. The term Post-Impressionism, coined in the twentieth century by the British art critic Roger Fry, is too imprecise to describe as a group artists so distinct in style and thought as Cézanne, Seurat, Gauguin, and van Gogh. Cézanne and Seurat concerned themselves with an essential pictorial order, though each was in debt to Impressionism for its release of color. Vincent van Gogh and Odilon Redon, in their separate ways, and Paul Gauguin and the painters around him, drew their support from the current of literary Symbolism. They were interested in converting art into a vehicle for more personal emotions, for fantasy, reverie, and dream. Within the two major camps that succeeded the Impressionists—the Neo-Impressionists and the Symbolists—were a number of significant divisions, or subgroups, defined by the individual manner of the artist. New meanings were being sought by artists of different styles, but all were moving away from classic Impressionism. The new styles might, in turn, be described as academic, primitive, esthetically refined, philosophically weighted, or, indeed, mixtures all of all of these.

In this period of shifting artistic values, three little-regarded figures who had pioneered literary subject matter and fantasy in their exhibited art of the 1870s emerged from their comparative isolation to a new prominence—Gustave Moreau, Pierre Puvis de Chavannes, and the young Odilon Redon. In their hands, and in those of the growing ranks of emulators of the 1885 generation, a bizarre, new romantic beauty came to birth and with it a revised conception of the artistic process. The first conclusive public expression of the new artistic viewpoint appeared in a sensational novel of 1884 written by Joris-Karl Huysmans, *Against Nature (A Rebours)*. That influential book set forth the essential credo of the new spiritualism two years in advance of the Symbolist movement's official birth in the form of Jean Moréas's Symbolist Manifesto, which was issued in 1886. Arthur Symons hailed Huysmans's novel as the "breviary of the decadence"—the literary movement in France and England characterized by delight in the perverse and the artificial, a craving for new and complex sensations, and a desire to extend the boundaries of emotional and spiritual experience. The year 1884 also saw the formation of the Belgian association of artists, the XX, and although it had no consistent esthetic program, this group soon became the respected sounding board for new forms of advanced art, including Symbolist painting. In Paris in the spring of that year, another blow was struck at the old order and at the more romantic Impressionists especially, as Pissarro later described Renoir, Monet, and others, with the formation of a rival group, the Society of Independent Artists, one of whose leaders was Redon. The society's first exhibition included Seurat's *Bathers*, a painting ridiculed in the press, rather interestingly, as "un faux Puvis de Chavannes."

In his Symbolist Manifesto Jean Moréas singled out for special attention as father figures of the movement three poets: Baudelaire, Mallarmé, and Verlaine. Of the literary giants of Symbolism Moréas wrote: "Charles Baudelaire should be considered the true precursor of the present movement... Stéphane Mallarmé endowed it with a sense of the mysterious and the inexpressible; Paul Verlaine shattered in its honor the cruel chains of verse which the subtle fingers of Théodore de Banville had already made more flexible."[1] The major features of the Symbolist position in painting as well as poetry can be traced to these three poets. The element of subjectivity acknowledges,

Paul Gauguin. *The Yellow Christ*. 1889. Oil on canvas, 36⅜ × 28¾". Albright-Knox Art Gallery, Buffalo. 15

above all, Baudelaire's concept of the poetic imagination as a repertory of symbols of a transcendental reality to which the artist has special access. From Mallarmé, the Symbolists gained sanction for one of their primary aims, to intimate things rather than state them directly. Verlaine's pious verse and musical diction, which dissolved sense in sound, confirmed, in terms of religious belief, Mallarmé's esthetic objectives by calling upon poets to explore the transcendental truths that lay behind the visible world.

Finally, Schopenhauer's oft-repeated view that the world was merely a representation and thus the product of subjective imagination became the basic intellectual rationale for the new mood of spiritual adventure. His philosophical writings also encouraged a pessimism of outlook in its darkest form, suitable to the despairing moods and the cultivation of personal eccentricity in behavior that became familiar features of the 1890s.

Moréas's more restrained and abstract statement of the Symbolist esthetic also draws directly upon Schopenhauer's idealism. "Symbolist poetry," wrote Moréas in his manifesto, "endeavors to clothe the Idea in sensitive form." [2] Sometime later, answering attacks upon the controversial new artistic doctrine, the poet Gustave Kahn asserted: "As to subject matter, we are tired of the quotidian, the near-at-hand, and the compulsorily contemporaneous; we wish to be able to place the development of the symbol in any period whatsoever, and even in outright dreams The essential aim of our art is to objectify the subjective (the externalization of the Idea) instead of subjectifying the objective (nature seen through the eyes of a temperament)." [3] He thus succinctly expressed the essential differences between the liberties that the Impressionists took with nature for the sake of spontaneity and the far more arbitrary and subjective moods of Symbolist invention.

In defining the distinctive character of the Symbolist movement in both the visual arts and literature, it is useful to compare its helplessly egocentric focus with the more outgoing stamp of earlier manifestations of nineteenth-century Romanticism. The militancy of Romantic poets and painters contrasts sharply with the morbid inaction and esthetic specialization of the Symbolists. Their subjectivity took a deliberately escapist route. Essentially, the Symbolists set themselves against the facile extroversion of the age. Turning away from social action and from the triumphs of science and technology, they preferred a dreamworld of languid beauty or one of elaborate and stylish artifice to the vulgar present. Oscar Wilde was later to predict the success of a decadent Romanticism in his essay "The Decay of Lying": "Facts will be regarded as discreditable, Truth will be found mourning over her fetters, and Romance, with her temple of wonder, will return to the land." [4] An even more dramatic and revealing rejection of the *engagé* heroism of early Romanticism was conveyed in a disillusioned and fanciful letter from the Belgian Symbolist poet Émile Verhaeren to Redon, which read in part: "I fly into a fury with myself because every other form of heroism is forbidden to me. I love things that are absurd, useless, impossible, frantic, excessive, and intense, because they provoke me, because I feel them like thorns in my flesh." [5]

With such abundant literary and philosophical support for the Symbolist position, the overlooked "idealist" paintings of the 1860s of Pierre Puvis de Chavannes (1824—1898) and Gustave Moreau (1826—1898) began to recapture the public imagination. Puvis and Moreau had been the only artists of their generation to introduce a new kind of subject matter, poetic in inspiration yet opposed to the traditional iconography and mythologies that satisfied Delacroix and Ingres. They had encountered harsh criticism and appeared isolated from contemporary painting. Moreau had become something of a recluse until the younger Symbolist painters revived his languishing reputation. Puvis kept bringing his ambitious allegorical frescoes and smaller easel paintings before the public, but found little encouragement in its response. In the 1880s, when the need for a spiritual approach to painting manifested itself, however, a new generation rallied around these idealist artists. The appeal of Puvis, Moreau, and Redon coincided with the emergence of Victorian Symbolist painting and its public triumph in England under the Pre-Raphaelites, whose reputation had already reached the continent. The remote world of legendary romance contrived by Edward Burne-Jones (1833—1898) and Dante Gabriel Rossetti (1828—1882) especially conferred new prestige on the

pl. 16

pl. 17

Gustave Moreau. *Chimeras (Satanic Decameron)*. 1884. Oil on canvas, 92⅞ × 80¼". Moreau Museum, Paris. 16

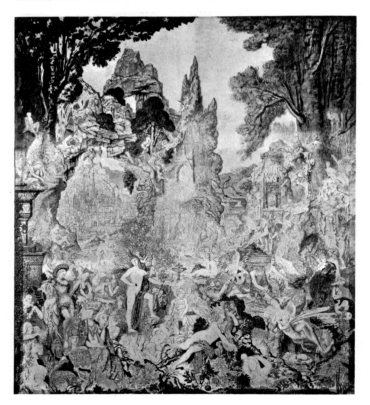

26

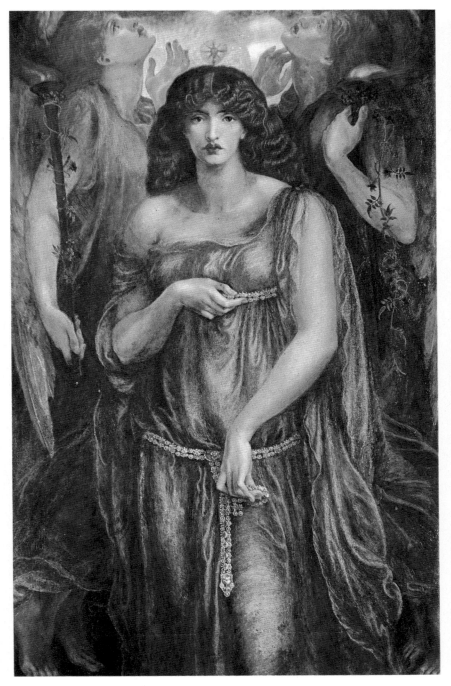

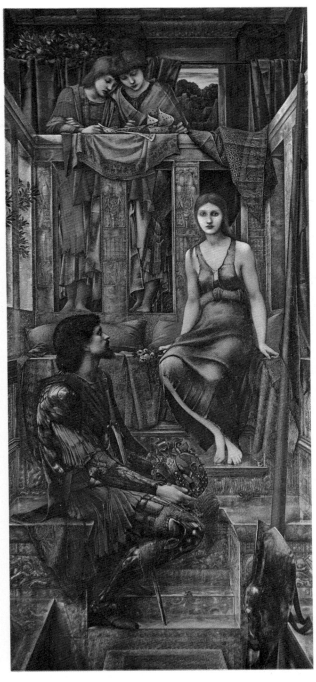

Dante Gabriel Rossetti. *Astarte Syriaca*. 1877. Oil on canvas, 72 × 42".
City Art Galleries, Manchester. 17

Edward Burne-Jones. *King Cophetua and the Beggar Maid*.
1884. Oil on canvas, 9' 7½" × 53½". Tate Gallery, London.
 18

French idealist painters of the 1860s, for it similarly offered a vision of "beautiful romantic dreams" to counter the noisy and banal age of progress. Both tendencies had obviously long been out of tune with dominant realist or Impressionist modes, until the climate of art began to shift once more toward a painting of ideas.

The French discovered the Pre-Raphaelites William Holman Hunt and John Millais at the Universal Exhibition of 1855 in Paris.[6] Many of the minor Symbolist artists in Paris were directly influenced, and turned to the Pre-Raphaelites for a new image of beauty, as they did to William Morris (1834—1896) for a new decorative style, and later, to Aubrey Beardsley (1872—1898) for his provocative draftsmanship and decadent themes. A key figure, Burne-Jones first showed in Paris at the International Exhibition of 1878, and thenceforth began to enjoy a considerable reputation abroad. His combination of spiritual content with the cult of primitive style appealed to a jaded artistic public, discouraged by the dominant materialism of the age and openly seeking refuge in a world of fantasy. Puvis said he never forgot Burne-Jones's *King Cophetua and the Beggar Maid*, pl. 18 in the 1889 Paris International Exhibition.

Rossetti's obsessive, mediumistic pictures of his model, mistress, and finally, wife, Elizabeth Siddal, as early as 1850 had prophesied the fatal Medusan beauty later characteristic of the French Symbolist female temptress. This was, for the most part, the same ambiguous female whom Walter Pater discerned in the *Mona Lisa* in his *Studies in the History of the Renaissance* (1873): "A beauty 27

wrought out from within upon the flesh, the deposit, little cell by cell, of strange thoughts and fantastic reveries and exquisite passions." And concluding his overwrought passage on the new beauty of the age which was to inspire countless poets and painters, with words apropos of both the nostalgic and the emancipated aspects of the later Symbolist heroines, Pater wrote, "Certainly Lady Lisa might stand as the embodiment of the old fancy, the symbol of the modern idea."[7] Pater's Lady Lisa was in fact a curious mixture of *femme fatale* and sacrificial victim, empress and

erotic slave, fragile androgyne and raving maenad. She anticipates new types of expressive womanhood found again and again in paintings of the period—with varying degrees of psychological or decorative emphasis—by Jan Toorop (1858—1928), Ferdinand Hodler (1853—1918), Gustav Klimt (1862—1918), Aubrey Beardsley, Johan Thorn Prikker, and many other Symbolists. It was in the context of such imagery that Moreau, Puvis, and Redon, heretofore considered archaic and retrograde or stigmatized as primarily literary painters, came to enjoy their new prestige.

pl. 20

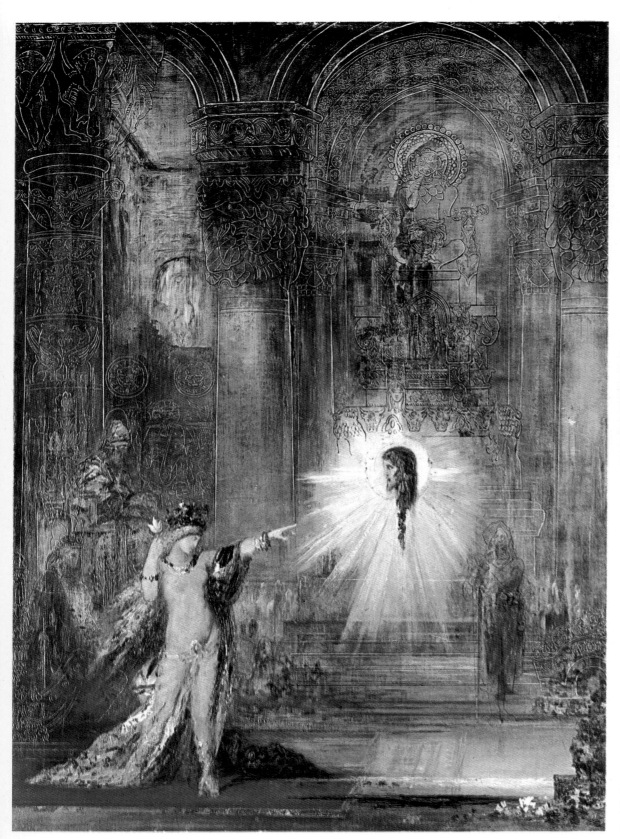

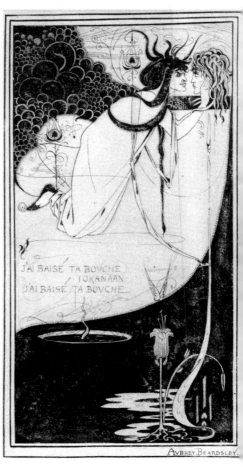

Aubrey Beardsley. *"J'ai baisé ta bouche Jokanaan."* 1893. Preliminary drawing for Oscar Wilde's *Salomé.* Ink and watercolor, 10⅞ × 5¾". Princeton University Library. 20

Gustave Moreau. *The Apparition.* c. 1876. Oil on cardboard, 12½ × 19⅜". Moreau Museum, Paris. 19

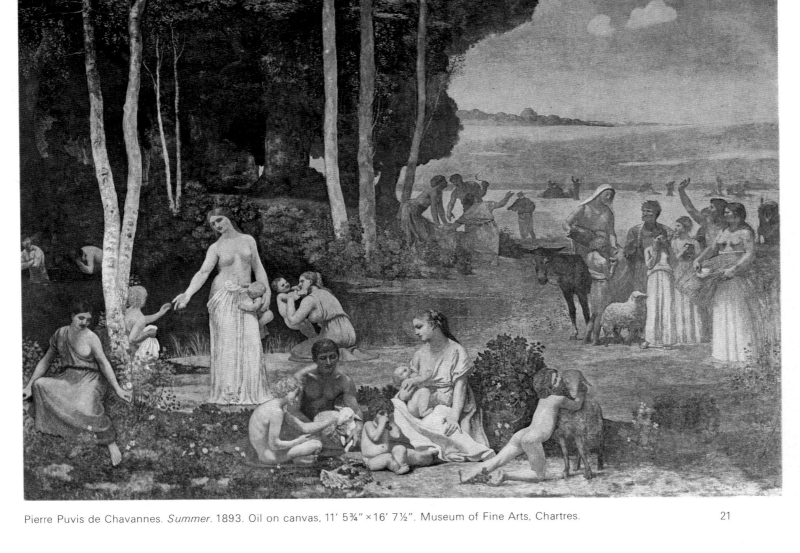

Pierre Puvis de Chavannes. *Summer*. 1893. Oil on canvas, 11′ 5¾″ × 16′ 7½″. Museum of Fine Arts, Chartres.

pl. 19

As early as 1876, in his painting *The Apparition*, Moreau summarized, in an image of rich sensuality, many of the concepts that linked the melancholy beauty of the Pre-Raphaelites with his own native poetic tradition depicting the fatal woman, for example, Baudelaire's *femme damnée* described in *The Flowers of Evil*:

> Thou'dst take the world to bed with thee, vile woman!
> Thy boredom makes thy soul the more inhuman.
> To keep thy fangs fit in the curious sport,
> Each day thou need'st a man's heart freshly caught.[8]

Moreau's painting combines a hallucinatory mythic subject matter with the conscious attempt to achieve his own stated objectives of a "beauty of inertia" and a "necessary richness" of pictorial effect. His spangled, jeweled color and voluptuous imagery sent Huysmans into a paroxysm of rhapsodic description in *Against Nature*. The elaborate technique of loaded paint application, tumescent forms, and erotic fantasies conspires to lend his mythic scenes the quality of mystery and scandal admired by succeeding Symbolist poets and painters. Moreau introduced into the Paris art world the visual image of pitiless womanhood, the first in a long line of sadistic females in art, from Edvard Munch (1863—1944) and Klimt to Egon Schiele. The prototype can be regarded as the reigning goddess of the Decadents, a bizarre and voluptuous image, dominated by the twin forces of eroticism and mysticism.

Just three years earlier, in his painting *Summer*, given the place of honor in the 1873 Salon, Puvis seemingly had set himself in clear opposition to Moreau's extravagant fancies with his simple pastoral scene, characterized by naive handling and archaic style. The agitated and fantastic portrayal of Salomé as a wicked goddess of lust appeared remote from Puvis's mood of innocence. Yet, the two works are linked at least by their neotraditional pictorial styles and iconography; they share a revivalist myth-making effort contrary to the literary Naturalists and the Impressionists, with their exclusive interest in modern life. As a critic of the times noted, Puvis's summer season is nonspecific and nostalgia-laden, a dream of some haunting Golden Age: "Summer in that eternal country where the artist's soul lives; feelings are no less acute in that country, merely more generalized."[9] Here, then, was perhaps the first definition by an art critic of Symbolism in painting, underscoring its vague and universal character, and the yearning for an ideal world as escape from the unsatisfactory actual moment which the realists and Impressionists innocently celebrated.

Elevated to heroic status by the painters and

pl. 21

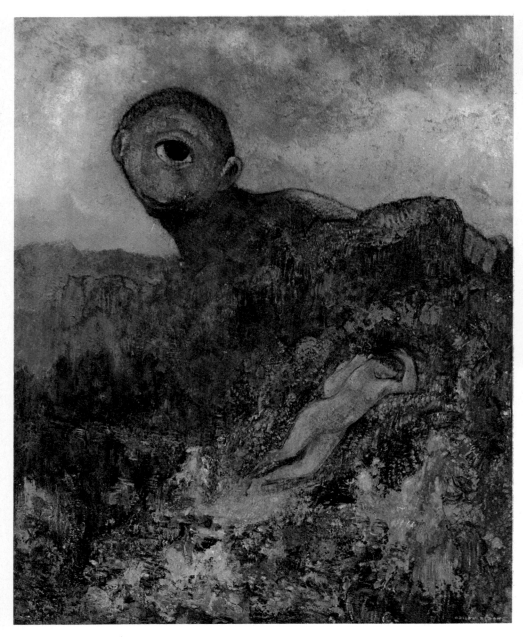

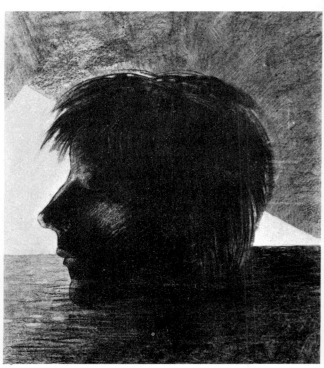

Odilon Redon. *Head of Orpheus Floating on the Waters.* 1881. Charcoal on paper, 16⅛×13⅜". Kröller-Müller Museum, Otterlo. 23

Odilon Redon. *Cyclops.* c. 1895—1900. Oil on wood, 25¼×20". Kröller-Müller Museum, Otterlo. 22

poets of the 1880s, despite his rather sterile academicism, Puvis conceived an idyllic art that would contain a generalized content without the use of classical personification, allegorical attributes, and other outmoded devices of traditional art which no longer commanded public credence. The fruit of this would, to his mind, be an ennobling art immediately comprehensible to all viewers. He wrote: "For all clear thoughts there exists a plastic equivalent A work of art emanates from a kind of confused emotion I meditate upon the thought buried in this emotion until it appears lucidly and as distinctly as possible before my eyes, then I search for an image which translates it with exactitude This is symbolism, if you like."[10]

Despite his willingness to identify with Symbolism, Puvis remained bound to tradition, to historical and allegorical painting. Although Symbolism was certainly mixed in plastic, spiritual, and psychological motivation, its distinguishing mark in painting was not, in fact, spiritual content but the new relationship *between* form and content. Émile

Bernard made this clear: "Thus form and color become the most important elements in a work of art. The artist's role was to reduce every form to its geometrical base in order to allow its mysterious hieroglyph to emerge more clearly In contrast to the classical artist, the symbolists sought to find and emphasize the significant distortion."[11]

Odilon Redon (1840—1916) felt himself sympathetically drawn to Puvis's vision and aims, but he translated his own emotion and dream into visual symbols more in keeping with Bernard's formulation. Although his art is heavily loaded with literary allusions, and he sensitively illustrated Flaubert, Poe, and Huysmans, among others, still his art is closer to the plastic invention of Gauguin than to the naive mythologies of Puvis or the intricate literary archaeology of Moreau. Many of the younger Symbolist writers, such as Gide, Valéry, and Jammes, regarded Redon as the Symbolist artist par excellence, the man who found convincing plastic formulations for his vision and philosophy of life. The Nabis revered him, and

pl. 13 Maurice Denis honored him in his *Homage to Cézanne*.

Redon's originality, in his own words, was "in placing . . . the logic of the visible at the service of the invisible."[12] Passing through some kind of mystical experience in the 1870s, he seemed compelled to explore the depths of soul. He invented a mysterious world of infinite spaces, limitless vistas of land and sea, strange growths, and monstrous apparitions. Unlike some of his compatriots, however, he felt that plastic invention, as he put it, began where literature left off. His smiling,

pl. 22 hideous *Cyclops* has the disarming gentleness and sorrowful mien that had become one of the hallmarks of Symbolist imagery, an involuntary melancholy that somehow joined the strange and fantastic with a sympathetic human yearning for the unattainable. As in the severed and trans-

pl. 23 figured head of Orpheus in one of his delicate drawings, many of these monstrous creatures seem to embody visual analogues for the dilemma of the alienated artist enduring a lonely exile from the protective community of mankind.

The Belgian painter Fernand Khnopff (1858–1921) provides one of the more extravagant examples of the tormented visions and erudite Romantic iconography explored by the literary Symbolist

pl. 24 painters. His most famous painting was *I Lock My Door Upon Myself*, a work inspired by a line of Christina Rossetti's poetry. The face of his female subject represents both the artist's beloved, dead sister whom he painted repeatedly and the Medu-

sa, while the classical cast suggests a preoccupation with death and a lost antiquity, anticipating the Surrealist imagination. The window in the painting opens onto a dead city, evoking a vacant de Chirico piazza. Khnopff, significantly, had been Moreau's pupil in 1879; he was infatuated by the Pre-Raphaelites and showed in the first Rose + Croix Salon of 1892 in Paris.

One of the most bizarre phenomena of the Symbolist episode were the six Rosicrucian salons organized between 1892 and 1897 by the outrageously eccentric and picturesque literary figure Joséphin Péladan, whose bogus spiritualism, provocative manner, and eccentric sartorial style attracted, understandably, the more visionary and irrational of the decadent Symbolists. Among them was Khnopff, whom he hailed as "the equal of Gustave Moreau, of Burne-Jones, of Chavannes and of Rops."[13] For weaker or more self-indulgent personalities, who embarked on the Symbolist adventure, a private dreamworld became an open invitation for literary reveries in a gilded style. The religious mysticism of the Rose + Croix group, led by their self-appointed messiah, the Sâr Péladan, some of Moreau's tortuous imagery and ornamental surface, and Puvis de Chavannes's pallid Pre-Raphaelite Arcadia were at worst symptomatic of the bloodless, introverted styles that characterized the Romantic decadence. In another example, Eugène Carrière (1849–1906) expressed the melodramatic anguish of the artist with a celebrated Rodin litho-

Fernand Khnopff. *I Lock My Door Upon Myself*. 1891. Oil on canvas, 28⅜ × 55⅛". Bayerisches National Museum, Munich. 24

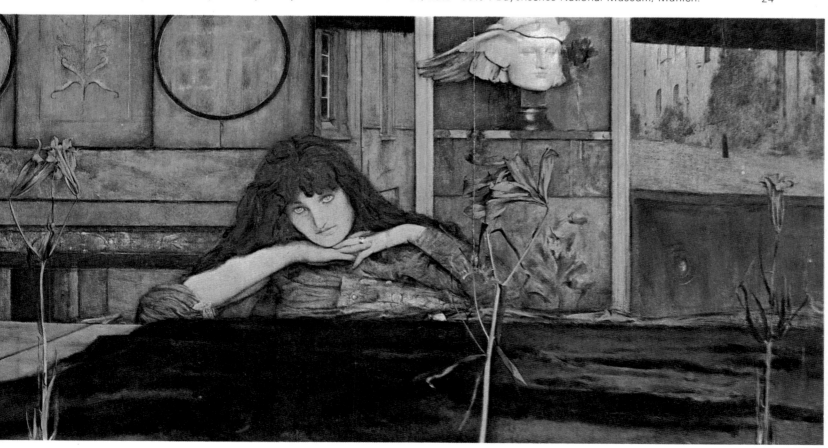

graph, whose vagueness and twisting ectoplasmic forms, very much like those of Munch, characterize so much Symbolist art. The dim and misty portrait of the writer Georges Rodenbach by Lucien Lévy-Dhurmer (1865—1963) is another rather morbid and indulgent Symbolist confection, a portrait of a figure who typified the period's self-fascinated dandy in his nostalgic attachment to the ancient city of Bruges, which forms the background for his portrait. The mildness of the visual image scarcely plumbs the depths of narcissism suggested by Camille Mauclair's description of the subject: "He had very little interest in life, and was full of crepuscular dreams, religious images, sickness and suffering; but he hid these deep-seated wounds beneath an elegant exterior."[14] Set against the work of Gauguin and van Gogh, that of Carrière, Lévy-Dhurmer, and others who matched their wistful literary interests may seem vapid or frivolous. They are minor, but representative, accents in a still-unresolved creative moment in which bold new affirmations and a decadent Romanticism competed for critical attention.

The more esoteric literary aspects of the Symbolist movement held out an ambivalent promise for the major French Post-Impressionist painters who reached maturity in the last two decades of the century. Perhaps Paul Gauguin (1848—1903) felt closest to its major figures and ideas, but even he made his independence clear. Although he paid homage to the Symbolist poets in word and image, counted himself a friend of Mallarmé's, and frequently attended his literary soirées, he did not follow their program uncritically. The literary Symbolist coterie enthusiastically took up Gauguin after his Café Volpini exhibition of 1889, but he repeatedly made clear his distaste for those painters they particularly admired, like Moreau and Puvis, whose methods and use of imagery he compared unfavorably with his own. Gauguin always drew critical distinctions in his paintings between literary content and plastic invention. The Impressionists' rainbow palette and sensuous, painterly brushstroke continued to influence his art, as did their basic respect for material medium. Art, Gauguin declared, was an abstraction to be dreamed in the presence of nature, but impeding that fantasy were the oppressions and the corrupting influence of modern European life, a life Gauguin now abhorred as passionately as the Impressionists had uncritically celebrated its innocent middle-class pleasures. The old rapport with bourgeois values and life-styles was dissolving. To the critic André Fontainas he complained bitterly, in a letter of 1899, of public indifference to the modern artist: "We painters, we who are condemned to penury, accept the material difficulties of life without complaining, but we suffer from them insofar as they constitute a hindrance to work. How much time we lose in seeking our daily bread! The most menial tasks, dilapidated studios, and a thousand other obstacles. All these create despondency, followed by impotence, rage, violence."[15]

The founders of the Impressionist movement had been, without exception, men of rude health, vigorous in body, sound of mind, sober in habit. And there was a corresponding simplicity, serenity, and sanity in their paintings despite the bitterest of economic struggles. They perceived the world about them as a healthy social organism, and delighted in translating the spectacle of middle-class life and nature into a rapturous pictorial imagery. They were able to establish a common ground with their fellow men in a shared body of ideals and generous feelings. The Post-Impressionists, especially Gauguin, van Gogh, and Lautrec, different though they were in their lives and art, inhabited a new and ambiguous moral atmosphere. They no longer put their trust in common life, and they did not form among themselves a sustaining Bohemian community—a twentieth-century development that made artistic isolation bearable. The pursuit of artistic objectives for their own sakes was not considered a sufficiently compelling *raison d'être* for the artist, unless he engaged in the dandyish posturing of the more extravagant Symbolists. If he could not make peace with European society, he had either to rage at it in lonely martyrdom or invent an ideal community in the South Seas or in Christian brotherhood, to which he might consecrate his life.

Like Gauguin, whose new pictorial formula and attitude were to have a revolutionary impact on the art of his time, van Gogh already regarded himself as something of a messiah figure, the prophet of a new morality as well as an art of direct emotive power. Some of his torment is captured in the sorrowful mien of the haunting portrait of his psychiatrist and friend, Dr. Gachet. In pl. 26 contrast to van Gogh, who conceived of art as a means of improving the lot of mankind, Lautrec expressed in his work a search for moments of intense physical and psychic sensation in a world devoted to carnal pleasure and threatened with inevitable annihilation. He could almost envisage himself as the embodiment of Oscar Wilde's prefatory aphorism for *The Portrait of Dorian Gray*: "The artist can express everything Vice and virtue are to the artist materials for an art It is the spectator, and not life, that art really mirrors."[16] Lautrec's sexual candor in his portrait of two lesbians, *The Bed*, aborts conventional morali- pl. 42 ty in favor of the visual truths of expressive art.

Lautrec died of a stroke brought on by alcoholic excess at the age of thirty-seven, the same age at which van Gogh took his own life. And Gauguin died at fifty-five of heart disease and neglect on a remote Pacific island. Their brief careers represent a tragic and heroic effort to find a place in a world which was not receptive to the progressive artist. Their fragmented and self-destructive personal lives also represent the first symptoms of a period of cultural crisis that persists to this day.

Paul Gauguin had begun to paint as a gifted amateur in 1873 while pursuing a very successful business career with a Paris brokerage firm. His interest in painting was first stimulated by the

Paul Gauguin. *Self-Portrait, "Les Misérables."* 1888. Oil on canvas, 28⅛ × 35⅝". Stedelijk Museum, Amsterdam. 25

Vincent van Gogh. *Portrait of Dr. Gachet* (second version). 1890. Oil on canvas, 26¾ × 22½". The Louvre, Paris. 26

Impressionists, whom he met soon afterward through his friend and first teacher, Pissarro, and he became a modest but discriminating collector of their paintings. One of the canvases he remained attached to was a still life by Cézanne, which he apparently kept with him always and even introduced into the background of one of his portraits. In 1876, Gauguin had a little landscape accepted by the Salon, and he felt encouraged to give more and more attention to painting until finally, in 1883, at the age of thirty-five, he resigned his position on the stock market to devote himself exclusively to art. He took his Danish wife and their children to Rouen, where life promised to be cheaper, but the experiment proved to be a failure. When he went to Copenhagen to stay with his wife's family and try his hand at business once again, the results were even more disastrous. He antagonized his wife's relatives by his arrogance, and his efforts to sell tarpaulins to the Danes for a French firm were as unsuccessful as his efforts to find a new market for his paintings. Gauguin left his wife behind and returned to Paris with the understanding that the family would be reunited when better days came along, but the separation became permanent as his commitment to painting grew.

In Brittany in 1888, Gauguin arrived at his original style after an apprenticeship in a soft,

formless Impressionist manner. The *Self-Portrait* pl. 25 *"Les Misérables,"* painted in Brittany and given to van Gogh, already shows him in the ambivalent role of martyred Christ, with the floral decoration forming a halo; and yet the facial expression suggests ferocity of character against the background symbolizing purity. He was attracted to this remote corner of France by the primitiveness of the life and the savage desolation of the landscape. He felt at home in Brittany because it also, to a degree, had the appeal of the exotic and was inhabited by a simple, pious people whose nature the Symbolists were to equate with soul, or spirituality. "When my wooden shoes ring on this granite, I hear the muffled, dull, powerful tone I seek in my painting,"[17] he wrote his friend the painter, Émile Schuffenecker, early in 1888.

At Pont-Aven, in a little inn frequented by other impecunious artists whose company and talents the morose and egocentric Parisian scorned, Gauguin began to paint with strong expressive outlines and in the bright, patterned colors that were to become characteristic of his later works. The word Synthetism soon figured in his conversations and descriptions of his work. It defined a less imitative approach to nature, a technique of reducing forms to their essential outlines and arranging them with a new simplicity in brightly colored, flat patterns.

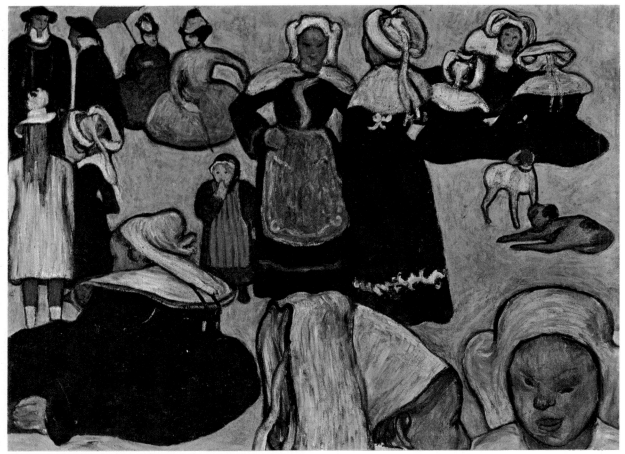

27

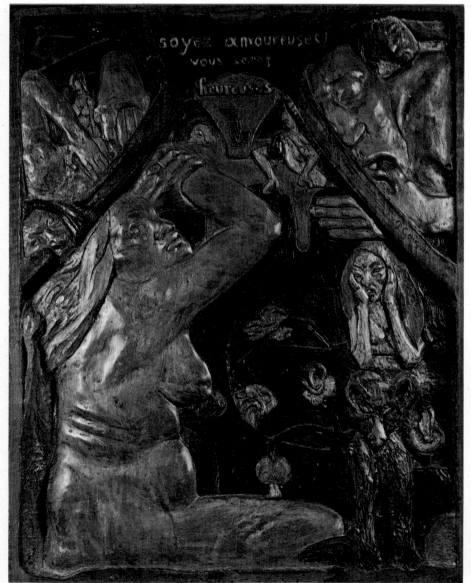

Émile Bernard. *Market in Brittany (Breton Women in the Meadow)*. 1888. Oil on canvas, 29⅛ × 36¼". Private collection, France. 27

Paul Gauguin. *Be in Love and You'll Be Happy*. 1890. Painted wood relief, 37½ × 28⅝". Museum of Fine Arts, Boston. 28

Paul Gauguin. *The Vision After the Sermon (Jacob Wrestling with the Angel)*. 1888. Oil on canvas, 28¾ × 36¼". National Gallery of Scotland, Edinburgh. 30

Paul Gauguin. *Nirvana (Portrait of Jacob Meyer de Haan)*. c. 1890. Gouache, 8 × 11½". Wadsworth Atheneum, Hartford. Ella Gallup Summer and Mary Catlin Summer Collection. 29

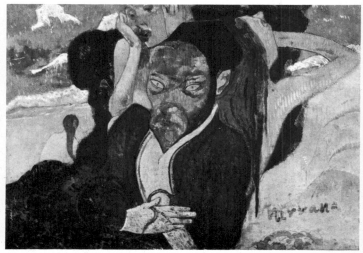

By 1889, Gauguin had completely abandoned the amorphous shapes and graduated color of Impressionism for a crisp and more arbitrary definition based on his new theories. He and a young painter friend, Émile Bernard (1868—1941), who had joined him in Brittany, declared that their intention was to "paint like children." Gauguin's work of the period has all the quality of naive, children's art: bright, gay colors, dramatic patterns, an apparent disregard for proportion or natural coloration, and the substitution of distorted shapes or elliptical references in place of natural appearances. Despite their apparent crudity, and obvious effort to recover a simpler, infantile vision, there was nonetheless a good deal of intellectual sophistication behind these paintings.

Gauguin wished to recover in, and through, painting the fundamental aspects of existence. He felt acutely the desiccation of instinct, as had so many sensitive, overcivilized moderns in the industrial age, and he welcomed the unsophisticated culture of the Breton peasants. But he also sought a new expression for the intangible and mysterious aspects of esthetic experience, in full awareness of the theory and practice of contemporary Symbolist literature. His art is suffused with the subtle, imaginative shadings and enigmatic subject matter typical of Symbolism, and there is evidence of some personal demonology. These traits characterized the most refined literary creations and the more elaborate examples of pictorial Romanticism of the period. With the poet Mallarmé, his contemporary literary champion and friend, Gauguin would no doubt have entirely agreed that the artist must proceed obliquely. Of the Impressionists' direct address to life the painter spoke scornfully: "They look for what is near the eye, and not at the mysterious centers of thought.... They are the official painters of tomorrow."[18] And in his most famous letter, he told his confidant Schuffenecker on August 14, 1888: "Don't copy nature too much. Art is an abstraction; derive this abstraction from nature while dreaming before it, and think more of the creation which will result."[19]

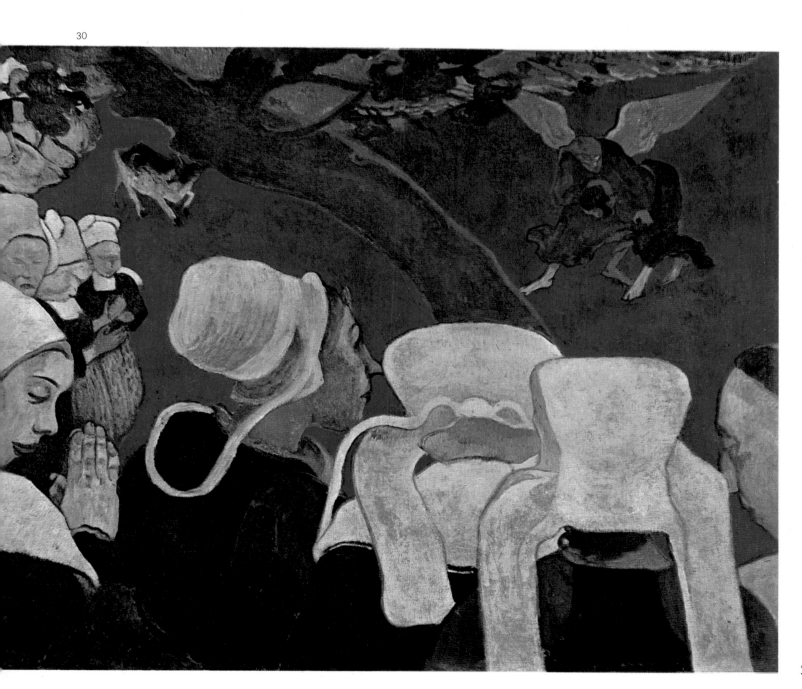

30

35

Gauguin's conflict between a deliberately uneducated style and preciosity, between the urge to get back to fundamentals and a romantic escapism, reflects a typical *fin-de-siècle* ambivalence. In Brittany and then in the primitive environment of Oceania, he found and re-created an authentic reality that funneled off his fantasies into a new myth. While Gauguin registered his protest against industrial society to some degree in the spirit of an escapist and romantic nostalgia by forsaking Europe for the South Seas, in an even more profound and positive sense he utilized plastic means to make his point. He dreamed of reviving a precivilized, mystical unity between man and nature, but at the same time he set out to create works that went beyond the convention of easel painting, works whose frankly mural character endowed art with the potential of monumental decoration and a new public significance. If the artist could not control his actual environment, Gauguin seemed to assert, he could at least paint works of art which, by their nature, created an ideal environment. His approach to an art of a

more decorative and public character became the basis for a new esthetic program elaborated by his numerous followers.

Two of the most influential examples of Gauguin's revolutionary outlook were the paintings he made upon his second and third trips to Brittany, in the years 1888 and 1889: *The Vision After the Sermon* and *The Yellow Christ*. Undoubtedly *The Vision* was directly influenced by Gauguin's encounter with Bernard's new works, such as *Market in Brittany (Breton Women in the Meadow)* with its unmodeled, heavily outlined, and simplified figures placed on a flat abstract ground. *The Vision After the Sermon* represents the first widely noted and dramatic departure from Naturalism, far outdoing Seurat's fanciful visual inventions in its figure distortions, emotionalism, and arbitrary, if vividly expressive, palette. One of the most startling and novel aspects of the work, apart from its abstract and flat color shapes, is the abrupt psychological division of surface between the vision of Jacob wrestling with an angel, which is the spectator's fantasy, and the actual group of credulous

pl. 30

pl. 15

pl. 27

peasants huddled in the foreground. The following year, in several compositions inspired by Breton stone crucifixes and by a wood Christ in the chapel of Trémalo near Pont-Aven, Gauguin tried to capture a "great and rustic superstitious simplicity," in order to liberate himself from an oversophisticated esthetic and from the Impressionists' faithful record of nature.

An important facet of Gauguin's ideas, which helped enforce his revision of painting's syntax, was the element of diabolism. His subject matter attempted to challenge existing systems of good and evil and establish him as a messiah figure—prophet of a new morality as well as a new art. pl. 29 Thus, in *Nirvana (Portrait of Jacob Meyer de Haan)*, he created an almost naively didactic, Symbolist portrait of his friend and fellow painter. The rather sinister-looking artist has virtually been transformed into a primitive idol, a visual prototype of the enigmatic "dark gods" which Gauguin (like D. H. Lawrence, among others after him) admired openly as a life-giving force. In this imaginary, equivocal Eden, two wan, disconsolate Western

Eves wail and avert their eyes in shame at their nudity. They are the guilt-ridden, "civilized" Eves whom the artist later, in a letter to the writer August Strindberg, compared so scornfully with his sensual and unashamed pagan female figures from Tahiti: "that ancient Eve, who frightens you in my studio."

In 1888, following Gauguin's revolutionary new teachings, the painter Paul Sérusier (1863—1927) pl. 31 had come back from a summer in Brittany with a cigar-box lid on which he demonstrated to Pierre Bonnard (1867—1947) and Édouard Vuillard pl. 32 (1868—1940) Gauguin's revolutionary principles of flat color shapes. These artists, with Maurice Denis, Aristide Maillol, and others, were to comprise the group of painting disciples called the Nabis, a Hebrew word meaning prophets. And the next year the young painters had a chance to see Gauguin's theories even more dramatically demonstrated when the acknowledged leader and the close friends who had worked with him in Brittany—Bernard, Schuffenecker, Charles Laval, Louis Anquetin, and Daniel de Monfreid, among 37

Pierre Bonnard. *Dining Room on the Garden.* 1934. Oil on canvas, 50×53⅜". The Solomon R. Guggenheim Museum, New York.

33

others—showed their paintings and lithographs at the Café Volpini. They called themselves the Impressionist and Synthetist Group. Gauguin soon tired of his small "movement," however, and disassociated himself from the work of his followers, for he felt their mediocrity was compromising. The loose association of Nabis continued, however, and under the leadership of Sérusier grew and attracted more artistic and literary disciples.

By the mid-1890s, Vuillard and Bonnard had abandoned the rather plain, simple colors and increasingly flat, abstract composition associated with Gauguin for more conservative, but also more subtle and nuanced, personal styles. They returned to their bourgeois backgrounds, and even seemed stylistically retrograde in restoring to their paintings the broken, flecked brushwork of Impressionism. Their unassuming interiors, with family members or intimate friends caught read-

ing or working at unimportant domestic tasks, are treated with humor and tender affection, and also with an almost awesome sense of tranquility echoed in classical, stable compositions. Bonnard's paintings, particularly in his later period, are even more luxuriously sensual and abandoned in color than Vuillard's. His last works are truly a grand meditation on man, whether in his home or an outdoor setting.

pl. 33

Gauguin and Bernard had been influenced by the decorative conventions of medieval stained glass as well as the expressive outlines of the Japanese print. That esthetic interest also jibed with their familiar, romantic hopes of restoring to the artist the role of craftsman, which he had enjoyed in the medieval community, the tendency first made manifest by the influential English Arts and Crafts movement. Gauguin never actually carried these ideas very far, but he did at one time

express a belief in the possibility of a new, more primitive artistic community. He had planned to take a whole group of artists with him to the tropics to begin a new life "free from the bondage of money, beyond the reach of the corrupting influence of civilization." And it was from a similar urge to revive the role of craftsmanship in art that he began in Brittany to make rather primitivist woodcarvings.

Gauguin consciously modeled his style on non-Western cultures, drawing on a variety of traditions—Indian, Indonesian, Egyptian. In Paris he was a regular visitor to the newly created Museum of Ethnography and the Guimet Museum, and he made a thorough study of decorative objects, sculptures, and paintings from many unfamiliar cultures, including black Africa—which was to inspire, directly, the later generation of Matisse and Picasso. He advised his friend Monfreid to avoid "the Greek" above all and to have always before him "the Persian, the Cambodian, and a little of the Egyptian." Gauguin's primitivism was in part the result of a socially conditioned aspiration toward a style of monumental decoration and of the wish to rejuvenate art and human feeling, by going to "savage" sources; it was also a product of the encyclopedic museum, which represented a new cultural phenomenon of the late nineteenth century.

Gauguin's desire to find a new primitive basis for art and for his own life, and his powerful atavism—he had Peruvian and Incan blood on his mother's side—finally took him to Tahiti in 1891. Led by the poet Verlaine and the theater impresario Lugné-Poe, Gauguin's friends organized a "Symbolist" evening to help raise money for the trip. Vicariously, the Symbolists seemed to welcome the flight by a fellow artist from decadent European civilization.

In Tahiti, and later in the Marquesas Islands, Gauguin lived on "ecstasy, quiet, and art" in "amorous harmony with the mysterious beings around me." The splendor of tropical color and the touching simplicity and mysticism of the natives impressed and inspired him. His paintings subsequently acquired far more brilliance, power, and complexity, and his command of chromatic technique grew more expressive even though the fundamentals of his style changed little from the days in Brittany. Gauguin returned to Paris in 1893 and held an exhibition which impressed at least Mallarmé, who expressed his wonder that Gauguin could achieve "so much brilliance" with "so much mystery." The show excited almost as much curiosity as did the artist's exotic appearance and his style of life. He now affected an odd combination of Oceanic and Bohemian costume, outfitted his studio with masks, spears and native furniture, and kept a Javanese mistress and a monkey.

By 1895, he had had his fill of civilization and returned once again to his Oceanic paradise. There he worked steadily, first in Tahiti and then, feeling the encroachment of French colonialism, on the more primitive island of Hiva-Hoa in the nearby Marquesan archipelago. Unnerved by friction with the island administration, haunted by mounting debts and deteriorating health, he contemplated suicide. Before making an unsuccessful attempt on his life, he worked for one intense month in 1897 on a huge canvas entitled *Where Do We Come From? What Are We? Where Are We Going?*, a work that measures approximately five and a half by fifteen feet. This painting is another extraordinary and original masterpiece in a period notable for novel and major efforts.

It is a flowing composition divided into three main figure groupings set in a jungle clearing with the sea in the background. In the center a Polynesian Eve, reminiscent of Botticelli's Giuliano di

pl. 34

Paul Gauguin. *Where Do We Come From? What Are We? Where Are We Going?* 1897. Oil on canvas, 67" × 14' 9". Museum of Fine Arts, Boston.

34

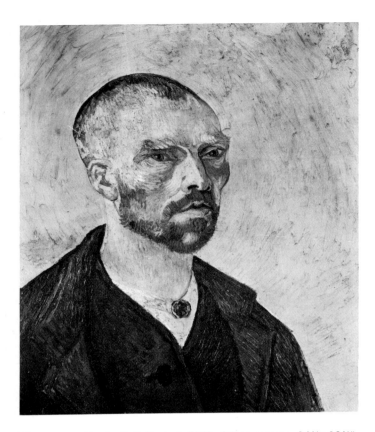

Vincent van Gogh. *Self-Portrait*. 1888. Oil on canvas, 24½×20½".
Fogg Museum of Art, Harvard University, Cambridge, Mass.
Maurice Wertheim Collection. 35

mystery of what might lie beyond death, preoccupied many artists of the Symbolist movement.

Gauguin died in his little hut in Hiva-Hoa, embittered by his economic struggles and his isolation. With characteristic candor, he had advised his friend Monfreid what he imagined his main contribution to painting would be. "I have wished to establish the *right* to dare anything . . . ," wrote Gauguin just before he died, "the public owes me nothing, since my achievement in painting is only *relatively* good, but the painters—who today profit by this liberty—they owe something to me."[22]

The painter of Gauguin's own generation most profoundly in his debt was the Dutchman Vincent van Gogh (1853—1890) who had come to Paris in 1886 to study painting after unsuccessful efforts to make himself into a picture salesman, a pastor, and an evangelist preacher in the Belgian mining country. His many early disappointments included a number of unhappy emotional experiences with women, whom he frightened away by his intense need for love and by his religious fervor. He had already begun to make oils and etchings in the Netherlands; in Paris he met the Impressionists, Degas, Seurat, and Lautrec and shared their excitement in color and in the Japanese print. He worked with Signac, lightening his dark, northern palette with bright, sunny colors and employing a pointillist technique. But he also learned to inject a deeply felt emotion into his somewhat moralizing art.

In 1888, weary of café esthetics, van Gogh left Paris for Arles. He dreamed of a new artistic community "created by groups of men combining together to execute an idea held in common," a dream that was never to be satisfied. His powerful emotions found release, however, under the brilliant southern sun, in a "kingdom of light," as he ecstatically described the new locale. Like Seurat, Cézanne, and Gauguin, he declared his new allegiance to Delacroix rather than to the Impressionists. "Instead of trying to reproduce exactly what I have before my eyes, I use color more arbitrarily," he wrote, "in order to express myself forcibly."[23] Influenced by Gauguin, whom he had come to know in Paris and whose Symbolist aims he found sympathetic, van Gogh told his brother Theo that he was "trying now to exaggerate the essential and to leave the obvious vague."[24]

At van Gogh's behest, Gauguin joined him at Arles in the fall of 1888, and for a brief time they worked together. Gauguin was influential in van Gogh's transition from an Impressionist manner to a more personal expression which utilized flat areas of uniform color and aggressive outlines. His *Self-Portrait*, dedicated to Gauguin, with its almost Byzantine, iconic power, is a tribute to that artist's influence as well as to van Gogh's completely original expressive force. The intense temperaments of the two artists soon led to violent quarrels. "Our arguments," van Gogh wrote to his confidant and protector, Theo, "are terribly electric; we come out of them sometimes with our heads as exhausted as an electric battery after it is

pl. 35

Medici in the *Allegory of Spring*, reaches up to pick a fruit from a tree branch; at either side are groups of native women and children, apparently representing the various ages of man. In the background an idol glows with an eerie bluish light, and two rosy phantomlike figures glide by. Before them, in the words of the artist, "an enormous crouching figure, out of all proportion, and intentionally so, raises its arms and stares in astonishment upon these two, who dare to think of their destiny."[20] The pervading tonality is blue-green; the bodies of the main figures are a darkish golden yellow. (These tonalities and the mannered archaic poses of the figures seem to have influenced Picasso during his so-called Blue period.)

Gauguin denied that the allegory had any explicit meaning and, in a letter to André Fontainas, stressed the vague and uncertain nature of his creation and its abstract, musical quality. "My dream is intangible," he wrote, "it implies no allegory; as Mallarmé said, 'It is a musical poem and needs no libretto.' "[21] Be that as it may, the imagery suggests certain general meanings: life and a supernatural Beyond confront each other and merge imperceptibly in a primeval setting. Lascivious, curving forms of jungle growth and the languorous, rhythmic undulation of the sea gently envelop living forms. The painting is both a cyclical allegory of life, from birth to death, and a philosophical meditation played out on a darkening stage. Related allegories, showing a similar preoccupation with the life cycle and with the

discharged." [25] In the first of his pathological episodes, van Gogh attempted to kill Gauguin, and then cut off his own ear and delivered it as a Christmas present to a prostitute who had once playfully asked for it. On petition of the alarmed townspeople, van Gogh was soon afterward hospitalized in Arles. His illness is now attributed to epilepsy and was possibly the result of venereal disease attacking the brain.

During his four years of artistic maturity, from 1886 until his death by suicide in 1890, he spent brief periods in mental hospitals, at Saint-Rémy and at the asylum of Dr. Gachet in Auvers. But with the exception of a few very late canvases, in which a chilling darkness falls over his ecstatic palette and rhythms become compulsive, his art shows no direct evidence of morbid self-preoccupation. There is struggle, conflict, and even extreme nervous excitement but neither an oppressive introspection nor a sense of paralyzing despair. His purity and realism as an artist, even in landscape paintings and drawings whose explosive linear energies border on incoherence, won through and subdued his powerful fantasies. It is interesting that van Gogh, despite his intense need for salvation and his Christian feeling about human solidarity, should have rejected as unhealthy the nostalgic religious pictures of his friend Bernard, revivalist, neotraditional paintings inspired by medieval Christianity. His sincerity

pl. 26

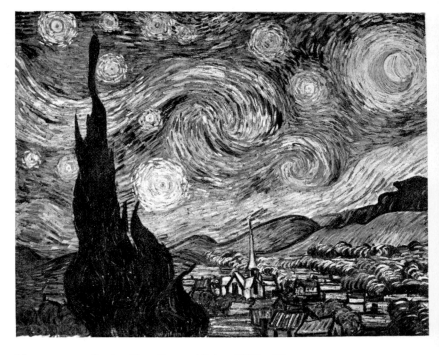

Vincent van Gogh. *The Starry Night.* 1889. Oil on canvas, 29 × 36¼". The Museum of Modern Art, New York. Acquired through the Lillie P. Bliss Bequest. 36

Vincent van Gogh. *Night Café.* 1888. Oil on canvas, 28¾ × 36¼". Yale University Art Gallery, New Haven. Bequest of Stephen C. Clark. 37

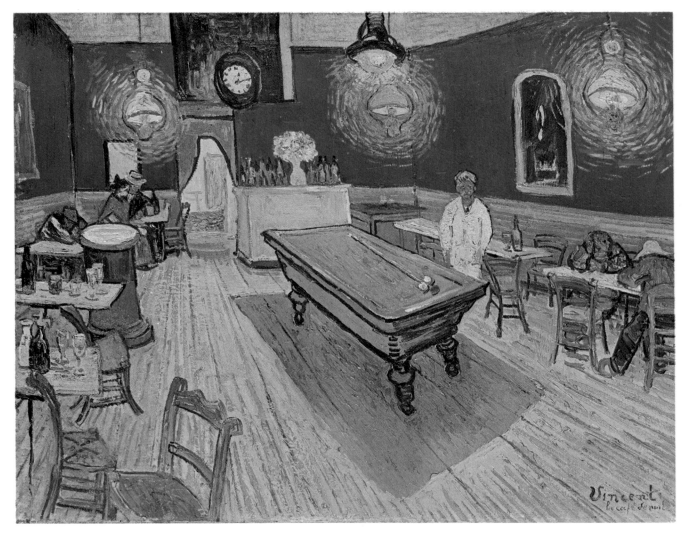

41

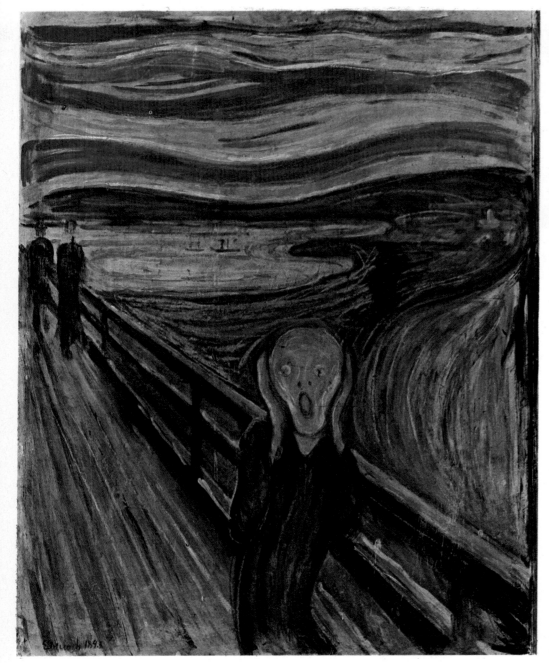

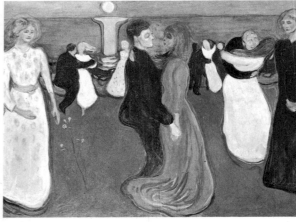

Edvard Munch. *The Dance of Life.*
1899—1900. Oil on canvas, 49¼×75".
National Gallery, Oslo. 39

Edvard Munch. *The Cry.* 1893. Oil and
tempera on board, 35¾×29". National
Gallery, Oslo. 38

pl. 37

required that he address himself to subjects of contemporary life, which, in his terms, meant the peasant folk of the south of France and their lyrical natural setting. He elaborated on some of his themes in his poetic letters to Theo, but the actual paintings often appear less bizarre than he made them out to be in his own mind.

This is true of one of his masterpieces, the café-poolroom scene in Arles. Figures hunched over absinthe-green tables are illuminated by brilliantly shining light globes against a decor of red and green walls and a dazzling yellow floor. The floor goes off in rapidly converging perspective lines. The dramatic mood is further heightened by a certain strangeness in the color scheme and by the whole burning brilliance of the impression. But was the scene as sinister as the artist later imagined? He wrote to Theo that he had portrayed the café as a place of wickedness, "a place where one can ruin oneself, go mad, or commit a crime.... I have tried to express the terrible passions of humanity by means of red and green."[26] Yet, in

the actual work there is no such simple didactic content. If there were, the painting would be only an extended monologue on anxiety, and it surely transcends the author's inner torment and most sinister fantasies.

Whatever the real or imagined symbolism of his art, van Gogh found a non-naturalistic and more emotional use for color, as did Gauguin at the same time. Like Gauguin, he "simplified" in an effort to get back to fundamentals, to deepen common truths that made him feel more authentic as a man and creative artist. "In a picture," he wrote to Theo, "I want to say something comforting as music. I want to paint men and women with that something of the eternal which the halo used to symbolize, and which we seek to give by the actual radiance and vibration of our colorings."[27] In style, van Gogh combines the innocence of children's art with the flat, decorative monumentality and brilliance of color of early Christian mosaics. He, too, was moving away from easel painting toward a broader style of

42

monumental decoration characteristic of the great archaic periods in art.

Without van Gogh's pioneering, self-conscious exploration of pain, and without his powerful, expressive means, the Norwegian Edvard Munch is inconceivable. He shared the Dutch artist's concern for human suffering, and also invented new pictorial means to dramatize his feelings. Although he began as a Naturalist, a visit to Paris in 1889 and the impact of contemporary French painting changed the direction of his art drastically shortly thereafter. "No [more] interiors with men reading and women knitting," he wrote, in a possible allusion to the emerging Nabis. "There must be living beings who breathe and feel and love and suffer. I would paint such pictures in a cycle. People would understand the sacredness of them and take off their hats as if they were in church."[28]

Munch did, in fact, paint what can be considered at least the beginning of a picture cycle, in *The Dance of Life*, which combines allegory and psychological penetration within a theme that became obsessive both with the Symbolists and twentieth-century Expressionists: the varying roles of women, as unsullied idealized virgin, and as temptress, a ravaged and degraded creature who preys on man. Munch's morbid and pessimistic views of the sexual relationship were derived in

part from his friend, the Swedish dramatist Strindberg, and from his own unfortunate life experiences with family illness, death, and his own mental instability and alcoholism. His extraordinary range of subjects included an understanding of the nameless sexual fears of adolescence and the hysterical anxiety of perhaps his most famous painting, *The Cry*. The sense of losing oneself in the cosmos, a fusion of individual personality with the absolute, curiously derives from the same mania for totality evident in the compulsively agitated, parallel lines of van Gogh's great and disturbing visionary painting, *The Starry Night*. For Expressionist fury, only the works of the Belgian James Ensor (1860—1949) with their grotesque and cynical charade of the persecution of a risen Christ by the populace, can equal the cathartic emotion and violent pictorialism of these influential works. Together, they helped transform European sensibility at the turn of the century.

Munch's work became known, and especially influential, in the evolution of later German Expressionism as much through his graphic work as his oil paintings. He translated his mordant images of the distressed modern psyche into lithographs and woodcuts, finding, like Gauguin, who showed an interest in the graphic art of the Middle Ages, that the crudeness of the medium enhanced his meanings and gave his message added

James Ensor. *Entry of Christ into Brussels in 1889* (detail). 1888. Oil on canvas, 8' 5½"×14' 1½" overall. Royal Museum of Fine Arts, Antwerp.

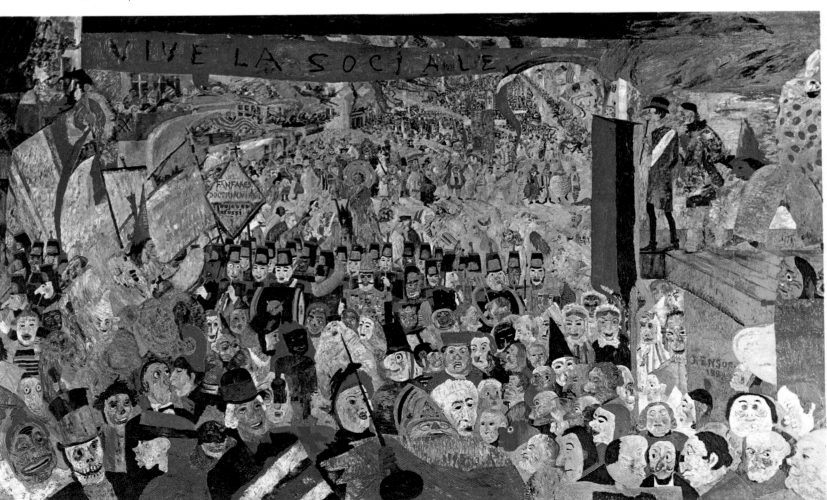

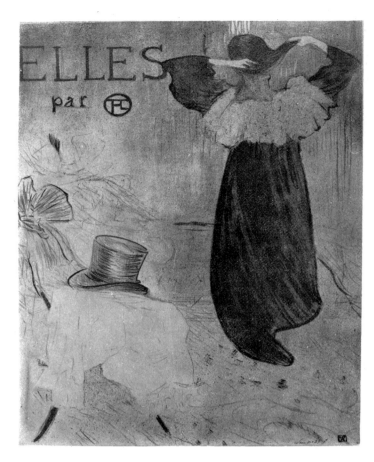

Henri de Toulouse-Lautrec. Frontispiece for "Elles." 1896. Color lithograph, 20⅜ × 15¾". The Museum of Modern Art, New York. Gift of Abby Aldrich Rockefeller. 41

force. Dissatisfaction with traditional mediums was common to artists of the 1890s, and there was, in fact, a remarkable revival of interest in every kind of graphic art—book illustration and poster design as well as the production of prints.

One of the most powerfully expressive artists of the period, in the graphic and print mediums, for whom color lithography proved especially congenial, was Henri de Toulouse-Lautrec (1864—1901). He expressed himself in drastic silhouettes, bold outlines, and original color, a form of dramatic presentation that put over its message in a single statement. The simplicity and economy of his expression is deceptive, however. Lautrec was an uncannily sharp observer of life as well as a brilliantly succinct and expressive draftsman. His resourcefulness in the graphic mediums allowed him to set down his subjects with a stylized flatness and still to characterize them in the psychological round. He had a genius for reducing the whole style of a personality to a few gestures and capturing it with a bold silhouette or a single line. He managed to hold the spectacle of life and pure pictorial values in a wonderful tension. Like Gauguin and van Gogh, he wished the spectator to experience his painting directly through the dynamic operation of his surfaces and with a minimum of interference from pictorial illusion. The spectator is invited to participate in the experience of form and color to a much greater

Henri de Toulouse-Lautrec. *The Bed.* 1892. Oil on canvas, 21 × 27½". The Louvre, Paris. 42

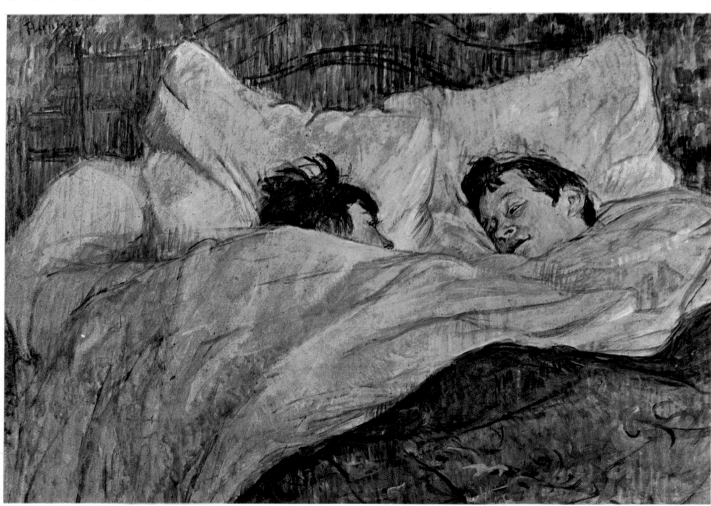

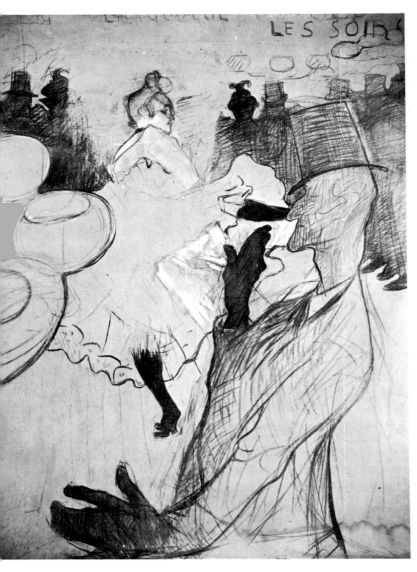

Henri de Toulouse-Lautrec. *Moulin Rouge: La Goulue.* 1891. Charcoal heightened with color, 60⅝ × 46½". Toulouse-Lautrec Museum, Albi.

43

the demimonde, an underworld of pleasure and vice, as his social and artistic habitat.

Lautrec came to Paris in 1882 to paint and, in the next five years, attended a number of studios. He had begun to paint and sketch scenes of sporting life at home at the early age of sixteen: horses in motion, tandems being driven along in the Toulouse region at a great clip. Some of these scenes are reminiscent of the reportage of Constantin Guys, but they have a greater and, for a young boy, remarkable expressive force. Then he learned to work in a soft Impressionist manner, but, unlike Monet and Pissarro, always fixed on the human figure as a center of interest. He later told his biographer and closest friend, Maurice Joyant, that nothing exists but the figure and that landscape should only be used to make the character of the figure more intelligible. François Gauzi has left a vivid record of Lautrec's artistic tastes and methods when they were both students at the Paris studio of Fernand Cormon. "At Cormon's studio," wrote Gauzi, "he wrestled with the problem of making an accurate drawing from a model; but in spite of himself he would exaggerate certain typical details, or even the general character of the figure, so that he was apt to distort without even trying or wanting to The painter he loved best was Degas, and he worshipped him.... He was fascinated by the Japanese masters; he admired Velázquez and Goya; and, astonishing as it may seem, he had a high opinion of Ingres: in that respect he was following the taste of Degas."[29] At Cormon's, Lautrec also met such independent spirits as van Gogh and Bernard, and he soon began to seek a more original and vital style. In this, he was deeply influenced by the Japanese print, which had already played an important part in supplying new pictorial conventions for the other Post-Impressionists. And he became an admirer and rapt student of the art of Degas, whom he probably met in 1884.

Degas supplied Lautrec with forms of composition, which he freely adapted in a simpler and more audacious fashion, and with a whole new repertory of unromantic contemporary subjects. Under the spell of the animated nocturnal life of the Montmartre music halls, cabarets, and brothels, Lautrec pushed on even beyond Degas's most controversial subject matter. Degas, in his collotypes, had depicted inmates of brothels but never with the knowledge and firsthand experience that Lautrec brought to the same themes. Lautrec went to live in the bordellos and became a confidant of prostitutes and pimps, partly no doubt because he wished to defy convention and thereby assuage his own feeling of being socially undesirable. But Lautrec also approached human squalor for the most serious artistic reasons. He refused to be intimidated by taboos on subject matter. For the painter still working in the spirit of nineteenth-century Naturalism, human degradation and the more sordid truths of sexual life in the great city were simply one set of facts among others. Since art had not dealt squarely with

pl. 42

degree than, for example, in the paintings of Manet, Degas, and the Impressionists. The elementary potencies of medium and the artist's operations take on an almost independent, abstract importance. This is particularly true in the case of Lautrec's nervous, mobile line, which continually stresses the active presence of the creator in the work of art.

To arrive at his style, a style that was vitally of its period, Lautrec passed first under the influence of Impressionism and then of Degas and the Japanese print. His painting was also directly connected with the life that he chose for himself in the pleasure traps of Montmartre and with his physical appearance, which influenced that decision. Lautrec was born a count in a family of provincial aristocrats; his name was Count Henri-Marie-Raymond de Toulouse-Lautrec-Monfa. He was a delicate, rachitic child, and after two falls in early adolescence, which broke both his legs, he never regained normal growth. In maturity he was physically grotesque, with a fully developed torso and head and tiny, shrunken legs. His curious appearance cut him off from a normal social life and probably was the factor that led him to choose

45

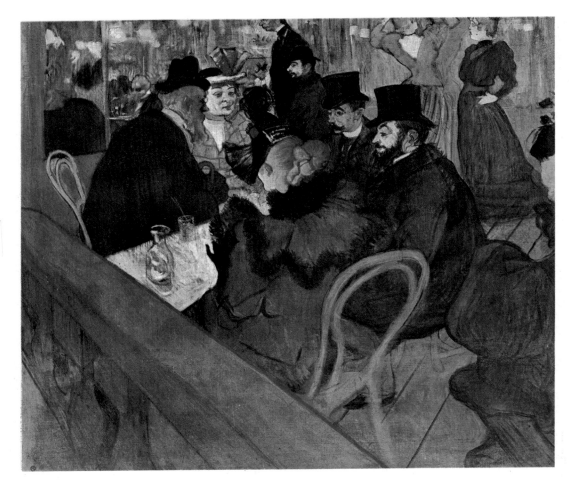

Henri de Toulouse-Lautrec. *At the Moulin Rouge.* 1892. Oil on canvas, 48⅜ × 55¼". The Art Institute of Chicago. Helen Birch Bartlett Memorial Collection. 44

them, they were still fair game. Lautrec's unprejudiced observation of sexual matters, neither morally aghast nor sensational in any way, reaffirmed the artist's prerogative to set down the truth of life as he found it.

Sometimes Lautrec, who had a natural instinct for the preposterous, could not help twitting his subjects. In the dress or undress of his models, in their boredom, or in their contrasting characters, he found much that lent itself to ironic treatment or outright comedy. Yet his approach was as serious and detached, rather than professionally disenchanted, and as intensely honest as was Degas's attitude toward his little ballet "rats."

While he investigated low life, Lautrec, in the early 1890s, was also developing an expressive style which managed to find public favor in song-sheet illustrations, posters, and lithographs. Something of a natural showman, he had a feeling pl. 43 for good visual copy, as the success of his posters of La Goulue dancing and of various vignettes of cabaret life attested. At the same time, he had begun to penetrate the shadier regions of the Paris underworld and to present its subject matter with a candor that shocked and alienated the public. He was finally as unable to satisfy conventional taste and morality in his own time as were van Gogh and Gauguin.

In his oil paintings, Lautrec learned to enrich his surfaces and marry line and color as he mastered technique. Near the end of his career, he produced works (they were few, as in the case of Seurat) of remarkable magnitude and power. Per-
46 haps his greatest technical innovations were made

in the color lithograph and poster; between 1891 and his death in 1901 he produced some three hundred lithographs and thirty posters, which were distinguished by their boldness of attack, freedom of invention, and expressive color. But a precious handful of large paintings were his major effort; and they stand with the greatest masterpieces of the modern period.

Among them is the painting *At the Moulin Rouge.* pl. 44 A group of ladies and gentlemen gather around a table; in the right foreground a woman, theatrically illuminated by a greenish light full on her face, is cut off by the picture edge. In the background, a figure we recognize as the dancer La Goulue adjusts her hair while nearby pass an incongruous pair, the tall, funereal Dr. Gabriel Tapié de Celeyran and his cousin, Lautrec himself. The composition burns with electric colors of orange and green; structurally it is organized along the diagonal axis of a handrail, Degas-fashion. The gay-nineties costumes—dresses with leg-of-mutton sleeves, elaborate plumage in the ladies' hats, stovepipes for the gentlemen—have been pushed to the glittering edge of fantasy. The atmosphere is unreal and bizarre; the characterization of personality, brilliantly incisive. Lautrec has endowed a rather shabby music-hall setting with barbaric splendor. His figures are described by sinuous, curving contours somewhat in the manner of Art Nouveau (although he was openly critical of the new style of decoration, which he had had occasion to see firsthand on trips to Belgium). While Lautrec's figures are fitted into a decorative ensemble of arabesques and curves,

they give an impression of mass and bulk. They break out of their molds and live an intense life of their own, both as personages and as vigorous plastic forms.

Lautrec's late lithograph series, called "Elles," was devoted to women, women who serve sullenly in a world dedicated to carnal pleasure but whose forms have a monumental import and dignity. Like Degas, Lautrec made something legendary and immense out of the stereotypes of naturalistic subject matter. He was perhaps the last modern artist who was able to express a vital interest in life and a curiosity about the human animal without compromising his pictorial values. In the process of doing so, he introduced dynamic new elements into his art: irony, fantasy, and an interest in forms and colors as expressive ends in themselves. When he died, the effort to capture modern life in terms of some realistic convention had been exhausted. The twentieth century took its inspiration instead from van Gogh's proto-Expressionism, Gauguin's advice that "art is an abstraction," and from the formal logic of Cézanne's last compositions.

Gauguin, van Gogh, Seurat, Lautrec, and Munch certainly, and to some degree even Cézanne, shared stylistic characteristics and elements of ideology, which became the basis of Art Nouveau, the counterpart in the applied arts of Symbolism in painting. While it may seem inappropriate to include Cézanne among these Post-Impressionists in view of his insistence on the basic architecture of form, in another sense, ornamental arabesque and structure were soon found to be interconnected in both painting and design. All the Post-Impressionists showed an increasing interest in decorative values, and they were very much in accord, in their different ways, with the

pl. 41

Paul Signac. *Against the Enamel of a Background Rhythmic with Beats and Angles, Tones and Colors: Portrait of M. Félix Fénéon in 1890*. Oil on canvas, 29⅛ × 36⅝″. Private collection, New York.
46

most essential trend of the time: the cult of line. For Art Nouveau's leading designer, the Belgian Henry van de Velde (1863—1957), line was a welcome antidote to imitations of nature; it was perceived as a force which might alternately or simultaneously be abstract, symbolic, ornamental, or structural. Van Gogh's flamelike cypress trees, the pine branches and winding roads of Cézanne's Provençal landscapes, Seurat's whiplash line in the ringmaster of *The Circus*, innumerable Lautrec music-hall scenes, and Gauguin's curving, decorative forms, not to mention Munch's linear treatment of landscape and figures, where decoration was raised to levels of excruciating emotional intensity, all these pictorial effects directly anticipate Art Nouveau's curvilinear ornament.

Among architects and designers of the German *Jugendstil*, as Art Nouveau was known in that country, there was a tendency to push decoration over the borderline into an independent abstract art. The famous plaster relief by August Endell (1871—1925) on a Munich photographer's studio, now destroyed, is an example of the more extreme abstraction of the *Jugendstil*. And in France, too, under the aegis of Neo-Impressionism, Paul Signac's *Portrait of M. Félix Fénéon* bore a title which testified to an increasing awareness of abstract expressive elements: *Against the Enamel of a Background Rhythmic with Beats and Angles, Tones and Colors*. Employing the musical analogy which so frequently entered esthetic discussions, Endell had envisioned another kind of Symbolism, in the form of an absolute art freed from representational function, with an expressive emphasis given form, line, and color for their own sake: "We stand at the threshold of an altogether new art, an art with forms which mean or represent nothing, recall nothing, yet which can stimulate our souls as deeply as only the tones of music have been able to do."[30] Art Nouveau, like so many aspects of Post-Impressionist and Symbolist painting,

pl. 45

pl. 46

August Endell. Atelier Elvira, Munich. Facade. 1897—98 (demolished). Photograph courtesy The Museum of Modern Art, New York.
45

formed a watershed between new affirmations of expressive novelty, supported by daring artistic theory, and the artifice and escapism of the Romantic decadence.

Art Nouveau dominated architecture and the applied arts in Europe for more than a decade, from the early 1890s until about 1906. In architecture, the style originated in Brussels with Victor Horta's house for the engineer Tassel in 1892. In the applied arts, precedents were found in English Art Nouveau by the historian Nikolaus Pevsner dating back more than a decade earlier, in the textiles of William Morris and the engravings and household objects of Arthur H. Mackmurdo (1851—1942). There has been a priggish tendency on the part of formalist critics to dismiss Art Nouveau as little more than a fanciful and capricious style of decoration, a shallow expression of *fin-de-siècle* estheticism that has little to do with the evolution of serious modern art forms. The phenomenon has been associated with the esoteric convolutions of Aubrey Beardsley's drawings, the decorative posters of Alphonse Mucha (1866—1939) and others, the attenuations of Tiffany glass, and the curlicued iron grilles of Hector Guimard's Paris Métro entrances.

pl. 20
pl. 48

pl. 47

Henry van de Velde became the spokesman and chief theorist of Art Nouveau. He bears a major responsibility for crystallizing its viable structural and modernist ideas, especially in relation to the Arts and Crafts movement in England whose social orientation influenced his thought. Van de Velde's first writings in the early 1890s, such as *Déblaiement d'Art*, and articles in *L'Art Moderne*, already showed familiarity with the social ideals of the English craft-oriented artists in the tradition of William Morris, who sought an all-embracing vision of the arts in society. Unlike his English predecessors, van de Velde wished to tap the potential for human betterment as well as the esthetic felicity of standardized machine products. In place of William Morris's regressive views, which called for a return to handmade crafts and the communal ideals of the Middle Ages, he welcomed the machine as an acceptable tool for the designer and the engineer in whom he envisioned "the creator of the new architecture". Otherwise faithful to English theory, he showed a more flexible imagination and grasp of the social implications of art. Perhaps his major theoretical contribution lay in the awareness that abstract ornament and structure need not conflict. His respect for functional needs in the context of the fashionable, often frivolous Art Nouveau style was forward-looking and socially enlightened. He tried to bridge the gap between an essentially romantic play with line and form and an artistic style that met the pressing needs of the modern technological age.

pl. 50

Van de Velde wrote that the role of ornament should not be merely decorative, but directed "to structure: the relationship between this 'structural

Henry van de Velde. *Abstract Composition*. 1890. Pastel, 18⅝ × 20″. Kröller-Müller Museum, Otterlo. 47

Alphonse Mucha. *"Job" Cigarettes*. 1898. Lithograph poster, 61 × 39¾″. The Museum of Modern Art, New York. Gift of Joseph H. Heil. 48

49

51

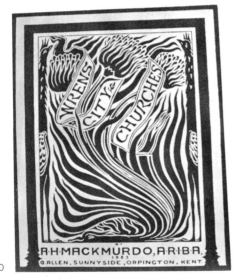

50

Walter Crane. Repeat of "The House that Jack Built". 1875. Wallpaper. Victoria and Albert Museum, London. 49

Arthur H. Mackmurdo. Title page for *Wren's City Churches*. 1883. Victoria and Albert Museum, London. 50

William Morris. Repeat of "Pimpernel". 1876. Wallpaper. Victoria and Albert Museum, London. 51

Henry van de Velde. Cover illustration for Elskamp's *Dominical*. Antwerp, 1892. Photograph courtesy Houghton Library, Harvard University, Cambridge, Mass. 52

52

and dynamographic' ornamentation and the form of the surfaces, should appear so intimate that the ornament seems to have 'determined' the form."[31] Van de Velde's cover vignette for Elskamp's *Dominical* supports that argument for the formal potential of ornament. Like a number of other Art Nouveau and Symbolist inventions, it anticipates Kandinsky by two decades in its transformation of a natural scene into expressive linear rhythms and bold abstract design. Unlike his fellow Symbolist painters, with whose work his own rather interesting early graphic design and paintings were associated, he demanded that utilitarian objects express something beyond themselves. It was not a symbol for transcendental ideas, or for nature in its organic growth, which he sought; instead, he wished to symbolize the decadence of the naturalistic object itself. Van de Velde urged the creation of a "healthy human understanding" of the world through the visual arts, and the formulation of a new art ("un art nouveau"). He was thus responsible for the first use of that phrase in relation to a rebirth of the visual arts. His views were prophetic of the preoccupation with function, structure, and fitness of the artists of the twentieth century.

Van de Velde parts company with the organicist theory of most other Art Nouveau spokesmen and with those English designers and book illustrators like Walter Crane (1845—1915), who concerned themselves primarily with the emotive and expressive power of their forms. It was Crane who best summarized the familiar concern with the abstract and rhythmic quality of the dominant line in Art Nouveau design, with his statement: "Line is all-important. Let the designer, therefore, in the adaptation of his art, lean upon the staff of the *line*—line determinative, line emphatic, line delicate, line expressive, line controlling and uniting."[32] The symbolical powers of line as an evocative force can be seen to correspond generally to the melodious role of sound in Symbolist poetry, going back for its antecedents to the hypnotic use of repeated sounds to dissolve the boundaries between real and imaginary worlds in the poetry of Edgar Allan Poe.

Nothing is more striking than the dual origins of Art Nouveau. On the one hand, there is an evident debt to William Morris's Arts and Crafts movement in the deep and fiercely held ethical sense of the utility of the arts which so many

pl. 52

pl. 49

49

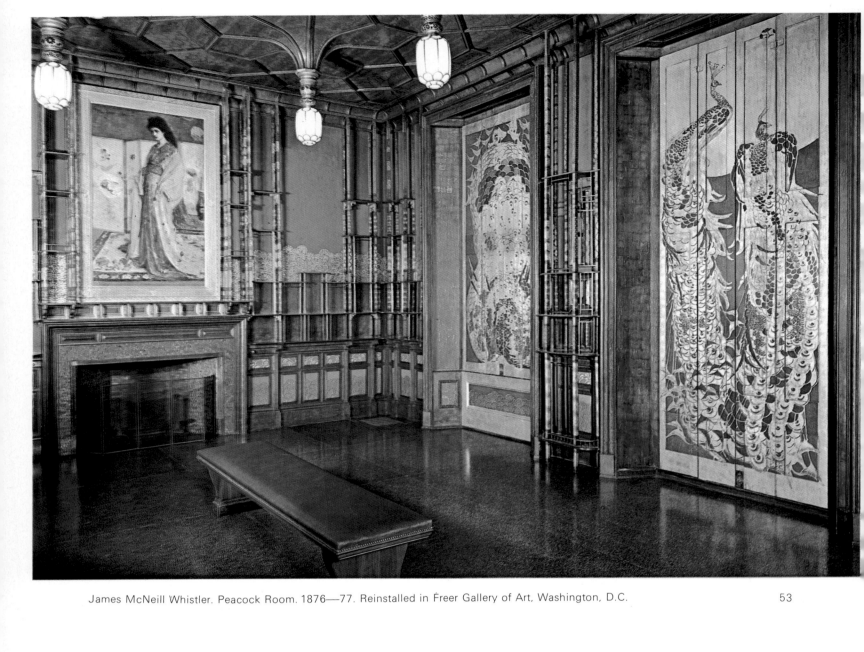

James McNeill Whistler. Peacock Room. 1876—77. Reinstalled in Freer Gallery of Art, Washington, D.C. 53

spokesmen articulated. And Art Nouveau also acknowledges the exquisite tastes and esoteric interests of the English Esthetic movement. Yet both artistic groups seemed to agree that a synthesis of the arts was desirable. Even the most spectacular and precocious artist among the English Esthetes, the American James McNeill Whistler (1834—1923), brilliantly, if inadvertently, established the integral concept of the unity of art and its environment with his famous Peacock Room as early as 1877; his decorative design and synthesis of fine arts and architectural setting were inspired by Japanese interiors. Despite its populist character, Arthur H. Mackmurdo's Arts and Crafts publication *The Hobby Horse*, demonstrated a fresh artistic approach to problems of design and typography; his title page for *Wren's City Churches* has been singled out by Pevsner as the very first, and conclusively English, example of Art Nouveau in spirit and form, anticipating curvilinear design on the Continent by more than a decade.

Another significant source of Art Nouveau design and of the flat, serpentine linear style evident in Post-Impressionism was the poster art of Jules Chéret (1836—1932). It is worthwhile comparing his relatively primitive style of drawing with the more fully evolved efforts in the same general style by Lautrec and Bonnard, who were clearly influenced by Chéret. By 1890, poster art and color lithography had become so popular that the critic Robert Koch could speak of a "Poster Movement" associated with Art Nouveau. Lautrec continued where Chéret left off, with greater verve and expressive power in his nervous contour and color shape. Mucha created the period's Gibson, or pin-up, girl in an energetic curvilinear style, and innumerable other artists, including Toorop, van de Velde, Eugène Grasset (1841—1917), and Will Bradley, extended the possibilities of the Art Nouveau poster, although none created the brilliant and commanding visual effects of Lautrec.

It is ironic that the excessive refinement and egocentric sensibility basic to Symbolism, in literature and the visual arts, should find its way into the decorative and public concept of the poster. As the century progressed, with the example of Post-Impressionist painting and the advent of men

pl. 53

pl. 51

pl. 56

pl. 54,55

of progressive social vision like van de Velde, the idea of a new decorative totality across all the arts began to suggest concrete ways of implementing a new and healthier environment. The significative qualities of line and form, once associated almost exclusively with the highly private excursions of Symbolist art, assumed wider public meanings, pointing to a more productive relationship between art and mass society.

Although Art Nouveau decoration often retained the appearance of mere whimsical invention, its major designers and theorists managed to penetrate artistic problems and contemporary realities deeply. In their practices and precepts can be discerned the indispensable link to the rational constructions of twentieth-century build-ing. For example, when the persistent Art Nouveau plant motifs were rather improbably translated into iron and steel building supports, they assumed potent new functional and esthetic prerogatives in the revelation of architectural structure. A legitimate analogy can be drawn with the new candor of expressive means which Post-Impressionist painting made explicit. Together, the radical painters and designers broke the stultifying grip of an exhausted Symbolism. At the close of the century, the fine and applied arts realized a rare unity, and together they bridged the gap between nineteenth-century eclecticism and the distinctive expressions of that collective visual revolution we know as the modern movement.

Jules Chéret. *Loie Fuller*. 1893. Lithograph poster, 48⅞×34⅝". Musée des Arts Décoratifs, Paris. 56

Henri de Toulouse-Lautrec. *Loie Fuller*. 1893. Pastel, 24×17⅜". Toulouse-Lautrec Museum, Albi. 54

Pierre Bonnard. *France-Champagne*. 1891. Lithograph poster, 30⅛×23". Bibliothèque Nationale, Paris. 55

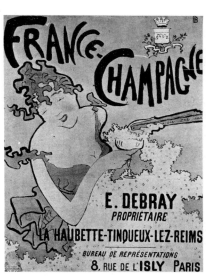

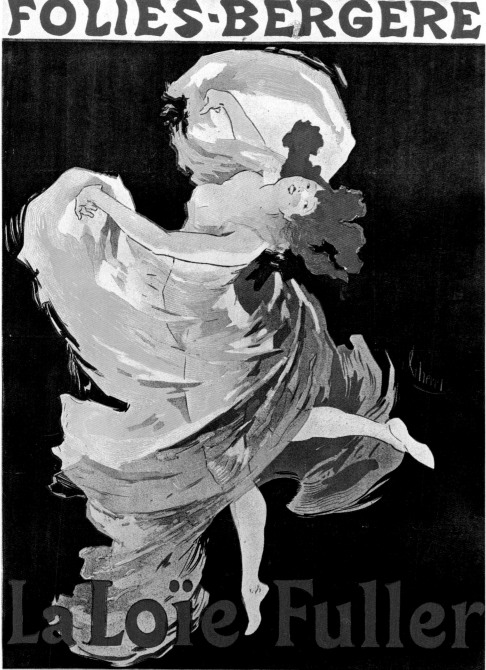

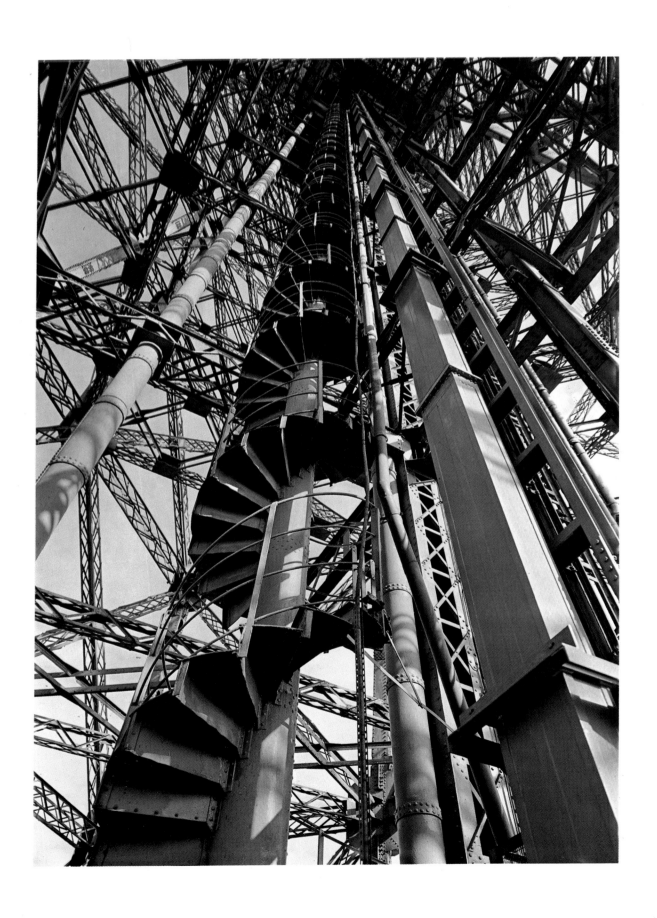

TRADITION AND INNOVATION IN ARCHITECTURE: 1880-1914

The last quarter of the nineteenth century was an unsettled, contradictory period in architectural history, quite without precedent. Its upheavals were too violent to be merely the normal symptoms of one more transition between established styles. The disappearance of stable values in architectural design had become painfully obvious by the second half of the century despite the efforts of many self-appointed reformers. Even the forceful works of several exceptionally gifted architects failed to re-establish any kind of viable center. As the century progressed, more of the major designers came to occupy maverick positions, gradually detached from a colorless professional mainstream and frequently denied easy access to such sources of work and prestige as government patronage or academic recognition. Nonetheless, it was a period rich in invention and creative controversy in spite of its disorder.

No single creative figure or patron presides over the inception of modern architecture as Abbot Suger does over the Gothic or Brunelleschi over the Renaissance. Nor can a single datable event or unique landmark be cited as marking the commencement of the movement that is still struggling through a kind of prolonged adolescence in our own day. The beginnings of our architecture reach back into the troubled, subversive undercurrents of late eighteenth-century design and theory (with sources reaching tenuously all the way back to the inception of the Western tradition in the buildings of antiquity), and the gestation process, sporadic rather than continuous, lasts well into the first decade or two of the twentieth century. Indeed, the ultimate acculturation of modern design into everyday architecture, reaching beyond a small, confined avant-garde to the remotest and most stubbornly recalcitrant corners of the profession, was not achieved until about 1950, a century and a half after the first premonitions of a new movement had appeared. This reluctant, sluggish, tortuous process is unprecedented in history, where new styles, while infrequent, usually burst suddenly into the light of day.

During the nineteenth century, in spite of internal crises which heralded its gradual diminution if not its outright collapse, the academic-classic mode produced numerous pertinent public monuments, and even occasional outstanding ones, such as the Paris Opéra, 1861—75, by Charles Garnier (1825—1898) and Joseph Poelaert's Palace of Justice, 1866—83, in Brussels. Matching the exuberance of nineteenth-century academic monumentality, whose excesses are regularly censured, if sometimes secretly envied, by modernist theory, was the freshness and probity of the best Neo-Gothic work, whether civic, ecclesiastical, or residential. The work of William Butterfield (1814—1900), an almost exact contemporary of the loquacious, influential critic John Ruskin, deserves mention for both its scholarship and its originality. Even more surprising, when viewed from a purist, historically autonomous twentieth-century esthetic, is the candor and relevance of many eclectic, or even bastard, designs of the era such as the Galleria Vittorio Emmanuele II, Milan, 1864—67, of Giuseppe Mengoni (1829—1877), whose theoretically incompatible components of traditionally massive masonry walls surmounted by a light iron and glass barrel vault turn out to be a startling yet convincing design system.

New scientific discoveries and their applications in technology, together with unprecedented growths of population and venture capital, changed the mode and scale of architectural operations a century ago. However, many of the structural forms provoked by application of new techniques were devoid of economic potential. The steel frame, while making possible the development of fireproof skeleton construction and hence the skyscraper, a typically speculative and profitable office building, is specifically celebrated in the singular tower designed by Gustave Eiffel (1832—1923) for the Paris International Exposition of 1889. It was a symbolic monument to technology, expressive of the limits, or frontiers, of the art at that time, but also one that served no contemporary function. Ironically, modern technology is better expressed here than in works of more obviously utilitarian purpose.

pl. 58

pl. 60

pl. 59

pl. 57, 61

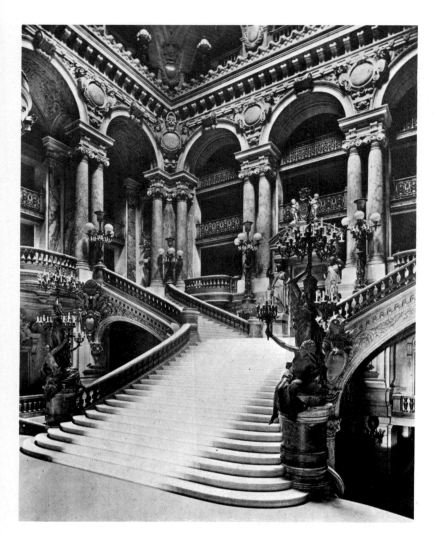

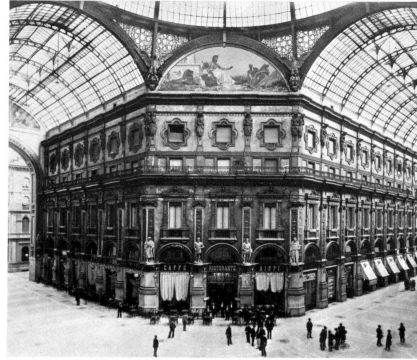

Giuseppe Mengoni. Galleria Vittorio Emmanuele II, Milan. Interior. 1864—67. 59

Charles Garnier. L'Opéra, Paris. Grand Staircase. 1861—75. 58

William Butterfield. All Saints, Margaret Street, London. Exterior detail. 1859. 60

Of course, the *form* of Eiffel's 984-foot tower is not conventionally monumental. Rather, its exposed skeletal frame is virtually transparent, its "interior" open to the exterior. Its importance lies in its uniqueness, one key aspect of its modernity. Unlike the first Doric temple or the first Gothic church, it has no direct formal progeny. Special to our contemporary tradition is the fact that many of our masterpieces are hybrids frequently incapable of reproduction. Modern design would, from its very nature, seek to become an antitradition, since whatever is repeatable seems destined to become banal. And yet, if the Eiffel Tower is neither typical nor seminal of our architecture, it nonetheless remains one of the most revealing landmarks of the period, representing in a bold, even outrageous, way powers of extension in height and transformation in substance that are unprecedented.

Eiffel's metamorphosis of pure engineering into the most symbolic of architectural monuments, a performance that would continue to excite the admiration of artists and modernist critics (particularly the Orphist Robert Delaunay), should not lead us to overemphasize the role of technology as a shaper of new architectural language. Eiffel, one of the great engineers of the golden age of bridge construction, was not truly a pioneer in the use of metal structures in bridges—a tradition that goes back to the eighteenth century. Moreover, all late nineteenth-century exhibition structures are in one way or another the progeny of the epochal

London Crystal Palace, 1850—51, by Joseph Paxton, where glass and iron were employed on a colossal scale for the first time. Nor did Eiffel's work apply directly to the articulate, expressive use of iron or steel in ordinary architectural design.

Two architects among many in mid-nineteenth-century France, Henri Labrouste (1801—1875) and Eugène Viollet-le-Duc (1814—1879), had previously addressed the problem thoughtfully, and with notably personal results—both seeking to use iron in the context of historically proven, yet, from the nineteenth-century point of view, contemporary styles. Labrouste had received a conventional academic education, culminating in its ultimate reward, the Prix de Rome, which entitled him to a five-year sojourn at the Villa Medici, the French school in Rome. Viollet-le-Duc was a maverick who eschewed that same academic education. He was partly self-taught and partly tutored by his uncle, and, at a time when it was grossly unfashionable, took up the cause of medieval architecture, championing the preservation, often through drastic renovation and restoration, of the Romanesque abbeys and Gothic cathedrals of France. Both architects were thorough historians, partisan to particular styles, though it was only the latter whose fame was based upon his profuse architectural writings. Labrouste's renown is based upon a handful of buildings, two of which made use of cast iron in the vaulting of large spaces. In the later of the two, the reading room of the Bibliothèque Nationale, Paris, 1862—68, Labrouste adapted the Roman, or Byzantine, dome with oculi to a repetitive cellular system, drastically slenderizing the columnar supports to accord with the structural

pl. 63

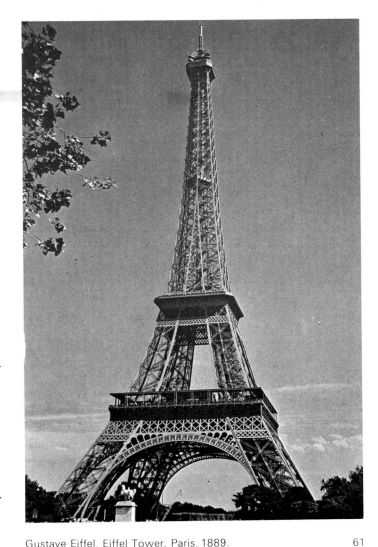

Gustave Eiffel. Eiffel Tower, Paris. 1889. 61

Eugène Viollet-le-Duc. Project for a Concert Hall. 1864. 62

Henri Labrouste. Reading Room, Bibliothèque Nationale, Paris. 1862—68. 63

Anatole de Baudot. Church of St. Jean-de-Montmartre, Paris.
Interior. 1894—1902. 64

advantages of metal. The details are a mixture of old and new, of modified and attenuated classical shafts in conjunction with open-trussed arches. Classical elements here frame a modern, open space.

pl. 62 Viollet-le-Duc's unbuilt project for a Concert Hall, 1864, published in his principal theoretical work on the problems of contemporary architecture, is disconcerting in its application of iron technology to a historical prototype, one that is on the surface infinitely less coherent than Labrouste's essay in the telescoping of past and present. He was a firm rationalist who believed that the forms of art were brought about only by a severe, logical study of the nature of a specific problem, and his work is more radical in its departure from precedent. He was especially interested in the principles of structure that he deduced from a study of Gothic piers, vaults, and buttresses, and his published drawings and diagrams of these historic monuments possess a dissecting-room severity that is surely related to the diagrammatic and argumentative nature of his work. The form of his Concert Hall is that of a rotunda covered by a multicelled polygonal dome of variously profiled metal ribs, the linear contours carried down in a consistently tortured way to the masonry walls and foundations by a system of thin vertical and diagonal iron columns. From these tentative beginnings, Anatole de Baudot (1834—1915), a pupil of both Labrouste's and Viollet-le-Duc's, pioneered in the development of ribbed, reinforced concrete construction in the

pl. 64

1890s, in the Church of St. Jean-de-Montmartre, Paris (1894—1902), whose cross-ribbed vaults manifest a passing similarity with Viollet-le-Duc's Concert Hall but abandon any suggestion of Gothic articulation except for the retention of variously pointed arches and ribs. Here, as was so often the case in the 1880s and 1890s, modern design appears, subversively, by negation, by a process of erasure.

The stripping down of traditional forms, with a concomitant blurring of historical references until the result seems starkly original, is revealed in the works of several architects of the late nineteenth and early twentieth centuries, all of whom worked independently in different centers, largely unaware—at least at first—of the accomplishments of the others. Among these are the Viennese academician Otto Wagner (1841—1918); the American Henry Hobson Richardson (1838—1886), trained at the École des Beaux-Arts, Paris, but whose work was deeply influenced by Romanesque prototypes; the English house builder Charles F. A. Voysey (1857—1941); and Hendrikus Petrus Berlage (1856—1934), a Dutch architect of medieval proclivities. To this group of transitional figures, roughly contemporary with Rodin and the Post-Impressionist painters, may be added Louis Sullivan (1856—1924), the Chicago-based prophet of organic architecture and a key figure in the development of the tall building; and the Catalan, Antoni Gaudí (1852—1926), whose fantastic forms look back to the ideas of the English critic John Ruskin and the structuralism of Viollet-le-Duc, but whose expressive extravagance appealed much later to a Spanish compatriot, the Surrealist Dali, a proponent of the "paranoiac-critical" method of pictorial invention.

A school or historical group cannot be formulated from so diverse a body of designers, but, nonetheless, a common reductive approach can be detected in the way in which they developed solutions to programs of great functional and cultural diversity. All produced exceptionally individual styles reflective of the values and traditions of their native climes, and yet the works of all can, in one way or another, be cited as premonitions, if not as outright models, of twentieth-century architecture. To a man they were, at least in their mature designs, developing away from the articulated, richly sculpted and colored designs of the mid-nineteenth century, whether classic, medieval, or more exotic in allegiance. In certain instances, their works are comparable to the Romantic and revolutionary designs of the late eighteenth century, such as those by Claude-Nicolas Ledoux and Étienne-Louis Boullée, whose clear geometric forms broke so emphatically with the extravagant practices and platitudes of the Late Baroque. Moreover, many of the ideals of such mid-Victorian radicals, reformers, writers, and designers as William Morris, Philip Webb, and even Viollet-le-Duc came to the surface in their works. The sources of this architectural tran-

sition, on the eve of the twentieth century, thus reach into successive, and often subterranean, phases of protomodernism for ideas and support. Late nineteenth-century architects were increasingly concerned with the employment of contemporary building technology as a means of gaining a degree of freedom from a dogmatic reliance upon past styles, but none made his art subservient to applied science. Richardson and Voysey are exceptions to this pattern, being more conservative in construction methodology, but, by way of compensation, each made a distinctive virtue of traditional craft and material in his work.

Richardson, the most conservative "innovator" of this generation, was educated in Paris in an atelier directed by Théodore Labrouste, brother of the architect of the Bibliothèque Nationale reading room. Richardson's work suggests that he was not overly interested in Labrouste's essays in iron, even less in Viollet-le-Duc's projects and contentious rationalist theories. On the other hand, he was no more inclined to perpetuate the formal classical style of the École des Beaux-Arts or its newly fashionable embellishment as seen in the Opéra. In an eclectic age, he was an individualist who kept his own counsel and who gave his name to a style that he popularized: Richardsonian Romanesque. His work is not outwardly that of a radical, except at the very end, and in his own lifetime he was without doubt the most admired architect at work in the United States. Although he was neither a progressive thinker nor radical innovator, his buildings, especially the late ones, are candidly original, moving beyond the orbit of their historical sources. He remains a paradoxical independent artist of great influence, superficially upon the architecture of his own day, profoundly upon that of the next generation.

Richardson's earliest works normally reveal Romanesque sources and tend to emphasize decorative clusters of great strength. However, his style evolves toward a simple expression of the overall mass, often dispensing with ornament, employing throughout powerful, rusticated masonry, with window and door openings terminating in vast round arches, a magnification of a basic Romanesque, but also Roman, theme. In domestic work, this assertive stone rustication, actually more characteristic of ancient Roman engineering than of medieval Romanesque churches, is replaced by wood shingles, half-timbering, and related materials (borrowed from late medieval England)—a use of natural surfaces that would be passed on into the twentieth century through the organic architecture of Frank Lloyd Wright and, more traditionally, in the Romantic, regional architecture of Bernard Maybeck, another American trained in Paris, and others on the West Coast. Richardson's greatest achievement, an early important instance of stylistic abnegation on the part of a modern architect, the Marshall Field Wholesale Warehouse in Chicago, 1885—87 (demolished 1930)—a patient distillation of diverse elements into a clear, ordered solution— was completed only after his untimely death at the age of forty-eight.

pl. 65

If Richardson's major work, which was also his last, was accomplished in early middle age, the precise opposite was true of his European contemporary, Otto Wagner. His most influential works, portents of the future, were not designed until after 1900, when he was in his sixties. In the world of official Austrian architecture he plays an exploratory, innovative role as artist and pedagogue similar to that played by Labrouste in Paris a half century earlier. But with an important differ-

Henry Hobson Richardson. Marshall Field Wholesale Warehouse, Chicago. 1885—87 (demolished 1930). 65

Otto Wagner. Church of St. Leopold, Steinhof Asylum, outside Vienna. 1905—7. 66

ence: whereas Labrouste's followers tended to fritter away their opportunities in petty, if occasionally clever, ways, Wagner's pupils and admirers had incalculable impact upon subsequent architecture. Wagner's most famous work is the glass-vaulted Post Office Savings Bank in Vienna, 1904—6, a stylistically neutral hall, exquisitely detailed with inverse-tapering steel piers, their rivets visible, intersecting the unusual curve of the vault. Wagner's interior would seem to be a refined miniature study of the vast train sheds or exhibition structures, such as the Machinery Hall of 1889, the companion of the Eiffel Tower at the Paris International Exposition of that year, in which proportions, details, and structural expression are treated with the care of a Doric colonnade or a Gothic vault.

pl. 69

pl. 67

Wagner's eclecticism in its modernist cloak is best seen in the domed Church of St. Leopold, which he built on the grounds of the Steinhof Asylum, outside Vienna, 1905—7. Its chic decoration is consistent with Art Nouveau, or, as it was known in Vienna, Secession, after the name of a new society of artists opposed to the Academy. Although the fundamentals of Wagner's church are neoclassic, its innovations in proportion and decoration are convincing while mannered and ironic. Of his many disciples, the most loyal seems to have been Joseph Maria Olbrich (1867—1908), whose Secession Gallery, 1898—99, actually predates most of Wagner's more modern buildings and projects. A domed and pyloned rectangular block, it is more forthright in its presentation of a new stripped-bare esthetic in a traditional format than anything by Wagner at that time. Here we have a remarkable instance in which the student's adventurousness did much to liberate his master from the literalism of his earlier manner. Significantly, Wright manifested an interest in Olbrich's work at an early date, on the basis of photographs reproduced in international magazines of the period.

pl. 66

pl. 70

At the same time, the Amsterdam architect Hendrikus Petrus Berlage, fifteen years Wagner's junior, was working his way out of a neomedieval, rather than an academic-classic, tradition. He was as characteristically Dutch in his plain brick surfaces as Wagner was Viennese in his more gracefully severe facades, yet his work was equivalent to Wagner's in its evolutionary modernism. Berlage's Stock Exchange, 1897—1903, also predates Wagner's more advanced designs. In this project, he transforms an ornate, turreted, local neo-Renaissance style into a calmer, less agitatedly picturesque mass by means of a direct expression of brick surfaces punctuated by stone-framed windows and entries. Berlage's achievement here, and in other contemporary buildings, is that he has simplified to the point of abstraction and autonomy the fashionable, relevant local style of the day. Berlage's long career was marked by his absorption in many of the new trends of later design. He was one of the first European architects to become interested in the work of Frank Lloyd Wright and, in addition to inspiring a number of younger Dutch ar-

pl. 68

58

Victor Contamin and Ferdinand Dutert. Machinery Hall, International Exposition, Paris. Interior. 1889. 67

chitects, was important in the development of Ludwig Mies van der Rohe, according to the latter's own testimony.

The English architect Charles F. A. Voysey was also inspired by local historical traditions, in his case the vernacular late- and post-medieval cottages and small manor houses of rural England, whereas Berlage had been inspired by the more urban and urbane vernacular of The Netherlands. However, this particularization of early modern architecture on regional bases does not obscure the similarity of its reductive design methods and reveals a growing consensus of taste, if not of style, as the century moved to a close. Voysey's own house, The Orchard, Chorley Wood, Hertfordshire, 1900, is a concise example of his neotraditional approach. Although his distinctive style of pale, monochromatic surfaces and blunt, rectangular windows is tempting to cite as a specific predecessor of the autonomous International Style of the 1920s and 1930s, in later life Voysey disclaimed any intent at radical innovation. In principle, his art exemplifies those ideals of William Morris which sought to restore the importance of the craftsman's role in art.

pl. 72

If Voysey was a special instance of a solitary regional architect whose works, by their very precision and simplicity, seem a relevant, if somewhat accidental, predecessor to modernist design, his younger contemporary, Charles Rennie Mackintosh (1868—1928), designed in a more forthrightly innovative mode, also based upon a late medieval, regional vernacular. Moreover, he enjoyed a considerable influence in such centers as Darmstadt and Vienna, where he participated in the annual exhibition of the Secession in 1900. Mackintosh's *magnum opus* is the Glasgow School of Art, begun in 1898 in a starkly simplified

pl. 71

Otto Wagner. Post Office Savings Bank, Vienna. Interior Court. 1904—6. 69

Hendrikus Petrus Berlage. Stock Exchange, Amsterdam. Interior. 1897—1903. 68

Joseph Maria Olbrich. Secession Gallery, Vienna. 1898—99. 70

neomedieval mode, only to be completed a decade later with a library wing which is the architect's most autonomous conception, full of mannered manipulations of solid and void, surface and mass, and which parallels and equals the contemporary innovations of Frank Lloyd Wright. Its exterior wall treatment and interior lighting transcend specific historical association, and, although it remains faithful to the Morris Arts and Crafts tradition, it represents a rare instance of autonomous design prior to 1914.

The protomodernism of Mackintosh, whose subsequent career was frustrated by a lack of suitable commissions, is matched and surpassed in invention and fantasy, in a combination of sophistication and innocence, by the much more autochthonous architecture of Antoni Gaudí, a Barcelona figure of legendary renown. With the exception of Frank Lloyd Wright, no other architect active in these years was so fertile an inventor, and none managed to free himself of the past so gracefully as did Gaudí. Moreover, the streak of fantasy—of expression and imagination freed of rational and traditional constraints—which forms so important a part of our contemporary tradition, is represented for the first time in his varied and numerous works.

pl. 75 Gaudí's masterpiece is the cathedral-scaled votive Church of the Sagrada Familia, Barcelona, on which he worked throughout his life and which remained, at his death, a minor fragment of the projected design. Gaudí, having worked on the restoration of medieval churches, inherited a literal Neo-Gothic design for the Sagrada Familia in 1884 and only gradually liberated his imagination, creating, in the process, rich naturalistic decorative motifs, colorful ceramic ornaments applied to sinuous, twisting sculptural forms, and figura-

Charles Rennie Mackintosh. Glasgow School of Art. Library interior. 1898—1909. 71

Charles F.A. Voysey. The Orchard, Chorley Wood, Hertfordshire, 1900. 72

Antoni Gaudí. Casa Milà, Barcelona. 1905—10. 73

Louis Sullivan. Transportation Building (Golden Portal), World's Columbian Exposition, Chicago. 1893 (demolished). 74

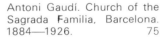

Antoni Gaudí. Church of the Sagrada Familia, Barcelona. 1884—1926. 75

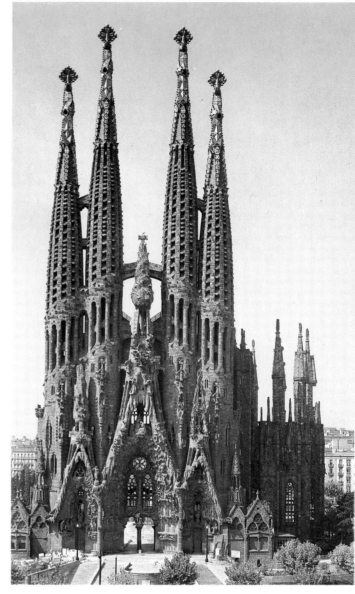

tive sculpture that was occasionally based upon plaster casts of the actual living model. The Sagrada Familia, with its seemingly bizarre transformations of pointed arches and multiple spires, is certainly the most unaccountable work of lyrical imagination in architecture of the past century, and is in no way a characteristic symbol of the new age immortalized by the Eiffel Tower. Nevertheless, taken together, these diverse monuments—sites of pilgrimage and objects of veneration for totally divergent purposes—suggest the extraordinary conflicts of technique and goal that are characteristic of our architecture.

pl. 73 Gaudí's domestic work, notably a large apartment, the Casa Milà, Barcelona, 1905—10, indicates other issues provoked by his always-startling inventions. Its rippling horizons of curved forms which dominate the masonry bulk and the cast-iron balcony rails, and its fantastic roof scape of wavelike crests and coniferous turrets, all seem to reflect the Art Nouveau style. However on target such an association may be, Art Nouveau is by far too restricted a term to circumscribe the coruscating variety of Gaudí's work and the ironic consistency of its evolution. Art Nouveau was a fashion of momentary impact, if long-term influence, of

the 1890s, which, for the most part, was a transitory phase in the careers of several architects of widely different backgrounds, some of whose lasting importance would have been negligible without their participation in that agitated movement. Not so Gaudí, whose futuristic anachronisms were more profound, isolated from the whims of fashion. Alas, unlike Wright, his equal in autonomous formal innovation, Gaudí's impressive constructive vocabulary exercised almost no immediate, and little subsequent, influence on mainstream developments, though he was admired by Le Corbusier as early as 1930.

The squandering of Gaudí's potential influence, owing partly to his isolation within the local, separatist avant-garde of Barcelona, is matched in the United States by the more frequently lamented waste of the special gifts of Louis Sullivan, a difficult, original mind, a courageously independent designer whose many-faceted importance, as well as his shortcomings, is still difficult to assess today, a half century after his death. Sullivan's work can best be considered in the overall context of the World's Columbian Exposition held in Chicago in 1893 to commemorate, a year late, the four-hundredth anniversary of the discovery of 61

America. Its sedate, generously scaled academic classicism, more reserved and "correct" than that currently fashionable in Paris, was an anxiety ridden rejection of indigenous progressive trends by a culture that had already developed its own distinctive, modern architecture—a craven turning to the past that eliminated adventurous risk in favor of certainty of taste. Sullivan's work at the pl. 74 Columbian Exposition, the Transportation Building, was in no way a design expressing the speed, noise, and excitement of modern travel. It was traditional, but not conventionally academic, in a way that paralleled Gaudí's drastic adaptation of Gothic forms. It took as its source the massively exaggerated round arch of Richardson and transformed it through decorative elaboration (in which the young Frank Lloyd Wright aided) into something virtually unrecognizable, a reconstituted Byzantine fantasy which, elegant to our eyes today, surely seemed coarse and overstated then in contrast to the sober, tasteful classicism all about.

Sullivan is customarily remembered for two somewhat distinct contributions: his writings, in which an organic theory of architecture, based in large part upon a biological analogy, is developed, including the universally abused epithet "form follows function"; and, secondly, an original, personal system of ornament which, when applied to the steel-framed skyscraper, then just barely out of its infancy as a building type, seemed to give special promise for the development of a distinctly integrated constructive and decorative system. Unfortunately, after a decade of notable achievement, Sullivan's career, and ultimately his personal life, suffered a series of irreparable reverses, and for the last quarter century of his existence his work declined into a curious provinciality which, while it is of great biographic significance for Sullivan, was largely devoid of any major influence on the profession. Early in his career, he worked in Philadelphia for an intransigent Neo-Goth, Frank Furness; subsequently, he spent a brief period in Paris sampling the teaching of the École des Beaux-Arts; and returning, he went to Chicago, where he worked for William Le Baron Jenney, who is credited with the first use of modern skyscraper construction, that is, a load-bearing, skeletal steel frame sheathed with a fireproof masonry cladding, this cage then enclosed by a nonsupporting curtain wall that permitted exceptionally large windows.

Tall buildings had already appeared in New York and elsewhere in the 1870s—made possible by the elevator—but it remained for Chicago architects to develop a consistent steel frame. At first, architects decorated such buildings indifferently, mostly with reference to historical motifs that were as likely as not to be ineffectual as well as inappropriate. Sullivan's early commercial work in the 1880s, designed in partnership with Dankmar Adler, an astute businessman well versed in the art of building, had manifested no special stylistic affiliation until he fell under the spell of Richardson's stark Marshall Field design. The exterior shell of Sullivan's Auditorium Building, 1886—89, is the most conspicuous result. Like the successive designs for Berlage's Amsterdam Stock Exchange, Sullivan's preliminary studies for the Auditorium Building reveal a process of simplification and stripping away of agitated excrescences. The interior of the Auditorium featured a decorative tour de force in its proscenium arch, which paved the way for the similarly orchestrated ensemble on the 1893 Transportation Building. But it was not until 1890, and the design of the Wainwright Building, St. Louis, that Sullivan addressed, head-on, the problem of establishing a suitably original outline and decorative system for a massive, steel-skeleton commercial building. The problem was altogether different in scale, material, and technological sophistication from the earlier cast-iron-fronted commercial buildings that had proliferated in American cities since the middle of the century. This earlier type was limited in height to about five floors, and ultimately proved to be a fire hazard, since the metal parts were not protected by heat-resistant materials.

Skyscraper construction did not evolve directly from this metal-frame type, but resulted from a rethinking of the problem. Moreover, the matter of finding a logically appropriate style for these taller buildings proved especially elusive, since a certain kind of superficial logic suggested that if a steel frame is to support a masonry skin framing windows, the architect is at liberty to exercise his imagination, calling upon history or upon his own taste. Sullivan chose to restate the entire question in the Wainwright Building. The building block was divided into three vertical components: a street-level podium, different from the rest because of its function of providing entrances and display windows; a shaft of many floors, basically and appropriately vertical in emphasis while relatively uniform in component parts; and a cornice level that was markedly horizontal, terminating the rising form of the shaft. The logic of this tripartite composition was used by Sullivan in subsequent buildings, and Midwestern architects employed this formula time and again, ultimately in buildings of tiresome mediocrity.

Later in the decade, Sullivan invented still another design type for large-scale, urban commercial buildings in the Carson, Pirie and Scott Store, Chicago, begun in 1899 and subsequently added to by other architects who followed his simple modular scheme. This formula was based upon the proportion of the steel frame, which established the shape of the window. Thus arose the concept that the building could be extended in breadth and in height at the pleasure of the client at whatever future time expansion might be required. This design was Sullivan's most advanced concept. With some exaggeration, it has been cited as a prototype of the glass curtain wall introduced by Dutch, German, and French masters of the International Style in the 1920s. However, it was also his last large commercial

building in Chicago, as he gradually became isolated from the profession and from prospective clients. The few works of the second half of his career, a series of small banks in Midwestern farm communities, are modest in size, yet are gemlike designs of a pariah, one of the rare outcasts in the history of architecture, which thus renders him the social and artistic equal of such alienated Post-Impressionist or Symbolist painters as Gauguin, Moreau, or even Cézanne. Yet these late designs by Sullivan had only a minimal influence upon subsequent buildings, though they have found passionate admirers in the past quarter century. Of greater consequence to succeeding generations were his writings, *Kindergarten Chats* and *The Autobiography of an Idea*.

Sullivan's organic theory seems to resist application to architecture as it has been practiced as a fundamentally urban art throughout much of the twentieth century. His sensuous, original, freshly studied decorative motifs represent a reform of various nineteenth-century efforts in this direction; but, in a period like ours, where decoration in architecture is not a matter of applied ornament but of the studied rhythmic modulation of surface—masses and voids—Sullivan's accomplishment seems irrelevant if admirable. His later buildings are simple cubes, normally of brick, vehicles for dense patches of inspired ornament applied to the plane surfaces with which they contrast. If the urban commercial buildings of his first maturity were the most radical and progressive to appear before 1900, the modest-sized works built after that date were stylistically equivalent to the more up-to-date designs of Otto Wagner, in spite of their distinctly original, autographic quality. In his isolation Sullivan followed a pattern of conservatism, if not of actual reaction, in accord with the major direction of American architecture in the wake of the Columbian Exposition, a trend counter to Continental architecture at the time.

Charles F. McKim (1847—1909), an assistant of Richardson's in the 1870s and a partner in the influential, prolific firm of McKim, Mead and White, could not be more of a contrast with his contemporary, the mercurial, impulsive Sullivan. Nonetheless, McKim towers above all but one or two French academic architects of the day, and his work is readily comparable in quality to that of Berlage or Wagner, though it remains laconic, tightly disciplined, and untouched by the slightest trace of permissive departure from historical prototype in style or ornament, or even the faintest licentiousness in the selection of any but the most orthodox prototypes. If McKim's architecture seems a paradigm of reaction, it should nonetheless be pointed out that his works, notably his pl. 76 masterpiece, Pennsylvania Station, New York, 1906—10 (demolished 1963), have a quality of simplified abstraction that is not unrelated to the more modernist works of the time, even those of so inventive a designer as Wright, and this pared-down quality is at odds with the more ornament-charged symmetries of his Beaux-Arts contempo-

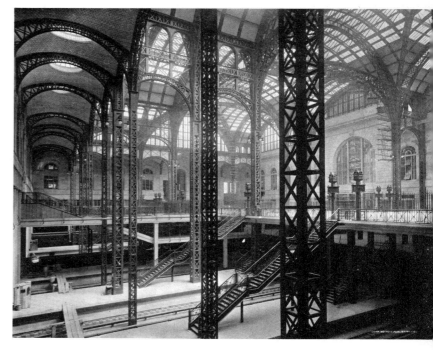

McKim, Mead and White. Pennsylvania Station, New York. Original track level and exit concourses. 1906—10 (demolished 1963). 76

raries at home and abroad. Moreover, the Roman interiors of Pennsylvania Station find a machine-age counterpart in the exposed iron and glass concourse leading to the platforms. McKim may remain an anachronistic figure whose work evokes the ghosts of Ledoux and Labrouste, but the presence of so skilled a designer in a traditional mode, which refuses to relinquish its position in the face of innovation, indicates the inertial strength of these counterforces in modern architecture. It helps explain the isolation of Sullivan and, subsequently, of others—Wright, Le Corbusier, and Louis Kahn—even though all of the architects were, in one way or another, influenced by academic design methods.

In contrast to Sullivan's fate, the success of Art Nouveau, as an avant-garde that found favor with a considerable segment of the public, is instructive. It is tempting to relegate this sprightly movement—headed in architecture by Victor Horta (1861—1947), Henry van de Velde, and Hector Guimard (1867—1942), and drawing into its orbit architects as individual and removed as Gaudí, Sullivan, Mackintosh, those of the Viennese Secession, and Peter Behrens—to the realm of operetta and music hall. While subsequent vanguard movements in modern architecture would usually begin with archaizing, primitivistic, or reductive attitudes toward form, Art Nouveau, taking its cue from contemporary eclecticism, started from a ripe, cosmopolitan base. Compounding the situation was the sheer fashionableness of the decadent in art and literature of the day; and thus the attenuated mannerisms of Art Nouveau architecture could be seen as effete transformations of academic eclecticism, tinged with wit and irony, rather than as bold innovation. Interestingly, certain young painters and architects destined for future

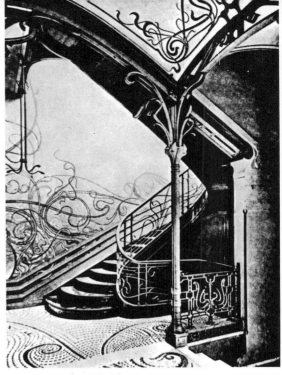

Victor Horta. Tassel House, Brussels.
Staircase. 1892—93. 78

Victor Horta. Maison du Peuple, Brussels.
Auditorium. 1897—99 (demolished). 77

fame seem to have deliberately resisted or rejected the wiles of Art Nouveau during its heyday in the 1890s: Matisse and most of the Fauves are a case in point; among the younger architects, Auguste Perret, Tony Garnier, and Adolph Loos remained aloof or were outrightly hostile, and when Le Corbusier arrived in Paris as a wandering student in 1907, he found Art Nouveau to be ludicrous.

However, this rapid, ruthless rejection after a scant decade of *succès fou* did not prevent the completion of a number of important structures in this style, chiefly in Brussels, Paris, and Nancy. In architecture, Art Nouveau was an explicit fusion of rational principles of structural expression to a fresh appreciation of natural forms as themes for ornamental motifs, an attitude that is similar in its components to Sullivan's organic theory, though formulated independently and in a less sonorous language. These ideals were enunciated by Guimard, but they would seem to apply also to the work of Horta, which enjoys a priority in time. His Tassel House, Brussels, 1892—93, is one of the rare exclamation marks in modern architecture. The sources of its indolently sinuous iron members, expressively articulated to the masonry, have taxed many commentators. Certainly Viollet-le-Duc's style of combining metal and stone provided a conceptual base. Beyond this, one must look to possible influences from painting, then as now the more exploratory of the visual arts, and finally to Horta's own personal growth in the immediately preceding years, a period in which he seems to have deliberately withdrawn from creative work, and in which Brussels was an important center for exhibitions of art by Rodin, Renoir, Seurat, Cézanne, and van Gogh, as well as by William Morris.

Horta's masterpiece is the now-destroyed Maison du Peuple, Brussels, 1897—99, a building whose facade was required to curve in a serpentine fashion because of the exigencies of the site. On the exterior, the mixture of exposed metal, masonry, and glass was clearly and forcefully articulated. However, this particular mix of metal frame and masonry was a far cry from that of the Chicago architects, where, because of past experience and new regulations, structural iron or steel could not be exposed. On the interior of the Maison du Peuple, Horta created a ground floor space roofed with metal trusses in the then-outdated manner of Viollet-le-Duc, but, in the auditorium above, he designed an original space dominated by supports inclined inward from the vertical, which are smoothly joined to the crosspieces to produce an organic, expressive structural effect, one of the most lyrical interiors of Art Nouveau.

The phenomenon of a close, but not yet completely realized, conjunction of art and technology is also present in the works of Hector Guimard, a Parisian architect whose earliest works also reveal an interest in Viollet-le-Duc's stridently awkward proposals for the use of iron. But Guimard, probably partly under the influence of Horta, graduates to the sinuously fluent Art Nouveau line in his ornament and ultimately in his building masses shortly thereafter. Known primarily as the designer of chic, luxurious villas and apartments, Guimard designed one large public building, the

pl. 78

pl. 77

short-lived Humbert de Romans Concert Hall, Paris, 1897—1901 (demolished 1905), and the famous Paris Métro entrances, the first line of which was opened in 1900. The largest of these were ornamental cast-iron and glass miniatures which have now vanished, with only the balustrades and lampposts of the lesser stations now remaining. These Métro entrances were the most extraordinary bits of architecture ever to grace the squares and boulevards of modern Paris, which had been extended and planted by Haussmann in the 1860s and subsequently celebrated in the Impressionist paintings of Renoir, Monet, and Pissarro. At odds with the rather uniform, nondescript academicism of the standard street facade of the city, Guimard's expressive, artfully composed cast-metal abstractions of natural forms were intended to mediate between the restful calm of nature and the bustle of modern urban life.

The delicate balance of opposites contained in Art Nouveau could not be sustained for long; it was too much of a juggling act. In Paris, its waning was signaled by the emergence just after 1900 of two architects, Auguste Perret (1874—1954) and Tony Garnier (1869—1948), who were closely associated with, although not inhibited by, the academic tradition from which most Art Nouveau designers had largely disassociated themselves. Perret, who came from a family of builders, is best known as a pioneer in the development of the reinforced-concrete-frame method of construction. However, except for a passing and inconclusive

reference to Art Nouveau in his earliest work, a block of flats in the Rue Franklin, Paris, 1902—3, he is equally significant for his efforts to relate the advantages of a new technology to the inherited wealth of the academic-classic repertory, especially the latter's concern for regulated proportions, its preference for symmetrical layouts, and its use of details and combinations adapted from the Greco-Roman tradition and its subsequent dependents.

Perret's Rue Franklin apartments show him in the process of working out his synthesis of concrete construction, contemporary taste, and classical heritage. The subsequent Champs-Élysées Theater, 1911—14 (the design of which had originally been given to Henry van de Velde), is indicative of his early mature style: formal, stately, and a bit stiff. It was destined to be a major formative influence upon the widespread Art Deco fashion of the 1920s, and its scraped-down classicism gave yet one more boost to a stubborn, if doomed, academicism. His best works, inventive and clearly expressive of function and technique, are the Church of Notre-Dame, Le Raincy, 1922—23, and the Esders Factory, Paris, 1919. Both achieve a precarious balance between tradition and innovation. However, by this date the vanguard edge of new architecture was moving away from Perret's personal mode, and, although he preserved for a time the role of patriarch among the avant-garde, particularly in France, he was grudgingly and half-heartedly co-opted by a beleaguered ac-

pl. 79

pl. 80

pl. 81

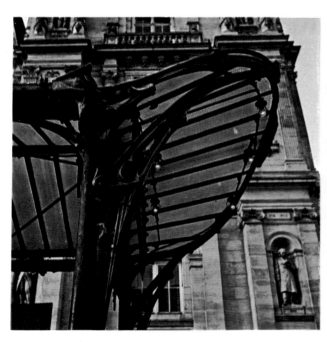

Hector Guimard. Métro Entrance, Paris. Detail. c. 1900. 79

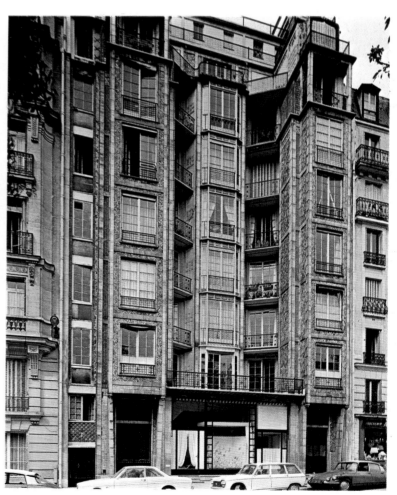

Auguste Perret. Apartment Block, Rue Franklin, Paris. 1902—3. 80

65

ademic establishment. After the Liberation in 1945, Perret was assigned the task of rebuilding the war-obliterated heart of Le Havre, where, in addition to a core of commercial and residential buildings around a central, sunken square, he furnished the design for the Church of St. Joseph, a square central plan surmounted by a lantern inspired by the form of a lighthouse, a surprising variant on a dome or cupola, albeit one quite appropriate for a major seaport.

Perret's contemporary, Tony Garnier, was a more typical product of the École des Beaux-Arts. Attaining the Prix de Rome in 1899 after several tries, he had already conceived the idea of designing a modern industrial city the previous year. He spent his years at the Villa Medici working on this project, much to the distress of his teachers, and, concurrently, challenged the relevance of studying antiquity. Upon his return to France in 1905 he was appointed architect to the city of Lyons, where, by the time his projects for an Industrial pl. 82 City were published in 1917, he was already building a hospital, slaughter house, and stadium for the municipality—designs in which a Beaux-Arts fondness for order and grandiloquence were wedded to a contemporary concern for construc-

tive clarity and efficiently simple forms. His houses of the period were anticipations of Le Corbusier's Purism, and some of Garnier's domestic schemes for his Industrial City were illustrated in *Vers une Architecture* in 1923. However, at the time, the most spectacular achievement of vaulting utilizing the new concrete technology was the work of an engineer, Eugène Freyssinet (1879—1962). His parabolic arched hangars at Orly, 1916, may coincidentally evoke the similar profile of the third century A.D. brick-vaulted audience hall at Ctesiphon, built by the Sassanian Persians, but they are in fact infinitely freer of historicizing inhibitions than any vaulted space by Perret or Garnier, not to mention de Baudot, the pioneer utilizer of concrete in St. Jean-de-Montmartre.

pl. 83

In Germany, Peter Behrens (1868—1940) typifies the best of the rising new generation represented elsewhere by Perret and Wright, a generation in succession to Wagner and Richardson, Sullivan and Gaudí. However, his enormous achievement in industrial design as well as architecture does not overshadow the innovative buildings and interiors of Josef Hoffmann (1870—1956), Joseph Maria Olbrich, Adolf Loos (1870—1933), and Eliel Saarinen (1873—1950). Behrens, however,

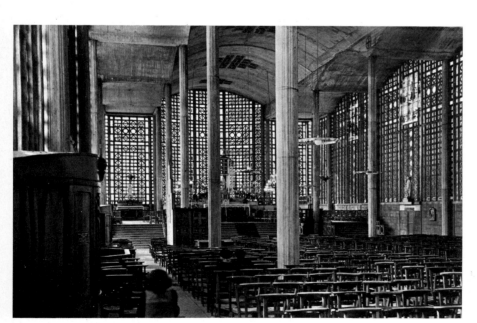

Auguste Perret. Church of Notre-Dame, Le Raincy. Interior. 1922—23. 81

Tony Garnier. Project for an Industrial City. Residential District. 1901—4. 82

Eugene Freyssinet. Airship Hangars, Orly. 1916 (demolished 1944). 83

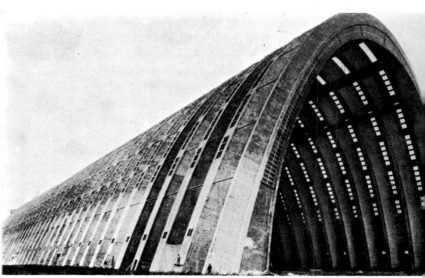

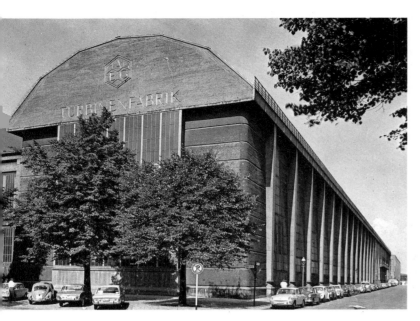

Peter Behrens. AEG Turbine Factory, Berlin. 1909. 84

Peter Behrens. I.G. Farben, Hoechst, Frankfurt. Entrance Hall, Administration Building. 1923—24. 85

remains the linchpin of his generation, tying together earlier pioneering efforts with later, more radical departures, in this particular respect almost overshadowing even the titanic Wright, whose work is undisputedly the most formally inventive of his generation. And it was in Behrens's office that three of the heroes of modernism, Walter Gropius, Ludwig Mies van der Rohe, and Le Corbusier, served apprenticeships.

Behrens's importance extends to his role in giving direction to the industrial arts as applied to machinery and machine-produced household objects, a movement that paradoxically grew out of a reassessment of issues and values initially raised by the Arts and Crafts movement. As architect and design consultant to the AEG (General Electric Company) in Berlin, he designed a series of pl. 84 factories, beginning with the Turbine Factory of 1909, with its recessed, inclined concrete corner pylons (to be contrasted with the corner towers of Wright's Unity Church), which constitute the first landmarks of the new factory style. This is all the more remarkable since Behrens began as a designer in the Art Nouveau manner and only after 1900 turned to a rather personal neoclassic, neo-Renaissance mode of expression, as part of the general reaction of the time against both the sinuous linearism of Art Nouveau and the overwrought abundance of *fin-de-siècle* academicism. The most notable example of Behrens's neoclassicism is to be found in the facade of his German Embassy in St. Petersburg, 1911—12, with its attenuated, engaged columns paralleling the modified classicism of Perret's Champs-Élysées Theater

and foreshadowing the authoritarian government styles of the 1930s. Behrens's work thus heralds the reactionary as well as progressive phases of twentieth-century architecture. The Expressionist aspect of his contribution is found in the factory designed for I. G. Farben at Hoechst, 1923—24, pl. 85 with its brick-arched exteriors, which romanticize the factory style in a way suggestive of Richardson's enlarged simplifications of the Romanesque. Behrens's complex at Hoechst aspires to a somewhat Gaudí-like fantasy, and the enigmatic lobby, an expressionistic evocation of a Gothic cathedral interior, can profitably be compared with the more rational, yet equally ecclesiastical, interior of Wright's Larkin Building. pl. 96

Had Olbrich not died prematurely in 1908, we could well imagine him designing in the mode of Behrens's Hoechst plant, as his style, formed during his long association with Wagner in the 1890s, was less industrially oriented. The various buildings forming an artist's colony of houses and exhibition halls at Darmstadt, beginning in 1899, are Olbrich's masterpieces, and collectively suggest that his turning away from Art Nouveau did not imply a rejection of the fanciful. Among other notable European architects, the one most comparable to Olbrich would seem to be Eliel Saarinen, whose son Eero was destined to leave his distinctive imprint upon post-1945 American building. Saarinen's Helsinki Railway Station, 1904—14, is pl. 87 one of the most typical of the day, additive rather than integrated in composition, a rambling collection of related motifs that are a hard-to-define mixture of innovation and historicizing. Saari- 67

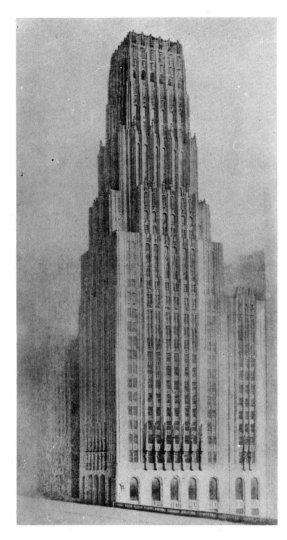

nen's later career included his much-admired, unbuilt second-place design for the Chicago Tribune competition, 1922, a Secessionist Neo-Gothic design that had a marked influence upon American commercial skyscraper architecture in the 1920s and 1930s. Finally, his life's work merges with that of his son, as we shall see subsequently. pl. 86

Josef Hoffmann's work, and especially his masterpiece, the Palais Stoclet, Brussels, 1905—11, provides a most intriguing foil for the factory-style works of Behrens. It is a design of elaborate, almost pretentious simplicity, the general massing of which suggests houses of about 1900 by Voysey or Mackintosh. Its details, and particularly a Secessionist neoclassic cupola, are evocative of Wagner, Olbrich, and Behrens. Its richly furnished interiors feature splendid mosaics by Gustav Klimt, thus constituting one of the rare collaborations between a major architect and a gifted painter in the twentieth century. However, in an age that saw the emergence of the factory esthetic, this was one of the last vital manifestations of Arts and Crafts. In this way, Hoffmann's work is analogous to the more elaborate domestic works of Wright of the same decade, houses that are also late exam- pl. 88

Eliel Saarinen. Project for the Chicago Tribune Tower. 1922. 86

Eliel Saarinen. Railway Station, Helsinki. 1904—14. 87

Josef Hoffmann. Palais Stoclet, Brussels. Street facade. 1905—11. 88

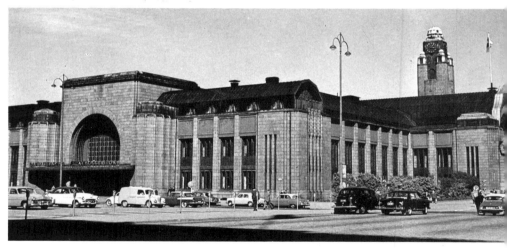

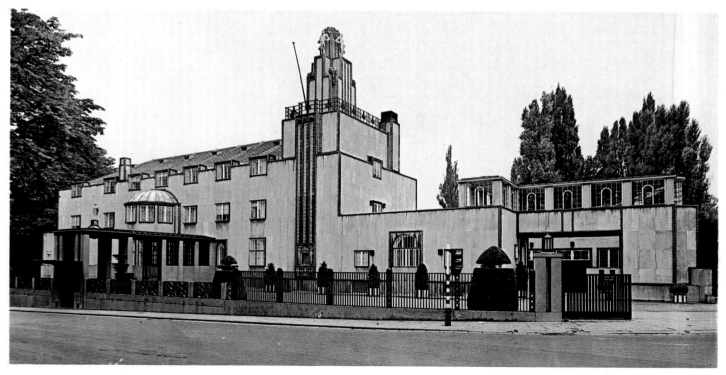

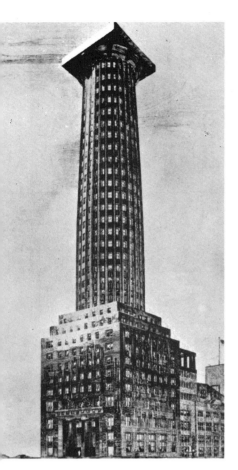

Adolf Loos. Project for the Chicago Tribune Tower. 1922. 89

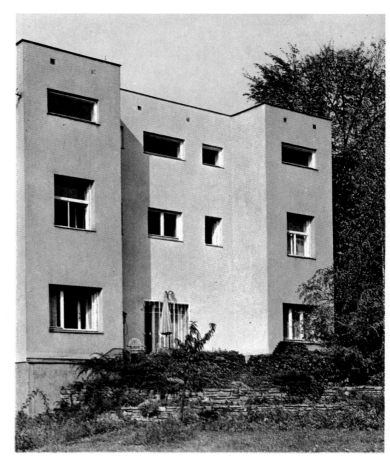

Adolf Loos. Steiner House, Vienna. Garden facade. 1910. 90

ples of the nineteenth-century effort to elevate craftsmanship to the level of a mystique.

The work of Adolf Loos, another Viennese architect of a stature comparable to Hoffmann's, also demands comparison with that of Wright; this is especially true with respect to his domestic interiors, which are detailed with a sparseness and innate sense of proportion and unusual spatial relationships that bring them into the orbit of the American master. Loos developed a concise, laconic, absolute style, at once severely rational and conceptually Romantic. Two works by Loos, the Steiner House, Vienna, 1910, and the project in the form of a Doric-column colossus for the Chicago Tribune competition, 1922, illustrate the extremist, outrageous design frontier always present in his work. While his earlier houses indicate a closer relation to Boullée and the generation of revolutionary classicism, the Steiner House, notably its garden facade alone, is his most personal design: symmetrical to a fault and utterly devoid of ornamental softening anywhere. The Doric column enlarged to the scale of a skyscraper, which is to be taken seriously and not as a joke, as it sometimes has been, evokes memories of similarly outrageous adaptations and tormented changes of scale and context found in the Romantic designs of the late eighteenth century. Not only does it seem surreal in a way parallel to the architectural fantasies of de Chirico, Magritte, and Delvaux, but it is part of the parentage of the "absolute architecture" of Walter Pichler and Hans Hollein in the 1960s, as well as of the monument projects of such recent sculptors as Claes Oldenburg and Robert Smithson.

pl. 90

pl. 89

It would be hard to imagine a more searing contrast than that between the elementary, pure work of Loos and the many-sided career of Frank Lloyd Wright (1867— or 1869—1959). Although Wright seems to have drawn inspiration from revolutionary classicism's strange scale and smooth surfaces in such late works as the Guggenheim Museum, 1943—59, this distant, if relevant, antecedent of the modernist tradition was not a major component in shaping his initial style. While he drew upon many aspects of conventional practice as he found it in his day (and in this respect he is much like Behrens) and even took several years to digest these influences, he arrived about 1900 at an individual style unique beyond that of his peers elsewhere, a complex fusion of parts that is unlike the more heterogeneous works of his European contemporaries. Of them, only Loos seems more relentless in developing a new architecture, but he arrives at his synthesis through negation, Wright through affirmative action. While Loos's distinctive esthetic was aristocratic, Wright's work was more populist, characteristic of the egalitarian Midwest where he was equally successful in building modest, as well as elaborate, houses—nearly all in a style that, significantly, did not vary much with the client's pocketbook.

It is appropriate that Wright's work should occupy the penultimate place in this chapter since it was his work, and only his, that, through a process of selection (and to a lesser degree, of rejection), was able to create a total synthesis of architectural design, the whole leavened with Sullivan's organic theory.

pl. 307

Sullivan's contribution to the realization, as opposed to the idea, of organic architecture had been his imaginatively proportioned and ornamented urban skyscrapers and, later, his smalltown banks. Wright's contribution to that American tradition was the Prairie House, with the unusually ordered mass of the exterior and the distinctively integrated spaces of the interior functioning in the place of Sullivan's additive ornament. Wright had carried the new theory a crucial step further, making a building not just a part of nature, but giving to its overall design a quality that suggested its own inward, plantlike growth from root and stem to leaf and blossom. This was accomplished not through the plantlike mimicry of Art Nouveau decoration but through the integrated massing of intersecting rectangular volumes, broadly projecting low-hipped roofs, and a formal landscaping freed of the rigors of the French academic tradition, which drew his characteristic architectural motifs into the out-of-doors where they blended and ultimately died away amid the abundance of the native site. In addition to Wright's perception and use of environmental circumstances as a stimulus for creative design, his extraordinary historical erudition demands recognition. For an architect who towers over his contemporaries on account of his "originality," this realization is nothing short of devastating to the critic, and bewildering, to say the least, to the casual spectator. However, Wright acquired much of his initial experience working in the suburban domestic modes popular in his day: the shingled cottage style, popularized a generation earlier by Richardson; the revival of eighteenth-century Georgian colonial forms, initiated by McKim, Mead and White; and English half-timbered Elizabethan. Moreover, he contended with the academic tradition of symmetrical layouts and hierarchic massing, and came away the winner twice over. Sometimes, in a public structure, he employed something suggestive of an academic plan but then did something different for the elevation; or, in a house, large or small, he took the intersecting, balanced axes of the Beaux-Arts and displaced them, altered their proportional relationships, and otherwise manipulated the static geometry into something fluid and dynamic, an architecture of freely flowing spaces.

The layout of the Ward Willetts House, Highland Park, Illinois, 1902, is the archetypically organized Prairie House, as centrally anchored as Palladio's Villa Rotunda, but with differences so important as to make his an utterly revolutionary design, one he employed in infinite variation. Symbolically, functionally, and structurally, a massive, low brick hearth is the central core from which radiate living and dining spaces as well as anteroom and entrance. The entrance is to the side, played down and largely concealed by the porte-cochere to the right of the building's mass. The eye is first caught by the unusually low silhouette, compounded out of a very low-hipped roof with an unusually pronounced wide spanning overhang, which is only barely supported by hard-to-discern, recessed piers. The horizontal, ground-hugging emphasis is furthered by the omission of the conventional cellar or half-basement, so that the main floor seems to float only a step or two above the ground. pl. 91

In addition to the dozens of houses of Wright's first creative period, which includes the well-known Robie House, Chicago, 1909, there are a few large public buildings, although, with one important exception, they have now vanished. The Imperial Hotel, Tokyo (begun about 1915 and completed just before the earthquake of 1923), was perhaps his greatest work, in elevation a vast, enlarged Prairie House, giving the aspect of a Midwestern country inn (a prototype of some pl. 92 pl. 93

Frank Lloyd Wright. Ward Willetts House, Highland Park, Ill. 1902. 91

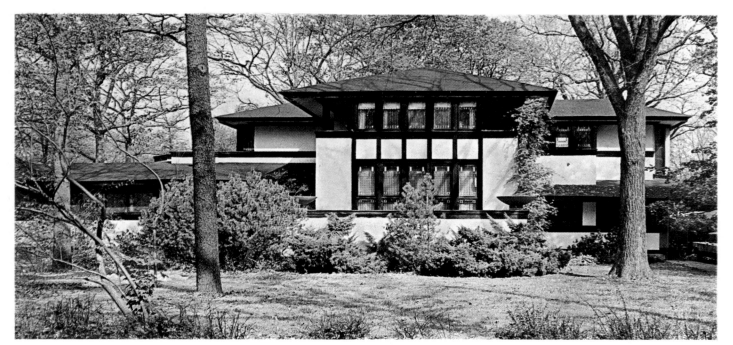

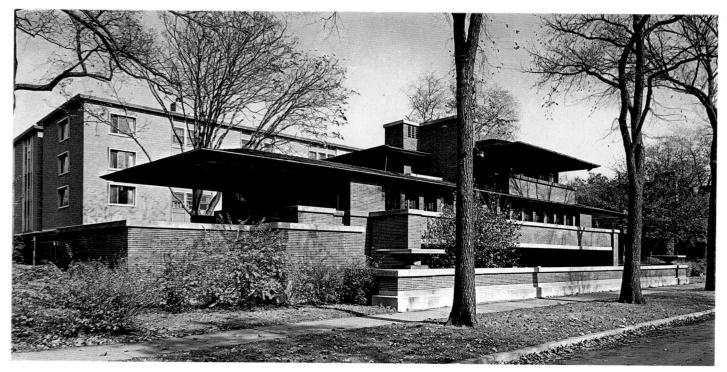

Frank Lloyd Wright. Robie House, Chicago. 1909. 92

Frank Lloyd Wright. Imperial Hotel, Tokyo. c. 1915—23
(demolished). 93

Frank Lloyd Wright. Unity Church, Oak Park, Ill. Interior. 1906.
 94

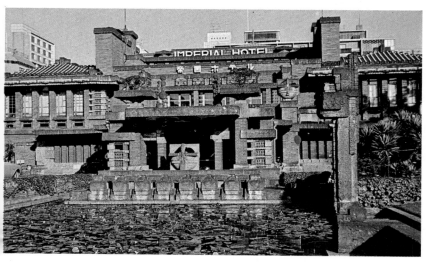

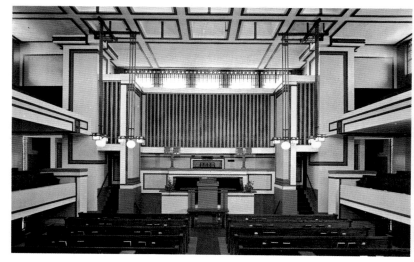

ideal motel which has, alas, never existed!) in the midst of a thoroughly Westernized business district of Tokyo. Though there were many veiled indications of his passionate interest in Japanese art and architecture in his Chicago-suburb houses of 1900 and afterward, these references were banished when he was given the opportunity of actually building in that country. Here the rich, perforated cubic ornament suggests many analogies: from contemporary radical trends in European painting to the richly sculpted mosaiclike friezes of Mayan or Toltec buildings. The Imperial Hotel, important as a monumentalization of an essentially domestic style, is also one of his most orthodox, hierarchic academic plans, a double H, in which a central core is flanked by two side wings, the exterior massing piling up in a stepped climax toward the rear center. It is a composition that can be appropriately compared

to the more stiffly, literally Roman-revival Pennsylvania Station in New York, by Charles McKim, and, to even greater advantage, to the somewhat more permissively conceived Edwardian academicism of the Viceroy's House in New Delhi, 1913, of Sir Edwin Lutyens (1869—1944), where the familiar domes and smaller cupolas have been rendered not in the usual Baroque but in the indigenous Mogul style of the sixteenth and seventeenth centuries.

Wright's earlier public buildings are closer to home. Unity Church, Oak Park, Illinois, 1906, which still survives, is, in fact, only a few blocks from Wright's house and studio, which he occupied until 1909. A pioneering edifice in poured concrete, its chunky, cubic masses could not be more different from the contemporary concrete structures of Perret. With this building Wright completely transforms, through elimination, the

pl. 94

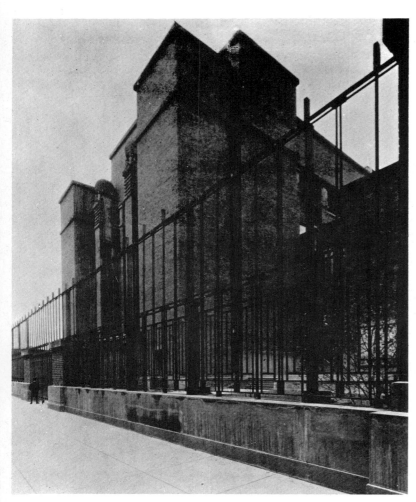

Frank Lloyd Wright. Larkin Building, Buffalo. Exterior. 1904 (demolished 1930s). 95

Frank Lloyd Wright. Larkin Building, Buffalo. Interior. Both photographs courtesy The Buffalo and Erie County Historical Society. 96

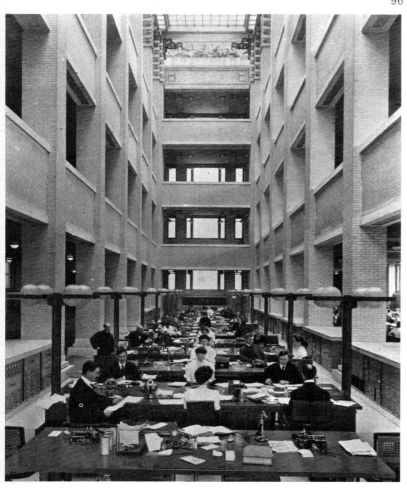

Sullivanian system of ornament which he had inherited more than a decade before. From a stylized naturalism he moved to abstract geometries which, when further refined and denatured, would become the stark primaries and grid rectangles of the painting, sculpture, and architecture propagated by the Dutch De Stijl, one of the major components of the International Style of the 1920s.

Wright's other lost masterpiece of this period, the Larkin Building, Buffalo, 1904, was an office structure for a mail-order concern and was demolished in the 1930s. A far-reaching, integrated design tailored to the specific needs of a particular firm, as opposed to the more uniform, flexible space of office buildings that then and now are so frequently constructed on speculation, its very uniqueness may have helped determine the building's fate. Nonetheless, it is a landmark of design integration, indeed, one of the first instances of environmental design, from the monumental hulk of its exterior to the smallest detail of metal office furniture on the interior. The enclosed space was unique in its mechanical circulation of fresh air, anticipating later refrigerated air conditioning, and the central light well, a feature normally treated with disdain in commercial blocks and early skyscrapers, was here given featured treatment. As Behrens demonstrated that a factory could have an esthetic, Wright demonstrated, in his many works, that houses and offices could be works of art. It was not for the first time, but Wright achieved it with greater consistency, and with a memorable appropriateness and originality.

pl. 95

pl. 96

If Wright's early work takes us to the eve of the Great War, there remain a number of other major contemporary efforts worthy of note. However, these were the works of men whose fame would be shaped by their creative efforts following 1918, and analysis of these works had best wait. There is one exception, the projects for an ideal city by the single Futurist architect of renown, Antonio Sant'Elia (1888—1916). He was the one major architectural casualty of the war, and, although he is the exact contemporary of Gropius, Mies, and Le Corbusier, it is well to treat him now as a culmination of earlier trends rather than later, even if his legacy helped shape aspects of postwar idealism.

Of all the prewar tendencies, Futurism seems to have exerted the most incisive influence upon subsequent architecture—either that or it was the first to clearly articulate a series of issues that were on everyone's mind. Sant'Elia's Futurist City (*Città Nuova*), together with the manifesto prepared with the help of the writer Marinetti, idealizes the vertical skyscraper form set on a terraced site on which the various means of transportation move swiftly, unhindered, separated on distinct levels. Movement, flux, dynamism; these were the major themes expressed in the impulsive, simply massed forms of Sant'Elia's projects. His architecture made explicitly modern what Wright's forms only rendered implicitly. In retrospect, we can see

pl. 97

how Wright's style of 1900—1910 was the vital wave of the future; however, the younger Italian architect's unexecuted projects were more recognizably so at the time and are, significantly, cast in an urban rather than suburban context. For perhaps the first time the American-bred skyscraper appeared as a commonplace in European design, and in a context that made the American ones look old-fashioned. However, the setback shapes of Sant'Elia's tall buildings, with their detached, outrigged elevator shafts connected to the main form by arched bridges, suggest an analogy with Gothic flying buttresses, implying thus a kind of Futurist cathedral. This effect is most remarkable for two unrelated reasons: because of Sant'Elia's historical iconoclasm and because the cathedral-of-the-future image is a key element in the writings and projects of later architectural Expressionism. But the Italian architect shaped concepts more than he shaped a new style: "Modern architecture ... has nothing to do with settling on formalistic differences between new buildings and old ones.... It must be as new as our state of mind is new.... In modern life, the process of consequential stylistic development comes to a halt. Architecture, tired of tradition, begins again, forcibly, from the beginning."[1]

Ignored during his lifetime, Sant'Elia later found a receptive audience ready to assimilate his formal inventions, thanks to the groundwork laid by the two generations of consciously modernist designers reaching from Wagner to Loos. This progressive strain was largely absent in the United States in McKim's purged classicism, which sought to reform a wayward traditionalism by a narrow reconsideration of specific historic models rather than an exploration of new frontiers.

A comparison of Loos, the most individualist architect of his generation in Europe, with Irving Gill, an American contemporary of Wright's (and with whom Wright's son Lloyd worked), is instructive. Gill's Dodge House, Los Angeles, 1915—16, seems to offer the same austerity of mass and contour as Loos's houses of the period or a little earlier. However, each architect's style arose out of vastly different local, cultural, and stylistic conditions, and the results, though important as a historical parallel, were hit upon quite independently. It is therefore a curious irony of recent design history that Loos's disciple, Rudolph Schindler, and a Viennese compatriot, Richard Neutra, who migrated to the Los Angeles area, were the ultimate, effective founders of the new architecture in southern California in the 1920s. Indeed, it might be argued that they usurped the work that might otherwise have gone to the local pioneer, Gill, whose career subsequently petered out in provincial obscurity. But obscurity was the fate of most radical American designers throughout this period, as Gill's career illustrates. The American had no following to speak of, while Loos, whose works offered a similar austerity of mass, made a tremendous mark, after 1918, on the next generation, often through direct contact. Isolated, American architects could not benefit from the social and professional contacts enjoyed by the Europeans, who were able, before 1914, to participate in international exhibits and to make contacts beyond their national boundaries. At home, Wright was barely an architect of national reputation during more than the first half of his career, but, rather, a provincial, even old-fashioned, one in the eyes of American academic critics. No wonder he considered settling in Europe around 1910. There, his work was not just a part of the mainstream; it precipitously assumed seminal quality just before 1914, and after the war the consequences of this force would continue. It could never have done this in his native land.

Antonio Sant'Elia. Project for a Futurist City. c. 1914. 97

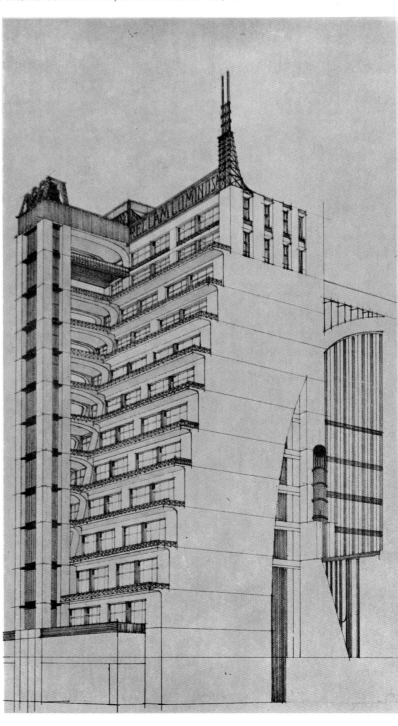

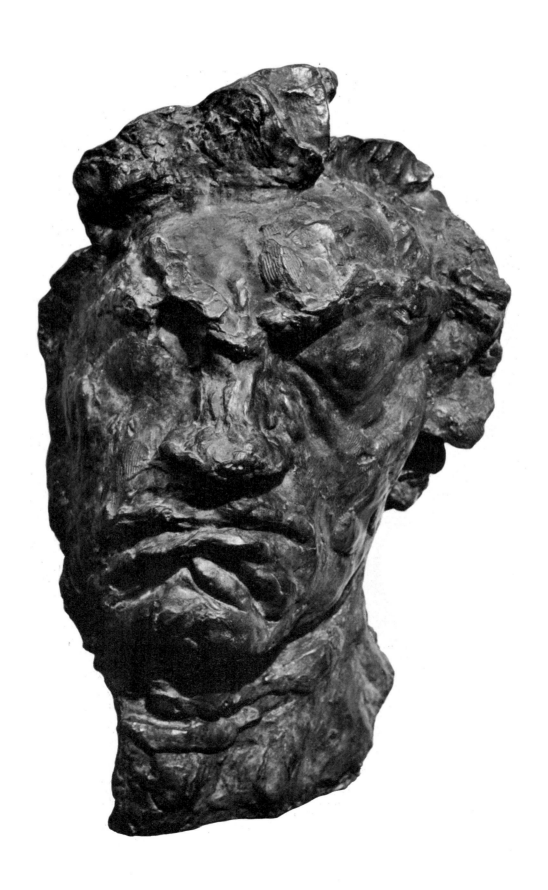

EARLY MODERN SCULPTURE: RODIN TO BRANCUSI

During the Impressionist and Post-Impressionist periods, sculpture lagged behind painting in achieving a specifically modern idiom. The dominant academic obsessions with outdated mythologies, historical events, and themes of personal heroism inhibited discovery and development of new artistic methods that were evident elsewhere in the visual arts. Neither the realistic observation of life, which in painting dated as far back as Courbet, nor contemporary moods of experiment seemed to have affected sculpture very deeply. The most influential traditions were still linked to the prestige of ancient statuary transmitted through various neoclassical models, revived earlier in the century. Only with the advent of Auguste Rodin did sculpture emerge as an independent art form with fresh vitality and promise. In part, this came about through the work of several great painters who did important sculpture; in part, a sense of independence asserted itself when the sculptors after Rodin responded to the revolutionary times with new styles.

During the Impressionist period, the best-known and most admired sculptors—now for the most part mercifully consigned to oblivion—were products of the Beaux-Arts tradition. They expected to be judged more as dramatists and poets than inventors of new form or searchers for a more valid contemporary subject matter. Virtuosity and painstaking, if shallow, craftsmanship were the accepted criteria of artistic achievement, even though the most serious painters, critics, and patrons were aware of the lack of real feeling, sensitivity, or significant content in academic sculpture. Sculpture had not been the dominant visual art form since the days of Michelangelo or at best Bernini, and nineteenth-century sculpture was unable to sustain a continuous development or serious esthetic purpose comparable to advanced painting.

The Impressionists' emergence coincides roughly with Rodin's public notoriety and the scandal of his *Age of Bronze*. The lifelike sculpture caused a sensation when it was shown at the Salon of 1877, in the midst of the Impressionists' own controversial series of exhibitions and their regular rejections by the annual salon juries. But Rodin enjoyed no sense of solidarity with a contemporary group of fellow sculptors of serious purpose and radical aim. Nor could he look for support to a body of sculpture expressing new attitudes toward nature and past artistic tradition, as was the case in progressive painting. The late nineteenth-century sculptor understood that in order to enjoy public esteem, or even to attract notice at the vast annual salons, he must embody such themes as patriotism and the universality of humanist values, usually in some elaborate allegorical form, or at least memorialize heroes and important national events. Conservative critics viewed the adherence of sculpture to familiar figural conventions as a firm bastion against the rising tide of artistic anarchy represented by the Impressionists, whose unstructured visions of the world of appearances caused them such consternation. Anyone who conscientiously sought, in the annual salon sculpture, some evidence of the freshness of outlook and radical innovations that stirred progressive painting looked in vain. He invariably found himself, instead, benumbed by a spectacle of mediocrity and visual bombast, a panorama once characterized as "a white plaster and marble world populated by operatic figures."

The potpourri of subject types at the annual salons with which Rodin's pragmatic honesty and depth of expression contrasted so dramatically has been evoked with fitting relish by Albert Elsen, with the following inventory of improbable juxtapositions: "Olympian divinities and Louis XIII musketeers, ballerinas and Venetian gondoliers, Caesar and Cléo de Mérode, farmers and miners, and such ironic personifications as 'The Force of Hypocrisy Oppressing Truth.'" He continues, "Inveterate Salon visitors could count upon an 'eternal population of women,' sleeping, waking, performing their toilette, bathing, reclining, being taken by surprise, experiencing their first romantic shiver, and grieving at the tomb, all in the service of the renewal of beauty and the sexual education of the young"[1]

Émile-Antoine Bourdelle. *Beethoven, Tragic Mask*. 1901. Bronze, 30½" h. The Museum of Modern Art, New York. Grace Rainey Rogers Fund. 98

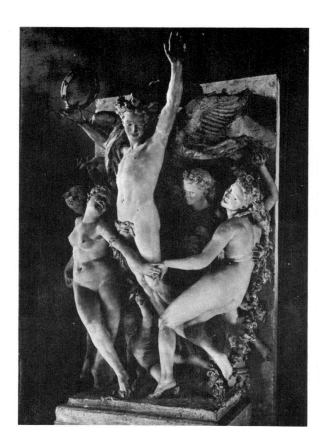

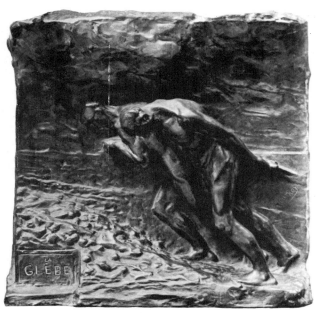

Jean-Baptiste Carpeaux. *The Dance*. 1867—69. Plaster model, c. 15′ × 8′ 6″. Opéra Museum, Paris.
99

Constantin Meunier. *The Soil*. 1892. Bronze relief, 17⅜″h. Royal Museums of Fine Arts, Brussels.
100

pl. 99 Against this background of literary themes, frozen neoclassical anguish or other conventional tableaux, and empty virtuosity in handling—the sculptural equivalent of the absurdly affected painting of Bonnat, Bouguereau, and Cabanel—*The Dance*, by Jean-Baptiste Carpeaux (1827—1875), installed at the Paris Opéra in 1869, seemed fresh and compelling. Here was an allegorical sculpture with a difference; disarmingly Baroque in its animated movement and elaborately curvilinear contours, it managed to convey an almost irresistible energy and charm. Yet the bloodless pretensions of academic tradition were so in command of public taste that a scandal was created around Carpeaux's freshly observed nude figures. Their sensibility, which conformed to the new spirit of painting evident in Manet, among others, only invited violent censure. "They reek of wine and vice . . . their lascivious postures and cynical expressions provoke the beholder," wrote a fanatical, but typical, critic in the press, who concluded with the rebuke, "an insult to public morality."[2]

Even more spontaneous effects of touch in modeling and greater freedom of movement were visible in some of Carpeaux's small statues of a more private character and in his portrait studies. The antagonism Carpeaux aroused at the Academy with his fresh and direct observation of life might be likened to Courbet's liberating and challenging role in painting. With Honoré Daumier, he takes his place as one of the few memorable precursors of the Impressionist painters as well as, in his spontaneous modeling techniques, of Rodin. Actually, Carpeaux briefly taught Rodin at the "Petite École" but had no further connection with him before his early death in 1875.

A growing distaste for the conventional and vapid salon nude and for allegorical "histories" in the later decades of the century resulted in another countertradition, derived essentially from François Millet, which idealized the worker in the field and the proletariat of the city. This preoccupation with all forms of labor—*la plèbe et la glèbe*, "toil and soil"—replaced the tiresome salon dream world with a more viable, modern subject matter. The sympathetic treatment of working people and peasants in the art of Constantin Meunier (1831—1905) and Jules Dalou imbued their figures with a new dignity and a certain awkward, if stereotyped, power. In any case, the introduction of themes of social misery provided relief from the vapid trivia of the salon in a new, though not strikingly original, genre of sculpture. However, one could scarcely expect such mild forms of social idealism to re-establish sculpture as a major art form. It took the genius of Auguste Rodin (1840—1917) to overcome the profound and numerous obstacles that confronted the modern sculptor. In the third quarter of the nineteenth century, almost single-handedly, he reinstated sculpture as a serious enterprise and re-established its eminence after four centuries of relative neglect. pl. 100

Despite his veneration of the most ambitious, historical monumental sculpture, from the cathedrals of France to Donatello and Michelangelo, Rodin takes his place as our first significant modern sculptor, in the sense of breaking with accepted traditions of the past and creating forms more in tune with the temper of the age. Whether in portrait busts or epic figure groups, intimate pieces or public monuments, or forms in calm repose or energetic and contorted action, Rodin breathed new life into the art of sculpture. A

phrase he applied to his art, "the latent heroism of all natural movement," defines both his continuing attachment to the rhetoric of the heroic past and his interest in the dynamism of contemporary life. It also prefigures the unique synthesis of poetic Symbolism, powerful movement, and vigorous realism which characterizes his sculpture in its many and varied phases of development; and it seems to echo Baudelaire's comment that the heroic nature of modern life could be expressed in everyday dress and gesture. Rodin's most fundamental contribution in redefining the role of modern sculpture, and thus allying it with advanced painting of his time, was to make it the vehicle for his personal interpretation of both nature and art. Despite his reverence for the heroic past, he did more to free sculpture from the imaginary salon world of extravagant allegory, literary illustration, religious subject matter, and mythologies than had any predecessor.

pl. 101 *The Man with the Broken Nose*, modeled when the artist was only twenty-three, offered the first stunning public evidence of Rodin's expressive complexity and rather brutal realism. The work demonstrates the originality of his inspiration, even before he was exposed to the traditional heroic sculpture of Michelangelo and Donatello, which later had a profound effect on his work. The poet Rainer Maria Rilke, who wrote a sensitive study of Rodin, described the surface of this small sculpture in terms that would have perfectly suited the emerging Impressionist painting of the next decade. "There were no symmetrical planes in this face at all, nothing repeated itself, no spot remained empty, dumb or indifferent,"[3] he wrote. It is expressiveness of surface, betraying both the urgent emotion of the creator and his preoccupation with artistic process, which ultimately defines Rodin's modernity. His uninhibited modeling of "lumps and holes" to define form made Rodin's art distinctive even when he seemed preoccupied with psychological realism or was consciously depicting an "ugly," unidealized head. Rilke described how Rodin discovered "the fundamental element of his art; as it were, the germ of his world. It was the surface—this differently great surface, variedly accentuated, accurately measured, out of which everything must rise—which was from this moment the subject matter of his art."[4]

pl. 102 *The Age of Bronze*, shown at the 1877 Salon, was Rodin's first major signed work. With this sculpture began the pattern of public disapprobation that was to haunt him throughout his life, despite public honors, an increasing sculptural eminence, and worldly commercial success. The philistine attacks on this lifelike figure, caught in a pose of awakening consciousness, were based, contradictorily, on both its lifelike quality and the artist's license in modeling. There was still a hint of the ominous symbolism of the salon in the pose, which evoked Michelangelo's tormented Slaves. But public and critics, dulled by lifeless salon statuary, charged Rodin with making a life cast, on the one

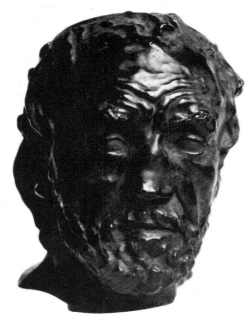

Auguste Rodin. *The Man with the Broken Nose*. 1863—64. Bronze, 9½" h. The Hirshhorn Museum and Sculpture Garden, Smithsonian Institution, Washington, D.C. 101

Auguste Rodin. *The Age of Bronze*. 1876. Bronze, 71" h. The Minneapolis Institute of Art. John R. van Derlip Fund. 102

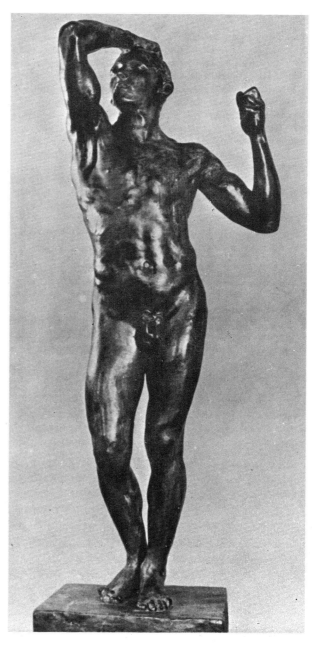

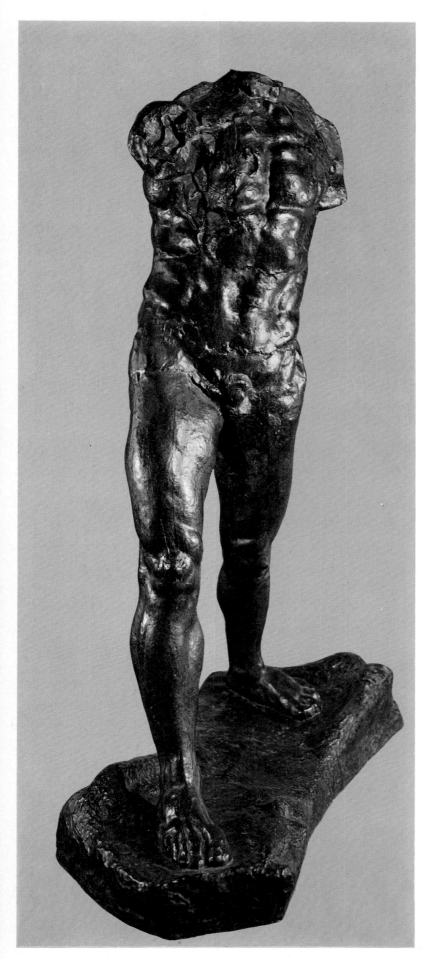

Auguste Rodin. *The Walking Man* (enlarged scale). 1905 (first cast 1907). Bronze, 83¾" h. Rodin Museum, Paris. 103

hand, and then accused him of creating a loose sketch rather than a finished sculpture. In fact, both charges bore elements of truth. Rodin did meticulously observe his model, in ways previously ignored by the academic sculptor, and he also wanted to emphasize the ever-changing surfaces of his sculptural form, in order "to capture life by the complete expression of the profiles." He thus introduced that exaggeratedly impressionistic technique of working in broken planes to reveal incompletely defined forms as if seen in flickering illumination. Rodin's preoccupation with figure and object under the transitory impact of light was matched by an integral expressive power that owed an acknowledged debt to his Romantic predecessors François Rude and Barye.

To dispel the suspicion that he worked from casts of live models, Rodin's next major sculpture, *St. John the Baptist Preaching*, and the study for it, which he called *The Walking Man*, were exaggerated and melodramatic in the vigor of pose. Created in 1878, the study was not conceived as a finished sculpture but rather as a concentrated analysis of skeletal and muscular structure necessary to work out the completed figure. Relevant today, with our advantage of hindsight, was Rodin's use of the partial figure, minus head and arms, as if in emulation of fragments of classical torsos—thus simultaneously evoking and challenging traditional sculpture forms. Also, the sophisticated sense of kinetic action which Rodin himself described as "the progressive development of movement" predicts modern attitudes. He wanted his fractured figure to be read as if vigorously in motion, and yet to synthesize successive stages of movement so that we feel the figure pushing off from the back leg and shifting its weight down on the front leg at the same time, all in a single aggressive, striding pose.

Interestingly, despite his energetic and brilliant descriptive modeling, there was a current of Symbolism in Rodin's complex figure groups. It is an error to limit Rodin's achievement to the vivacious, impressionistic manipulation of surfaces of clay or cast bronze. In accord with the Symbolist painters and poets, he believed that "painting, sculpture, literature, and music are more closely related than is generally believed. They express all the sentiments of the human soul in the light of nature."[5] Many of Rodin's most ambitious commissions, and even his less formal work, accurately reflect the spiritual malaise of the times which gave the Symbolist program its emotional power and relevance. The first evidence, on a large scale, of his philosophical ambition and of a certain modern ambivalence of mood emerged in the unfinished *Gates of Hell*, commissioned but never installed by the state as a monumental bronze door for a new museum of decorative arts.

Given the choice of theme, Rodin selected a Dantesque program of damnation but modified it by introducing Baudelaire's modern concept of ennui, derived from *The Flowers of Evil*, which he greatly admired and had, in fact, illustrated. For

pl. 103

pl. 104

Rodin, Hell was the spiritual nightmare of estranged and impotent modern man, unconsoled by church or state, nor supported by any attachment to nature. Hell could be better defined as a condition of psychic distress than as a place of eternal physical pain. Quite in keeping, then, with Baudelairean imagery and despair, Rodin's *Thinker* sits in the center of the lintel of *The Gates of Hell*, surmounting a turbulent flow of sinners who writhe and gesticulate in the agony of their shame and desire. Later enlarged to heroic scale, as an independent figure, *The Thinker* symbolized for Rodin introspective modern man reduced to impotence by thought, rather than the conventional Christ who sits in judgment. The convulsive

pl. 104

scenes, the rising and falling movement of the carnal lovers and other sinners, are more reminiscent of Michelangelo's *Last Judgment* in the Sistine Chapel than of Ghiberti's doors on the Florentine Baptistry which first inspired Rodin's magnificent invention.

Even more than in Ghiberti's panels, the final effect of Rodin's powerful and monumental relief is essentially pictorial, with its myriad figures (186 in all) covering a surface eighteen feet high. Indeed, the forms of *The Gates* are almost cinematic in their agitated movement and in the effect of dissolving into and emerging from the surface. Actually, then, in addition to its spiritual message, which for the first time made of Hell a modern

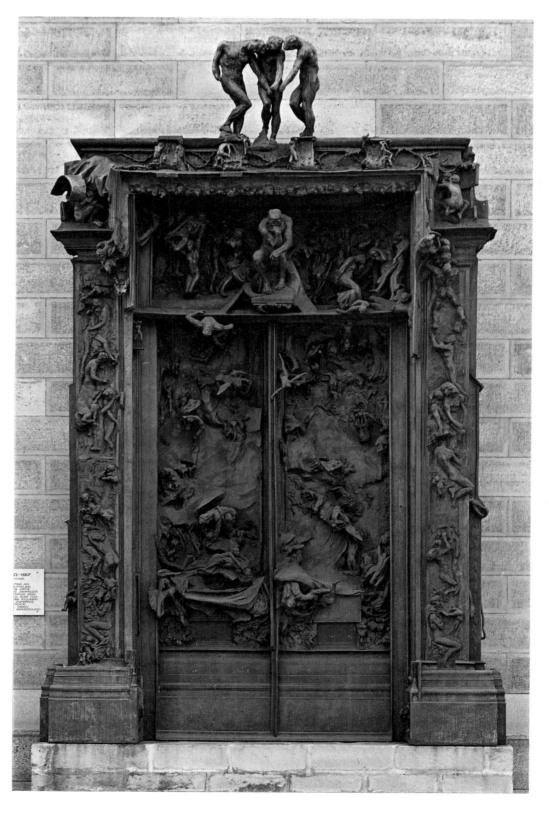

Auguste Rodin. *The Gates of Hell.* 1880—1917 (cast 1925—28). Bronze, 18′ × 12′ × 33″. Kunsthaus, Zurich. 104

Existential nightmare rather than the anachronistic metaphor of traditional theology, the concept of flux and metamorphosis dominates this vast, deeply moving structure. Figures are identified with the matrix of the bronze itself to such a degree that even the impressionistic character of the surface finally gives way to a more dominant expressionist esthetic. The sculptural process and the sculptor's creativity and involvement in the artistic act themselves become a decisive part of the subject matter.

pl. 104 At the artist's death in 1917, *The Gates of Hell* was left unfinished in the original plaster and was not cast in bronze until the 1920s. Yet it remained Rodin's incomparable masterpiece, despite its disunity, incompleteness, distracting pictorialism, and episodic character. It represented a final synthesis of all the major themes that dominated Rodin's creative expression; he had spent a lifetime reworking many of its dominant subjects separately, on a larger scale, including *The Three Shades*, *The Thinker*, *Eve*, and *The Old Courtesan*, among others.

The complex nature of Rodin's genius and, indeed, his continuing relevance to modern sensibilities are best summed up in two of his large-scale, pl. 105 freestanding ventures: *The Burghers of Calais* and the *Monument to Balzac*. The figural composition *The Burghers of Calais* was the first major public commission awarded to Rodin, in 1884. His assigned theme was taken from an account of noble self-sacrifice in Froissart's *Chronicles*, the story of six leading citizens of Calais who voluntarily surrendered themselves, clad in sackcloth, with ropes tied around their necks, to the English King Edward III laying siege to the medieval French city.

The contorted poses, which impart pathos to his figures, suggest similar poses and the strident emotional content in van Gogh and Munch. They even anticipate the more exaggerated gestures and morbidity of much twentieth-century German and Viennese Expressionism, from Lehmbruck's gentle figures of immolation to Schiele's tormented seers. Perhaps even more modern, however, is the formal concept of the antimonument, for the figure grouping is conceived virtually without intervention of the pedestal to demarcate the artistic space from that of the observer. The idea of arranging the figures in a kind of *ronde*—to follow Elsen's revealing analysis—as if a single figure were seen in successive moods and positions, became a device favored by many of the later Symbolists, and it predicted the psychological and kinetic effects of early Futurism. Finally, the informal and open arrangement of the figures in successive rhythmic poses was a direct attack on the classical tradition of the stable, closed monument, invariably removed from the spectator's arena.

Rodin apparently would have even preferred the more radical device of setting his figures directly on the ground rather than on a unifying plinth. He later wrote that his original plan had been "to fix my statues one behind the other on the stones of the Place, before the Town Hall of Calais, like a living chapelet of suffering and sacrifice . . . and the people of Calais of today would have felt more deeply the tradition of solidarity which unites them to their heroes."[6]

It is curious that even as Rodin wished to engage the spectator directly in the drama, a contrary impulse took him in the direction of creating sculptural effects bordering on formal incoherence. The flow of shadows and concavities encountered by the viewer moving around the figure group makes it difficult to read as an intelligible sequence. The drama of light and dark, of recessive shadow playing against protruding mass, erodes the individual figures, their features and physiognomy, and even plays tricks with their anguished expressions. To a surprising degree, dramatic content or narrative substance is denied rather than reinforced by form. An overriding attention to certain shapes and the intervals between them, and the resulting abstract play of forms, disrupt our reading of conventional meanings. In his later works, Rodin often distorted his forms so extravagantly that they lost anatomical coherence and recognizability.

With his imposing *Monument to Balzac*, com- pl. 106 pleted after seven years of protracted labor, distractions, and numerous preliminary sketches, Rodin realized perhaps his most radical and self-expressive sculpture. The colossal and vital figure, almost superhuman, seemed to represent the sculptor's effort to identify himself with the writer's creative force. The Balzac commission was awarded to Rodin in 1891 by the Writers Association *(Société des Gens de Lettres)* and was presented publicly at the Salon of 1898. But the pusillanimous literary society led by Émile Zola, who had wished to memorialize Balzac, rejected the final version of Rodin's monument on the ground that it was a crude, monstrous, incomprehensible image, "an ignoble and insane nightmare" that violated the writer's memory. With its broad summary planes and look of caricature, the work incited a critical tempest in the press, which finally supported the rejection.

Most of Rodin's contemporaries, expecting a conventional likeness, could see only an ugly, shapeless, and unfinished mass. But the head was recognizably Balzac's, and soon after the sculpture was rejected, the critical community came to understand the work for what it was, a symbol of the vigor and heroism of a prolific literary genius. Actually, the monument seemed an almost literal realization of Lamartine's inspired description of the nineteenth-century novelist: "It was the face of an element; big head, hair dishevelled over his collar and cheeks, like a wave which the scissors never clipped; very obtuse; eye of flame; colossal body."[7]

The contemporary public, however, remained blind to the virtues and power of the *Balzac*, failing to react to its abstract form and symbolism of a kind "yet unknown," to adopt Rodin's words. The sculpture represented one of the first occasions in which the artist's private values conflicted

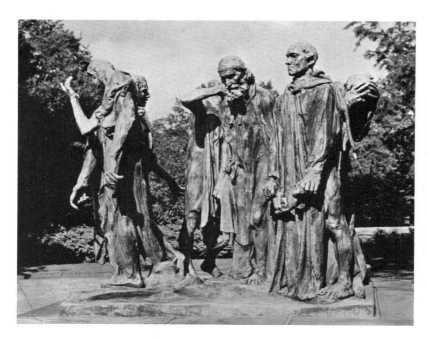

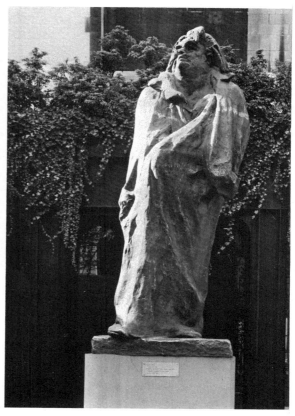

Auguste Rodin. *The Burghers of Calais*. 1886—87 (first cast 1895). Bronze, 85″ h. The Hirshhorn Museum and Sculpture Garden, Smithsonian Institution, Washington, D.C. 105

Auguste Rodin. *Monument to Balzac*. 1897 (first cast by 1930). Bronze, 9′ 3″ h. The Museum of Modern Art, New York. 106

quite openly with outdated public expectations of monumental art. Even Rodin's psychological realism and Impressionist surface could neither mitigate nor elucidate the sculpture as a new kind of icon. Attacked in the press and harassed by his sponsors, Rodin refused to change his design and withdrew his statue, which now stands in Paris at the juncture of the boulevards Raspail and Montparnasse. At the time of this public rebuff he made the following statement: "One can find errors in my *Balzac*; the artist does not always realize his dream; but I believe in the truth of my principle; and *Balzac*, rejected or not, is nonetheless in the line of demarcation between commercial sculpture and the art of sculpture that we no longer have in Europe. My principle is to imitate not only form but also life. I search in nature for this life and amplify it by exaggerating the holes and lumps, to gain thereby more light, after which I search for a synthesis of the whole I am now too old to defend my art, which has sincerity as its defense."[8]

In his later work, beginning with *Balzac* and *Flying Figure*, Rodin achieved such violent, contorted poses that the drama of the modeling itself, and the abstract form achieved by his dismembered fragments, became the work's expressive *raison d'être*. Van Gogh, Gauguin, and the Symbolists similarly had intended to render feelings and ideas through the direct impact of artistic form, and they used external appearance as the equivalent of underlying emotion and a nonperceptual, ideal reality. Rodin took this essentially Symbolist device a step further toward sculptural autonomy. He found a new expressive synthesis in his radical distortions of the human form, which dispensed with the old visual rhetoric of body structure and

yet retained an anatomical authenticity. His role in sculpture was rather like Cézanne's in painting, and, similarly, gained for him a reputation as the "primitive of a new art."

Almost the same combination of psychological realism, painful figure distortion, and pictorialism could be found in the occasional sculptures of Edgar Degas, whose vivacious wax figures were cast in bronze only after his death. *The Fourteen-Year-Old Dancer*, doll-like and appealing, was shown at the Impressionist exhibition of 1881, but it only hinted at the unknown aspect of his work comprised by his sculptures. Degas dispensed with the base and pedestal in even more drastic fashion than did Rodin, placing his little dancer on the floor of a practice hall. *The Tub* presents the illusion of bather and water in a metal tub, which functioned, along with a sculpted floor, as an expedient base. Degas's figures in motion were the very essence of momentary action, permanently fixed in the bronze medium. They were modeled so that the fall of light or shade on mass and plane built an exciting, expressive form. Unlike Rodin, however, Degas did not strive for generality, but, rather, for sharply individualized characterization. His *Dancer* even has flesh coloring and a tulle skirt, and conveys an uncanny waxworks verism that rebukes the artificiality of academic sculpture.

Paul Gauguin's occasional relief and freestanding sculptures, of which the wood carving *Be in Love and You'll Be Happy* is a prime example, carry significance as sculptural expressions for their symbolic themes and for their rejection of the "error of the Greeks" in favor of folk- and tribal-art prototypes. Although twentieth-century artists made their discoveries of primitivism independently, it was Gauguin who first pointed the

pl. 107

pl. 108

pl. 28

81

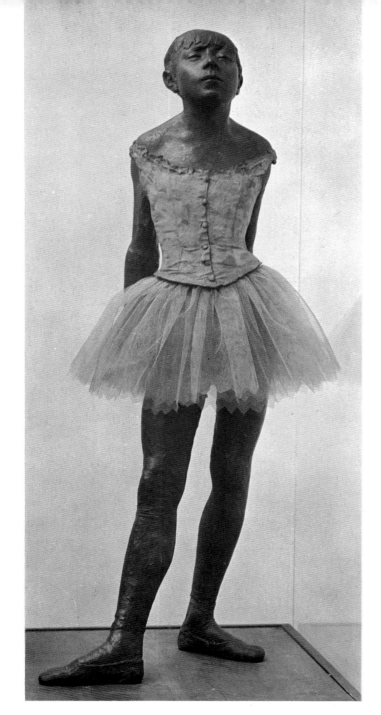

way, when he found his inspiration in sources outside the mainstream of traditional European culture.

In sculpture, the synthesis of illusionist naturalism and an enchanting, sensuous formlessness derived from an exaggerated Impressionist technique was most dramatically realized by the Italian Medardo Rosso (1858—1928). Rosso had met pl. 110 Rodin in Paris, but his figure groups are small, casual, and intimate and avoid both the epic scale and the elaborate mythologies of Rodin's heroic compositions. Rosso chose to portray the banal, everyday world and treated it with the tender humor of Vuillard and Bonnard. Sharply contemporary genre themes, alien to all but a pictorial sculptural mode, served him as inspiration. His preoccupation with light was even more acute than Rodin's, and he keenly responded to its power to dissolve solid bodies in space. He preferred working in wax, which minimized the hard, tactile qualities of sculpture and emphasized momentary appearances. Wax also gave his sculpture a more luminous and chromatic effect, allowing his molten surfaces to reflect vibrations of suggested movement as well as changes in lighting. Rosso's radical dissolution of form anticipates the Italian Futurists, who greatly admired his work and cited him as a precursor in their manifestoes.

Rodin's influence on Rosso, and others as well, was incalculable. It has been pointed out that the scope and intensity of the imagination of this artistic giant can best be compared to Wagner's in the same period. The proof of his greatness lay not in his immediate followers, but even in the work of artists who used his art as a point of departure, like Maillol, Brancusi, and Matisse, and then proceeded to reject his techniques and program in order to assert their own independence.

Perhaps his strongest and most immediate influence, apart from the radical Impressionism

Edgar Degas. *Fourteen-Year-Old Dancer.* 1880—81. Bronze with tulle skirt, satin hair ribbon, and wooden base, 39" h. The Metropolitan Museum of Art, New York. The H.O. Havemeyer Collection. 107

Émile-Antonio Bourdelle. *Hercules the Archer.* 1909. 97⅝" h. Musée National d'Art Moderne, Paris. 109

Edgar Degas. *The Tub.* 1886 (cast 1920). Bronze, 18½ × 10½". The Metropolitan Museum of Art, New York. The H.O. Havemeyer Collection. 108

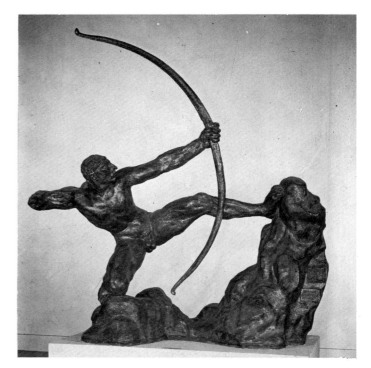

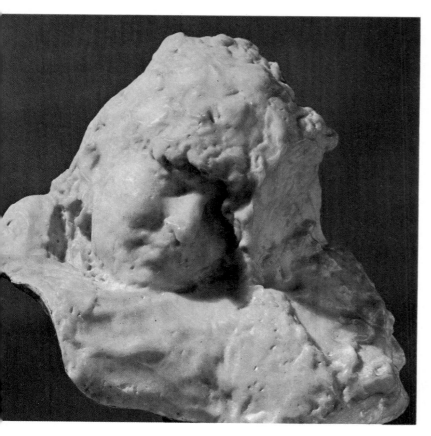

Medardo Rosso. *Carne altrui*. 1883. Wax-covered plaster, 17" h.
Galleria Nazionale d'Arte Moderna, Roma. 110

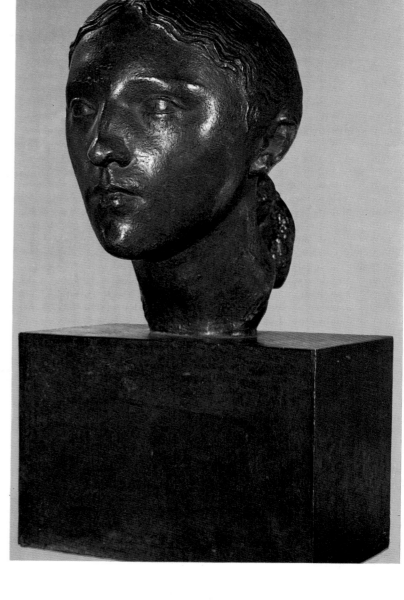

Charles Despiau. *Young Girl from Lands*. 1909. Bronze, 19⅜" h.
Musée National d'Art Moderne, Paris. 111

of Rosso, was upon his chief studio assistant, Émile-Antoine Bourdelle (1861—1929). Bourdelle's imaginary portrait, *Beethoven, Tragic Mask*, translated the close-up, highly accented mask of the composer into an expressionistic landscape of powerful emotion bordering on incoherence, in anticipation of the turbulent paintings of Soutine and others. After his first success at the 1901 Salon, however, Bourdelle turned to a more stereotyped, archaic idiom, as in his *Hercules the Archer*, whose neoclassical mannerisms removed him from the vital sources of Rodin's Impressionist and realist tradition. Nevertheless, he remained an impressive and influential teacher for many years, and assisted others in seeking out the rich possibilities of architectonic form and poetic statement in so-called primitive forms. Another assistant of Rodin's, Charles Despiau (1874—1946), was a master in a minor key, achieving memorable images of poise and restraint in his sensitive nudes and portrait busts.

During the first decade of the new century, when Rodin was at the height of his fame, a number of other sculptors developed new and opposing ideas, in particular, Aristide Maillol (1861—1944). He only turned to sculpture when he was forty, after a long apprenticeship with the Nabis

as a painter and decorator, but he returned the art of sculpture to more legitimately sculptural directions. He re-established its validity as pure form of an almost classical stability and simplicity, after the long domination of Rodin's agitated figures and complex themes. Reflecting on the serenity and immobility of ancient art, and looking to the unity of the sculptural mass as a regulating idea, Maillol declared: "For my taste, sculpture should have as little movement as possible. It should not fall, and gesture and grimace. The more immobile Egyptian statues are, the more it seems as if they move."[9]

With his personification of natural forces in the form of stocky, full-bodied country girls, Maillol restored the Greek classic tradition, which the academicians had eviscerated. To Grecian poise, harmony, and containment he added his own robust, earthy vigor and breadth of treatment. Commenting on his replacement of Rodin's dramatic figures with the greatest possible simplicity of gesture and pose, Maillol said: "There is something to be learned from Rodin ... yet I felt I must return to more stable and self-contained forms. Stripped of all psychological details, forms yield themselves up more readily to the sculptor's intentions."[10]

pl. 98

pl. 109

pl. 111

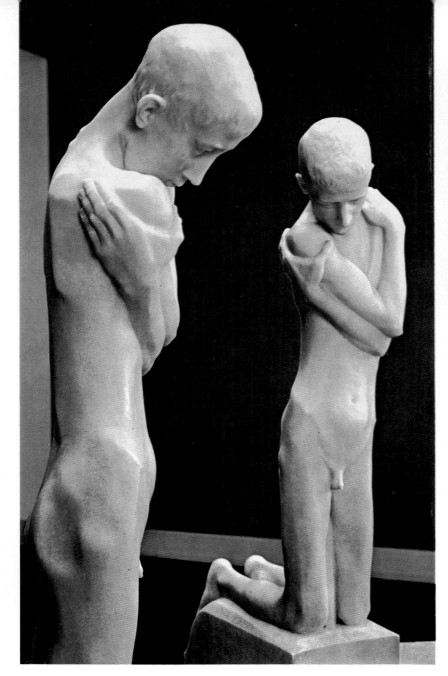

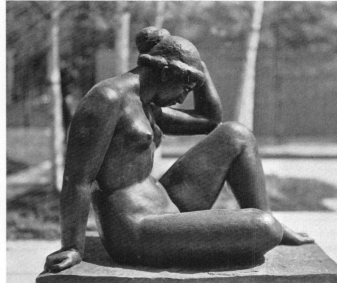

Aristide Maillol. *The Mediterranean*. 1902 — 5. Bronze, 41" h. The Museum of Modern Art, New York. Gift of Stephen C. Clark. 113

George Minne. *Foutain of Five Kneeling Youths* (detail). 1898. Marble, 67" h. Folkwang Museum. Essen. 112

Aristide Maillol. *The Young Cyclist*. 1907 — 8. Bronze, 38⅝" h. Musée National d'Art Moderne, Paris. 114

Adolf Gustav Vigeland. *Monolith*. 1927 — 43. Stone, 55' h. Frogner Park, Oslo. 115

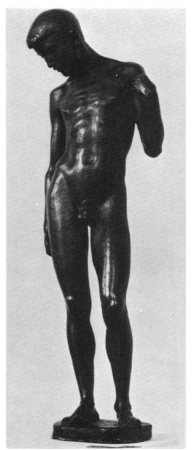

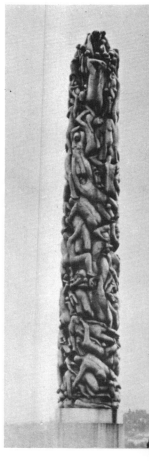

 With Maillol, the human figure became a focus of a detached objectivity, and he achieved a new balance of abstract volumes and proportions in his heavy, articulated torsos. He thus achieved a radical new plastic simplicity, in marked contrast, as he himself noted, to surface complexities of pl. 113 Rodin's highly inflected manner. His figure *The Mediterranean* presents a smoothly flowing, carefully constructed balance of contour and volume at odds with the agitation and straining for epic pl. 116 content of Rodin's figures. *Action in Chains*, originally conceived as a monument to the socialist Blanqui, is more dynamic in its rhythmic disposition of masses, but its energy and forceful movement are restrained. The action is held in a controlled tension.

pl. 114 In an earlier work, *The Young Cyclist*, Maillol had sensitively modeled an adolescent youth with the touch of pathos and introversion reminiscent of the melancholy preoccupation of the Symbolists. The *fin-de-siècle*'s pervasive spiritual malaise even more explicitly shaped the work of the Belgian George Minne (1867—1941). His *Relic Bearer* of 84 1897 suggests, in its attenuated figure, inward-

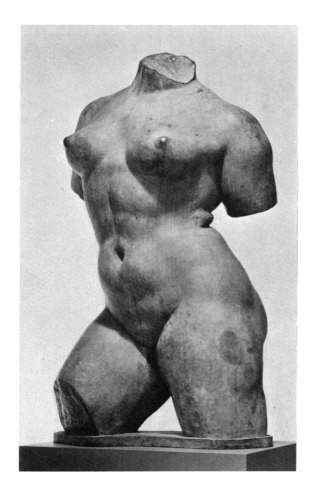

Aristide Maillol. *Torso of Action in Chains*. 1905
Bronze, 51¼″ h. Private collection. 116

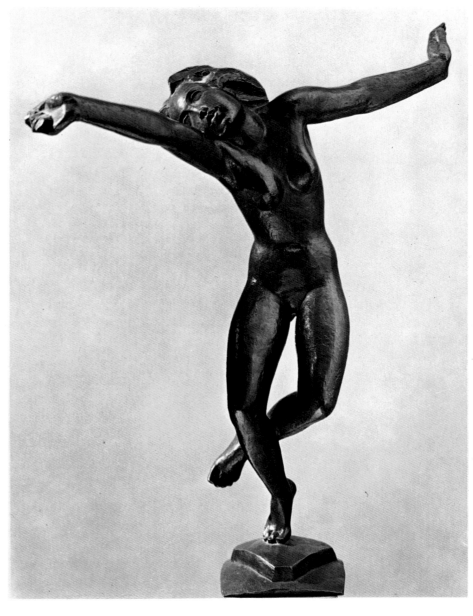

Georg Kolbe. *Dancer*. 1922. Bronze, 19¼″ h. Wallraf-
Richartz Museum, Cologne. 117

turning gesture, and almost excruciating sensitivity of modeling, a withdrawn, unworldly mood. The pose of silent resignation was repeated in five marble figures set on the rim of a large simple basin for a fountain commissioned in 1906 for the museum at Hagen, now called the *Fountain of Five Kneeling Youths*. Another, rather more sensational, Symbolist sculptor was the Norwegian Adolf Gustav Vigeland (1869—1943) whose dramatic allegories on humanity's passage through life became the basis of the colossal bronze fountain in Frogner Park outside of Oslo with its 121 statues. His portrayal of the human passions in the grand manner was reminiscent of Klimt's mosaics and murals; more generally, he conveyed the mood of disillusionment and his conception of man's inexplicable destiny that so dominated Symbolist art of the 1890s.

Wilhelm Lehmbruck (1881—1919) took from Minne's Symbolist sculpture its unstable proportions, attenuated limbs, and depiction of inner feelings as outward signs of the spiritual life. While the stylization of Rodin and Bourdelle, who also influenced him, expressed intense and positive emotion, Lehmbruck's tentative, nervous contours

pl. 112

pl. 115

and almost painfully articulated elongations of the human anatomy suggest a contemplative mood rather than one of energy. The asceticism and denial of his figures, qualities which became more exaggerated as German Expressionism developed, are gentle rather than brutal or self-punitive. The pattern of transforming exasperated feelings into an imagery of violence, which often evoked the darker regions of the human psyche and abnormal psychology, had been sanctioned by the confessional art of Munch and Ensor's savage and grotesque caricature. These precedents, however, had greater impact on painting than upon German Expressionist sculpture. Lehmbruck became probably Germany's greatest twentieth-century sculptor. Like the more vehement and strident Expressionist painters who followed him, there was in his work more than a touch of the Gothic, and of the anguished contortions of Grünewald's elongated figures. Yet they also retained a certain poise and grace even in their extreme departure from naturalistic proportions.

Lehmbruck worked in Paris between 1910 and 1914, and there he was first influenced by Maillol. The harmonious serenity of his fully developed

85

style ties him as closely to classical tradition as his distortions and preoccupation with suffering link him to the romantic Expressionist tendency. Lehmbruck's work possesses a moving, inward feeling, a sense of inherent dignity, and is touched with compassion for erring humanity, as well as melancholy. The *Fallen Man*, a war memorial, is the antithesis of military pomp and posturing, and surely as a result, it was bitterly attacked during the Nazi regime. His even more touching and eloquent figures, such as *Kneeling Woman*, were banished from public exhibition on the grounds that they were non-Aryan.

pl. 118

Other German sculptors, particularly Georg Kolbe (1877—1947) and Gerhard Marcks, refined forms and contours in sensitive figures imbued with an appealing, lyric simplicity. Contrasting sharply with these are the blunt, terse figures of Ernst Barlach (1870—1938), who took his inspiration from late medieval wood carving. The strength of folk and primitive art, and respect for the profundity of the peasant soul, which shaped his powerful art, derived from his personal experience and from such artistic sources as Brueghel and van Gogh. He bypasses classical charm in favor of an almost visionary seizure of emotion and dramatic action, as is evident in his sculpture *The Ecstatic*. A most refreshing and apropos characterization of Barlach's vernacular subject matter is given by Elsen: "In form and subject, this self-styled 'Low German' sculptor cherished his own type of primitivism that involved places

pl. 117

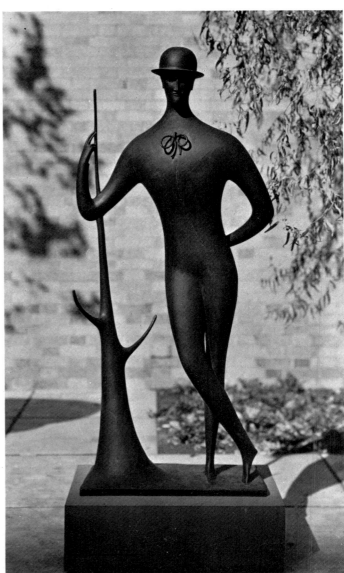

Elie Nadelman. *Man in the Open Air*. c. 1915. Bronze, 54½" h. The Museum of Modern Art, New York.　　120

Gaston Lachaise. *Standing Woman*. 1932. Bronze, 7′ 4″ × 41⅛″ × 19⅛″. The Museum of Modern Art, New York. Mrs. Simon Guggenheim Fund.　　119

Wilhelm Lehmbruck. *Fallen Man*. 1915—16. Bronze, 30½ × 94 × 32¾". Collection the Lehmbruck family, on loan to the National Gallery, Berlin.　　118

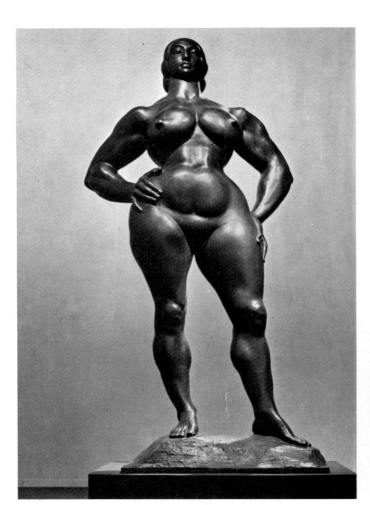

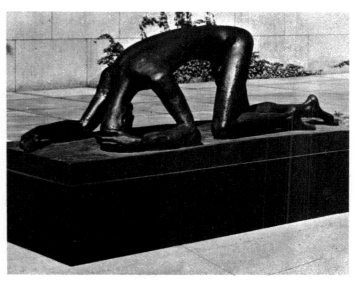

86

relation between mass, plane, and contour. In his five versions of this subject, Matisse begins with a relatively detailed naturalism but concludes with a broad, powerful interpretation and transformation of the motif into virtual abstraction.

In addition to the progressively more drastic formal invention, the serial character of the five portrait busts, developed over a three-year period, de-emphasizes motif as such. A shift in esthetic priorities can be perceived, from represented subject matter to the process of artistic creation. In this, Matisse differed fundamentally from Rodin, who remained attached to the model despite the high-flown dramatic ends to which he might have manipulated his human figures. No matter how sensual his touch, in Matisse's figures we always encounter an indifference, typical of all great formal art, to the emotional potential of the subject.

Another hint at the revolutionary esthetic behind Matisse's work lies in his willingness to let the five versions of the portrait bust of Jeannette remain in an apparently crude and unfinished state. His own standards of what constituted finished work had little to do with nineteenth-century preconceptions as to unity of style or surface. Despite their rudimentary lumpiness, expressive distortions, and general ungainly look at first glance, upon study and sustained exposure the Jeannette series is, finally, most impressive in its sculptural clarity and intelligence. On the one hand, Matisse showed an incomparable sensuousness in his use of clay; yet his responses to the model in terms of fresh formal solutions were controlled by the same qualities of intellect and expressive restraint which governed even the most uninhibited of his Fauve paintings. As he himself put it in his "Notes of a Painter" in 1908, he opposed an emotional and excessively dramatic expressionism, connected primarily with gesture and rhetoric of pose. He preferred to be judged by the total expressiveness of his work, in sculpture as well as in painting. In other words, it was what the sculptor does, his achieved vision and the handling of his materials, that are expressive, rather than power or drama of the subject.

Matisse's most ambitious exploration of the monumental possibilities of sculpture, corresponding to the impressive paintings made under Cubist influence, such as *Piano Lesson* and the even larger *Bathers by a River*, occurred with his great Back series. He experimented with these life-size forms in shallow relief between 1909 and 1930. The subject itself had an honorable history going back to Courbet and Cézanne, a version of whose Bathers Matisse kept in his studio for many years. The *Back, I*, was influenced by Rodin, as can be seen in its more naturalistic character, freely expressive modeling, and anatomical detail. The fourth, and final, version, completed after an interval of twenty years, was so radically simplified and stylized that the figure takes on an organic and abstract power. The limbs have become rigid trunks, virtually unrecognizable tubular forms, and the bisecting tail of hair has taken on more of an architec-

pl. 125, 126,127

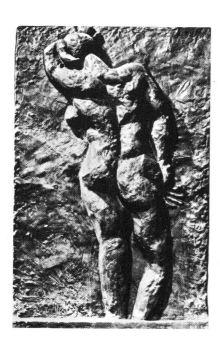
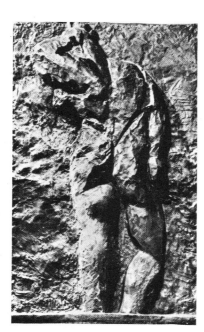
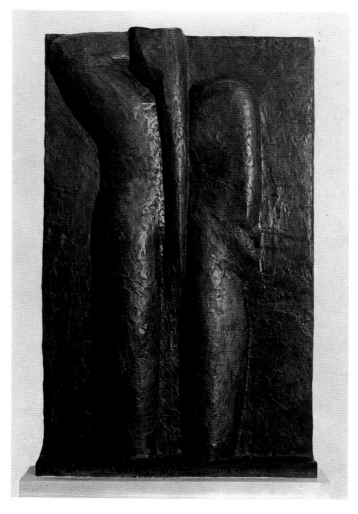

Henri Matisse. *Back, I*. 1909. Bronze, 6′ 2⅜″ × 44½″ × 6½″. The Museum of Modern Art, New York. Mrs. Simon Guggenheim Fund. 125

Henri Matisse. *Back, II*. 1913. Bronze, 6′ 2¼″ × 47⅝″ × 6″. The Museum of Modern Art, New York. Mrs. Simon Guggenheim Fund. 126

Henri Matisse. *Back, IV*. 1930. 6′ 2″ × 44¼″ × 6″. Tate Gallery, London. 127

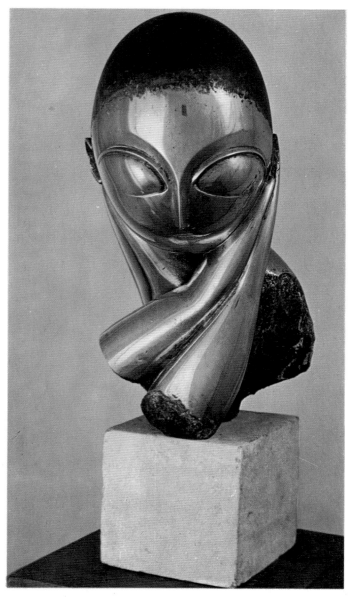

Constantin Brancusi. *Mlle Pogany*. 1913. Polished bronze, with black patina on hair, 17¼″ h. The Museum of Modern Art, New York. Acquired through the Lillie P. Bliss Bequest. 128

In the first two decades of the new century, under the impact of Cubist formalism, sculpture moved toward geometric stylization and a new Purist esthetic. Matisse's sensuousness and somewhat tortuous treatment of form seemed flabby and *retardataire* by comparison, and sharply limited his influence. The impression of a minor sculptural achievement was enforced by the relatively small number of sculptures he actually produced. However, since World War II his influence has expanded considerably, and his unique synthesis of intellect and sensuality has aroused firm allegiance among the more painterly avant-gardes, in both pictorial and sculptural modes, especially during the past two decades. His capacious achievements in painting, sculpture, and collage are now seen to reflect, separately and together, an integral greatness in different mediums and forms, and each medium carries the full range and power of his experience in art.

The sculptor with the most revolutionary artistic vision and a profound influence in the early twentieth century, whose name became identified with modernism for a universal public, was Constantin Brancusi (1876—1957). Unlike Matisse, he was a full-time sculptor, and his impact was felt immediately by his peers after 1910, when he began to create highly polished and streamlined geometric forms, which displayed a new, vitalistic spirit despite their elementary character. Brancusi retained tenuous attachments to descriptive forms and themes and, in fact, framed these allusions to nature with considerable wit. Nonetheless, he really deserves consideration as the pioneer abstract sculptor of the century, in advance of the Constructivists and contemporaneous with Kandinsky's path-breaking innovations in painting. Like the work of Kandinsky and Mondrian, Brancusi's gleaming abstract forms seem less the product of Purist esthetic theory than of private intuition and Eastern mysticism. Brancusi and a number of early modernist abstract painters were drawn to the cosmic imagery and universal themes popular with the Symbolists. Kandinsky and Mondrian apparently practiced theosophy, and Brancusi was also an enthusiast. For all of these artists who pioneered abstraction, the visible world veiled mystic truths and obscured the essence of reality. In the purification of one of his best-known images, *Mlle Pogany*, we sense his Neoplatonizing inspiration. Albert Elsen has pointed out that possibly Charles Blanc's text, which students used in Paris at the École des Beaux-Arts, came to his attention, for it suggested that artists elevate individual portrait to type and then pursue their subject's "primitive essence." [13]

pl. 128

That sense of primitive essence was, in fact, the basis of Brancusi's first identifiably modern sculpture, *The Kiss*, completed in 1908 in its original version. Its heavy, blocky forms, massiveness of design, and elementary stylization reflect the primitivist interests of his contemporaries among the French Fauves, German Expressionists, and Picasso. Like so many of his painter friends, Bran-

pl. 130

tonic than descriptive function. The sense of the living model's ample proportions and sensuous ripple of flesh and muscle somehow survived the reductive process as Matisse reached the rather brutal formal synthesis of his maturity.

The use of modeled relief with such sculptural power was unique in modern art. It is a tribute to Matisse's sense of sculptural volume and to his unerring pictorial taste as well, that he could produce, in shallow relief, such strong formal tensions. While the work may not have solved the problem of defining monumentality within its medium, as his large paintings had done, it was a noble effort. The experiment was constrained by the structure of the vertical rectangle and condition of physical flatness, which the artist's pictorial preoccupations and habits of a lifetime necessarily imposed upon him. But Matisse probably showed wisdom in choosing shallow relief, even on this large scale, as it was uniquely suited to his pictorial inclinations and enabled him to achieve a work of great originality and sculptural feeling.

cusi was influenced directly by the radical simplifications in form and the erotic candor of African sculpture. Other evidence of the pervasive influence of African forms and archaic Greek, Cycladic, Iberian, Polynesian and other remote and exotic sculptural examples can be found in the early sculptures of Jacob Epstein (1880—1959), and the painter André Derain (1880—1954). Actually, *The Kiss* appears rather abruptly in Brancusi's development, and after he showed great promise in a Rodinesque manner. Brancusi's *Sleep* shows Rodin's direct influence in its soft modeling and in the rough-cut stone from which the expressive head emerges. A later version of the same subject, *Sleeping Muse*, forcibly demonstrates the radical result of the meticulous process of formal and technical refinement which Brancusi's sculpture underwent as he purified the facial mask and the virtually featureless head into his characteristic primal ovoid mass.

pl. 129
pl. 131

pl. 133

pl. 132

After rejecting Rodin's modeling and Naturalism, as well as a flattering invitation on the part of the eminent older artist to work as his studio assistant, Brancusi declared: "What is real is not the external form, but the essence of things. Starting from this truth it is impossible for anyone to express anything essentially real by imitating its exterior surface."[14] It was this revolutionary vision that gave a new visual and tactile reality to modern sculpture and, at the same time, managed to identify the sculptural object with universal elements of spirituality.

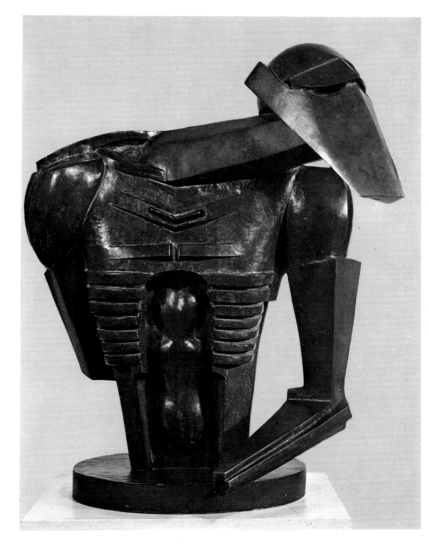

Jacob Epstein. *The Rock Drill*. 1913. Sculptured bronze, 27¾" h. Tate Gallery, London. 129

Constantin Brancusi. *The Kiss*. c. 1912. Limestone, 23×13×10". Philadelphia Museum of Art. The Louise and Walter Arensberg Collection. 130

André Derain. *Crouching Man*. 1907. Stone, 13" h. Museum of the Twentieth Century, Vienna. 131

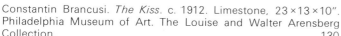

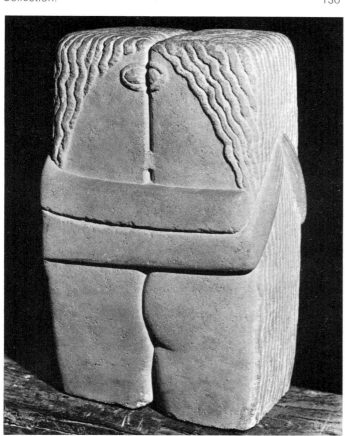
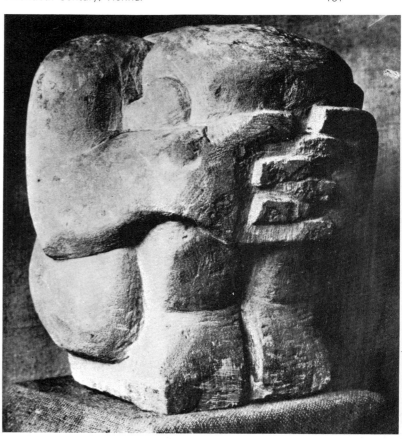

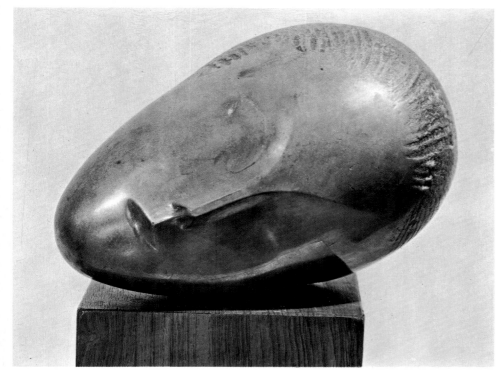

132

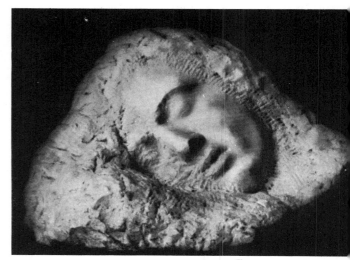

Constantin Brancusi. *Sleep*. 1908. Marble, 10¼" l. National Gallery, Bucharest. 133

133

Constantin Brancusi. *Sleeping Muse*. 1910. Bronze, 10⅝" l. Musée National d'Art Moderne, Paris. 132

Constantin Brancusi. *Bird in Space*. 1928? Bronze, 54" h. The Museum of Modern Art, New York. 134

Constantin Brancusi. *Adam and Eve*. 1916—21. Oak, chestnut, and limestone, 94¼" h. The Solomon R. Guggenheim Museum, New York. 135

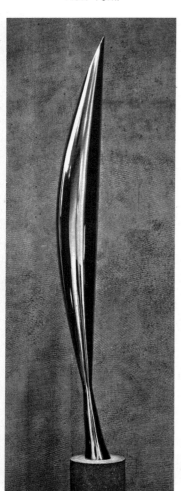

134

135

In addition to his incomparable purity of form, achieved by simplicity of shape and the use of a single continuous sculptured surface, Brancusi brought to modern sculpture a new respect for the nature of materials, whether carved wood, marble and other stones, or impeccable, polished bronze. His biographer, Ionel Jianou, suggests that Brancusi's "choice of a medium was determined by the content. Marble lends itself to the contemplation of the origins of life, while wood lends itself more easily to the tumultuous expression of life's contradictions. Brancusi's intimate knowledge of the laws and structures of his materials enabled him to achieve a perfect harmony between form and content."[15] Possibly the mystique of materials may have been exaggerated, in view of the varied versions of such themes as *Mlle Pogany*, which seems an image beyond material considerations, and works as well in stone as metal. Nonetheless, one senses throughout Brancusi's *œuvre* a search for the essence of things, and that search is bound up with inanimate matter. The optical and tactile perfection of his stone and metal contributed to their specific content, whether in the soaring impression of flight in *Bird in Space*, which became the symbolic abstract work of the early twentieth century, or in the mysterious presence of the more brutal, direct carving in wood of his extraordinary male-female totem, *Adam and Eve*.

pl. 128

pl. 134

pl. 135

Brancusi's repertory of shapes conveys poetic and symbolic meanings with the dazzling power of a vision seen in a completely fresh, imaginative manner. Although he remained attached to such formal prototypes of earliest antiquity as Cycladic sculpture, he also, of course, created forms which influenced the familiar streamlined objects in our culture. Nevertheless, his sculpture comes down to us uncompromised by its degraded imitations, as the very essence of modernity. It is also timeless. A

Brancusi sculpture would be equally at home in the presence of archaic Greek sculpture and in a Hindu temple. *The New Born* is the essence of his genius, in its summary oval mass and schematic suggestion of the mouth of a howling baby. It symbolizes rather than describes the idea of beginnings.

Contrasting with the perfection and control of his polished metal surfaces, Brancusi's wood carving recalls the brute force and the libidinal content of African sculptures. His wood carving also makes allusions to Rumanian folk art, to the repetitive geometrical ornament on peasant houses in his native land, and to the familiar carved screws of wooden farm machines and wine presses, which reappear literally in his notched and grooved sculpture bases. It is interesting to reflect on the dual aspect of his sculpture. Highly rationalized, polished metal forms contrast with the folkloristic and irrational content of the wood carvings; the obsessive theme of the life-force takes form, alternately, as the organic essence of materials refined to the point of pristine absolutism and as a clearly sexual expression allied to tribal faith in potency.

Among Brancusi's major achievements was the remarkable triad of sculptures in the park of Tirgu Jui in the southwest of Rumania: *The Endless Column*, *The Gate of the Kiss*, and *The Table of Silence*. Rising triumphantly ninety-six feet in the sky, the immense column is a masterpiece of monumental sculpture that was incomprehensible in its own time. Its repeating, modular units of form forecast a more conceptual role for sculpture that only came to fulfillment, with a comparable

formal ambition, in contemporary creations beginning in the late 1960s. One of the most lucid evocations of Brancusi's artistic quality and almost mythic stature in twentieth-century sculpture came from the late English sculptor, Barbara Hepworth, who described a visit to his studio in 1932. Her quietly eloquent appreciation of Brancusi's achievement reminds us that the search for elemental sculptural form and meaning early in the century, notwithstanding a mechanical precision of surface or presumed mystic profundities in content, remained a personal adventure, guided by familiar humanist values:

> In Brancusi's studio I encountered the miraculous feeling of eternity mixed with beloved stone and stone dust. It is not easy to describe a vivid experience of this order in a few words—the simplicity and dignity of the artist; the inspiration of the dedicated workshop with great millstones used as bases for classical forms; inches of accumulated dust and chips on the floor; the whole great studio filled with soaring forms and still, quiet forms, all in a state of perfection in purpose and loving execution, whether they were in marble, brass or wood—all this filled me with a sense of humility hitherto unknown to me.
>
> I felt the power of Brancusi's integrated personality and clear approach to his material very strongly. Everything I saw in the studio-workshop itself demonstrated this equilibrium between the works in progress and the finished sculptures round the walls, and also the humanism, which seemed intrinsic in all the forms.... To me, bred in a more northern climate, where the approach to sculpture has appeared fettered by the gravity of monuments to the dead—it was a special revelation to see this work which belonged to the living joy of spontaneous, active, and elemental forms of sculpture.[16]

pl. 136

pl. 137

Constantin Brancusi. *The New Born*. 1915—16. Marble, 6 × 8½ × 5¾". Philadelphia Museum of Art. The Louise and Walter Arensberg Collection. 136

Constantin Brancusi. *View of the artist's studio with several versions of Endless Column*. c. 1918. 137

EXPRESSIONISM

The descriptive epithets we have encountered thus far in our study of modern art, such as Neo-Impressionism or Symbolism, were adopted usually by the artists themselves who formed a movement, or they were applied later by critics to describe a clearly defined artistic group with common aims or characteristics. The term Expressionism poses a more complex problem, however. It denotes, in one sense, a general tendency in any art with strongly asserted emotional content. In keeping with the romantic spirit where its origins lie, Expressionist art prefers personal vision to knowledge, values inward revelation over the observation of nature. In more precise usage, the term became popular in Munich around 1911 in the pages of *Der Sturm*, a leading avant-garde periodical edited by Herwarth Walden, and it was used to elucidate and support—often in rhapsodic terms—the many divergent revolutionary tendencies in European art of the period. "We call the art of this century Expressionism," he wrote, "in order to distinguish it from what is not art. We are thoroughly aware that artists of previous centuries also sought expression. Only they did not know how to formulate it."[1] But this epithet was soon appropriated by other German critics to characterize the primitivizing Bridge group *(Die Brücke)*, which had begun to show in Dresden in 1905, and to define the more abstract and intellectually oriented Blue Rider group *(Der Blaue Reiter)* in Munich, whose leader was the Russian Wassily Kandinsky.

A foretaste of the Teutonizing of the term came with the appearance of an essay, "Expressionism," by the critic Paul Ferdinand Schmidt, published in *Der Sturm* in 1912, which outlined the development of this interesting new movement: "Cézanne taught the simplification of tone values, Gauguin the effect of the plane, and van Gogh added the flaming luminosity of color. Maurice Denis, Vuillard and Bonnard attempted to prepare a planar simplification in the grand style, but they lacked persuasive expression. This was found by the Teu-

tons of the north and south, Munch and Hodler."[2]

Edvard Munch, in particular, had been an influential figure in Germany, and his works were widely known in Berlin as early as 1892. Later, he was invited to exhibit as "guest of honor" at the Berlin Secession and showed such dramatic works as *The Kiss* and *Death Chamber*, which caused wild protests, demonstrations, and public scandal. Munch stayed in Berlin intermittently until 1908, and there painted his great *Dance of Life*. In the 1920s, when the exasperated feelings of the postwar period were at their height, another German critic wrote that Munch had indeed been the first artist to recognize and adopt the essential characteristic in Expressionist art—communication of emotion through the pictorial elements themselves. "Munch dared to paint the incidents of the inner life We saw that brush and stroke were able to divulge deeper things."[3]

Yet no one seems further from the psychological turmoil, the mood of despair, and the autobiographical obsession of Munch than the artist who apparently first adopted the word "expression" in the twentieth century and who painstakingly explained the means for achieving expressiveness in art: the Frenchman Henri Matisse. The Germans, following the example of Munch, Hodler, and their Gothic forebears (Grünewald particularly), sought an art that went beyond visual impressions to express emotional experiences and spiritual values; but Matisse and his group of so-called Fauves deserve priority for investigating the concept of expression as such. Indeed, during a limited period, they painted with an abandon, passion, and even violence of pictorial means that justifies their claim to being the century's first Expressionist artists.

The association of Expressionism with Matisse is supported by a passage in "Notes of a Painter." One of the fundamental documents in the history of modern art, this work was immediately translated into German and Russian. In it Matisse made a statement that clarifies his independence of the emerging German Expressionists, whose views were taking shape at the same time:

What I am after, above all, is expression I am unable to distinguish between the feeling I have for life and my way of expressing it.

Otto Müller. *Gypsies Around a Fire.* c. 1925. Oil on canvas, 43¼ × 63″. Private collection, Hamburg. 139

Expression to my way of thinking does not consist of the passion mirrored upon a human face or betrayed by violent gesture. The whole arrangement of my picture is expressive. The place occupied by figures or objects, the empty spaces around them, the proportions, everything plays a part. Composition is the art of arranging in a decorative manner the various elements at the painter's disposal for the expression of his feelings.[4]

Matisse then goes on to say that there are generally two ways of expressing things: "one is to show them crudely, the other is to evoke them artistically."[5] Here, then, is an essential difference between Matisse, as the representative of French Expressionism, and the German Expressionists. The French were primarily committed, under Matisse's leadership and as a matter of both long-standing tradition and deeply rooted habits of mind, to exploring formal problems of pictorial method and design. When Matisse used the term expression in reference to something more than a facial expression, as he frequently did around 1908, he was quick to couple it with "sensibility" or with some "higher ideal of beauty" and a "decorative manner." His viewpoint was essentially esthetic and rigorously detached. The Teutonic obsession with the "spiritualization of ex-

pression" and with human suffering was entirely alien to Matisse's Mediterranean spirit and classical moderation. He was never concerned, as were the Germans, with urban themes as such, with the freedom and nudity of the human body understood as a liberating element, or, most importantly, with portraying psychic states, especially of anxiety. The German artists reacted to a corrupt society by assuming the role of savage moralists, and concerned themselves with the psychological situation of modern man. Significantly, both the French Fauves and The Bridge group shared the interest in the newly discovered "primitive" art of Oceania and Africa, but with antithetical responses. The Germans found an affinity with the life-style and the mysticism of primitive peoples, whereas the French limited their discovery to the new formal and expressive possibilities of primitive art. Matisse and his associates preferred form to magical content, and diffused the more savage and disruptive elements of primitivism in their paintings by subordinating them to decorative artistic values.

But to understand the relationship of Matisse and French painting to the broader phenomena of Expressionism after the turn of the century, we must consider some of the salient differences in

pl. 139

relation to the development of Matisse's own work and its abiding humanism.

In the early years of this century, Henri Matisse was exposed, in Paris, to a number of great retrospective exhibitions of the Post-Impressionist masters, which deeply stirred the new generation of painters. In 1901, the Bernheim-Jeune Gallery put on a sizable van Gogh show; van Gogh was shown again in a large exhibition at the Independents Salon in 1905. In 1903 and 1906, Gauguin was honored with important exhibitions at the Autumn Salon and the Independents. Cézanne's late rise in esteem had begun with Vollard's first retrospective of his work in 1895, which so impressed the Nabis, and in 1904 and 1905 he was given larger salon shows that won him an even more important following among the younger painters. That year Cézanne's name was, more than any other, on the tongues of members of the avant-garde. The electrifying effect of the Post-Impressionists' exhibitions was not surprising, for the new painters had had no prior opportunity to examine their works. Cézanne was something of a myth in his lifetime, a recluse in the south whom few of the young painters had ever seen, and whose work was largely legend.

Van Gogh and Gauguin were known by the somewhat diluted derivatives of their paintings produced by the Nabis. None of these artists had been experienced at first hand by the neophyte painters. In fact, up to 1900 the most important and influential artistic event had been the 1897 exhibition of the Caillebotte bequest at the Luxembourg; that exhibition, we know, had stirred Matisse and many other artists very deeply. The bold colors and refined crudeness of Gauguin and van Gogh, and Cézanne's modeling with color, came as revelations to Matisse and his colleagues. Their discovery of these artists was the immediate inspiration for their daring new experiments and the violent colors suddenly released in their painting around 1905.

In 1899, Matisse had adopted the Neo-Impressionists' vibrant, intense color, and he had begun to apply pigment in pointillist dots. But immediately afterward he reverted to a darkish palette, taking his cue from Courbet and the early Manet. *Carmelina*, a work of 1903, demonstrates Matisse's pl. 141

Paul Signac. *View of the Port of Marseilles*. 1905. Oil on canvas, 35×45¾". The Metropolitan Museum of Art, New York. Gift of Robert Lehman. 140

Henri Matisse. *Carmelina*. 1903. Oil on canvas, 31½×25¼". Museum of Fine Arts, Boston. 141

Maurice de Vlaminck. *Picnic*. 1905. Oil on canvas, 35×45⅝". Private collection, Paris. 142

ability to draw together diverse influences. The subject makes us think perhaps of Courbet or the early Lautrec, until we realize that the girl is not given any strongly personal associations except for the blue bow in her hair. She is simply a model, posing in the artist's studio, and in the mirror we catch a glimpse not only of her back but also of the artist himself at work on the picture. Thus Matisse reminds us of his attachment to an illusionist tradition, as did both Courbet and Manet before him, or Velázquez in *The Maids of Honor*—the ultimate source of this particular reference and one much admired by Manet.

pl. 140 In 1904, Matisse met Paul Signac and spent the summer working near him at Saint-Tropez on the French Riviera. Under Signac's influence he began using the bright colors of Neo-Impressionism, but loosened his forms and allowed color to function more freely, much to Signac's dismay. In the Independents Salon held the following spring, Matisse exhibited a large outdoor figure composition, *Luxe, Calme et Volupté*, which was a rather free and personal adaptation of Signac's methods. Actually, despite Matisse's greater freedom, the painting was still unmistakably derivative in character and relatively conservative.

In the fall, however, Matisse exhibited a new group of paintings whose assertive originality and

independence could not be denied. Joining him in the exhibition at the celebrated Autumn Salon were André Derain, Henri Manguin, Albert Marquet, Jean Puy, Louis Valtat, Maurice de Vlaminck, Othon Friesz, and Georges Rouault. pl. 142 Many of these artists had been fellow students of Moreau's or Carrière's. Maurice de Vlaminck (1876—1958), an outsider, was a fellow townsman of Derain's from Chatou, one of Renoir's former painting locales. Matisse had met him with Derain at the van Gogh exhibition at Bernheim-Jeune in 1901, where, legend has it, he heard Vlaminck loudly and extravagantly singing the praises of van Gogh: "You see, you've got to paint with pure cobalts, pure vermilions, pure veronese."[6] From Le Havre had come Friesz, another charter member of the Fauves. In 1906, at their second exhibition, two more Havrois, Raoul Dufy and Georges Braque (1882—1963), joined the group.

The label Fauves ("Wild Beasts") was a term of derision coined by the journalist Louis Vauxcelles. After seeing a small bronze in Renaissance style set amid the gallery reserved for the young radical painters, he remarked, "Donatello au milieu des fauves" ("Donatello among the wild beasts"). The phrase stuck, and afterward the central gallery where the works of Matisse and his friends

were hung was jocularly referred to as the *cage centrale* or the *cage des fauves*.

The Fauve exhibition was as much a *succès de scandale* as the first Impressionist group show had been. Tired old epithets were dusted off and refurbished by glib philistine journalists: "pictorial aberration," "color madness," "unspeakable fantasies," "the barbaric and naive sport of a child who plays with the box of colors he just got as a Christmas present." The fresh color and free handling blinded critics to the Fauves' originality and, indeed, to their charm. They rendered landscapes, marines, city views, and holiday crowds with savage splashes of pure pigment, but their mood was sanguine and lyrical. The public made no mistake in sensing a genuine violence and even a predatory character in Fauvist color, brushwork, and distortions of form; but it confused means and ends. That violence—which today, however, seems relatively tame—represented an effort to breathe new life and vigor into painting by restoring the free play of spontaneous feeling.

The Fauves' outlook corresponded to a new, intoxicated rediscovery of natural life and feeling, which had already been expressed in the closing years of the century in such books as André Gide's *Fruits of the Earth* and by the literary movement of Naturism. As early as 1895, in his *Essay on Naturism,* Maurice Le Blond had voiced the mounting reaction of writers to Romantic decadence: "Our elders preached the cult of unreality, the art of the dream, the search for the new shudder. They loved venomous flowers, darkness and ghosts, and they were incoherent spiritualists. As for ourselves, the Beyond does not move us, we profess a gigantic and radiant pantheism."[7] And the novelist Charles-Louis Philippe had declared in a letter written in 1897: "What we need now are barbarians.... One must have a vision of natural life.... Today begins the era of passion."[8] Fauvism, similarly, grew out of this new spirit of joyous, pagan affirmation and represented a return to natural reality after the Romantic interregnum.

The Fauves did not willfully distort reality for purposes of sensationalism; they were intent on recapturing, through new strategies, the nature that had begun to elude the oversubtle Neo-Impressionists and belated Impressionists. Matisse and his associates intended to make nature exist freshly, with more spontaneity—just as in their own time, first Manet and then the Impressionists had rejuvenated the visible world by new methods. The Fauves broadened their techniques and used juxtapositions of complementaries, but in wider slashes, and followed instinct rather than any reasoned or "scientific" analysis. Above all, they sought vividness and whatever new combinations of pure pigment would transmit the greatest possible luminosity.

Despite his vehemence of expression and a high pitch of emotion, Matisse was closer to the spirit of Cézanne than to any other Post-Impressionist. While his first Fauvist ventures seemed not at all to emphasize structure, Matisse was conscious of using color to establish solid form. His arbitrary splotches of pigment conveyed vivid impressions of something actually seen or felt in nature. He later spoke of "re-creating" color, of finding a chromatic harmony that at once corresponded to his sensations before nature and created a more intense, independent pictorial reality. By way of explanation of the liberties he took, Matisse wrote: "He [the artist] must feel that he is copying nature—and even when he consciously departs from nature, he must do it with the conviction that it is only the better to interpret her."[9] For many other Fauves, an academic style derived from Gauguin's color oppositions or from van Gogh's vehement brushstrokes in pure color. Matisse took Cézanne as his primary source of influence, even though his own exuberant, flat color planes seem so remote from the relatively restrained and systematic palette of the nineteenth-century master. Georges Duthuit, the brilliant historian of the Fauve movement, asked Matisse how it would be possible to associate Cézanne with "the idea of using pure colors." To this Matisse replied, "As to pure color, absolutely pure colors, no. But Cézanne constructed by means of relations of forces, even with black and white."[10] For Matisse, pure colors became plastic forces, too.

Among the paintings Matisse showed at the 1905 Autumn Salon were a small landscape he had painted that summer at Collioure under strong Mediterranean light, *Open Window*, and a portrait, *Woman with the Hat*. On the advice of Leo Stein, the first important Matisse collector, or perhaps at the urging of Sarah Stein, his sister-in-law (accounts of the purchase differ), *Woman with the Hat* was obtained for the Stein family. It hung for many years in the celebrated apartment shared by Leo and Gertrude Stein on Rue de Fleurus, among the many superb early Matisses and Picassos these dedicated patrons of twentieth-century art acquired. This painting had aroused considerable dismay in the press owing to its distortions of the human countenance and the liberties taken with composition. Unlike either Cézanne or Gauguin, Matisse made no effort to set up a suave harmony of cool and warm tones; purples, greens, and blues all registered at fullest intensity, creating a wonderfully vivid, if discordant, effect against high-keyed oranges and yellows. The result was a new chromatic magnificence, but it irritated contemporary sensibilities, and finally even those of Leo Stein, who took some time getting used to the new color combinations and, after 1907, was no longer able to accept Matisse's bold innovations.

Along with the offending color, an extreme sketchiness of form was singled out for criticism in Matisse's work. Contours were defined by changing, ragged patches of color; many areas were left thinly painted, almost untouched, as Cézanne had done, to take advantage of the luminous show-through of white canvas. Oddly enough, even in Matisse's most extreme Fauve paintings, behind

pl. 143

the free, spontaneous expression, one feels the invisible armature of nature. The expressive attitude of the head in *Woman with the Hat* is the result of careful observation; and *Open Window* carefully establishes a spatial relation, near and far, both in the room and in the balcony vista. Matisse's most abandoned chromatic expression cannot disguise the operation of intelligence and moderating good taste; something exquisitely cerebral, as well as a real impression of the external world, controls expressive license in his art.

The most interesting criticism of the Fauves' exhibition was that of the former Nabi Maurice Denis. Writing in *L'Ermitage*, he took a negative stand against what he saw as a new cult of novelty for its own sake and the fashion of the sketch, but he credited Matisse and his friends with vitality and force. His remarks unwittingly anticipated the abstract art Fauvism soon engendered. "One feels completely in the realm of abstraction," he wrote. "Of course, as in the most extreme departures of van Gogh, something still remains of the original feeling of nature. But here one finds, above all in the work of Matisse, the sense of the artificial; ... it is painting outside every contingency, painting in itself, the act of pure painting. ... Here is in fact a search for the absolute. Yet, strange contradiction, this absolute is limited by the one thing in the world that is most relative: individual emotion."[11] The Fauves' lyrical release of emotions and emphasis on "the act of pure

Georges Rouault. *The Old King.* 1916—36. Oil on canvas, 30¼ × 21¼". Museum of Art, Carnegie Institute, Pittsburgh. 144

Henri Matisse. *Woman with the Hat.* 1905. Oil on canvas, 32 × 23¾". Collection Mr. and Mrs. Walter A. Haas, San Francisco. 143

painting" were to be major factors in the development of both German Expressionism and abstract painting, as we shall see.

Georges Rouault (1871—1958) was the only French artist comparable in sensibility to the Germans in his anguished Expressionist character. He exhibited with the Fauves but never really shared their aims. Rouault had participated in the Autumn Salon of 1905, but his work must have looked out of place despite the vigor of his expression. He set his low-keyed colors in murky washes of blue, animated by a network of energetic black lines. There was an unusually somber mood to his entries. While his style and imagery suggested Lautrec, his paintings were cruder in feeling and full of strong, disapproving moral overtones. He painted professional entertainers and the Paris underworld from the point of view of a stern evangelist loose in the fleshpots; yet he did it with a profound sense of human pathos. With forceful line and radical simplification of form, Rouault created moral caricatures of remarkable power. Influenced by the Catholic mysticism of Léon Bloy, he intensified the religious character of his art in later years. These densely luminous paintings took their inspiration from medieval stained glass. (He had begun his career as a stained-glass worker.) On the whole, he stood apart from the

pl. 144

great movements of his time, a solitary poet of exalted religious feeling.

The Fauve group held together for only three years. Individual personalities within it were too independent to sustain common aims, and all the members soon exhausted the high pitch of their feelings and felt compelled to find a more formal structure for painting. Even in the second joint exhibition in 1906 there had been a visible reaction against the informal character of their earliest painting. With its clean divisions of broad color areas, Matisse's portrait *Madame Matisse*, for example, is a more compact and simple structure than the *Woman with the Hat*. There is a certain sobriety and gravity in the mien; the blue-purple mass of hair and the emphatic eyebrows throw the head into sharp relief, as if Matisse were reverting by means of pure color to the sharp value contrasts and more sculptured form of his earlier "dark" period.

pl. 138

Similarly, canvases by Dufy, Vlaminck, and Derain employed repeated linear accents to clarify and emphasize structure. In the next two years the renewal of interest in Cézanne and the emergence of Cubism, with its emphasis on formal doctrine, checked the more inspirational impulses of Fauvism. The movement had done its work, however. It had freed instinct and wiped out the lingering, decorative trivialism of turn-of-the-century styles. Through Matisse, in particular, French painting began ambitiously once again to address itself to some of its major traditional considerations.

In the years after 1908, the various participants in the Fauve exhibitions turned toward other goals and developed individual styles. Some of the most unmanageable Wild Beasts became tame and docile and were satisfied to work in minor modes, unable to sustain the inspiration of Fauvism. Derain, Vlaminck, and Dufy all developed less controversial and far less "difficult" solutions. Only Braque, under the stern discipline of Cubism, and Matisse, on his own terms, had the strength of artistic personality and sustained inventive capacity to continue making pictorial progress, propelled by the momentous impulse Fauvism had provided. Of the original group, it was Matisse who showed the most consistent development and was able to build constructively on the pure color expressions of his Fauve period.

Even while his *Woman with the Hat* was goading Paris tempers, Matisse had begun a major composition that was to go well beyond his Fauve work. The painting *Joy of Life* was completed for the spring 1906 Independents Salon. Measuring nearly six by eight feet, this grand canvas shows a number of nudes sporting amorously in an Arcadian setting. The figures are flattened into two-dimensional shapes whose flowing contours form a series of rhythmic arabesques linked up to the arching trees in the wood clearing. Rhythmic line and flat design suggest Art Nouveau sources, as do the uniform, unbroken color areas, but these devices add up to a dynamic expression that goes

pl. 145

beyond surface decoration and has none of the decorative artifice associated with Art Nouveau. Color is distributed in broad planes so as to express space and movement; lines describe volumes while they organize surface pattern. The artist had invented a new stenographic shorthand of line and color which re-created in a flat design the complex sensations of mass and depth that we experience in the presence of nature.

The next year, in 1907, Matisse sent to the Autumn Salon a figure composition which was even more stark in design: *Music (Study)*. Of this painting, which Leo and Gertrude Stein first acquired, Alfred Barr wrote in his classic study: "Few paintings by Matisse have greater germinal significance than this canvas.... For this small composition not only anticipates the subject matter of two of Matisse's greatest works, the *Dance* and *Music* of 1910 ... but also their style."[12] It represented the beginning of a period of monumental painting culminating in the two great wall decorations, or, rather, oils designed for a wall surface, *Music* and *Dance*. These murals were commissioned by Matisse's Russian patron Sergei Shchukin, who in time acquired thirty-seven of Matisse's paintings. In both these compositions the artist sought a more radical simplification of form and design, again emphasizing a sinuous arabesque of line and immense, uniform areas of pure color. Matisse himself understood that these simplifications were meant to intensify his sensations before nature and the human model. He had written how his methods differed from those of the Impressionists: "A rapid rendering of a landscape represents only one moment of its appearance. I prefer, by insisting on its essentials, to discover its more enduring character and content, even at the risk of sacrificing some of its pleasing qualities."[13]

pl. 147

In a 1909 version of the *Dance*, now in the Museum of Modern Art, New York, Matisse used

pl. 148

Henri Matisse. *Joy of Life*. 1905—6. Oil on canvas, 68½ × 93¾". The Barnes Foundation, Merion, Pa. 145

a brilliant blue as a background for his terra-cotta figures and green earth. These dazzling color combinations were apparently further intensified in the final version, *Dance*, 1910, which now hangs in the Hermitage in Leningrad. For the Paris editor Christian Zervos, Matisse summed up his color scheme in these words: "For the sky, the bluest of blues (the surface was colored to saturation, that is to say, up to a point where the blue, the idea of absolute blue, appeared conclusively), and a like green for the earth and a vibrant vermilion for the bodies."[14] Color saturation over an immense surface and "the idea of absolute blue," or some alternative "absolute" hue, became the keys to the artist's chromatic intention, rather than the ever changing, broken, multicolored surfaces of his Fauve period.

A simpler polyphony of color, a cruder, yet still elegant figuration (which more than anything else suggests the lively figures and moving line of Attic or Etruscan vase painting), and a decorative unity by means of rhythmic line, all on a grand scale, were the astonishing new elements of Matisse's expression. They were fused in a monumental style that combined powerful expressiveness and refinement, blunt directness, and esthetic subtlety. Matisse's monumental aspiration was echoed in Paris only by Picasso and the Cubists. Not since the last great canvases of Gauguin and Cézanne had a French artist tried to achieve such an ambitious expression or go so far beyond easel painting.

Matisse went to Munich in 1910 to see an exhibition of Islamic art and made a careful study of the rugs, aquamarines, textiles, and other Eastern *objets d'art*. The next winter he visited Morocco and then repeated the trip in the winter of 1912—13. His response, like that of Delacroix and Renoir, to the violent color, brilliant light, and lush nature of North Africa was intense. In conjunction with his growing interest in the ornamental and sophisticated art of the East, it led to stylistic developments based on emphatic decoration and on a more voluptuous feeling for color. In 1911, Matisse played alternately with loaded Rococo decoration and simplified forms. He painted four interiors in that year which show his new interests; their flower-figured wall patterns in repeated curvilinear accents and flat-perspective compositions suggest Persian miniatures and Mohammedan art. The last version of these related motifs, *The Red Studio*, demonstrates again Matisse's admirable ability to simplify ruthlessly, "even at the risk of sacrificing ... pleasing qualities." As in the *Dance*, he here insists on a single color statement, this time by saturating his canvas with a vibrant brick red. Against this ground he sets many small elements of form and color: a twining·green and yellow plant, the outlines of various studio objects and canvases hung on the wall or resting on the floor, which contribute a variety of touches of pink, green, and lemon yellow to the general harmony. Each object is a suggestive cameo and an apparently isolated element, yet each plays its part in the general decorative ensemble and subtly relieves, with a new accent, the overall sonorous red tone.

This painting converts a decorative, miniaturist style into something grave and monumental. Deliberate intellectual control is imposed on color sensibility, limited to a narrow tonal scale, and space is simply diagrammed by bare outlines of form, yet without monotony. A number of small compositional elements are scattered over the large surface, each intact and apparently unrelated. In conjunction they make new patterns and suggest a general movement. Matisse has intellectualized and refined his Fauve chromatism and yet avoided any rigid schematization. In fact, he seems to be trying to balance an apparently anarchic effect in his disposition of forms and color within a very calculated formal pattern. This was Matisse's way of keeping alive his Fauve spontaneity and, to go further back in time, the "freedom" of Impressionist selection.

Matisse wished to be less synthetic than the more controlled Post-Impressionists and to restore to painting instead the freer sensibility of the Impressionists by following the random dictates of his senses. But he also wished to avoid the excessive informality and objectivity of their rather diffuse, amorphous painting. With extraordinary originality he was able to achieve a modern synthesis of these contrary pulls: to organize the senses by the intelligence and to stimulate the mind by fresh perceptions based on nature. In *The Red Studio* all the little visual data of the room refresh the eye and keep it moving from one pictorial element to another. There are two characteristically French phrases which together might well define the tonic qualities of Matisse's art: *arrière-pensée* and *l'imprévu*, the utmost calculation and the unexpected. Active intelligence and an equally active sensibili-

Henri Matisse. *The Red Studio*. 1911. Oil on canvas, 71¼" × 7' 2¼". The Museum of Modern Art, New York. Mrs. Simon Guggenheim Fund. 146

pl. 149

pl. 146

Henri Matisse. *Music*. 1910.
Oil on canvas, 8' 5⅝" ×
12' 9½". The Hermitage,
Leningrad. 147

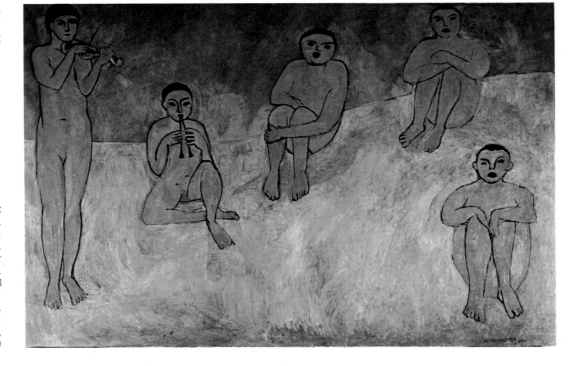

Henri Matisse. *Dance* (first
version). 1909. Oil on canvas,
8' 6½"×12' 9½". The Muse-
um of Modern Art, New York.
Gift of Nelson A. Rockefeller
in honor of Alfred H. Barr, Jr.
148

Henri Matisse. *Dance*. 1910.
Oil on canvas, 8' 5⅝" ×
12' 9½". The Hermitage,
Leningrad. 149

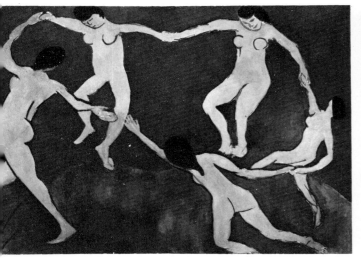

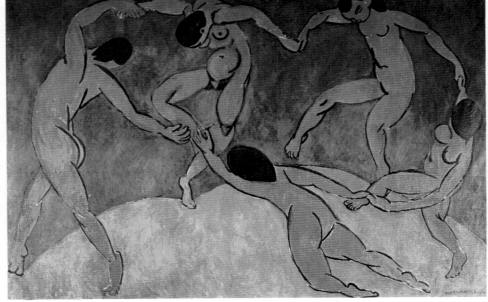

ty, ever susceptible to new impressions, exist together harmoniously in the best of his paintings.

It was precisely that balance of intellectual control and responsiveness to a harmonious natural world that were notably absent from the early products of German Expressionism, similar in so many other respects to the Fauvist art of Matisse. Both French and German Expressionism shared certain formal elements, and had a common source not only in the *Jugendstil*—Art Nouveau decorative mannerism but also in the more emotional or expressive aspects of the art of Gauguin, van Gogh, and even Cézanne. What distinguished German Expressionism from the French version was the Germans' interest in psychology as subject matter, in an emotional content that went far beyond Matisse's sensible restraints in its tragic power and an almost clinical ability to lay bare the depths of tormented, even pathological, personality. The dominance of a formalist esthetic in France in the first decade of the new century made only a superficial impression in Germany.

In spite of its spontaneous eruption in several German cities during the early years of the new century, German Expressionism drew from numerous traditional sources, not the least of which was the anguished sensibility of its own Gothic past. Since the medieval period, German art had been the epitome of emotionalism and spirituality, as opposed to Gallic rationality. That basic prejudice toward a tortured expressiveness, which alternated between meaningful depth or bathos, found definition, interestingly, in two important books published just at the time the Expressionists achieved public recognition. These books, written by the leading German art historian, Wilhelm Worringer, gave primacy to what he was to call "the transcendentalism of the Gothic world of Expression."[15] Worringer's two treatises, *Abstraction and Empathy* and *Form in Gothic*, became deci-

Karl Schmidt-Rottluff. *Summer (Nude Study in Open Air).* 1913. Oil on canvas, 34⅜ × 40″. Niedersachsische Landesgalerie, Hanover.

150

sive documents in the development of German Expressionism.

Abstraction and Empathy proposed for the first time in relation to modern art the concept of empathy, the direct involvement and identification of both artist and spectator with the forms depicted. Above all, it proposed that human emotions be released from the surveillance of intellect, good taste, or decorative values and be cultivated and communicated directly. Worringer explained Expressionism as a unified concept rooted in northern tradition and related it to the discovery of primitive art. He exalted primitivism with a Nietzschean delight in its brute forms which had heretofore been considered too uncivilized for high art. Worringer linked primitivism, abstraction, and folk art to Expressionism, as part of a broad campaign to break with Renaissance illusionism. Worringer rejected the idea of nature as a serene setting for human actions, which had dominated classical ideals of art since the Greeks,

replacing it with the concept of a hostile environment, and of man cast in the role of the alienated antihero, or the Christian martyr of Gothic art.

The first systematic evidence of the incursions of the spirit of the Gothic in modern German art came with the banding together in Dresden of four artists all in their twenties: Ernst Ludwig Kirchner, Karl Schmidt-Rottluff, Erich Heckel, and Fritz Bleyl. They had found common interests in Munch and primitive and folk art. In 1905, they exhibited together for the first time in a disused chandelier factory, calling themselves The Bridge, by which they meant to express a sense of their art as a revolutionary link between the present epoch and the creative future. The most vital expressive forms of high art of the past as well as the artifacts of primitive cultures were viewed as part of a new, inclusive creative program. Writing to Emil Nolde to invite him to join them, Schmidt-Rottluff amplified the intentions of The Bridge group: "One of the aims of The Bridge is

pl. 150

to attract all the revolutionary and surging elements—that is what the name signifies."[16] And, in a memorable declaration of principle on the occasion of their first public exhibition, Kirchner reached out to form a new community, especially among the young, of related and responsive spirits: "With faith in development and in a new generations of creators and appreciators we call to all youth. As youth, we carry the future, and want to create for ourselves freedom of life and of movement against the long-established older forces. Everyone who with directness and authenticity conveys that which drives him to creation belongs to us."[17]

Written to attract support for the first exhibition of The Bridge, these words might have been used as a proclamation of faith for young artists throughout Germany in the years before World War I. New ideas were abroad, new attitudes toward man and society, calling for exciting new means of expression. Socially, the young artists were publicly protesting the hypocrisy and materialistic decadence of those in power; in art, they were rebelling against the old tyranny of the Academy and the new tyranny of Impressionism and Neo-Impressionism, whose tasteful, painted tapestries of bright color no longer seemed meaningful in the fast-moving, amoral, machine-age world in which the new generation suddenly found itself. The new art in Germany attempted, above all, to be honest, direct, and spiritually meaningful. Powerful decorative impact, heightened emotional intensity, compelling abstract symbolism, and brutally honest craftsmanship were the chief means to these new ends, and all of these strategies showed an acquaintance with the paintings of the Fauves.

The Bridge was conceived both as a return to the medieval cooperative craft guild and as a twentieth-century approach to art. Drawing not only from European sources, but also from the primitive art of Africa and Oceania, its members strove to intensify man's realization of himself and nature through jarring contrasts of color, jagged, slashing lines, and forced distortion of natural forms. Primitivism pervades the paintings of these artists, not only in the deliberate crudity of technique, but also in the choice of subjects—the low

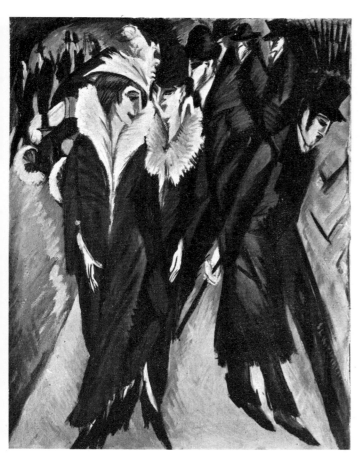

Ernst Ludwig Kirchner. *Street, Berlin.* 1913. Oil on canvas, 47½ × 35⅞". The Museum of Modern Art, New York. 151

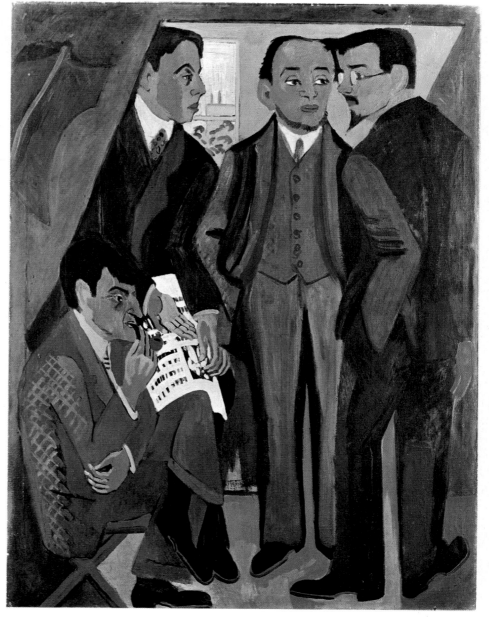

Ernst Ludwig Kirchner. *The Painters of The Bridge.* 1925. Oil on canvas, 66⅛ × 49⅝". Wallraf-Richartz Museum, Cologne. 152

pl. 150

life of the streets, the naked form, male and female, often in a woodland setting. The subject matter was nearly always transformed, however, into new levels of meaning by the consistent distortion and bold, painterly treatment of the forms.

pl. 152

Ernst Ludwig Kirchner (1880—1938) was the acknowledged spiritual leader of The Bridge. His work is perhaps the most characteristic of the group, beginning with a kind of emotionally charged decorative style, very close to Fauvism; then turning progressively to human commentary, to psychological exploration, and finally to a quieter, more formalized style related to Cubism.

pl. 151

The works of Erich Heckel (1883—1970) are often very close to those of Kirchner, although his subjects are sometimes more lyrical and sometimes more penetrating psychologically than Kirchner's. If Heckel is the most poetic of The Bridge members, Karl Schmidt-Rottluff (b. 1884) is the most earth-bound. Primitivism is perhaps most authentic in Schmidt-Rottluff, and his rough-hewn forms carry few psychological overtones.

In 1906, soon after the foundation of The Bridge, Emil Nolde (1867—1956), an older artist who had independently arrived at a similar attitude toward art, was invited to join the group. His impact was immediately felt, although he remained associated with them less than two years. Working primarily with strident contrasts of color, Nolde created visions charged with almost unbearable emotional power. His most impressive paintings are those which depict the life of Christ—especially the series executed between 1909 and 1912. In *The Last Supper* Christ and his disciples are portrayed as simple German peasants, in a primitive vision matched by the childlike crudity and simplicity of this powerful painting. Unmixed colors are laid down directly on canvas; the composition is clumsy but sure, the touch rugged and unrefined. In Nolde's later work, religious emotion is transferred as a kind of pantheistic aura to landscape—the seaside views of his native Seebüll, with its stormy seas and threatening cloud banks. It is extraordinary how much emotion and what overtones of impending visionary events Nolde could inject into a subject matter that would have suggested serene and idyllic nature even in the hands of the Fauves.

pl. 155

pl. 154

Max Pechstein, also admitted to The Bridge in 1906, had the most commercial success, possibly because he responded to the influence of French art and hence was more decorative and less brutal than his associates. Otto Mueller (1874—1930), the last painter to join The Bridge, shared the primitivism and the technical approach of the other artists but was interested primarily in depicting the nude, which he painted in endless variations in natural settings with muted and harmonious colors. An example of the difference in expressive content of the Fauve and Bridge painters can be seen in a comparison of Matisse's *The Blue Nude* with Mueller's *Gypsies Around a Fire* or with Schmidt-Rottluff's *Summer (Nude Study in Open Air)*. The German figures look naked and

pl. 139

pl. 150

vulnerable, and hence introduce questions as to the place and propriety of undressed figures in modern life—and, indeed, the whole northern European mystique of nudity and health. Even Matisse's rather brutal nude figure is more serene and ideal by comparison, and lacks the Germans' social or psychological connotations.

Between 1905 and 1911, most of the artists of The Bridge worked, and often lived, together in Dresden and in the nearby countryside. They published a number of portfolios and re-established the woodcut as an important art form in Germany; this is dramatically illustrated by Kirchner's searching characterization of the art dealer Ludwig Shames. By the end of 1911 the artists had moved to Berlin. Within two years they had matured in different directions and, in the tensions of the prewar period, found it impossible to maintain the spirit of the group any longer. The Bridge group was dissolved in 1913.

pl. 153

Munich was a much more important art center than Dresden in the early years of the century. To it flocked artists from many countries—Russia, Switzerland, Austria, and even the United States—and exhibitions of Post-Impressionist, Fauvist, and Cubist art from France could be seen in the art galleries. The artists who formed the second major German Expressionist group, The Blue Rider, were quite naturally more sophisticated, more intellectual, and less primitivistic than the members of The Bridge. The emphasis in The Blue Rider was upon the spiritual and symbolic properties of natural and abstract forms rather than upon the evocation of emotional intensity through impact and distortion.

The Munich group was an informal association of highly gifted individuals who believed in freedom of expression and experiment primarily, and wanted assurances that proper opportunities could be created to exhibit their work. When the NKV (*Neue Künstler Vereinigung*, or New Artists Federation), of which they were among the earliest members, proved too conservative, Wassily Kandinsky (1866—1944), his long-time companion Gabriele Münter, and Franz Marc (1880—1916) together organized their own exhibition, which opened in December 1911 under the rather enigmatic title First Exhibition of the Editorial Board of the Blue Rider.

The title was selected for the almanac which Kandinsky and Marc had been planning for some time, and which appeared in May 1912 with an abstract drawing by Kandinsky of a mounted horseman in blue and black on the cover. According to Kandinsky, "We both loved blue, Marc also loved horses and I horsemen. So the name came by itself."[18] This collective volume of esthetic studies contained illustrations of Bavarian peasant art, primitive art, Gothic sculpture, early medieval woodcuts, and paintings by El Greco (whose monograph written by August Mayer appeared that year), as well as paintings by Cézanne, Rousseau, and Picasso. Even more ambitious perhaps than The Bridge, The Blue Rider

pl. 158

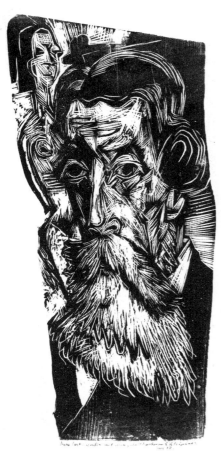

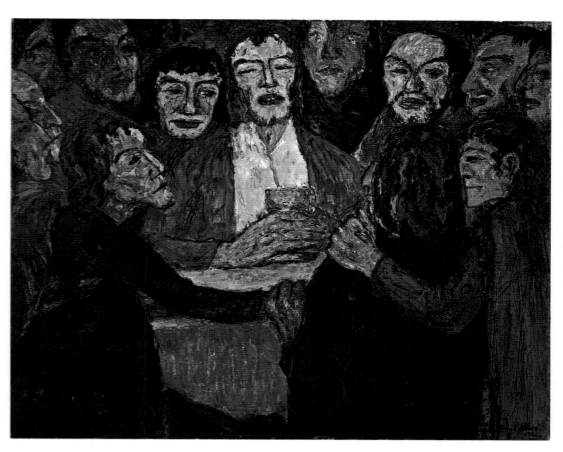

Ernst Ludwig Kirchner. *Head of Ludwig Shames*. 1918. Woodcut, printed in black, 22⅞×10¼". The Museum of Modern Art, New York. Gift of Kurt Valentin. 153

Emil Nolde. *The Last Supper*. 1909. Oil on canvas, 32⅝×41¾". Nolde Foundation, Seebüll, Neukirchen, Germany. 154

Emil Nolde. *Tropical Sun*. 1914. Oil on canvas, 27½×41¾". Nolde Foundation, Seebüll, Neukirchen, Germany. 155

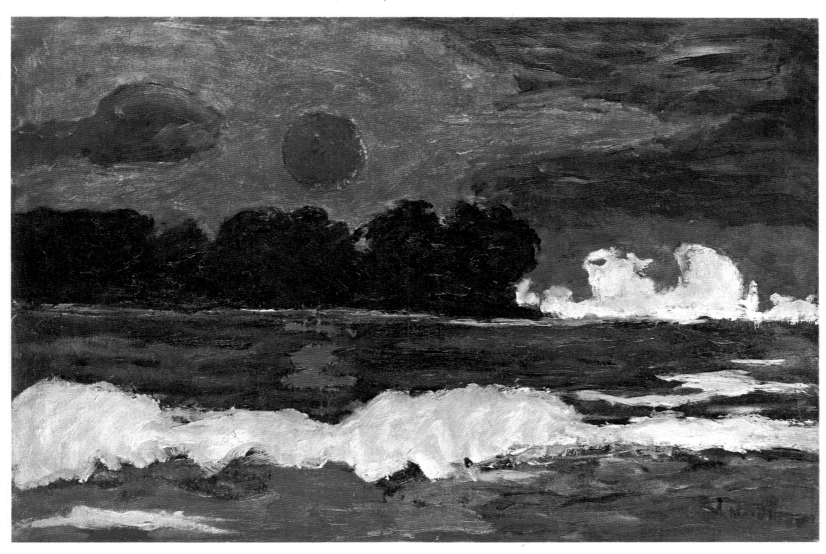

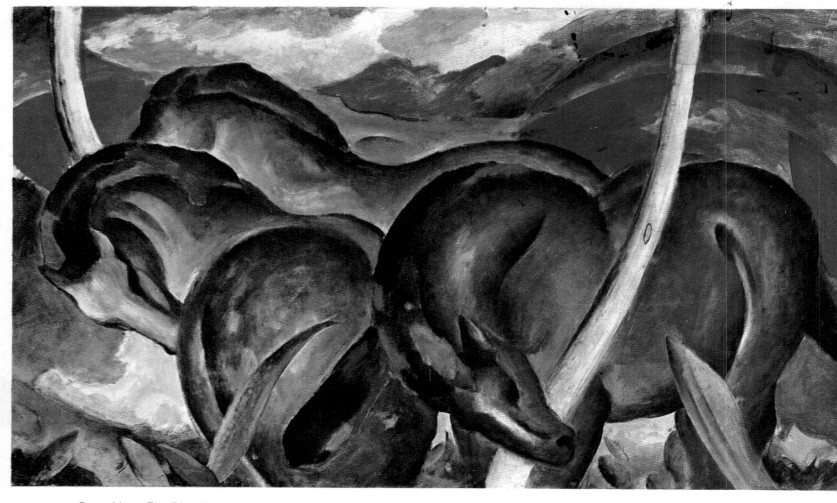

Franz Marc. *The Blue Horses*. 1911. Oil on canvas, 41¼ × 71½". The Walker Art Center, Minneapolis. Gift of the Gilbert M. Walker Fund.
156

Wassily Kandinsky. Untitled (first abstract watercolor). 1910. Watercolor, wash, and brush, pen, and ink, 19⅝ × 25⅝". Collection Nina Kandinsky, Neuilly-sur-Seine.
157

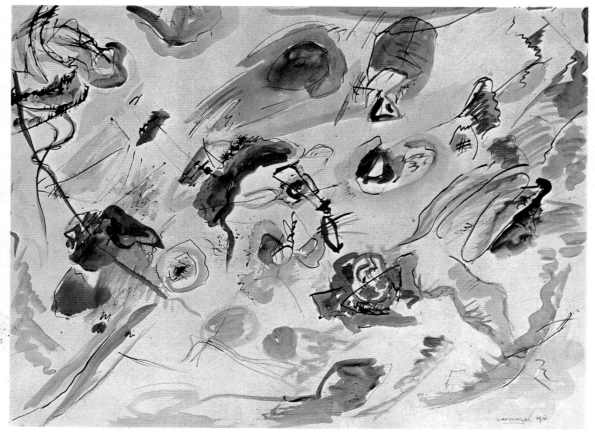

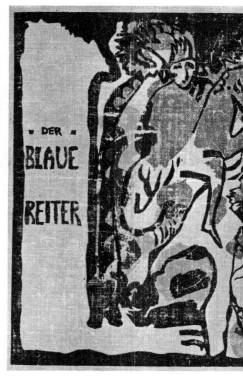

Wassily Kandinsky. Cover for *The Blue Rider Almanac*. 1912. Woodcut.
158

artists wished to assimilate and synthesize the far-ranging esthetic interests and influences of modern art. Under the leadership of Kandinsky and Marc, the group was augmented by August Macke, Heinrich Campendonk, and Gabriele Münter in 1911; and in The Blue Rider almanac of 1912 Paul Klee (1879—1940) was represented by a small drawing. In September 1913, a large and influential international exhibition called the First German Autumn Salon was held at Der Sturm Gallery in Berlin; among the large group of artists representing many different tendencies, members of The Blue Rider were prominent, and two painters newly recruited to their program, Lyonel Feininger (1871—1956) and Alexej Jawlensky (1864—1941), a friend and fellow-countryman of Kandinsky's, exhibited with them. Although The Blue Rider existed officially for only two years, it produced publications, exhibitions, and esthetic theories that have profoundly affected the art of our time.

If one may hazard a generalization, the styles of The Blue Rider can be said to have combined the geometric structure of Cubism with Robert Delaunay's, and the Fauves', pure color, to which was added a distinctly Teutonic brand of vehement emotionalism and "spirituality." Delaunay's brilliant color disks and rhythms were more systematically ordered and showed a Gallic reserve in comparison with Kandinsky's somewhat parallel style. Where the Futurists had exalted modern life and the machine age, expressing a disillusionment with humanistic sentiment, the German artists now turned aside from man to find their solace and inspiration in a more primitive nature, or in an animal mysticism. Marc, an artist celebrated for his animal themes, wrote: "The impure men and women who surround me did not arouse my real feelings; while the natural feeling for life possessed by animals set in vibration everything good in me."[19] Such primitivistic feeling, and the forceful artistic means through which they were expressed, perhaps could be related to the remote example of Gauguin. Marc's style, however, was given a stricter formal decorum as the result of his assimilation of Cubist painting, and his whole psychology of expression, and essential mysticism, as

pl. 156

we shall see, had other sources and more atavistic meanings.

Wassily Kandinsky was the guiding spirit and main theorist of The Blue Rider, and he was also their most radical inventor of artistic form. After painting rather freely distorted but still representational landscapes in opulent color, after the Fauve example, he began in 1910 a series of purely abstract "improvisations," the first experiments

pl. 157

in a free-form, nonobjective art of the new century. It was Kandinsky who literally fulfilled Maurice Denis's prophecy that Fauvism would lead to a "search for the absolute." In 1911, he wrote *Concerning the Spiritual in Art*, which appeared in *Der Blaue Reiter* in 1912. This essay elaborated on his esthetic theories and, for the first time, gave theoretical sanction to a nondescriptive art. Kandinsky methodically elucidated his abstract art of pure color and form relationships in terms of spiritual and "musical" ideas. His romantic point of view may be associated with Symbolist doctrine and Gauguin's statement that "Color, which is vibration, just as music is, is able to attain what is most universal yet at the same time most elusive in nature: its inner force."[20] Kandinsky similarly stressed the inwardness and intuitional qualities of his style of painting, and utilized the arabesque and a free color lyricism stemming both from Symbolist and Fauve art. Paintings, he held, should be created in a state of inner tension and looked upon as "graphic representation of a mood and not as a representation of objects." The spiritual and introspective aspects of his art were to have a profound effect on the developing Expressionist tendencies in Germany.

One also finds, most interestingly, a certain Utopian idealism in Kandinsky's discussions of abstract art, which recurs somewhat later in Piet Mondrian's writings about his own machine-oriented, totally different style. Both artists, in fact, treated abstraction as an evolving blueprint for a more enlightened and liberated society. "We have before us," Kandinsky wrote in his treatise, "an age of conscious creation and this new spirit in painting is going hand in hand with thoughts toward an epoch of greater spirituality."[21] From Gauguin and Symbolist painting to Kandinsky, a growing process of abstraction in painting was linked to an undercurrent of mysticism and romantic transcendentalism. The artistic productions of this tendency, with its emphasis on irrationality, on an occult spirituality—which almost hysterically opposed the materialism of the age—and on creative intuition, in many ways anticipated the Surrealists' conception of artistic creation as an essentially subconscious experience, or process.

Kandinsky's crucial breakthrough into nonobjective painting, that is, to an art emancipated from the motif, was achieved in direct association with the elaboration of his rather complex esthetic theories. The philosophical justification of a wholly abstract art was empirical in origin, for it grew directly from an experience in Moscow in the 1890s, when Kandinsky saw at an exhibition one of Monet's Haystack paintings, which left a lasting impression. Later he wrote, "Deep inside me was born the first faint doubt as to the importance of an 'object' as the necessary element in painting."[22] It was the Fauves, however, with whom he became acquainted in a lengthy sojourn in Paris, that provided Kandinsky with the decisive clue that color could be liberated entirely from the object.

The process of dispensing with subject matter in favor of an autonomous pictorial expression, freed from descriptive function, marks such an important historical moment in the evolution of modern art that it is worth pursuing in even more detail. The moment of decisive revelation for Kandinsky came about 1910 when he viewed one of his own

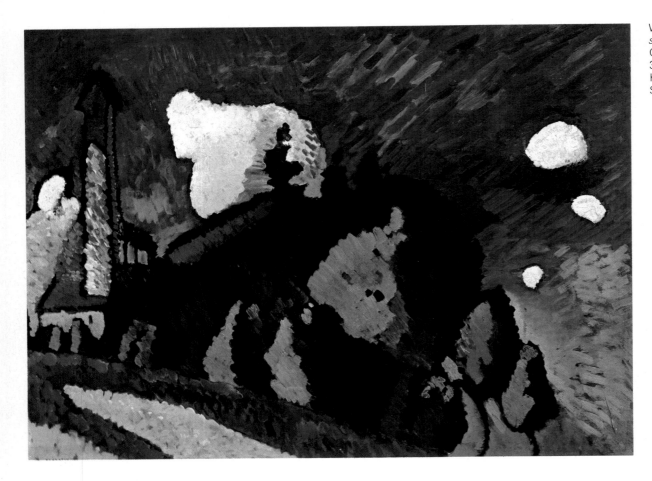

Wassily Kandinsky. *Landscape with Tower.* 1909. Oil on cardboard, 29¾ × 39¼". Collection Nina Kandinsky, Neuilly-sur-Seine. 159

pl. 159 landscapes, painted in the countryside around Munich, in an unfamiliar context and had eyes only for its abstract presence and values. He explained this important experience thus, as one who has found a new faith might describe his moment of conversion:

> I was returning from my sketching, deep in thought, when, on opening the studio door, I was suddenly confronted with a picture of indescribable incandescent loveliness. Bewildered, I stopped, staring at it. The painting lacked all subject, depicted no recognizable object and was entirely composed of bright patches of color. Finally, I approached closer, and only then recognized it for what it really was—my own painting, standing on its side on the easel
>
> One thing became clear to me—that objectiveness, the depiction of objects, needed no place in my paintings and was indeed harmful to them.[23]

pl. 161 Thus, in his abstract "improvisations" between 1910 and 1914, Kandinsky initiated the fateful process of abstracting natural appearances to create an autonomous structure, where we can see line and color take on an independent existence, creating dynamism and rhythmic movements that reflect inner agitation rather than observed events or a rational spatial experience. Kandinsky's halting progress toward abstraction, which today we so readily take for granted, was linked with deeply held spiritual views, views whose simplistic, theosophical bias is considered intellectually disreputable today. Yet the naiveté of Kandinsky's spiritual aspiration and theory should be taken as a measure of the difficulties a sincere man of the spirit might have encountered in overcoming the oppressive materialist assumptions that dominated thought and values in the early years of the century.

Franz Marc, like his colleague Kandinsky, pursued spiritual and mystical values through art, but his symbolism identified feeling with animal existence in nature rather than a purely abstract system of color forms. He wrote: "I try to heighten my feeling for the organic rhythm of all things, try to feel myself pantheistically into the trembling and flow of the blood of nature—in trees, in animals, in the air I see no happier means to the 'animalizing' of art, as I like to call it, than the animal picture."[24] Thus Marc described his enthusiasm for animals and nature, not seen from without, with normal human vision, but viewed as if one were emotionally and physically inseparable from the animal portrayed. For Marc, art had a special part to play in a world that had rejected both Christianity and nineteenth-century materialism. He wanted to "create symbols, which could take their place on the altars of the future intellectual religion." To do this, Marc tried at first to contrast the natural beauty of animal life with the sordid reality of man's existence. The essential mysticism of this approach, so Germanic in its rejection of the human and in its sense of alienation, falls occasionally into a mawkish sentimentality. Curiously, it also raises psychological questions, as did Kandinsky's expressed disgust with the human form of the models of his student days, as to the exaggerated prudery of the artists who founded The Blue Rider.

Marc's greatest paintings, and his assured masterpiece, *Animals' Lot* of 1913, utilized Delaunay's pl. 160

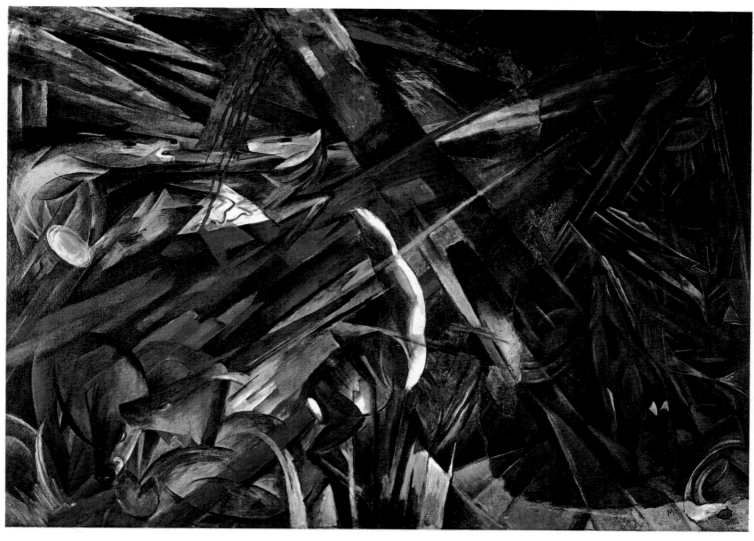

Franz Marc. *Animals' Lot*. 1913. Oil on canvas,
76¾" × 8' 9½". Kunstmuseum, Basel. 160

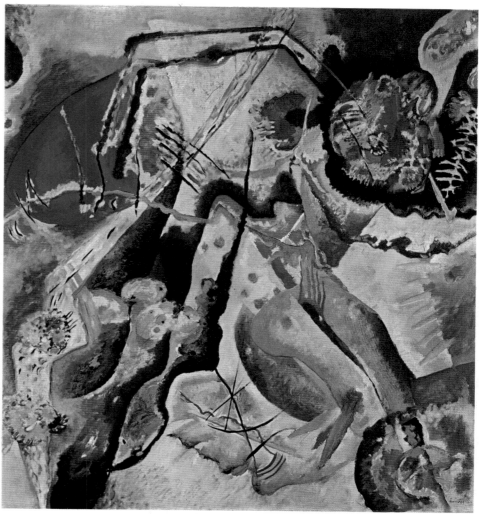

Wassily Kandinsky. *Painting with Red Spot*.
1914. Oil on canvas, 51⅛ × 51⅛". Collection
Nina Kandinsky, Neuilly-sur-Seine. 161

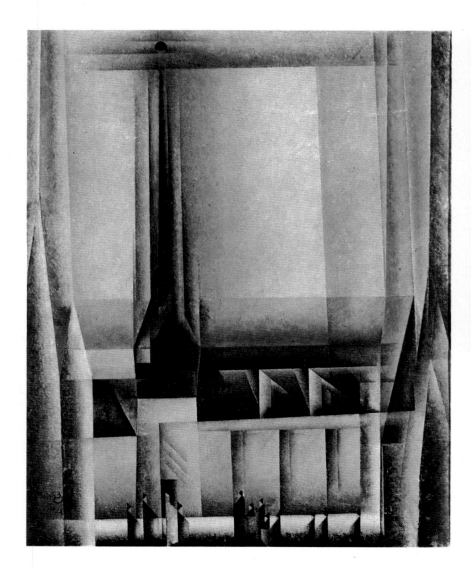

Alexej Jawlensky. *The Hunchback*. 1911. Oil on cardboard, 21¼ × 19¼″. Private collection, Krefeld. 163

Lyonel Feininger. *Gelmeroda VIII*. 1921. Oil on canvas, 39¼ × 31¼″. Whitney Museum of American Art, New York. 162

intensified spectral color and a Cubist-Futurist vocabulary as a kind of formal decorum to contain and focus his poignant emotionalism. The picture's original title is written on the back: "All being is flaming suffering." In an apocalyptic holocaust, a blue deer lifts its head to a falling tree; there are red foxes on the right, green horses at the top left. Colors have symbolic value, as in Kandinsky, but with a different code: blue is the color of hope, but it is in the process of being extinguished as animal life, in the forest and by implication on earth, is being destroyed by cataclysm. Just before his death in action on the Western Front, Marc sent a postcard of *Animals' Lot* to his wife. "It is like a premonition of this war," he wrote, "horrible and shattering. I can hardly conceive that I painted it. It is artistically logical to paint such pictures before a war—but not as stupid reminiscences afterwards, for we must paint constructive pictures denoting the future."[25]

American-born Lyonel Feininger joined The Blue Rider in 1913, bringing with him a firsthand knowledge of Cubism, which he transformed into a sensitive, delicate, and at times humorous version of Expressionism. The bright color and irregular forms of his early canvases gradually gave pl. 162 way to a crystalline structure of interpenetrating planes. His love of music may have suggested the subtle rhythmic organization of his scenes of ships and cities. Upon his return to the United States, Feininger's influence upon American art and the appreciation of Expressionism was widespread.

The oldest member of The Blue Rider was the Russian, Alexej Jawlensky. Preoccupied first with pl. 163 the decorative, then with the psychological, and finally with the spiritual qualities of the human face, as well as with the color symbolism of nature, he painted with an austerity and monumentality unmatched in the Munich group. After World War I, he became increasingly involved in a personal, introspective, and mystical expression. Other figures in The Blue Rider group were Alfred Kubin, and Adolf Erbslöh.

Many significant artists worked outside the organized groups before World War I. Among them were Paula Modersohn-Becker, Christian Rohlfs, and Käthe Kollwitz (1867—1943), a graphic artist of first importance, who was obsessed with the plight of the destitute and by the austere themes of suffering and death. Carl Hofer (1878—1955) was already creating figure studies that appeared half classical and half Expressionist before the war, a style which he followed until his death. Of all the prewar Expressionists, Ludwig Meidner (1884—1966), painting in Berlin, revealed most clearly the anxiety and restlessness of the times.

More socially oriented than many of his fellow artists, he seemed to prophesy the war in Europe in his *Judgment Day* of 1912.

Paul Klee was the most poetic, original, and certainly the most singular artistic personality of The Blue Rider, although his relationship with their exhibition activities and the theories of Kandinsky and Marc was tangential. He participated in the 1912 publication and exhibition, and the following year arrived at a virtually abstract style. His art may best be understood as a form of poetic metaphor, a system of private signs that attain universal meanings. Marc, whom Klee admired deeply, had impressed him with his description of the condition, or state of mind, of "sensing the underlying mystical design of the visible world." And Klee himself sought poetic and visual equivalents, very much like his spiritualizing Blue Rider associate, for some mystical conception of the unity of all being. In the period when he came directly under The Blue Rider influence, he wrote, "What a lot of things an artist must be—poet, naturalist and philosopher."[26] And, in his most famous statement, made during his Bauhaus years, and which suggests his abiding philosophical and poetic inclinations, he said, "Art does not render the visible, rather it makes visible."[27]

Klee sought to translate his own rather precious visual meanings into universal images of both artistic and cosmic creation. He typically referred to his work at one time as "a cosmic picture book." Klee's semiautomatic techniques and hieroglyphs also offer close parallels with the emerging Surrealist movement and its practices after the mid-1920s. His imagination, however, was not directed specifically to the unconscious or to any programmatic exploration of free association. Rather, he sought signs and images for man's tragicomic predicament, in a humorous and punning fashion, without much explicit pyschological content, or, alternately, he explored symbols for universal forces much as Marc and Kandinsky had done. It was this mystical aspiration that shaped his art. Klee was essentially a fabulist, a creator of myth, but on a miniaturist scale; he admitted his modesty early in his career, when he spoke of preferring the "tiny, formal motif."

Technically, his art was extremely inventive and scarcely seemed to recognize any formal limitations at all. In fact, he experimented freely in style, with various pastiches of styles, and with every sort of visual effect that came so readily to his virtuoso hand. His art was childlike, deliberately artless and unspoiled even as it attained rare degrees of sophistication, and he obviously

pl. 164

pl. 165

Paul Klee. *Around the Fish*. 1926. Oil on canvas, 18⅜ × 25⅛". The Museum of Modern Art, New York. Abby Aldrich Rockefeller Fund. 164

enjoyed, and took advantage of, this paradoxical quality. It is interesting and significant that Klee exhibited with The Blue Rider artists just as they were elevating the art of children to the level of educated and sophisticated expression by illustrating children's art in their almanac. Primitivism was equated with instinct, with innocence, and with a refusal to accept established values in society, art, or education, which institutionally seemed to betray or suppress individual truth. As early as 1902, on his return to Bern from his first visit to Italy, Klee typically wrote in his journal:

"I want to be as though newborn, knowing nothing, absolutely nothing about Europe, ignoring facts and fashion, to be almost primitive."[28]

Early in his career, it was apparent that Klee understood that he was essentially a poet, and that his gnomic art could best be apprehended in terms of a personal search for the succinct symbol, verbal as well as visual (for his suggestive, if mystifying, titles contribute much to the resonance of his art), a symbol that would manifest fantasy, the psychic event, the reality of the unseen experience. In his paintings the metaphysical and

Paul Klee. *Hyway and Byway*. 1929. Oil on canvas, 33 × 26½". Wallraf-Richartz Museum, Cologne.

165

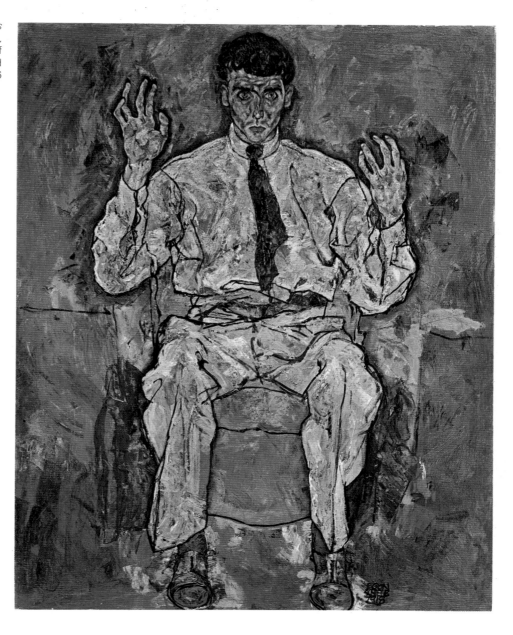

Egon Schiele. *Portrait of the Painter Paris von Gütersloh*. 1918. Oil on canvas, 54½ × 42¾″. The Minneapolis Institute of Art. Gift of the P.D. McMillan Land Company. 166

the everyday, gentle humor and pessimism, and virtuosity and a deliberate clumsiness achieved a rare, felicitous balance. Behind Klee's mask of the child, or of the clown, lay a profound spiritual quest and a deep moral sense of the plight of man in a corrupt society, which link his work more to Expressionism than to the Freudian fantasies of the French Surrealists or to Paris-based abstract art.

German Expressionist art had its counterpart in the vivid and powerfully original painting of Austria. Although the art of Austria was integrally connected with German idioms, a strong local accent was preserved. At the turn of the century, Vienna's cultural atmosphere combined excessive refinement with a stifling sense of decadence, fed by Hugo von Hofmannstal's melancholy poetry, Richard Strauss's frenzied operas, and Franz Werfel's metaphysical quest for God, in literature. Viennese art attained an introspective and neurotic content which even the most bizarre and extreme examples of German art of the period could scarcely equal.

The *Jugendstil* took more extreme forms in Vienna, notably in the controversial murals made by Gustav Klimt (president of the influential Vienna Secession) for the University of Vienna, representing Philosophy, Medicine, and Jurisprudence (1899—1907, destroyed in 1945). Instead of a familiar allegory of historical figures, Klimt created vermiform masses of huddled naked forms symbolizing varieties of the human condition, both philosophically and medically, and calling attention especially to the degenerative diseases flesh is heir to. The imagery was far too brutal and macabre, as well as erotic, for the academic faculty, and they rejected the murals. By evoking an extreme, if characteristic, Symbolist mood of despair, Klimt had actually painted a true picture of the spiritual condition of the day, and his work, decorative though it was, anticipated the offending mixtures of dream, eroticism, and personality abnormality in subject matter that later marked the anguished art of his Expressionist descendants in Vienna, Egon Schiele (1890—1918) and Oskar Kokoschka (b. 1886).

Klimt's brilliantly ornate and rather diabolical style reached a heady climax in murals made for the dining room of the Palais Stoclet in Brussels, designed by Josef Hoffmann, a Viennese Secession 115

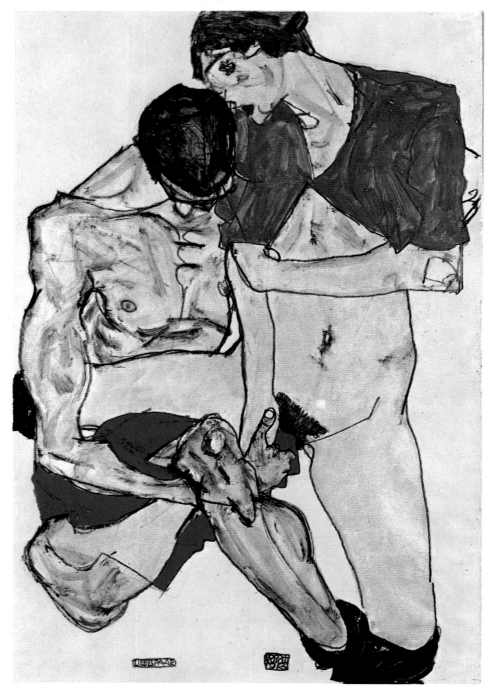

Egon Schiele. *Lovers*. 1913. Galatea Gallery, Turin. 167

Oskar Kokoschka. *The Tempest (The Wind's Bride)*. 1914. Oil on canvas, 40¼ × 75¼". Kunstmuseum, Basel. 169

Oskar Kokoschka. *Portrait of Karl Kraus*. c. 1909. Ink wash and pen and ink on paper, 11½ × 8". Collection Marianne Feilchenfeldt, Zurich. 168

architect. The sumptuous ornamental detail and geometric design in precious stone and mosaic elaborate such themes as the tree of life, dancers, and intertwined lovers, but these acceptable themes only manage to heighten the mood of anxiety and a kind of cerebral eroticism typical of late Symbolist painting.

For Schiele, who met Klimt in 1907 and worked somewhat under his influence, emotional stress rather than decorative considerations or a decadent and artificial demonism dictated his startling, angular, and visionary style. His ungainly, contorted human figures have been described, appropriately, as suffering some form of spiritual arthritis. Like Thomas Mann in his novel *The Magic Mountain*, Schiele was preoccupied with disease and death in the midst of an apparently disintegrating society. His bizarre, maimed, grotesque, but somehow touching, figures have been described as "spiny, thorny, angular, Gothic . . .

the very antipodes of a world of culture and luxury."[29] They show very powerfully the northern European anguished, sardonic, and even ghoulish career sensibility, in sharp contrast to the idealizations of French artistic humanism. Schiele's unabashed emphasis on nudity and sexuality is extremely poignant in its effort to establish some kind of human communication, even in apparent loveless sexual play and contact, despite the gruesomeness of his desolated figures. But his candor got him in trouble with the authorities. He was imprisoned for immorality, in a kind of premonitory warning of more sadistic, repressive acts to follow in Germany and Austria upon the part of the official guardians of public morality.

That increasing gap between public or community standards of morality and the sincere artist's psychic reality was also dramatized by the life and career of perhaps the most important Viennese Expressionist, Oskar Kokoschka. The public's

pl. 166

pl. 167

116

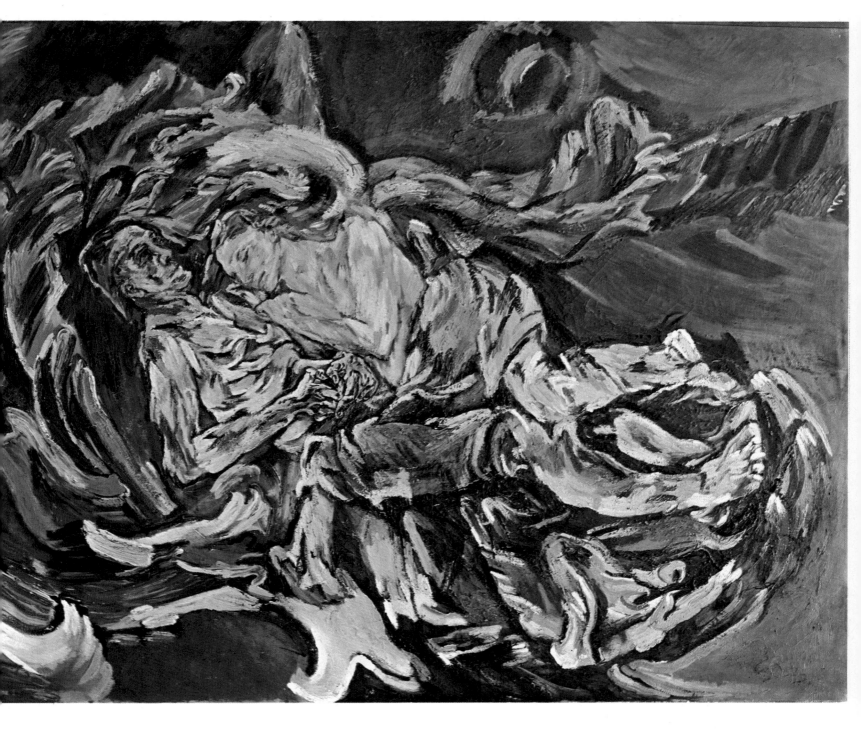

incensed reaction to his paintings of 1908, followed the next year by the performance of a controversial play which was a wild drama of sex and violence, compelled him to leave Vienna. Shortly after encountering the work of van Gogh in 1906, Kokoschka had begun a series of excruciatingly sensitive "black portraits," as the artist himself referred to them, which seemed to unmask and bare the soul of his uneasy sitters, often prominent personages in the social, intellectual, or artistic world of Vienna. The artist felt that his visionary portraits performed a kind of cathartic act of self-confrontation for his trancelike victim-sitters, which forced them, therapeutically, to surrender their "closed personalities, so full of tension," in his words. "My early black portraits," he said, "arose in Vienna before the World War; the people lived in security yet they were all afraid. I felt this through their cultivated form of living which was still derived from the Baroque; I painted them in their anxiety and pain."[30] The painter could reveal beyond the cultivated facade his sitter's emotional and intellectual disequilibrium. It is difficult not to relate these remarkable disclosures of personality in conflict with Freud's studies of the role of unconscious conflicts in human behaviour and with his insistence, which took so long to gain popular credence, that psychic states could be represented in objective, scientific facts. Kokoschka has been called the Freud of painting, and in Vienna it was often said: "He paints the dirt of one's soul."[31]

pl. 168

The vitality of Kokoschka's early portraiture, the precocious artistic capstone of a long and otherwise less distinguished career, is conveyed by a nervous, highly expressive, insinuating line that scratches the surface like grafitti, quivering with febrile life. Line probes the sitter's inner drama with an unmerciful and uncanny sense of the narrow boundary in human personality between sani-

ty and madness, or, less dramatically, neurosis and normalcy. His early paintings, so ruthless and psychologically penetrating, created an atmosphere of nightmarish anxiety and tragic portent, in a city whose complacent indulgence in decadent luxury and pleasure seeking was only the lull before the storm of World War I. In the 1920s, however, his art became less feverish as he was drawn to Cézanne, and more hedonistic color schemes dominated his palette. Along with the luxurious color a new sense of optimism came to the fore.

pl. 169

After the war, Expressionism changed radically. The revolution of modern art had been fought and won, temporarily at least. The personal sense of pioneering that contributed to the cohesion of The Bridge and The Blue Rider could not be recaptured. The surviving artists reacted in different ways. At the Weimar Bauhaus after 1922, Kandinsky's style changed to one of rigid geometric design of a Constructivist character. For some,

such as Kirchner, Heckel, Schmidt-Rottluff, and Pechstein, the end of the artistic revolution meant the end of their most creative periods.

Another kind of revolution took place in Germany in 1918, a social revolution which gave some artists a new cause. Social democracy, as it existed in postwar Germany, was weak and ineffective. A number of intellectuals, artists among them, joined forces in a radical association called The November Group (*Novembergruppe*), which affirmed the alliance of the intellectuals and the poor. Ludwig Meidner wrote in a militant Socialist pamphlet: "We painters and poets are bound to the poor in a sacred solidarity. Have not many among us learned to know misery and the shame of hunger? . . . Are we any more secure in society than proletarians? Are we not dependent upon the whims of the art-collecting bourgeoisie?"[32] Other Expressionist artists collaborated on the pamphlet, with Pechstein contributing the cover of a man standing firm against a background of

George Grosz. *Funeral of the Anarchist, Dedicated to Oskar Panizza*. 1917—18. Oil on canvas, 55⅛ × 43¼". Staatsgalerie, Stuttgart. 170

Max Beckmann. *Departure*. 1932—33. Oil on canvas; triptych, center panel 7' ¾" × 45⅜", side panels each 7' ¾" × 39¼". The Museum of Modern Art, New York. 171

conflagration, a symbolic reference to the idealized proletariat's capacity to reconstruct Germany from the ruins of war.

Much of postwar German art was specifically oriented to the social problems of the time and tried to clothe Utopian socialism in Expressionist forms. George Grosz (1893—1959), however, worked out of disenchanted feeling. He became the most savage critic of the bourgeois-dominated, demoralized Germany of 1919. His raw, coldly analytic, semi-Cubist pictures of streets filled with wounded veterans, beggars, prostitutes, degenerates, and wealthy capitalists carry all the shock value and emotional intensity of The Bridge painters, but now the ugly and the cataclysmic aspects of life, rather than the strong and the primitive, are insisted upon. Otto Dix also paraded the indecencies of postwar life before the eyes of the world. In both Grosz and Dix, however, non-Expressionist attitude toward modern life can be seen in works that stress the almost magical value of physical reality, an attitude called the New Objectivity, meticulously exact descriptive technique of representation in contrast to the spontaneity of Expressionism.

One great Expressionist painter remains to be discussed: Max Beckmann (1884—1950). Although he belonged to the generation of The Bridge painters, he did not take part in their organization. Before the war, however, Beckmann revealed an increasing tendency in his painting toward tragic themes. Experiences in the army as a medical orderly profoundly affected his thinking

pl. 170

Max Beckmann. *Night*. 1918—19. Oil on canvas, 52⅜ × 60¼". Kunstsammlung Nordrhein-Westfalen, Düsseldorf. 172

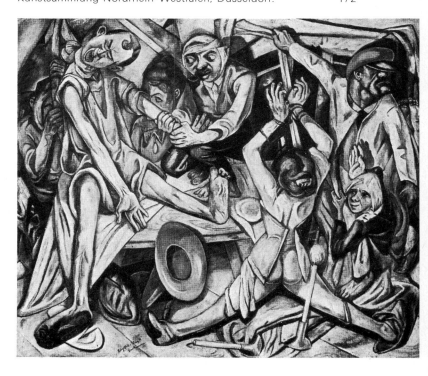

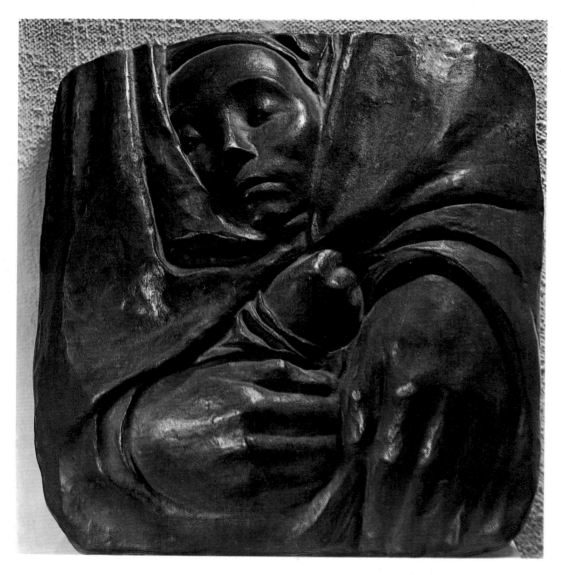

Käthe Kollwitz. Relief for the tomb of the artist: "Rest in the Peace of His Hands." 1936. Bronze, 13¾" h. Peter Stuyvesant Foundation, Liechtenstein. 173

pl. 172

and his art. Among the first paintings in a new style of grotesque figuration and charged symbolism was *Night*, of 1919. From that point on he turned increasingly to the development of powerful expressionistic symbols. Unlike those of Grosz and Dix, his subject was not specifically social criticism; he delved instead into the psychological and spiritual relationships of man, painting always with such force and solidity that his strange world is absolutely convincing.

Beginning in the war years, and through the early 1920s, Beckmann's imagery was almost pathologically bitter and gruesome. In the 1930s, these moods gave way to a more hopeful and universal allegory, but as he surrendered something of the pointedness and acuity of content, his painting means became more original and remained intensely expressive and personal. pl. 171 In such works as *Departure*, Beckmann's feverish colors and emphatic black outlines were applied to an uncompromising imagery of human violence and affliction, which commented obliquely on the predatory impulses of the period of German Nazism. The picture quite clearly symbolized the artist's own sense of relief on departing from Germany for The Netherlands and freedom, leaving a world of sadistic memories, symbolized by the tortured and trussed figures, to find a more serene

life beckoning from beyond the brilliant blue sea. Beckmann's art, which began as an instrument of social and psychological criticism, became increasingly philosophical and spiritual. He saw his work in universal terms, under the light of eternity, and remained preoccupied with the symbolism of man's fate, a drama, as he later put it, where "my figures come and go, suggested by fortune or misfortune. I try to fix them divested of their apparently accidental quality."[33]

Expressionist sculpture seldom reached the extremes of emotional intensity found in painting. Only Käthe Kollwitz and Ernst Barlach, in their profound identification with the laboring and peasant classes, produced forms expressive of the suffering and anxiety of prewar Germany. Wilhelm Lehmbruck created sculpture of enormous power and monumental dignity through a sensitive use of the attenuated human figure. Georg Kolbe worked with the rhythms and natural grace of the human form in a more classical manner, which sets him apart from the mainstream of Expressionism. Several Expressionist painters produced interesting sculpture, but only occasionally; among them were the members of The Bridge and Klee, Kokoschka, Marc, and Feininger.

Nearly all of the Expressionists were active printmakers. The art of the woodcut was revived

pl. 173, 175

pl. 174

pl. 117

with particular vigor by members of both The Bridge and The Blue Rider as well as by the independents, Kollwitz, Rohlfs, and Barlach. Other print mediums often used were etching, drypoint, and lithography. The brutal simplicity of The Bridge prints was influenced by the late medieval German woodcut. But Expressionist prints in a variety of mediums also extended the influence of Japanese woodcuts, Félix Vallotton's bold juxtapositions of large black-and-white surfaces, and, most significantly, Edvard Munch. Munch's rough cutting tools, utilization of the natural textures of his wood blocks, and morbid or highly emotional subject matter deeply impressed the early Expressionists. In the case of The Bridge painters, the efforts in woodcut not only belonged among their most important accomplishments, but decisively determined the character of their painting. The critic Hartlaub wrote: "It is the knife of Munch, which in contradiction to all classical idealism and Renaissance taste first spoke its own peculiar barbaric dialect in rough wood."[34] The influence of the Expressionists

has been deeply felt by graphic artists everywhere.

The Expressionist movement was effectively suppressed when the Nazis took power in the 1930s and labeled almost all Expressionist work degenerate. In the thirty years of its existence, Expressionism had drawn sustenance from many roots, flowered splendidly just before World War I, sown the seeds of new movements to come, and produced many important new artistic personalities. Many German artists fled before the Nazi persecution, taking refuge in other European countries and in America. The Expressionist approach was thus widely dispersed and became one of the major directions of art in this century. Kirchner's moving summons to the younger generation in his program for The Bridge in 1906, inviting them to join in creating a new and more hopeful artistic future, has been answered by artists throughout the civilized world. Whenever the urgencies of personal passion have overcome a dominant formal order or decorative values in painting and sculpture, the original Expressionist spirit finds itself renewed.

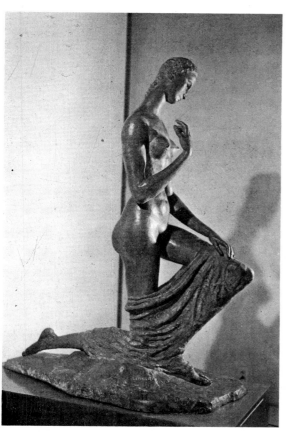

Wilhelm Lehmbruck. *Kneeling Woman.* 1911. Cast stone, 69½" h. The Museum of Modern Art, New York. Abby Aldrich Rockefeller Fund. 174

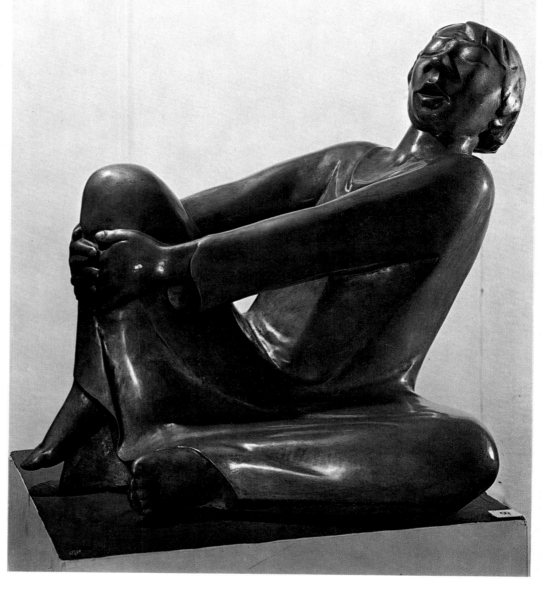

Ernst Barlach. *Singing Man.* 1928. Bronze, 19¾" h. Peter Stuyvesant Foundation, Liechtenstein. 175

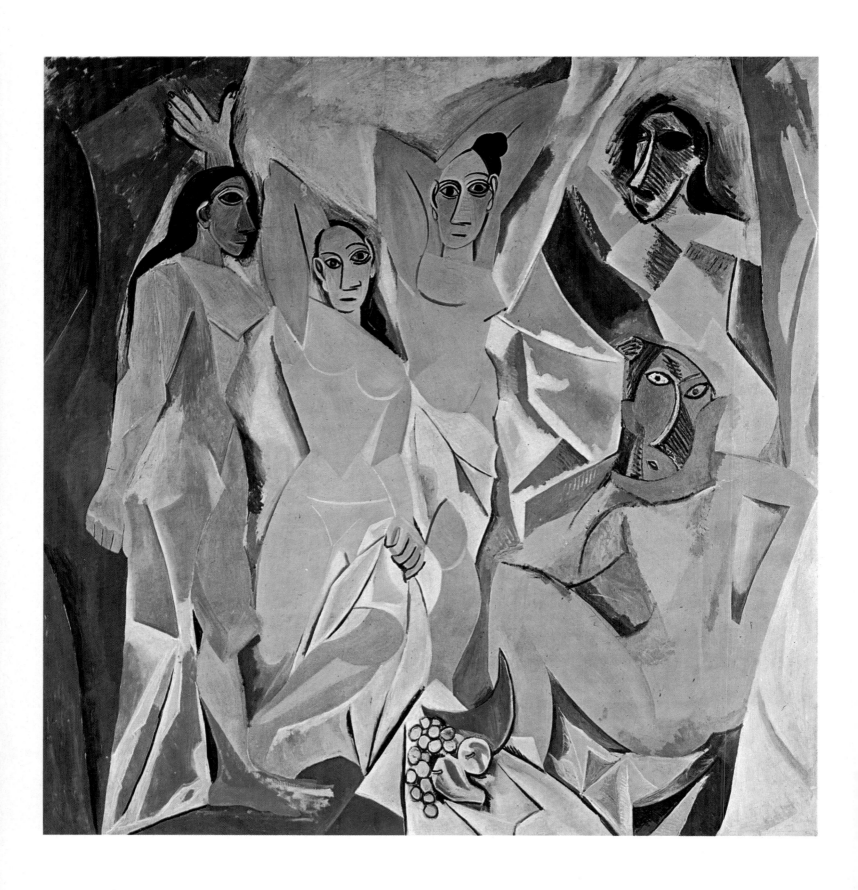

CUBISM AND ABSTRACT ART

pl. 145

pl. 176

The years between 1905 and 1908 were as critical to the development of twentieth-century styles as the early 1880s had been to the formation of Post-Impressionism. In both cases, painting moved from free color expression toward firmer pictorial structure. Seurat, Cézanne, and, in the later years of the decade, van Gogh and Gauguin, used more explicit design in their compositions and went well beyond pure optical sensation and the basic pictorial premises of Impressionism. In 1906, when Matisse painted *Joy of Life*, the informality and inspirational character of the Fauvism of the previous year were superseded, just as a new formalism had supplanted Impressionism. In 1907, Paul Cézanne's correspondence with Émile Bernard was published; it contained, among other remarks, the advice to "seek in nature the cylinder, the sphere, the cone," an expression of formal principle which in a short time was to be adopted as a major premise by the members of the new Cubist movement.

Pablo Picasso (1881—1973) had no doubt seen Matisse's *Joy of Life* at the Rue de Fleurus apartment of Gertrude and Leo Stein where it hung in the fall and winter of 1906, for he frequently visited those enlightened patrons of modernism. In his study *Matisse: His Art and His Public*, Alfred Barr suggests that early in 1907 Picasso began to prepare a large composition as a challenge to Matisse's great canvas. This was to be *Les Demoiselles d'Avignon*. The title refers ironically to the inmates of a Spanish brothel on Avignon Street in Picasso's native Barcelona. *Les Demoiselles* joins Matisse's major work of 1906 to mark another great watershed in modern art. Cubism emanated directly from this critical painting, and with it, Picasso took his first significant step toward assuming the unchallenged leadership of vanguard painting. Contrasting sharply with his preceding styles of the Blue and Rose periods, *Les Demoiselles* represented an abrupt reversal of artistic direction which initiated the pattern of radical stylistic changes throughout his career. But before we can appreciate the full import of the change that Cubism brought to both Picasso's art and twentieth-century art forms generally, we must place it in the context of the artist's own eclectic development.

Picasso had been born in Malaga, on the Mediterranean coast of Spain. In 1895, after living for several years in Coruña, his family moved to Barcelona where his father, Don José Ruiz Blasco, an art teacher, became an instructor at the School of Fine Arts. (According to Spanish custom, Picasso was free to choose either of his parents' surnames, and he took his mother's.) Barcelona was a lively intellectual center, and Picasso's precocious artistic talent soon brought him into contact with local poets and painters of progressive tendency, and in time stirred him to go to Paris. Between 1900 and 1904, he stayed for a number of lengthy periods in the international capital of art, and after 1904 he lived there permanently. On his first visit he had painted street and café scenes in alternately somber and vivid colors, with savage brushstrokes and a disenchanted eye; these rather melodramatic paintings evoke Lautrec, Théophile Steinlen, and an exacerbated, disenchanted *fin-de-siècle* atmosphere.

Toward the end of 1901, Picasso began to use a pervasive monochromatic blue tonality that seemed to have been chosen because of its association with melancholy. There were precedents for the use of dominant blue in Degas's paintings of toiling laundresses, Gauguin's mystic allegories set in the tropical jungles of Tahiti, and Cézanne's Provençal skies. Picasso's blues also suggested the void, and visually echoed the sense of unreality and infinity of *l'azur* of Mallarmé's sonnets. His subject matter—human derelicts, beggars, and the emaciated, starving children and oppressed poor of Paris—may have reflected his own actual economic distress. By 1903, when he painted *Two Women at a Bar*, he had achieved a number of remarkable works in a consistent style, full of brooding personal poetry and an almost morbid emotionalism. The lugubrious, bluish darkness of these canvases recalls the somber tonalities of Spanish painting, and their motifs are reminiscent of Manet's picturesque *Topers* and his elegant Parisian version of Velázquez's early subject matter of human pariahs, beggars, and entertainers.

pl. 177

Pablo Picasso. *Les Demoiselles d'Avignon.* 1907. Oil on canvas, 8′ × 7′ 8″. The Museum of Modern Art, New York. Acquired through the Lillie P. Bliss Bequest. 176

Pablo Picasso. *Two Women at a Bar.* Oil on canvas, 31½×36". Collection Walter P. Chrysler, Jr., New York. 177

Pablo Picasso. *La Vie.* 1903. Oil on canvas, 77⅜×50⅛". The Cleveland Museum of Art. Purchase from Hanna Fund. 178

To these sources, Picasso added an El Greco-like attenuation of form and an excruciating spirituality, reflected in the poetic vulnerability of his figures' faces and attitudes.

In a period when he was engaged in intense experimentation with many influences, Picasso also seems to have discovered Gauguin's primitivism, and felt the impact of his great painting pl. 34 *Where Do We Come From? What Are We? Where Are We Going?* Not only does his palette of blues and ochres recall the mysterious, synthetic color of Gauguin's painting, but the large, flattened forms and hieratic profiles of Picasso's figures have similar primitivistic character. Picasso fused these elements into a highly personal style, and his affecting imagery served as commentary on the human wreckage of the modern city, rather than as an invitation to taste the pleasures of a tropical Eden. Interestingly, the allegorical content of Gauguin's masterpiece and other paintings of the 1890s, under the aegis of Symbolism especially, did not pl. 178 escape his attention. *La Vie*, like so many turn-of-the-century paintings, deals poetically with the theme of the human life cycle, and evidently represents three stages of human existence, from young love to a weary disillusionment and maternity. Like other paintings of the Blue period, it is haunted by a mood of pessimism and stoic suffering.

About 1905, Picasso lightened his palette, relieving it with pink and rose, and restrained the

pl. 179

more extravagant pathos of his Blue period. He began to paint circus performers in a more airy and graceful manner, with extraordinary subtlety and sensibility. These touching, fugitive visions of a strange gypsy tribe of entertainers, half mournful, half heroic, are among the most poetic visual creations of the modern period. Certainly the touching troupe of mountebanks, *Family of Saltimbanques*, is one of the most eloquent and poignant of these visual documents of alienation. In a sense, Picasso revived a special theatrical world even more acutely than Degas and Lautrec had done with their ballet and cabaret scenes. Yet Picasso's stoic old saltimbanques and emaciated young acrobats with reproachful eyes haunt us like a dream; they are the stuff of vision rather than reality. They also express something of a metaphor for Picasso's sense of his own artistic isolation. These figures eloquently express the plight of the man of superior sensibility whose gifts outlaw him from conventional society and force him to wander, rootless, in a shadowy limbo of heroic, if futile, dreams. Throughout his brilliant career, Picasso demonstrated affection for the melancholy lyricism of the clown, and even in his more abstract inventions he consistently used figures of *commedia dell' arte* origin.

As in the Blue period painting, one of the striking features of Picasso's obsessive theme of acrobats and circus performers is the degree of his personal involvement; a passionate, if muted, subjective emotionalism pervades every inch of the canvases. When he painted *Family of Saltimbanques*, he also must have intended us to see the fate of the circus performers, condemned to a wandering existence and unstable relationships, as symbolic of the fate of humanity. That, at any rate, is how the German poet Rainer Maria Rilke interpreted the picture in a celebrated Duino elegy. His Fifth Elegy begins with a meditation on the haunting painting:

> But tell me, who *are* they, these acrobats, even a little
> more fleeting than we ourselves—so urgently, ever
> since childhood,
> wrung by an (oh, for the sake of whom?)
> never-contented will?[1]

In the Rose period of 1905 and 1906, generalization and a greater breadth of style became evident in Picasso's figuration and suggested the supple grace of Hellenistic sculpture or Pompeian frescoes. The roses, terra cottas, and siennas of his palette summon up the warm colors of Roman wall decorations and the atmosphere of classical Mediterranean culture. This was part of his search for a less emotional, more objective art. He had begun to look closely at Greek vase painting and Etruscan and archaic Greek sculpture in the Louvre, and his interests quickly expanded, in a

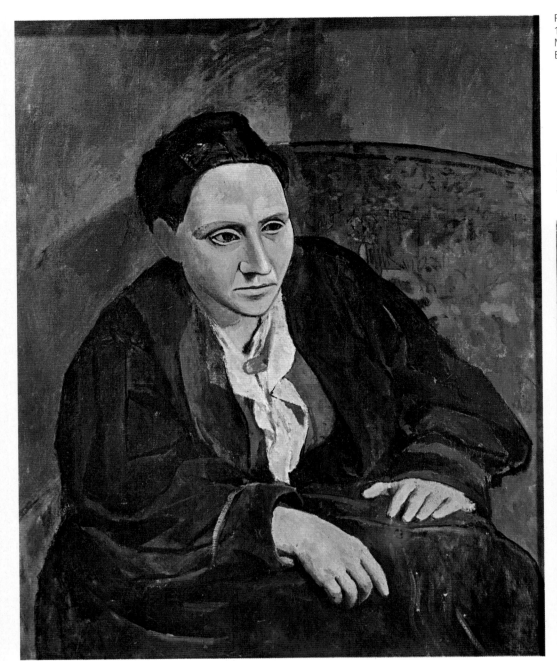

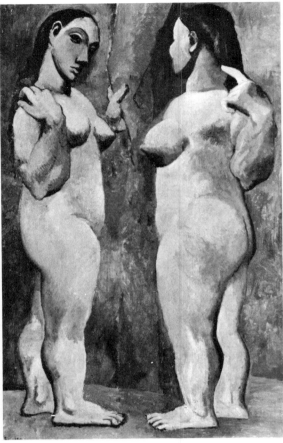

year of dramatic developments, to include primitivist, pre-Christian Iberian carving. The even more revolutionary influence of recently discovered African sculpture was also soon to play a dominant role in his shifting style. In such mercurial changes was the first hint of a constant element in Picasso's art, lost and recovered again throughout his career: a remarkable ability to re-create the mannerisms of classical figuration which evoke, in turn, the atmosphere of the first dawn of Mediterranean humanism, and, further, to oppose this mood of civilized humanism with allusions to the discordant violence of primitivism. Out of the tension between the elements of classical humanism and primitivism evolves the rich iconography of Picasso's art and its formal diversity. He even used the disparate styles and artistic sources metaphorically, to express mental states analogous to the idea of ego control and a subconscious fantasy life, and thus suggested the evident discontinuities of modern culture, as well as the complex depths of human personality.

Picasso's primitivism was fused with a system of revolutionary, formal ideals in the summer of 1906, which he spent at Gosol, a small town in the Spanish Pyrenees. At this time, the precocious and charismatic Spaniard was only twenty-five years old. During the previous five years, he had produced over two hundred paintings and many hundreds of drawings, developed a style of intense originality—two complementary styles, in fact—and revealed exquisite poetic gifts, an achievement that would have satisfied all but the most restive of temperaments. Like Matisse during his Fauve period, Picasso was driven to pursue deeper visual truths, even when they threatened momentarily to brutalize his finer sensibilities. He seemed to sense that new and more vital artistic solutions lay before him, when he began, at Gosol, to realize, in stylized and forceful painting and drawing, his interest in the simplified forms of archaic Iberian sculpture.

Before he had left Paris, Picasso had been at work on a portrait of Gertrude Stein. Despite

pl. 180

some eighty sittings, he had been dissatisfied with the face and had left it unfinished. He returned in the fall to repaint the face in a completely different style, transforming it into a stiff but powerfully expressive mask. The soft, gentle style of his Rose period was now a thing of the past. In *Two Nudes* and subsequent paintings of 1906 and 1907, Picasso went on to create squat, angular, primitive-looking figures; heavily pigmented until the paint stood out in low relief, they were at once sculpturesque and intensely expressive of brute paint matter.

pl. 181

Cubism received its climactic impulse in 1907, with Picasso's revolutionary *Les Demoiselles d'Avignon*. This work, like Matisse's critical *Joy of Life*, took its general inspiration from Cézanne's monumental Bathers compositions. In a similar spirit, Picasso emphasized the architectural development of a group of nudes whose anatomies form the ribs of a vaultlike space. However, the painting's violent dissonances obviously make it a far more ugly and difficult work of art than Cézanne's. While there is still some evidence in it of Picasso's preoccupation with classical figuration, and with the pink and ochre coloration of Roman fresco painting, the two heads at the far right are completely out of character. Although Picasso denied that any influence shaped these figures other than Iberian sculpture, which he had seen at an exhibition in the Louvre, on purely visual grounds the right-hand visages seem almost irrefutably inspired by African masks of the French Congo.[2] It is clear that Cézanne's structural esthetic and the example of his *Great Bathers* have been imaginatively united with the geometric volumes of African sculpture, with their crude forms and expressive intensity, in order to liberate an utterly original artistic style of compelling force.

pl. 176

pl. 14

The angularities of the two right-hand figures in *Les Demoiselles* announce the geometric bias and shifting planes of Cubism and, beyond that, all the rationalized and structural abstract idioms of twentieth-century art. These dissonant figures also introduce into the general scheme of modern art a new psychological content and different criteria for pictorial consistency. The visible evidence of the artistic process is allowed to stand in the finished painting, rather than being eradicated or assimilated to a more unified image. Painting may, henceforth, contain conflicting tendencies and describe within the same visual field a diversified morphology, covering a stylistic spectrum from realism to total abstraction, or show pictorial ideas in a state of incomplete realization.

Matisse or perhaps Derain—the accounts vary—had introduced Picasso to Negro sculpture and to the flat masks of Congo or Ivory Coast art while *Les Demoiselles* was in progress, and the two figures at the right were apparently painted under the new influence. Their barbaric spirit and vehemently textured paint surfaces surpassed the most violent coloristic and formal distortions of the Fauves. Picasso had, in fact, injected a note of psychological terror with his imagery. The shocking anomaly of these two masks prophesied the violent fantasies of the Surrealist incubus dredged up from the subconscious mind, which appeared in Picasso's art of the late 1920s and in work of the Surrealist movement.

An assimilation of primitivistic forms to classical or traditional art was apparent in other forms of expression at the time, most particularly in the music of Picasso's close friend, Igor Stravinsky. In 1910, he composed *The Firebird* and, three years later, *The Rites of Spring*, with its wild rhythms and even more uncivilized, dissonant sounds. A decade later, T. S. Eliot wrote his classic poem *The Wasteland*, an elaborate allegory describing the plight of overcivilized modern man in search of spiritual rejuvenation, with rich allusions to the fertility rites of a more primitive society. If we consider the morbidity and self-indulgence of the late Romantic decadence of Symbolist art, we can better understand the search for new sources of passion in the individual's instinctual life and in tribal art forms embodied by the Expressionist violence of early twentieth-century painting, whether Fauvist or Cubist. It should be noted in this context that by 1900 Sigmund Freud had published his great work on dreams and begun his exploration of the unconscious, an investigation which indicated that a more primitive instinctual life lurked beneath modern man's civilized veneer.

During the remainder of 1907 and 1908, Picasso continued painting figures and heads with the simplified planes of African Negro sculpture, which not only provided emotional stimulus but also suggested that such radical simplifications of form might have new esthetic meaning. Picasso's enthusiasm for primitivism can be seen in his interest in the ingenuous painting of *le douanier* Henri Rousseau (1844—1910), who had been taken up by Guillaume Apollinaire, the Steins, and other friends of Picasso's. In 1908, Picasso bought for a few francs a large portrait by Rousseau which he found in a junk shop. To celebrate the purchase, he gave a now famous studio party commonly referred to as Le Banquet Rousseau. The guests included Braque, Apollinaire, Marie Laurencin, Leo and Gertrude Stein, Fernande Olivier, and a number of avant-garde critics. The guileless *douanier* was overwhelmed by speeches, toasts, and a poem which Apollinaire wrote and recited for the occasion. Picasso and the vanguard painters had "discovered" for the first time in the obscure Rousseau a "naive" painter.

In his innocence of artistic traditions, powerful archaic forms, and flat presentation, they found a sympathetic note; the search for a new simplicity was the order of the day. A sober, rather timid *petit bourgeois*, on canvas Rousseau created heroic personages and exotic dreamlike settings that conveyed the powerful fantasy and myth-making powers slumbering in the brain of Everyman. His untutored forms had the primitive authority of the urgent shapes found on fantastic Romanesque capitals, yet his art was also accessible and popular in character, as bright and gay as a contempo-

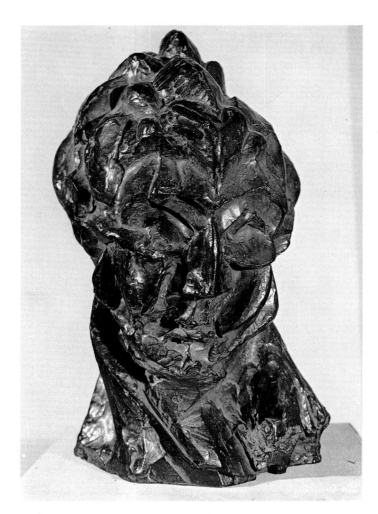

Pablo Picasso. *Woman's Head.* 1909. Bronze, 16¼″ h. The Museum of Modern Art, New York. 182

Working together, in Braque's words, "rather like mountaineers roped together," Braque and Picasso pushed their pictorial innovations to the logical conclusion of near abstraction. The faceting of figures and objects was extended to the environment—to the space around them—so that space and volume formed a continuous whole and the picture took on a tangible surface. Landscape, still life, and human figure motifs were reduced to an almost nonrepresentational arrangement of overlapping flat planes, wedges, and curves, quite as if natural appearances had been exploded and the artists were attempting schematically to reassemble the fragments.

In 1908 and 1909, Picasso painted in the south of France and in northern Spain. His landscapes of the Spanish town of Horta de San Juan had gone far beyond *Les Demoiselles* in its drastic simplification and breakup of natural forms into a limited repertory of geometric shapes. And in the same year Picasso first tested the planes of Cubism as a sculptural strategy in his *Woman's Head.* The pl. 182 work of both Braque and Picasso between 1909 and 1911 rigorously conceptualized and anatomized form into cubic volumes and angular, faceted planes, with the fewest possible concessions to sensory experience. The primary esthetic delectations that Analytic Cubism provided were of the mind rather than the senses. Despite the monochromes of early Cubism and its mechanization of form, however, such Picasso masterworks of obsessive, analytical intelligence as *Portrait of Ambroise Vol-* pl. 184 *lard* of 1910 represent a triumph of subtle lyrical sentiment over an impersonal formalist esthetic. Braque's *Violin and Jug,* made in the same year, pl. 183 carries the process of dismantling form to an even more extreme point of dissociation and marginal recognizability.

It is interesting to observe the prophetic note in the top central portion of the canvas, where a nail and its shadow are clearly indicated. The introduction of such *trompe-l'œil,* or eye-fooling, illusionistic detail opened up an entirely new phase of invention in the succeeding years, as references to the real world transformed Cubism from an art of virtually pure abstraction into an amalgam of elements of Naturalism, Symbolism, and abstract art. In the first, Analytic, phase of Cubism, Picasso and Braque limited their palettes to grays, beiges, tans, and whites, almost as if they were conducting a laboratory in form and wished to limit the number of variables, the better to control their experiment. Never willing to abandon natural appearances completely, however, they introduced hints of recognizable reality in geometrically schematized forms: fragments of anatomy or the ubiquitous still-life props of guitars and pipes. These variations on an original motif appeared on canvas more as abbreviated signs or emblems than a fully developed subject matter, as intended in traditional representational painting of the past.

The general public had its first taste of Cubist innovation at an exhibition arranged by the deal-

rary color print. It was some time, however, before Rousseau's inventions were paid the most solid tribute painters can accord another artist's work, that of imitation. In the 1920s, Fernand Léger adapted Rousseau's robust forms to his own purposes; and in the 1940s, Picasso directly referred to the more fantastic and mysterious side of Rousseau's genius in some of his compact and monumental figure studies.

The formal crudity and violently expressive content of Picasso's so-called Negro period soon gave way to a renewed interest in the art of Cézanne, who was honored by a large memorial exhibition at the 1907 Autumn Salon, and whose newly published letters to Émile Bernard supported Picasso's efforts to reduce visible nature to a simplified geometry. During 1908 and 1909, Picasso's palette shifted to more somber and resonant colors: first reddish browns and greens and then khakis, beiges, and steel grays. From a sculpturesque rendering of form and a solid masonry-like surface, he moved to abbreviations of forms and a kind of visual shorthand of angular fragments, with still more sober color schemes, less opaque and weighty in tone. In 1909, the new style, which Apollinaire later called Analytic Cubism, crystallized. Georges Braque had followed Picasso's experiments with interest and in 1908 joined him in exploring the new manner.

Pablo Picasso. *Portrait of Ambroise Vollard.* 1909–10. Oil on canvas, 36×25½". Pushkin Museum, Moscow. 184

Georges Braque. *Violin and Jug.* 1910. Oil on canvas, 46½×28¾". Kunstmuseum, Basel. 183

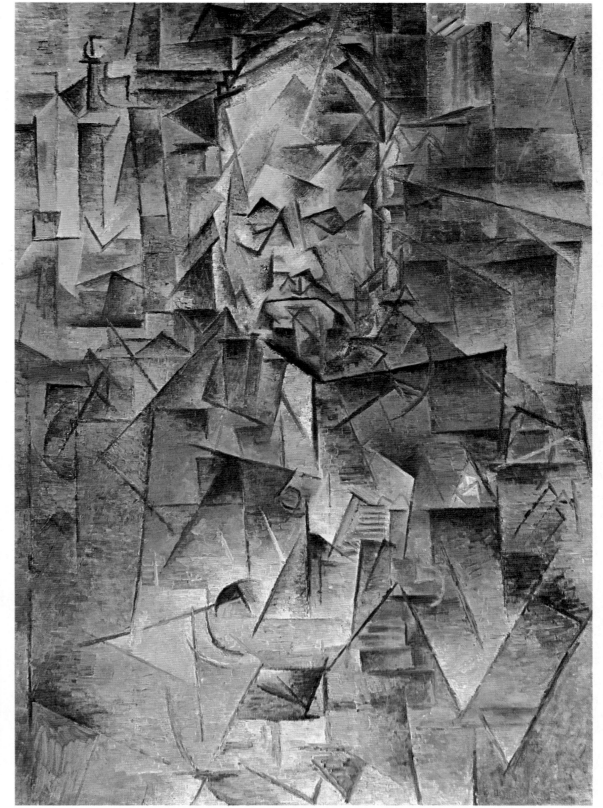

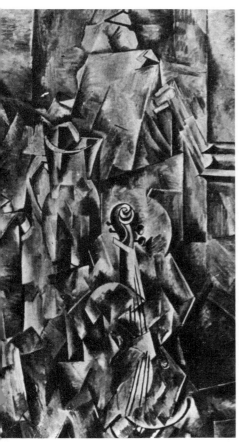

pl. 186

er Daniel-Henry Kahnweiler in November 1908 of Braque's work of the previous year. Reviewing the Kahnweiler show, and subsequently the spring Independents Salon, the critic Louis Vauxcelles severely took Braque to task. He "mistreats form," wrote Vauxcelles, "and reduces everything . . . to cubes."[3] Later Apollinaire officially adopted the term Cubism to describe the movement. In the immediately ensuing years, a host of young painters began to work in the new style: Jean Metzinger, Albert Gleizes, Fernand Léger, Juan Gris, Francis Picabia, Roger de La Fresnaye

(1885–1927), Jacques Villon, Marcel Duchamp, Robert Delaunay, Le Fauconnier, and others. Some were content to work in almost anonymous, impersonal styles but not without recognizable individual distinction; others not only added their own inflections but, in some cases, radically altered the character and structure of Cubist style. Cubism became the most generative and influential movement of the period, and directly inspired a variety of foreign movements, dedicated to other objectives, such as Futurism in Italy and The Blue Rider movement in Germany. 129

As the Cubist revolution spread throughout Europe, with vastly differing results and visual character in Italy, Germany, and Russia, Analytic Cubism in Paris achieved a rare and exalted moment of intellectual elegance. Picasso's portrait of the art dealer Vollard and Braque's *The Portuguese* provide supreme examples of this uncompromising, mandarin phase which managed to hold in an exquisite tension the observed subject and independent formal invention. While Cubism had, at this point, almost severed ties to recognizable reality, it was nevertheless far from being dryly intellectual or entirely nonsensuous. Taking their cue from the Neo-Impressionists, the Cubist painters strongly emphasized touch and a brush-

pl. 184
pl. 185

stroke that stood out in assertive texture and relief, employing this painterly resource to reaffirm the physical concreteness of the painting surface as well as the sensuous pleasures of a retinal art. Braque's painting *The Portuguese* builds up its surface in small loaded strokes of the brush, thus embodying an elevated formal concept in palpable medium. No matter how fragmentary and remote, references to the object are still discernible, and one can piece together a plausible subject matter of musical instruments and anatomical allusions.

The mixed mood of intellectual pleasure and visual uncertainty which Cubist invention brought to observers accustomed to traditional

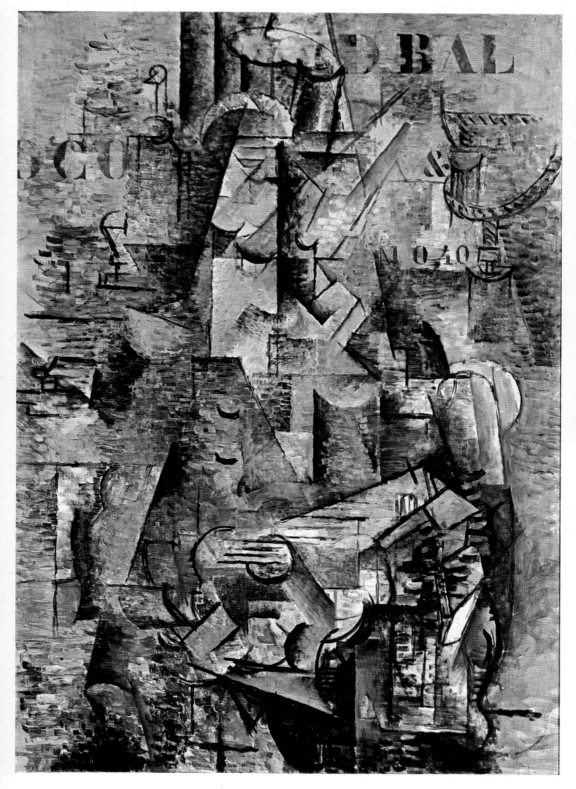

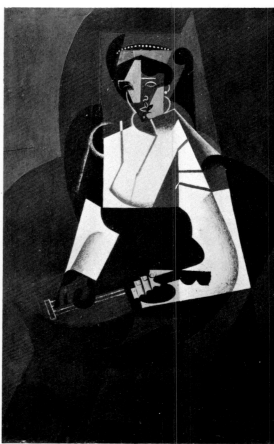

Juan Gris. *Woman with a Mandolin (after Corot)*. 1916. Oil on plywood, 36¼×23½". Kunstmuseum, Basel. 186

Georges Braque. *The Portuguese*. 1911. Oil on canvas, 45⅞×32⅛". Kunstmuseum, Basel. 185

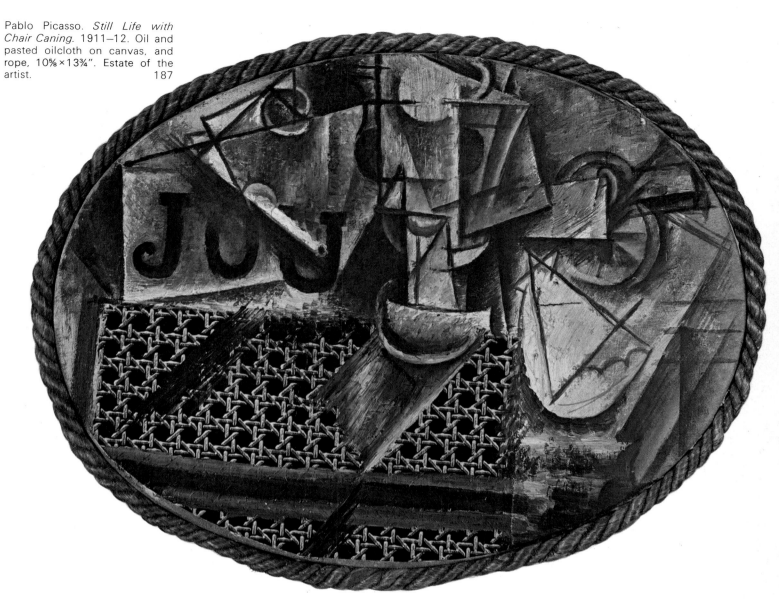

illusionistic systems in painting had been eloquently evoked by a passage in Max Kozlof's provocative study, *Cubism/Futurism*, where suggestive language often matches in straining nuance the complex structure of the paintings under consideration:

> Underlying the Cubist world there is, indeed, a metaphysical doubt, a kind of pleasing treachery, that corresponds to our own concourse with sensation. Objects that are foreshortened to the glance are literally truncated in the painting. A shape that seemed large will be shown by the artist to have been encroached upon by its surroundings. We suppress those fleeting misadventures of sight, those gratuitous occlusions, and above all, those optional judgements of material which Cubism was designed to reveal. They well up softly but no less tangibly because they are represented in art. But there, at least, they are contained, conventionalized, and put on record, whose evidence is the Cubist moment. [4]

Beginning with *The Portuguese*, stenciled or commercial lettering appeared on the surface for the first time, to be followed at a later date by the *trompe-l'œil* imitation of wood grains and varied textural effects normally alien to conventional painting methods. Such visual *non sequitur*s violated the traditional integrity of painting's "noble means." An effect of psychological surprise and dislocation was achieved by introducing bits of reality out of context, but the Cubists also stressed the physical reality of the painting by forcing the frontal plane into new prominence. Picasso's *Still Life with Chair Caning* was a radical departure, for here Picasso took the logic of imitating the banal aspects of the physical environment one important step further, by incorporating actual materials alien to the medium. *Still Life with Chair Caning* included a piece of oilcloth with a lithographic imitation of actual caning pasted to the canvas. To leave no doubt about the coexistence of dual realities—the representation of the still life and its evocation with real-life fragments of materials—Picasso framed the small oval canvas with a hemp rope, which paradoxically imitated the scroll-like shapes of a conventional gilded wood frame.

pl. 187

The curious combination of banality and metaphysical doubt which Picasso's collage symbolized was first pointed out by Apollinaire in the most poetic and perceptive appreciation of Cubism. He wrote of Picasso:

> Then he sharply questioned the universe. He accustomed himself to the immense light of depths. And sometimes he did not scorn to make use of actual objects, a two-penny song, a real postage stamp, a piece of oil-cloth furrowed by the fluting of a chair. The painter would not try to add a single picturesque element to the truth of these objects.

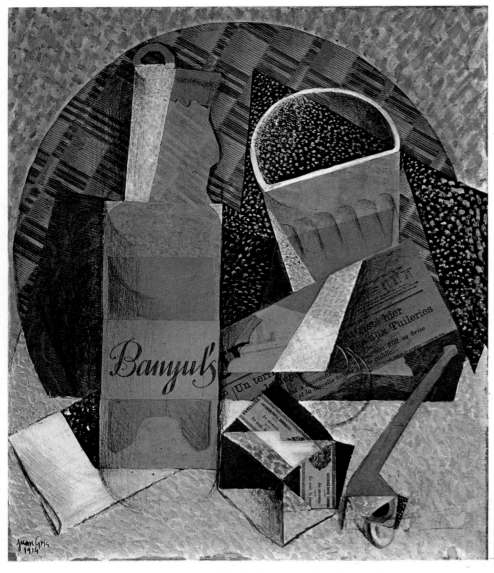

Juan Gris. *Bottle of Banyuls.* 1914. Collage, pencil, and gouache on canvas, 21⅝×18⅛". Kunstmuseum, Bern. Hermann and Margit Rupf Foundation. 188

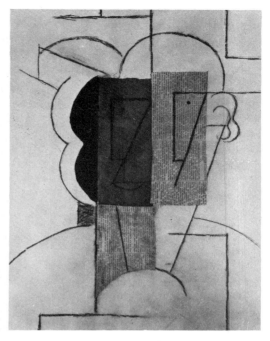

Pablo Picasso. *Man with a Hat.* 1912. Charcoal, ink, and pasted paper, 24½×18⅝". The Museum of Modern Art, New York. 189

Kurt Schwitters. *Merz Construction.* 1921. Painted wood, wire, and paper, 15×8½×2½". Philadelphia Museum of Art. The A. E. Gallatin Collection. 190

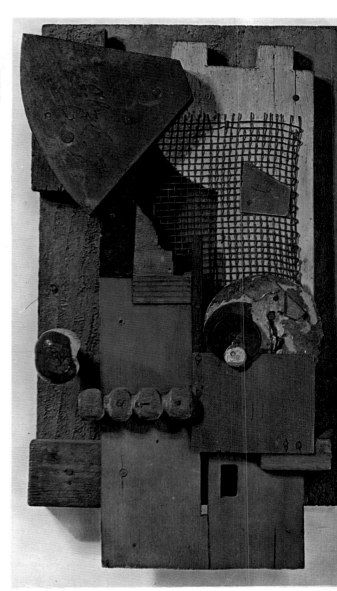

> Surprise laughs savagely in the purity of light, and it is perfectly legitimate to use numbers and printed letters as pictorial elements; new in art, they are already soaked with humanity.[5]

These disruptive and antitraditional effects of the collage strangely achieve a consoling harmoniousness. The stratagem of using untransformed materials, or a variety of details selectively edited from external reality, seemed irrational and perverse at the time, or at best frivolous. Now it can be understood as a sincere and serious method of exploring the new expressive possibilities of mixed mediums, while at the same time freeing the art object from the pretentious associations of its fine arts status by resituating it in the commonplace environment. This represents the first instance in our century where the modern artist utilized a deliberately vernacular, or vulgar, visual language to challenge so-called high art.

These hybrid works of art—in part imaginative fiction and in part everyday visual prose—were known as *papiers collés,* or pasted papers, but they

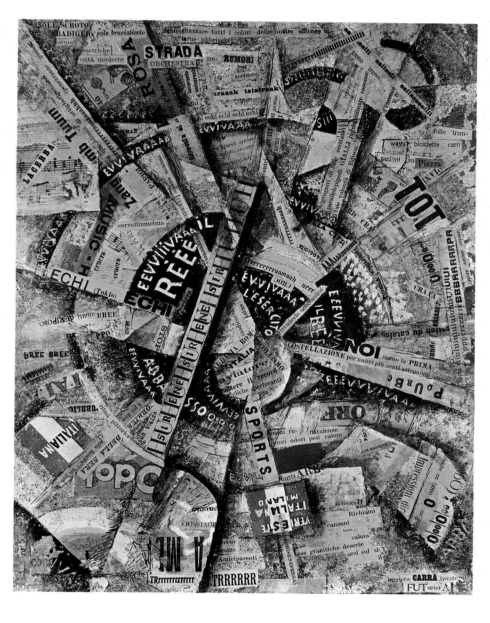

pl. 188

pl. 189

soon came to be called collages by artists and the wider public. Among them are some of the most beautiful and serious works of Cubist art. *Bottle of Banyuls* by Juan Gris (1887–1927) is an extraordinary harmony of vivid and sober colors, and of subtle textures in conjunction with delicately muted, shaded drawings, all of which lend an air of fragile mystery to the banal fragments of the bottle's label, the newsprint, and silhouetted pipe and glass which comprise its imagery. New possibilities of witty condensation and paradoxical juxtapositions of art and life in the collage form were realized by Picasso in such effective visual puns as *Man with a Hat.*

The humor and destructive potential of the collage and its basic anti-art impulse were carried to an outrageous extreme, with intimations of social violence, by other artists less attached to the stabilizing scheme of French decorative values. As Alfred Barr has put it, the Cubists seem to be saying, and not without some arrogance, "Look, we can make works of art out of the contents of waste baskets."[6]

pl. 190

pl. 191

After World War I, in Germany, Kurt Schwitters (1887–1948) brought to the collage a degree of refinement that was nothing short of uncanny, in view of both its limitations as a medium and the iconoclastic character of his commonplace subject matter. Implicit in his collages is a commentary on a shredded and disintegrated postwar society which he interpreted from a profoundly disenchanted, Dadaist, point of view. In Italy, beginning in 1914, Carlo Carrà (1881–1966), a Futurist, used the collage with didactic intent as an inciting, hysterical summons to action, supporting Italian intervention in the war. He arranged his bits of paper and dramatic verbal legends in centrifugal designs that emphasized dynamic movement.

After 1914, Braque and Picasso abandoned their experiments with pasted papers, and reverted once again to a more conventional painting medium. However, they now enriched their surfaces with stippled effects, bright color, and Rococo pictorial ornament in the beginning of a period that was later dubbed Synthetic Cubism, a style

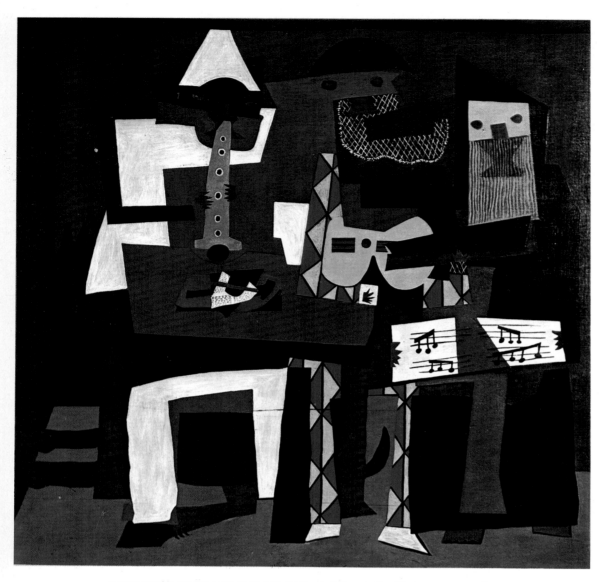

Pablo Picasso. *Three Musicians.*
1921. Oil on canvas, 6'7" × 7'3¾".
The Museum of Modern Art, New
York. Mrs. Simon Guggenheim
Fund. 192

Pablo Picasso. *Still Life with
Fruit, Glass, Knife, and News-
paper.* 1914. Oil and sand on
canvas, 13⅝×16½". Collection
David Lloyd Kreeger, Washington,
D.C. 193

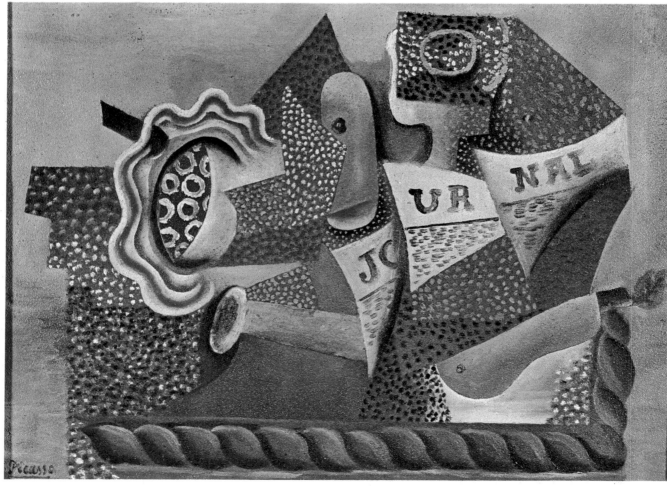

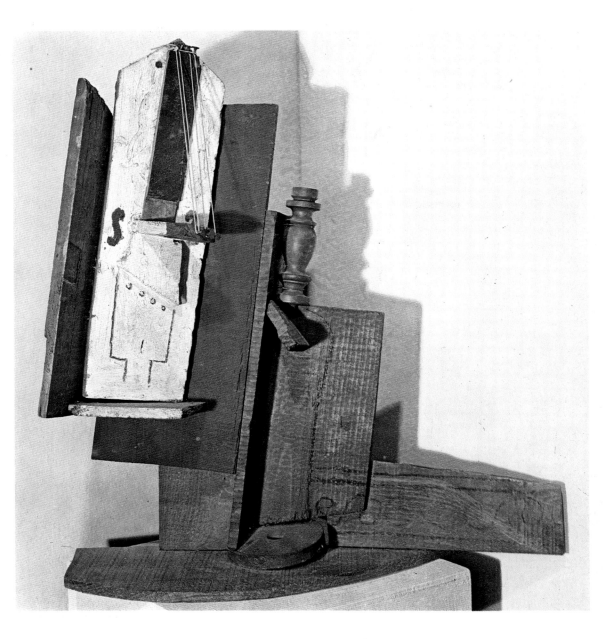

Pablo Picasso. *Violin and Bottle on a Table.* 1915–16. Painted wood, tacks, and string, 18½" h. Estate of the artist. 194

pl. 193 handsomely represented by Picasso's *Still Life with Fruit, Glass, Knife, and Newspaper.* This decorative manner, in which the object fragments of Analytic Cubism were synthesized into distinct and legible flat color masses, reached its apogee in Picasso's two magnificent versions of a monumental compo-pl. 192 sition, *Three Musicians,* both of which were painted at Fontainebleau in the summer of 1921. The figures recall a classical theme taken from the iconography of the *commedia dell' arte.* In the Museum of Modern Art's version, a Pierrot at the left is playing a woodwind, a harlequin at the center plays a guitar, and a monk at the right, masked like his fellow performers, sings from sheet music in his lap. The simplicity of the theme is countered by the extraordinary intricacy of a system of interlocking jigsaw-puzzle fragments and by the theatrical brilliance of the color. Both works have fantastic overtones and even a touch of the sinister in their distortions, which anticipate the dreamworld imagery of Surrealism, a movement launched in the mid-1920s to which the ambiguous, shifting identities of Cubist imagery contributed significantly.

The great wave of Cubist pictorial innovation and abstraction altered the character of contem-

porary sculpture just as decisively as it had painting. We have already seen how Picasso tested the planes of Cubism in three-dimensional form with his *Woman's Head* of 1909. Within a few short years, under the accelerating impact of Cubist analysis of form and the concept of the interpenetration of mass and space, Picasso's constructed sculpture became almost completely abstract. In *Violin and Bottle on a Table,* dated 1915–16, the pl. 194 traditional sculptural materials of bronze or stone were discarded in favor of a painted wood and string construction, which is marginally representative of the objects the title describes. Only remote hints of the musical instrument remain, in the jagged sound hole, vertical strings painted yellow, and the S-shapes cut into the violin surface. The solidity of early Cubist sculpture volumes, as in the *Woman's Head,* has been abolished in favor of "virtual" volumes and an effect of shallow relief.

Julio González, a compatriot and sculpture assistant to Picasso, before he was recognized as an independent figure in his own right, reported how Picasso radically conceived of the new sculptural object. Picasso managed to transform Cubist sculpture by employing humble materials like

wood and metal, a strategy that exercised a profound influence on the Russian Constructivist movement. Linking Picasso's first Cubist paintings of 1908 and his constructed sculpture of the late 1920s, González wrote: "Picasso gave us form not as a silhouette, not as a projection of the object, but by putting planes, syntheses, and the cubes of these in relief, as in a 'construction.' With these paintings, Picasso told me, it is only necessary to cut them out—the colors are only indications of different perspectives, of planes inclined from one side or the other—then assemble them according to the indications given by color, in order to find oneself in the presence of a 'Sculpture.'"[7]

Others were quick to explore and expand the new vision. Among the most important Cubist pioneers in sculpture were the Russian-born Alexander Archipenko (1887—1964) and Polish-born Jacques Lipchitz (1891—1973). With its interplay of concave and convex volumes, Archipenko's *Seated Woman* is typical of the new definition which Cubist sculpture now gave to form and space. One of his most influential innovations was the use of a void to represent the human head—a solid volume pierced and opened, so that the surrounding spatial ambience became an integral part of the total form. Other Archipenko inventions included a series of semiabstract figures constructed of painted wood, metal, and glass, among them the *Médrano II*. These illusionistic figures, which adapted the techniques of collage to sculpture, tended to be rather mannered and garish, however, and decorative styling replaced that concern for re-creating spatial relationships which provided inspiration for the most serious Cubist sculptors, Lipchitz, Duchamp-Villon, and, of course, Picasso.

Jacques Lipchitz produced mannered, Art Nouveau–type decorative sculptures before attempting the Cubist methods of open volume construc-

pl. 197

pl. 196

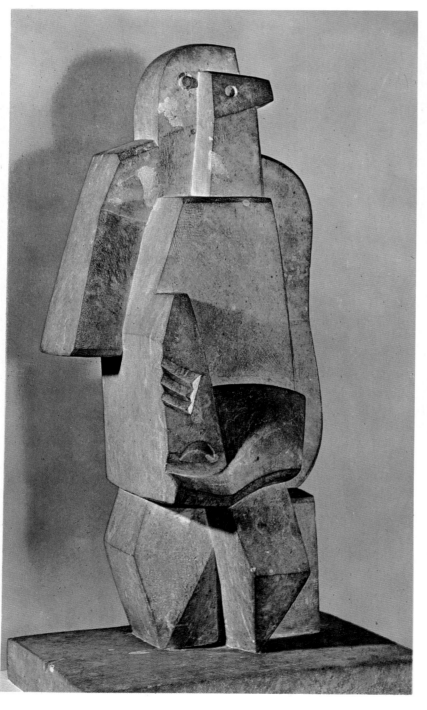

Alexander Archipenko. *Médrano II*. 1914. Painted tin, wood, glass, and oilcloth, 50″ h. The Solomon R. Guggenheim Museum, New York. 196

Alexander Archipenko. *Seated Woman*. 1916. Stone. Private collection, Milan. 197

Jacques Lipchitz. *Woman*. 1918. Stone. Present whereabouts unknown. 195

Henri Laurens. *Composition*. 1914. Black and red sheet iron, 8×11¾". Collection Maurice Reynal, Paris. 198

tion in late 1914. His sculpture prospered through his association with Juan Gris particularly. Lipchitz apparently submitted to the influence of Gris's esthetic ideas as they were later set forth in the magazine *L'Esprit Nouveau*. Gris described there his own practices, which became, in fact, the classic definition of the last phase of Synthetic Cubism, and of the abstract sculpture associated with it: "I try to make concrete that which is abstract.... Mine is an art of synthesis, of deduction.... Cézanne turns a bottle into a cylinder, but I begin with a cylinder and create an individual of a special type: I make a bottle—a particular bottle—out of a cylinder.... That is why I compose with abstractions (colors) and make my adjustments when these colors have assumed the form of objects."[8]

In the years of his friendship with Gris, in 1916—19, Lipchitz introduced a different approach to Cubist sculpture. He made his subjects—bathers, sailors, a Pierrot playing a clarinet, men playing guitars—less abstract and more legible (as Gris was doing in his painting), while pl. 195 emphasizing their mass. In these figures, Lipchitz used chunky, geometricized forms, which he articulated subtly to evoke fuller volumes than had Archipenko. In total formal impact, these powerful, and yet elegant, masterpieces of Cubist sculptural method are a far more complete and satisfying expression of the spirit of Cubism than Archi-

penko's interplay of shallow convexities and concavities. Lipchitz's *Woman* creates a vertical, ascending rhythm of light masses set in opposition, not unlike the compact setbacks of skyscraper architecture.

Another important Cubist sculptor whose later work in the 1930s and 1940s changed, like Lipchitz's mythical and more urgent themes, from the geometric to Baroque, rounded, voluptuous figures was Henri Laurens (1885—1954). Besides pl. 198 his extremely refined and straightforward Cubist work, Laurens, as early as 1914, anticipated later developments with colored abstractions made of sheet iron.

Raymond Duchamp-Villon (1876—1918; brother of Marcel Duchamp and Jacques Villon) showed promise of being the major Cubist sculptor until his career ended with tragic abruptness in 1918, when he died of typhoid contracted at the Front. He sought not only new sculptural form, but an integration of sculpture with architecture.

His mastery of the Cubist idiom in sculptural form attained an epic power in the *Large Horse*, a pl. 199 striking representation of machine and animal imagery in a synthesis utilizing the contemporary language of abstract mass, movement, and suggestive symbol. He began the sculpture as a group with a rider trying to restrain a rearing, almost mechanically impelled, horse. At that time, the obsession with machines, speed, and motion effects 137

was very much under discussion, and he had already seen how they were embodied and expressed in the work of his brother Marcel Duchamp, the Futurists, Francis Picabia, and Fernand Léger. Combining fragments of an identifiable horse's anatomy—head, neck, and hoof—with machine forms, the compact, dynamic design suggests both straining, muscular animal energy (of a kind that would at that moment in time prove equally fascinating to the German Blue Rider group) and the piston thrusts of an engine. The *Large Horse* marks an early high point in Cubist sculpture.

The logical extension of the pictorial ideal which Braque once described as "the materialization of a new space" into convincing sculptural objects was but another of the many imaginative developments of the spreading Cubist revolution. The same Cubist spatial concepts that permeated three-dimensional sculptural form also had far-reaching effects, both in social and esthetic terms, for architecture, as we shall see.

In formal and esthetic terms, as well as in its psychological expression of the multiplicity of individual experience in a technologically complex age, Cubism has become the cornerstone of the modern movement in the fine arts and inseparable, generally, from modern consciousness. Without an awareness of Cubism's formative role in stimulating a unified style in art, architecture, and design, we could scarcely appreciate the visual character of the modern world, nor understand our own complex interaction with that world. Basically, the Cubist artists replaced an outworn traditional illusionism and undercut the spiritual or symbolic values that had supported that artistic vision.

In further significant innovations, based on Cubist principles of design, Robert Delaunay (1885—1941) and Frank Kupka (1871—1957), a Czech working in Paris, together developed a new heresy in the form of abstract color painting. They fused the spectrum colors of Fauvism with Cubist design and created the pure color abstraction which Apollinaire later called Orphism. Using softened circular forms to interpret mystical intensities of radiant light, Delaunay anticipated by two years some of Severini's and Balla's most interesting abstract geometric representations of brilliant color patterns alluding to the dynamic energies of modern life. In their work, Delaunay and Kupka arrived at some of the first systematically abstract painting of the century, coincidental with Kandinsky's abstract improvisations in Munich. Their paintings preserved the triangular and circular segment forms of the Cubists, but softened the edges of their arcs and planes into radiant cores of light of graduated intensities.

pl. 200, 20

Robert Delaunay. *Carrousel with Pigs or Electric Carrousel*. 1913–22. Oil on canvas, 98⅜×98⅜". Musée National d'Art Moderne, Paris. 200

Frank Kupka. *Amorpha, Fugue in Two Colors*. 1912. Oil on canvas, 83⅜× 86⅝". Národní Gallery, Prague. 201

Marcel Duchamp. *Nude Descending a Staircase, No. 2.* 1912. Oil on canvas, 58×35″. Philadelphia Museum of Art. The Louise and Walter Arensberg Collection. 202

Fernand Léger. *Contrast of Forms.* 1913. Oil on canvas, 51⅜×38½″. Philadelphia Museum of Art. The Louise and Walter Arensberg Collection. 203

Fernand Léger. *The City.* 1919. Oil on canvas, 91″×9′½″. Philadelphia Museum of Art. The A. E. Gallatin Collection. 204

After an apprenticeship in Analytic Cubism, Fernand Léger (1881—1955) began to employ lightly tinted color planes, fixed shapes, and silhouettes suggesting machine parts. In 1919, with his painting *The City*, surely one of the most powerful and memorable of Cubist compositions, Léger emerged into a style of epic breadth and unselfconscious modernity. It represents a brilliant synthesis of detached esthetic objectives and the contemporary preoccupation with machine imagery. By 1921, Léger had painted such monumental figure compositions as *Three Women*, which showed an even more extreme, machinelike transformation of his tubular Cubist imagery. Léger's paintings were allied to the contemporary efforts of the Purists, a group composed of the painter Amédée Ozenfant and the architect Le Corbusier—who painted under his name, Charles-Édouard Jeanneret—to re-establish the esthetic worth of ordinary manufactured objects, within the basic form language of Cubism. The simplicity and anonymous felicity of machine-made objects

pl. 203
pl. 204

pl. 341

pl. 205
140

and bare, functional furniture were later to dominate Le Corbusier's architectural interiors and design.

During the war and early postwar years, a more sardonic spirit and irrational fantasy took root, in the machine art of Marcel Duchamp (1887–1968) and Francis Picabia, proclaiming a new mood of nihilism. Duchamp's famous *Nude descending a Staircase, No. 2* of 1912, had scandalized the American public at the Armory Show in New York in 1913. Although he still worked within the Cubist convention, he had begun to exploit extrapictorial associations. His figure in motion symbolized the almost coercive sense of the new mechanical factors at large and their dehumanizing effect. Soon Duchamp and Picabia began to fashion even more literal machine forms to which they gave absurdly romantic or satirical titles; an example is Picabia's bizarre *Amorous Parade*, whose designation adds an erotic component to the fantastic machine creatures and stirs an ancient fear in man of being replaced in his vital functions by robots. These images and their meanings, either explicit or veiled, were calculated to shock and disturb the public, thus anticipating the disruptive iconoclasm which became the official program of the organized Dadaists.

Even within the Dada movement, Cubist design made itself felt in the collage constructions of waste materials by Schwitters, as we have seen. And George Grosz's savage attacks on the moral disintegration of wartime German society also reveal an underlying Cubist structure, as does the witty and fantastic imagery of Paul Klee. In Germany, where the more habitual and charged emotional climate for art could have been expected to impede the acceptance of an analytical, objective style, Cubism nonetheless had a direct influence. Work by members of The Blue Rider group combined the geometric syntax of Cubist style and Delaunay's intense, prismatic color with a native Teutonic tradition of romantic transcendentalism.

In Italy, Cubism provided the major impetus for the furiously modern innovations of the Futurists, who first came to public notice as serious and original artists when they began to show with the Cubists in Paris, in 1912. While the Futurists wanted their paintings to express speed, violence, dynamic movement, and the passage of time, their technique nonetheless

pl. 202

pl. 236

Charles-Édouard Jeanneret (Le Corbusier). *Still Life of the Pavilion of "L'Esprit Nouveau"*. 1924. Oil on canvas, 32×39⅜". Le Corbusier Foundation, Paris.
205

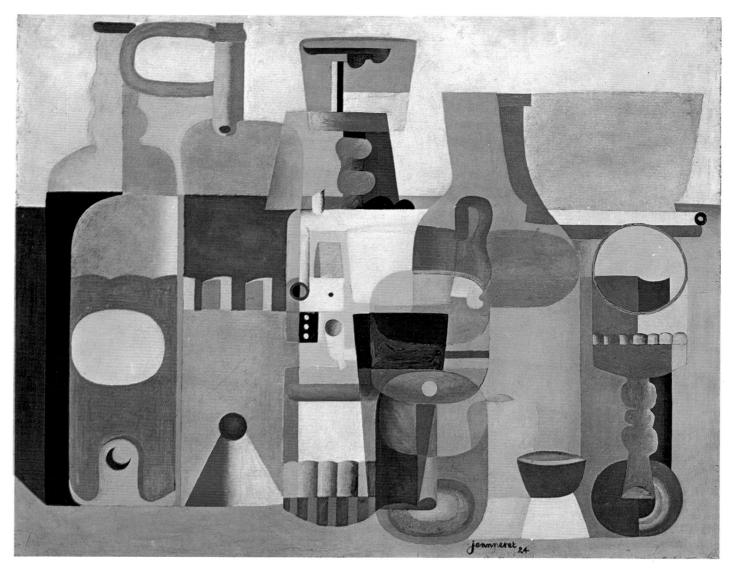

derived from the more static and contemplative art of the Cubists. Their militant program of action, however, violently opposed the Cubist spirit. In 1909, the Belgian Symbolist poet Émile Verhaeren declared prophetically, in a statement: "Future, you exalt me as once my God exalted me."[9] That same year the Italian poet who was the ideological father of the Futurist movement, Filippo Tommaso Marinetti, wrote from Paris that the modern poet should henceforth sing only of "the multicolored and polyphonic surf of revolution in modern capitals; the nocturnal vibration of arsenals and docks beneath their glaring electric moons...; factories hanging from the clouds by the threads of their smoke."[10] Then he proceeded to distribute throughout the world a manifesto which proclaimed, in alternately idealistic and rather brutal rhetoric, the demise of the art of the past and the birth of the art of the future.

Around him he gathered a group of painters, the most important of which were Umberto Boccioni (1882—1916), Carlo Carrà, Luigi Russolo, Giacomo Balla (1871—1958), and Gino Severini (1883—1966). Boccioni, Carrà, and Russolo composed the *Manifesto of the Futurist Painters*, which was published on February 11, and publicly proclaimed on March 8, 1910, in a disruptive meeting before an outraged audience at the Chairella Theater in Turin. This official declaration of Futurist artistic principles was followed on April 11 of the same year by the *Technical Manifesto of*

Giacomo Balla. *Street Light.* 1909. Oil on canvas, 68¾× 45¼". The Museum of Modern Art, New York. Hillman Periodicals Fund. 206

Umberto Boccioni. *Dynamism of a Soccer Player.* 1913. Oil on canvas, 6'4⅛"×6'7⅛". The Museum of Modern Art, New York. The Sidney and Harriet Janis Collection. 207

Futurist Painting. Further demonstrations of an increasingly provocative character, and manifestoes, appeared in quick succession. In 1912, the group organized an exhibition of their work in Paris, and in 1914 Boccioni published a book that gave their ideals final expression.

Living in the shadow of an overwhelming artistic tradition, the Futurists felt impelled to rid themselves of the past, and used their art to celebrate modern urban existence. Undergoing a ritual baptism as children of the machine, which had become a burning issue in art, both as imagery and form, the Futurist painters appropriately proclaimed themselves "the primitives of a new and transformed sensibility."[11] An exalted sense of change and an almost mystic transport of identification with some universal dynamism, experienced through the machine, marks the romantic rhetoric of their jointly sponsored manifesto of April 11, 1910, where they were led to declare:

> 1. That all forms of imitation must be despised, all forms of originality glorified.
>
> 2. That it is essential to rebel against the tyranny of the terms "harmony" and "good taste" as being too elastic expressions, by the help of which it is easy to demolish the works of Rembrandt, of Goya and of Rodin.
>
> 3. That the art critics are either useless or harmful.
>
> 4. That all subjects previously used must be swept aside in order to express our whirling life of steel, of pride, of fever and of speed.

> 5. That the name "madman" with which it is attempted to gag all innovators should be looked upon as a title of honor.
>
> 6. That innate complementariness is an absolute necessity in paintings, just as free meter in poetry or polyphony in music.
>
> 7. That universal dynamism must be rendered in painting as a dynamic sensation.
>
> 8. That in the manner of rendering nature the first essential is in sincerity and purity.
>
> 9. That movement and light destroy the materiality of bodies.[12]

Indeed, with this manifesto and others that followed, it became clear that polemics on the part of poets, literary propagandists, and the artists they represented were to play a major role henceforth in the formation of artistic movements. Futurism was perhaps the first militant movement of this distinctly modern character, where radical esthetics and a program of action joined hands.

Curiously, the Futurists all showed the influence of the fantastic Symbolist styles of *fin-de-siècle* decadence, even as their new ideas were taking plastic form. After 1911, however, their art took its formal cues from Cubist innovation but charged Cubist formal structure with new bustle, aggressive movement, and feverish energy. From Cubism's pictorial language of shifting planes, the Futurists had also learned to break through the surfaces of objects and show them moving in

pl. 206

Gino Severini. *Dynamic Hieroglyphic of the Bal Tabarin.* 1912. Oil on canvas, with sequins, 63⅜×61½". The Museum of Modern Art, New York. Acquired through the Lillie P. Bliss Bequest. 208

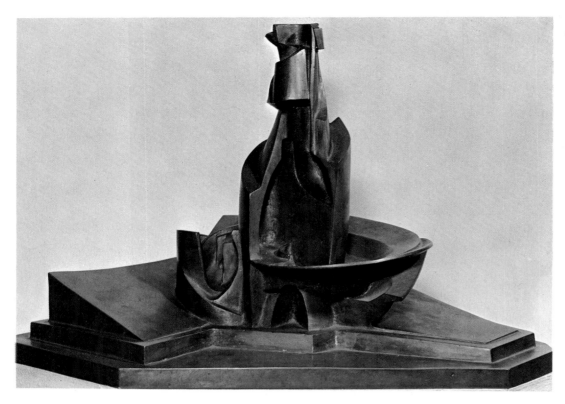

space, and to make such movement reflect states of mind. The Futurists glorified the modern delirium of speed, and, with perhaps an undiscriminating appetite, swallowed the contemporary machine environment whole, discharging their new impressions in a kaleidoscope art of force lines, vectored shapes, and mobile patterns.

pl. 207

Umberto Boccioni was one of the most expressive and artistically powerful members of the Futurist group. His *Dynamism of a Soccer Player* synthesized the two important lines of Futurist investigation, that of the representation of movement and that of the creation of a pictorial equivalent for the machine. Through an interest in the Neo-Impressionists' brushstroke and bright palette, Boccioni and his fellow Futurists also contributed to the revival of the interest in color. Indeed, just when monochrome Cubism was at its height, Gino Severini, working in Paris, had already repudiated the beiges, grays, and tans of Braque and Picasso in favor of a brilliant palette which made the initial Cubist mood of chromatic repression seem antiquated.

pl. 208

The major painter of Futurism, Boccioni was also its only significant sculptor. Calling traditional sculpture "a mummified art," he wished to reconcile it with the movement and dynamism of the modern world and to relate his forms to the ubiquitous machine. His highly imaginative, streamlined sculptures were as mobile in form as contemporary stroboscopic photography. In 1912, he wrote the *Technical Manifesto of Futurist Sculpture*, which boldly and prophetically called for new space concepts and new materials: "The enclosed statue should be abolished, the figure must be opened up and fused in space ... we shall have in Futurist composition planes of wood or metal, stationary or mechanically mobile."[13]

His bronze sculptures, cast from maquettes of plaster, were homogeneous in their metal. In *Development of a Bottle in Space*, the solid sculptural forms are opened and penetrated by concavities symbolizing intersecting rays of light and force lines, which suggest the thrust and wake of movement, much as they do in his paintings. As the bottle emerges from a tablelike base, it is analyzed into planes which extend explosively beyond the circumscribed contours of a delimited mass into the surrounding atmosphere. The sculpture achieves monumental scale on the powerfully rotated plinth from which it rises, although it is intimate in its actual size.

pl. 209

The classic of Futurist sculpture is Boccioni's *Unique Forms of Continuity in Space*, a powerfully arresting evocation of power and speed. The massively muscled human form is encased in spiraling scallops of metal which reinforce the impact of continuous motion. Boccioni's famous figure seems to epitomize Marinetti's phrase: "A roaring automobile, which seems to run like a machine-gun, is more beautiful than the *Victory of Samothrace*."[14]

pl. 210

The Futurists' mechanolatry, in effect, translated such images as Boccioni's speeding figure of Machine-Age Man into a kind of Nietzschean Superman and clearly had an element of irrational worship in it, just as some of their more overheated rhetoric sounded like science fiction. Some may find in the Futurists' boast and stridency a prophecy of Fascism, and in fact Marinetti was an early follower of Mussolini. Certainly their emphasis on kinetic sensation, their insistence that "art enter into life at any price," and the generally programmatic character of their art put them at some distance from the French Cubists' conception of painting as an object of esthetic contemplation. Curiously, however, despite the evident attraction to raw sensation and machine culture, the Futurists also managed to tap a source of mysti-

cism and spirituality, putting them surprisingly close in mood to the Expressionists Marc and Kandinsky. Futurism evolved toward a universalized and nonspecific art of abstract harmonies, not unlike Kandinsky's. Giacomo Balla's development from the witty depiction of motion in his celebrated *Dynamism of a Dog on a Leash* of 1912 to the abstract *Mercury Passing Before the Sun as Seen Through a Telescope*, two years later, marks a significant change from the visual, almost cinematic record of the movement of objects to the consciousness of the dynamic aspects of form itself—some universal rhythm in nature which knows no boundaries and recognizes no isolation, finally, between mind and matter.

pl. 211
pl. 212

Perhaps the most enduring meaning of the Cubist heritage for the future lay in its impact on entirely nonrepresentational art forms, first in Russia and then in The Netherlands during the decade between 1910 and 1920. Geometric abstraction developed directly out of Cubism, first in Russia about 1913 and then in The Netherlands in 1917. For both Kasimir Malevich (1878—1935) and Piet Mondrian (1872—1944) Cubism became a profound inspiration and then, surpris-

ingly, an unsatisfactory halfway house en route to an absolute rejection of materialism and the objective world. By 1913, Malevich had worked his way through a variety of vanguard styles from Symbolism to his own form of Cubist collage. He termed the collage "nonsense realism," because it combined abstract structure and *trompe-l'œil* fragments of actuality cut out with shears, all reassembled in a new and, at first glimpse, incoherent syntax. Devoid of particularities of textures and object definition, his painted squares and rectangles became the basis of a purely abstract art. Malevich first demonstrated his simplistic ideas in the backdrop of a Futurist opera performed in St. Petersburg in December 1913. He paradoxically defined his invention of Suprematism as "the supremacy of ... feeling in ... art."[15] Suprematism was perhaps the most revolutionary conception to date in modern art. When Malevich painted his first radical abstract picture of a black square on a white ground, he explained it with a messianic fervor typical of the first generation of pioneer abstractionists. "In ... 1913, in my desperate attempt to free art from the ballast of objectivity, I took refuge in the square."[16] Further-

pl. 213

pl. 214

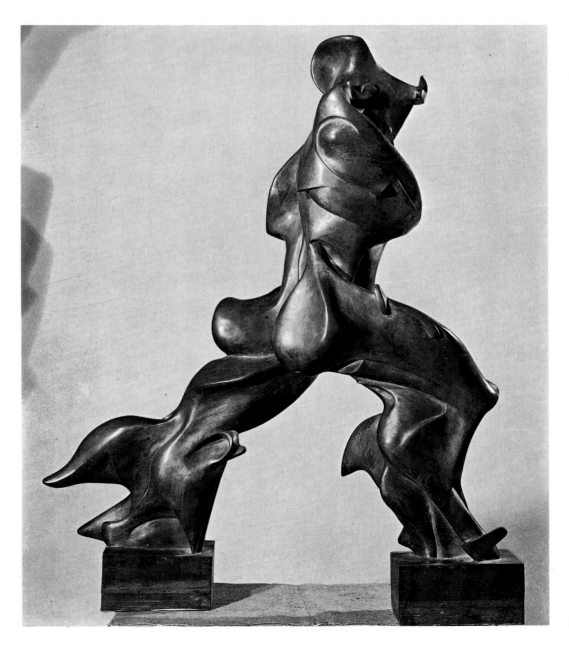

Umberto Boccioni. *Unique Forms of Continuity in Space.* 1913. Bronze, 43⅞×37⅞× 15¾". Private collection, Milan. 210

more, he believed that painting had become an instrument of universal knowledge, and he sought in abstract art the same mysticism and cosmic unity that Kandinsky pursued. Both artists inherited their mysticism from the ideology, if not from the actual imagery, of Symbolism. The feeling to which Malevich alludes, however, is not personal emotion connected to the individual's psychic life but, rather, a form of revelation and transcendence. All psychic tensions dissolved in the apprehension of a new kind of absolute truth. Abstract art replaced the familiar world of naturalism, mundane objects, and events to form an esthetic blueprint for a Utopian world and for superior forms of personal expression.

Malevich's Purist art and idealist aims were temporarily set back with the growing influence of Vladimir Tatlin (1885—1953), an abstract artist

Giacomo Balla. *Dynamism of a Dog on a Leash*. 1912. Oil on canvas, 35⅝×42½". Albright-Knox Art Gallery, Buffalo. Courtesy George F. Goodyear and The Buffalo Fine Arts Academy. 211

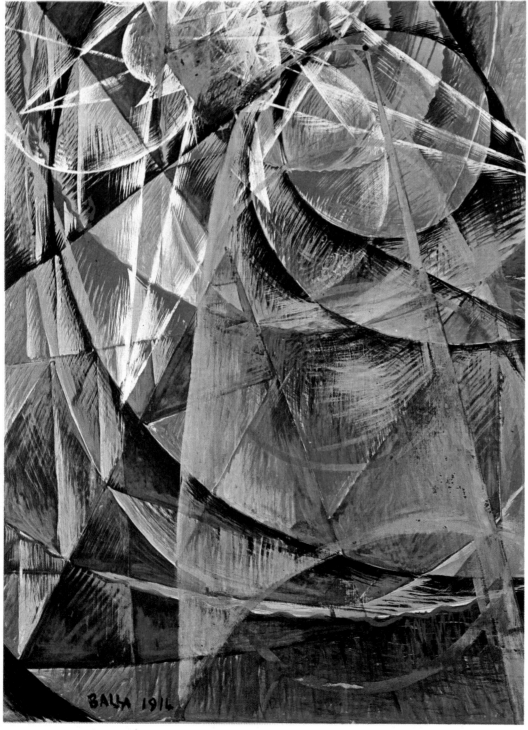

Giacomo Balla. *Mercury Passing Before the Sun as Seen Through a Telescope*. 1914. Tempera on paper, 47¼×39". Private collection, Milan. 212

Kasimir Malevich. *Woman Before an Advertisement Column.* 1914. Collage and oil on canvas, 28 × 25¼". Stedelijk Museum, Amsterdam. 213

Kasimir Malevich. *Suprematist Painting.* 1915. Oil on canvas, 40 × 24¼". Stedelijk Museum, Amsterdam. 214

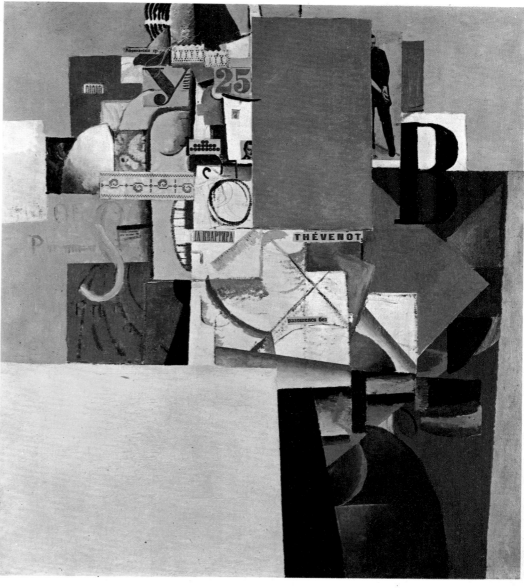

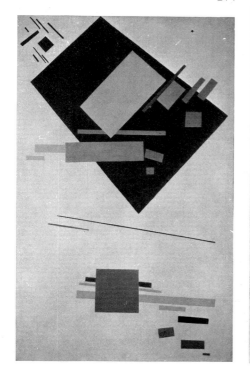

pl. 217

pl. 290

pl. 215

and dedicated materialist in art. Tatlin had visited Picasso in his Paris studio in 1913 and knew his three-dimensional constructions, which he emulated in his earliest counter-reliefs. With the Russian Revolution, his ideas changed radically and he became convinced that art should be primarily social in its purposes and function. His point of view, rather than Malevich's, came to dominate the new Soviet art. In time, the insistence that art be practical, easily comprehensible, and socially useful led directly to the emigration of the most vital and internationally influential Russian avant-garde artists, the Constructivists. Their adventurous abstraction was replaced by a banal, unchallenging Social Realism. Tatlin's most memorable achievement was his proposed Monument to the Third International, an open, spiral metal tower designed to contain revolving chambers housing governmental agencies.

The irreconcilable differences between Malevich's Purist viewpoint and Tatlin's utilitarianism were momentarily resolved in favor of Malevich in 1920 when the brothers Naum Gabo (b. 1890) and Antoine Pevsner (1886—1962) achieved a novel synthesis of Tatlin's conviction that art must adapt itself to modern technology and the nonobjective style of Malevich's detached abstractions.

pl. 218

In 1920, the brothers published their historic *Realist Manifesto* to explain and defend their own constructions, which were exhibited in Russia for the first time that year. In that document, Gabo proposed an art constructed out of modern materials and "in the forms of space and time,"[17] thus simultaneously accepting the modern world and yet opposing materialist ideology. Another radical departure was the statement that they would affirm "a new element, a kinetic rhythm, as the basic form of our perception of real time,"[18] a promise of a new kind of motion sculpture which, curiously, was realized in only one art object, Gabo's *Kinetic Construction: Vibrating Spring* of 1920. Gabo's transparent structures in glass, metal, and plastic suggested not only an affirmation of modern technology, but even a dependence on certain topological models and mathematical formulations. However, qualities of sensibility and invention reclaim his works from sterile formula or excessive worship of scientific models. Indeed, his sculptures even hint at organic and spiritual experiences, in keeping with the universalist aims of the other pioneers of twentieth-century abstraction. Other Russian Constructivists who remained behind in their native land, like Alexander Rodchenko (1891—1956), only briefly

pl. 216

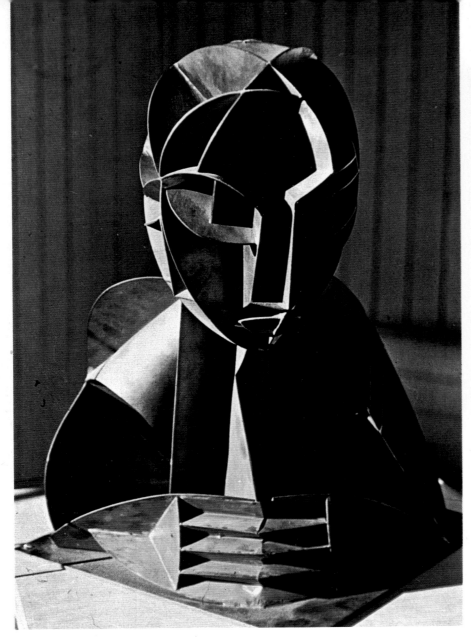

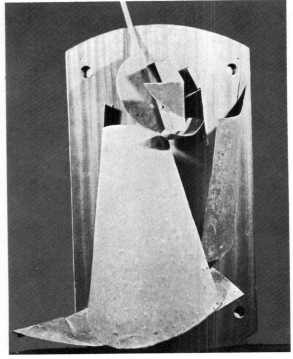

Vladimir Tatlin. *Counter-Relief.* 1917. Wood and zinc sprayed on iron, 39⅜ × 25¼". Tretiakov Gallery, Moscow. 217

Antoine Pevsner. *Fountain.* 1925. Plastic, 15¾" h. Collection S. and C. Giedion-Welcker, Zurich. 218

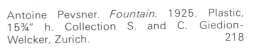

Naum Gabo. *Constructed Head, Number 2.* 1916. Galvanized iron, 17⅜" h. Collection the artist, Middleburg. 215

Alexander Rodchenko. *Suspended Construction in Space.* 1920. Wood. Private collection, U.S.S.R. Photograph courtesy the archive of Alfred H. Barr, Jr. 216

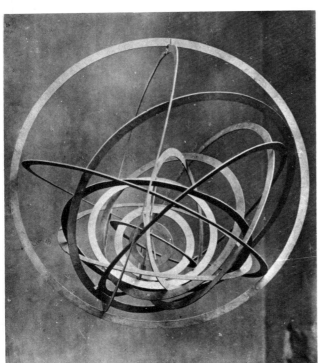

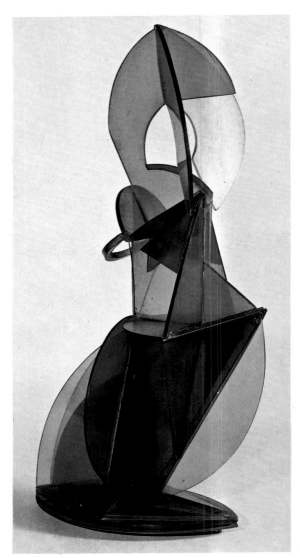

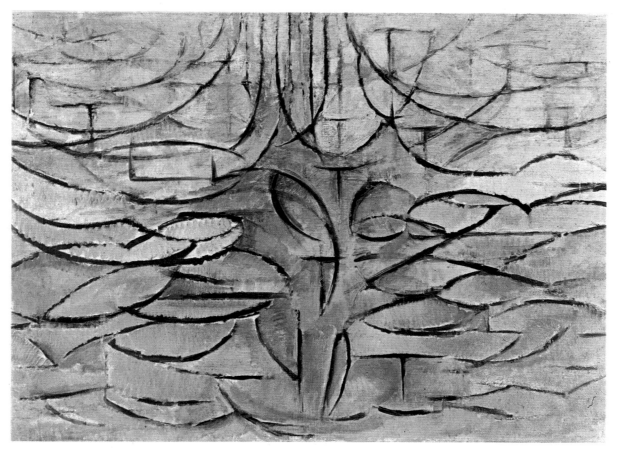

Piet Mondrian. *Flowering Apple Tree.* c. 1912. Oil on canvas, 30¾×41¾". Gemeentemuseum, The Hague. 219

Piet Mondrian. *Composition N° 10: Pier and Ocean.* 1915. Oil on canvas, 33½×42⅝". Kröller-Müller Museum, Otterlo. 220

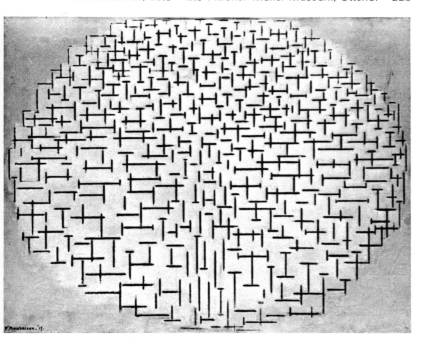

achieved the high level of Gabo's abstract art, sustained by the momentum of the first phase of Russia's truly revolutionary art. In time, as the official party line in esthetics asserted the equality of the practical arts to the fine arts, Social Realism of an anecdotal and unchallenging character supplanted Constructivist "realism." Constructivist ideals and methods, however, were disseminated throughout Europe in the 1920s and 1930s by El Lissitsky and László Moholy-Nagy. The latter, in particular, became influential through his teaching at the Bauhaus.

In The Netherlands, perhaps the most consistent development of abstract art took place in the movement called De Stijl. Under the leadership of the painters Piet Mondrian and Theo van Doesburg (1883—1931), a group was formed which included architects J. J. P. Oud and Gerrit Rietveld, furniture makers, sculptors, and designers. Their aim was to reconcile the findings of Cubism with a more comprehensive machine-age esthetic that could have meaning for all the arts, fine and applied.

Mondrian had come to Paris late in 1911 and pl. 219 was directly influenced by Cubism, but in 1914 and 1915, in his so-called Plus and Minus compositions, he abandoned references to representational subject matter. He began to compose oval fields of repeated, but minutely varied, crosses and small vertical and horizontal lines that did not intersect, in an effort to create new pictorial rhythms, or as he put it, "a pure plastic representation of space." Despite a greater uniformity of pl. 220 design in these drawings and related paintings, and complete nonobjectivity, the works nevertheless evoke the Cubists' geometric honeycomb and 149

tonal modulations vaguely suggesting light and atmospheric depths of space. Mondrian soon turned away even from these austere works, because he found their Cubist derivations too naturalistic. He opposed Cubism for not "accepting the logical consequences of its own discoveries" by "developing abstraction toward its ultimate goal, the expression of pure reality." Further, he wrote: "While in Cubism, from a naturalistic foundation, there sprang forcibly the use of plastic means, still half object, half abstract, the abstract basis of pure plastic art must result in the use of purely abstract means."[19]

pl. 222
pl. 287, 289

It was not until 1917 that Mondrian began to combine flat areas of pure color with geometric form, following the example of Bart van der Leck, whom he met the year before. In 1917, Mondrian also began the historic collaboration with the painters van der Leck and van Doesburg, the architects Rietveld and Oud, and the sculptor Georges Vantongerloo in founding the influential review *De Stijl*. But his art still had to pass through a number of intermediate stages before he reached his characteristic style.

In 1919, Mondrian began to build his paintings exclusively of horizontal and vertical lines intersecting at right angles to form perfect squares. The resulting small, uniform planes were massed in pairs, triads, and subdivided squares and painted in grays and pastel shades of red, yellow, and blue. That same year Mondrian wrote the first important theoretical exegesis of his art, the small pamphlet *Neo-Plasticism*, and he began work on the extensive and brilliant imaginary dialogue on esthetics, *Natural Reality and Abstract Reality*, completed the following year. In 1920 and 1921 he replaced the small squares in his compositions with simplified grids whose broad connecting planes were painted evenly in brilliant primary colors. Disposed in asymmetric balance, the colored rectangles were set against a ground of neutral hue. In the early 1930s, he evolved his

pl. 221

mature style, using a background of pure white. From that time until the last two years of his life in New York, he made no essential changes in style. And even in New York, when his compositions became more impressionistic and he momentarily returned to a color scheme of intermediate

pl. 223

hues, he religiously preserved his right-angle theme and uncompromising nonobjectivity.

Out of the exquisite formalism of Analytic Cubism, Mondrian created a supraindividualist expression more in tune with the modern age of standardization and machine products. In the modern world, mass society and production have supported an artistic ideal of collective expression, a "constructive" spirit, that still dominates machine-age art and architecture. The arts are in many ways the anonymous, rational servants of the machine, expressing its epoch as profoundly and as unconsciously as the Byzantine mosaic expressed the age of faith. One of the first and most radical rebels against traditional easel painting, Mondrian felt compelled to work out a systematic

ideology for his drastic pictorial innovations. In *Neo-Plasticism* he envisioned a universal panacea, an art directed at an ideal society not yet born, or as he put it, at the "new man." It is important to remember that many of the pioneer abstractionists, Mondrian, Malevich, and Kandinsky, among others, felt that the ideal order of nonobjective art was linked to a coming Utopian social order, and that artists had been summoned to help reconstruct man's life and world.

Of all the doctrinaire programs and Utopian prophecies of modern art, Mondrian's actually proved the most viable and came closest to success. Through Neo-Plastic painting he sought to express the unity of the modern spirit, but he suspected that its most satisfactory expression might come ultimately in modern architecture and design. The concreteness and simple factuality he wanted for painting seemed to conflict with the vagaries of individualistic temperament. He identified his esthetic ideal with the precision of the engineer and the impersonality and predictability of manufactured materials. Indeed, he even insisted that Neo-Plastic painting itself must finally wither away, like the political state of the radical social thinkers. Mondrian anticipated the day, in an ideal social order, when art would have no role; he foresaw "the end of *art as a thing separated from our surrounding environment, which is the actual plastic reality*. But this end is at the same time a new beginning. ... By the unification of architecture, sculpture, and painting, a new plastic reality will be created. Painting and sculpture will not manifest themselves as separate objects, nor as 'mural art' which destroys architecture itself, nor as 'applied' art, *but being purely constructive* will aid the creation of a surrounding not merely utilitarian or rational but also pure and complete in its beauty."[20]

Mondrian's total artistic vision was transmitted to modern architecture, furnishings, interiors, typography, and objects of everyday use by the Stijl group. The scrupulous regrooming of the modern environment in accordance with rigorous abstract principles received an even more decisive international impulse from the artist-designers of the Bauhaus with whom van Doesburg made contact in 1922 and whom he influenced.

Today, there is ample evidence in America and Europe of the triumph of De Stijl, although inevitably much of its influence has been corrupted by popularization. But where modern techniques of manufacture, geometric abstraction, and artistic genius have been harmoniously married, as in the architecture of Mies van der Rohe, Mondrian's prophecy of the unity of the arts reaches a convincing fulfillment, even though the millenium is not any nearer at hand than it was during the more hopeful period of early abstraction. Mondrian and the Stijl group of architects and designers have had a more direct and revolutionary impact on the modern environment, perhaps, than any other artistic movement rooted in Cubism.

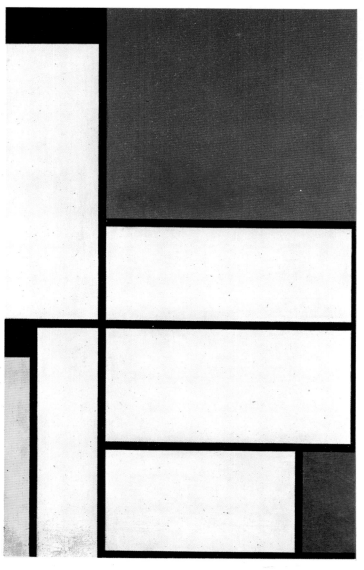

Cubism remains relevant to the creative expression of the artist today, and to contemporary architects and designers as well. It haunts even such unlikely but vital expressions of our turbulent postwar world as Willem de Kooning's powerful and frenzied distortions of the female form in his Woman series. Cubism was also clearly the inspiration of the last, monumental constructions of David Smith, perhaps the most original and powerful American sculptor of the past three decades; significantly, he called his finest late sculpture series by the name Cubi. More recently, the works of the English Minimalist sculptor Anthony Caro combine Cubist geometry and painted industrial steel to create confounding effects of weightless mass and sensuous color. An unexpected heroic scale introduces a new psychological element of inappropriate size in this, and in related serial constructions by the Americans Don Judd and Robert Morris. Here the Cubist geometric principle is turned against itself as a result of the new emphasis given to a single, saturated hue, or to the uniformity of the design components and their expansion into a continuous field of repeated units. While Cubism may not be entirely relevant either to the psychology or to the deliberate formal redundancy of today's avant-garde art, it nevertheless still constitutes a living language of some currency, after more than half a century of development and transformation.

Piet Mondrian. *Tableau I.* 1921. Oil on canvas, 38×23¾". Wallraf-Richartz Museum, Cologne. 221

Piet Mondrian. *Broadway Boogie-Woogie.* 1942—43. Oil on canvas, 50×50". The Museum of Modern Art, New York. 223

Theo van Doesburg. Typography: Sheet with 11 monograms (from 6 names). 1917. Printed, 15¾×12¾". Collection Mrs. N. van Doesburg, Meudon. 222

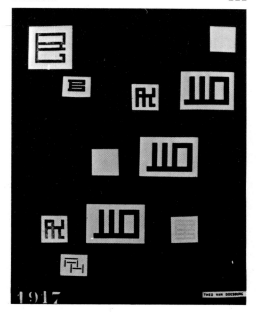

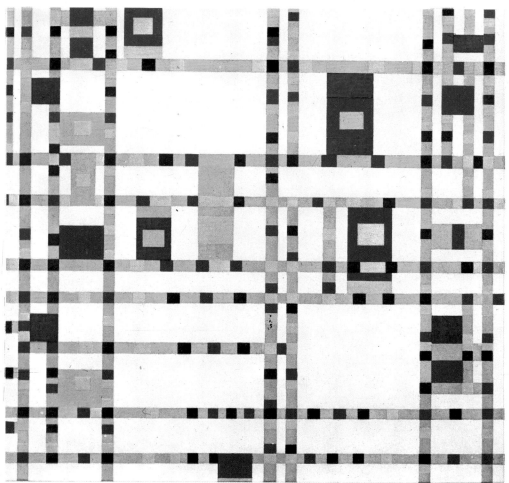

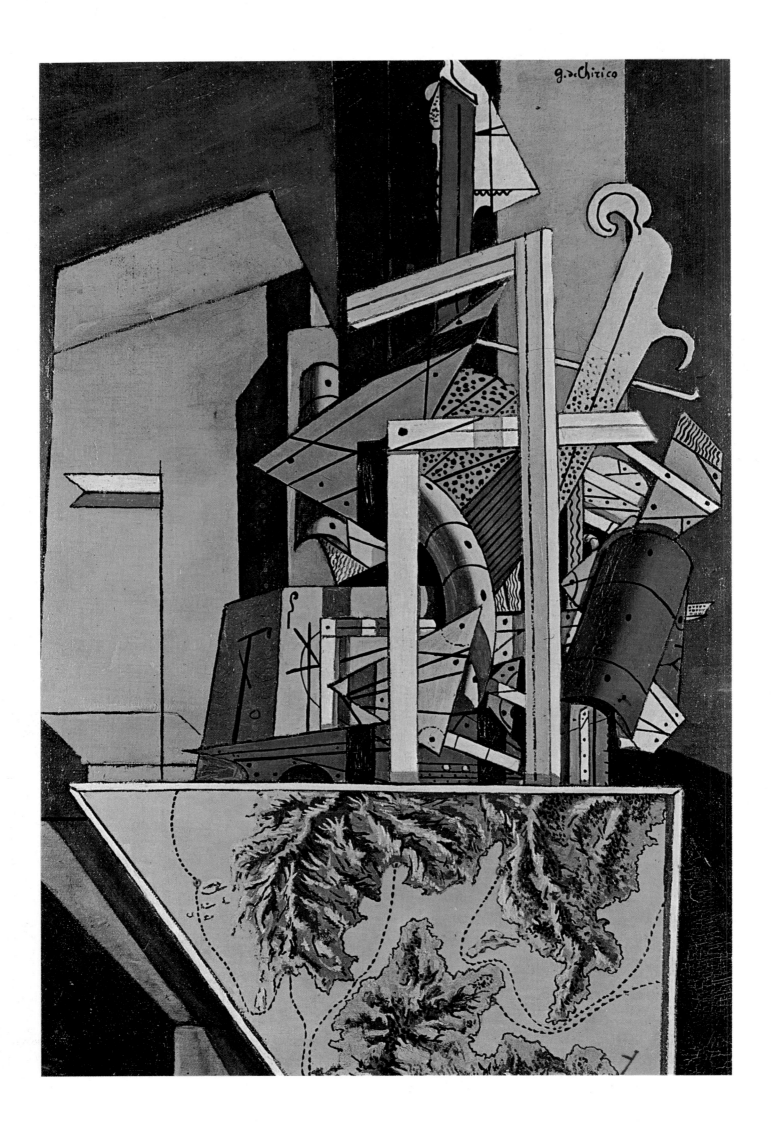

DADA AND SURREALISM

The element of fantasy has been a powerful current throughout the history of modern art, beginning with the Symbolists' reaction to the Impressionists' faithful observations of nature. One of the first champions, in literature, of the subjective imagination, Charles Baudelaire, had already commented disapprovingly that the Impressionist painters painted "not what they dream but what they see."[1] And thirty years later, Odilon Redon deplored the condition of contemporary painting where "great art no longer exists," which he attributed to "the right that has been lost and which we must reconquer: the right to fantasy."[2] The allure of the enigmatic, the shock appeal of the bizarre, the disquieting character of hallucinatory visions in art of different periods later sanctioned and inspired the work of the Dadaists and Surrealists in the second and third decades of the twentieth century. Their delighted rediscovery of the irrational in the visual arts drew upon the tradition of Symbolist poetry, with its quest for a superior reality and metaphysical knowledge, on the one hand, and upon its contrary evangelical, reformist impulse to "change life," as Rimbaud had put it. The general tendency to question rationalist views of the world was linked to human personality by Freud's theories of psychoanalysis and the popularization of his findings during the first two decades of the new century.

The emergence of explicit fantastic content in art after 1914 was undoubtedly hastened by the destructive impulses unleashed in the war, which impelled artists to answer social violence with a violence internalized in imagery and technique, and which also produced a revolutionary attitude toward traditional esthetics. Even the rational art of the Cubists acknowledged the new mood, and introduced surprising elements of ambiguity within its rigorously structured forms. The Cubist collage dislocated normal reality in order to make room for anti-art materials, visual wit, and a gratuitous violence, or associations with the gro-

pl. 189

tesque. But the commitment to radical new forms of visual scepticism that challenged conventional assumptions about observed reality, and the subversion of the traditional integrity of medium, required the disruptive shock of a revolutionary political situation to sustain first Dadist and then Surrealist objectives. The disillusionment of the war years provided the necessary catalyst for change. The visionary art that finally emerged, sanctioned by the wartime violence, found inspiration in the rediscovery of the work of three artists of fantasy whose example helped unlock the forces of the unconscious mind and consecrated revelation and dream: Henri Rousseau, Marc Chagall, and Giorgio de Chirico.

The naive vision and exoticism of Henri Rousseau gave the Surrealists an important forerunner. His work prompted the question always pertinent to the Surrealists, whether, and in what degree, it was the product of imaginative vision, an arbitrary invention of the mind's eye, or a remembered experience.

His remarkable exhibitions at the close of the nineteenth century represented the first childlike art of the modern period and provided new standards for an acceptable primitivism and romantic innocence. His paintings also make an interesting parallel to the wild, theatrical caricature of the poet-playwright Alfred Jarry, both scandals in terms of traditional artistic values, although Rousseau would scarcely wish to compete with Jarry's mocking provocations of the bourgeoisie. Both artists were formal iconoclasts who cheerfully subverted previous assumptions about the nature and content of art, and even the level of literary or visual literacy. Rousseau's archaic style and grave icons, however, were actually meant to be as respectful of tradition as Jarry's inventions and blasphemous language were deliberately subversive. Significantly, it was Jarry who first discovered and sang the praises of the painter at the 1886 Independents Salon where his *Carnival Evening* was exhibited, treating Rousseau, to everyone's astonishment, as a serious innovator.

Unlike the Surrealists, who later admired him, Rousseau needed neither the inspiration of a movement nor a literary program to liberate his remarkable visions. In his own life, he drew no

pl. 225

Giorgio de Chirico. *The Melancholy of Departure.* 1916. Oil on canvas, 20½×14¼". Collection Sir Roland Penrose, London. 224

153

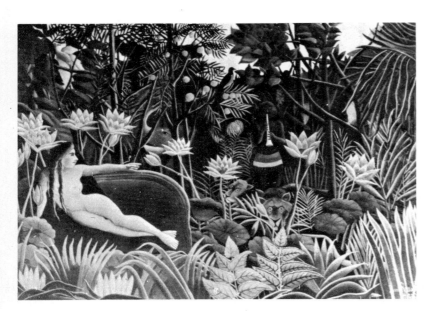

Henri Rousseau. *The Dream.* 1910. Oil on canvas, 6'8½"×9'9½". The Museum of Modern Art, New York. Gift of Nelson A. Rockefeller. 225

hard and fast line between the real and the supernatural, and the invisible world of his own imagination was as concrete and plausible to him as nature. He believed in the reality of ghosts, and even complained about his own private specter because it followed him about and annoyed him. Rousseau's instinct for the supernatural and his utter credulousness captivated Apollinaire, and elicited from him the comment that Rousseau "sometimes took fright and, trembling all over, had to open a window" while painting his fantastic creations. Overlooked in the Surrealists' official register of honored precursors of the First Surrealist Manifesto, Rousseau's trancelike paintings finally generated a myth which even André Breton, poet and high priest of the Surrealist movement, acknowledged with the observation that "It is with Rousseau that we can speak for the first time of Magic Realism ... of the intervention of magic causality."[3]

In his later years, Rousseau became something of a celebrity for two successive avant-garde generations, first when Apollinaire rediscovered him as a "primitive," and then when Breton and the Surrealists admired his visionary subject matter. Although Rousseau had been showing regularly at the Independents Salon and could boast of a small coterie of admirers, it was only in the early years of the twentieth century, when the taste for primitivism and for archaic and stylized forms was at it height, that he first became widely appreciated.

Another influential artist of fantasy was the Russian-born Marc Chagall (b. 1887). After studying in an experimental school in St. Petersburg directed by the Symbolist-influenced theater designer, Léon Bakst, Chagall emigrated to Paris in 1910, entering the circle of Apollinaire and the Cubists and meeting Amedeo Modigliani, Chaim Soutine, and Jules Pascin, all of whom were later identified with the School of Paris. Chagall soon attained a reputation as a fantasist comparable to

Rousseau; in his work he evoked memories of his native village of Vitebsk. Although the Surrealists generally showed little interest in Chagall, Breton did praise him, writing, "With Chagall alone ... metaphor makes its triumphant entry into modern painting."[4] Unlike the orthodox Surrealists, however, Chagall presents a dreamlike imagery that is gently lyrical rather than Freudian and disturbing.

In the delightful painting *I and the Village*, shifts pl. 226
and displacements of images take place as in the dream process, and the metamorphic principle dominates. The "dreamer" of the painting (with whose perceptions the artist makes us identify) is an improbable but appealing cow, which impresses the viewer both as icon and nature spirit. Chagall communicates a highly individual poetry, but he also concerns himself with the abstract dynamics of the painting process. His uninhibited zest stems as much from Cubist inspiration as native folkloristic memory. Chagall adopted the Cubist rearrangment of visual reality not merely as a formal device but as a system of values. Their structures apparently symbolized for him a belief in constructive and innovating intelligence, which gave tension to his predictable folk fantasies. Although Breton admired Chagall for introducing metaphor into modern painting, Chagall tended to reject literary explanations of his work. He said of his paintings: "I don't understand them at all. They are not literature. They are only pictorial arrangements of images that obsess me The theories which I would make up to explain myself and those which others elaborate in connection with my work are nonsense.... My paintings are my reason for existence, my life, and that's all."[5]

The artist of fantasy destined to play the most decisive role in the development of Surrealist painting was the Italian Giorgio de Chirico (b. 1888). Coming to Paris from Italy in 1911, he made contact with Picasso and the ubiquitous and influential Apollinaire. De Chirico's art seemed to address itself directly to Rimbaud's exhortation to the artist to make himself "a seer" in order to plumb the depths of the "unknown," and to attain a hallucinatory state of "clairvoyance."[6] In a brief four years in Paris, he created a body of work which fulfilled Rimbaud's program as well as Jarry's admonition to seek a fantastic world "supplementary" to our own familiar universe.

Not only did de Chirico create an authentic, troubling dream imagery of great power and intensity for the first time in the century, but he also managed to capture the spirit of the age, to convey, in Breton's words, its "irremediable anxiety." Influenced by the melancholy, romantic landscape and diminutive figures of Arnold Böcklin, by Max Klinger's fetishism of objects, and by Alfred Kubin's chimeras, de Chirico's art attained the mystical and prophetic state which had been the aim of Symbolist art since the period of Baudelaire. His luminous ensembles of disjunctive objects—modern images such as locomotives and mannequins set among monuments of the past—

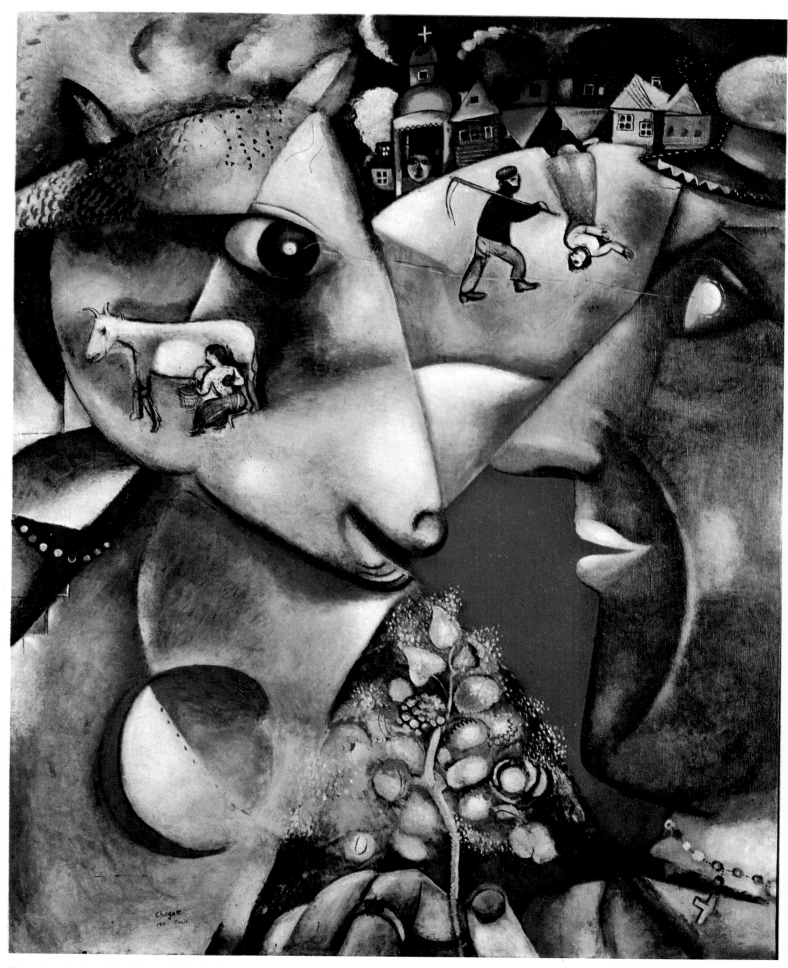

Marc Chagall. *I and the Village*. 1911. Oil on canvas, 6′3⅝″ × 59⅝″.
The Museum of Modern Art, New York. Mrs. Simon Guggenheim
Fund. 226

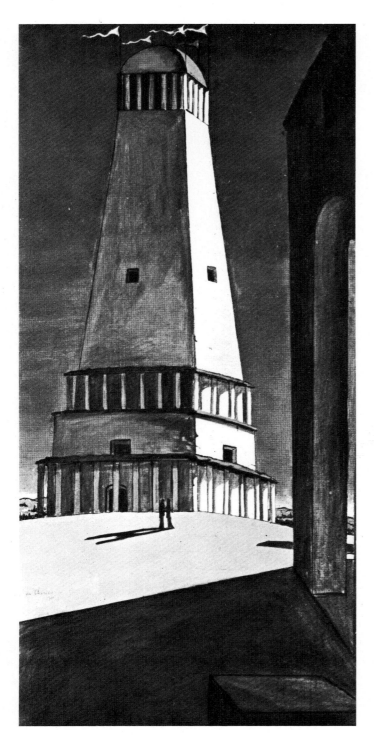

Giorgio de Chirico. *The Nostalgia of the Infinite*. 1913–14? (dated on painting 1911). Oil on canvas, 53¼×25½". The Museum of Modern Art, New York. 227

this alien reality, in the mysterious relationships between banal objects set against incongruous modern and antique backgrounds; his illogicality baffled the ordinary viewer by subverting visual sense, yet he remained faithful to the condensed, vividly heightened, and portentous symbolism of actual dreams, with their charge of anxiety.

De Chirico painted his haunting cityscapes at a time when everything in art and life opposed their dominant mood of romantic melancholy. Cubism had reached its height of formal exploration in a highly intellectual, geometric mode of expression. Italy responded to the Cubist challenge with the militant activism, the exaltation of progress and machine culture, and the noisy assault on tradition launched by the Futurists. In this heady atmosphere, de Chirico's program of meditation and poetic nostalgia, and even the archaism of his clumsy technical means, could only seem both perversely conservative and irrelevant to the most productive moods of art. By 1913—14, his painting *The Nostalgia of the Infinite* had reintroduced pl. 227 anecdote, sentiment, and an outmoded descriptive technique into his art. More importantly, a decade and more before the Surrealists, he made painting an occasion for actualizing the dream process with baffling, illogical imagery, and for exploring, in the artist's words, the "troubling connection that exists between perspective and metaphysics." The word metaphysical frequently appeared in his discourse, and in 1916 it was officially adopted to describe his work when he met Carlo Carrà in a Ferrara hospital. Together, pl. 224 they formed a new artistic association called the Metaphysical School *(scuola metafisica)*.

De Chirico's paintings freeze his reality into a trancelike immobility, amid a scenario of improbable vistas, perspectives with conflicting vanishing points, and dramatically heightened contrasts of deep shadow and intense light. In a strangely ominous atmosphere, where time has ceased to exist, curious events transpire: unseen presences cast long shadows; in the motionless air, pennants catch a hidden breeze and flutter; the illusion of infinite spatial extension does not dispel anxiety but only confirms it, giving the viewer the sense of being imprisoned in a nightmare. Everything has too bright and disturbing a clarity, creating an unnatural luminosity from which we seek release. In *The Nostalgia of the Infinite*, the tower becomes a desolate and forlorn image, like Gérard de Nerval's famous "forsaken tower" in the poem so admired by the Surrealists, *The Prince of Aquitaine*. Yet it is transfigured by a mystic brilliance of light. Remote, inaccessible to his diminutive and impotent human phantoms, it also carries subtle Freudian overtones in its phallic power, although the associations seem almost innocent and naive by comparison with Dali's later self-conscious eroticism.

In his mannequin figures, the sense of emotional numbness is translated into an imagery of mutilated, armless, and eyeless tailors' dummies. These seem to allude both to a heroic past of

present us with a new and enigmatic system of poetic metaphor, whose meanings are deliberately obscure. De Chirico's phantomic figures and deserted squares at the Paris Autumn Salon in 1913 attracted the attention of Apollinaire, who commended "these curious landscapes, full of new intentions, of a powerful architecture, and of great sensibility."[7] De Chirico had defined his program as the "enigma of sudden revelation," and he was deeply influenced by the German idealist philosophers, particularly Nietzsche, who had described his sense of "foreboding that underneath this reality in which we live and have our being, another and altogether different reality lies concealed."[8] De Chirico poetically apprehended

antique statuary and to a lost world of silence, impotence, and poignant longing for human community. Like Picasso's neoclassical and traditionalist figures, de Chirico's meditation on a noble past was riddled by irony and self-doubt. He could only perceive the heroism of a bygone age through the eyes of his own melancholy, until the past became merely a distorted dream image. It was the strongly original forms of this influential imagery which later so deeply impressed the official Surrealist movement and a number of individual artists. In words and by example Ernst, Tanguy, Magritte, and Dali, among others, showed a rare unity in acknowledging de Chirico as a master. He provided the primary inspiration for the illusionistic Surrealists, who made an effort to convert the indispensable and creatively liberating, if disruptive, Dada episode of the war years into a more systematic and constructive romanticism.

The Dada movement took form simultaneously during wartime in a number of art capitals, and among them, significantly, were two neutralist centers, New York and Zurich. This spontaneous revolt against reason in art represented many of the same deliberately infantile impulses that had surfaced in the primitivist art of Rousseau, in Jarry's theatrical grotesquerie with its contemptuous bravado, and in the nostalgic fantasy world of de Chirico's paintings. One of the founders of the Zurich Dada group, the German poet Hugo Ball, significantly hailed the spontaneity and irresponsibility of childhood as a new artistic model in a diary entry of 1916, which was the year of the official birth of the Swiss movement. "Childhood," he wrote, "as a new world, and everything childlike ... and symbolic in opposition to the senilities of the world of grown-ups."[9] In keeping with that defiant spirit, the nonsense vocable "Dada" was selected at random from a dictionary by Tristan Tzara and came to symbolize the release of new psychic energies based on instinct, which the Zurich group celebrated.

By loudly proclaiming the uselessness of social action, the Dadaist artists acknowledged their sympathetic identification with the futility of those dying senselessly in the monstrous charade of World War I. Dada began primarily as a wrecking enterprise, an art of protest directed against the insane spectacle of collective homicide. Yet its nihilism also embraced a sweeping summons to create a *tabula rasa* for art and presented serious creative options despite its disorder and anarchy. Dada unlocked new sources of spontaneity, fantasy, and formal invention and left a lasting imprint both on the art of its time and on the future. Adapting the slogan of the revolutionary Bakunin that destruction is also creation, the Dadaist put art on the barricades, redefined the nature of artistic experience, and extended its material possibilities even when that meant accepting scandalous objects as works of art. Official Dada came to birth as a collaborative activity in wartime Zurich. There, in 1916, Hugo Ball gathered around him a group of exiles from the war which included the writer (and later psychiatrist) Richard Huelsenbeck; the Rumanian poet Tristan Tzara; the Rumanian painter Marcel Janco; the Alsatian painter and sculptor Jean (Hans) Arp (1887—1966); Arp's future wife, Sophie Taeuber; and the German painter and later experimental filmmaker Hans Richter. In an old quarter of the town, they founded the Cabaret Voltaire, inviting all the wartime disaffected to join their courageous new association of free spirits in order "to remind the world that there are independent men, beyond war and nationalism, who live for other ideals," in Ball's words. Arp, a gifted poet as well as visual artist, eloquently described the spirit with which he entered in the mad games, playful entertainments, and somewhat more sober artistic activities of the Cabaret Voltaire group: "In Zurich in 1915, losing interest in the slaughterhouse of the world war, we turned to the Fine Arts. While the thunder of the batteries rumbled in the distance, we pasted, we recited, we versified, we sang with all our soul. We searched for an elementary art that would, we thought, save mankind from the furious folly of these times. We aspired to a new order that might restore the balance between heaven and hell."[10]

In another revealing statement which prophesied the new prerogatives conferred upon fantasy and irrational association, and which comically summarized the Dada contempt for the public's superstitious reverence for traditional art, Arp wrote: "Dada aimed to destroy the reasonable deceptions of man and recover the natural and unreasonable order. Dada wanted to replace the logical nonsense of the men of today by the illogically senseless. That is why we pounded with all our might on the big drum of Dada and trumpeted the praises of unreason. Dada gave the Venus de Milo an enema and permitted Laocoön and his sons to relieve themselves after thousands of years of struggle with the good sausage python. ... Dada is senseless like nature. Dada is for nature and against art. Dada is direct like nature. Dada is for infinite sense and definite means."[11]

With Tristan Tzara's participation in the Zurich Dada group, more aggressive assaults were directed at the audience, who, curiously, attended the public Dada demonstrations in the tradition of the provocative behavior of the Italian Futurists at their mass meetings. Poets recited inaudible nonverse, drowned out by deafening nose-music, or "bruitism," thus adopting directly the Futurists' strategy of insult and outrage. Poems were made by picking from a bag words randomly cut out from newspapers. Tzara's "accidental poems" coincided with Arp's experiments in automatism in his collage compositions, among them *Squares Arranged According to the Laws of Chance*. Bewildered spectators at Dada meetings were called upon to function as chairmen and then ignored or humiliated. Pandemonium was encouraged, perhaps as a parody and an exposure of the falsity of public rhetoric with its appeals to patriotism in support

pl. 230

Jean Arp. *Before My Birth.* 1914. Collage, 4⅜×3⅝". Estate of Herta Wescher. 228

Jean Arp. *Mountain, Table, Anchors, Navel.* 1925. Oil on cardboard, with cutouts, 29⅝×23½". The Museum of Modern Art, New York. 229

Jean Arp. *Squares Arranged According to the Laws of Chance.* 1916–17. Collage, 19⅛×13⅝". The Museum of Modern Art, New York. 230

of the war. Today this kind of antic, more familiar and even stereotyped in the Happening, seems outdated. In its time, Dada nihilism had more relevance as social criticism; moreover, it frequently resulted in bouts of inspired wit and verbal invention, and the liberation of significant new forms of poetry and art.

Arp was the major figure in the plastic arts to emerge from Zurich Dada. His early works in collage and relief sculpture reflected the inventive disorder and wit of Dada, but he later developed more soberly as a sculptor of forms in the round. Arp's works of about 1916 were the first artistic creations deliberately, perhaps self-consciously, designed to realize Tzara's principles of "continuous contradiction" and "immediate spontaneity," both in poetic and plastic terms. His experiments with chance and automatism, in collab-

oration with Sophie Taeuber, were the first in the twentieth century. His chance compositions became the basis of a primary Surrealist creative principle. They were made by tearing up fragments of paper, letting them fall on a surface at random, and then gluing down the accidental compositions. Speaking of chance compositions, Arp declared: "The 'law of chance,' which embraces all laws and is unfathomable like the first cause from which all life arises, can only be experienced through complete devotion to the unconscious."[12] Arp's collages of the period, however, were actually closer to a more relaxed version of Cubism than to what the later Surrealists understood as "automatic" drawing.

In later reliefs, Arp began to utilize free forms, kidney and amoebalike shapes resembling Miró's. These forms became an important link between

pl. 228

the nascent biomorphism of Gauguin, Kandinsky, and Miró. His elegant and increasingly abstract reliefs of the late 1920s, whose contour lines suggest living organisms, established free-form, or biomorphic, abstraction as an alternative to geometric form. Soon after, in 1932, he abandoned Dada aims altogether for sculpture in the round, which he insisted on describing as "concrete" rather than "abstract," or as "autonomous and natural forms," another kind of dream nature in line with the Surrealist aspiration to create a supplementary universe. But Arp replaced Surrealist dislocations and grotesquerie with a more gentle and poetic whimsy. His voluptuous abstract forms were essentially celebrative of nature's bounty rather than disturbing or convulsive dreams.

pl. 229

The most enigmatic Dada intellectual and a primary innovator was Marcel Duchamp, one of the legendary figures of twentieth-century art. He is recognized as a pioneer spirit of Dada, even though he never officially declared himself a Dadist. It was Duchamp who anticipated their most fertile and challenging conceptions, including the whole complex of anti-art ideas, which refuse to make elitist distinctions about the art object. Duchamp tried instead to reconcile art experience to a society dominated by mass-produced, manufactured objects. The challenges posed by his art were evident as early as 1912 when he showed his Cubist, mechanist anatomies in *Nude Descending a Staircase, No. 2*. This original and rather baffling painting outraged the orthodox Parisian Cubists, including the artist's brother Jacques Villon, as much as it scandalized American audiences in New York a year later in the celebrated Armory Show. With Duchamp's arrival in New York in 1915, and the formation of the periodical *291* under the auspices of the photographer and art impresario Alfred Stieglitz, New York Dada came to birth actually a year in advance of the Zurich movement. Overnight, Duchamp became the leader of a new breed of iconoclasts determined to shake the foundations of modern art.

pl. 202

Rejecting the decorative values of Cubism for a more ambiguous content, Duchamp's mechanized nudes suggested a metaphor for the Conquest of Man by the Infernal Machine, in sharp contrast to the mechanized world that the Futurists, Léger, and other Cubists had uncritically celebrated. The robotlike action of Duchamp's figures opened up startling vistas of paradox in what had heretofore seemed an iconographically neutral area. Duchamp turned away with disdain from the traditional image of the artist-craftsman and his dependence on his sense impressions. Beginning in 1912, he struck out on a boldly independent course, breaking with what he contemptuously termed "retinal" painting, which he considered intellectually inferior since it appealed to the eye and the senses rather than to the mind. "I was interested," he later said, "in ideas—not merely in visual products."[13] And with added vehemence,

he stated that he preferred "an intellectual expression . . . to [being] an animal. I am sick of the expression 'bête comme un peintre'—stupid as a painter."[14] Duchamp conceived of the work of art freshly as an autonomous reality which mediated between the physical world and his own psychic perceptions. Art was to be a "brain fact" henceforth, to adopt his epithet.

The work of art could be painted, constructed, or merely "designated," a word he applied to the Readymade, or common manufactured product which he elevated to the level of an art object. Duchamp thus broke down one of the primary attributes of the work of art, which defined its privileged fine arts status. By associating art with anti-art, he confused the traditional hierarchy of artistic values and produced objects and new ideas about art which remain profoundly disconcerting. With his friend and associate in the New York Dada adventure, Francis Picabia, he insisted on challenging audience preconceptions about art and taste. "There is no rebus, there is no key," wrote Picabia. "The work exists, its only *raison d'être* is to exist. It represents nothing but the wish of the brain that conceived it."[15]

The themes that first appeared only tentatively with Duchamp's *Nude Descending a Staircase* received further definition in the following years in his familiar combination of mechanical form and imagery, erotic content, and esoteric titles. *The Bride* and *The Passage from Virgin to Bride* both suggest human organs transposed into machines, alluding clearly to automated male and female sexual organs and sexual activities. Duchamp's erotic obsession, combined with an extremely complex iconography and erudite philosophical references, culminated in a "love machine," the construction of which he mysteriously titled *The*

pl. 231

Marcel Duchamp. *The Passage from Virgin to Bride.* 1912. Oil on canvas, 23⅜ × 21¼". The Museum of Modern Art, New York. 231

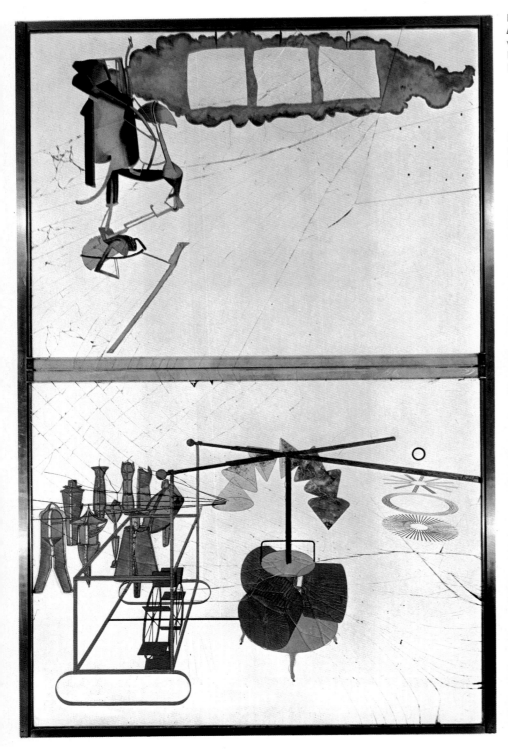

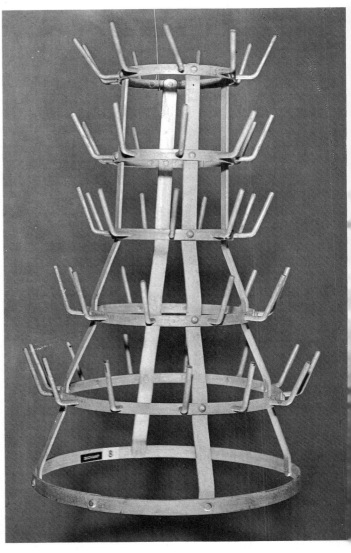

Marcel Duchamp. *The Bride Stripped Bare by Her Bachelors, Even* (the *Large Glass*). 1915–23. Oil, lead wire, foil, dust, and varnish on glass, 8'11"×5'7". Philadelphia Museum of Art. Katherine S. Dreier Bequest. 232

Marcel Duchamp. *Bottlerack (Bottle Dryer)*. Full-scale replica. 1964 (original 1914, lost). Readymade: galvanized iron, 25¼" h. Schwartz Gallery, Milan. 233

pl. 232 *Bride Stripped Bare by Her Bachelors, Even* (the *Large Glass*). This intricate construction cannot be understood, however, without first examining Duchamp's own notes of explanation, and without considering his effort to reappraise the world of common manufactured objects in the form of the Readymade.

As early as 1911, Duchamp had been attracted to common manufactured objects. In his notes for the *Large Glass*, as his love machine became known, he observed: "One day, in a shop window, I saw a real chocolate grinder in action and this spectacle so fascinated me that I took this machine as a point of departure."[16] Soon he was painting a *Chocolate Grinder* in a dry and academic technique. It was but a short step to the discovery of the Readymade, and in 1914 Duchamp desig-
pl. 233 nated the first of these, a *Bottlerack*. With a superb

disdain for traditional art values, he conferred a kind of derisive prestige on found objects by the act of his choice of them. It was a tribute to the power of Duchamp's wit and ironic intelligence that he was able to make publicly acceptable such outrageous appropriations of banal objects from the cycle of used and disused objects.

Significantly, Duchamp divorced his Readymades from esthetic criteria. Their choice, he declared in his notes for the *Large Glass*, "was never based on aesthetic delectation," but, rather, "on a reaction of visual *indifference*, with at the same time a total absence of good or bad taste, in fact, a complete anaesthesia."[17] The Readymades were the familiar mass-produced products of department and hardware stores or other commercial outlets. In addition to the bottlerack, he mounted a bicycle wheel on a stool, parodying

museum sculpture on its conventional pedestal; and he signed a urinal "R. Mutt," entitled it *Fountain*, and submitted it unsuccessfully to the Independents Exhibition in New York in 1917. The same paradoxical value he conferred on these objects and the mocking, intellectual gamesmanship their choice involved also motivated the *Large Glass*, his most remarkable invention.

The *Large Glass* is a windowlike, transparent structure made of two panes of double-thick glass, diagramming in wire relief the amatory subject matter that had been evolving in his paintings and objects of the preceding years. The work has become the object of a cult and spawned numerous conflicting readings, which range from its relationship to machine-art imagery to a symbolism of the occult and alchemical. Its most plausible meanings are still those elaborated by Breton in a well-known essay, which describes its lavish ingenuity as "a mechanistic . . . interpretation of

. . . love."[18] The *Large Glass* shows the bride disrobing in its upper portion, as she both frustrates and attracts her suitor, setting off a series of visible reactions. The fact that the "love operation" (Duchamp's words) is not fulfilled seems clearly a metaphor of sublimation. As has so often been the case, celibacy is associated with intellect and with a creative aberration in opposition to nature's cycle of sex and procreation. In this case, there are other levels of meaning, and even "the fourth dimension" comes into play as an ideal beyond human perception.

The acts of defiance incorporated in Duchamp's elaborate mythology of sex and technology both in the *Large Glass* and in his signed Readymades achieved memorable public scandals in his famous reproduction of the *Mona Lisa* with a moustache drawn on it. He entitled this "assisted" Readymade *L.H.O.O.Q.*, which when said quickly in French sounds like *Elle a chaud au cul*, "She has hot

pl. 234

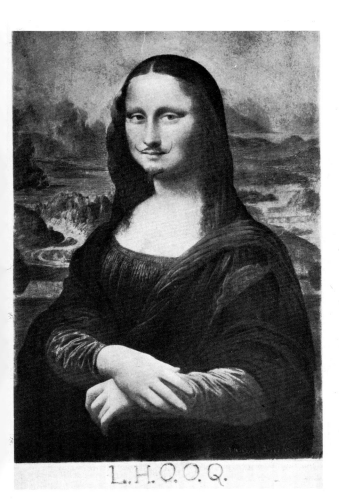

Marcel Duchamp. *L.H.O.O.Q.* 1919. Rectified Readymade: reproduction of the *Mona Lisa* altered with pencil, 7¾×4⅞". Private collection, Paris. 234

Marcel Duchamp. *Why Not Sneeze Rose Sélavy?* Replica 1963, by Ulf Linde (original 1921). Semi-Readymade: painted metal cage, marble cubes, thermometer, and cuttlebone, 4⅞×8¾×6⅜". Moderna Museet, Stockholm.
235

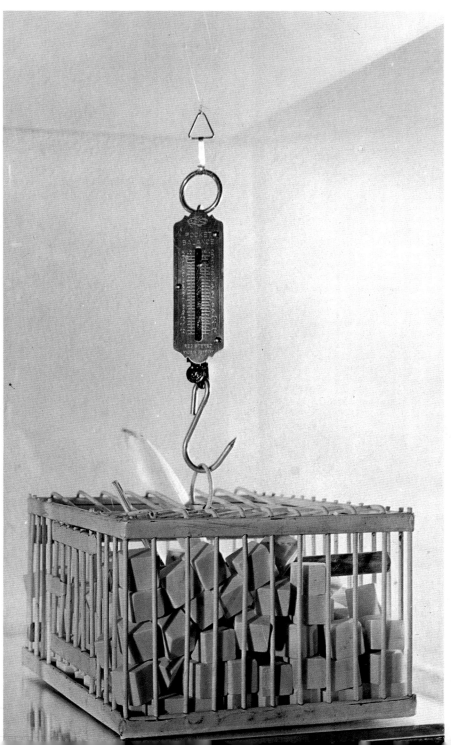

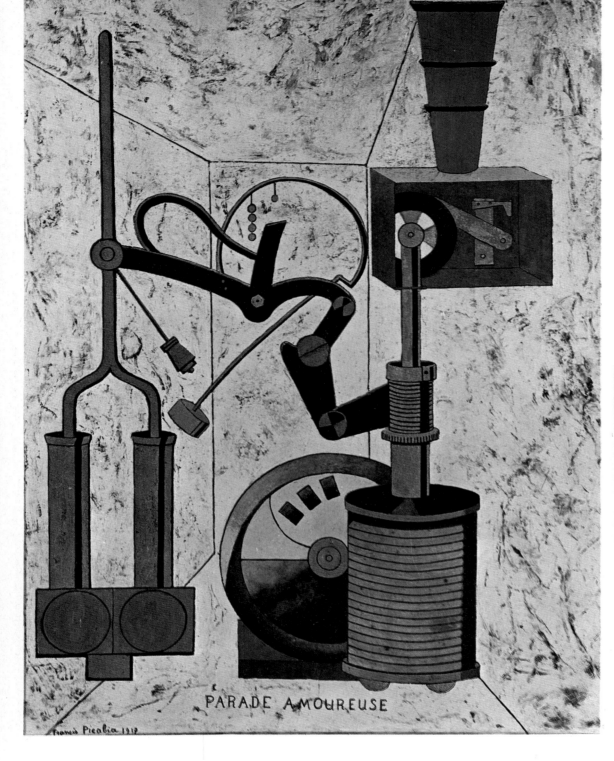

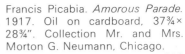

pants." The Surrealists responded even more enthusiastically to his discoveries in the realm of fantasy. Duchamp's more bizarre objects evoked the classical example of incongruity in the writings of the French nineteenth-century Romantic poet, Isidore Ducasse, the self-styled "comte de Lautréamont." One of Lautréamont's phrases became, in fact, a critical definition of beauty and a household aphorism for the Surrealists: "as beautiful as the chance encounter of a sewing machine and an umbrella on a dissection table." The power and mystery of unexpected juxtapositions, unlocking fantastic content was evident, perhaps for the first time since de Chirico's painted imagery, in Duchamp's *Why Not Sneeze Rose*

Sélavy? (Rose Sélavy, Duchamp's female alter ego, is a pun in French; Eros is life.) The construction is a wood and wire bird cage filled with marble lumps simulating sugar, a cuttlebone, and a thermometer, predicting the irrational and mysterious objects later developed by the Surrealists.

In 1923, when he stopped work on the *Large Glass*, Duchamp virtually abandoned art for chess, occasional experiments in optics and mechanics, or assisting the Surrealists in exhibition installations. His explorations with chance, the designation of the manufactured Readymade as art, and his many acute observations on the problem of art and anti-art were particularly influential and today continue to shape the conceptions of contemporary art.

pl. 235

Man Ray. *Gift*. Replica 1963 (original 1921, lost). Flatiron with metal tacks. Collection Mr. and Mrs. Morton G. Neumann, Chicago. 238

Morton L. Schamberg. *God* (miter box and plumbing trap). c. 1918. Wood and metal construction, 10½" h. Philadelphia Museum of Art. The Louise and Walter Arensberg Collection. 239

Hannah Höch. *Cut with the Kitchen Knife*. 1919. Collage of pasted papers, 44⅞ × 35½". National Gallery, Staatliche Museum, Berlin. 240

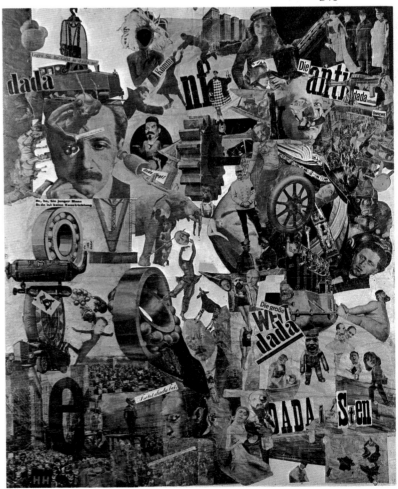

In 1910, Duchamp had met Francis Picabia (1879—1953), a wealthy Parisian of Cuban and French descent, who shared his taste for paradox and public obfuscation. Picabia visited New York at the time of the Armory Show, where he exhibited a number of Cubist-inspired paintings with enigmatic overtones. Two years later, like Duchamp who inspired him, he launched a similar erotic-mechanical style. A typical creation, which made a visual pun on American innocence and machine worship, was the *Young American Girl in a State of Nudity*, nothing more than a mechanical drawing of a spark plug with the brand name For-Ever. Picabia helped stimulate certain phases of American vanguard art, and his machinist pl. 236 imagery in *Amorous Parade* exerted a direct impact on the so-called Precisionists, Charles Demuth, Charles Sheeler, and others. He also bore direct responsibility, no doubt, for America's most daring native Dada object, a miter box with a pl. 239 plumbing connection ironically entitled *God*, by Morton L. Schamberg (1881—1918). Picabia injected a proto-Dada spirit into Alfred Stieglitz's pl. 237 review *Camera Work*, and later the Gallery journal, *291*, which affected the course of progressive American art for some time.

Sharing his activities, perceptions, and inspired forms of wit was the photographer, and tireless experimenter in form, Man Ray (b. 1890), who expatriated himself to Paris in 1921, where he

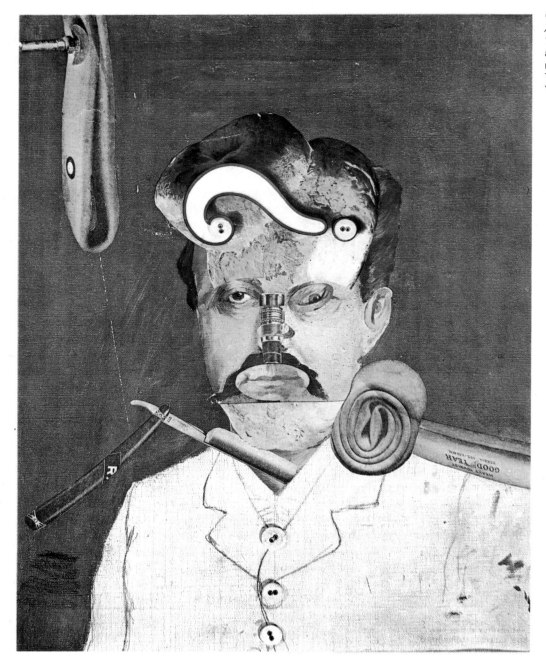

George Grosz. *Remember Uncle August, the Unhappy Inventor.* 1919. Oil on canvas, with cut-and-pasted magazine advertisements and buttons, 19¼×15⅝". The Reis Family Collection, New York. 241

devised a form of abstract, camera-less photography by printing patterns of forms directly on sensitized paper, which he called Rayographs. He also created a corpus of remarkable paintings of fantastic content and some of the most enigmatic Dada objects, among them the sadistic *Gift,* a small flat pressing iron whose face is studded with tacks turned outward.

pl. 238

Between 1918 and 1920, Dada spread from Zurich into Germany, creating not so much a consistent artistic style as a wave of liberating nihilism. In Berlin, Dada took its most overt political form, shaped by the sense of disillusionment of the desperately harsh postwar years. In Zurich, Tzara had insisted that Dada meant nothing, but in Germany, he said, Dada "went out and found an adversary."[19] There it was linked with Communism, and militantly involved itself in urgent political issues. Although Berlin Dadaists produced little significant painting, their contribution to the development of collage and caricature was unique. George Grosz's savage satires on the corrupt bourgeoisie, clergy, military, and bureaucra-

cy of Berlin are grotesque, subhuman, and altogether memorable.

Also in Berlin were artists who used photographic images directly. Hannah Höch (b. 1889), Raoul Hausmann, and others found in photocollage a dramatic mode of registering their crushing indictment of capitalism and militarism in the period between the wars, when the dissident Nazi movement came to birth. In Hanover, Kurt Schwitters created trash pictures and constructions, *Merzbild,* which poetically redeemed anonymous rubbish salvaged from the gutter in exquisite formal structures based on Cubism. He first exhibited them at the Sturm Gallery in Berlin in 1917. By incorporating commonplace object fragments taken directly from life, Schwitters posed the question of anti-art content, but in a manner different from Duchamp's. He also extended the material possibilities of artistic expression. And in a subtle, poetic way, he commented on contemporary materialism by collecting in structures of indubitable artistic quality the detritus of society. Many years later, Joseph Cornell united Schwit-

pl. 241

pl. 240

pl. 190,
242

Kurt Schwitters. *Merz 94 Grün-
fleck.* 1920. Collage, 6¾×5½".
Collection Eduard Neuen-
schwander, Zurich. 242

ters's mania for collecting trash and visual ephe-
mera with a Surrealist juxtaposition of found ob-
jects and his own private world of fantasy to

pl. 428

create some of the most enchanting "junk" con-
structions of modern art.

Finally, the transition from Dada to Surrealism
was hastened dramatically in Germany by the
Cologne Dada group, dominated by Max Ernst
(1891—1976). With the assistance of Jean Arp,
Ernst began in 1919 to make a remarkable group
of collages from illustrations taken out of sales
catalogues, scientific journals, popular Victorian
fiction, and machinery advertisements. The visual
and psychological impact of Ernst's collages was
startling, as he used machine forms, strange ap-
paratuses, and geological strata to explore explicit
themes of sexuality, following the example of
Duchamp and Picabia before him. But he added a
new and personal mythos and intensity to his
collages, discovering in his imagery a hallucinato-
ry potential. Ernst conceived of the collage in a
paraphrase of Lautréamont's famous epithet, as

"the exploitation of the chance meeting of two
distant realities on an unfamiliar plane," or as
"the culture of systematic displacement and its
effects."[20] The overt libidinal content of his
material paste-ups and objects represented a sig-
nificant advance in the realm of fantasy from the
preoccupation with protest and scandal as such,
which had heretofore dominated Dadaist expres-
sion. Ernst's description of his initial discovery of
the hallucinatory power of commonplace
materials is the first explicit acknowledgment by a
twentieth-century artist of the appeal of the un-
conscious. As he put it in an excerpt from a
famous passage:

One rainy day in 1919 ... my excited gaze is pro-
voked by the pages of a printed catalogue. The ad-
vertisements illustrated objects relating to anthropo-
logical, microscopical, psychological, mineralogical,
and paleontological research. Here I discover ele-
ments of a figuration so remote that its very absurdi-
ty provokes in me a sudden intensification of my
faculties of sight—a hallucinatory succession of con-

tradictory images, double, triple, multiple.... By simply painting or drawing, it suffices to add to the illustrations a color, a line, a landscape foreign to the objects represented—a desert, a sky, a geological section, a floor, a single straight horizontal expressing the horizon, and so forth. These changes, no more than docile reproductions of *what is visible within me*, record a faithful and fixed image of my hallucination. They transform the banal pages of advertisement into dramas which reveal my most secret desires.[21]

Max Ernst. *To 100,000 Doves.* 1925. Oil on canvas, 32×39½". Collection M^me Simone Collinet, Paris. 243

Influenced by de Chirico's deep space and trancelike reverie, Ernst began to make illusionistic paintings which transposed some of the monstrous imagery hinted at in his collages into more complex visual symbols. De Chirico's presence accounts for such enigmatic, if more aggressive, images as *The Elephant Celebes* and *Oedipus Rex*. In the pl. 244 construction *Two Children Are Threatened by a* pl. 246 *Nightingale*, made the year Surrealism was launched, de Chirico's pacific dream world has been supplanted by a sense of nightmare. The terror of

Max Ernst. *The Elephant Celebes.* 1921. Oil on canvas, 51⅛×43¼". Collection Sir Roland Penrose, London.

244

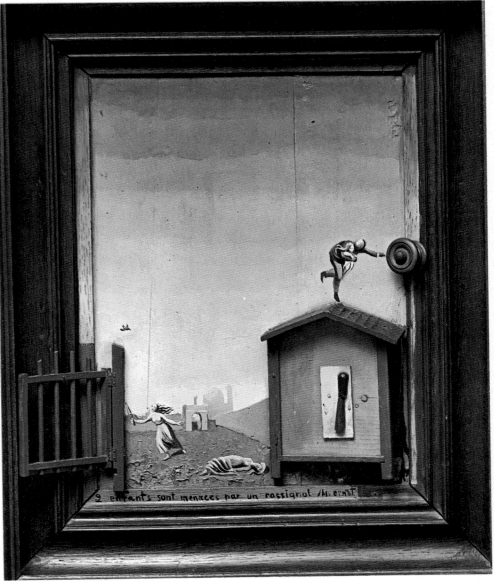

the children is perhaps reminiscent of Gothic tales of the late eighteenth century, or earlier German fairy tales. Much like Ernst's collages, these more realistic dream images are based on incongruous juxtapositions of strange material objects and painted human figures set in a picture-postcard space. The painting supports the same conception of "the culture of systematic displacement," or of alienation and disorientation, which Ernst defined as the inherent technique of the collage. Ernst's original paintings and constructions in illusionistic form of the early 1920s dramatize the growing differences between Dadaist disgust and protest, and the Surrealist affirmation of a new reality that was becoming evident in other art of the period. They represent the true beginnings of Surrealist painting even before Breton had officially codified the movement in his first manifesto.

As adept in automatic techniques as he was in illusionist forms of painting, Ernst replaced his machinelike imagery with more complicated visual metaphors as he continued to experiment with the visual process. In 1925, he produced a series of drawings called Natural History in which various textures obtained by rubbing objects and surfaces were arranged in suggestive sequences.

Ernst called the technique *frottage* and used it as his form of spontaneous creation, akin to the Surrealist literary process of automatic writing. Automatism in literature became a method of tapping the unconscious by writing in a trancelike state and registering the involuntary, vivid images that tumbled out. Similarly, Ernst allowed his uncensored tracings and rubbings, with minor alterations, to evoke fantastic visions of landscapes, animals, and hybrid creatures. In his *frottages*, the ambiguous stains, blots, and "hallucinatory" textures prompted elaboration of the imagery of his persistent bird-personage, Loplop, and the thematic Forests, Hordes, and other obsessive figures and scenarios of his developing illusionistic paintings. Undoubtedly inspired by Ernst's *frottages*, Oscar Dominguez (1906—1957) exploited the possibilities of *decalcomania* by peeling paint off paper with another sheet to which it adhered, and creating accidental and dreamlike configurations of exotic flora and fauna in imaginary landscapes.

Ernst's reputation spread quickly from Cologne to Paris after Breton arranged an exhibition for him there in 1921. He settled in Paris in 1922, sponsored by an admiring Breton who, together with the poets Soupault and Paul Éluard, gave

pl. 243

pl. 247

pl. 245

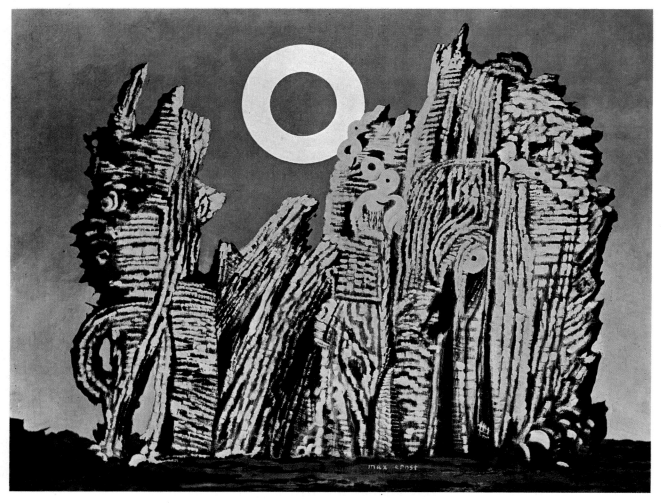

Max Ernst. *Gray Forest.* 1927. Oil on canvas, 31⅞×39⅜". Private collection, Liège

247

birth to literary Surrealism. The movement was given focus and soon thoroughly dominated by Breton, who proved as effective an art propagandist as he was a gifted poet and insatiably curious intellectual. With his cerebral interests, Breton had grown weary of the Dadaist provocations and infantile rebellion. He felt it was time for intellectuals to act more constructively, and he built Surrealism out of the ruins of Dada, whose unrelieved pattern of nihilism had become sterile and self-defeating. In negating everything else, Dada logically had to end by eliminating itself. The February 1920 *Bulletin Dada* carried a prophetic inscription in large type: "The real Dadaists are against Dada. Every one is a director of Dada."[22]

The Surrealist movement, unlike Dada, was composed of a highly organized group of artists and writers who rallied around Breton in Paris when he issued his First Surrealist Manifesto in 1924. That document made it clear that Breton, had adopted for Surrealism the basic premises of psychoanalysis. Indeed, he actually believed quite literally in the objective reality of the dream. For Breton, automatism, hallucinatory and irrational thought associations, and recollected dream images were a means of liberating the psyche from its enslavement to reason. Although his manifesto stresses automatism, and contains a long section devoted to dreams as the expression of the unconscious mind, it actually proposes ideas contrary to

Freud's intentions, for it glorifies irrationality and gives an objective status to a wide range of fantastic imagery that science would consider symptomatic and would seek to cure. Rather than use psychology to illuminate human conduct, Breton decided that the wellspring of Freudian psychology—the subconscious mind, repressed desire, the imagery of dreams—was itself worth exploiting. In fact even the dream was to be understood only as a mode of perception and experience, which permitted the Surrealists to transform the world of concrete reality completely in response to man's desire, dispelling all contradictions in a new and blissful state of psychic unity. Some time later, in an interview which appeared in the *Corero Literario*, Breton insisted that Surrealism reconciled all contradictions in thought and in the human condition, enabling "the mind to leap the barrier set up for it by the antimonies of reason and dreaming, reason and madness, feeling and representation, etc., which constitute the major obstacle in western thought."[23]

A simplistic statement of the redemptive side of Surrealist vision and of its search for a higher reality through the medium of the subconscious is contained in one of Breton's best-known passages: "I believe in the future resolution of these two states, dream and reality, which are seemingly so contradictory, into a kind of absolute reality, a *surreality*, if one may so speak."[24] To achieve this

condition Breton therefore proposed in the first manifesto the systematic exploration of the unconscious, and as the technique to that end he provided a dictionary definition of Surrealism of admirable succinctness:

> Surrealism, n. Psychic automatism in its pure state, by which one proposes to express—verbally, by means of the written word, or in any other manner—the actual functioning of thought. Dictated by thought, in the absence of any control exercised by reason, exempt from any aesthetic or moral concern.
> Encyclopedia. *Philosophy.* Surrealism is based on the belief in the superior reality of certain forms of previously neglected associations, in the omnipotence of dream, in the disinterested play of thought. [25]

A long passage in the manifesto is devoted to the "Surrealist image," which is defined as the product of the chance juxtaposition of two different realities, in terms very similar to Breton's preface for Ernst's first Paris exhibition. Surrealism, however, was primarily a literary movement in the beginning, and it looked for its precursors to the poets Baudelaire, Lautréamont, Rimbaud, and Apollinaire. (It had been Apollinaire who first used the term for his fantastic farce, *The Breasts of Tiresias*, in 1917, which he subtitled a "surrealist drama.") No plastic artist was invited to sign the 1924 manifesto, and only a few names of painters were even mentioned in it, and those in a footnote. It was a strange company that included, among others, Seurat, Moreau, Picasso, Picabia, Duchamp, Klee, Ernst, Masson, de Chirico, and Paolo Uccello. A number of the artists exhibited together the following year as Surrealists, at the Pierre Gallery. Although Breton wrote the preface for the exhibition, he later referred to painting as a "lamentable expedient," and never arrived at a consistent or convincing definition of Surrealist art. Surrealist painting did exist, however, independently of Breton. As it emerged in the mid-1920s, painting quickly divided itself into two major directions—automatism and an illusionistic dream imagery.

André Masson (b. 1896) independently and precociously discovered his own visual equivalents for the automatism of the poets, and his example became extremely influential, affecting artists as different as Miró and Jackson Pollock. His form of automatism was a kind of abstract calligraphy, where the rhythm of swift lines or cursive brush marks generated images of violence and dramatic encounters of form. His pen-and-ink drawings of 1924, made just after meeting Breton, are remarkable both for inventing visual equivalents of automatism and for plausibly creating a magical and autonomous world, with hints of anatomical and mythic imagery. Some of Masson's most effective ensembles of metamorphic hybrids were made in 1927, in a medium that mixed tube pigment and sand which was randomly poured over areas of spilled glue. The animal violence of works in this style, like the *Battle of Fishes*, became powerful metaphors for human passion. pl. 248

Although Joan Miró (b. 1893) had shown in the 1925 Surrealist exhibition and Breton later claimed him as "the most surrealist of us all," he steadfastly refused to be officially assimilated either by the Surrealists or any other school. Miró held himself somewhat apart from all Parisian movements, although Surrealism was a powerful and acknowledged formative influence on him, and he used automatism to free his paintings from both Cubism and an earlier, tightly representa-

André Masson. *Battle of Fishes.* 1927. Oil, sand, and pencil on canvas, 14¼×28¾". The Museum of Modern Art, New York. 248

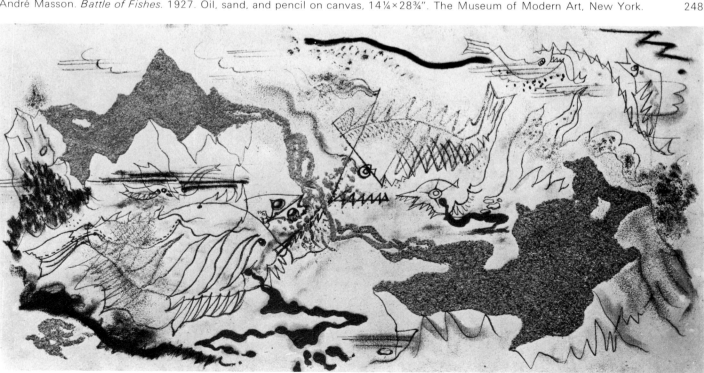

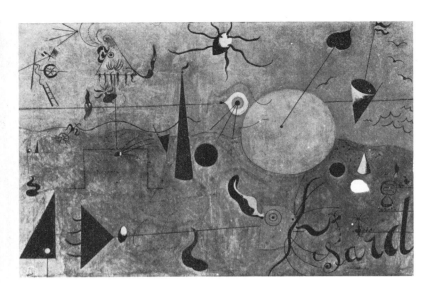

Joan Miró. *The Hunter (Catalan Landscape)*. 1923–24. Oil on canvas, 25½ × 39½". The Museum of Modern Art, New York. 249

Joan Miró. *The Harlequin's Carnival*. 1924–25. Oil on canvas, 25¼ × 35⅞". Albright-Knox Art Gallery, Buffalo. 250

tional style. Occupying the studio directly next door to Miró in Paris in 1924, Masson introduced him to contemporary literary romanticism as well as automatism. Miró writes:

> Masson was always a great reader and full of ideas. Among his friends were practically all the young poets of the day. Through Masson I met them. Through them I heard poetry discussed. The poets Masson introduced me to interested me more than the painters I had met in Paris. I was carried away by the new ideas they brought and especially the poetry they discussed.
>
> As a result of this reading I began gradually to work away from the realism I had practiced . . . until, in 1925, I was drawing almost entirely from hallucinations. At the time I was living on a few dried figs a day. [26]

The influence of Masson, and perhaps Arp, liberated Miró's poetic fancy, and a radical process of formal elision and evocative association became apparent in his increasingly abstract and fantastic art. One of the first mature examples of Miró's Dada-Surrealist style was *The Hunter (Catalan Landscape)*. Here he introduced a freely moving, cursive calligraphy and ideographs in place of

pl. 249

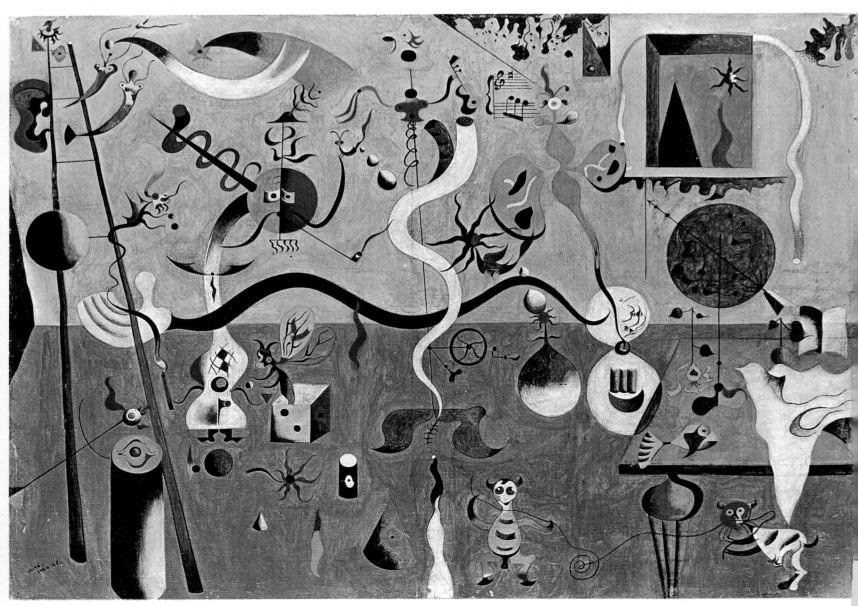

descriptive detail. He still managed to suggest the familiar scenes of his favorite motif, his farm at Montroig, but his forms derive more from fantasy and childhood memory than visible nature. His invention reached a climax of dramatic enrichment in the dense, brilliant detail of *The Harlequin's Carnival*, an agitated colorful dance of insectile phantasmagoria, animated toys, and gaudy baubles—as if the nursery had sprung to life.

pl. 250

Unlike many of the orthodox Surrealist painters, Miró never embraced the more picturesque tendencies of the movement, its *trompe-l'œil* techniques of illustration and incongruous association. He worked within the formal side of Surrealism mainly, adopting its automatism and its hyperactive principle of analogy. His paintings remained plastic creations first and last, and in them even the data of the unconscious submit to the control of an unerring pictorial logic. The material function of his expressive means remained uppermost in Miró's mind. Ideas and poetry were embodied rather than illustrated, and they communicated directly through pictorial values. Miró's independent position, and his utter devotion to painting per se, understandably aroused ambivalent feeling among the more orthodox Surrealists. While Breton praised him for his "pure automatism," he also reproached him for his stubborn individualism as an artist. "Pure imagination," Breton wrote, "reigns supreme over everything it day by day appropriates, and Miró should not forget that he is nothing but its instrument."[27]

The automatism of Masson and Miró, and Ernst's *frottage* technique, dominated the first year of Surrealist painting following publication of the manifesto. With the emergence of René Magritte (1893—1967) and Yves Tanguy (1900—1955) in 1926 and 1927, a contrasting style, which fixed hallucinatory and fantastic subject matter in meticulously painted images of academic precision and clarity, became a viable alternative. In 1929, Salvador Dali (b. 1904) joined the Surrealists and, in Breton's view, best "incarnated the Surrealist spirit."[28] With Dali's arrival as a full-fledged member, illusionistic technique rather than automatism and spontaneity became the prevailing form of Surrealist painting. Dali's haunting and plausibly realistic "hand-painted dream photographs," as he styled them, not only brought a new objectivity to Surrealism but a startling new subject matter and an elaborate scheme of rationalization for dealing with personal fantasy. Dali joined the movement at a time when Surrealism was torn by personal and political conflicts. His microscopically detailed, realist style and imagination provided a new focus for Surrealism. In *The Persistence of Memory* Dali created an enigmatic and controversial imagery of limp watches, arid landscape, and a monstrous fetal creature, at once jewel-like and putrescent in physical substance. At their best, such paintings encapsulated the anxieties, the obsessive eroticism, and the magic of a vivid dream imagery.

pl. 251

pl. 252

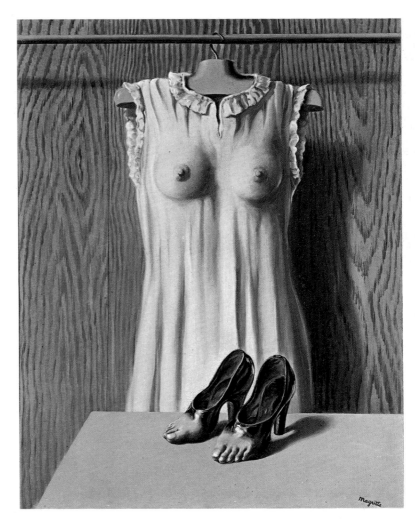

René Magritte. *The Philosophy in the Boudoir.* 1948. Oil on canvas, 31⅞ × 24". Collection Mr. and Mrs. T. Claburn Jones. 251

Dali also wrote copiously in elaborate defense of his methods and proposed a point of view based on what he called "paranoiac thought." He defined his "paranoiac-critical" methods as a "spontaneous assimilation of irrational knowledge based upon the critical and systematic objectification of delirious phenomena."[29] In place of the passive trancelike state of automatism favored by the early Surrealists, Dali recommended an aggressive principle of subjectively distorted vision and the cultivation of delusional thought patterns. His scheme still adhered to the paramount Surrealist objective in art of creating a convincing counterreality. For example, Dali transformed the innocent legend of William Tell from one of filial devotion to a scandalous theme of incestuous mutilation. By such high-handed, consciously shocking perversions of sentimental folklore, Dali hoped to bring common-day reality to its knees, as it were, and open up fresh imaginative possibilities. He adopted outrageously provocative attitudes in his public behavior and utterances, and he incited passions and criticism by the fanaticism and imperious tone of his critical writing. "I believe," he predicted, "that the moment is near when by a procedure of active paranoiac thought, it will be possible . . . to systematize confusion and contribute to the total discrediting of the world of reality."[30]

In discarding automatism as an artistic strategy, Dali proposed to paint like a "madman" rather than a somnambulist. He added, paradoxically, that the only difference between himself and a madman was that he was not mad. By simulating madness, however, he hoped to demonstrate the absurdity of worldly existence and to comment mockingly on what passed for reason. Dali paraded in his painting a challenging repertory of taboo sexual symbols and thus imposed, with some violence and with a keen appetite for public scandal, the painter's dream of reality. Dali, Ernst, and the other illusionistic Surrealists particularly, whose fantasies the public could not mistake in the form of a meticulously exact imagery, discovered that the uncensored dramatizations of their private psychological states and tastes carried many possibilities of meaning beyond simply defending artistic freedom. Their often perverse and grandiose imagery also yielded a heady sense of power. In the realm of the imagination, the artist found he enjoyed special prerogatives. Dali's obsession with such themes as castration, impotence, voyeurism, putrefaction, and coprophilia, for which he invented obvious, if theatrical, visual symbols, not only reflects his awareness of abnormal psychology and Krafft-Ebing; it also represents a sincere intellectual effort to achieve the kind of absolute freedom that was part of the Surrealist program to promote the revolutionary transformation of consciousness.

The poetic aggrandizement of a personal fantasy life in a startlingly lucid, compelling dream imagery, derived from de Chirico's dazzling apparitions and inexplicable confrontations of symbols. Dali transformed de Chirico's illusionism into new perspectives of delirium, and Tanguy used the same source to create a more precious and magical submarine dreamworld, inhabited by barely living creatures rendered in three-dimensional biomorphic form. Tanguy began to paint his tight academic, illusionist works even before Dali, and his manner reached maturity in 1927. After seeing a painting by de Chirico that deeply moved him, he painted *Mama, Papa Is Wounded!*, pl. 253 a key work in his own repertory of images. It represents a visionary re-creation of some desolate desert plateau, or ocean floor, where even natural properties are confused and mingled in their own liquid, gaseous, and crystalline states. His paintings have the ambiguous perspectives, long vistas, and distant horizons of de Chirico's, and also the contradictory ambience of air, water, and light that makes Ernst's early Surrealist paintings so ambiguous in locale. There are obvious Freudian allusions in the hairy membranous pole, at right, with its bulbous tip and its elongated geometric shadow. His biomorphs seem to anticipate Dali's

Salvador Dali. *The Persistance of Memory*. 1931. Oil on canvas, 9½×13". The Museum of Modern Art, New York. 252

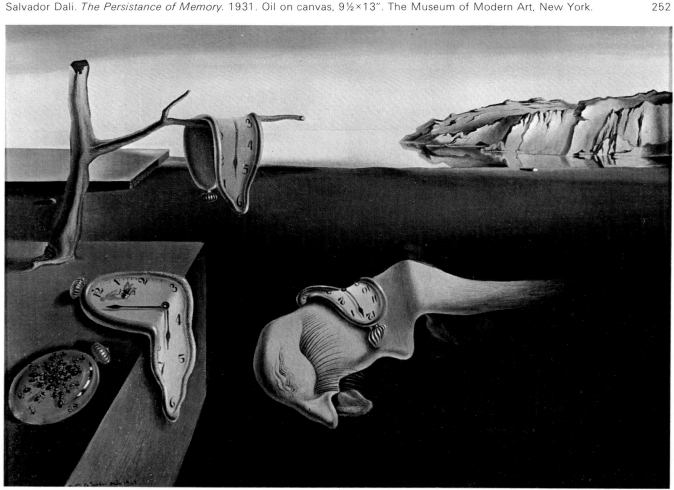

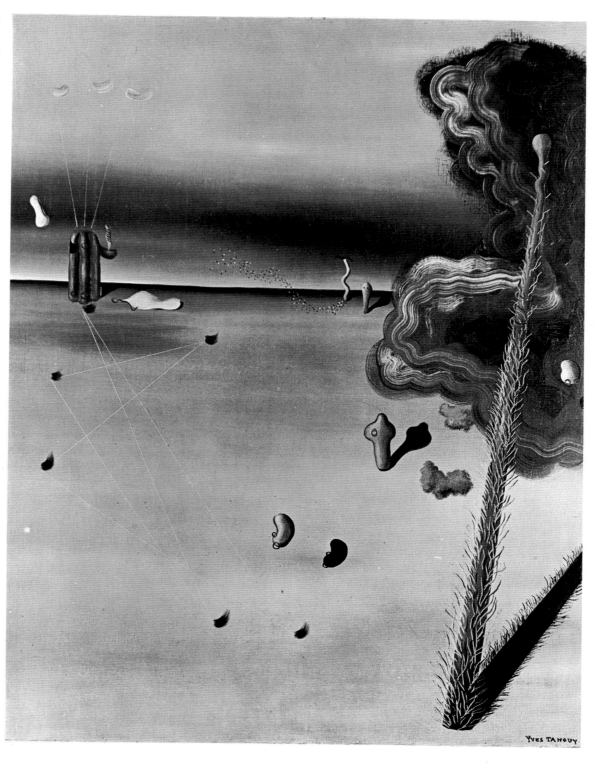

amoebalike, fetal forms as directly and transparently as Tanguy had assimilated de Chirico's oracular statuesque forms and hallucinatory brightness of light and space. For Breton, Tanguy's paintings seemed to realize his own dream, in the book *Clair de Terre*, of reconstituting the banal earth as a new habitat. He wrote that Tanguy had the ability "to yield to us images of the unknown as concrete as those which we pass around of the known," and added that his paintings provided "the first nonlegendary glimpse of the considerable area of the mental world which exists at the Genesis."[31]

Like a remembered dream that haunts waking consciousness, Tanguy's locales are familiar without being specifically recognizable. Amoebas, bones, soft bean forms, waving hairs, clouds, smoke puffs, earth, sky, water, amphibians, all are, in their own particular contexts, perfectly normal and natural enough. In Tanguy's paintings, however, their irrational relationships to each other create the confusion of identity so beloved by the Surrealists. The combination of bizarre humor in Tanguy's titles with a sense of fatality and eerie menace reminds us that Breton had warned, in his novel *Nadja*, that "Beauty will be convulsive or it will not be." Curiously, even the title *Mama, Papa Is Wounded!* acknowledges the quest for new means of probing the unconscious. It was taken from a statement of a patient

pl. 253

173

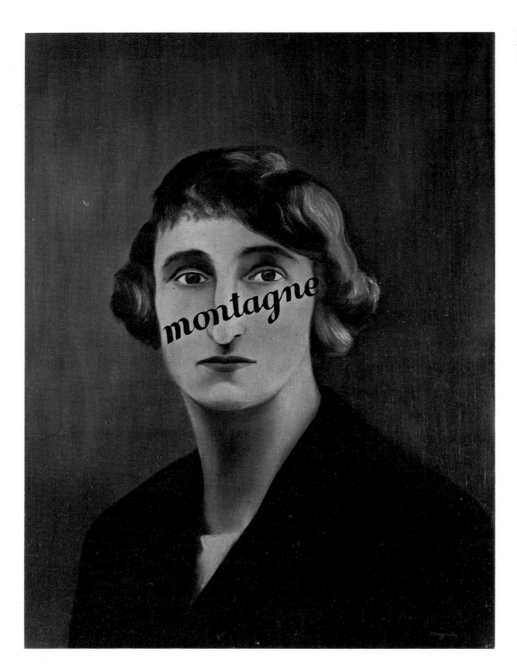

René Magritte. *The Phantom Landscape.* 1928–29. Oil on canvas, 21¼×28¾". Private collection, Turin. 254

in psychiatric treatment, at the suggestion of Breton.

In Tanguy's last works, an even more cruel and enigmatic drama is enacted, in a more foreboding atmosphere which the critic James Thrall Soby called "a sort of boneyard of the world." These are dream pictures of an almost unrelenting oppressiveness, where the sense of the miraculous is strongly qualified by repeated vistas of tiered boulders and pebblelike forms, in a nearly black light, that seem designed to eliminate any possibilities of animate survival, or of human hope.

The Belgian Surrealist René Magritte frequented the Breton circle in Paris in 1927—30 and then returned to Brussels, where he painted his haunting visual conundrums in a scrupulously exact and banal technique. Among the illusionistic Surrealists Magritte bears the most relevance to contemporary art, because his dissociated images and contrasts of objects and unrelated words pose questions of meaning and relationship between painted and real objects. They present the problem of creating new forms of identity as a part of the creative process. In an article which appeared

in *La Révolution Surréaliste* in 1929, the painter explained his riddles with such illogical statements as: "An object is not so attached to its name that one cannot find another which might suit it better."

Magritte had formulated within his own more commonplace system of visual images another strategy for evoking the new Surrealist reality, in which the normal associations of objects, images, and their names were dissolved in a scheme of identities whose rules were still to be fathomed and reconstructed. In one painting, a woman's face is overprinted with letters spelling out the word mountain. The device is disruptive, but it also has the suggestive effect of modifying and petrifying her features, by association, into a kind of landscape. pl. 254

One of his best-known visual riddles is *The Human Condition, I*, with its easel and transparent canvas which manage to thoroughly confound depicted art and natural landscape. The contradiction between the painted illusion and the actual scene questions the nature of reality, but the real magic of the work lies in the threatening sense

pl. 255

one has that neither nature nor subjective vision can be anything more than a hallucination or a fabrication. While he often painted residential interiors or street scenes in his native, middle-class city, Magritte still achieved a startling sense of the fantastic from juxtapositions of images. His plain but limpid technique probed the contradictions of existence and, in his own words, revealed "the present as an absolute mystery."[32] The artist himself perhaps best explained his intentions and the profoundly disturbing impact which his paintings have had on their audience:

> In my pictures I showed objects situated where we never find them. They represented the realization of the real, if unconscious, desire existing in most people.
> The creation of new objects, the transformation of known objects, the change of matter for certain other objects, the association of words with images, the putting to work of ideas suggested by friends, the utilization of certain scenes from half-waking or dream states—all were means employed with a view to establishing contact between consciousness and the external world. The titles of the pictures were chosen in such a way as to inspire a justifiable mistrust of any tendency the spectator might have to overready self-assurance. [33]

Another Belgian painter, Paul Delvaux (b. 1897), came to Surrealism later under the influence of Magritte, primarily. His transcriptions of a dream imagery with obvious erotic content in

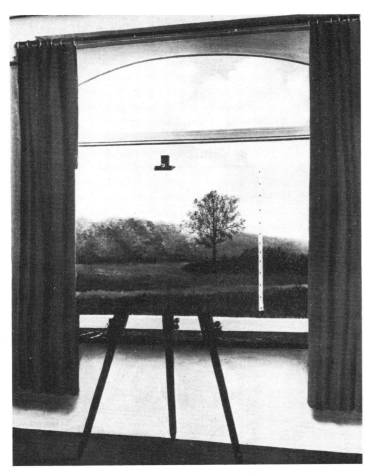

René Magritte. *The Human Condition, I.* 1934. Oil on canvas, 39⅜ × 31⅞". Collection Claude Spaak, Choiseul, France. 255

Paul Delvaux. *The Break of Day.* 1937. Oil on canvas, 47⅜ × 59¼". Collection Peggy Guggenheim, Venice. 256

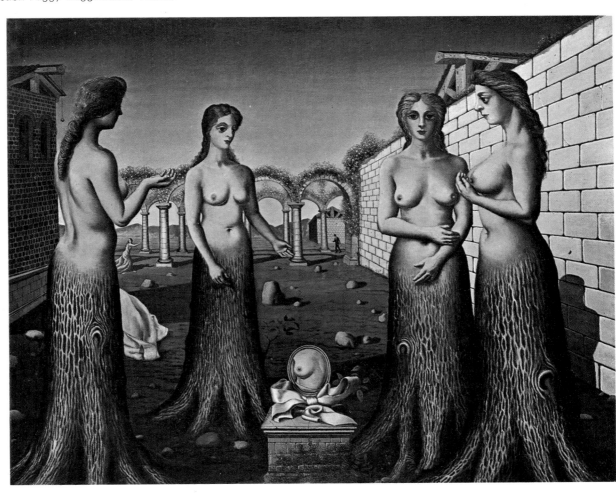

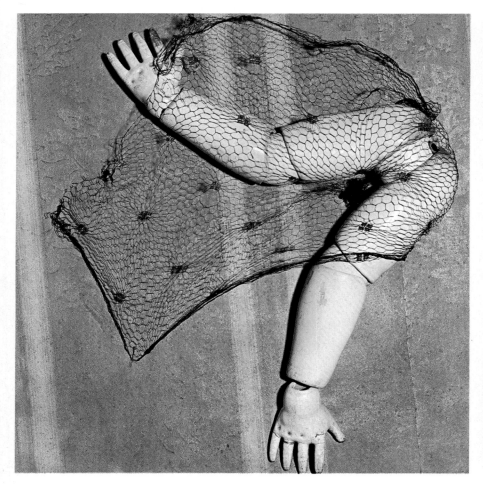

Hans Bellmer. *Ball Joint.* C. 1936. Present whereabouts unknown. 25 /

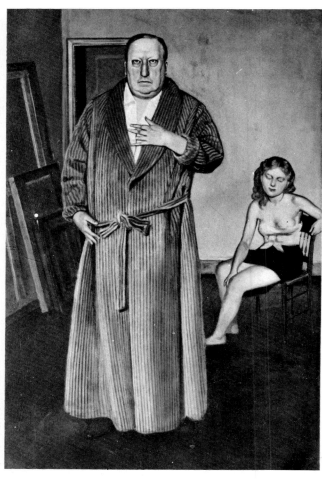

Balthus. *Portrait of André Derain.* 1936. Oil on wood, 44⅜×28½". The Museum of Modern Art, New York. Acquired through the Lillie P. Bliss Bequest. 258

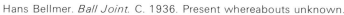

pl. 256 the repeated forms of vacuous and wistful female nudes, owe a debt to his fellow countryman, but the elongated vistas and disquieting city perspectives evoke de Chirico as well. Delvaux's gentle, erotic dreams are amusingly reminiscent of classical ideals in their figuration, but the clash of his metropolitan settings, statuesque females, and formally attired voyeuristic males creates a poignant tension between frustration and desire. His bizarre scenes simultaneously evoke an innocent golden age, a somewhat sinister eroticism and sense of guilt, and a dated, genteel urban environment of the turn of the century. Frustrated passion, heterosexual and homosexual, and anxieties scarcely veiled about the passage of time and the ineluctability of death haunt this original iconography.

Like Delvaux, Hans Bellmer (b. 1902) explored new veins of eroticism in his paintings, in extremely refined drawings, and in a group of provocative Surrealist objects that culminated in the mannequin, or *Poupée*, which he showed in many variations at the controversial International Exhibition of Surrealism of 1938, in Paris. The confused compl. 257 bination of limbs and erogenous areas, and the fetishistic character of Bellmer's aggressive sexual object, are echoed in his rather sadistic, unpublishable drawings of pubescent girls.

The preoccupation with a perverse eroticism
176 was evident in many later Surrealist works, as well

as in many late paintings by Ernst, and in the work of Bellmer, Delvaux, and others. Their work represented the pathological side of the more usual Surrealist exaltation of romantic love. With Breton's publication of *Mad Love (L'Amour Fou)* in 1937, the adoration of woman with a kind of sublime love, not to be confused with eroticism or its travesty in pornography, joined automatic writing and spiritism as a major strategy for attaining the desired state of revelation. Benjamin Péret described love as a new divinity fusing dream and reality, as one of the "exalting and incredible myths which will send one and all to lay siege to the unknown."[34] But the inclination toward the perverse persisted as the dark and anguished side of Surrealism, and it became an important part of its heritage. The French painter of Polish origin, Balthus (b. 1908), demonstrated the continuing validity of eroticism even within a prosaic naturalistic technique. His nude or semiexposed adolescent girls sprawl about in claustrophobic interiors in abandoned poses, inviting sexual violence and seduction. pl. 258

By the mid-1930s, Surrealist images and fantasies were refreshed and enriched in a context of three-dimensional execution. Painters turned directly to the physical world for inspiration in order to make their pictorial vision tangible in material terms. The Dadaists had already provided rudimentary prototypes of Surrealist objects

in Duchamp's assisted Readymades, or in Man Ray's *Gift*. These objects were somewhat restricted, either as primarily intellectual concepts or for their shock appeal, and failed to explore a full range of imaginative possibilities. With the emergence of Dali and his painted objects of concrete irrationality, the Surrealist process of *dépaysement*, or disorientation, was applied directly to physical reality, and objects were endowed with new functions and relationships. The most notable public evidence of the phenomenon was the Exhibition of Surrealist Objects held at the Charles Ratton Gallery in Paris in 1936. It was this exhibition Object, inspired Breton's article "Crisis of the Object," published in the May number of *Cahiers d'Art* that year. There, Breton recalled that he had as early as "1924 ... proposed the fabrication and circulation of objects appearing in dreams."[35] He conceived fanciful objects as a way of downgrading conventional objects "whose *convenient utility* (although often questionable) encumbers the supposedly real world."[36] And he repeats the various classifications and types of objects presented in the Ratton Gallery exhibition: "Mathematical objects, natural objects, primitive objects, found objects, irrational objects, ready-made objects, interpreted objects, incorporated objects, mobile objects."[37] And the Ratton Gallery show had been preceded in 1933 by a smaller exhibition of objects at the Pierre Colle Gallery in Paris which presented, among other things, "disagreeable objects, sexes, phobias, interuterine memories, taciturn conflicts, sausages, hammers, palaces, fried eggs, failed portraits, breads, photos, tongues."[38]

Among the Surrealist objects in the Ratton Gallery exhibition was the popular favorite and by now classic *Object*, by Meret Oppenheim (b. 1913). Unlike the Dada objects, her distracting associations are not designed merely to assault the

pl. 259

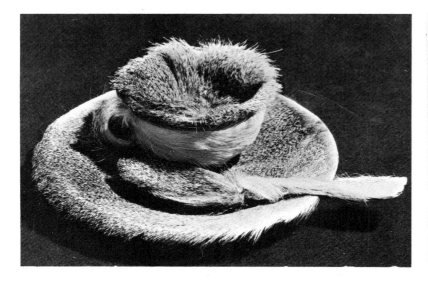

Meret Oppenheim. *Object (Le Déjeuner en Fourrure)*. 1936. Fur-covered cup, saucer, and spoon; cup 4¾" diam., saucer 9⅜" diam., spoon 8" l., overall 2⅞" h. The Museum of Modern Art, New York. 259

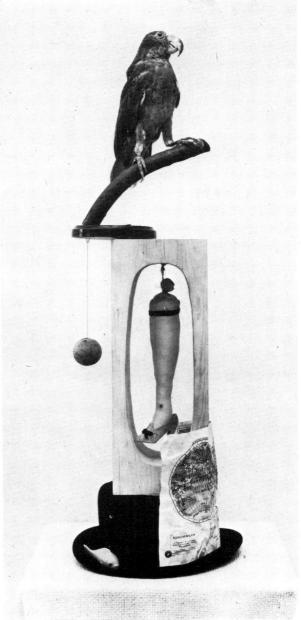

Joan Miró. *Poetic Object*. 1936. Construction of hollowed wooden post, stuffed parrot on wooden stand, hat, and map, 31⅞" h. The Museum of Modern Art, New York. Gift of Mr. and Mrs. Pierre Matisse. 260

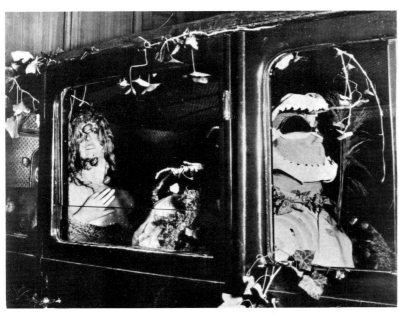

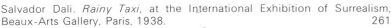

Salvador Dali. *Rainy Taxi*, at the International Exhibition of Surrealism, Beaux-Arts Gallery, Paris, 1938. 261

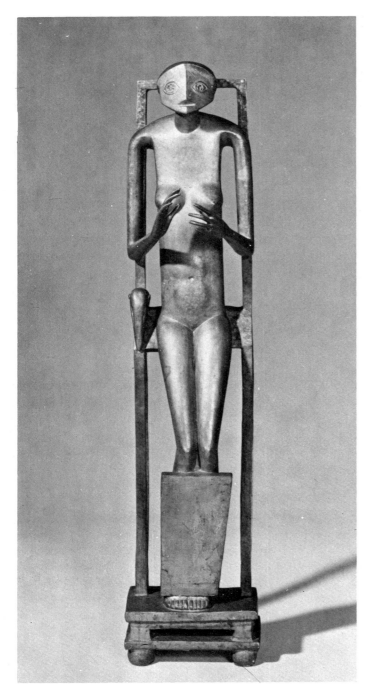

Alberto Giacometti. *The Invisible Object*. 1934–35. Bronze, 61″ h.
Collection Mrs. Bertram Smith, New York. 262

Alberto Giacometti. *Woman with Her Throat Cut*. 1932 (cast
1949). Bronze, 34½″ I. The Museum of Modern Art, New York.
263

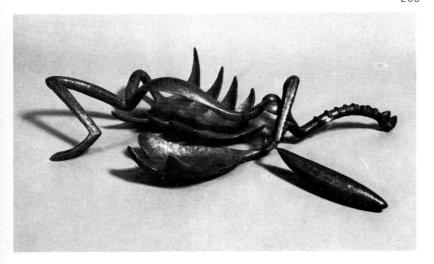

viewer but, rather, to release anthropomorphic associations. Although the cup and saucer are presumably used for drinking tea, here they have a strange animate life of their own, suitable for a beast or even a fur coat but disconcerting in a domestic context. Dali's *The Venus de Milo of the Drawers* transforms classical statuary, a symbol of sacrosanct high art, into bizarre household furniture, while at the same time adding new and intriguing openings and textures to the ideal female anatomy. In other instances, Surrealist assemblages such as Miró's *Poetic Object* proved to be pl. 260
more esthetic and formal than disruptive, and they formed a coherent and recognizable part of the artist's development, somewhat alien to the more extravagant Surrealist objects of fantasy.

Carrying their interest in fantastic objects into a total environmental and theatrical expression at the International Exhibition of Surrealism held in Paris in 1938, Surrealist artists created a "Surrealist street" lined with intriguing mannequins, decked out by Ernst, Arp, Tanguy, Man Ray, Dali, Miró, and Duchamp. Duchamp also arranged the ingenious main installation area by hanging 1,200 sacks of coal from the ceiling and covering the floor with dead leaves and moss around a water pond framed by real ferns and reeds. At the entrance, Dali produced perhaps the exhibition's most sensational object, *Rainy Taxi*, a pl. 261
derelict vehicle with dummies drenched by a continuous shower inside. One of the mannequins was a wild-eyed, unkempt female figure on whom live snails crawled. The elaborate and spectacular exhibition was the last major Surrealist event before World War II. The war dispersed the Surrealists from Paris, and many of them, including Breton, Ernst, Masson, and Tanguy, came to New York briefly, and there they stimulated the formation of American Abstract Expressionism.

Some years before the 1936 Exhibition of Surrealist Objects, Alberto Giacometti (1901—1966) had begun to construct his own rather aggressive objects, anticipating the fetishism and sado-masochism of works in that exhibition. Yet he translated the sense of dream and the disparate realities of the Surrealists into authentic sculptural form, distinct from the conglomerate Surrealist object. His pioneering effort directly affected the only other artists who can also be said to have made Surrealist sculpture in the 1930s: Arp and Ernst. Giacometti became a formal member of the Surrealist group in 1929, an association which lasted only six years, after which he disavowed the movement and sought a more personal vision based on a more tentative, impressionistic technique of modeling his familiar anguished, spindly human figures. It was during his Surrealist period that Giacometti made *The Invisible Object*, which Breton described pl. 262
as "an emanation of the desire to love and be loved, in quest of its true human object and in all the agony of this quest."[39]

The strange figure, bound to an imprisoning armature, emerging fearfully from its confines and holding the void, evokes the poignancy of human

Alberto Giacometti. *The Palace at 4 A.M.* 1932–33. Construction of wood, glass, wire, and string, 25×28¼×15¾". The Museum of Modern Art, New York. 264

Jean Arp. *Human Concretion.* 1933. Stone, 22×31⅞×21¼". Kunsthaus, Zurich. 265

yearning and, paradoxically, the hollowness of hope, thus echoing the disenchanted mood which undermines so many of even the bravest Surrealist

pl. 263

fancies. *Woman with Her Throat Cut,* executed two years earlier, constitutes an even more exasperated and violent evocation of the human form and of the human predicament, with its terrifying imagery which transforms the female anatomy into a crustacean. Giacometti's cage sculptures, of

pl. 264

which the best known is *The Palace at 4 A.M.,* provided key prototypes in the evolution of open-form, contemporary welded sculpture in America and elsewhere.

The compulsive and memorable image of his dream palace is his most complex Surrealist invention. It seems to be a visual recollection of a love affair, which the artist later elliptically described in a lengthy and moving prose poem. The construction, he wrote, "is related without any doubt to a period in my life that had come to an end a year before, when for six whole months, hour after hour was passed in the company of a woman who, concentrating all life in herself, magically transformed my every moment."[40] The work set a precedent for narrative sculpture that was at the same time rigorously formal and derived essentially from Picasso's and Lipchitz's constructions.

Although Jean Arp's sculpture in the round is reminiscent of Brancusi's in its reductive abstraction, it is associated with Surrealism by reason of its poetic metaphor of growth and change. Arp believed that "art is a fruit which grows in man, like a fruit on a plant, or a child in its mother's womb." He called his organic sculptures "human

concretions," insisting they were not abstractions despite their obvious resemblance to Brancusi's Purist forms. "Concretion," wrote Arp, "is the result of a process of crystallization: the earth and the stars, the matter of the stone, the plant, the animal, man, all exemplify such a process. Concretion is something that has grown."[41] Often his sinuous forms suggest the human figure, but they simultaneously evoke cloud shapes, stones, plants, beasts, and a host of associations from nature. Arp purged his forms of the violence and aggression that was so much a part of Surrealist painting, with its emphasis on the forces of unconscious inspiration.

pl. 265

Max Ernst first tried his hand at sculpture in 1934, after spending the summer with Giacometti in Maloja, Switzerland. The chance discovery of some rounded granite rocks in a mountain stream, worn by the rushing waters, provided the necessary found object to stimulate his creative impulses. His first sculptures were these small stones, simply painted or carved in shallow relief. In the winter of 1934—35, he embarked on a different and far more interesting sculptural process, combining ensembles of casts of whole and fragmentary common objects until a personage or presence emerged. The rather fortuitous method of assembling reproductions of real objects echoed his graphic and *frottage* techniques, but his final castings in bronze of such works from this fruitful period as *Oedipus, Lunar Asparagus,* and others are powerfully sculptural and totally transformed into new and surprising images.

Perhaps Ernst's most impressive mythology in sculpture was the monumental *Capricorn* group,

pl. 266

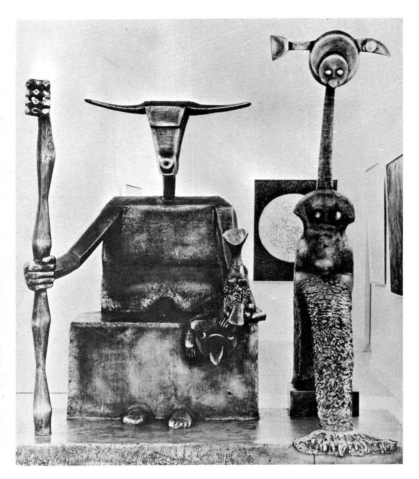

Max Ernst. *Capricorn.* 1964 (cast of concrete original, 1948). Bronze, 7'10½" h. Collection Mr. and Mrs. Albert A. List, New York. 266

which he made in cast cement (later cast in bronze) at his temporary home in Sedona, Arizona in 1948. The forms combine the exoticism of African or Oceanic art with suggestions of astrological symbolism and allusions ideas of fertility and rebirth in what is essentially a group portrait of himself, his wife, and their two dogs. Ernst's plaster sculptures and his one monumental figure group in cement all dated from the 1930s and 1940s, but they remained largely unknown in those decades, since they were not cast in bronze or shown publicly until much later. They form one of the most impressive bodies of rare Surrealist sculpture by a master whose universality has recently been increasingly recognized.

Between the wars, Surrealism did not generally encourage the production of sculpture; its most fertile ideas were developed either in painting or in the alternately magical and scatological Surrealist objects shown in Paris in 1936. Interestingly, Picasso occasionally essayed Surrealist methods like those of Max Ernst in sculpture, depending on subjective metamorphosis to transform simple found objects into fantastic imagery with double meanings. His well-known *Bull's Head* is simply a casting of an ingenious ensemble of a bicycle seat and handlebars formed into a powerful animistic presence. But, with some exceptions, his meanings and intentions were rarely so perverse or obscure as the Surrealists'. Despite his many warm relationships with poets and painters in the group, he,

like Miró, generally stood apart from their dogmas and methods. However, at certain dramatic moments of his career, a strongly personal vision was lent credence in images of public nightmare and anguish based on Surrealist fantasy and figurative prototypes.

Picasso was perhaps the first modern artist of major stature to show elements of Dada, and later of Surrealism, in his painting. We have seen that his wooden constructions and many collages done about 1913 contained deliberate visual inanities in the ironic spirit of Dada. During the later phases of Cubism, a fantastic and grotesque character increasingly asserted itself. The dualism in Picasso's work between a realistic figurative style and highly charged abstraction, or collage, with Dada overtones continued throughout the early 1920s. While he pushed Cubism to new heights of monumental decoration, which reached its peak in 1921 with the *Three Musicians*, he was working simultaneously in a neoclassic style. His compositions of violently distorted figures running on a beach, of sleeping peasants, and of nudes modeled after classical gods and goddesses, and his occasional meticulously realistic portraits, grew more gigantic in scale. There was a flavor of Roman or Egyptian decadence in Picasso's classicism, in the colossal, nerveless torsos and stuffed and lifeless heads.

Then about 1923, just before the official announcement of Surrealism, Picasso's neoclassical figures underwent traumatic rebirth into monstrous parodies of themselves. They endured violent deformations of limb and gesture, and uncomfortably occupied a space that was dramatically foreshortened. By the end of the decade, he had replaced the huge, stolid figures with sculpturesque, almost entirely abstract forms. He painted these forms so that they might suggest grotesquely immense monuments set in a natural environment against a wide blue Mediterranean sky or a stretch of sea. Although classical figuration had challenged Picasso's virtuoso powers, it provided scant refuge from the violent dissociations of modern life, and in his hands it soon produced puzzling chimeras, just as his concurrent style of Cubism had given way to Dadaist discontinuities and fantastic content.

An admission of the irreconcilable conflict of styles and divided psychic content in Picasso's protean art, and one of his most explicit Surrealist inventions, was an etching for the series "The Sculptor's Studio." Here a bemused and radiantly lovely, nude classical model contemplates a monstrous, fantastic anatomy of ambivalent sexual character, a hybrid of furniture, legs, cushion, and human limbs. The dreamlike confrontation of classical image and grotesque object places the print close to Surrealism, and reminds us that late in the 1920s Picasso's art had been convulsed by Expressionist violence. *Seated Woman* is typical of the psychological tremors of his art of the period. The jigsaw arrangement of curved and angular shapes makes a brilliantly succinct design and a

pl. 267

psychologically gripping complex of profiles, each more spectral than the last.

Picasso apparently found the Surrealist movement supportive of his own tendency to explore fantastic content. It also helped shape the direction which his art subsequently took. During the last years of the 1920s, an art in constant metamorphosis took the form of drawings and paintings of visionary, colossal bone forms and stonelike monuments. These potent abstract forms suggest themes of aggression and sexual violence, and

pl. 268

Pablo Picasso. *Seated Bather*. 1930. Oil on canvas, 64¼×51". The Museum of Modern Art, New York. Mrs. Simon Guggenheim Fund. 268

Pablo Picasso. *Seated Woman*. 1927. Oil on wood, 51⅛×38¼". The Museum of Modern Art, New York. Fractional gift of James Thrall Soby. 267

Pablo Picasso. *Crucifixion*. 1930. Oil on wood, 20⅛×26". Estate of the artist. 269

Matta. *Psychological Morphology.* 1938. Oil on canvas, 35¼×28⅜". Private collection. 270

creatures with subhuman intelligence cast in distorted human form. The same mindless distortions of the human form and elements of the grotesque make his *Crucifixion* unique and remarkable. It was preceded by many fantastic variations on Grünewald's great altarpiece in the form of drawings; these forms and their agonized mood, for which Picasso formulated his extraordinary visual equivalents, anticipate the invention of *Guernica* seven years later. Picasso's paintings of the 1930s provided a point of reference for younger Surrealist painters, and their traumatic mythologies of pain affected older artists, in and out of the Surrealist movement, as different as Masson and Lipchitz.

pl. 269

The last notable cultural success of Surrealism took place far from the scenes of its earlier triumphs, in New York during World War II, where most of its leading figures took refuge around 1940. Here they helped sow the seeds of the American postwar movement, Abstract Expressionism. A particularly important catalyst in the adoption, by Americans, of certain critical aspects of Surrealist ideology and method was the Chilean painter Matta (Echaurren), the last young artist officially embraced by Breton as a

member of the Surrealist movement. Matta (b. 1911) came to New York in 1939, just in advance of his more celebrated older colleagues, and made contact in the early 1940s with several of the younger American abstract artists. Arshile Gorky (1905—1948) felt his influence most directly, and in his own paintings he fused Matta's ideas on automatism, subconscious imagery, and the role of myth in art with a previous style which had been based on Picasso's Cubism.

For Gorky and a few other Americans, Matta's fantastic landscapes, or "inscapes," as he termed them, were of more interest for their morphologies than for their visual and theatrical effects, often reminiscent of the fantasies of Dali and Tanguy. Gorky also assimilated something of Matta's veiled eroticism, but he turned his own sensuality to a different account. Matta's brilliant forms, whether psychological, cosmic, or machine-oriented, were basically illusionistic and rather cinematic. The American artists who responded to his painting, however, eliminated Matta's deep space for an abstract, anti-illusionistic style. More important than the visual illusion for artists like Gorky, Jackson Pollock, Willem de Kooning,

pl. 270

pl. 272

Hans Hofmann, and others was their own compelling belief in the act of painting itself, as a primary source of content and meaning of the work of art.

Jackson Pollock (1912—1956) was perhaps the most revolutionary of America's pioneer Abstract Expressionists. He suggested in a statement both the influence of the expatriated European artists on the emerging New York avant-garde and the less than wholehearted manner with which Americans actually embraced the Surrealist program: "The fact that good European moderns are now here is very important, for they bring with them an understanding of the problems of modern painting. I am particularly impressed with their concept of the source of art being the unconscious. This idea interests me more than these specific painters do, for the two artists I admire most, Picasso and Miró, are still abroad."[42]

Pollock's admission that the unconscious, and by implication automatism, were factors to be reckoned with became evident in his early paintings. *Pasiphaë* presents a content of totemic and mythic imagery, and its turgid forms seem to allude to paintings by Masson, one of which bore the same title and was painted in the same year.

pl. 271

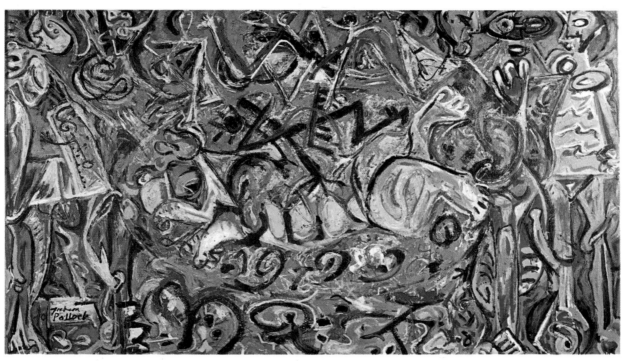

Jackson Pollock. *Pasiphaë*. 1943. Oil on canvas, 4'8"×8'. Collection Lee Krasner, New York. 271

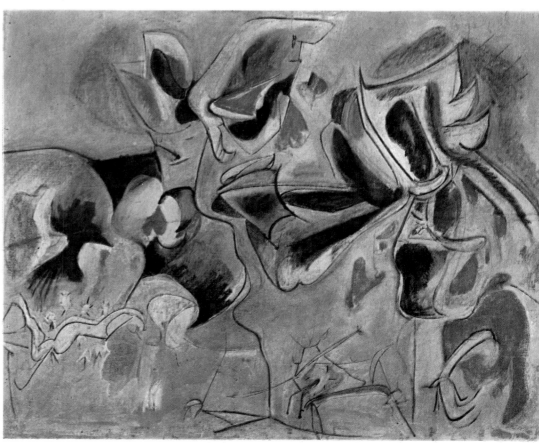

Arshile Gorky. *The Apple Orchard*. 1943—46. Pastel on paper, 42×52". Collection Mario Tazzoli, Turin. 272

The differences are crucial, however, for Pollock's forceful and disturbing image, his abundant energies, and the materiality of his pigment make the model of Masson seem tame, contrived, and even strangely anachronistic. By 1943, paintings not only by Pollock and Gorky but by Mark Rothko (1903—1970), Adolph Gottlieb, William Baziotes, and Hans Hofmann (1880—1966) shared with Surrealism a common interest in the primitive, the use of myth both as subject and as a mode of probing the collective unconscious, and variations on automatism in technique.

As the American Abstract Expressionists matured, they increasingly modified Surrealist doctrine and radically departed from its methods. Even the sacrosanct notion of automatism was revised. Robert Motherwell rejected Breton's "psychic automatism," the uncontrolled exploration of the subconscious, in favor of "plastic automatism," a use of controlled free association to invent new forms.[43] For Pollock, Hofmann, and Willem de Kooning (b. 1904), a gradual shift in the use of automatism came about; rather than emphasizing automatism as a process of invention for the creation of images, these painters reinterpreted automatism by stressing the importance of

pl. 273

pl. 274

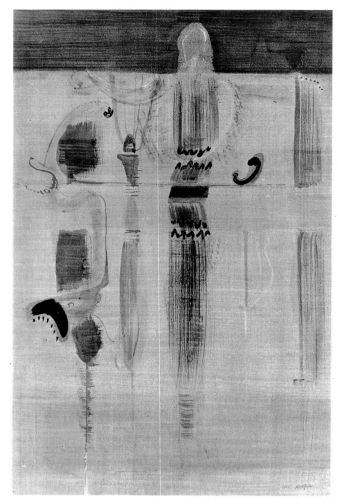

Mark Rothko. *Vessels of Magic.* 1946. Watercolor on paper, 38¾×25¾". Brooklyn Museum, New York. 273

Hans Hofmann. *Birth of Taurus.* 1945. Casein and oil on plywood, 50×50". Collection Mr. and Mrs. Fred Olsen, Guilford, Conn.
274

the painting process. In this they had already been anticipated even by the more European and refined art of Gorky, who expressed a totally un-Surrealist delight in the manipulation of paint for its own sake, as well as the development of a complex, allusive, semiabstract imagery. The transformation from automatism to a more Existentialist pattern of decision making is evident in de Kooning's *Pink Angels*. Although the painting alludes to Miró, de Kooning eliminates Miró's witty characterizations and personages, focusing attention on the paint quality and his own dominant plastic concerns.

pl. 275

By 1947, most of the European Surrealists had returned to France, but their influence was already on the wane in the face of independent American accomplishments. Pollock's breakthrough to his drip style is symbolic of the change and of the new authority in American painting. In one sense, his open drip paintings, made by spilling liquid paint on unstretched canvases placed flat on the floor, took automatism to its logical conclusion, to its apotheosis in lyrical abstraction. But Pollock's paintings from 1947 to 1950, in particular, are remote from their earlier Surrealist inspiration. Their forms no longer stem from an awareness of subconscious forces, but from a more objective mood. They are determined by the actions of the artist working with the exigencies of the moment. Like the process of

living, that of painting is conceived as being open-ended; chance, risk, and the actions of the artist provide the way to the finished work. The form created is invented anew at every step of the way, and it is equally remote from the realization of a pre-existing idea, and the operation of the psyche understood in orthodox Surrealist or Freudian terms. The idea of painting and its content comes into being with its form as a discovery, and in the process elements of stridency, aggression, and the Surrealist view of the traumatized ego give way to a new mode of contemporary heroism, the Existentialist encounter with world and self. Existentialist engagement thus replaced the Surrealist commitment to dream and the unconscious.

Vestiges of Dada and Surrealist ideas can be discerned in subsequent artistic movements of the 1950s and 1960s: in assemblage, in Europe's so-called new realism, and in Pop Art, which incorporated elements of Dada to pass ironic comments on a rampant and reckless consumer society. But the original inspiration has become so diffused that it has imperceptibly merged into a vocabulary of international art forms and passed quietly into common intellectual currency. Yet, the Dada and Surrealist vision, their compelling urge to reorient reality to the extravagant needs of the psyche and to fabricate a world more consoling than the actual, can never be extinguished. Their mysticism and sense of revolt has surfaced unexpectedly in the immoderate scale of Earthworks today, or in the hermeticism and riddles of Conceptual Art. Here, as in the case of Duchamp, the whole point of the esthetic idea lies in concept. Albert Camus has described Surrealism this way, implying that it was inadequate either as philosophy or as a plan of action: "Absolute revolt, total insubordination, sabotage on principle, the humor and cult of the absurd—such is the nature of surrealism, which defines itself, in its primary intent, as the incessant examination of all values."[44]

The genius and universality of Surrealism, however, lay in its affirmations rather than its presumed negations. It was Dada and not Surrealism that engaged in provocative gesture for its own sake, and in "total insubordination, sabotage on principle," as Camus put it. Breton's Surrealism imposed a concrete philosophical system and a program upon Dada's open-ended assumptions, systematically exploring the subconscious mind in the search for a higher reality behind our common-day perceptions of objects. This search was linked to a reformist impulse and a rather muddled identification with social revolution. Breton incorporated the ideas of chance, automatism, and the irrational, which had already erupted in Dada, into orthodox Freudian and Marxist viewpoints within his own typically French, structured theoretical principles. Apart from its intellectual substance, Surrealism also presented artists with possibilities of fantastic image elaboration, which proved, in many ways, to be an eloquent, expressive vehicle peculiarly suited to the modern psyche and troubled times.

Willem de Kooning. *Pink Angels*. c. 1945. Oil and charcoal on canvas, 52×40". Collection Mr. and Mrs. Frederick Weisman, Beverly Hills. 275

THE SHAPING
OF A NEW ARCHITECTURE:
1918-1940

Before 1914, progressive architecture was represented by multiple, sometimes contradictory, tendencies and certain autonomous developments whose filiations would become clear only through subsequent events. Abruptly, after 1918, these disparate elements joined together in a common direction, if not into an exactly unanimous creative pattern. Unlike that of the preceding decades, the architectural activity of this new period may be conveniently arranged into relatively clear-cut strata; and the avant-garde minority, more agressive than before, stood distinctly apart from the routines of the professional majority.

The sweeping reformist and revolutionary programs of this young, impetuous, postwar generation represented a vociferous indictment of recent design practices, even certain of the more progressive ones. Academic ways, which earlier had seemed malleable and fertile in the hands of Peter Behrens or Auguste Perret, suddenly appeared tainted and compromised. Architects like Ludwig Mies van der Rohe and Le Corbusier, who, before the war, had tended to modify or transform, rather than reject, academic methods of design, abruptly turned about and developed autonomous styles based on totally different assumptions and ideals. Whereas the diluted classical tradition had influenced their earliest works, their subsequent purpose was to create an architecture wholly new and unheralded, one seemingly free of traceable historic roots, incorporating ideas from fields as different as engineering and technology, on the one hand, and the arts of painting and sculpture, on the other. So profound was this upheaval that even established architects of the generation of H. P. Berlage and Behrens with respected, progressive prewar styles were impelled to make drastic changes in their work after 1918—changes that were more than just superficial accommodations to current fashion.

Few periods in history have witnessed the appearance of an authentic innovative style of such far-reaching consequence. For architecture, the 1920s was one of those privileged epochs. It was a turbulent, immoderate era, offering the spectacle of a new architecture locked in mortal combat with an established order capable of all sorts of devious and superficial compromises. Throughout the years between the two wars, this professionally isolated vanguard, subsequently identified as the International Style, found its rational clarity challenged by other progressive movements such as Expressionism and organic or empiric architecture and even such subversive fashions as Art Deco, or "streamline," industrial design, early examples of radical chic. Recently, most of these once-scorned rivals of the International Style, even the most parasitic, have attained a new respectability with historians and critics, not always an undeserved rehabilitation. Much as such rediscoveries may complicate, and even distort, they do not nullify the general picture of a unified, integrated, modernist tradition dating from 1918.

It is at once easy and difficult to characterize this revolutionary style, especially as it became established during the last half of the 1920s, since today, a half century later, it is a commonplace, even banal, one. Because of its present overfamiliarity, it is now difficult to re-create the excitement surrounding its initial appearance and the intense partisan feelings and virulent hostility that it originally provoked. During this period, buildings and projects of "modern design" were matters of concept and ideology, and not mere exercises in form and space. Only later, after 1930, do we encounter efforts to develop and expand the new and originally narrow formal language per se. In the 1920s, what the building *represented* was often what counted most. These radical designers commonly lacked opportunities to put their ideas into practice in large-scale projects. More commonly, they received commissions for small buildings, frequently houses, where demonstrative, even polemical, design may have been justified on an instructive, symbolic level, but sometimes compromised functional appropriateness in the process.

Of course, no single building of the period can encapsulate all of the theories and forms of the period, but one house, Le Corbusier's Villa

Frank Lloyd Wright. Johnson Wax Company. Racine, Wisc. Administration Building. 1936–39.

276

pl. 277

187

Savoye, Poissy, 1929—31, a weekend house in the outer suburbs of Paris, is an archetype of advanced architectural goals. So complete, calm, and integrated is the Villa Savoye, a concise spatial manifestation of the Cubist-inspired machine esthetic, that it is tempting to look back upon it as *the* classic realization of the period. Even more, in general histories, its generic and discrete classicism is today commonly associated with the more distant, familiar classicism of Doric temples or Palladian villas. Sited in a broad, tree-lined meadow, it appears from a distance as a pure, unadorned rectangular cube elevated above the landscape on remarkably thin columns. The lowest of its three stories is sharply recessed to accommodate a wraparound driveway; the second level is as much open, roofless deck as it is enclosed living space; and the deck is carried to the upper level by means of a gently inclined reverse ramp. Concrete wall surfaces are rigorously planar; many walls are transparent rather than opaque, and the possibilities of seeing through the basic structural form are many. What seems to be a regular, enclosed shape turns out, on closer examination, to be a complex of forms and volumes perpetually shifting in relation to each other as the position of the observer changes. Le Corbusier here perfected a fundamentalist architecture, at once artful and artless, which he and his contemporaries had been fashioning for a decade. The Villa Savoye may superficially suggest an ocean liner's superstructure, but otherwise it is quite independent of familiar formulas. Its planar surfaces, apparently weightless volumes, sweeping areas of glass, and asymmetrically open plans have been viewed as the hallmarks of the new architecture.

At first, the architects of this generation wanted to escape from style altogether, and this quixotic goal helps explain the unanimity with which designers from such varied cultural backgrounds hit upon a simple, reductive mode—negative, yet ironically susceptible of stylization through the adjustment of proportion and the manipulation of solid and void. This fundamentalism, recognizable in the works of Le Corbusier, Walter Gropius, Ludwig Mies van der Rohe, and other major, if less well-known, figures, is not, contrary to popular belief, founded upon an overriding concern for functionalism, but, rather, with a passionate altruistic need to reject the trappings of the past, especially anything remotely resembling applied ornament. Nevertheless, there were certain style sources that these new architects consulted, creations of modern engineering and technology such as bridges, hangars, silos, factories, ocean liners, automobiles, and airplanes. In the realm of architecture, primitive and vernacular sources were also sought out, and even examples of certain historical styles were studied, though chiefly for their mathematical and proportional systems or for the nature of their placement on the site. Supplementing this novel encyclopedia of forms was the crucial influence of Cubist and abstract painting of several sorts; this is remarkable since the visual and representational arts had exerted almost no influence upon architecture for more than a century, some exception made for Art Nouveau.

The war lent special urgency to the clamor for profound change in architecture, which was coming to be viewed as an instrument that could provide the setting for a new life, one freed from those patterns and habits of the past that had led to the recent cataclysm. The proliferation of Utopian designs immediately after 1918 and the feedback of this passion for universality into the design of the smallest building component are characteristic of the 1920s. After 1918, the design of ideal cities became a major concern of architects, and these large-scale aspirations were reflected in the enthusiasm with which this generation addressed the question of an altogether new style. The idealism of the new architecture was totally at odds with the idealism of the waning academic tradition. The old order was the institutionalized heir of the

Renaissance-Baroque tradition; in the nineteenth century, this tradition had been codified in France into the Beaux-Arts system, based upon bureaucratic state patronage and the endless elaboration of formal planning patterns. These rigid compositional values stressed permanence and continuity with the past and, quite simply, offered little or no help in solving new quantitative problems in the fields of housing, industrial construction, office buildings, and the like. All that remained useful from the academic tradition was an axial type of design which occasionally might serve as the formal infrastructure of vast contemporary-scaled urban plans. In contrast, the new post-1918 idealism rejected this heritage and opted for either an implicit or explicit Futurism.

These hopes for a new era were first manifest in the mythic, fantastic projects of Bruno Taut (1880—1938) and his followers, best seen in his *Alpine Architecture*, 1919, a book whose contents must be compared with the remote, otherworldly communities later imagined in the novels of Hermann Hesse and Thomas Mann. By the end of the decade, in his landmark volume, *Modern Architecture*, 1929, Taut had transformed himself into a rationalist and champion of what soon became known as the International Style. Like so many other German architects in the years immediately after 1918, his dreams for a new architecture attained a purely fictive realm, an idealism as remote from current circumstances as was that of the despised, rejected Beaux-Arts. In 1919 he asked: "Is there any architecture today? Are there any architects? . . . Are not we, who are at the mercy of all-devouring society, parasites in the fabric of a society that knows no architecture, wants no architecture and therefore needs no architects! For we do not call it architecture to give a pleasant shape to a thousand useful things. . . . We call upon all those who believe in the future. All strong longing for the future is architecture in the making. One day there will be a world-view, and then there will also be its sign, its crystal—

architecture."[1] Out of this declaration of despair Taut fashioned some of the most transcendental designs ever set to paper. It was a momentary outpouring necessary to clear the way for the more mundane design tasks to come. Taut, Sant'Elia, and their successors, by placing themselves in an extreme, admittedly unrealistic, pose of autonomy and summarily dismissing their architectural heritage along with many of the values of contemporary culture, founded, for the first time in centuries, a new style.

pl. 278

At an early date, the overriding importance of three figures—Le Corbusier—Gropius, and Mies van der Rohe in the evolution of the new architecture was recognized; and today, after their passing from the scene and after much research that has justly rehabilitated the reputations of numerous forgotten, overlooked contemporaries, there is nothing in the record that would substantially negate their earlier reputations—even though it is now recognized that each man was, in various specific instances, stimulated or influenced by the contributions of lesser-known peers. These three architects began their practices before World War I and, in varying degrees, were radically transformed by that experience.

Le Corbusier (1887—1965) came from an arts and crafts background and subsequently participated, as a painter, in the evolution of the post-Cubist style Purism. Walter Gropius (1883—1969) was the organizer of a remarkable institution, the Bauhaus (1919—33), a fusion of an arts and crafts school and a conventional art academy, first in Weimar and after 1925 in Dessau. Gropius's appointment had been encouraged by the former director of the arts and crafts school Henry van de Velde, once a pioneer of Art Nouveau and subsequently the designer of a proto-Expressionist theater at the 1914 Cologne Werkbund exhibition. As director, Gropius was responsible for the inclusion on the Bauhaus faculty of such major artists as Kandinsky, Klee, and Moholy-Nagy. Soon the school produced such students as the architect Marcel Breuer and the painter Josef Albers, each of whom later taught there. After 1933, these masters, Gropius included, dispersed to Zurich, Paris, London, and, in the United States, Cambridge, Chicago, and New Haven. As teachers at Harvard, Gropius and Breuer guided the professional education of the American architects Philip Johnson and Paul Rudolph. The more taciturn Ludwig Mies van der Rohe (1886—1969) was, during the 1920s, a vice-president of the Deutscher Werkbund, an influential organization dating from the prewar period, and the organizer of an important international exhibition of contemporary housing, the Weissenhof project, at Stuttgart in 1927 (with buildings executed by himself, Gropius, Le Corbusier, and other architects from The Netherlands, Belgium, France, Germany, and Austria). After 1930, during the troubled political period preceding the Nazi assumption of power, he served as director of the Bauhaus and, several years after its closing, joined

Bruno Taut. "Crystal House in the Mountains," from *Alpine Architecture*. 1919. 278

189

his fellow architects in exile, becoming chairman of architecture at the Illinois Institute of Technology, Chicago (then known as Armour Institute). There he refined, perfected, and classicized his laconic style, establishing by 1950 a mode of skyscraper design that would become the norm for architecture worldwide for decades to come, a mode that also seemed to relate historically to the pattern of Chicago designs of the 1890s by Sullivan and his contemporaries.

pl. 279

The factory at Alfeld, 1911, by Gropius and his partner Adolf Meyer (1881—1929), has been cited as perhaps the most advanced building in Europe of its date by virtue of its continuous three-story glass wall and, particularly, by the way it is joined together at one of its angles without a structural column at the corner. This effect of transparency is created by the cantilevering of the concrete floor slabs of the interior, which can just be detected through the glass from the outside. To twist a phrase, this compositional principle of transparency, with its implication of weightlessness where the eye would expect a more conventional opaque supportive material for the wall, is the cornerstone of the new architecture. It is significant that the architect *later* acknowledged the importance of these characteristics, but it will probably always be a moot point as to how aware he was of the significance of this phenomenon at the moment of design.

In any event, Gropius and Meyer, in their next major work, the Model Factory at the Cologne Werkbund exhibition, developed this architecture of transparency in a more deliberately formalist way. The layout is curiously academic: an office wing with central entry leading to a courtyard, giving excuse for a second formal facade, and,

finally, a machine hall on axis on the opposite side of the court. The facades are, in their outlines, adaptations of a composition by Frank Lloyd Wright of 1909 that had been published along with many others in the form of elegant, simplified drawings by Ernst Wasmuth in Berlin in 1910. In fact, this publication and a smaller companion volume of photographs of Wright's buildings were much studied and emulated by the new generation of European designers. Gropius and Meyer transformed the Wrightian formula into something radically different through the extensive use of glass on the court facades and the "wrap-around" corner spiral stairs, with its Futuristic implications of movement. However, it is the pervasive transparency and the hovering, weightless, floating form of the court facade's glass wall, which runs unbroken around each end of the building and provides a revealing, see-through effect, that create the unique sensation. The building is no longer bounded at its angles by emphatic structural verticals, no longer confined by opaque walls into which windows intrude. Here the tables are turned, and glass appears to be the ambiguous "enclosing" surface (of course, visually, it is not exactly an enclosure), and the brick piers and planes seem to be the intruders. There are suggestions of a space infinitely extendable beyond the glass-enclosed volume—qualities that have been much discussed but little exploited in subsequent modernism, perhaps because their implications seem to lead to a renunciation of architecture itself, so long as architecture remains a matter of structure, volume, and space.

If, from the foregoing analysis, it would seem that Gropius and Meyer had forged ahead into a new constructive esthetic by 1914, they nonethe-

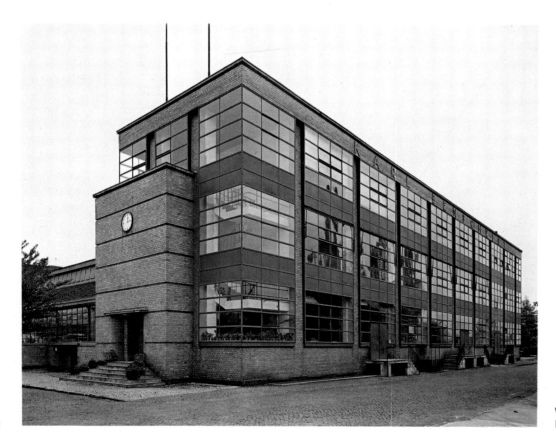

Walter Gropius and Adolf Meyer. Fagus Factory, Alfeld, 1911.

279

pl. 280

less relied upon a formalist academic composition, which substantially mutes their achievement, placing it squarely in the prewar period of contradictory tendencies. Much is likewise true of the Schwob House, built in 1916 at La Chaux-de-Fonds, Switzerland, by Le Corbusier, then still known as Charles-Édouard Jeanneret. This villa, framed in reinforced concrete, climaxes a decade of work in domestic architecture by this young man who had spent much of his time traveling through much of Europe in search of ancient and contemporary—architecture—venturing from Istanbul, Athens, Rome, and Pisa to Vienna, Berlin, and Paris. His education was a self-administered Grand Tour suggestive of the practice of eighteenth-century English gentlemen, but also in the spirit of contemporary postgraduate traveling fellowships awarded to architectural students. In any case, it was an education that was a curious alternate to the customary French academic one: five years as a prize-winning laureate in Rome following the successful completion of a long series of competitions at the Beaux-Arts in Paris.

The Schwob House was the only one of his pre-1918 houses that Le Corbusier himself published in his own works. Significantly, he went out of his way to ignore, if not exactly suppress, his juvenilia, preferring to give the idea that his work had sprung spontaneously and parthenogenetically from a fresh, chaste reconsideration of architectural problems around 1918 rather than from firsthand experience in the building of private dwellings. Not surprisingly, this house is ambivalent, in keeping with its period, stylistically a restatement of themes adapted from Hoffmann, Behrens, and Perret. Conceptually it is something else: a foretaste of ideas that will be fulfilled in his work later. The flat roof is more than a device; it is a matter of theory—a terrace for activities that otherwise might be conducted on the ground. But it is also, arrogantly, a matter of Le Corbusier's subjective taste, since he wrote that he was repelled by the sight of pitched or hipped roofs, feeling that they destroyed the geometry of the rest of the house. The two-story, studiolike living space with balcony and with a full glass wall at one end is another key feature of doctrinaire Corbusian significance. It is at the heart of his conception of the ideal dwelling form, individual or collective, from the 1920s to the end of his creative life. These features are as fundamental to Le Corbusier's unique design orthodoxy as are the column, capital, and entablature to the Greek Doric.

Subsequently, in 1918, Le Corbusier turned his energies to painting—refining and perfecting his sense of form—and collaborating with Amédée Ozenfant on a book, *After Cubism*, which laid the basis for the Purist esthetic. In *Vers une Architecture*, 1923, he proposed a series of models for contemporary architects, images for "eyes which do not see," such as industrial buildings, automobiles, pipes, the Greek temples, and, on a somewhat tentative note, the works of ancient Rome and of

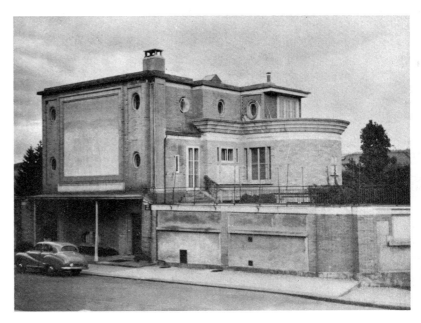

Le Corbusier. Schwob House, La Chaux-de-Fonds, Switzerland. 1916. Photograph courtesy The Museum of Modern Art, New York. 280

Michelangelo. This repertory has since become a sacred spring for aspiring modernist architects. These heterogeneous elements are unified by the practical efficiency of their design together with the exacting geometric clarity of their form, which, through convention and familiarity, is made to seem logically inevitable. The Parthenon is interpreted with a lyric enthusiasm that seems appropriate to a paean for a machine, and it is proposed that the formal history of the automobile might be expounded in terms analogous to the evolution and refinement of the Doric temple. It was in the pages of this volume that the notion of the house as a machine for living was first declaimed, a contentious proverb that has been fought over more than any other in the history of modernism.

However, complimenting the Purist esthetic of Le Corbusier were other adventurous strands that found outlets shortly after 1918. Expressionism is a difficult enough concept in the history of painting, but its application in architecture is even more problematic; moreover, architectural Expressionism is largely independent of that movement in the representational arts. The projects of Bruno Taut have already been mentioned as instances of an idealistic architecture striving toward a mythic, even mystic, state. His building at the 1914 Cologne Werkbund exhibition, a pointed domical Glass House, was already a symbolist manifesto, in pl. 281 contrast to the rational exploitation of clear glass in the Gropius and Meyer Model Factory. Employing colored glass and Luxfer prisms, a type of glass brick, Taut created a phantasmagoria of light on the two-level interior, a sanctuary of luminous space and translucent surfaces that no black-and-white photograph can possibly hint at. Bruno Taut was at the center of the Expressionist maelstrom in Germany, which included a group of architects who called themselves the Glass

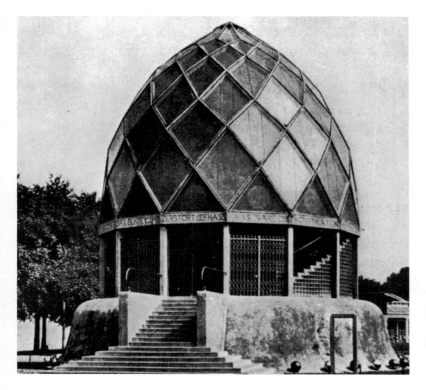

Bruno Taut. Glass House, Werkbund Exhibition, Cologne. 1914.
281

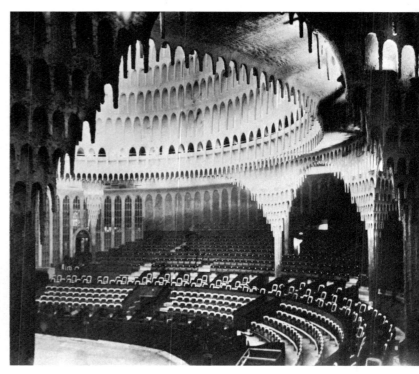

Hans Poelzig. Grosses Schauspielhaus, Berlin. Interior. 1919.
282

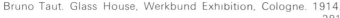

Chain, whose members gave themselves symbolic names like "Glass," "Mass," "Beginning," or "Prometheus" and believed that an "architecture of glass" would create the atmosphere for a new culture. The participants included Gropius, Taut and his brother Max, Hans Scharoun, and the Luckhardt brothers. Mies, though he had participated in some exhibitions, was conspicuous by his absence from this group. Nonetheless, he designed two Expressionist-influenced glass skyscraper projects at this time that have become two of the most important incunabula of the modern movement. Understandably, the forms imagined by Taut and his circle found no realization in actual building, nor were they meant to. Utopian architecture has a demonstrably polemic function in which the chimerical and even the preposterous find a proper place. This was, indeed, the most important function of Expressionism in the midst of a nascent modern architecture.

pl. 282 One of the most remarkable Expressionist works was by Hans Poelzig (1869—1936), the Grosses Schauspielhaus, Berlin, 1919, designed in collaboration with the theater director Max Reinhardt. Its auditorium was a stage-set-like fantasy of a stalactite-encrusted dome, with intriguingly concealed sources of light, built inside the vast space of an old riding hall. Equally notable is the Goetheanum at Dornach, Switzerland, the design of the philosopher and mystic Rudolph Steiner (1861—1925). The first building, a vast double-domed affair in wood that was begun in 1913, burned to the ground in 1923 and was replaced pl. 285 by an even more extravagantly massed concrete 192 building completed in 1928. The first Goethea-

num seems to have been a distant cousin of the architecture of Otto Wagner and the Viennese Secession. In contrast, the second building is a more extravagantly sculpted work rivaling Gaudí, so unusual in shape as to defy description in familiar architectural terms. As a temple to a secular religion it seems to be the one challenging realization of the notion of the Cathedral of the Future referred to in Expressionist literature, though its dense, molded forms bear no relationship to the linear, skeletal, luminous interiors of the Gothic era, and its opacity is a world removed from most Expressionist projects.

Probably the best known Expressionist building is by Erich Mendelsohn (1887—1953), the Einstein Tower for the Astrophysical Institute at pl. 283 Potsdam, near Berlin, 1920. Its svelte, undulating forms, a kind of Baroque abstraction, are suggestive of Gaudí. It was designed to be executed in concrete, but for practical reasons the shape of the tower was built up in masonry and then covered in stucco. This was a common, if not very candid, procedure at a time when concrete was being held up in many quarters as an ideal building material for the new architecture, yet this counterfeiting of effect seems foreign to the high moral tone of the period. Mendelsohn's Einstein Tower was based upon sketches similar to a series of imaginary studies that the architect had done during his military service: small drawings of vast edifices, some proposed as hangars or cinema studios, others simply titled "Toccata and Fugue." Although, like Sant'Elia's Futurist projects, Mendelsohn's drawings seem to have been developed from the late works of Otto Wagner, they have a distinctive

personal quality of rounded contours that contrasts with the angularity characteristic of the work of the Italian designer. Unlike most other Expressionists, Mendelsohn went on to a varied international career. Leaving Germany in 1933, he worked in England, Israel, and the United States, settling in the San Francisco Bay area just before his death. Never a member of Taut's Expressionist circle, his work became more typically international in the late 1920s. Most of his stores and offices of this period in Germany, his best works, have vanished, and he is now remembered for several synagogues built in the United States in the 1940s and 1950s, designs in which he sought

to revive the rhetorical forms of his youth, but, alas, did so with indifferent success.

Of the other, younger men who adhered to the Glass Chain, Hans Scharoun (b. 1893) should be singled out. His early projects were typical of the movement, although in 1927 he built a house for the Weissenhof project under the aegis of Mies that is scarcely representative of his early allegiance. He remained in Germany, without work, during the Nazi era, and his major building, the Berlin Philharmonic (1956—63), is one of the most dramatic realizations of Expressionist ideals, even if, historically, it is an anachronism by virtue of its mid-century date. By then, historians of the

pl. 284

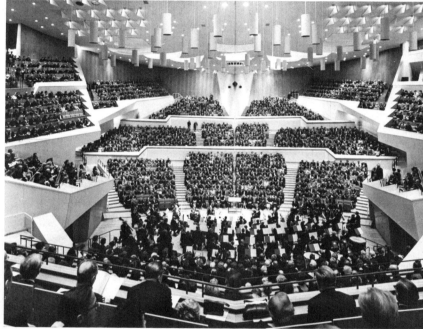

Hans Scharoun. Berlin Philharmonic. Interior. 1956—63. 284

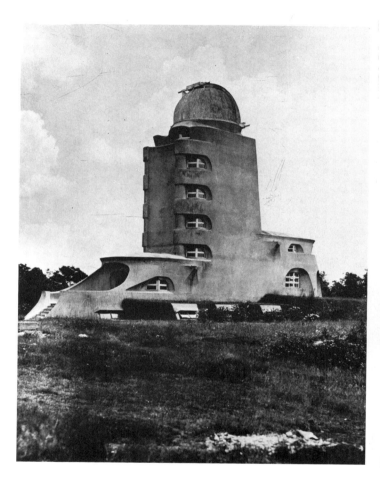

Erich Mendelsohn. Einstein Tower, Potsdam. 1920. 283

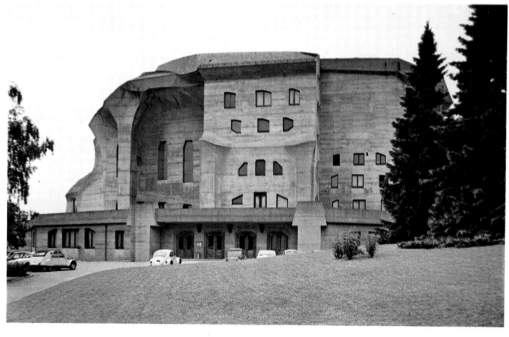

Rudolph Steiner. Goetheanum, Dornach, Switzerland. 1913—28 285

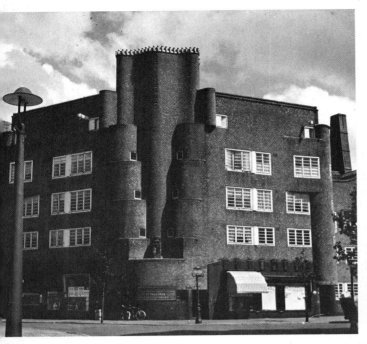

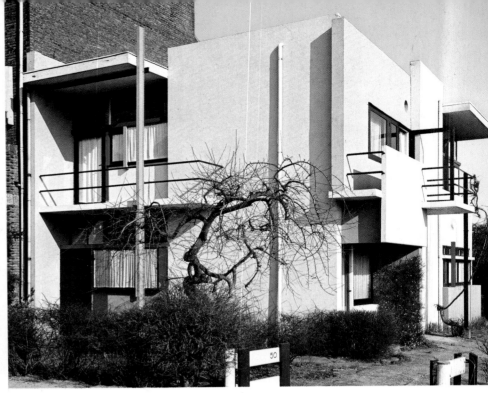

Piet Kramer. Dageraad Housing, Amsterdam. 1918–23.
286

Gerrit Rietveld. Schroeder House, Utrecht. 1925 (demolished).

287

Jacobus Johannes Pieter
Oud. Workers' Housing,
Hook of Holland. 1924–27.
288

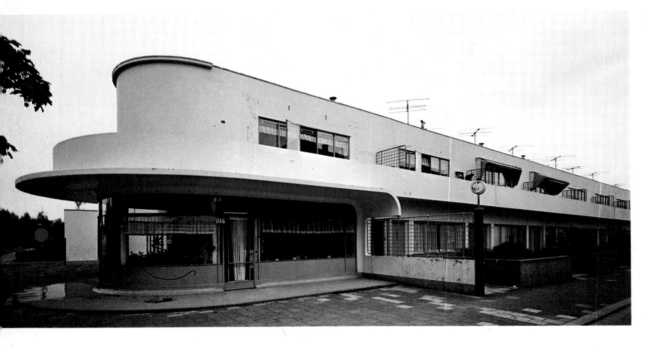

contemporary movement who had ignored, or sidestepped consideration of, the romantic, irrational strain in modern architecture were ready to accept and even welcome Scharoun's work, which, ironically, shares its site with Mies's templelike glass and steel National Gallery (1962–68), the monumental culmination of his stern architectural vision.

Expressionism was largely, but not exclusively, a German phenomenon. In The Netherlands, a group of architects known as the Amsterdam School was especially active in the field of public housing in the years before, during, and after the war. Taking their cues from the local brick architecture of Berlage, Michael de Klerk and Piet Kramer (1881–1961) designed such groups of flats as the Eigen Haard, 1921, by de Klerk, and the Dageraad, 1918–23, by Kramer, which stand out from the miles of uniform brick facades being thrown up in the new residential quarters of Amsterdam. Taking off from the nineteenth-century neomedieval rationalism of Berlage, the younger architects expanded the mode into something bordering on fantasy. De Klerk's work is characterized by turrets, casement windows, chimney pots, and spires that are freely borrowed from the Middle Ages, but not in the rational spirit of an earlier day. An octagonal spire rising above the pitched roofs of the Eigen Haard flats is stark yet vaguely Gaudíesque, an ecclesiastical image in a domestic context, a quality that is likewise present in the curving frontispiece of Kramer's Dageraad.

If the Amsterdam architects found ways to update aspects of prewar modernism in their work, the handful of architects adhering at one moment or another to the organization of painters and sculptors known as De Stijl represented a more radical departure, closely linked with new devel-

pl. 462

pl. 286

pl. 288

pl. 287

pl. 289

opments in abstract painting that were largely the work of Piet Mondrian and Theo van Doesburg. In architecture, the major figures were Jacobus Johannes Pieter Oud (1890—1963), builder of a number of housing projects in the 1920s, and Gerrit Rietveld (1888—1964), who began as one of the most original furniture makers of the century and went on to design the most remarkable structure of the movement, the Schroeder House, Utrecht, 1925. Oud had been associated with van Doesburg since 1917, the year of the movement's founding, and in 1919 he produced two sketch projects for a small factory. One of these has been widely reproduced since and cited as conclusive evidence of the fruitful coming together of the Wrightian strain of American modernism (the horizontal extension of forms and the dynamically balanced asymmetry of various parts) with the language of contemporary post-Cubist, abstract painting (the interlocking mesh of horizontal and vertical elements), a style dubbed Neo-Plasticism by Mondrian.

The nature of this mode, the precision in the use of various materials—some cheap and hard to maintain—the incisive contours separating part for part, together with the appearance of efficiency through repetition of elements, standardization of parts, and the absence of ornamentation, grew out of specific theoretical commitments combined with a loyalty to a compositional technique shared with painters and sculptors. This was a formal language developed as one of the first nonrepresentational styles in modern art. In the history of painting, the key figure was the solitary Mondrian; but for architects and designers the key *painter* is the energetic, gregarious van Doesburg. He was briefly the collaborator of the architects Cornelis van Eesteren and Rietveld in several projects of 1923, visionary schemes that had widespread influence upon actual buildings, then and subsequently. Had it not been for this intimate collaboration, it is doubtful that Rietveld's Schroeder House would have emerged as so encyclopedic a demonstration of the movement's aims and potential in architecture. Had it not been for

Oud's even earlier collaboration with van Doesburg, it is doubtful that his remarkable, posterlike facade for the restaurant-café De Unie, Rotterdam, 1925, would have possessed so graphic a stylistic imprint.

De Stijl produced numerous pronouncements and manifestoes to explain its universal goals. In 1922, Mondrian wrote on architectural problems: "Building and decoration as practiced today are compromises between 'function' on the one hand and the 'aesthetic idea' or 'plastic' on the other... the two will have to be combined. Use and beauty purify each other in architecture. ... Function or purpose modifies architectural beauty."[2] This effort to fuse art with life, imagination with reality, was phrased another way by van Doesburg and van Eesteren in 1923: "Art and life are no longer separate domains.... The word 'art' no longer means anything to us.... We demand the construction of our environment according to creative laws derived from a fixed principle ... linked with those of economics, mathematics, technology, hygiene."[3] These principles would include the creation of a balanced unity out of spatial contrasts and dissonances, the creation of a new dimension in space and time through the use of color, the creation of a final unity from the relating of dimension, proportion, space, time, and material, and the elimination of the interior-exterior duality through the breakup of enclosing walls.

There is, of course, a certain amount of pretentious cant in these lines by van Doesburg, but they provide a firsthand statement of the visionary and practical intentions fundamental to the creation of Rietveld's Schroeder House. His earlier furniture designs give more than a hint of the "assembled" look of the dwelling's exterior, with its projecting slabs on several planes setting in motion an otherwise static cube. Nonetheless, the crucial sources for the building are the imaginary architectural projects of van Doesburg and van Eesteren of 1923, multilayered, multiplaned, asymmetrically fused assemblages of rectangular cubes—their surfaces alternately voids, whites, grays, blacks, yel-

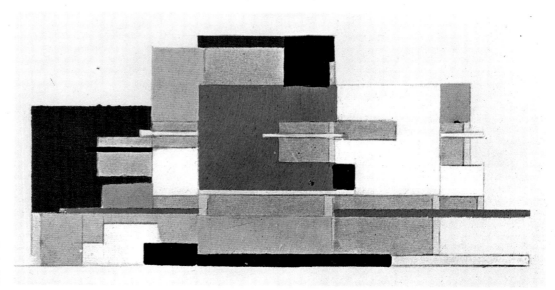

Theo van Doesburg. Color Study for a Building. 1922. Collection Mrs. N. van Doesburg, Meudon. 289

lows, blues, and reds. These projects and models, along with Rietveld's seminal masterpiece, are thoughtful projections into three dimensions of the carefully considered, stabilized imbalances of Mondrian's paintings of the 1920s (and of many of van Doesburg's as well) so that, in entering the living space of the Schroeder House, one has the sense of literally stepping into the pictorial world of Mondrian. It is a sensation that Mondrian would certainly have approved, to judge by photos of his Spartan studios in Paris and, subsequently, New York.

Compared to this artful, extravagant design, crammed with surprises and conceits and featuring such up-to-date contrivances as folding interior walls, thus rendering the space adjustable at the will of the occupant, the contemporary row houses of Oud, equally exemplary of De Stijl ideals, seem stark, uncontrived, and minimal. Such designs as the Kiefhoek, Rotterdam, 1924—27, imply an ideal life style, a sparse, Spartan materialism that is reflected not only in the privation apparent in Mondrian's studios but in the frugal dwelling ideals of Le Corbusier. This mode is, of course, a reaction to the crammed bourgeois interiors of the late nineteenth century, but it also represents an imposition of a kind of stark Bohemian existence upon ordinary inhabitants, plain

Vladimir Tatlin. Project for a Monument to the Third International. Original model 1920, destroyed; reconstruction of model, 1968. Wood and metal with motor, 15'5" h. Moderna Museet, Stockholm.
290

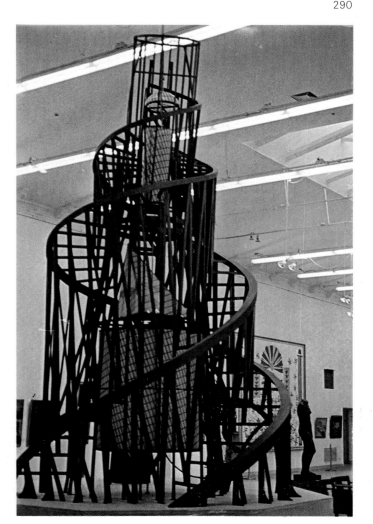

196

unadorned surroundings that were often the artist's lot not through choice but through deprivation. As will be seen later, this character, implicit in much housing of the 1920s, becomes an explicit subject, literally "represented" in Le Corbusier's houses of the period, where time and time again he uses the two-story space of the artist's studio as a crucial functional and compositional element.

The contribution of The Netherlands to the emerging International Style has sometimes been associated with the carefully arranged paintings of interior scenes of such seventeenth-century Dutch artists as Vermeer and Ter Borch, domestic spaces where doors and windows leading to other interiors, or opening out to the town and sky, imply spatial relationships that are characteristic of the new architecture. Strained as this analogy is, it does accord with the placid harmony of much Netherlands architecture of our day. Nothing could be more of a contrast with the equally original, equally International radical buildings of Russia in the same epoch, an architecture which was programmatically and socially revolutionary, at least for a brief period before the Stalinist reaction.

Since the creative flow begun in the 1920s was abruptly shut off as part of the purge and the Social Realist academic reaction of the 1930s, it is difficult to single out major figures, since individual careers had too brief a span for development. Some of the earliest Soviet projects are chimerical, but in a more rationally propagandistic way than the work of the Berlin Expressionists. Little was actually built because of economic difficulties, and that little often was constructed in a haphazard, unsatisfactory way. Vladimir Tatlin's tower, the Monument to the Third International, 1920, is an extravagant scheme comparable to the imaginary architecture of Sant'Elia and Taut and, also, lest it pass wholly into the realm of the fanciful, to the Eiffel Tower, that singular work of engineering vision that somehow, in the most prosaic and conservative of times, was actually erected. Tatlin's project, though never realized, was carried as far as a large-scale model. Unlike Eiffel's tower, Tatlin's was intended to contain three revolving architectural volumes of glass—in the shape of a cube, a pyramid, and a cylinder—spaces housing the various functions of the Communist International. They were to revolve at different speeds— year, month, and day—possibly to reflect the frequency of meeting of the various agencies. The 1,300-foot-high spiral frame, representing the advance of humanity, was an expressive, abstract warping of the contours of the Eiffel Tower, and one cannot help wondering if Tatlin had not been inspired for his "invention" by Robert Delaunay's numerous Cubist alterations of its structure.

Tatlin's extravaganza is representative both of the Utopian urges of the postarmistice period elsewhere and of the distinctive role that architecture was to play in the new Soviet state. Other achievements of Russian architecture in the 1920s include the development of new programs and

pl. 290

plans for housing, featuring the inclusion of a number of collective services within blocks of flats such as canteens, implying a broad reorganization of urban family life and social relationships—transformations that never came about on a large scale. However, some of these concepts were later adapted by Le Corbusier and incorporated in his schemes for large collective dwellings in the West, with predictably meager social results though designed with consummate panache—one of the finer ironies of contemporary architecture! Of the Russian architects, Alexander, Leonid, and Victor Vesnin were among the most prominent with their project of 1923 for the Palace of Labor, Moscow, which would seem to have provided a more functional, though less monumental, resolution to the program of Tatlin's tower. Quirkier is their *Pravda* project of the same year, a mini-skyscraper of varied rectangular shapes, its twin elevators manifestly visible (shades of Sant'Elia), and banner-headline lettering the principal decorative feature.

By 1925, the new Russian architects were ready to demonstrate their achievements abroad in the Paris Exposition des Arts Décoratifs, where Le Corbusier would also be an exhibitor and, stylistically, an equally alien one. Konstantin Melnikov was the architect of the Soviet Pavilion, a small wood building with large glazed areas and a diagonal roof structure echoing the diagonal path of the stair cutting through the partly open structure. In addition to constructing for himself, in

1929, one of the rare private dwellings of the time in Russia, a unique double-circle plan with a large studio window and numerous smaller hexagonal ones, Melnikov participated in the design of workers' clubs, the so-called social condensers in the often immoderate party language of the period. The most remarkable of these was the Rusakov Club, Moscow, 1928—29, notable for its exterior volumes, slanted, projecting shapes that contained the three separate balcony areas of the theater interior, the division accounting for the fact that it could be divided into three spaces or opened into one—a preoccupation with the possibilities of transformable spaces that we have already seen in the living area of Rietveld's Schroeder House. Of the other clubs, the Professional Workers' Club, Lesney Street, Moscow, 1926, by Ilya Golosov (1883—1945), is notable for its dramatic contrast of glass cylinder with concrete slabs and rectangles, though its exterior is not so startlingly revealing of its interior as is Melnikov's.

El Lissitzky enjoyed a special, international prominence in Russian architecture during this period when, visiting Germany in the 1920s, he came in contact with De Stijl and the Bauhaus, encountered Moholy-Nagy and Mies van der Rohe, founded groups and magazines, and spread Russian Constructivism through all these contacts. He was the designer of several important projects, including the Skyhook towers, a 1924 project for novel skyscrapers—done in collaboration with

pl. 292

pl. 291

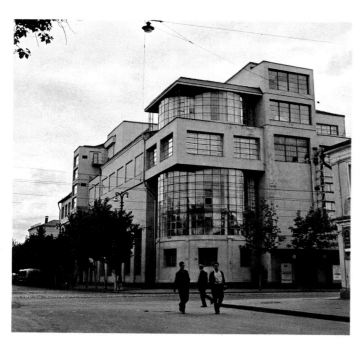

Ilya Golosov. Professional Workers' Club, Lesney Street, Moscow. 1926. 291

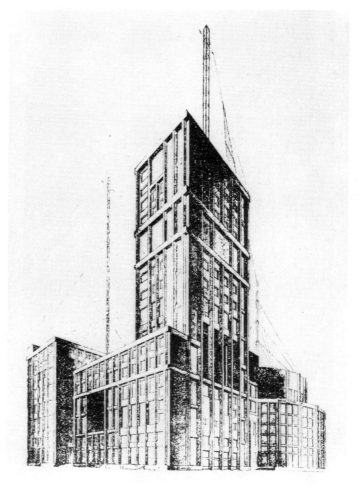

Alexander, Leonid, and Victor Vesnin. Project for the Palace of Labor, Moscow. 1923. 292

Mart Stam—in which tall elevator shafts supported large volumes of working space above the skyline of the city, thus necessitating only a minimum of demolition to insert these mammoth new buildings into the existing urban fabric. Mention should also be made of the architectonics of the abstract painter and sculptor Kasimir Malevich, founder of Suprematism, fantasies whose forms suggest the distinctive geometries of the International Style as well as the autonomous, unrelated geometric massing of American ziggurat, or setback, towers of the 1920s. If Soviet design was given to a certain extravagance, surely, in part, a byproduct of the economic and bureaucratic, difficulties encountered in actual construction, much of it was aimed at re-equipping Russian society for its leap into the industrial age. While Russians like Lissitzky traveled abroad to spread ideas, foreigners came to Russia to engage in actual building. From the Bauhaus came Hannes Meyer, Gropius's successor as director (not to be confused with his partner, Adolf Meyer), and from The Netherlands and the fringes of De Stijl came Mart Stam, who had participated in the Stuttgart Weissenhof project in 1927.

But of all the European architects who traveled to Russia, the most successful was Le Corbusier. In 1929, he was commissioned to build the Moscow headquarters of the organization of co-operatives, the Tsentrosoyuz, a spectacular glass-walled composition of three interconnected slabs, crystalline forms raised on *pilotis*, or stilts, much as he was doing in the contemporary Villa Savoye. This was the architect's largest work actually built before World War II and preceded an invitation to participate in the competition for the design of

pl. 293

the Palace of the Soviets, 1931, a program that must have evoked memories of Tatlin's tower in the minds of many. It certainly did in the case of Le Corbusier, as his vast project, with the volume of the large auditorium suspended from a colossal parabolic arch, is clearly of the same techno-expressive, Constructivist genre as the earlier monument. There were other solid, contemporary-style projects by Gropius and Mendelsohn, but they were somewhat conventionally ponderous, if otherwise modern. Le Corbusier's extraordinary scheme was certainly the most daring, far-reaching effort by a proponent of the new architecture in the realm of symbolic, public governmental buildings. Programmatically it was the twentieth-century equivalent of the nineteenth-century Neo-Gothic London Houses of Parliament or the neoclassic Washington Capitol. Yet the forms of Le Corbusier's Palace of the Soviets grew out of an already-rich modernist tradition, its infrastructure drawn from Tatlin's scheme and the Constructivist sculpture of Naum Gabo. The architectural details came from the vocabularies of Purism, the Bauhaus, factory architecture, and experimental theater and exhibition design. Long recognized by critics and historians, but still only incompletely appreciated, Le Corbusier's unsuccessful project for this competition possesses historical importance equal to Bramante's unrealized central plan for St. Peter's. It draws together innumerable facets of a new style, then just reaching its full potential, into an ideal scheme that unfortunately exceeded political, if not architectural, realities— a crucial event for just that reason, since it probed and extended the frontiers of creative possibility.

The winning entry in the 1931 Palace of Soviets competition was not one of the several by leaders of the modern movement, Russian or otherwise, but a wedding-cake project by Yofan, Gelfreikh, and Shchuko that signaled the onset of the architectural reaction of the 1930s, a movement of international scope, represented in Nazi Germany by the neoclassicism of Troost and Speer; in Italy by Mussolini's Third Rome, the architecture of Piacentini and the ill-starred EUR; in Geneva by the League of Nations Palace, constructed by an international committee of academicians following the intrigues that had discarded Le Corbusier's project; and, in the United States, by the banal classicism of New Deal Washington, culminating in the Pentagon, 1943. It is an immeasurable

pl. 295

catastrophe that the new architecture was checkmated at the very moment that broad public success seemed near at hand. Never before in history

Le Corbusier and Pierre Jeanneret. Project for the Palace of the Soviets. 1931. Model. Collection The Museum of Modern Art, New York. 293

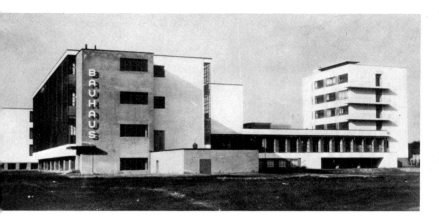

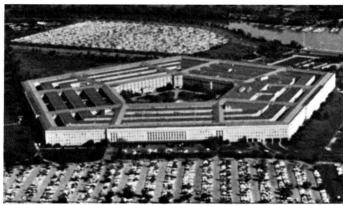

Walter Gropius. Bauhaus, Dessau. View from northwest. 1925–26. Photograph courtesy The Museum of Modern Art, New York. 294

Pentagon, Washington, D.C. Airview. 1943. 295

had the majority of political institutions been so inflexibly massed against the creative talents of the architectural profession, an art and a science that even the most repressive regimes had used effectively in times gone by.

The academic and Social Realist aspects of the Yofan-Gelfreikh-Shchuko project for the Palace of the Soviets, itself unexecuted because of other priorities in the Soviet state, brought together just about all the current platitudes imaginable: the Eiffel Tower and the Empire State Building were to be exceeded in height; the statue of Lenin seems as colossal as the Franco-American Statue of Liberty; and the terraced, layered design seems more inspired by the set-back profiles and proportions of large-scale "modernistic" skyscrapers in the capitalist United States than by the ambitious socialist dreams of earlier Russian Constructivism or the crisp, energetic silhouettes of the International Style, now denounced in the Union of Soviet Socialist Republics as formalist and individualistic.

German modernism suffered a similar fate in the early 1930s when the best architects were driven into exile, where they sowed the seeds of a postwar revival. However, for a brief period, the Bauhaus, Dessau, 1925—26, by Gropius, served as the Sainte Chapelle of modern building, providing in its educational plant a paragon of modern design and offering in its curriculum the ultimate model for the postacademic "academy." Though sadly mutilated after its closing, the buildings of the Bauhaus, a multiwinged block consisting of offices, classrooms, workshops, and dormitories, with each interconnected pavilion distinct in shape and the whole organized like the blades of a windmill about an imaginary hub, formed a key part of modernism's classical canon. It would seem that Gropius had here simply picked up the thread of the new architecture, especially the glazed, transparent mode that they had developed before the war in their factories at Alfeld and Cologne. In reality, the path leading to this rational, even functionally stark, Bauhaus "style" (an application of the term which its members would have found repugnant, since their goals

pl. 294

were beyond any single style, was much more complicated.

In 1918, Gropius was a member of various action groups in Berlin, and, although no fanciful, Utopian projects from his pen are known, he was an articulate pamphleteer. "Artists," he wrote, "let us at last break down the walls erected by our deforming academic training between the 'arts' *and all of us will become builders again!* Let us together will, think out, create the new idea of architecture."[4] These lines were written just as Gropius was preparing to take over the Weimar Bauhaus, whose ideals were originally conceived in a spirit of stylistic independence but, nonetheless, within the emotional and esthetic climate of Expressionism. "The ultimate aim of all visual arts is the complete building! ... Today the arts exist in isolation, from which they can be rescued only through the conscious, co-operative effort of all craftsmen.... The old schools of art were unable to produce this unity.... They must be merged once more with the workshop.... Architects, sculptors, painters, we must all return to the crafts! For art is not a 'profession.' There is no essential difference between the artist and the craftsman."[5] The very name Bauhaus, deliberately chosen by Gropius to identify the uniqueness of his new school—a union between an academy and a craft school—resembles the German word for the medieval cathedral master-mason's lodge, the *bauhütte*.

Gropius's change during the next few years is explained by his encounters with other masters of the modern movement and the development of an encyclopedic awareness of the new rational style. During his travels, Gropius met van Doesburg, who settled briefly in Weimar in 1922, causing some dissention among faculty and students but apparently influencing a stylistic shift there, the source and importance of which have long been a matter of contention. The Dessau buildings of 1925—26 can be analyzed either as a nonacademic evolution by Gropius and Meyer from their prewar factories, which preserved traces of Behrens-like classicism in the midst of a progressive, innovative use of glass, or as constructive adapta-

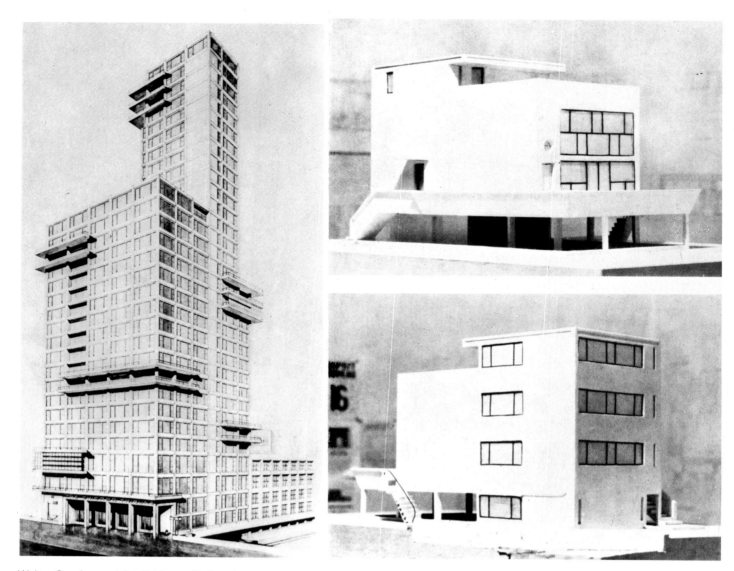

Walter Gropius and Adolf Meyer. Project for the Chicago Tribune Tower. 1922. 296

Le Corbusier. Second Citrohan House. Model. 1922. 297

tion of the asymmetrical cubic assemblies of van Doesburg and his Dutch associates. In fact, both inspirations would seem germane.

In Gropius's statement, "Principles of Bauhaus Production," 1926, new concepts supplement the earlier ideals, concepts that nicely match the commitment to an architecture of glass, concrete, and right angles: "The Bauhaus wants to serve in the development of present-day housing, from the simplest household appliances to the finished dwelling. . . . Modern man, who no longer dresses in historical garments but wears modern clothes, also needs a modern home. . . . An object is defined by its nature. In order, then, to design it to function correctly . . . one must first of all study its nature . . . it must fulfil its function usefully." Moreover, he goes on to call for "a resolute affirmation of the living environment of machines and vehicles . . . the limitation to characteristic, primary forms and colours," and asserts, "The creation of standard types for all practical commodities of everyday use is a social necessity." [6] Clearly Gropius has been affected here by De Stijl, by a rethinking of Futurism, and by the hortatory writings of Le Corbusier where, among other things,

an enthusiasm for the machine, for the painstaking analysis of all objects, however humble, and for standardized elements, is crucial. Gropius's style and ideas became purified by the mid-1920s, but, ironically, this seems to have been accomplished by an eclectic receptivity to the works of his contemporaries. So, the Bauhaus, cited above as the Sainte Chapelle of the new architecture, is also, to coin a Bolshevism, an "artistic condenser," an artist's union where many threads came together. Interestingly, if architecture was considered there to be a kind of ultimate art, it was not at first a formal part of the program, Gropius having postponed its creation until after the first generation of students had been formed in its unique ateliers, where two masters held forth simultaneously, one a form giver, like Klee or Kandinsky, the other the master of the particular craft in question.

In 1928, Gropius resigned as director, turning the post over to Hannes Meyer, to devote himself to his architectural practice. His unsuccessful project, with Adolf Meyer, for the Chicago Tribune Tower of 1922, the first international competition of the decade that would presage the relentless

pl. 296

200

determination of those hostile forces ranged against the new architecture, marked his abandonment of any lingering Expressionism. After the construction of the Bauhaus, Gropius's most revealing work were the flats at Siemensstadt, Berlin, 1929, whose extensive horizontal four-story facades are typical of the high level of collective housing of this epoch in the German capital, work by architects such as Taut, Scharoun, and Hugo Haring, as well as Gropius. The advent of the Nazi regime put an end to this endeavor, and Gropius departed in 1934 for England where he worked in association with the pioneer British architect E. Maxwell Fry. Although Britain had been a leader in the development of both eclectic and industrial architecture during the nineteenth century, the generation of Voysey and Mackintosh had no immediate successors, and, in the years just before 1914, their commissions became increasingly rare. It was only in the 1930s that the new architecture took root as a foreign import. Gropius's timely arrival gave support to a fledgling movement that was spurred on by partnerships like Tecton, led by the Russian émigré Berthold Lubetkin, who gained fame through their Highpoint Flats, Highgate, Hampstead, 1933—35, and their Penguin Pool at the Regents Park Zoo, London, of the same years; or by Connell, Ward, and Lucas, who built a series of still much-admired houses in studied emulation of the new Continental manner. Soon Gropius was joined in exile by Mendelsohn and Marcel Breuer. However, the gathering clouds of a new war dispersed these wanderers once again in the late 1930s to the United States, where they re-established their careers on firmer ground, in a land that was itself just becoming curious about the new European architecture.

Crucial to the establishment of what was to become the International Style was Le Corbusier, already mentioned here as the architect of the Villa Savoye, virtually a sacred shrine of the new style, the architect of a Moscow ministry, and the designer of a spectacular scheme for the Palace of the Soviets. Le Corbusier is the Prometheus figure of the movement, an artist of Leonardesque proportions, much of whose work has either been lost or mutilated, or has remained unbuilt. His concepts, first formulated in the esthetic of Purism, are more comprehensive than those of the Expressionists' idealism, De Stijl's universalism, or Gropius's early aspirations. The English translation of the title of his first book, *Towards a New Architecture* (*Vers une Architecture*), errs grievously by the seemingly innocent insertion of the word New since Le Corbusier's subject was the common ground between all architecture. He was not intent upon creating a revolutionary architecture per se; for him there was an inexorable choice: "architecture *or* revolution."

Le Corbusier represents a peculiar, idiosyncratic fusion of ideals drawn from two seemingly opposed sources: the French classical tradition of Descartes, Poussin, Racine, Versailles, the Place de la Concorde, and even the Beaux-Arts, on the one hand, and, on the other, the new tradition in art and literature of Courbet, Baudelaire, Manet, Symbolism, and, more recently, Cubism and Futurism. Consequently, he is the most complete and integrated figure of his generation in architecture and the most intellectually gifted and influential creator and disseminator of the new formal language. Architecture was for him a mistress, a religion, to a degree that is virtually without precedent: "Architecture is the first manifestation of man creating his own universe, creating it in the image of nature, submitting to the laws of nature, the laws which govern our own nature, our universe." [7] For Le Corbusier the ultimate game of architecture may not have resided solely in the creation of visionary cities, which he so fluently conjured up with his pen, but equally in his private rivalry with such matchless monuments as the Parthenon, the houses of Pompeii, the works of Michelangelo, and that notable symbolic achievement of contemporary engineering, the cylindrical, concrete grain silo—those granaries of the modern world that a primitivist like Adolf Loos might have ironically likened to the corresponding mud-plastered structures of tribal Africa.

The litany that opens *Vers une Architecture* is as important for the lapidary economy of its prose style as for its substantive content:

> The Engineer's Aesthetic, and Architecture, are two things that march together and follow one from the other: the one being now at its full height, the other in an unhappy state of retrogression.
> The Engineer, inspired by the law of Economy and governed by mathematical calculation, puts us in accord with universal law. He achieves harmony.
> The Architect, by his arrangement of forms, realizes an order which is a pure creation of his spirit; by forms and shapes he affects our senses to an acute degree ... he determines the various movements of our heart and of our understanding
> Our eyes are constructed to enable us to see forms in light.
> Primary forms are beautiful forms because they can be clearly appreciated
> The great problems of modern construction must have a geometrical solution
> The Plan is the generator.
> Without a plan, you have lack of order and wilfulness
> A great epoch has begun.
> There exists a new spirit. [8]

Le Corbusier's frugal prose matches the style of his projects and buildings of the 1920s. His measured, rhythmic version of the International Style and his subsequent plastic inventions invariably contained an idealistic substructure, possessed implicit goals that went far beyond the momentary realization of the specific building, and hinted at urban or environmental consequences beyond the building's four walls—later to be realized in projects for the ideal city.

Fundamental to this is his concept of the individual dwelling unit, a minimum space arranged for livability. Le Corbusier's prototype, the Citro-

han House project, 1921—22, was as revolutionary as some of the housing ideas that would be developed in Russia at the time, yet was based upon some remarkable sources: the two-story artist's-studio living space is taken over from the familiar ateliers of Parisian artists and mechanics; moreover, it has been proposed that this form is akin to the ancient Mycenaean megaron, the planning type of almost legendary antiquity comprising the apartment unit familiar from the Cretan palace and, still more important, the antecedent of the porticoed Doric temple. The Citrohan House illustrates the five points of his architecture, principles that are characteristically more actual than abstract, more a matter of concrete building components than of universal categories. The five points are: *pilotis*, raising the building above the ground; the roof terrace, functioning as garden and outdoor recreation room; the free plan, achieved by interior walls independent of structural supports; the free facade, a concomitant of the previous point, its composition liberated from repeating the structural frame; and, finally, the continuous, horizontal window, a point virtually synchronous with the free facade. These elements remained in various guises in nearly every project or building until the end of his career, with the exception of those few instances when the nature of the vault or covering did not permit a flat roof. Together with certain secondary features, such as his use of gently inclining ramps, multistoried spaces with galleries, and the like, these elements may be thought of as Le Corbusier's "order," much as such elements as base, shaft, capital, entablature, and pediment comprise the order of a columnar Greek temple.

Though he built a number of houses in the 1920s, each a special demonstration of his spatial and formal resourcefulness, Le Corbusier's most important manifestation of domestic architecture was the temporary Pavilion of *L'Esprit Nouveau*, sponsored by the avant-garde magazine that he had cofounded and edited since 1920, erected at the 1925 Paris Exposition des Arts Décoratifs (from whence the contraction Art Deco). A rethinking of the Citrohan House type, featuring an outdoor terrace-balcony to one side and at the same level as the main two-story living area, it could be considered as either a detached private villa or as the individual component of a multiple dwelling. It was Le Corbusier's response to the problem of confinement encountered in the conventional urban flat, to provide space, air, and direct contact with the green landscape—since it was his intention that these units be assembled as multistoried terraces in an urban context in which all buildings were set in a park. At this same exposition he showed his Voisin plan for Paris, a scheme for the total reconstruction of the Right-Bank commercial center of the French capital that was adapted from his more schematic, philosophical project of 1922, A Contemporary City of Three Million Inhabitants. pl. 298

Le Corbusier's villa type of 1925 and its various predecessors, or the various houses actually constructed at the time, are basic components of his vision of the city, tailored to fit with precise tolerances, as in a car, ship, or plane. For the business district of his city he took over the American tall office building, but characteristically rationalized it into his Cartesian skyscraper. When he visited New York in the 1930s he quipped to reporters meeting him at the dock that the skyscrapers were not big enough—good bait for gullible journalists, but also his elliptical way of saying that it was the concept, not the actual bulk, of Manhattan's towers that was wanting for grandeur. For his ideal City of Three Million, as for the later Voisin plan and still later Radiant City variants, Le Corbusier visualized a regular parade of uniform, fifty-story glass skyscrapers, cruciform in plan, isolated on verdant superblocks between networks of freeways with limited-access approaches. Vehicular traffic was separated into isolated levels so that the

Le Corbusier. Project for A Contemporary City of Three Million Inhabitants. View of center. 1922. 298

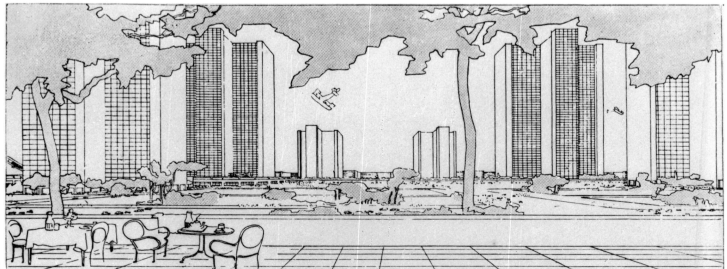

Giuseppe Terragni. Casa del Fascio, Como Italy. 1932–36.
299

pedestrian could stroll across terraces and through parks free of the menace of traffic. Beyond this center were vast ribbon terraces of houses five stories tall. Significantly, the plan for this contemporary city was firmly rooted in tradition. Much had been adapted, albeit vastly enlarged, from Ebenezer Howard's Garden City scheme of 1899, but, faithful to the traditions of his adopted land, Le Corbusier employed a Versailles-like street network, star-shaped, with avenues radiating from the center, with a superimposed rectangular grid—a planning technique that had been employed with varying results from Paris and Washington to New Delhi and Canberra. Sant'Elia's Futurist City was also of great help.

Le Corbusier and his supporters might later argue that these schemes were but diagrams, that in execution the Cartesian skyscrapers might be the different works of different designers, and that the plans would bend to circumstances; but to little avail. The hypnotic, classic ironically academic rigidity was an indelible image and was instinctively likened to totalitarianism by many who might otherwise have been sympathetic to the ideals. And, by applying it to Paris, he brought down a fury of abuse matched only by that provoked by Eiffel two generations earlier because he had dared to tamper with the sacred skyline of the historic city. Le Corbusier's threat was a mere paper one; at this time no one was equipped to carry out the proposals.

Le Corbusier's unflagging plastic invention, and his disciplined composition of abstract elements possessing an uncanny, classic certainty, cast into deep shadow the works of several deserving radical contemporaries working in France. However,

they lacked his polemical flair and could not match the broad sweep of his philosophy. Indeed, the only European architect of the epoch who could match him in formal composition was Giuseppe Terragni (1904—1942), designer of several houses and apartments in Como, Italy, as well as of the Casa del Fascio there, 1932—36. pl. 299 The youngest of the masters of the heroic International Style, Terragni's work was possible in a totalitarian Italy since the authorities there were somewhat vacillating and inconsistent in their repression of radical cultural manifestations. The rhythmic articulation of his facades in regular, modular bays is characteristic of his distinctive style, and the projection and recession of surfaces indicate a compositional system different from that of Le Corbusier's free plan and free facade, a system that seems more akin to Renaissance notions of order.

Le Corbusier's unique position in French architecture also obscures the achievement of the Art Deco mode popularized at the 1925 exposition. It was an impure, mod-eclectic style, officious, if not exactly official, which had partly supplanted academic Beaux-Arts classicism in the 1920s. This mode not only invaded the realm of the decorative arts but also touched that of monumental architecture, not just in France; it had widespread consequences in the United States, where it strongly influenced designs of large-scale office buildings by Beaux-Arts-trained architects looking for an alternate to the familiar historical modes. Indeed, an echo of Art Deco's chic, up-to-date quality can even be detected in the reactionary architecture of Italy, Germany, and Russia in the 1930s, where established proportions and ex-

act classical detail were typically altered, attenuated, and simplified. In the midst of this stylistic chaos, featuring a ravaged, esthetically ineffectual academic tradition, rife with a pathological uncertainty as to the appropriate stylistic choice or direction, Le Corbusier, the Bauhaus, and several parallel or related movements of the 1920s offered the profession and the public an articulate, resounding architecture whose distinctive style, for all its limitations and immaturity, was an integral part of the art and science of the twentieth century.

Astoundingly, this new architecture, which proposed to resolve the technical and plastic quandaries, as well as the menacing urban and environmental problems of the day, with functional and monumental solutions, was generally rejected. Subsequent critics and historians may have deplored this negative, reactionary trend, but they have also been too free with petty, if obvious, criticisms of the new architecture's social, technical, and formal shortcomings to realize the unprecedented magnitude of the disaster, which, for the first time in history, deprived an entire emerging civilization of an architecture rightfully its own. The cumulative effects of this rejection so traumatized the modern movement that when, belatedly, recognition was finally accorded, a generation later, the earlier proponents could only respond in a way that was largely private and self-indulgent. They could create personal masterpieces attesting to their own design capacity, but they were no longer inclined to provide useful guidance to younger architects, many of whom were uncertain whether to accept or reject the earlier modernist tradition, which had fallen on evil days only a decade after its initial successes.

If Le Corbusier, the most protean inventor of modern architecture, was, for historical as well as personal reasons, the great creative loner of the day, in contrast to Gropius, there is a solitary, isolated quality to the taciturn Ludwig Mies van der Rohe as well. Both men maintained very private lives, but Mies went further, revealing his professional thought in only a few impersonal formulas and distilling an architectural style that became so concise and simple (or simple-seeming) that, at the end, it appeared reduced to a least common denominator. He was as concerned with eternal verities as was Le Corbusier, though his manner of address was not as hortatory. His comments on the contemporary situation, made in 1930, reveal an attitude more detached and dispassionate than most: "The new era is a fact.... But it is neither better nor worse than any other era. It is a pure datum and in itself neutral as to value.... Let us also not overestimate the question of mechanization, standardization and normalization.... All these things go their destined way, blind to values." [9] Although Mies's work, even from an early date, seemed more narrowly formalist than most, he was, in fact, concerned with the more generative aspects of architecture:

I do not oppose form but only form as a goal....
Form as a goal always ends in formalism. For this

striving is directed not towards an inside, but towards an outside....

Only intensity of life has intensity of form....

We do not evaluate the result but the starting point of the creative process. Precisely this shows whether the form was discovered by starting from life, or for its own sake.

That is why I consider the creative process so essential. Life is for us the decisive factor. [10]

He preferred his buildings to be good rather than novel or inventive. Sometimes his works seem bland or uninteresting, though this fault, more properly, should be laid at the feet of his often inept imitators who have thoughtlessly repeated his formulas ad infinitum, producing bowdlerized clichés.

His earliest projects after 1918 were Expressionist glass skyscraper projects, down-to-earth versions of Taut's glass architecture, or studies of country houses in brick or concrete and glass in which the geometric austerities of De Stijl were used to clarify the open plans of Wright's Prairie Houses, much admired and emulated at the time. There is little invention here, but much condensation, and, in a work such as the Barcelona Pavilion, 1929, an exhibition structure built for the German marble industry, much jewel-like precision. This open structure, with its unrestricted flow of space and its hovering, overhanging slab roof reflected in the podium's pool, representative of Mies's view of the ideal dwelling, should be compared to Le Corbusier's ideal dwelling, the Citrohan House project. The latter was intended as a machine for living; Mies's pavilion did not aim to be a house in the functional sense of a habitation, but a more abstract shelter of a stylish, artful sort. In the Barcelona Pavilion, the *style* of modern architecture has become the subject and content of the building. The style is no longer expressive of function but is used by Mies in a lyrical way, much as an eclectic architect might select a given historical style for expressive effect. This metamorphosis was, of course, a great artistic achievement for which Mies deserves credit—*but*, it proved to be the Trojan Horse of the new architecture when his style was later taken over by less disciplined designers. Lacking the intense moral purpose of Mies, more commercially inclined imitators have travestied his forms. They have largely overlooked his feeling for space, scale, and proportion and, through their endless repetitions of the steel and glass package, have sullied the reputation of one of the most meditative architects of the early twentieth century. His perception of a universal, open, flexible space is as fundamental to modern architecture as is the free plan of Le Corbusier.

Although it confuses issues to acknowledge that there was an innovative aspect within the Beaux-Arts tradition during this period—a tentative American venture related to Paris Art Deco—it nonetheless helps explain the compromising circumstances under which the new architecture itself was much later—after 1950—accepted as the commercial norm in the United States. One

pl. 300

Ludwig Mies van der Rohe. German Pavilion, International Exhibition, Barcelona. 1929. Photograph courtesy The Mies van der Rohe Archive, The Museum of Modern Art, New York. 300

Shreve, Lamb, and Harmon. Empire State Building, New York. 1930–31. 301

should hasten to add that this movement was altogether distinct from the later work of that elder pioneer, Frank Lloyd Wright, or from the emerging International Style in the United States, then largely centered in southern California. This somewhat autonomous development, neither radical nor academic, was focused upon the continuing, vexing problem of skyscraper design. Historians have tended to assume, but with incomplete evidence, that the early Chicago style of the 1890s, with its expressed skeletal frame, was *the* right solution and that subsequent mercantile classicism and its companion Gothic idiom were altogether false paths with no exit. Moreover, until recently it was felt that such "modernistic" successors of twentieth-century urban eclecticism as New York's Chrysler, 1928—30, and Empire State, 1930—31, buildings are flawed, unworthy of consideration alongside the skyscraper proposals of Mies, Le Corbusier, and other European pioneers. Such a view is much too simplistic and overlooks the fact that the architects of these American commercial edifices of 1918—39, academically trained either at home or abroad, were interested in a variety of new movements, mostly non-International Style ones, such as the romantic brick architecture of Germany and The Netherlands, a remnant of Expressionism, as well as the more innovative aspects of Art Deco as it spread from Paris to London and across all of Europe. In fact, the greatest Art Deco ornament on the exteriors of monumental buildings is to be found on the skyscrapers of American cities.

pl. 301

Significantly, it is in American architecture of the 1920s and 1930s that the actual confrontation with the question of skyscraper construction took place. In Europe it was, to all intents and purposes, a question of theory, of conjectural projects, and, for an architect like Le Corbusier, of polemic. The skyscraper is the unique architectural genre invented by modern Western architecture, as distinctive as the pyramid to Egypt, the colonnaded temple to Greece, the pagoda to China and Japan, the tepee to the American Plains Indian. Yet the characteristic architectural mode of our time, the European International Style and its progeny, evolved along a largely independent course, taking over the American-developed skyscraper type when it finally served its purpose. Indeed, the ultimate coming together of the new building type and the new style is achieved only in the 1950s. Until then, we are really confronting two separate histories with an interesting set of conflicts and relationships. It is worth remembering that such pioneers as Gropius and Le Corbusier are not thought of as architects of skyscrapers, except in their unexecuted projects, and that, of the key masterpieces of the new architecture, none are towers, again, save for projects. Mies is the chief exception to this rule, and, indeed, it was through his honed-down, reductive style of metal and glass that the tenets of the International Style were universally, if tardily, adopted for urban high-rise structures.

The history of the tall office building has been influenced to a greater degree by real estate spec-

ulators, financial institutions, aggressive patrons, and even municipal regulatory codes than by architectural designers. The visionaries of the genre, in one sense, were skyscraper builders like Frank Woolworth and Colonel Robert McCormick, patrons who were more responsible for the Gothic fantasies of the Woolworth Building, New York, 1913, and the Tribune Tower, Chicago, 1923, than their malleable Beaux-Arts-trained architects, Cass Gilbert for the first, Raymond Hood for the second. Hood, one of the few who might be called venturesome, if not pioneering, in the context of American architecture during the 1920s and 1930s, stated that he was unsure of the style that was appropriate to a skyscraper, and it is reported that this designer of Gothic, Art Deco, and International Style towers was also an admirer of Le Corbusier's projects. But in spite of a 1932 exhibition at the Museum of Modern Art, New York, many architectural critics cast doubts on the importance of the International Style, and, for a decade more, it remained a mode popularly associated with contemporary art but not with contemporary American building. The one clear-cut exception is the distinctive Philadelphia Savings Fund Society Building, 1931—32, designed by George Howe (1886—1955), a renegade eclectic, and the Swiss architect William Lescaze (1896—1969), who brought direct knowledge of the new style to the development of this edifice. Hood's McGraw-Hill Building, 1930—31, featuring horizontal bands of windows and blue-green cladding tiles, contradicts the inherent verticality of the form and the recent tradition of American skyscraper design that virtually mandated vertical window strips. The skyscraper thus remains a genre slow to be drawn into the history of modern architectural design, an essentially American phenomenon like the suburban cottage or villa— open to the space and light of nature—culminating in the Prairie Houses of Wright.

The ideals of American architecture during the first third of the century are represented by the extravagant drawings of an architectural renderer, Hugh Ferriss (1889—1962), whose services were used by many architectural firms of the day. In 1929 he published *The Metropolis of Tomorrow*, which reproduced a selection of his shadowy, twilight renderings of recent skyscrapers along with several schemes showing how to gain maximum enclosure advantage with the new building codes mandating that skyscrapers be set back from the street a certain distance beginning at a specific height. These drawings, done in collaboration with the architect Harvey Corbett, later one of the designers of Rockefeller Center, became the models for the legions of site-filling ziggurat buildings that gave the New York skyline its characteristic silhouette during the next few decades. In the final part of Ferriss's book, "An Imaginary Metropolis," he seeks to associate the image of the skyscraper with the legendary splendors of the

pl. 302

pl. 303

past, a vision worthy of comparison with the contemporary cinematic visions of D. W. Griffith, Cecil B. De Mille, and other Hollywood masters. Looking like romantic archaeological reconstructions, and sharing their unreality with the less ponderous visions of Berlin Expressionism, Ferriss's tower cities seem the murky opposite of Le Corbusier's luminous Radiant City of glass, concrete, and verdure. True, the style of his renderings makes the forms seem too obscure and remote, perpetually lost in shadow, much as the opposite is true in the sharply lined ink drawings of Le Corbusier, where an even, shadowless solar light perpetually reigns.

One of the inherent problems of the skyscraper was that its form was so prone to romanticizing, either in picture or prose. In varying degrees and directions, Sullivan, Ferriss, and Le Corbusier are all answerable in this respect, and, indirectly, each is responsible for the urban blight that has been generated by the high-rise. Only recently has it been recognized that the skyscraper, seemingly the most original characteristic architectural form of the industrial-age city, is a contradictory beast possessing numerous destructive antiurban features. The contents of its vertical mass require services which the network of choked city streets is hard-pressed to provide, especially when that street system is one of an earlier century, meant originally to service an architectural horizon of no more than four or five stories. Even allowances for pedestrian plazas and underground parking at the foot of towers frequently exceeding fifty stories are woefully inadequate. More comprehensive efforts at planning, in which tall buildings are situated on vast, often elevated plazas that would seem to provide sufficient space above and below ground for the necessary services and urban amenities, have their own inherent vices since such buildings tend to cut themselves off from the established urban network of streets and services. The plazas turn out to be lonely, windswept wastelands of pavement, as alienated from the city as the buildings they are meant to serve, fragments of a Radiant City that cannot work out of context. Presumably, buildings came to be as high as they are because of pressing economic reasons. However, many of these now seem to have come about through manipulative speculation, created more to drive up property values, and, concomitantly, to raise the tax rolls of financially strained municipalities, than merely to answer the need for more space at less cost in a desirable location. The characteristic form of the industrial-age city, providing much of its characteristic sublime splendor, is equally the instrument of its relentless decay.

Frank Lloyd Wright carried on a profound love-hate relationship with the city during the last half of his life. During the construction of the Tokyo Imperial Hotel he settled temporarily in pl. 93 Los Angeles, where he worked on a number of extraordinary houses that were thoroughly unlike his Prairie dwellings. Built up of a patterned concrete block, they lacked the broad overhanging eaves of the Midwest, their sculpted forms distantly inspired by pre-Columbian monuments and the adobe architecture of the Southwest. Their individuality contrasted with the prevailing bungalow and Spanish colonial revival popular in the area, and their opaque monumentality was at variance with the fragile, open forms of the International Style, which would soon be introduced into southern California by two Austrian architects, Rudolph Schindler (1887—1953) and Richard Neutra (b. 1892). Ironically, the former had worked as a close associate of Wright's before striking out on his own in the early 1920s, and the latter, who came to the United States at Schindler's urging, spent a few weeks in transit at

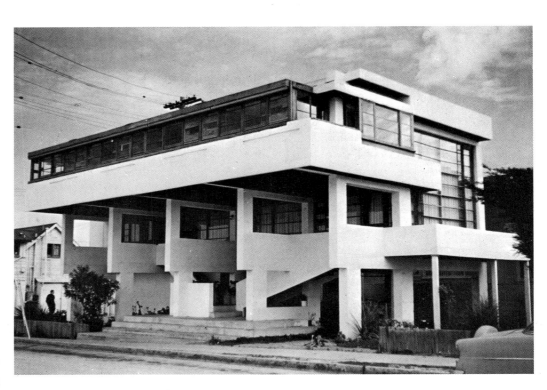

Rudolph Schindler. Lovell House, Newport Beach, Cal. 1926.

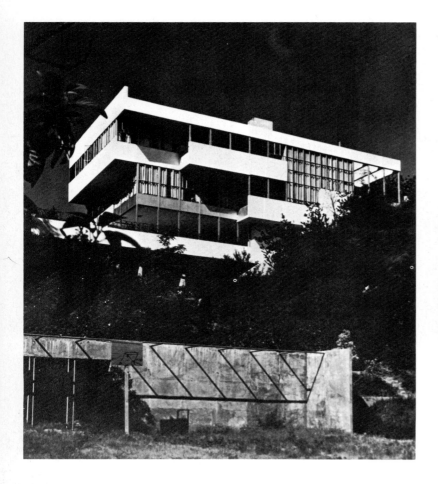

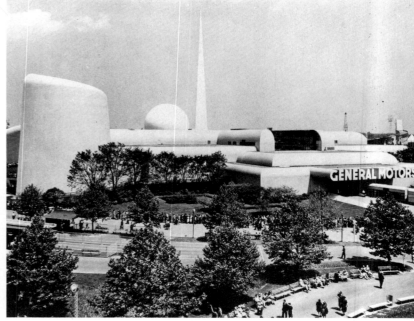

Norman Bel Geddes. General Motors Futurama, New York World's Fair. 1939–40. 306

Richard Neutra. Health House (Lovell House), Los Angeles. 1927–29. 305

pl. 304 Wright's studio. In his Lovell House, Newport Beach, California, 1926, Schindler produced the first International Style residence in the United pl. 305 States. In his house for the same clients in Los Angeles, 1927—29, Neutra produced one of the great canonical structures of the heroic phase of the International Style, a concrete and glass volume on a steel frame of great elegance and refinement.

Wright turned away from this new European idiom, ridiculing it in his writings and seeking alternate forms of expression. A New York tower apartment project of 1929, a form unlike any skyscraper image of the day, American or European, came to naught because of the Depression, but its form was adapted for a skyscraper constructed in Bartlesville, Oklahoma, in the 1950s. During 1930—34, he developed the plan of Broadacre City, an ideal scheme that, like Ferriss's imaginary city, was a critical reaction to the terse, linear diagrams of the Radiant City. Otherwise, they bear not the slightest relationship to each other, though both visions were probably raided by Norman Bel Geddes for his city-of-the-future pl. 306 model at the General Motors Futurama of the New York World's Fair, 1939—40, a rare and successful presentation of a futurist fantasy to a wide audience. Wright's Broadacre City is in reality an anticity, a realization of that facet of the American dream that turns its back on congested, densely populated urban centers with their tall buildings and impersonal human relationships—an intellectual tradition that has contributed to the 208 urban blight that was worsened, if not originally

caused, by the frantic construction of ever taller buildings. Broadacre is super-suburbia, a pastoral fantasy which seeks to build upon the rural implications of the typical American residential subdivision. To bring industrial-age urban man back into contact with nature, Wright would give him individual houses on large, one-acre plots, establishing an even, low density of population across what then seemed to be an endless countryside. There would be occasional towers, presumably to house stubborn urbanites (perhaps artists, intellectuals, managers), and this extended horizontal city would, of course, be highly mechanized and automobile-oriented. Le Corbusier's way of bringing man back into contact with nature was the alternate, high-density solution, stressing collective, rather than personal, open space. The compact tall offices and the ribbons of apartments of the Radiant City made possible the open space for landscaped public parks directly adjacent to the monumental structures. Alas, neither vision was to prevail, and in the years after World War II urban builders gradually adopted Mies's reductive modern style rather than Le Corbusier's more plastic one, with only token allotment of spatial amenities on the ground. As for the suburbs, they grew by speculation rather than design, a tragic parody of Wright's vision.

The offices for the Johnson Wax Company at pl. 276 Racine, Wisconsin, 1936—39, the brick and tubular glass forms likely inspired by the Expressionism of Mendelsohn and Poelzig, together with his numerous "Usonian" houses of the 1930s and 1940s, updated versions of the Prairie motif, give

some idea of the kind of architecture that would have populated Broadacre City. The Guggenheim Museum, New York, designed in 1943 but not completed until the year of his death, 1959, expands upon the circular and spiral motifs introduced in the Johnson Wax offices. Widely criticized as a structure inimical, if not hostile, to the exhibition of works of art, the domed well surrounded by the continuous spiral gallery demonstrates a spatial effect that was central to his work. The Guggenheim is a tour de force expressing Wright's antipathy to the rectangular towered architecture of the city, its curving lines indicating his love of the park across the avenue; it is a cenotaph dedicated by the artist to his distinctive achievement, to an aborted architectural revolution that had never been, indeed could never have been, welcomed in the modern city. It was a personal architecture that could exist only in remote hideaways, and it was in such situations that Wright invariably gave his utmost. The Kaufmann House, Falling Water, Bear Run, Pennsylvania, 1936, is not only a masterpiece of his own genius; it is also a belated example of International Style geometry, its concrete and glass form admittedly enriched with the natural textures of native stone. Wright may have inveighed against the attenuations and exaggerations of the new architecture in Europe for more than a decade, but he was willing enough to challenge these architects on their own ground, to come away the victor in a battle, if not the war. A many-balconied, cantilevered construction, Falling Water's hovering horizontal strata echo the rock formations in the bed of the stream over which the house is sited. In his writings, Wright liked to point to the fact that the principal form of Falling Water had appeared much earlier, in one of his Prairie Houses of the 1900s, his way of chiding his historians and biographers who had, with equal truth, claimed much of his later work as a transformation of the International Style, which, as a matter of personal honor, he had to contradict.

In his eyries at Taliesin, built on family land at Spring Green, near Madison, Wisconsin, and at Taliesin West, Scottsdale, Arizona, begun in 1938, Wright remained a splendid solitaire, surrounded by an admiring family and his constant apprentices. Taliesin West is a particularly apt instance of his acculturation to a new environment, and of his facility, when unhampered by the preconceptions of the client, at the manipulation of free forms, inclines, diagonals, and triangles. The house and studio are sited on a low, artificial mesa

Frank Lloyd Wright. The Solomon R. Guggenheim Museum, New York. 1943–59.

307

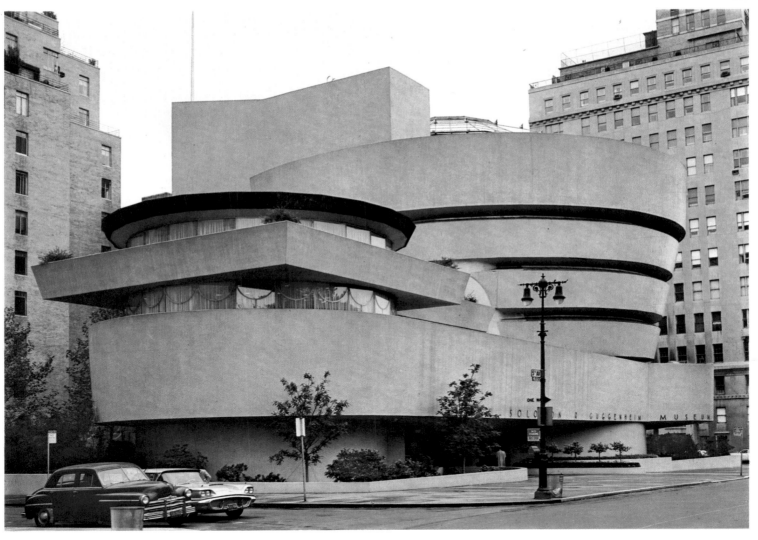

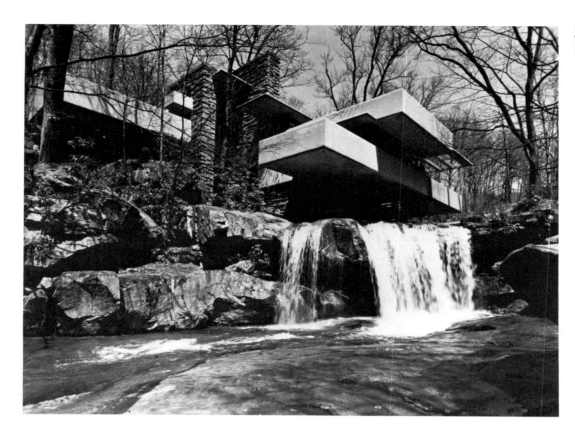

that contains watered lawn, souvenir of another climate in the midst of the arid desert, constructed out of timber and of native stone embedded in concrete. Its complex layout, full of surprises, is representative of his genius as it mellowed with age—comparable in its transcendental elaboration, though totally unrelated in style or theme, to certain of the late works of such contemporary twentieth-century masters as Matisse or Picasso. Along with Le Corbusier, Wright is the only twentieth-century architect deserving of mention in such company, an artist who well outlives his "own" epoch, still potently creative but working in a world of his own, publicly lionized yet largely out of touch with artistic, professional, or critical establishments. Wright's architecture of the last decades of his life was widely admired. Nevertheless, his influence upon the further evolutions of architectural form had taken place much earlier, in the 1910s and 1920s. He built some of the great monuments of the 1950s, but, although they were admired, they had no substantial influence upon current and subsequent events. Regrettable? Perhaps. Yet society and the profession had taken certain directions that had long ago rendered his architecture irrelevant, as, to a lesser degree, it would render Le Corbusier's proposals inoperative. The phobia of comprehensive planning in any field—economic, environmental, or architectural—insured, then as now, the limited role that innovative architects could play in future building developments.

The only new progressive architect of major consequence to appear on the scene during the troubled, contradictory 1930s was the Finn Alvar Aalto (b. 1898). His work is properly studied in the context of the style of the 1920s pioneers and of Wright's new achievements of the 1930s. The International Style characteristics of his early sanitorium, Paimio, 1929—31, mark a point of departure for his life work, whereas contemporary works by Gropius or Mies represent a culmination of efforts to overthrow the past. Understandably, Aalto's maturity came in the 1930s and 1940s and was upset for some years by the dislocations of the war. His modifications of the International Style are parallel to those introduced by Wright at the same time, but his designs are of personal inspiration, revealing distinctive insights into the characteristics of a wide range of materials. Related to this sensitivity for textures is a personal inventiveness with respect to compositional masses and details that goes beyond the geometrical rigors of the new architecture. Aalto's was the first major reaction against the machine esthetic that was creative rather than reactionary. His Viipuri Library, 1932—35, illustrates this new progressive trend, which was carried even beyond the canon of the International Style in the dark brick of his Baker House, MIT, Cambridge, 1948. There the river front is serpentine, regular rectangular windows replace the orthodox glass curtain wall, and the opposite side features a contrasting sawtoothed geometry. The result is the expansion of the vocabulary of avant-garde architecture (by reviving some of the Expressionist practices of two decades before) to the point where the original sources of the new style have virtually vanished. But this is to anticipate the story.

By the late 1930s the new architecture was in disarray, a turnabout from the situation a decade earlier. Economic and political forces had con-

strained it, severely limiting opportunities to build and excluding the new masters from significant, symbolic public monuments. Privately, internally, new architecture was itself changing, a normal process of evolution and growth, but one that was now taking place hidden and ignored. The one big building project *completed* in the 1930s was Rockefeller Center, New York, 1931—37, a work of innumerable associated architects, including Harvey Corbett, Raymond Hood, and Wallace Harrison, the latter of whom would become prominent on the postwar architectural scene. As a multiple collaboration between several firms, this collection of skyscrapers turned out to be a typical compromise effort with pallid, characterless detailing and a lack of stylistic or ideological commitment. Its vertical ribboned towers are thinned-down American Art Deco, and yet the slablike forms, differing from conventional, slender New York spires, suggest European moder-

nism. Bland and composite in style, trying, with partial success, to be a city within a city, seeking to provide open recreational space in an urban context yet being of economic necessity too stingy, Rockefeller Center symbolizes the defeat of the new movement through compromise. Hailed in some early histories as an encouraging instance of the salutary influence of the new architectural movements upon large-scale office buildings, Rockefeller Center, even taking into account its limited amenities, instead should have sounded a tocsin to perceptive critics and progressive architects. Elegant, up-to-date in appearance, it contained the look of modernism but virtually none of its substance. Later, the new style would be used more literally, even daringly, in the "development" of the new city, a process that would also bring with it the wasting, if not complete destruction, of the undervalued urban heritage of the recent past.

pl. 309

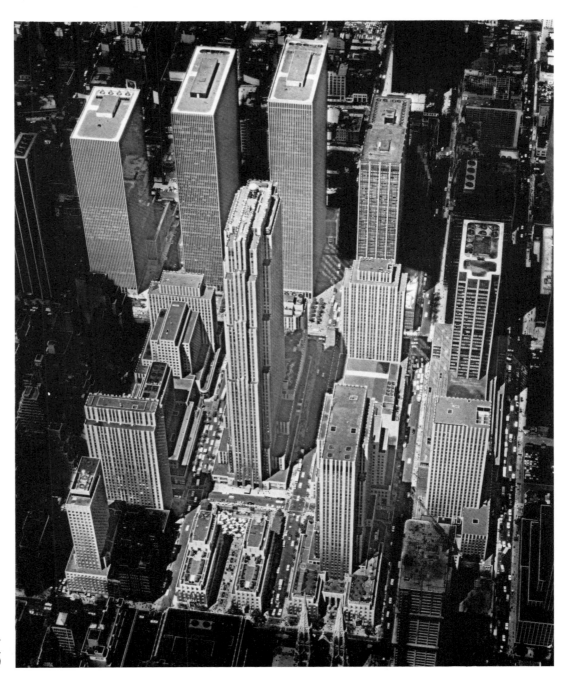

Rockefeller Center, New York.
1931–37 (with later buildings,
1960s). 309

ART BETWEEN THE WARS

With their public provocations and techniques for investigating the unconscious, Dada and Surrealism were anticlassical and antiscientific, in the mechanistic and rationalist sense. They opposed not only traditional academic art, but also the more formal avant-garde art of their own time. Even when Schwitters, Arp, or Ernst borrowed the collage technique from Cubism, their purposes and processes were ultimately different. They used the collage method to reveal new kinds of social and psychological meaning, rather than to create new kinds of forms.

For many other artists of the 1920s and 1930s, however, traditional values were not so easily surrendered. Imagination still afforded the possibility of dreaming another reality or contriving a superior or more attractive world—a world which an artist like Marc Chagall might build, innocently enough, with visual symbols of love and wonder rather than anguish. The period between the two cataclysmic world wars was one of *laissez-faire* in which many conflicting artistic styles coexisted. While the Dadaists and Surrealists aimed at provoking the public and liberating themselves from the constrictions of rationality and materialism, Social Realists addressed themselves to the cause of social revolution in artistic forms comprehensible to the common man. At the same time, the great modern masters Matisse, Braque, Léger, and others continued to create a reasonable art based on order, without compromising the formal innovations of the great prewar period of experiment and adventure. Picasso and Miró extended those innovations, and particularly the expressive fantasies which Surrealism released, in order to comment on a tragic and anguished social epoch. The diverse art of the 1930s offered innumerable alternatives based on its creators' response to the world about them. In a broad sense, art continued to mirror the world of outer reality, with the difference that the formal advances made by modern art complicated both its mode of pre-

sentation and the subjective input of that dialogue. Each artist carried his own mirror within himself.

Following Surrealism there were no truly revolutionary developments until the advent of Abstract Expressionism during and after World War II. The interval between the wars was not dominated by a single style or system of ideas. In the period immediately after World War I, a general reaction to the experimental excesses and sense of intellectual excitement of the preceding epoch manifested itself. It took the form of a renewed emphasis on classical clarity and order, and a return to realism. In German art, George Grosz, Otto Dix (1891—1969), and Max Beckmann, perhaps understandably, returned to the object with a certain anguish and element of powerful fantasy that indicated a relationship to nascent Surrealism.

pl. 311

The battle of styles in the 1920s and 1930s underscored the endemic problems of School of Paris art, and raised questions about the validity of its particular kind of ingratiating taste, hedonism, and traditional regard for *belle peinture*. A period that saw a worldwide depression and the growing threat of international fascism brought to art moods of caution, intellectual ferment, and protest. In the context of social events, the distinctions between an art of ideas engaged by contemporary history and an art that expressed the inherent possibilities of the means of painting also came into sharper focus. It is worth considering these many pertinent issues in relation to the standard artistic product of the School of Paris and how the antithetical positions assumed by perhaps the two greatest artists of the century, Matisse and Picasso, shed light upon them. The relationship between art and politics in an expanding industrial society received a dramatic, new impetus from Picasso's activism and, even more so, from the emergence of a significant mural art in revolutionary Mexico. In the panorama of evolving styles, a fascinating contrast to Social Realism was supplied by the revolutionary esthetic of the Bauhaus whose artists and architects dreamed of a renewal of society through abstract art and design. The period between the wars also brought to birth distinctly native artistic modes in Ameri-

Marsden Hartley. *Portrait of a German Officer*. 1914. Oil on canvas, 69¼ × 41⅜". The Metropolitan Museum of Art, New York. The Alfred Stieglitz Collection. 310

ca. A period of provincial retrenchment followed as Social Realism prevailed, only to be replaced by the more cosmopolitan outlook in the 1930s embodied in the paintings of Stuart Davis and sculptures of Alexander Calder.

The paintings associated with the School of Paris in the 1920s were produced by a group of extremely gifted, mostly foreign, artists whose miserable Bohemian lives in the Paris art capital earned them the reputation of *peintres maudits*. Their art was figurative and representational and, despite its stature, clearly peripheral to the truly momentous developments of twentieth-century art. Different though they are, their works share a curious and sometimes unstable amalgam of agreeable, well-made, tasteful effects and vivid Expressionist color and distortion of form for emotional purposes. Amedeo Modigliani (1884–1920), Chaim Soutine (1893–1943), Jules Pascin (1885–1930), Maurice Utrillo (1883–1955), and sometimes Marc Chagall have been linked as members of this school. They have in common the fact that none has been a significant innovator with a following, that they have all stood outside the great movements of their time, and that they wished to inject more sentiment into painting. In a period of movements and countermovements, they remained apart, and their rather conservative individualism perhaps proved a limitation. They were romantic, either in their lives or their art, and all but Chagall shared a fatal enchantment with the Bohemian life of Montmartre and Montparnasse.

The legend of Paris Bohemia began innocently enough with the Impressionists and was later given a more sinister twist by Toulouse-Lautrec, who painted Montmartre in its first bloom as an artistic quarter and gaudy district of nocturnal pleasures. Utrillo painted the same sector as a ruin of its former self, burned out and dying. He injected a melancholy poetry into the decaying walls and facades and tortuous streets of the hill of Montmartre with his almost compulsively repeated motifs. A monody of bleak walls, impoverished foliage, and leaden skies, particularly during Utrillo's best phase, his so-called White period between 1909 and 1914, represents the last twinge of a romantic nineteenth-century Impressionism. The touching lyricism of these early paintings and their feeling of emptiness and fatalism are matched by the unhappy story of his life. The neglected, illegitimate son of Suzanne Valadon, an alcoholic in his teens, trading pictures for wine and food and lodging, Utrillo grew up like a rank weed in a sunless, unwholesome atmosphere. The pathos of his painting is at least in part the unhappy story of the depressed fringe of Paris Bohemian life.

The same tragic-sensitive mood was also projected, but with more esthetic power and merit, in the painting of Jules Pascin, who came to Paris from Bulgaria and committed suicide there at the age of forty-five. Pascin developed an evocative but economical linear technique against zones of pale color washes. The shimmering translucent tints evoke the female flesh, in a mood combining eroticism and melancholy. His delicate and touching paintings of prostitutes and degraded adolescents are remarkable works of nervous sensibility, though he never made any startling technical discoveries and was almost compulsively limited in his subject matter.

A more virile spirit was Chaim Soutine, born in Lithuania and also something of a painter of despair. In the early 1920s Soutine developed a powerful Expressionist style, using searing, brilliant color and loading his pigment on canvas until it stood out in low relief. His tormented, cataclysmic landscapes and violent figure pieces, all set down in breathtaking color, added a new

pl. 313

pl. 315

pl. 312

214

Maurice Utrillo. *Rue des Saules.* c. 1917. Oil on cardboard, 20½×29½". Kunstverein, Winterthur, Switzerland. 312

Jules Pascin. *Young Girl Seated.* c. 1929. Oil on canvas, 36¼×28¾". Petit Palais Museum, Paris. 313

George Grosz. *Pillars of Society.* 1926. Oil on canvas, 78¾×42½". National Gallery, Berlin. 311

Amedeo Modigliani. *Reclining Nude (Red Nude).* 1917–18. Oil on canvas, 23½×36¼". Private collection, Milan. 314

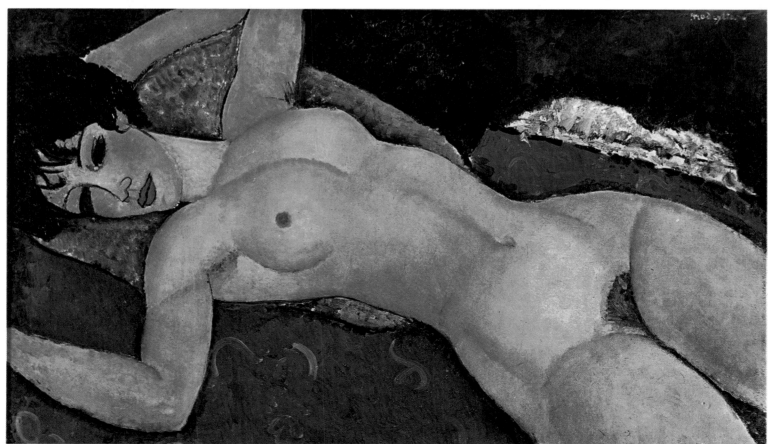

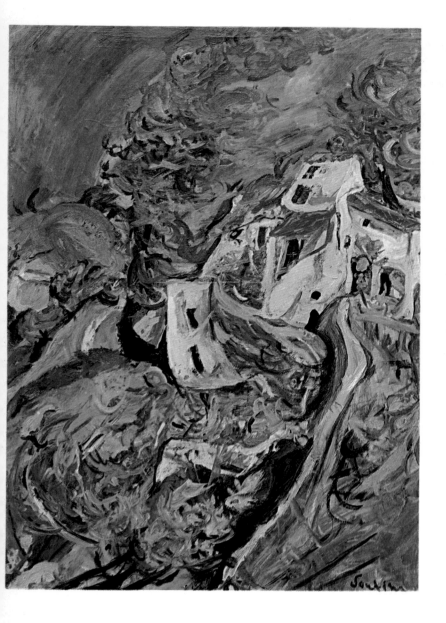

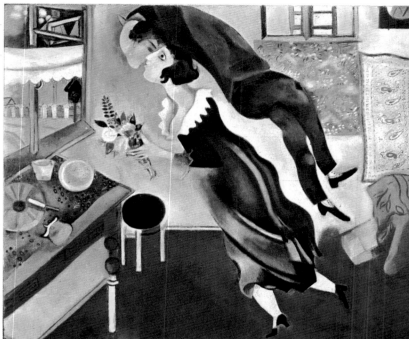

Marc Chagall. *The Birthday*. 1915. Oil on cardboard, 31¾×39¼". The Museum of Modern Art, New York. Acquired through the Lillie P. Bliss Bequest. 316

Chaim Soutine. *Landscape at Cagnes*. 1922–23. Oil on canvas. 36¼×25⅝". Musées Nationaux de France. 315

richness and emotionalism to School of Paris painting. The freedom and fury of his paint manipulation and his pure delight in pigment matter apart from representational aims make him an acknowledged and legitimate forerunner of American Abstract Expressionism. Another of the *peintres maudits*, Soutine endured a wretched and unhappy life in the cafés of Montmartre and Montparnasse. He died during World War II of sickness brought on at least in part by nervous instability and exhaustion.

The greatest waste, perhaps, in recent artistic history was the untimely death from tuberculosis of Amedeo Modigliani at the very young age of thirty-six. Modigliani's death was hastened by his disorderly living habits, his dissipations, unavoidable poverty, and reckless indifference to the general state of his body. He came to Paris from Italy in the early years of the century and was affected by the art of Cézanne, Cubism, and the fashion of Negro sculpture. Out of these influences, which he perhaps never explored very profoundly in formal terms, he fashioned an aristocratic and mannered figure style. Elegantly linear, his stylized and masklike heads with their columnar necks and ravishing, rich color are among the most enchanting portraits in modern painting. He left behind a

gallery of many of the most celebrated figures of Paris Bohemia, and some of the most sensuous nudes of the century. In all his work, a fine balance is struck between touching poetic sentiment and stylistic dignity, between romantic vision and some sad, cold reality. pl. 314

Romance, pushed to the point of fantasy, as we have seen, played a large role in the ingratiating paintings of Marc Chagall. After working in a Cubist manner modified by personal and emotional color, Chagall began to explore his imagery of rabbinical figures, village steeples, brides, bouquets, and clocks, derived from memories of Russian-Jewish village life and folklore. Like so many of the other School of Paris painters, Chagall found a satisfying pictorial formula and doggedly stuck with it, becoming in later years a sometimes repetitious performer, although an undeniable popular success. pl. 316

The popularity and success of Henri Matisse's later work present a remarkable exception to the School of Paris pattern of winning public approval for a tasteful and less challenging type of art. Despite the mundanity and inexhaustible delight of his subtly erotic theme of the female figure, often painted as an exotic odalisque in costume, Matisse's paintings remained so attached

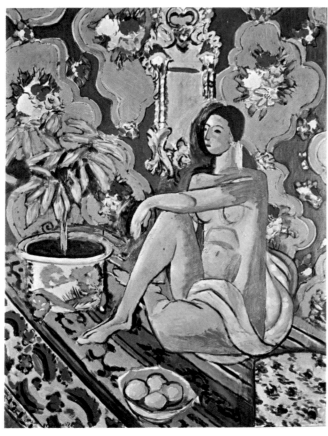

to a rigorously logical pictorial process that they must be exempted from the charge of mere decorativeness. Matisse's return to a more anecdotal and intimate style after the formal austerities of his post-Fauve and Cubist paintings reflected the influence of the wave of "humanism" in postwar European art. Yet, within an essentially less ambitious style, he was still capable of a monumental and opulent accomplishment. *The Plumed Hat* is pl. 318 an example of the artist's more relaxed style, a style which could nevertheless express the more profound implications of form in an image of solemn magnificence.

In the early 1920s, Matisse began to paint the exotic odalisques with which he is identified in the public mind. In some he used thin medium as transparent and delicate as watercolor; in others he modeled form solidly and enriched his surface with pigment that stood out almost in relief. He sought with both methods a solution to the problem that had concerned the Post-Impressionists: to reconcile the illusion of deep space and the flat painting surface. To this end he alternately emphasized elaborate Rococo ornament in wallpaper patterns and in a variety of colorful pictorial accessories, and then, by contrast, rudely simplified

Henri Matisse. *Decorative Figure on an Ornamental Background.* 1927. Oil on canvas, 51½×38⅜". Musée National d'Art Moderne, Paris. 317

Henri Matisse. *Piano Lesson.* 1916. Oil on canvas, 8'½"×6'11¾". The Museum of Modern Art, New York. Mrs. Simon Guggenheim Fund. 319

Henri Matisse. *The Plumed Hat.* 1919. Pencil on paper, 20⅞×14⅜". The Detroit Institute of Arts. Bequest of John S. Newberry. 318

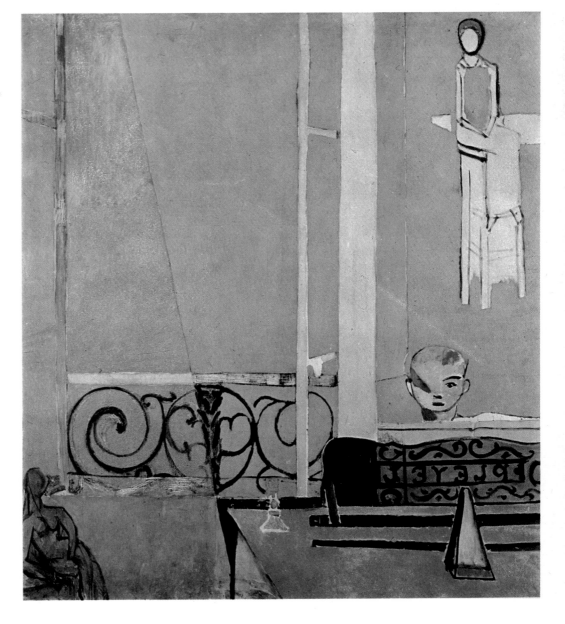

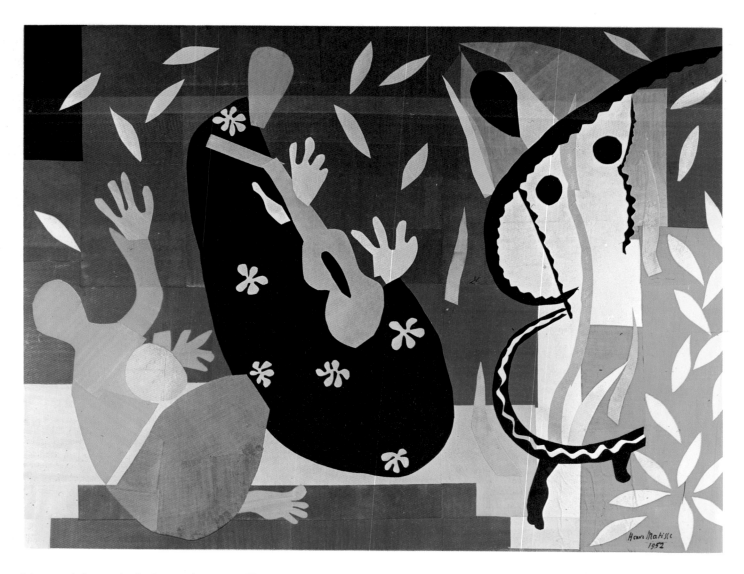

his models and their settings until they appeared as schematic as the flat, half-blank oval of the child's head in *Piano Lesson*. Where Matisse's sentiment and decorative detail threatened to compromise his esthetic detachment, or trivialize subject matter, he managed to offset this impression by emphasizing the abstracted mood of his models. Their introspective aspect provided a psychological stiffener and gave depth to the prevailing atmosphere of untroubled hedonism.

In his odalisques, Matisse revealed himself as an excellent connoisseur of feminine flesh, in the apt phrase of one of his critics. A playful eroticism has been a staple item of French sensibility from the great eighteenth-century decorators through Renoir. In the more relaxed moments of his "Rococo" style Matisse proved himself worthy of that tradition. But by 1927, with the *Decorative Figure on an Ornamental Background*, he had again forsaken the minor seductions of subject and medium for a greater expressiveness. Here he thickened his pigment to give form sculpturesque definition and at the same time embedded the figure in a wall of florid, insistent decoration, flattening it into the frontal plane. The competition between the nude and setting, between volume and the flatness of the loaded ornament, is extremely unrestful. If Matisse has not entirely successfully reconciled depth illusion and the flat surface, his failure, if indeed it is one, is brilliant and

pl. 319

pl. 317

218

Henri Matisse. *Sorrows of the King*. 1952. Gouache on cut-and-pasted paper, 9'7¼"×12'8". Musée National d'Art Moderne, Paris.
320

Henri Matisse. *The Dance, II* (detail of central lunette). 1932–33. Oil on canvas, 11'8½"×c. 47' overall. The Barnes Foundation, Merion, Pa.
321

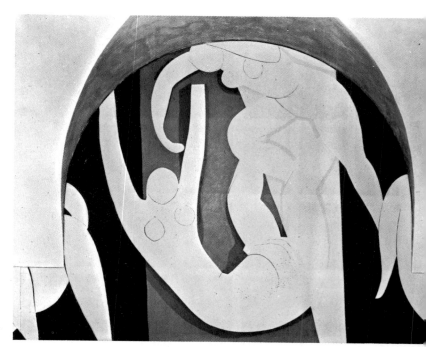

breathtaking for its boldness. It is typical of Matisse to turn his back on his earlier successes and seek more expressive means, "even at the risk," as he once put it, "of sacrificing ... pleasing qualities."

The question of pleasure and its affirmation or denial in artistic form has become basic to an understanding of his *œuvre* and of his ultimate artistic stature. Monet had described his late Water Lilies cycle as an island of tranquility for the troubled modern, a decoration in whose presence "nerves strained by work would relax." In 1908, Matisse explained his own artistic position in hedonistic terms not unlike Monet's when he alluded to his dream of "an art balance, of purity and serenity devoid of troubling or depressing subject matter, an art which would be for every mental worker ... something like a good armchair in which to rest from physical fatigue."[1]

The last two decades of Matisse's career are measured not only by his easel paintings and occasional sculpture, but by an achievement in a variety of forms of what can be loosely termed decoration. The first of a number of illustrated books, *The Poems of Stéphane Mallarmé*, was brought out in 1932 by the publisher Albert Skira with twenty-nine etchings by the artist. These etchings are without the descriptive light and shade or even the interior modeling of Matisse's early graphic work. Everything is expressed by a rhythmic, cursive line of descriptive economy yet capable of suggesting ample volumes. Form is described almost abstractly. The breadth and spaciousness of Matisse's late linear style are also pl. 321 demonstrated in the impressive mural decoration commissioned by Albert Barnes and installed in his picture gallery in Merion, Pennsylvania, in 1933. A flat frieze of dancing figures makes a dynamic, flowing rhythm of curved and angular shapes, with an effect of great simplicity and majesty.

Like many of the truly great artists of history, Matisse found, in his old age, hitherto untapped reserves of creative energy. Crippled with arthritis, he developed an incredibly vigorous and joyful style in the technique of *découpage* (cut paper). Lying on his back in bed, sketching with charcoal fastened to the end of a stick, on paper suspended pl. 320 overhead, and working with cut shapes colored with gouache according to his directions, Matisse created some of the most joyous and noble compositions of this, or any other, time. In 1951, he designed murals, chasubles, stained-glass windows, and furniture decorations for the Dominican Chapel of the Rosary at Vence. These gay designs attest to the lyrical upsurge of the splendid twilight of this artist's career. They also bring to a fitting conclusion the Fauvist tendency to juxtapose broad areas of pure tone in order to create the most lively and intense effects.

Matisse was not a profound commentator on his time in Picasso's sense. But there are absolute values in painting, beyond good and evil and beyond the pressure of history. Matisse addressed

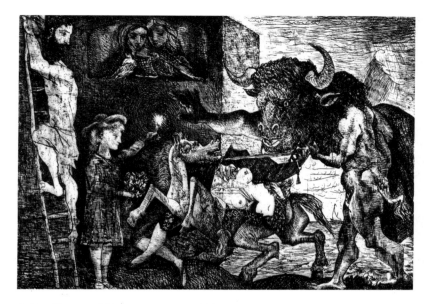

Pablo Picasso. *Minotauromachy*. 1935. Etching, 19½×27¼". The Museum of Modern Art, New York. Abby Aldrich Rockefeller Purchase Fund. 322

himself unsparingly to major pictorial problems, mastering them in his own vital idiom. His formal solutions were actually as convincing and pertinent as any, including the inspired geometries of orthodox Cubism. Although Matisse was often disparaged for ignoring the urgent moral and political issues of his time, his art is a perpetual challenge to the pessimistic mood and sense of estrangement and anxiety that sometimes seemed to dominate the age. His range of content was more limited than Picasso's in that he did not try to interweave formal invention and an art of ideas. Yet his creation of an art of profound intellect and sensuousness, an essentially civilized art, was also a way of preserving important human values in a time of social crisis. As a painter per se, he was without peer; within his own genre, he is the only artist who truly challenges Picasso for the right to be considered the dominant painter of the first half of the twentieth century.

Perhaps there is no real rivalry after all between the two greatest artists of our time because they belong to different spheres. Matisse is of the order of artists who express themselves through the inherent possibilities of the language of painting, and Picasso belongs with those who use painting to express states of mind, the life of the passions, or some of the more mysterious aspects of human and esthetic experience. In the period between the wars, Picasso continued to enlarge the possible meanings of art by inventing visual symbols and new myths to deal with the violence that increasingly dominated European history. After 1930, he began to explore the symbolism of the bull and the bullfight, themes which had played such an important role in Goya's art. The bull became a projection of his deepest atavistic impulses and, in the next years, an even more precise moral symbol of the threat of fascist brutality and domination.

In 1935, Picasso created a powerful, fearful, and yet somehow hopeful image in his greatest pl. 322 etching, *Minotauromachy*. After a visit to his home-

land, soon to be plunged into a suicidal civil war, and with fascism sweeping across Europe, the artist turned to the bullfight and to Greek mythology for images sufficiently terrible and rich in meaning to convey his feelings.

The great man-bull form of the Minotaur (symbolic of virility and oppressive power) is the dominant figure in the etching. On a seashore the beast advances into a shadowed corner toward the figure of a young girl holding flowers and a candle, reminiscent of the innocent child-victims of Picasso's circus paintings. A female toreador lies rigid in death across the back of a gored and terror-stricken, perhaps expiring, horse—the ritualistic sacrifice of the bull ring. The child calmly faces the monster bull, while a Christlike man tries to escape on a ladder. In a window overlooking the scene, a pair of young women behind two doves watch the drama. As an allegory, the scene does not explicitly declare its meaning, but, in terms of Picasso's whole development, one can discern a familiar play of harmonious and convulsive images.

Picasso was a fervent Loyalist partisan in the war and accepted from the Republican government an appointment as director of the Prado, although he was never able to go to Spain to assume official duties. He fought his personal war against fascism, however, in visual images which became the most eloquent indictments of organized brutality in modern times. In 1937, he did a series of etchings, *Dream and Lie of Franco*, and wrote a violent Surrealist poem to accompany the sequence of plates. The dictator Franco is described as "an evil-omened polyp ... his mouth full of the chinch-bug jelly of his words," and he emerges in the drawings as a hairy, three-pronged turnip with carious teeth and a ludicrous paper-hat crown. The rape of Spain is shown in an episodic sequence of scenes and images: a dead horse, human cadavers, women fleeing with dead children. The Franco "polyp" turns into a horse-like beast in one episode and is disemboweled by an avenging bull. In another, the majestic head of a bull confronts Franco's animal-vegetable incarnation and shrivels into impotence.

pl. 323

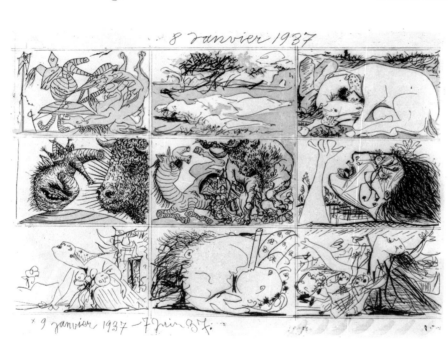

Pablo Picasso. *Dream and Lie of Franco II.* January 8–9 and June 7, 1937. Etching and aquatint, 12⅜×16½". The Museum of Modern Art, New York. Gift of Mrs. Stanley Resor. 323

Pablo Picasso. *Guernica.* 1937. Oil on canvas, 11'5½"×25'5¾". Estate of the artist, on extended loan to The Museum of Modern Art, New York. 324

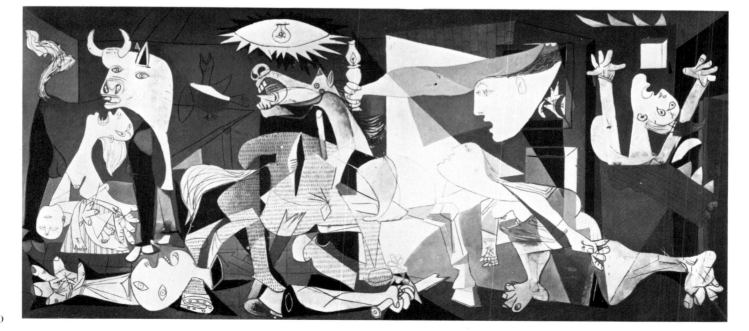

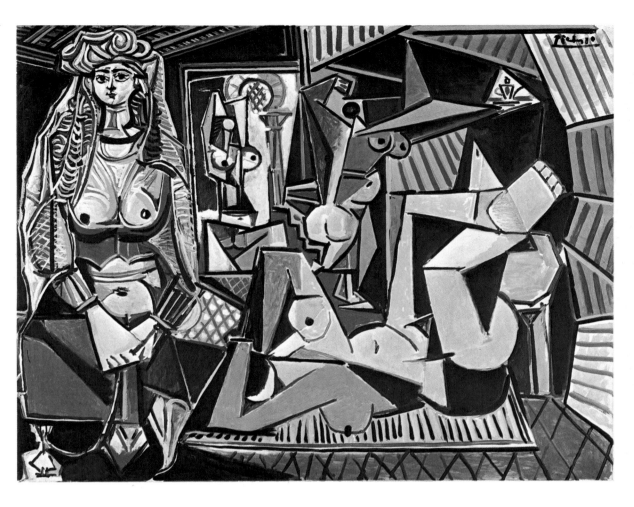

pl. 324

In the same year, Picasso painted his huge, tragic mural *Guernica.* The wartime agony of death and senseless destruction is dramatically heightened by the stark black, white, and gray composition. A broken, mangled form of a warrior at the base of the composition with his sculpturesque features askew; a woman with a dead child; a disemboweled horse at the center with a spearpoint tongue; another woman whose nipples have become bolts and who is crazed and cross-eyed with pain and grief—all these images and the expressive distortions suggest cruel affliction. Two forms dominate the composition, the triumphant bull and the dying horse. Out of a window flows the fearful face of a woman and a long arm, like a hallucination. She holds a lamp over the scene, a symbol of the conscience of a horrified humanity.

Picasso explained the symbolism of the work with a childlike simplicity, declaring that the bull "is brutality and darkness . . . the horse represents the people." The painting has the impact of a nightmare and the bold schematic presentation of the comic strip. The strict decorative form and strong figurative conventions managed to intensify the emotions Picasso wished to convey, by formalizing pain and grief. Much of *Guernica*'s force derives from the cruel distortions of the stricken horse and the anguished human figures. In these forms Picasso found a powerful subjective equivalent for public chaos and aggression. By dissociating the anatomies of his protagonists he expressed our deepest fears and terrors. Many writers have pointed out the resemblance of drawings

and paintings of the insane to Picasso's inventions: the disorganized anatomy, double-profile, aggressive, compulsive repetition of ornamental pattern. One of the profoundly tragic meanings of *Guernica* is the projection, through a controlled symbolism, of a kind of mass insanity in the language of psychotic drawing. Goya, in his "Caprices," had written an inscription to one of his etchings that "the sleep of reason produces monsters." Picasso's *Guernica* added an up-to-date, clinical postscript to Goya's vision of man's inhumanity to man in one of the most eloquent and memorable artistic statements of our century.

In the years after *Guernica,* Picasso explored, with inexhaustible variations, the themes of portraits and figures with features askew, constantly intensifying their Expressionist violence. At the same time, he continued to draw and make prints in a classical spirit. In fact, Picasso became a kind of voracious master thief able to transmute influence and style from any period of culture and make them his own. Behind his stylistic virtuosity and his insatiable historical memory lies the conviction that all art styles exist simultaneously and form one continuous living present. "To me there is no past or future in art," he wrote. "If a work of art cannot live always in the present, it must not be considered at all. The art of the Greeks, of the Egyptians, of the great painters who lived in other times, is not an art of the past; perhaps it is more alive today than it ever was." [2] Picasso possessed a universal mind in the grand style of Delacroix, and had a vast artistic culture at his disposal. His

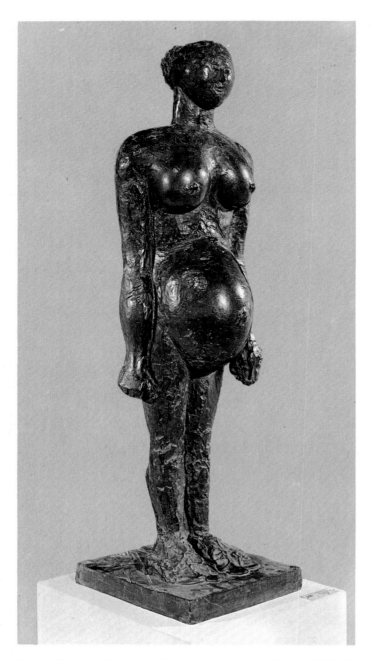

Pablo Picasso. *Pregnant Woman* (second version). 1950–59. Bronze, 43¼" h. Estate of the artist. 326

rich resources in art history were evident up to the very close of his life, when he played repeated variations on artistic themes, and in styles which evoked such illustrious names as Rembrandt, Cra-

pl. 325

nach, Delacroix, and Velázquez. Picasso's arbitrary changes of manner were often reminiscent of James Joyce's parodies of literary modes. As did Joyce in literature, Picasso became perhaps our greatest mythmaker in the visual arts.

Without worrying unduly about formal consistency, he drew freely from the Hellenic mainstream of humanist culture, from peripheral Mediterranean civilizations, and from the barbaric imagery of primitive peoples. His imagery shuttled brilliantly between the warring inspiration of Greco-Roman tradition and primitive art and found inspiration in their opposition. The bland, ideal beauty of Greek or Roman heads was recaptured in a lithograph; in a ceramic or a bronze, Cycladic, Etruscan, or Negro sculpture could be

the inspiration, passed through the sieve of

Cubism. Often the two sources fused in a painting or a drawing, establishing that characteristic psychological *frisson* between the civilized outer man and the awareness of subconscious forces that lurk not far beneath the surface. What gave significance to Picasso's erudition and recondite insight was pure artistic temperament. Sensibility vitalized every material and medium he touched in prints, paintings, sculptures, or the decorative arts. Until his death at the age of ninety-four, Picasso went on creating passionate and formally coherent imagery in a variety of modes. He always seemed capable of refreshing his vision, and behaved as if his art stood at the threshold of new beginnings, unprejudiced by his past achievement or taste.

pl. 326

Among the great modern masters working in Paris between the wars, Joan Miró provides a remarkable balance of political involvement and artistic detachment, which places him halfway between the positions of Picasso and Matisse. Like Picasso, he reacted violently to the Spanish Civil War. He was never so politically militant or outspoken as Picasso, but he did use painting as an eloquent vehicle to express his feelings of anger and dismay at the course of events in his homeland. In 1937, he painted his most naturalistic representation in many years, *Still Life with Old Shoe*, but the painting was riddled by double images, as if the incorporation of Surrealist techniques of dissociation might expose the underlying hallucinatory character of solid material existence. Both his realism and the adaptation of that genre to Surrealist methods represented an effort to reconcile the return to objective reality with the pressure of somber events in Spain. "Between the years 1938 and 1940," he declared, "I once again became interested in realism. Perhaps the interest began as early as 1937 in *Still Life with Old Shoe*. Perhaps the events of the day, particularly the drama of the war in Spain, made me feel that I ought to soak myself in reality. I used to go every day to the Grande Chaumière to work from a model. At the time I felt a need to control things by reality."[3]

pl. 327

With the tragic war in Spain very much on his mind, Miró also painted, in 1937, a large mural decoration, *The Reaper* (now lost), as a pendant in the Spanish Pavilion at the Universal Exhibition to Picasso's *Guernica*, which was shown there publicly for the first time. The intensity of this painting, its violence of color and form, suggests that it had some special significance for the artist. The torn, disjointed figure with its tuberous snout and stemlike neck has definite affinities with Picasso's animal-vegetable incarnation of Franco in the *Dream and Lie of Franco*. Miró's figure seems to push its way up out of a malevolent soil like some obscene growth, into a flaming apocalyptic night. Another powerful example of the distortions of his figuration of 1937 is *Woman's Head*, so reminiscent of Picasso's stricken, weeping women in the *Guernica*. Both artists present us with fearsome images of violence, incomprehension, and perhaps even

pl. 324

pl. 323

pl. 329

madness. Miró's figure is grotesque in its brutal transformations of the human form into an insectile creature. Yet the supplicating gesture of the arms and the curiously blank, red eye strangely invite pity.

In 1939, Miró's art shifted once more. Abandoning the emotionalism and high pitch of dramatic expression of the works inspired by tragic public events, he embarked upon a more neutral and flat calligraphic manner. It was a period when his farfetched, poetic titles often suggested the irrational system of causality in a Rube Goldberg cartoon, for example, *Drop of Rose Falling from the Wing of a Bird Waking Rosalie Asleep in the Shade of a Cobweb*. If the punning titles seemed gratuitously fey, they did capture the linking-and-chaining action of the artist's inexhaustible, metamorphic invention. Miró described these exotic and elegant paintings, whose fablelike qualities

and estheticism seemed remote from the anguished mood of work he made during the Spanish Civil War: "In 1939 began a new stage in my work, . . . about the time when the war broke out. I felt a deep desire to escape. I closed myself within myself purposely. The night, music, and the stars began to play a major role in suggesting my paintings. Music had always appealed to me, and now music in this period began to take the role poetry had played in the early twenties."[4] Even after the fall of France in 1940 and his abrupt departure for Palma de Mallorca, Miró continued making rather decorative work in a new spirit of controlled objectivity. A series of brilliant gouaches which he called Constellations "were based on reflections in water," he asserted, whose "main aim was to achieve a compositional balance."[5]

The Constellation paintings reduced Miró's

pl. 328

Joan Miró. *Still Life with Old Shoe.* 1937. Oil on canvas, 32¼×46¼". The Museum of Modern Art, New York. Fractional gift of James Thrall Soby. 327

Joan Miró. *Woman's Head.* 1938. Oil on canvas, 18×21⅝". The Minneapolis Institute of Art. Gift of Mr. and Mrs. Donald Winston. 329

Joan Miró. *On the 13th, the Ladder Brushed the Firmament* (Constellation series). 1940. Gouache and oil wash on paper, 18⅛×15". Collection Mrs. H. Gates Lloyd, Haverford, Pa. 328

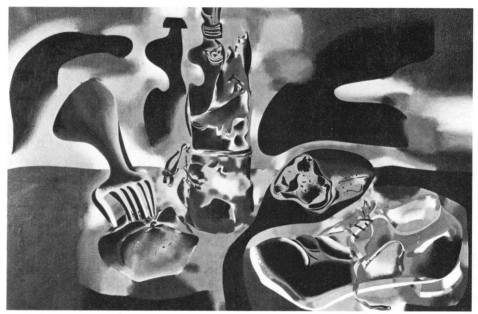

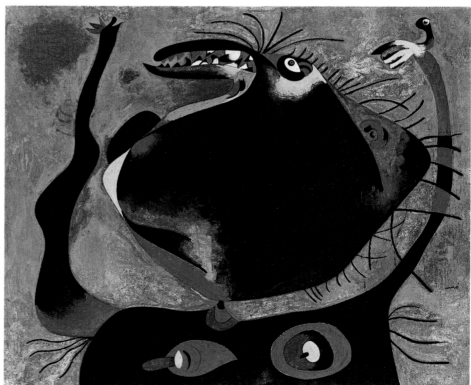

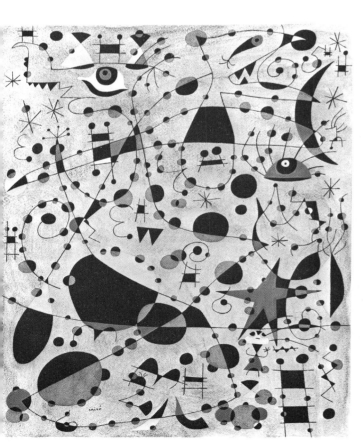

Georges Braque. *Still Life with Mandolin*. 1936–38. Oil on canvas, 44⅞×57½". Collection Mr. and Mrs. Leigh B. Block, Chicago. 330

familiar signs to a molecular structure of points, dots, and crisp interconnecting lines, forming an intensely active surface animated by bright color accents. It does seem rather incredible that at such a tragic moment in history Miró could have so completely withdrawn from outside events and created these untroubled lyrical images. However, his example was more consoling than evasive, in one sense. It was as though, the worst having happened, the artist rejected pessimism and illogically discovered new possibilities for the expression of humor, joy, and therefore hope and reconciliation. With the paintings of 1939 and 1940, the material function of medium was given greater emphasis. Action and passion were identified with immediate physical sensations rather than the familiar drama of Miró's fabulous world of personages.

The shifting esthetic grounds of his expression, from the development of an iconic imagery to a free graphism, became even more apparent during World War II with the renewal of his interest in ceramics. His art has not essentially changed since the war, when he, like Picasso, seemed able to find ever new, expressive possibilities in a wide range of materials and to work freely in a new mood of reconciliation and relaxed playfulness. Yet, so firmly did Miró establish his distinctive way of seeing, and so assured was his expression, that even his most casual forms and rudimentary gestures in his chosen medium seemed masterful and carried a resonance of residual poetic and plastic meanings.

Unlike the Spaniards Picasso and Miró, Braque continued to be involved with the problems of paintings rather than politics all during the 1930s. Reflecting the conservative mood after the war, Braque made a tentative return to the representation of natural appearances just as Picasso and Matisse had done before him. His forms became

even freer and less schematized, as his descriptive content grew more particularized. He translated into subtle tonal harmonies the sensuous properties of objects taken from nature. Against low-keyed backgrounds of beige-gray, apple green, and brown he painted in the most delicate tones the "dark purple of a grape, the bloom of a peach, the yellow brown of a pear,"[6] as Henry Hope described these effects in his monograph on the painter. Then, contemporaneously with Picasso's neoclassical figures, Braque began to paint large, semidraped female figures of classical inspiration, his so-called basket carriers. They vaguely suggested Renoir's late, "strawberry" nudes in their ample proportions and loose modeling, but they were schematized as flat, abstract shapes.

During the 1930s, Braque made a number of sketches, prints, plaques, and sculptures of nymphs and classical figures, utilizing a flowing calligraphic line. And, in the late years of the decade, he began to play off dramatically illuminated areas against deep shadow, and out of these contrasts to create a pictorial world of serene and gentle phantoms. At this time, he also completed a series of masterly still lifes. *Still Life with Mandolin* is among the most complex and fully integrated of those compositions. The artist's enormous skill in orchestrating somber colors, rich textures, and elaborate patterns is seen at its highest level in this painting. The images, as well as areas of surrounding space, are designed and organized in relation to the flat plane of the canvas. Areas that are in the background also play an important role on the surface. Yet the complexities of composition are masterfully resolved in an overall unity. Braque takes a place in the pantheon of French classical painters as an artist of supreme sensibility, measure, clarity, and balance. He is a legitimate heir to the poetic classicism of Poussin, Watteau, and Cézanne.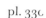

We have considered a number of the principal modern sculptors working in Paris between the wars, notably Brancusi and those identified with Surrealism, Giacometti, Arp, and Ernst. One of the most original and influential developments began in the 1920s when Julio González (1876–1942), Picasso's fellow countryman and technical assistant, began to help Picasso construct a number of his own welded sculptures. Together they invented open, welded iron construction, a form of drawing in space using modern industrial technology. In later decades, Julio González's independent role as one of the true makers and shapers of modern sculpture became apparent. More than perhaps any other individual, González had initiated the era of welded metal sculpture—a technical innovation that played such a dominant role among the postwar generation of sculptors. Cubism, abstraction, and even Surrealist fantasy were all deftly blended in his work.

Iron was a passion with González. He was born in Spain, his father a goldsmith and sculptor in a country long famous for its master craftsmen in metal; the entire family worked professionally in

pl. 330

bronze and forged and beaten iron. With this background, González later wrote: "The age of iron began many centuries ago by producing very beautiful objects, unfortunately for a large part, arms. Today, it provides as well, bridges and railroads. It is time this metal ceased to be a murderer and the simple instrument of a super-mechanical science. Today the door is wide open for this material to be, at last, forged and hammered by the peaceful hands of an artist."[7]

González settled in Paris in 1900, and for many years after, painting interested him more than sculpture. It was not until the mid-1920s that he came to grips at last with his true medium of expression. Even then his mature style evolved only when he began to assist Picasso in making welded iron constructions. González's contribution to modern sculpture is the fruit of only the last dozen years of his life. Under Picasso's influence, González's style became more abstract and he began to use space and intervals between forms as expressive sculptural elements. In *Woman Combing Her Hair*, 1936, the artist schematized his motifs in conventions very close to Picasso's fantastic bone figures and anatomies of the same year. Although Picasso stimulated González's welded metal sculpture, the artist achieved independence in a personal, rugged expressive man-

pl. 331

Julio González. *Woman Combing Her Hair*. 1936. Wrought iron, 52 × 23½ × 24⅝". The Museum of Modern Art, New York. Mrs. Simon Guggenheim Fund. 331

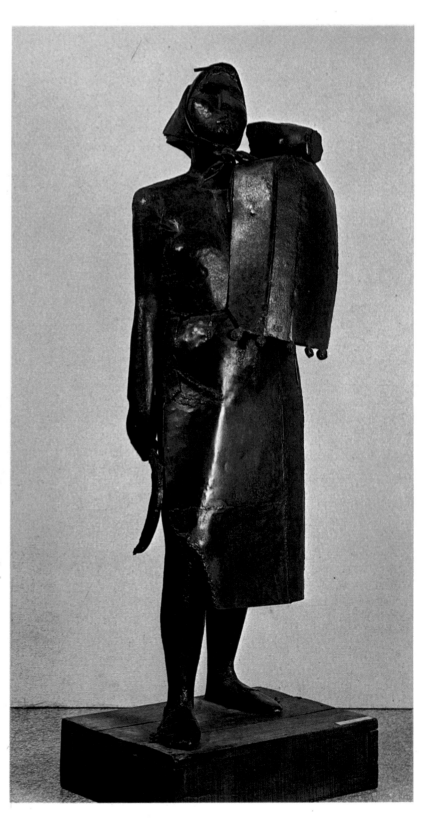

Julio González. *The Montserrat*. 1936–37. Sheet iron, 65" h. Stedelijk Museum, Amsterdam. 332

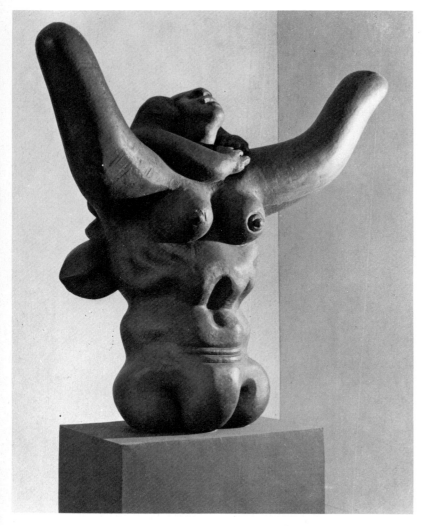

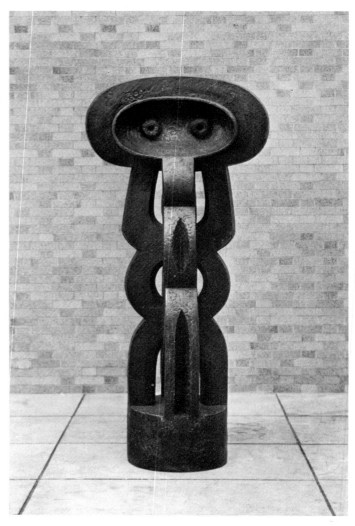

Jacques Lipchitz. *Mother and Child, II.* 1941–45. Bronze, 50×51".
The Museum of Modern Art, New York. Mrs. Simon Guggenheim
Fund. 333

Jacques Lipchitz. *Figure.* 1926–30 (cast 1937). Bronze, 7'1¼"×
38⅝". The Museum of Modern Art, New York. Van Gogh Purchase
Fund. 334

ner. For the Spanish Pavilion at the 1937 Universal Exhibition in Paris, González, like Picasso and Miró, created a memorable monument and a public symbol of Spain's anguish. His figure was more humanist than his formidable abstract sculptures, many of which closely resembled Picasso's nightmarish Surrealist imagery. For the pavilion, he created in sheet metal a recognizable and poignant peasant woman holding a child in one arm, a scythe in the other. He named the sculpture *The Montserrat* after Catalonia's holy mountain. The title thus suggested that the sculpture was a symbol of Spanish populist will and resistance to Nazi intervention and aggression in the civil war.

pl. 332

The open iron sculptures of Picasso and González were anticipated by the Cubist Jacques Lipchitz, although he always made a point of realizing his more composed metal forms in finished bronze castings. Cubism liberated Lipchitz from an earlier, stylized representational work, but even after he deserted Cubism, its new visual language—the compression of many forms into a compact mass and adventurous probing of many viewpoints—remained central to his philosophy of art. Though his later work was the antithesis of his

226

early, flat, vertical images, Lipchitz continued to call himself a Cubist. In the 1920s, he developed a more open, wiry style involving space as an integral element in the sculptures known as Transparents. Almost all of these pieces were done on a smaller scale (none over twenty inches high and most much smaller). Later, he developed a powerfully rhythmical, undulant, Baroque style. In his work during and since World War II appeared swelling, massive volumes with tumultuous shapes and a curving, complex flow of lines, with an almost Rodinesque counterpoint of light and dark. These sculptures were as far removed from his early work in theme as in form. The Cubist harlequins and guitars were replaced by subjects imbued with stirring feelings, poetic statements on the tragedy of human existence, personal heroism, and even a religious symbolism of transcendence. Almost unique in his *œuvre*, however, was the ferocious primitive icon called simply *Figure*. This monstrous yet compelling image stands totemlike with hypnotically staring eyes, dominating its environment. It is the one example of monumental work done in the manner of the small Transparents, and it demonstrates the artist's ability to integrate threedimensional forms and space in a

pl. 334

rhythmically organized plastic form of great expressive power.

pl. 333 Equally compelling in form and more complex in its symbolism, *Mother and Child, II* conveys with powerful eloquence the shattering mood of World War II. First there is the visual impact of unusual shapes and a decided somberness of mood as the legless mother and the truncated arms impress themselves on the spectator. Gradually, one is aware that these arms join the torso to form the image of a head of a bull. According to the sculptor, the statue had materialized almost subconsciously; only after it took on its final appearance did Lipchitz recall the full origin of the haunting image, and its meaning for him. Years before, Lipchitz had heard a musical voice in a rainy square and saw a legless beggar woman, supported on a cart, singing courageously into the night. The bull's head refers to the ancient Greek myth of Zeus in the guise of a bull carrying off Europa, who gave her name to the continent. Thus, the total composition became a moving wartime elegy to an occupied but undaunted Europe.

Under the dominant influences of Cubism, Constructivism, De Stijl, abstract Surrealism, and the impetus of Brancusi, abstraction rather than a humanist imagery became the favored mode of sculpture in the period between the two world wars. It ranged between two extremes: the biomorphism of Arp's concretions, the somewhat related forms of a new figure in England, Henry Moore, and Purist geometric and architectural forms purged of all human or naturalistic reference. We have seen how Constructivism emerged in Russia at the outbreak of the revolution when an adventurous avant-garde, with Utopian visions of a new society, created vital art forms in rigorously abstract modes. The Constructivists managed to make their rigorous forms symbolic statements at the same time, inspired encomiums to the new world of science and technology with its unfolding possibilities in an egalitarian society for social betterment. Within a few years, however, the conservative Soviet administration patronized only academism and Social Realism, repudiating abstract innovations entirely. Official disapproval became apparent in 1922, the year of the most important international showing of Constructivist art at the Van Diemen Gallery in Berlin. As a result of the interest generated by that show, Naum Gabo and Antoine Pevsner left Russia, and in 1924 they held their first joint exhibition in Paris at the Percier Gallery, where Alexander Calder a few years later was to show his first mobiles.

Naum Gabo disseminated his Constructivist ideas first in England, where he settled in 1935, and then in the United States where he has lived since 1947. During the 1930s and 1940s he made more use of new and stronger transparent plastics, and in several works he wound skeins of plastic thread around frameworks composed of a few planes, cut as identical parts but placed in reverse relation to each other. In 1954, he turned to metal

again to create the largest and most impressive example of Constructivist sculpture, the colossal freestanding form beside the Bijenkorf department store in Rotterdam. pl. 335

Gabo's brother, Antoine Pevsner, preferred to work consistently with metals, such as bronze, which reflect light, causing one to be aware of the surface, rather than the transparent and translucent plastics favored by Gabo. In 1948, Pevsner created *Construction in the Egg*, a complex organization of curved planes and spaces based on an egg shape. Bundles of bronze rods organized in curving sheets define the complicated, intricately interacting planes. Both light, reflected from the metal surfaces, and space play major roles in the total form, while the egg motif relates the notions of the cell and growth to that of form. In the years that followed, the two brothers continued to evolve their Constructivist ideas—ideas dealing mainly with the definition of space as a major element in sculptural form through the use of new pl. 336

Naum Gabo. Construction for the Bijenkorf Department Store, Rotterdam. 1954–57. Steel, bronze wire, and freestone substructure, 85' h. 335

Antoine Pevsner. *Construction in the Egg.* 1948. Bronze, 28″ h. Collection P. Peissi, Paris. 336

materials and the application of engineering principles.

The only new sculptor of international stature to emerge in the 1930s was the Englishman Henry Moore (b. 1898), a major figure who created an independent position for his art halfway between what appeared to be the mutually contradictory tendencies of Surrealism and abstraction. Moore became a welcome member of both camps: he contributed to *Circle*, the manifesto edited in London in 1937 by Gabo and Ben Nicholson, and he joined the International Surrealist Exhibition held in London in 1936. Picasso's drawings and paintings of imaginary monuments in the late 1920s, and Arp's biomorphic forms, both bore a relationship to Moore's organic forms, with their holes and rounded protuberances. Yet even his most blank and expressionless figures had tremors of mysterious vitality that spoke of an awareness of psychic life. Moore evolved his highly personal sculptural manner by taking elements from both types of art, the psychological probing and the blandest abstraction; to these he added the in-

fluence of English Romantic tradition and that of primitive cultures, particularly such ancient Mexican art forms as the sacrificial urns carved in the form of Chacmool figures from Chichén Itzá in the Yucatan. He has always evinced an interest in such natural forms as eroded bones and water-worn pebbles, objects shaped by time which seem to possess a special significance for human experience. In this sense, Moore has been primarily the Surrealist and humanist rather than the pure abstract artist. He accepted Surrealist notions of the hidden meanings of natural shapes, the central role of intuition in perceiving such meanings, and the analogous character of primitive and mythic imagery.

Among the principal preoccupations of Moore's work are his monumental reclining female figures. *Recumbent Figure* is a fine example of this theme, which the artist carried out year after year in so many versions, in wood, cast metal, and stone. The human figure is defined in a series of rhythmical relations between solid forms and pierced voids. The open areas are developed with as much consideration as the positive masses. Formally,

pl. 337

this work demonstrates Moore's involvement with the problem of correlating internal and external forms. Iconographically, it illustrates his continuing concern with a female image suggesting the ancient theme of the Great Mother. His archetypal fertility image was endowed with ample, generalized masses which evoked natural landscape as much as they did thighs, breasts, and other features of the female anatomy. Few sculptors expressed the relationship of hollow cavities to solid form so powerfully or effectively. Moore has said that "The hole connects one side to the other, making it immediately more three-dimensional. A hole can itself have as much shape—meaning as a solid mass. The mystery of the hole—the mysterious fascination of caves in hillsides and cliffs."[8]

pl. 339 During World War II, Moore made a memorable series of drawings of the huddled sleeping figures who were sheltered in London's subway tunnels. From these drawings dates his interest in figure groups and the design potentialities of drapery, which resulted in the notable public commission after the war of his *Madonna and Child* in St. Matthew's, Northampton, among others. When Moore was honored by a large retrospective at New York's Museum of Modern Art in 1946, and then won the major sculpture prize two years later at the Venice Biennale, his international reputation was assured. Since the war, he has continued to develop the themes that interested him in the 1930s and has added some new ones, such as his more mechanistic *Nuclear Energy* pl. 338 and innumerable large-scale, public commissions in bronze, many of them enlarged with the help of assistants working from small models. His work has not changed in essence for four decades. Al-

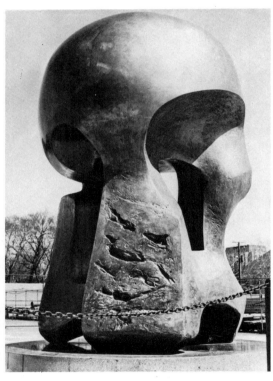

Henry Moore. *Recumbent Figure.* 1938. Green stone. 55" l. Tate Gallery, London. 337

Henry Moore. *Nuclear Energy.* 1965–66. Bronze, 12' h. Enrico Fermi Institute for Nuclear Science, University of Chicago. 338

Henry Moore. *Shelterers in the Tube.* 1941. Pen and ink, chalk, and watercolor, 15×22". Tate Gallery, London. 339

Fernand Léger. *Disks.* 1918. Oil on canvas, 94½×71″. Musée National d'Art Moderne, Paris. 340

Fernand Léger. *Three Women (Le Grand Déjeuner).* 1921. Oil on canvas, 6′¼″×8′3″. The Museum of Modern Art, New York. Mrs. Simon Guggenheim Fund. 341

though he has been discounted recently by the younger generation, who react negatively to his humanist rhetoric and monumental pretensions, Moore undoubtedly remains the last major European modernist sculptor.

Although Moore's art was stamped with picturesque reminders of English Romantic tradition, in another sense the abstract conventions which he so fluently mastered confirmed the fact that a new universality, and even a somewhat academic spirit, had overtaken international abstract art. The major sources of the new form-language essentially represented an amalgam of the geometric forms of Cubism, the absorption in science, engineering, and new industrial materials of Constructivism, and the fantasy of abstract Surrealism. By the 1930s, it had become clear that a common language of form was evolving not only in European sculpture but in painting, architecture, and design. The formation and the influential activities of the Bauhaus did a great deal to replace the rather tarnished romantic individualism of contemporary Expressionist or Surrealist art with a different ideal based on the similar feeling for form in various fields of art. The free,

organic forms of Brancusi, Arp, Miró, and Moore, the formal rigors of Mondrian's De Stijl, and Constructivist art in three dimensions, with its kinship to precise engineering constructions, were soon reflected in the shapes and forms of everyday objects and buildings.

However, it was neither the aim nor the effective practical result of the school's technical teachings to propagate a particular style or doctrine, but, rather, to come to some kind of artistic reconciliation with the machine age, to open it up to new forms and new potentialities of creativity. The Bauhaus episode created a new awareness throughout the world that the machine and its products were capable of producing beauty in art based not merely on craftsmanship but upon functional appropriateness, clarity, and precision—a beauty not of applied ornament but of abstract forms.

Among the Cubists, Fernand Léger had for some time operated on the optimistic Bauhaus assumptions that art of the machine age would do well to adopt the character of machine forms, but in a eulogistic spirit rather than through the derisive ironies of Duchamp and Picabia. The climax

pl. 340

El Lissitsky. *Proun 1 D.* 1919. Oil on canvas on plywood, 37¾×28⅛". Kunstmuseum, Basel. 343

Amédée Ozenfant. *Still Life with Red Wine Glass.* 1921. Oil on canvas, 19¾×24¼". Kunstmuseum, Basel. 344

Wassily Kandinsky. *In the Black Square.* 1923. Oil on canvas, 38⅜×36¾". The Solomon R. Guggenheim Museum, New York. Gift of Solomon R. Guggenheim. 342

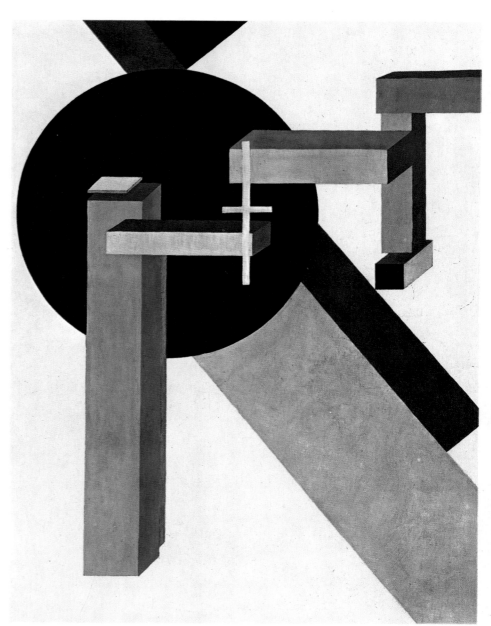

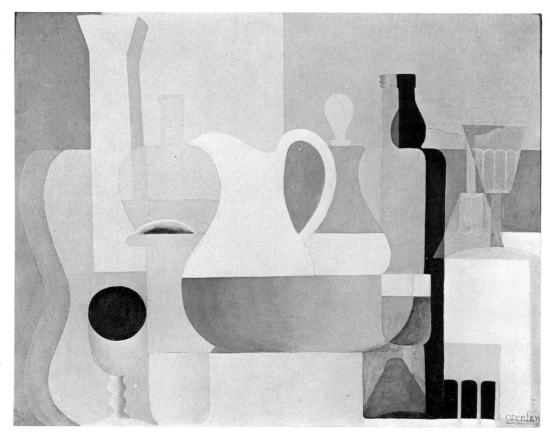

of his new style was *The City* of 1919. In 1921, Léger painted his more classical and stolidly monumental *Three Women (Le Grand Déjeuner)*. The broadly modeled figures and the pictorial accessories suggested a new admiration for cheap mass-produced objects, for the products of the machine as well as mechanical forms in themselves. Léger's interest in common objects was extended into a coherent esthetic philosophy by the contemporary effort of the so-called Purists Amédée Ozenfant (1886—1966) and Charles-Édouard Jeanneret (Le Corbusier). The same impulse to establish intelligible visual conventions for painting based upon machine design and manufactured objects of common use ultimately became institutionalized and codified in the Bauhaus curriculum.

When Wassily Kandinsky joined the Bauhaus in 1922, he had already begun to work in the new international language of severe geometric forms rather than the romantic and spontaneous style of his first nonobjective improvisations. The shift had taken place in the immediate postrevolutionary phase of Russian vanguard art, in the context of Constructivism and undoubtedly under Malevich's influence. Another important figure in the fundamental changeover at the Bauhaus from the esthetics of Expressionism to a structured abstract art was the Russian Constructivist El Lissitsky (1890—1941). After studying engineering in Germany, El Lissitsky returned to Russia where he had been born and began painting under the influence of Constructivism. With the establishment of a reactionary Soviet policy supporting Social Realist art, Lissitsky left Russia for Germa-

ny, where he became friendly with Moholy-Nagy, through whom he exerted a marked influence at the Bauhaus. Influenced by Malevich and Rodchenko, in 1919 he painted his first *Proun* ("For the New Art"), the title which he afterwards gave all his abstract paintings. Lissitsky transformed the Constructivist vocabulary of geometric forms on one plane into an illusion of three-dimensional forms. He also sought a multiple spatial and functional identity for his forms. He said: "A *Proun* is a station for changing trains from architecture to painting."[9] *Proun* demonstrates the artist's unusual ability to organize two-dimensional and three-dimensional abstract figures in compositions of great purity and balance while avoiding symmetrical arrangements.

Another Bauhaus figure who contributed significantly to the international language of abstraction was Josef Albers (1888—1976). Like Lissitsky, but by different means, Albers explored three-dimensional illusion, first in glass paintings and woodcuts, which he called Impossibles; their titles and forms suggest contradictory systems of perceiving the same geometric configuration, rather like the reversible optical illusions that Gestalt psychology utilized to demonstrate perceptual dynamics. Albers and Moholy-Nagy gave the celebrated preliminary course in basic design at the Bauhaus which has had a profound impact on visual education throughout the world ever since. When Hitler closed down the Bauhaus in 1933, Albers embarked on a long and influential American teaching career, first at Black Mountain College in North Carolina and then for another decade at Yale, until his retirement in 1960. In

pl. 341

pl. 344
pl. 205

pl. 342

pl. 343

pl. 345

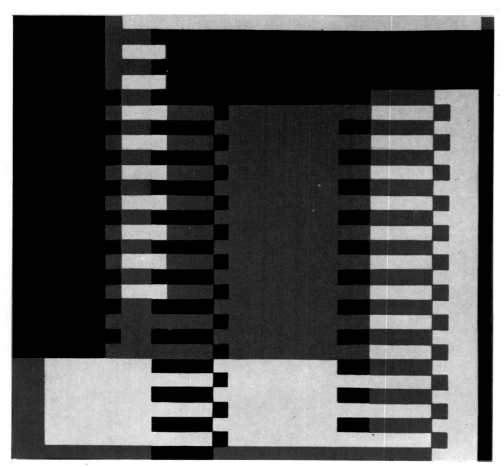

Josef Albers. *Walls and Posts (Thermometer Style)*. 1928. Sandblasted opaque glass colored red, white, and black, 11¾×12¼". Estate of the artist. 345

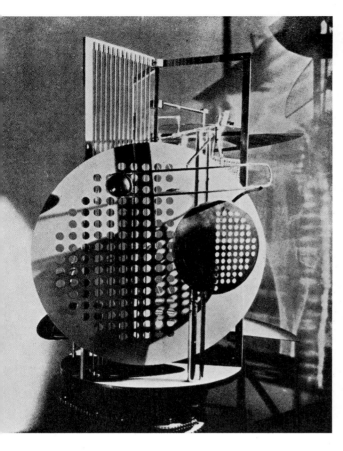

László Moholy-Nagy. *Light-Space Modulator.* 1921–30. Mobile construction of steel, plastic, and wood, 59½" h. Busch-Reisinger Museum of Germanic Culture, Harvard University, Cambridge, Mass. Gift of Mrs. Sibyl Moholy-Nagy. 346

László Moholy-Nagy. *Q VII.* 1922. Oil on canvas, 37⅝ × 27¾". National Gallery of Modern Art, Rome. 347

the course of his teaching, he renewed the foundations of abstract Constructivist art, and went far beyond the original Bauhaus precepts and practices to discover a new basis for a perceptually heightened color expression.

The presence at the Bauhaus after 1923 of László Moholy-Nagy (1895—1946) helped crystallize a drastic change in Bauhaus esthetics of far-reaching consequences. In place of the individualistic Expressionism and a mysticism about materials employed in Bauhaus pedagogy, there was a distinctive shift to the atmosphere of controlled laboratory exercises. Johannes Itten, an Expressionist painter, had taught the preliminary course; when Albers and Moholy-Nagy replaced him in 1923, they abandoned his intuitive approach for more objective and rationalist methods. Taking advantage of many aspects of modern technology and visual experience derived from photography, using industrial materials like clear plastics, they organized their teaching essen-

tially around a core of Constructivist esthetics. Moholy-Nagy's influence was second only to that of Walter Gropius. With Gropius he edited the fourteen Bauhaus books that appeared between 1925 and 1930 and included major theoretical statements by Malevich, Mondrian, van Doesburg, Gropius, Klee, and himself. His books, particularly *The New Vision*, 1938, and *Vision in Motion*, 1947, have been widely read, and are influential throughout the world.

One of Moholy-Nagy's boldest and most prophetic inventions was his *Light-Space Modulator*, the first electrically powered sculpture that emitted light. It stood with Gabo's *Kinetic Construction: Vibrating Spring*, made a decade earlier, as the paradigm and archetype of kinetic art for artists of later decades. Moholy-Nagy regarded his metal, glass, and plastic light machine both as a Constructivist sculpture in its own right and as an instrument for articulating light in motion—what he called an "architecture of light," and what

pl. 347

pl. 346

Max Weber. *Chinese Restaurant.*
1915. Oil on canvas, 40×48".
Whitney Museum of American
Art, New York. 348

Joseph Stella. *Battle of Lights,
Coney Island.* 1914. Oil on canvas,
75¾×84". Yale University Art Gal-
lery, New Haven. Gift of the
Collection Société Anonyme.
 349

would be known today as a light environment. The work engages our interest as a complex open-form sculpture of revolving mesh grids and perforated disks, and for its projections of changing configurations of light and shadow on the walls and ceiling of a room as it rotates. Moholy-Nagy felt that his machine was a forerunner of controlled light shows on a vast scale, to be projected on clouds and used in an industrial and urban context—a program which was actually fulfilled in the 1960s by such artists as Otto Piene and Nicolas Schöffer. Moholy-Nagy was also a visionary in regard to Minimal Art today and the concept of anonymous authorship. As early as 1922 he ordered a group of enamel "paintings" over the telephone from a sign factory, which meticulously followed his specifications but carried out all the details of execution without the artist present. In his first Bauhaus book in 1925, *Painting, Photography, Film*, he wrote with startling foresight: "People believe that they should demand hand execution as an inseparable part of the genesis of a work of art. In fact, in comparison with the inventive mental process of the genesis of a work, the question of its execution is important only in so far as it must be mastered to the limits. The manner, however, whether personal or by assignment of labor, whether manual or mechanical, is irrelevant." [10]

Moholy-Nagy and many of the other leading figures at the Bauhaus fled to America when Hitler disbanded the art school. Here their theory and design methods entered the basic teaching curricula of innumerable art and architecture schools, based upon Moholy-Nagy's example at his own School of Design, which he founded in Chicago in 1938, that of Gropius at Harvard, where he became chairman of the architectural department, and of Albers at Yale. The architecture and design principles developed at the Bauhaus were also disseminated through the examples of the American work of Ludwig Mies van der Rohe, Marcel Breuer, Herbert Bayer, and others. The Bauhaus thus had a direct impact on both American design and fine arts, and it became an important force in either establishing or reviving in the United States the international abstract traditions which the European avant-garde had long before assimilated.

Lacking the strong visual traditions of modern European art, or its commitment to theoretical principles that linked avant-garde art, and especially abstraction, to a vision of an ideal society, American progressive art in the twentieth century followed an erratic course, alternating between enthusiasm for the experimental and retrenchment during the 1920s and 1930s in a more provincial and familiar tradition of realism. The primary catalyst for the bolder attempts to reconcile European modernism with the American scene was the pioneer photographer and impresario of the arts, Alfred Stieglitz, who as early as 1905 established his small New York gallery at 291 Fifth Avenue, a gallery later known by its street

John Marin. *Lower Manhattan (Composing Derived from Top of Woolworth)*. 1922. Watercolor and charcoal with paper cutout attached with thread, 21⅝ × 26⅞". The Museum of Modern Art, New York. Acquired through the Lillie P. Bliss Bequest. 350

number, simply as 291. Almost immediately it became the headquarters for international modern art in America. The list of important European artists whose work was first shown in America by Stieglitz is an impressive one: Rodin, Cézanne, Toulouse-Lautrec, Matisse, Picasso, and Brancusi, and native debuts were made there by some of the most adventurous American moderns: Max Weber (1881—1961), Arthur Dove, John Marin, Alfred Maurer, Marsden Hartley (1877—1943), Joseph Stella (1877—1946), and Georgia O'Keeffe.

pl. 348
pl. 310
pl. 349

Another decisive factor in the development of a native avant-garde was the celebrated Armory Show of 1913, which brought modern European art on a vast scale to America. The immediate impact of the show on American artistic developments actually was mixed; on the one hand, it stimulated numerous artists like Stuart Davis, who later acknowledged that he discovered Cubism at the exhibition, but, in other cases, some resentment was stirred up by the fanfare which the dominant modern schools of painting and sculpture received. The American realist William Glackens expressed one prevalent view certainly when he said, "We have no innovators here. Everything worthwhile in our art is due to the influence of French art. We have not yet arrived at a national art." [11]

Many of the American artists whom Stieglitz first showed were surprisingly original, despite their obvious dependence on European models. Their provincial innocence was a source of strength as much as weakness, and actually in some instances it shielded the artist from the theoretical preoccupations of advanced European movements, with their distracting spate of manifestoes, polemics, and public scandals. As an

235

pl. 350

example, the fierce individualism of John Marin (1870—1953) proved refreshing rather than the customary liability of the provincial artist. He is an artist who does not easily date, even though his formula of Cubism-cum-Expressionism at times seems predictable enough, and even stereotyped. Marin bears interesting affiliations with contemporary American art of the postwar Abstract Expressionist generation. The lyrical effusions so often associated with his art, and his scintillating mastery of the watercolor medium, interest present-day artists less than Marin's expressive surfaces. Late in his life when Marin had begun to work more in oils, he told a biographer that he wished "to give paint a chance to show itself entirely as paint." This insistence on the stubborn, irreducible, material reality of paint later became the very heartbeat of contemporary artistic creation in America, with the emergence of the postwar Action painters.

Arthur Dove (1880—1946) and Georgia O'Keeffe (b. 1887), who became Stieglitz's wife, were two of the most original artists shown at 291. Both worked fruitfully within an idiom of organic abstraction which had not yet defined itself with the completeness of Cubism and thus afforded more freedom to the individual sensibility. Today, with hindsight and conditioned by the art of our own contemporaries, the work of these two Americans impresses us by its assimilation of European biomorphic tradition and by its stubborn independence, rather than by a sense of derivativeness. All the Americans emerging under the aegis of Stieglitz in advanced styles, whether Cubist-derived or organic, also shared a significant intellectual excitement as they explored new paths in the radical modes of European vanguard art. Yet

each of the major figures left a residue of identifiable and personal emotive characteristics: Weber's sober intellectual respect for Cubism; Hartley's affection for heraldic devices and symmetrical orders; the mysticism and romantic poetry of Dove and O'Keeffe; Marin's impetuousness and powers of improvisation; the rarity and fastidious elegance of the Precisionists Charles Demuth (1883—1935) and Charles Sheeler (1883—1965). pl. 353
pl. 354

Biomorphic abstraction was given a very individual inflection by Dove and O'Keeffe. In her painting *Light Coming on the Plains III*, O'Keeffe pl. 352 boldly reduces her pictorial means to a simple scheme of symmetrically opposed color stains. The imagistic and Symbolist overtones of these simple configurations are all the more surprising since the means are so thin, unpromising, and nonaggressive. In such early paintings she explored ideas of distinctness and indistinctness, concentration and diffusion, until they took on the character of statements about the essential ambiguities of experience itself. In terms of the conspicuous patterning of the art of Kandinsky, from whom her own abstract paintings derive, the greater "openness" of O'Keeffe's amorphous, stained image represents a sharp departure. In her sublimation of pictorial matter, in her feeling for limitless boundaries and self-renewing images, O'Keeffe treats her earliest abstraction not merely as an occasion for formal exposition, but as a mode of lived experience.

Dove seemed to approach related formal problems in a similar spirit. As early as 1910, he precociously painted what was undoubtedly the country's first entirely nonrepresentational painting, *Abstraction Number 2*. It coincided in time with the pl. 351 first of Kandinsky's abstract paintings, although

Georgia O'Keeffe. *Light Coming on the Plains III*. 1917. Watercolor, 12×9". Amon Carter Museum of Western Art, Fort Worth. 352

Arthur Dove. *Abstraction Number 2*. 1910. Oil on canvas, 9×10", Collection Mr. and Mrs. George Perutz, Dallas. 351

Charles Demuth. *Aucassin et Nicolette.*
1921. Oil on canvas, 23½×19½". Columbus Gallery of Fine Arts, Ohio. Gift
of Ferdinand Howald. 353

Charles Sheeler. *River Rouge Plant.* 1932.
Oil on canvas, 20×24". Whitney Museum
of American Art, New York. 354

Dove's discovery of abstraction now seems to have been fragmentary and inconclusive, since he did not develop a consistent nonobjective style in the years immediately following. The uncompromising abstract paintings of Dove and O'Keeffe made just before and during World War I stand in an equivocal relationship to European abstraction of that period. Both artists accepted the European mode of biomorphic abstraction, but subtracted some of its explicitness of effect in favor of an unbounded and more permissive experience. Their art seems characteristically American in standing aloof from final solutions. What must have once seemed a curious lack of commitment to formal exposition, or at best a weak and muffled echo of it, has today become a prevailing way of art in which we see reflected the ambiguity of our own experience of reality. Despite their essential modesty of scale and ambition, and without being a specific influence, the paintings of O'Keeffe and Dove prefigure attitudes and an imagery that belong to contemporary abstraction. They are thus part of an intelligible continuity of taste and change between two otherwise antithetical generations.

pl. 355, 356

A related pattern of development was evident in the phenomenon of Synchromism, an abstract style of color painting related to the Orphism of Kupka and Delaunay, which the Americans Stanton Macdonald-Wright and Morgan Russell (1886—1953) arrived at independently while living in Paris. Their paintings, which gained new recruits in America in the 1920s, were based on combinations of color planned in dynamic rhythm, which, according to Macdonald-Wright,

pl. 359

would refine art "to the point where the emotions of the spectator will be wholly esthetic." In theory such a doctrine anticipates the most advanced developments of American painting of the 1950s, as did the paintings of Dove and O'Keeffe. But the Synchromists soon lost interest in these objectives and the movement came to an end in a few years. American art has often been filled with brave beginnings which are without consequence, it being apparently a basic characteristic of American culture always to head for new and more distant frontiers and rarely to look back and consolidate gains.

In the 1920s, a conservative atmosphere reasserted itself more strongly until finally the center of gravity in art shifted once again, away from Europe and artistic innovation to the native scene and a revival of Naturalism. The realist vein of American painting was too strong to be overwhelmed by a still-controversial modernism. By 1920, when the first effects of the Armory show were pretty well spent, the American scene returned vigorously, both as an inspiration for artists and as a popular subject. Edward Hopper (1882—1967) and Charles Burchfield (1893—1967), the former romanticizing the unpicturesque loneliness of American town and country life, the latter dreaming up near-fantasies of similar subjects in his imaginative watercolors, were its most prominent figures. Their art was cheerless and harsh, haunted by romantic nostalgia but addicted to the grotesque. It sought refuge in the commonplace, as a rebuke to the esthetic conundrums of the modernists. But the scene it disclosed was not humanly reassuring, and the reality it set

pl. 358
pl. 357

Arthur Dove. *Nature Symbolized*. 1911. Pastel on paper, 17⅞×21½". The Art Institute of Chicago. Alfred Stieglitz Collection. 355

Georgia O'Keeffe. *Black Iris*. 1926. Oil on canvas, 36×29⅞". The Metropolitan Museum of Art, New York. The Alfred Stieglitz Collection. 356

Charles Burchfield. *Church Bells Ringing, Rainy Winter Night.* 1917. Watercolor, 30×19". The Cleveland Museum of Art. Gift of Louise M. Dunn in memory of Henry G. Keller. 357

Edward Hopper. *Office at Night.* 1940. Oil on canvas, 22⅛×25". The Walker Art Center, Minneapolis. The T. B. Walker Art Fund. 358

Morgan Russell. *Synchromy in Orange: To Form.* 1913–14. Oil on canvas, 11'3"×10'3". Albright-Knox Art Gallery, Buffalo. Gift of Seymour Knox. 359

239

forth was a world of shadows. Like some of the American modernists influenced by Duchamp who had begun to react negatively to the machine and to the new landscape of power, the romantic realists, employing different pictorial metaphors, also told the story of the disenchantment and spiritual vacancy behind the American success story.

Hopper was primarily a poet of human isolation, whose themes at their best have a universal appeal and relevance beyond the immediate social scene or their rather drab technique of Naturalism. *Nighthawks* demonstrates his ability to reveal with poignancy the personal loneliness that is so much a part of modern, highly organized urban existence. The composition is typically clear and ordered. It involves the figures of a counterman

pl. 362

and three customers in an all-night café, with empty stools, windows, and streets echoing the empty faces of the lonely figures whose lives touch briefly and accidentally. Other works by the artist have similar themes—for example, an all-night gas station attendant, a single figure in a cheap hotel room, a pensive theater usherette standing alone in a corner off an aisle, and an empty main street early on a Sunday morning.

In the early 1930s another kind of grass roots, or regionalist, realism, chauvinistic in its optimism and its strident distaste for European modernist traditions, asserted itself in the Midwest. Its creed can be summed up in the words of Thomas Hart Benton (1889—1975), one of its leading figures and spokesmen: "A windmill, a junk heap and a

pl. 361

pl. 360

Rotarian have more meaning to me than Notre Dame or the Parthenon." With that belief, he painted ruggedly picturesque landscapes. The same point of view was enthusiastically shared by Grant Wood (1892—1941), whose satirical paintings of American types were widely appreciated even by those satirized. The third member of this triumvirate, John Steuart Curry, dramatized the landscape of Kansas, as well as the fortunes and misfortunes of the farmer.

American Social Realist painting of the 1930s was not only the product of Burchfield's and Hopper's disenchanted views of the American scene, or of the regionalists' effort to build a sustaining myth of the frontier; it also reflected the economic crisis of the Depression. The impact of that traumatic and tragic event was to force a new kind of reappraisal among American artists of their cultural identity, first through themes of social protest in a style of parochial realism, and then, rather ironically, as a result of the stimulation supplied by the WPA Federal Art Project, in bold

and surprising experiments with Constructivist abstraction.

What could be defined loosely as Social Realism was the prevailing style of work done under the innovative federal government program of assistance to artists, which operated from 1934 to 1939. Some of the more directly political artists also benefited by the Federal Art Project. Painters such as Robert Gwathmey, Philip Evergood (1901—1973), Ben Shahn (1898—1969), and Jack Levine worked in a sharp and allusive realist style, entirely suitable for their main purpose, the communication in art of their strong feelings about social justice. The dependence of Social Realism on the work of Mexican artists like José Clemente Orozco and Diego Rivera was as evident as was its indifference to the sophistication of modernism and the presumed art-for-art's-sake attitudes of the abstractionists.

pl. 363
pl. 364

In the early 1920s, the Mexican social revolution had inspired a new school of nationalist mural painting, as the government began to com-

Philip Evergood. *Lilly and the Sparrows*. 1939. Oil on composition board, 30×24". Whitney Museum of American Art, New York.
363

Ben Shahn. *The Passion of Sacco and Vanzetti*. 1931—32. Tempera on canvas, 84½×48". Whitney Museum of American Art, New York. Gift of Edith and Milton Lowenthal in memory of Juliana Force.
364

mission monumental frescoes celebrating its achievements. While other Latin American countries remained tied to the School of Paris, Mexican painting went on to create a new kind of propagandistic and inspirational public art, reflecting the history of Mexico and the socialist spirit of the Mexican revolution.

Diego Rivera (1886—1956), the best known Mexican muralist and the busiest, filled the walls of public buildings with murals that preached the ideals of social revolution and the evils of capitalism in a style that combined decorative elements of Post-Impressionism, occasional savage caricature, and the hieratic quality of fourteenth-century Italian religious art. In the United States he executed murals for the San Francisco stock exchange, the Detroit Institute of Arts, and, in 1933, Rockefeller Center. The last work was destroyed and painted over, however, when the sponsors were offended by the inclusion of a head of Lenin in the mural.

José Clemente Orozco (1883—1949) did not preach visually, or sentimentalize, as did Rivera, and his work was neither so formal nor decorative. He was closer to the Expressionists in spirit, at first to the sculpturesque stylization of Barlach, and then later to the more dynamic and fluid forms of El Greco. He, too, worked in America, and stayed there from 1927 to 1934. He carried out important mural works in the dining hall of

Pomona College at Claremont, California, the New School for Social Research in New York, and in the Baker Library at Dartmouth College.

The third remarkable social-minded Mexican artist was David Alfaro Siqueiros (1896—1974), who tried to modernize his colleagues' techniques by employing industrial materials such as plastic paints, spray guns, and other mechanical devices to give modern meaning both to his art and to the concept of social revolution.

Rufino Tamayo (b. 1899) was another distinguished contributor to the revival of Mexican art, but, unlike the muralists, he reacted positively to the influence of the School of Paris and became the outstanding modernist in his country. He was also impressed by the Latin American past in the form of Tarascan sculpture, as well as by later native forms such as the colored *papier-mâché* figures used in holiday celebrations. Because he was not basically a mural artist, Tamayo found a career in Mexico rather difficult for a long time, especially since he did not share the leftist political viewpoints of the muralists. Feeling alienated from the dominant art forms of his native land, he came to New York in the early 1930s, and there he directly experienced the modern movement through the exhibitions at the Museum of Modern Art. These contacts, added to his already instinctive modernist tendencies, settled the future course of his art. In the United States he got his first

pl. 365

pl. 368

pl. 366

pl. 367

and other popular art forms, he sought also to inject brisk new rhythms and a somewhat irreverent gaiety into abstract painting. For the stage properties of Cubism, the pipes, mandolins, and harlequins, Davis substituted the surfaces of American life: ensembles of gas pumps, colonial houses, local street scenes, disembodied lettering and signs. Some of his more abstract, irregular silhouettes and his bright color effects resembled Matisse's vital and playful cutouts of his last years.

pl. 372

Davis's art is one of the most important, if rare, links of continuity between America's first phase of advanced art and postwar abstraction. Curiously enough, today his style and American-scene content are more related to Pop Art than abstract painting, but in the 1930s he provided a most useful frame of reference and a point of support for many of the young artists who were beginning to move toward abstraction. David Smith, the sculptor, later indicated that he found stimulation in Davis's liberal viewpoint on the WPA art project during the period dominated by regionalist styles and a somber urban Expressionism. Arshile Gorky's geometric abstractions bear a striking resemblance to Davis's work of the eggbeater phase, as do many of the paintings of the members of the American Abstract Artists group, formed in 1936, significantly, the year in which Alfred Barr organized the historic and trend-setting exhibition, Cubism and Abstract Art, at the Museum of Modern Art.

To the generation of Hopper, Burchfield, and others who drew on the American scene, Davis's art posed a challenge, for it provided more refreshing answers in the quest for a native art than the style of romantic realism could offer. "In my own case," Davis wrote, "I have enjoyed the dynamics of the American scene for many years, and all my pictures . . . are referential to it. They all have their originating impulse in the impact of the contemporary American environment."[13] For the generation of emerging younger artists who would soon be moving toward more radical modes of abstraction, Davis's work confirmed a growing resolve to find their artistic expressions outside representational styles. The Abstract Expressionists in the 1940s rejected Davis's forms and what were for them his anachronistic themes. They certainly took heart from his example, however, and from such steadying affirmations of principle as his statement: "The act of painting is not a duplication of experience, but the extension of experience on the plane of formal invention."[14]

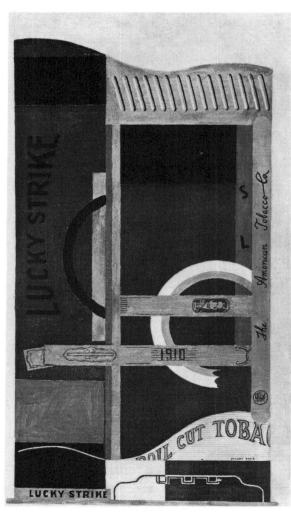

Stuart Davis. *Lucky Strike*. 1921. Oil on canvas, 33¼×18". The Museum of Modern Art, New York. Gift of the American Tobacco Company. 371

Stuart Davis. *Blips and Ifs*. 1963–64. Oil on canvas, 71×53". Amon Carter Museum of Western Art, Fort Worth. 372

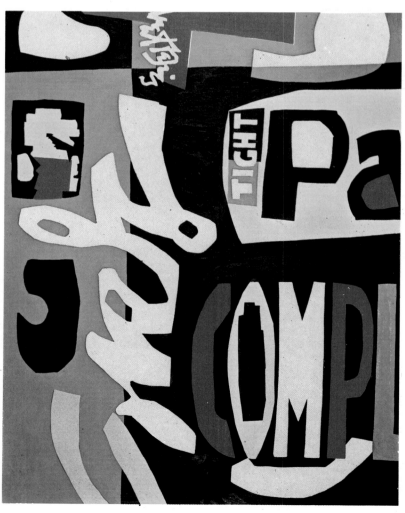

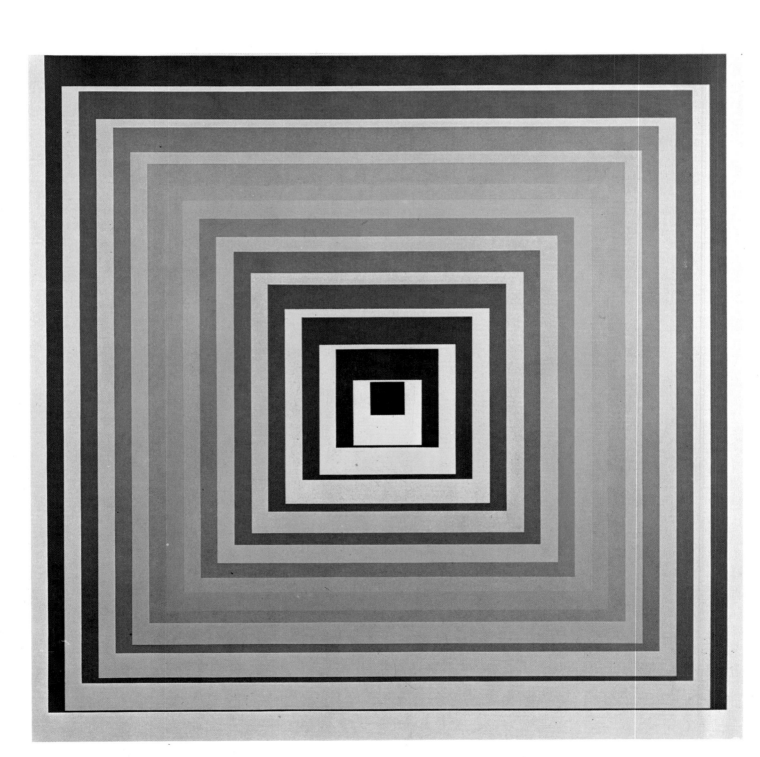

POSTWAR EUROPEAN ART

The close of World War II marked the opening of a new era in European art. With the stirring of new ideas among the younger artists, and after numerous exhibitions of the work of Picasso and other great figures of modern art, a serious reappraisal of prewar modernist movements began. There was evidence of a search for new points of departure that would overcome the contemporary mood of despair arising from the devastating wartime experience. Influenced by Existentialist philosophy, the artist struggled to inject a more meaningful content into the exhausted Purist-Constructivist tradition by inventing a more personal and subjective kind of abstract painting.

The abstract expression which emerged in painting and sculpture was international in scope, alternately identified with Paris and New York. It seemed to have arisen from a worldwide cultural crisis, and neither capital could legitimately claim priority as the sole source of significant formal innovations. The terms used to classify the free abstractionists in New York were the New York School, Action Painting, and Abstract Expressionism. Their European counterpart was called *l'art informel* or *tachisme*. It is clear today that both developments were essentially parallel and quite independent of each other.

Immediately after the war, the prestige of the surviving School of Paris painting of the past was judged on the wane. It revealed an unchallenging, predictable formula which usually combined Pierre Bonnard's hot palette with loose variations on the Cubist or Orphist formal structures of Robert Delaunay and Jacques Villon, exemplified by the rather tame painting of Charles Lapicque, Jean Bazaine, and Alfred Manessier. The established French tradition of *belle peinture*, of the painting as a sensuous and appealing object of good taste, stood in the way of any radical change. These artists and a number of others even went so far as to identify their carefully modulated, bright colors and orderly abstract structure with national artistic characteristics, and, at the height of the German occupation, in 1941, they produced a show of nonfigurative painting in a Paris gallery called Painters in the French Tradition. By contrast, the first prominent group of emerging postwar artists in Paris, Hans Hartung, Wols, Jean Fautrier, and Pierre Soulages, painted forms which were conceived as autonomous expressions in themselves, without the necessity of figurative reference or justificaton as a nationalist expression. The self-proclaimed painters of French tradition drew or painted from the motif, later transposing their landscapes or figures into a kind of naturalist symbolism. Bazaine, Manessier, and a few others, however, protested their association with the new School of Paris abstractionists. Nonetheless, members of both variants on Paris painting did share an opposition to traditional geometric abstraction and the lucid if somewhat academic design that continued the Constructivist, De Stijl, and Bauhaus traditions in Europe.

With the advent of the new Paris generation of Soulages, Hartung, Wols, Fautrier, the influential Jean Dubuffet, and a group of painters in northern Europe who called themselves the CoBrA, the dichotomy between figurative and nonfigurative styles was dissolved. In a few short years a broad new Expressionist abstraction established itself as the prevailing European mode. The emerging generation shared an interest in the most popular of postwar philosophies, Jean-Paul Sartre's Existentialism. Sartre gave them a convenient program for dealing with the emotional aftermath of the war years, which had left so many European intellectuals feeling demoralized and rootless. The individual's sense of alienation from any system of belief made even symbolic action imperative, and it became a saving catharsis in art. The act of painting was identified with the release from an anguished paralysis of will. All the complex motor operations and the emphatic brush marks of the new activist painting and sculpture functioned as a visible graph of the artist's rediscovered capacity to make effective decisions. Painting thus symbolized a renewed and affirmative commitment to reality. The most serious postwar artists felt com-

Victor Vasarely. *Vonal-A*. 1968. 63×63". Collection the artist, Annet-sur-Marne, France. 373

Wols. *January (Composition IV)*. 1946. Oil on canvas. Private collection, Milan. 374

Georges Mathieu. *The Great Dolphin*. 1960. Collection the artist. 375

pelled to reinvent their art *ex nihilo*, and in so doing redefined the human condition, admittedly with a certain self-consciousness, much as in Europe the ordinary man rebuilt new cities out of the rubble and devastation of the war.

From the rhetoric of Existentialist criticism, and from the new mood of subjectivism, a number of different types of expression emerged. In Paris, Georges Mathieu (b. 1921), Gérard Schneider, Soulages, Hartung, and others explored a brilliant draftsmanship in paint. They relied almost exclusively on swiftly registered calligraphic signs, and often worked in a palette restricted to black and white rather like their American counterpart, Franz Kline, with similar broad brushstrokes of a constructional quality. The spontaneity of "informal" abstract painting was married to rich texture and color obtained from a heavy impasto by a number of artists, including Antoní Tàpies (b. 1923) in Spain and Alberto Burri (b. 1915) in Italy. Burri showed an obsessive interest in surface textures and slow-moving rather than rapidly activated form. He was best known for his use of burlap and other foreign matter which he often joined with generous areas of red paint because they reminded him of the blood-soaked bandages he had seen in wartime. The symbolism may have been more compelling at the time than it is today, since the sensuousness and tastefulness of Burri's canvases, rather than their memories of pain, now

appeal to the eye. Fautrier and Dubuffet, as well as Tàpies, were the decisive influences in the development of relieflike paint surfaces, the mode which art critic Lawrence Alloway aptly described as "matter painting." The quietist, small-scale linear abstractions of Wols (1913—1951) in Germany were important, and he enjoyed, for a brief time after the war, an apocalyptic and legendary status much like Jackson Pollock's. Wols painted melancholy, self-revelatory, spidery abstractions of poignant intensity and despair.

The Expressionist current in the new abstraction received its major impetus from a series of interrelated artistic developments: the paintings of the CoBrA (an abbreviation of the cities from which the artists came—Copenhagen, Brussels, and Amsterdam); the new humanist sculpture of Alberto Giacometti; and the powerful figurative art of the two most important postwar European artists, Jean Dubuffet (b. 1901) and Francis Bacon (b. 1909). As the wartime experience was assimilated, a new concern with the human image became evident, and there was an awareness, as never before, of man's condition of loneliness and his will to endure. Expressionist abstraction was mediated by a fragmented, anguished humanistic imagery. Generally, it can be said that European vanguard painting and sculpture after the war was more somber than its American counterpart, in both figurative and abstract modes.

pl. 375

pl. 376
pl. 377

pl. 374

Antoní Tàpies. *White and Orange*. 1967. Mixed mediums on plywood, 24× 19¾". Collection Teresa B. de Tàpies, Barcelona. 376

Alberto Burri. *Large Sack*. 1954. Mixed mediums on canvas, 59×99½". Collection Phillippe Dotremont, Brussels. 377

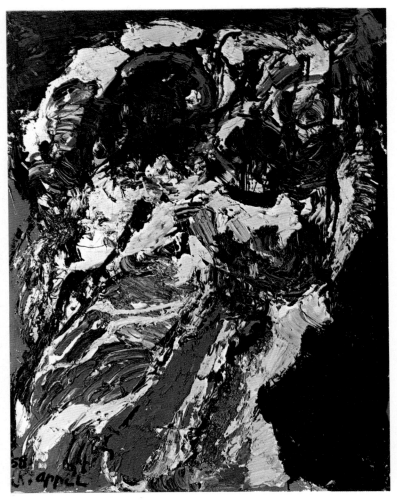

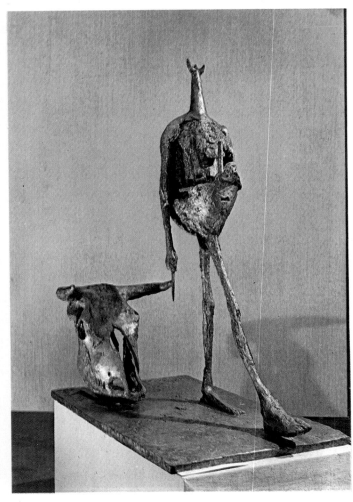

Karel Appel. *Personage*. 1958. Oil on canvas. Wallraf-Richartz Museum, Cologne. 378

Germaine Richier. *The Bullfight*. 1953. Bronze, 46″ h. Maison de la Culture, Caen. 379

Among the CoBrA members were the Dane Asger Jorn, the Dutchman Karel Appel (b. 1921), and the Belgians Corneille and Pierre Alechinsky. Appel described one of his more volcanic paintings, where pigment was whipped and dragged over the canvas with the knife in a kind of ecstatic frenzy, indicating the distance postwar abstraction had traveled from geometric and Constructivist art: "A painting is not a construction of colors and lines, but an animal, a night, a cry, a man, or all of them together."[1] Appel's rather brutal images managed to avoid melodrama or despair by their exuberance and visible pleasure of execution.

pl. 378

The tormented new European "humanism" evident in postwar figurative painting undoubtedly received a major impetus from the haunted and elongated sculpture forms of Giacometti. Jean-Paul Sartre introduced Giacometti's major one-man show in New York in 1948,[2] and his eloquent homage may be an indication of the sculptor's problematic and Existential content. He tried to unify individual human forms with a space that eroded their recognizable humanity, and covered his figures with "the dust of space," in Sartre's challenging phrase. Giacometti expressed by analogy the profound sense of solitude and anxiety of modern man, bereft of traditional institutional

pl. 381

consolations. Confronting a Giacometti sculpture, one sensed the predicament not only of postwar man but of urban man in mass society, dwelling in psychological isolation within large and complex social, political, and architectural structures which depersonalized him. In *City Square*, one of Giacometti's most poignant images of alienation, the rough, corrugated surfaces and blank, expressionless faces in telescopic scale give the diminutive figures an air of remoteness from one another, and from the observer.

pl. 380

This kind of nonheroic, figurative sculpture directly stimulated the amorphous forms and tortured imagery of Germaine Richier (1904—1959) and César in Paris. They shared a fascination with the grotesque, and invented horrid and fanciful insectile creatures or mythical personages, often spontaneously assembled from scrap metal. The savagery of their forms, with hydra heads, spiders' legs, and arms like tentacles, was countered by a lusty expressiveness of means, much as in the case of Appel, or Willem de Kooning's Woman theme. And their composite imagery incorporated a wide range of references, from myth, magic, and subconscious fantasy to child art and graffiti.

pl. 379

In Dubuffet's art the feelings of solitude and anxiety which dominated postwar European

250

pl. 382

moods found a resolution both awesome and comical in a vital new form of primitivism. His strangely vital, gnomic figurative painting and sculpture took as its conscious model the art of children, the insane, and the artistically naive, which he himself systematically collected under the rubric of *L'Art Brut*. Whether in wall graffiti, pathological art, or other primitivistic expressions, Dubuffet's astonishingly diverse formal explorations took the human situation rather than abstract pictorial values as their point of departure. His early exhibitions in Paris immediately after the Liberation were a revelation and became extremely controversial. Dubuffet's first crude effigy figures were blatantly childlike, scribbled and daubed in thick, sand-choked pigment, and they made their point dramatically both as surface and as disturbing hallucinatory imagery. Grotesque and cruel, they were at the same time culturally sophisticated and self-conscious despite the affectation of technical ignorance and their obviously macabre clowning. His coarsely textured visages and the anatomies of the "Corps de Dames" series, which followed in the early 1950s, read like textured maps of the female form, recalling archetypes that go back to paleolithic fertility-cult models rather than to the ideal beauty of the Greeks. But their material surface, placement, and spatial ambiguity lend them an expressive force comparable to the best of contemporary abstract painting.

Dubuffet's art is related to Surrealism, but the influence is less a matter of method than attitude. He has said that "the key to things must not be as we imagine it, but that the world must be ruled by strange systems of which we have not the slightest inkling."[3] His *assemblages*, a personal term for collage, used organic matter—lichens, leaves, dissected butterfly wings, sponge, cinder, lava stone—as the Cubists incorporated paper and wood in their collage constructions. In another notable difference, Dubuffet consciously emulated ancient cult objects to create what the artist aptly called a "mixture of familiarity and terror."

In the early 1960s, Dubuffet initiated a decorative painting series with the deliberately meaningless title of "L'Hourloupe." The new style, which continues today, in paintings, sculptures, and environments, showed a new debt to the ritualistic tightness of design and the sense of estrangement of psychotic art. The invented fantasy worlds of the disturbed mind appealed to Dubuffet for their visual and psychic drama, and as an expressive alternative to an overeducated esthetic system. Fragments of the human comedy, commonplace objects that lead an uncommon life, furniture impersonating men impersonating trees, and environments that illustrate ideas populate Dubuffet's new cosmology. Categories, species, and even physical properties are muddled and blurred, thanks to his masterful ambiguities of form. Since

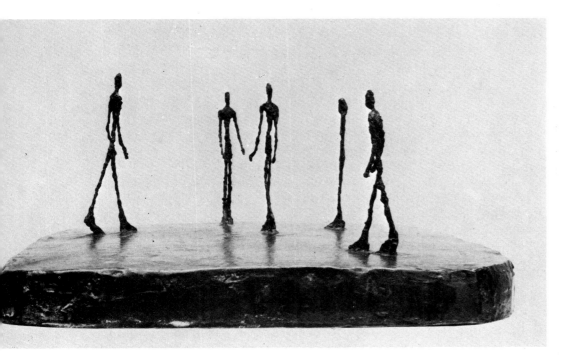

Alberto Giacometti. *City Square*. 1948. Bronze, 8½ × 25⅜ × 17¼". The Museum of Modern Art, New York.
380

Alberto Giacometti. *Figure from Venice II*. 1956. Painted bronze, 47½" h. Middeheim Museum, Antwerp.
381

251

Jean Dubuffet. Installation view of exhibition, The Practicables. Pace Gallery, New York, 1972. 383

Jean Dubuffet. *Mother Goddess*. 1945. Oil on paper mounted on cardboard, 12¼×11". Kunstmuseum, Basel. Gift of Werner Schenk. 382

his first cruel and hilarious portraits of the 1940s, there has been an element of sinister farce about Dubuffet's human comedy, whose dark psychic stirrings find an echo in the inanities and wild caricatures of Ionesco. The fantasy world of "L'Hourloupe" has a deceiving surface cheerfulness in its elementary patterns and bright nursery colors, but, upon closer inspection, the jumbled maps reveal obsessively tortured masks and the repetitive visual counterpoint of the mind in chains.

Until the "Hourloupe" cycle and Dubuffet's more recent large-scale fantastic sculptures and architectural environments, it was plausible to consider his achievement almost exclusively within the framework of the anguished mood after World War II when Giacometti produced his spectral sculpture. With his "Hourloupe" paintings, monumental sculptures, and visionary architecture, Dubuffet has enlarged his image and boldly sought a more expansive public style. At the age of seventy-four, he is probably producing the most challenging and original European art today outside of the younger new realist and Conceptual artists.

Eight years younger than Dubuffet, Francis Bacon was certainly the only British figurative painter to rank with the most distinguished artists of the postwar period. He has dealt with the same Existential sense of isolation and anguish, which he pushed to an even further point of psychic distress than did Dubuffet and Giacometti. His

pl. 383

preoccupation with terror was both melodramatic and psychological in impact, and it often seemed to be drained off directly from catastrophic journalism and visual accounts of the holocaust in World War II. With his sense of Surrealist menace and an imagery blurred as if in motion, Bacon stated the case for postwar European despair with a vehemence and originality that earned him a special place among contemporary Cassandras. His first important painting series were his variations on Velásquez's *Portrait of Pope Innocent X*, beginning around 1950. These vivid and powerful inventions transformed the crafty and smug prince of the church into a monstrously depraved image. Influenced by early film classics as well as tabloid journalism, Bacon synthesized photographic images of gunmen, Muybridge's motion studies, Eisenstein's *Battleship Potemkin*, and direct allusions to news photographs of Hitler and his barbarian lieutenants to create a half-real, half-fantastic world, a public chamber of horrors and private nightmares.

pl. 385

Bacon's distorted and idiosyncratic images bear eloquent witness to the actual events of the postwar period and more generally to man's innate capacity for violence. They may be considered the modern-day Freudian equivalents of Goya's savage visual commentaries on man's irrational violence in his "Disasters of War." For Bacon, pain and suffering are irremediable, inseparable from individual consciousness and the human condi-

tion. The only elation for the artist, he once observed, comes in the manipulation of paint, through the act of painting. The exhilaration of technique raises the public sense of crisis to the level of a great human drama of remarkable poetic intensity. One of Bacon's first sympathetic critics, Robert Melville, complimented the artist on his power and freedom of execution, but noted that Bacon's bravura pictorial effects occurred in the atmosphere of "a concentration camp."

The most original and compelling figurative painter to emerge in Latin America during the past two decades has been the Colombian Fernando Botero (b. 1932), now a resident of Paris. At first glance, his stubborn loyalty to a style of naive and meticulous realism might seem a pose of ingenuousness contradicted by plentiful evidence of sophistication in his unsettling scale and by the elements of savage social satire in his bizarre art. His undisguised reverence for the old masters, from Rubens and Caravaggio to Rigaud and Goya, is also frankly puzzling. Botero conducts his life and art innocently, as if Picasso and Bacon had never painted.

Upon careful consideration, however, it becomes clear that the historical past and the artist's own sense of role, whether as commentator or sycophant, seriously engage his energies and arouse in him a profound oedipal ambivalence. Even his most accomplished exercises in portrai-

Fernando Botero. *Self-Portrait with Louis XIV (After Rigaud)*. 1973. Oil on canvas, 9'6"×77½". Museum of Contemporary Art, Caracas. 384

Francis Bacon. *Two Figures*. 1953. Oil on canvas, 60×45⅞". Private collection, London. 385

ture carry the thrust of hidden allegorical meaning and fantasy. With a social irreverence worthy of Goya, he delineates the brutish physiognomy of a dissolute and vicious society comparable in cruelty and decadence to the grotesque caricature of the master's *The Family of Charles IV*. His effigies of military, clerical, and political leaders mercilessly lampoon the corruption of power.

Like the painters of medieval and quattrocento altarpieces, Botero himself takes a modest position in the diminished scale of a patron standing outside the main action. There is considerable irony in this manipulation of scale as it appears in his reconstruction of Rigaud's florid portrait of Louis XIV. He entitled this curious painting *Self-Portrait with Louis XIV*, as if to give the pneumatic and dropsical historical fiction the character of a projection of the artist's—and perhaps Everyman's—private fantasies of dominance and unconstrained *amour-propre*. pl. 384

European sculptors for the most part found it difficult to respond in kind to the challenge of the Expressionist and *tachiste* painting styles that dominated the postwar period. A number, however, did manage to learn a new approach from pictorial examples, and revitalized their art by trans-

253

Zoltan Kemeny. *Lines in Flight, 2.* 1960. Cut, bent, and beaten metal, soldered to metal base, 35½×45¼". Private collection, Rome. 386

Eduardo Paolozzi. *Akapotic Rose.* 1965. Welded aluminum, 9'1"×73"×50". Pace Gallery, New York. 387

pl. 387

pl. 386

pl. 390

pl. 388

pl. 389

ferring to a different medium the vehement brushstrokes, improvisational methods, and occasional calligraphic effects of the best informalist painters. Eduardo Paolozzi (b. 1924), in England, followed the pattern of Richier and César in assembling discarded industrial waste, which he cast into eroded human images. But by the late 1950s, he began to use more elegant, finished materials, polished aluminum and stainless steel, with which he created abstract architectural ensembles. One of the most elegant sculptors who explored metal relief and industrial scrap was the Swiss artist of Hungarian origin, Zoltan Kemeny (1907—1965). He used metal not only to evoke, by analogy, a nature of forest imagery, leaves, and winding streams; his imagery also alluded to a microscopic and submicroscopic world of textures, and even to scientific patterns of stress, refraction, and molecular distribution. Kemeny was one of the few artists emerging first from *l'art informel* and then from assemblage traditions to draw inspiration directly from the findings of modern science and technology.

In Italy, the lacerated surfaces of the thematic spheres, columns, and disks of Arnaldo Pomodoro (b. 1926) recalled Dubuffet's materially dense "landscape-tables" and the humanoid robots of Paolozzi of the early postwar years. In the late 1950s, Pomodoro's picturesque and sensitive surface calligraphy assumed the character of limited fractures, faults, and openings in otherwise unflawed geometric forms, whose mirrorlike surfaces recalled Brancusi's pristine volumes. Although there were clear allusions to technology in the simulations of gear teeth and machine parts, the flawed and eroded areas became acceptable expressive metaphors for introspection and a sense of personal vulnerability.

Pomodoro has, in recent years, elevated the postwar convention of personal torment beyond the private expressive plane to a mythic and public level by creating monumental outdoor sculptural forms whose structuring and elaborate fabrication both masked and refreshed his symbolism.

The Spanish sculptor Eduardo Chillida (b. 1924), on the other hand, forges powerful arrangements of iron bars out of a single continuous form without welding, and attains a calligraphic effect resembling to some degree Franz Kline's constructional brushstrokes, and aspects of David Smith's open-form iron works. His sculpture marked a new development in the art of the late 1950s toward austerity and reductive form, a bare and linear structural art. Chillida's straightforward ensembles of contorted and skillfully manipulated metal bars may be taken as symbols of the tension between individual effort and man's enormous, newly formed industrial powers, which he is nonetheless loath to trust fully.

Some figurative sculptors of the postwar period tried to arrive at a compromise between modernism and traditional expectations of the sculptural object, especially in Italy, where at least two significant artists made a serious effort to come to terms with the Italian past. Marino Marini (b. 1901) modeled his anguished equestrians of the immediate postwar years on T'ang dynasty statuettes and the bronze horses of St. Mark's in Venice, with echoes of Etruscan art. But the most powerful single inspiration for them, he revealed to a critic, were the homeless crowds of the common people of Milan desperately fleeing on horseback before the advancing Allied armies at the closing of the war. Marini's traditionalism is qualified by suggestions of eroticism in his striving phallic imagery and energy and by the influence of primitivism. Giacomo Manzù (b. 1908) is a curious case because his seductive portraits in bronze, and such commemorative works as the

Eduardo Chillida. *Dream Anvil No. 10*. 1962. Iron on wooden base, 17⅛×20½×15⅛". Kunstmuseum, Basel. The Emanuel Hoffmann Foundation. 388

Marino Marini. *The Concept of the Rider*. 1955. Polychromed wood, 88½" h. Collection the artist. 389

Arnaldo Pomodoro. *First Rotating Section*. 1966. Polished bronze. Private collection, Boston. 390

bronze doors which he designed for St. Peter's in Rome as a papal commission, bear almost no relationship to contemporary modes of sculptural expression. There are allusions to Donatello's low relief, to Bernini, and to Medardo Rosso. Despite the virtuoso craftsmanship of his modeling, Manzù's work lacks true inventiveness. It is significant in the context of an account of modern art history mainly because it indicates the disparity that exists between progressive and anachronistic art forms that fail to meet the most exacting esthetic standards and yet command public admiration and patronage.

A willingness to settle for tasteful refinements and traditionalist revivals increasingly came to dominate postwar European painting and sculpture as the *tachiste* and new figurative tendencies were assimilated. By the mid-1950s *l'art informel* had clearly exhausted its vitality and sunk into an agreeable but unchallenging set of stylistic mannerisms. A new postwar generation came forward to claim its liberation with art forms based on neo-Dadaism and strongly related to the material surfaces of contemporary life. The idea of establishing some parity in painting between representation and object qualities had been implicit in Jackson Pollock's free-wheeling abstractions which incorporated sand, discarded pigment

pl. 391

255

tubes, and other debris in the pictorial surface, as in the organic collages of Dubuffet, in Burri's burlap and paint arrangements, and in the collage process that Willem de Kooning adopted to arrive at his famous Woman series. Younger artists began to incorporate actual objects taken from daily life in constructions, tableaux, and environments—attaching them physically to their painting and sculpture, and thus creating dislocating shifts of identity between the actual objects and their constructed or painted simulacra. This was the period when discards from the industrial junk heap, random accumulation of commonplace commercial products, and the theatrical Happening, which utilized object fragments in a performance situation, came to the forefront as the basis of a new environmental art.

In Europe the trend was called new realism, after the movement founded by the French critic Pierre Restany in conjunction with the artist Yves Klein and others. The first exhibition of new realism was held in Milan in 1960 and included, pl. 392 among others, Yves Klein (1928—1962), Jean Tinguely (b. 1925), and Arman (b. 1928). It had been anticipated by Klein's monochrome painting, his outrageous promotional methods, and a

256

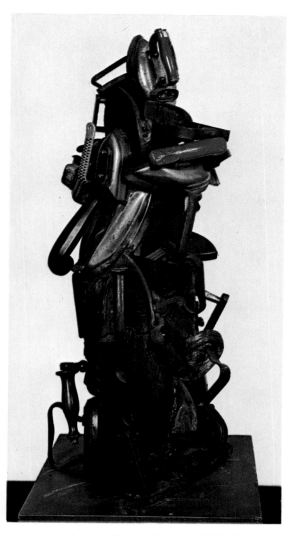

Arman. *Sonny Liston*. 1963. Flatirons, 33" h. Schwarz Gallery, Milan. 393

Jean Tinguely. *Pop, Hop and Op & Co*. 1965. Painted steel, toys, feathers, etc., with motor, 3'7¼"×6'10⅝". Collection the artist. 394

sensational exhibition, The Void, two years earlier at a Paris art gallery. The exhibition was dedicated to the theme of emptiness, in which only the gallery painted white, a member in full regalia of the French Garde Républicaine stationed at the door, the artist, and spectators constituted the action or subject matter of the event. Klein involved himself with modern technology and urbanist ideas when he and Tinguely collaborated on motion sculpture in another 1958 exhibition where Tinguely's kinetic machines spun monochrome blue disks at different speeds. Unlike his new realist associates, Klein placed far more importance on gesture and his own symbolic actions, using such unorthodox methods of producing works of art as a flamethrower, or rain, and directing a troupe of twenty musicians and naked girls smeared in his patented blue paint—IKB, "International Klein Blue"—as they rolled about on canvases laid out on the floor. A sequence from this rather spectacular and bizarre event, so far ahead of its time, was recorded for the film *Mondo Cane*.

Tinguely's motorized junk sculptures were more obviously inspired by urban life, like most of the

new realist art, and also had a critical social content. In 1958, he made a machine which he called a Meta-matic, and it literally produced on sheets of paper, at the press of the activating button, automated *tachiste* paintings, or Action Painting, replicating recent contemporary work by Hartung, Mathieu, and Pollock. These visual parodies effectively closed out the epoch of Abstract Expressionist painting, which was rooted in a romantic view of the creative process. Similarly, Arman created random accumulations of object fragments, which imitated the finesse and touch of Abstract Expressionist form, but without denying the insistent object status of his materials. The esthetic devices and theoretical speculations of the new realists coincided with the exacting and relentless descriptions of objects and the physical environment, at the expense of a psychology of human motivation, in the new French novels of the late 1950s and early 1960s. "The importance of objects, especially artifacts, in the recent films of Resnais and Antonioni," a New York critic noted, matched the emphatic materialism of new realism and Pop Art in a current exhibition review of 1962.[4]

pl. 394

pl. 393

257

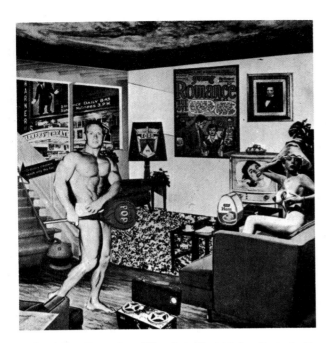

Richard Hamilton. *Just What Is It That Makes Today's Homes So Different, So Appealing?* 1956. Collage, 10¼×9¾". Collection Edwin Janss, Jr., Los Angeles. 395

Perhaps the *reductio ad absurdum* of the new realist object assimilations occurred in 1962 when the Bulgarian artist Christo (b. 1935) blocked the Rue Visconti in Paris with oil drums, turning the art of assemblage into an environmental experience on the grand scale, and a disorienting one at that. He had begun to make small-scale "packages" and to wrap objects four years earlier in Paris, using a technique which mysteriously concealed but also revealed the salient shapes of forms covered by progressively larger expanses of fabric and plastic materials. Settling in New York in 1964, he began his proposals for wrapping Manhattan skyscrapers. Finally in 1968 he wrapped the Kunsthalle in Bern, Switzerland, using 27,000 square feet of reinforced polyethylene tied with nylon rope, the first of his large realized environmental projects. It was outdone the following year when he ambitiously, and improbably, wrapped a mile of coastline at Little Bay, Australia. Christo has regularly produced large-scale landscape and environmental projects ever since, based on his early association in Paris with the new realist group.

pl. 396

In the early 1960s, the proliferation of the mass communications media converged with the diminishing momentum of European *tachiste* painting and the parallel American Abstract Expressionist movement to bring to birth an entirely fresh artistic phenomenon known as Pop Art. Pop artists took their imagery literally from popular entertainment and commercial sources. Their unabashedly imitative forms became the subjects of acrimonious dispute, among artists of the older generation especially, for it was charged that Pop Art did not expand sufficiently on its visual sources in commercial art. The new tendency seemed merely to confirm the anti-individualistic aspects of life and culture to which the *tachistes*

and Abstract Expressionists, by contrast, had proposed a violent dissent. Despite its generally detached or ironic attitude toward a vernacular subject matter, Pop Art was seen as pro-establishment and supportive of philistine tastes, at best an entertainment. The older avant-garde, feeling its own values threatened, preferred to restrict Pop Art's meanings to the banalities of commercial art which it openly imitated, and which serious artists had held in contempt. However, the emergence of a number of strong artistic personalities has made it impossible to underestimate the importance of this artistic phenomenon, or to set arbitrary limits on its expressive possibilities, influence, or growth.

It is generally agreed that Pop Art actually began in England in the 1950s as an involvement with popular culture, almost a decade before it was associated with a distinctive artistic style or method. It originally grew out of discussions and exhibitions held at the Institute of Contemporary Art in London by a number of artists, critics, and architects who called themselves the Independent Group. By the winter of 1954/55 the word "pop" was in current use in relation to popular culture, according to one leading member of the IG, the art critic Lawrence Alloway. The group included Paolozzi, Richard Hamilton, and the architectural and cultural historian, Reyner Banham. Urban folklore, popular culture and its visual embodiment in advertising imagery and signs, became the obsession of the group. In 1956, they held an exhibition at the Whitechapel Art Gallery in London called This Is Tomorrow, which showed a series of contemporary environments

Christo. *Wrapped Coast, Little Bay, Australia.* 1968–69. Woven polypropylene and rope, surface area 1,000,000 sq. ft. 396

developed from photographs of architecture and the vernacular imagery of the advertising world. Richard Hamilton (b. 1922) contributed a small collage that later became justly famous as the Pop Art forerunner, though it was actually unknown in America by the Pop artists, who arrived at their styles independently some years later. The collage picture was entitled *Just What Is It That Makes Today's Homes So Different, So Appealing?*, and it showed a photograph of a muscle-man and a pin-up girl wearing only a hat, in a modern interior, with the male figure holding a large lolly-pop on which the word POP was inscribed in bold letters.

pl. 395

The profound change in artistic values which had occurred was indicated by a statement that Hamilton made to the architects Alison and Peter Smithson the following year. He irreverently listed the desirable qualities for a new art as "popularity, transcience, expendability, wit, sexiness, gimmickry and glamor."[5] Parenthetically, Hamilton urged in the letter that Pop Art be low-cost, designed for a mass audience, aimed at youth, and emulate "Big Business." It should be noted that Hamilton was not alluding to an existing body of painting, for Pop Art as we know it had not yet crystallized. He was merely describing its source

material, with the same uncanny prescience shown by Marshall McLuhan in 1951 when he analyzed the hidden symbolism of advertising messages, verbal and visual, in his first brilliant book on popular culture, *The Mechanical Bride.* The English Pop artists themselves began to emerge in significant styles only in the early 1960s.

Among the most captivating in dealing with the clichés of commercially inspired imagery were Peter Blake, David Hockney (b. 1937), Allen Jones, and Patrick Caulfield. All of these artists were not concerned simply with imitating the model of commercial art, however. They also explored the relationship between fine arts and mass culture, and made a particular effort to assimilate to art the debased imagery and vision which mass culture and kitsch encouraged on a vast scale. Somewhat more subtle, visually, were the mysterious and poetic juxtapositions of oil-painted photographic life-size figures set on mirrored surfaces by the Italian painter Michelangelo Pistoletto (b. 1933). The spectator saw himself reflected in these scenes, and thus completed the composition in the space of the real world with a resulting Pirandellian confusion of levels of illusion. In France, Martial Raysse began the familiar pattern of parodying old masters in sentimental or erotic,

pl. 397

pl. 398

David Hockney. *Henry Geldzahler and Christopher Scott.* 1969. Acrylic on canvas, 84" × 10'. The Harry N. Abrams Family Collection, New York. 397

Michelangelo Pistoletto. *He and She Talk.* 1965. Oil on tissue pasted to stainless steel, 47¼ × 90⅝". Collection the artist, Turin. 398

Ben Nicholson. *Still Life*. June 4, 1949. Oil and pencil on board, 23¾×18¼". The Hirshhorn Museum and Sculpture Garden, Smithsonian Institution, Washington, D.C. 399

Pevsner; Moholy-Nagy from Hungary; van Doesburg, César Domela, and Mondrian from The Netherlands; Friedrich Vordemberge-Gildewart from Germany; while France was represented by numerous artists, among them such figures as Jean Arp, Auguste Herbin, and Jean Helion. Naum Gabo took the ideas of the Abstraction-Creation to England, and there in 1937 he joined the painter Ben Nicholson (b. 1894) in publishing the review *Circle*, which contained contributions by Mondrian, among others. Nicholson and his wife, the sculptor Barbara Hepworth, were just beginning to break away from an art tied to observation and create works using the visual vocabulary defined by Theo van Doesburg in his well-known *Manifesto of Concrete Art*. When Mondrian left Paris for England in 1938, he was welcomed by the Circle group. The geometrical abstraction that Nicholson has practiced with such purity over three decades essentially came to birth at that time. After meeting Mondrian, Nicholson developed the characteristic arrangements of circles, squares, and fine vertical-horizontal linear divisions which have scarcely been modified since. With the passage of time and in contact with new

pl. 399

Max Bill. *Black Column with Triangular Octogonal Sections*. 1966. Swedish granite, 13'8"×23½". Marlborough Gallery, New York. 400

mythic scenes. However, he abruptly updated his nostalgic visions of art history and made them relevant to modern technology by adding to his painted constructions such startling props as an illuminated neon heart.

While Pop Art represented a rather violent and deliberately vernacular reaction both to the ideological narrowness and the increasingly evident mannerisms of *l'art informel*, there was another kind of abstract art in Europe, which showed, on the other hand, surprising survival powers in the face of Expressionist abstraction. The work of a number of artists still rooted in an essentially Bauhaus tradition of Constructivist abstraction, usually described as concrete art, converged in a broad tendency of systematic and orderly but still experimental abstract painting and sculpture. Opposed to the intuitive and expressionist methods of *tachisme*, theirs was an art of clear forms, anonymous touch, clean, or hard, edges, and, above all, intellectual control. For the most part esthetic conservatives, the concrete abstractionists, nonetheless, bridged the considerable distance from Bauhaus formula to a more current interest in the dynamics of vision and optical illusion.

Concrete art had centered mainly in Paris during the 1930s, and there two important groups were formed—Circle and Square (*Cercle et Carré*), led by Michel Seuphor, and then Abstraction-Creation. Artists from many countries participated in these groups and worked in a style of concrete abstraction: from Russia, Kandinsky and

Lucio Fontana. *Spatial Concept.* 1962. Collection Graziano Laurini, Milan.

401

earlier abstractionist tradition by emphasizing intellectual control in works notable for their austere beauty, precision, and lucidity, but devoid of much personal emotional involvement.

Lucio Fontana (1899—1968), in Italy, provides an unusual and influential example of a truly protean inventor who spans many different modern traditions, from conventional concrete abstraction through *l'art informel*. He even anticipated, at an early date, some of the artistic attitudes and Conceptual projects of the 1960s. As early as 1946, while living briefly in Buenos Aires, Fontana published his prophetic *White Manifesto* proposing a closer alliance between art and science, one which would be free of esthetic artifice and the Utopian theorizing of the pioneer Constructivists. Then, after a brief flirtation with *tachisme*, Fontana began to slit and perforate his canvases with a pl. 401 knife or lacerate metal surfaces with an acetylene torch, in order to demonstrate what he termed were his "spatialist" ideas. In 1949, in Milan, he built a large-scale spatial environment that consisted of sculptural forms hung from the ceiling, coated with reflective paint and illuminated by ultraviolet light. His spatialist, or environmentalist, philosophy and his unusual techniques conceived of matter and space as pure energy and a dematerialized environment. It was this orientation which helped set the scene for later experiments along similar lines by such intransigents as Yves Klein, Piero Manzoni, the so-called Group Zero in Germany, and GRAV in France.

Fontana's monochrome, albeit perforated canvases are among the few significant examples that can be related to post-painterly abstraction and Minimal Art in America. The new styles of impersonal color-field abstraction which, from the late 1950s, played such a crucial role with the emergence of Morris Louis, Helen Frankenthaler, Kenneth Noland, Ellsworth Kelly, and others had very little impact on the European art scene, except perhaps in the work of some English abstract painters of minor stature. However, in the area of three-dimensional structures the very elements of simple polychromy, reductivist form, and optical ambiguity which had discouraged pictorial ventures can be associated with a wide range of European experiment in structurist sculpture, light and movement art, and mixed media.

The sculpture of Anthony Caro (b. 1924) pre- pl. 402 sents an intriguing case of an artist whose work mediates between pictorialism, in its elegant color surfaces, and modern structural expression on the highest level of formal achievement. He has been grouped with the American primary structurists and Minimalists because of the simplified geometric character of his work. Yet the differences from them are perhaps even more decisive. His sculpture emerged from the constructionist tradition of Picasso, González, and, most importantly, David Smith, but it also has affiliations with the "antirelational" paintings of Noland, Frank Stella, and the field painters in America. Caro articulates structure in a manner much like that of the Cub-

movements, they may have acquired more delicacy of color, refinement in composition, and more challenging qualities of optical ambiguity.

Max Bill (b. 1908), a Swiss artist, is another exponent of concrete art notable for his systematic pl. 400 and orderly procedures, but his range of formal invention is more extensive. His early painting and sculpture adhered closely to the rationalist design principles of the Bauhaus, whose view of the artist as a combined technician, researcher, and plastic inventor he admired. Bill had actually studied at the Bauhaus from 1927 to 1929, and later worked as a painter, sculptor, architect, and commercial artist. He became perhaps his generation's leading representative of van Doesburg's widely publicized effort to integrate art, science, and human reality as set forth in his manifesto. For Bill, the concrete concept could best be expressed through a mathematical formulation of reality in the visual factors of shape and color. He experimented, for example, with many variations in different scale of topological models of the Möbius strip and in metal strips of high finish. Like Pevsner before him, Bill demonstrated that art could absorb and transcend its mathematical models. Nonetheless, he has upheld steadfastly the

Anthony Caro. *Midday.* 1960. Painted steel, 91¾"×12'1¾"×37⅜". The Museum of Modern Art, New York. 402

ists, through an intuitive and improvisatory approach, rather than as a theoretical embodiment of doctrinaire ideas. It was David Smith who helped establish the course of Caro's art, beginning in 1959 when they met. His influence deepened subsequently when Caro came to teach at Bennington College in 1963/64. Following Smith's example, Caro used readymade steel parts of I-beams, sheet steel, coarse metal mesh; but he often painted these elements in homogeneous color, with far greater sensuous impact than Smith's. He assembled his forms in horizontal, sprawling, and linked compositions. Unlike Smith, Caro dispensed with anthropomorphic suggestion, and showed much more concern with occupying space along the horizontal plane, and thus engaging the spectator environmentally, than with establishing the vertical totemic presences characteristic of Smith. Caro is also something of a mannerist, admittedly eclectic in his borrowings and extremely refined in surface finish and polychromy. Even his deliberately crude surfaces in rolled, rusted steel of the 1970s reject Smith's unesthetic and raw directness. Caro's work embodies the ambiguities of mass and sensuous, polychrome surfaces of Minimalist sculptors in its weightlessness and in its formal rigor. Paradoxically perhaps, his complex and exquisite sculptures have strong ties to the pictorial concerns of the late 1960s as well as to David Smith's more simplistic structuralism.

Philip King (b. 1934) and William Tucker were students of Caro's at London's St. Martin's School of Art, and they acknowledge his influence. Both make sculpture that rises from the ground without traditional bases; and the ground serves essentially as a reference point to work against, rather

than a stabilizing element or source of gravitational pull. They, too, distribute the volumes in their work in such a way as to contradict traditional notions about weight and gravity. They use aluminum and processed industrial materials like polyester and fiber glass to model forms, and a color skin associated with mass-produced objects. Even more than Caro, and like many abstract sculptors since, among them the German Kaspar-Thomas Lenk and the American John McCracken, their sculpture reflects an impersonal, efficient technology, in either materials, color effect, or the fabrication process. Despite their alliance with modern technology, they are trying to strike a balance in their art, preferring to make sculpture, as Tucker has put it, "which is neither a private cult object nor a public monument."[6]

Postwar optical art in Europe represents a new alliance of abstract painting and sculptural traditions with contemporary techniques, novel materials, and a more dynamic psychology of perception. It includes works which appear to move, because of mysterious optical phenomena activated by the juxtaposition of certain color forms, and those which actually do move and change shape or position, usually driven by motor power. The idea of movement in modern art has been a source of experimentation for some time: first in illusionistic terms with the Futurists, about 1911, and then in terms of actual motion when Gabo electrified his *Kinetic Construction: Vibrating*

Yaacov Agam. *Double Metamorphosis II* (detail). 1964. Oil on aluminium, 8'10"×13'2¼" overall. The Museum of Modern Art, New York. Gift of Mr. and Mrs. George M. Jaffin. 403

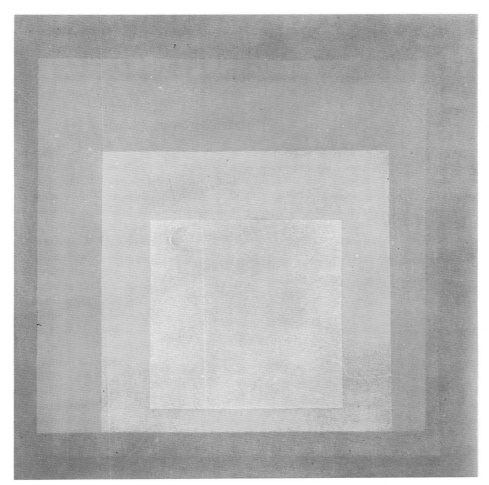

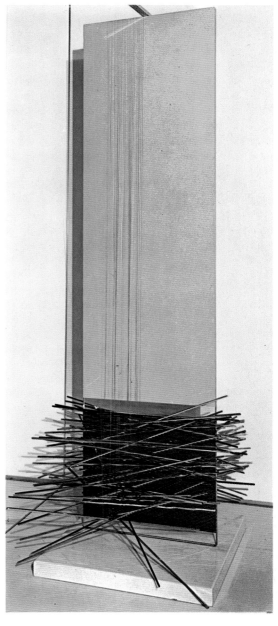

Josef Albers. *Homage to the Square.* 1967. Oil on board, 48×48″. Private collection, New York.
404

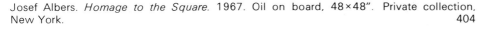

Jesus-Raphael Soto. *Yellow Plex.* 1969. Metal, wood, nylon cord, and paint. Naviglio Gallery, Milan.
405

404, 373

Spring in 1920. Only after World War II did artists like Josef Albers and Victor Vasarely (b. 1908), two of the principal originators of Op Art, seek to reconcile movement with an activated perceptual experience. For them, painting became a complex form of revelation and a means of exploring visual process rather than a clever exercise in multiplying decorative possibilities.

Vasarely, Albers, and such gifted young European followers as Bridget Riley (b. 1931) set every inch of their canvases in dynamic formal activity. It was this restless activism of surface and the perpetual flux of their color forms that link their art to the personally expressive varieties of contemporary abstraction. While the debt to the structural forms and schematic reductions of Mondrian, Moholy-Nagy, El Lissitsky, and the classical Constructivists is clear and acknowledged, the optical dynamics of their imagery subverts the closed geometric order of the old Purist generation. A sometimes subtle and often strident opticality assaults the eye in almost intolerable color intensities, and registers, in this way, the pulse of personal artistic sensibility. The optical approach to abstract art of the 1960s lent an essentially human dimension to the otherwise coldly rational art of geometric abstraction.

In Europe, Vasarely's dominant interest in affirming the relationship of art and technology through his optical experiments directly stimulated the formation in 1960 of GRAV (*Groupe de Recherche d'Art Visuel*) by eleven artists of different nationalities. Instrumental in creating the idea of the "multiple," the inexpensive fabricated object or print, which took advantage of the technology of large-volume production, Vasarely had been the first to dispel the idea of the individual masterpiece. "The masterpiece," he wrote, "is no longer the concentration of all the qualities into *one* final object, but the creation of a *point-of-departure prototype*, having the specific qualities, perfectible in the progressive numbers."[7] The rejection of traditionally admired personal creativity was endorsed by GRAV. A more factual view of artistic process was already evident in the many varieties of art forms of the 1960s as different as color-field abstraction and Pop Art. A decade earlier, artists such as Yaacov Agam

263

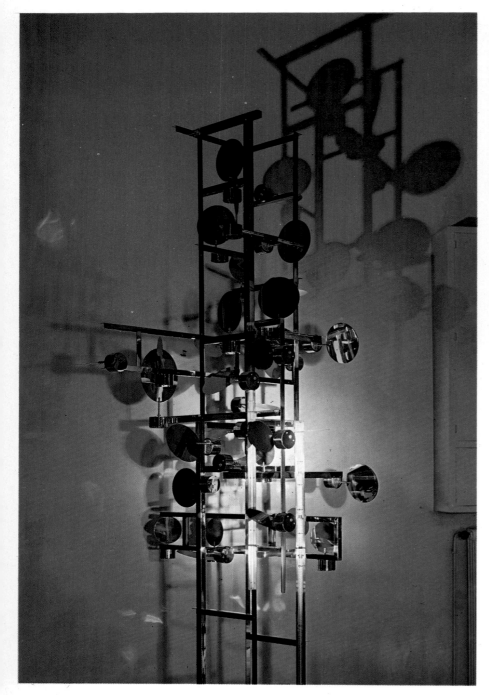

Pol Bury. *Red Points*. 1967. Plastic-tipped nylon wire in wood panel. Obelisk Gallery, Rome. 407

Nicolas Schöffer. *Chronos 8*. 1967–68. Stainless steel and motors, 9'10⅛"×49¼"×51⅛". Collection the artist, Paris. 406

pl. 403, 407
pl. 405, 406 (b. 1928), Pol Bury (b. 1922), Jesus-Raphael Soto (b. 1923), Nicolas Schöffer (b. 1912), and Jean Tinguely had sought a new synthesis of technology and art forms, either in optical or kinetic art, which would actively involve the spectator in the work through movement or through changes induced by the spectator's circulation and shifting viewpoint.

Jean Tinguely and Nicolas Schöffer represent the antipodes of a physically mobile kinetic art, or the "Movement movement," as Dada filmmaker Hans Richter wittily characterized it. Tinguely remains attached to obsolescent machine culture in the midst of the electronic age. His works take advantage of this irony by acting as antimachine gestures, and they maintain a precarious existence between mechanical efficiency and farcical malfunction. He enjoyed his greatest and most entertaining moment of success with the remarkable work he created in 1960 for the Museum of Mod-

ern Art's garden in New York. It was a huge, ramshackle, self-destructing machine entitled *Homage to New York*, which annihilated itself with much sound and fury, and with some unexpected help both from an internal fire and from the municipal fireman who appeared to extinguish it. pl. 408

Schöffer, on the other hand, makes use of the new computer technology, and his mood is one of basic social optimism. He has called a number of his ingeniously automated and programmed sculptures CYSPS (derived from the words cybernetics and spatiodynamics). They move, rotate on their bases, and project light shows and color spectacles in response to human presence. Schöffer's social interests and idealism have been fulfilled in a number of monumental structures of architectural scale. He built the first of his so-called cybernetic towers for national exhibitions in France in the 1950s, and in 1961 a permanent tower was erected in Liège, Belgium. Plans have

been approved for a tower in Paris higher than the Eiffel Tower, which will perform electronic concerts, present light shows, provide weather and traffic information, and even warn of atomic disaster.

The most important pioneer in postwar European light art was actually the prolific Yves Klein. By the late 1950s, he had created a blue-light environment, which represented only one of his many strategies in a broad campaign to desanctify the material art object and to saturate the world with "International Klein Blue." Shortly after, three young German vanguard artists banded together to form Group Zero (they included Klein's brother-in-law, Günther Uecker, Otto Piene, and Heinz Mack). Otto Piene (b. 1928) created a loose kind of outdoor light Happening utilizing powerful arc lamps and searchlights, aluminum foil, soap bubbles, white balloons, and the mobile forms of spectators themselves, which he called a *Light Ballet.*

Group Zero, GRAV, and other European artistic collectives pushed their experiments in light and movement to an extreme point of impersonality, in collaborative efforts at anonymous authorship which exchanged the conventional studio atmosphere for that of the scientific laboratory. By

de-emphasizing the artist's normal egoism, and depersonalizing and standardizing his creations, it was felt that art could be made more democratically viable and comprehensible to the layman. As early as 1960, Soto, François Morellet, Julio Le Parc, Jean-Pierre Yvaral, and other GRAV artists had produced electrically driven mobiles and light sculptures which reduced identifiable personal style and the idea of sculptural presence to a pure optical pulsation.

Apart from achieving a remarkable sense of collaborative effort, they also went far beyond Gabo's rudimentary pioneering venture in motion sculpture, or subsequent machine-powered Constructivist sculpture at the Bauhaus, such as Moholy-Nagy's *Light-Space Modulator,* to evolve new forms of kineticism more appropriate to the contemporary world. What was particularly innovative about their works is that they no longer existed primarily as form but as an immaterial energy. Optical and kinetic art today approach other European forms of dematerialized art, allied with Conceptualism, in a period when both electronic technology and the philosophical preoccupations of the contemporary artist seem to be directing a combined assault on the integrity of the traditional art object.

pl. 409

pl. 346

Jean Tinguely. *Homage to New York.* 1960. Mixed mediums, motorized. Created for the Sculpture Garden of The Museum of Modern Art, New York. 408

Otto Piene. *Hot Air Balloons.* 1969. Briggs Athletic Field, Massachusetts Institute of Technology, Cambridge. 409

THE AMERICAN CONTRIBUTION: FROM ACTION PAINTING TO MINIMAL ART

The artistic energies and sense of intellectual ferment released in Europe after the war found their counterpart in the American movement of Abstract Expressionism, or, to adopt Harold Rosenberg's suggestive epithet, Action Painting. These descriptive terms cover a loose association of artists guided by common aims who emerged after World War II in a period when most progressive American artists felt the School of Paris was vacant of new ideas and dying of skill. The decline in the pace of European innovation during the 1940s—with the exception of Dubuffet, Giacometti, Bacon, and a few artists of the *art informel* group—and catastrophic events on the Continent had the paradoxical effect of stimulating an episode of experimentalism among young American artists. For a moment, it even seemed that the impulse of modernism had been expatriated, and driven underground in this country, for the merging American vanguard drew support and inspiration in its complex beginnings from the presence in New York, during the war years, of a number of Europe's leading artists and intellectuals. Léger, Tanguy, Mondrian, Breton, Ernst, and Matta, among others, had come to New York by the early 1940s and maintained warm and influential relationships with many of the younger Americans, who thus bridged the intimidating distance between themselves and European modernism. A number of these European artists began to show at Peggy of This Century Gallery, and it was there that the pioneer American Abstract Expressionists, Jackson Pollock, Mark Rothko, Clyfford Still, Hans Hofmann, Robert Motherwell, and William Baziotes, held their first revolutionary one-man shows between the years 1943 and 1946.

In New York, Jackson Pollock's first one-man show in 1943 at Peggy Guggenheim's gallery became symbolic of the new wave in painting. In retrospect, it took on the character of a visual manifesto for an entirely new point of view in American art. In the beginning, Pollock was mis-takenly identified with the artistic productions of the European Surrealists shown in the same gallery, and his rather narrow and violent early painting did in fact show obvious relationships to Surrealist automatism. At the same time, Robert Motherwell (b. 1915) was also testing automatic painting, and Arshile Gorky worked directly under the influence of Matta and Miró's abstract Surrealism. Matta was the youngest member of the group of refugee Surrealists in the United States. More than any of the others, he acted as a liaison between the older Surrealists and the emerging American avant-garde. William Baziotes, Rothko, Adolph Gottlieb (1903—1974), Still, and Barnett Newman explored archaic and primitivist art forms independently of Surrealism and turned to myth for a promising new subject matter. Their originality lay in adopting primitive and symbolic content not only for their universal values, or nostalgic associations, but as a way of relating the findings of the collective unconscious mind to the act of creation itself. It was some time, however, before fantasy and personal expressiveness were purged and transcended in their art.

In his early style, Pollock wrestled with crude and vital fantasies derived mainly from the imagery of Picasso's *Guernica* and from Surrealism, but a free and powerful brush dissolved his content of violence, subtly transforming it into the nonrepresentational "writing" that became his recognizable trademark. Even with his innovative drip paintings after 1947, however, the charging energies and conflicting moods of Pollock's first imagist paintings remained as a significant presence. In the labyrinthine coils of his whipped lines some imaginary beast, or an invisible adversary, seemed trapped and struggling to free itself. To a lesser degree, Surrealist automatism formed the paintings of Willem de Kooning, who shared with Pollock the leadership of the American avant-garde and eventually became its most influential figure. His fragmented human figures of the 1940s owed their violent distortions and incompleteness to Picasso's fantastic anatomies of the late 1920s. It is only a short step in de Kooning's art from such imagery, essentially rooted in Surrealist inspiration, to the freely registered, abstract color shapes

pl. 273

pl. 412

pl. 324

pl. 411

Jasper Johns. *Target with Plaster Casts*. 1955. Encaustic and collage on canvas, with wood construction and plaster casts, 51×44×3½". Collection Mr. and Mrs. Leo Castelli, New York.
410

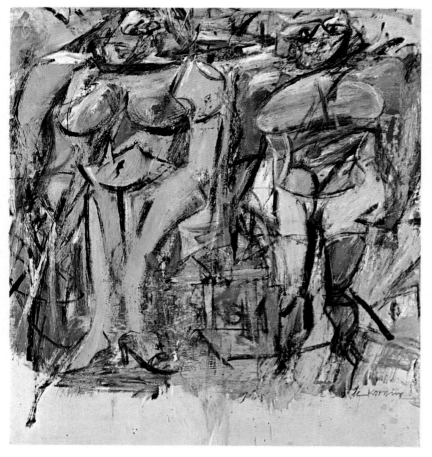

Willem de Kooning. *Two Women in the Country*. 1954. Oil, enamel, and charcoal on canvas, 46⅛×40⅞". The Hirshhorn Museum and Sculpture Garden, Smithsonian Institution, Washington, D.C. 411

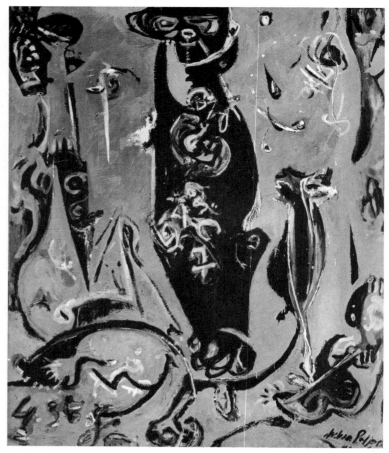

Jackson Pollock. *The Totem, Lesson II*. c. 1945. Oil on canvas, 72×60". Collection Lee Krasner, New York. 412

of his mature style. After 1948, his fantasies were still evident, but subdued and incorporated within a larger presence.

The process of sublimating fantasy and violent Expressionist accents also brought visible change in the work of other members of the American pl. 419 vanguard in the late 1940s. As Rothko, Newman, pl. 420 Gottlieb, and Still abandoned mythic and primitivistic content, they began to elucidate the creative act itself as their primary expressive content. A shift from what took place inside the artist's mind to the developing image that grew spontaneously under his hand was evident. In the process, the artist inevitably became something of a virtuoso performer, inviting his audience to admire his skill in improvisation, his boldness in gambling all his chips on a moment of great personal intensity and brief duration to which he committed his total personal energies.

The German-born modernist Hans Hofmann, whose influence on the American vanguard as a teacher was immense, can justly claim priorities in exploring the freer modes of Action Painting. As pl. 413 early as 1940, in his innovative painting *Spring*, he invented the technique of dripping and spraying paint on the canvas surface, a method that Pollock later appropriated, developed more consistently, and canonized. In his conversations, Hofmann distinguished between traditional concepts 268 of fixed form and the idea of mobile form which

might serve a process of continuous transformation and spatial movement. In his work, paint stroke, mark, and drip instantly registered as coherent and intelligible form when they encountered the canvas surface. This was the generic painting style that revolutionized American art in the 1940s.

The transition between various forms of expressionistic and romantic realism that had dominated the 1930s and the new abstraction was rather abrupt. Apart from Gorky, Hofmann, and de Kooning, most of the new generation had reached maturity as artists and had worked effectively to interpret the American social scene before their conversion to abstract idioms. It is significant that in the 1940s and early 1950s representational imagery reappeared in their work frequently and with intensity. Pollock's early anatomical fantasies were restored in his black-and-white paintings of 1951, as if he were compelled to repeat his rite of passage from recognizable figuration to abstraction in order to prevent any confusion with Purist or Constructivist forms of nonobjective art established earlier in the century. A similar romantic bias erupted within abstract painting at the same time in Europe, as we have seen in the primitivist figuration of Dubuffet and in the grotesque inventions of the CoBrA group. Only the human visage or the human body, and a fantastic bestiary, seemed capable of plumbing the intensity of feel-

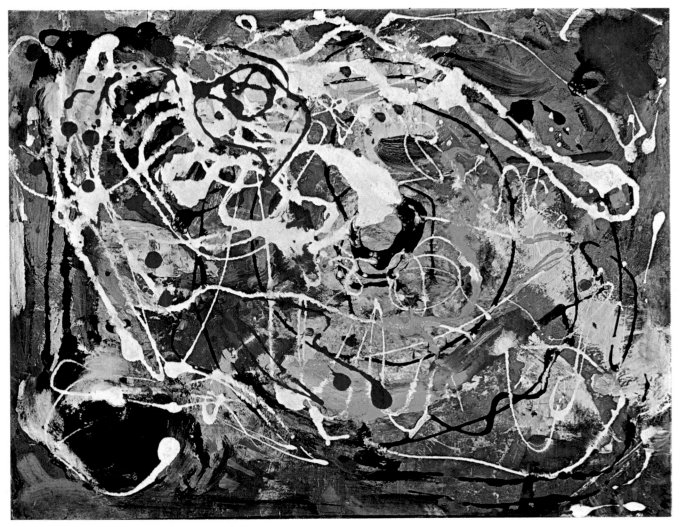

Hans Hofmann. *Spring*. 1940. Oil on wood panel, 11¼×14⅛".
The Museum of Modern Art, New York. Gift of Mr. and Mrs.
Peter A. Rubel. 413

ing which the painting "of extreme situations" on
both sides of the Atlantic made its principal con-
tent after the war.

Mark Tobey (1890—1976) represents the unusual
case of an American abstract painter who received
warmer appreciation in Europe than at home.
The refinement of means, the elements of a genial
mysticism rather than an obsession with extreme
human situations which his art transmits form the
touchstone of his European reputation. Tobey in-
vented the overall abstract painting in a delicate
calligraphy, his so-called technique of white writ-
ing, as early as the 1930s when he discovered, in
his extensive Eastern travels, oriental calligraphy
and the appeal of certain religious and philosophi-
pl. 415 cal ideas. All these ideas and methods contributed
major elements to his unique and delicately lyrical
art.

While Pollock, de Kooning, and Franz Kline
pl. 414 (1910—1962) registered their abstract imagery
with vigorous gestures of the entire body, or at
least of the arm, and with broad muscular strokes,
Tobey restricted his cursive writing to wrist and
hand movements. His paintings, though transcen-
dental in mood, are also more intimate and ele-
gant than those of his American contemporaries.
He utilizes a wiry, crisp, and fluid line in rich
combinations to build a texture of strokes that
makes space a tangible reality and finally, too, a
persuasive symbol of universal meanings.

Franz Kline. *Wanamaker Block*. 1955. Oil on canvas, 78¾×71¼".
Collection Richard Brown Baker, New York. 414

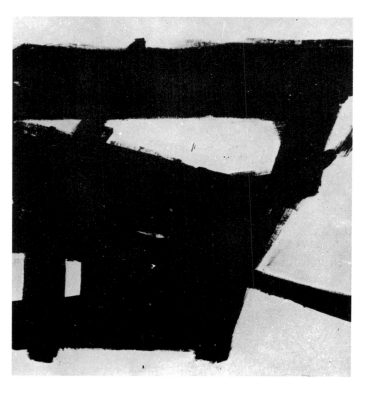

Mark Tobey. *Pacific Transition*. 1943. Gouache on paper, 23¼×31¼". City Art Museum, St. Louis. Gift of Joseph Pulitzer, Jr. 415

From the late 1940s until the mid-1950s, de Kooning became the acknowledged leader of American progressive painting, providing a dictionary of vital pictorial ideas and a point of departure for new explorations. Pollock's liberating energies and formal innovations had given him the status of a culture hero for young artists, and his untimely death in 1956 expanded the legend. But his direct influence was negligible until color-field painting came into vogue, and the optical vibrancy of his style became apparent at a later date. Rather, it was de Kooning's painterliness, with its aggressive incorporation of the traditional grand manner, on the one hand, and its equally compelling abstract invention, which decisively affected a generation of younger artists.

His position of leadership in the new American avant-garde was based on a unique stylistic synthesis of paradoxical elements. With considerable daring and brilliance he managed to combine qualities of personal intensity with plastic finesse, furiously muscular brushwork with refined abstract calligraphy, traditional figuration with a tensely structured, depthless space. In Europe, de Kooning has often been mistaken for a simple Expressionist whose distorted images served as a momentary release from tragic inner conflicts. In fact, his own motivation is far less psychological,

and proved more adaptable to the dynamic of an evolving pictorial language. The hot, improvisational rush of his images, along with the constant assault of changes and revisions, and his messy, overworked surfaces fused time, gesture, and event in a new, unified pictorial structure. His art symbolized all the personal dilemmas and heroism of the postwar epoch, with its chaos, confusion, and the capacity of the individual, nonetheless, to take authentic action.

De Kooning's painting became the potent antidote, by demonstrable effort and struggle, to lifeless abstraction and any doctrinaire formal principle. It was in this context that he invented his most famous image series, Woman, which persists today in less violent or mutilated form, neutralized and environed in the natural landscape. The series scandalized the more rigid nonobjective American vanguard artists, who viewed the invention as a surrender to reaction, and a pallid neohumanism. In fact, it represented an original assertion of individual freedom and established the relevance for high art of American pop culture and the urban environment, which in due course produced Andy Warhol's more detached Marilyn Monroe image series, ironically enough. The open de Kooning "image" repudiated style and studio professionalism, but it nonetheless seemed to en-

270

courage a surprising range of expression, from the refined lyricism of Jack Tworkov, the structured fluencies in paint and collage of Esteban Vicente, to the distinctive personalizations of his idiom among an emerging crop of brilliant young painters, Larry Rivers, Joan Mitchell, Grace Hartigan, Alfred Leslie, and others.

In the constellation of painters identified with de Kooning and Pollock, Action Painting presented itself from the beginning as an art of passionate gesture and large liberties on the canvas surface. The painting could be understood as the record of the creative act, since vital signs of personal involvement and spontaneous invention were left conspicuously visible on canvas. However, by the late 1940s, the charged expressive brushwork of even the orthodox Action painters and their vehement emotionalism had significantly given way to breadth, refinement, and objectivity.

Pollock's open, drip paintings absorbed pictorial incident and eruptive detail into a uniform field of accents. Disrupting image fragments and points of psychological stress and violence in paint handling were subordinated to the overall effect of the painting. As the entire painted rectangle became more uniformly accented, it achieved a single-image effect as a totality, arranging itself in the eye of the viewer as a consistent and unified optical texture. This development bore with it a drastic increase in scale, and thereby in impressiveness. In addition to operating as an absorbing spectacle of gesture, the large-scale Abstract Expressionist canvas invented by Pollock seemed to expand beyond the limits of the frame. Pollock's pl. 416 monumental mural paintings and de Kooning's few large-scale works are not meant to be confronted merely as gestural display or an athletic, virtuoso performance. They are too deeply medi-

tated and structured for a restricted reading as Expressionist outbursts. They represent, in fact, a heroic attempt to go beyond the easel convention to mural scale, and to expand optical perception into a total environmental situation, much like Monet's late Water Landscapes. In both cases, sheer physical extension erased, or at least confounded, the boundaries between the work of art and the spectator's space.

The same intuition of an expansive and uniform pictorial field, and a more monolithic pictorial order, was already embodied in the radical painting styles of Barnett Newman, Clyfford Still, and Mark Rothko. Their art, by the late 1940s, operated on a set of assumptions opposed to gestural Action Painting with its particular emphasis on swiftly executed fragmented forms and vehement personal attack. Where Pollock and de Kooning achieved spatial envelopment by dismantling form and setting it in motion, the more quietist abstract artists gained a potent expansive force by the deceleration of small variegated shapes into dominant islands, zones, and finally boundless fields of intense, homogeneous color. In place of the hand's motor activity, color sensation and optical ambiguity expressed qualities of change, playing on the dynamics of perception.

Some of these significant changes are experienced in the immense red color field of *Vir* pl. 421 *Heroicus Sublimis*, by Barnett Newman (1905—1970). This colossal painting deals with pictorial decorum in a new way. The familiar, agitated spatial movement, flux, and calligraphic signs of Abstract Expressionist painting have been eliminated, and replaced, absorbed, and grandly solemnized by a complex pulsation of high-keyed color over a pictorial field of vast expanse, divided by five fine vertical bands. The fragile and oscil-

Jackson Pollock. *Blue Poles*. 1953. Enamel, aluminum paint, and glass on canvas, 6' 11" ×16'. Art Gallery of New South Wales, Australia. 416

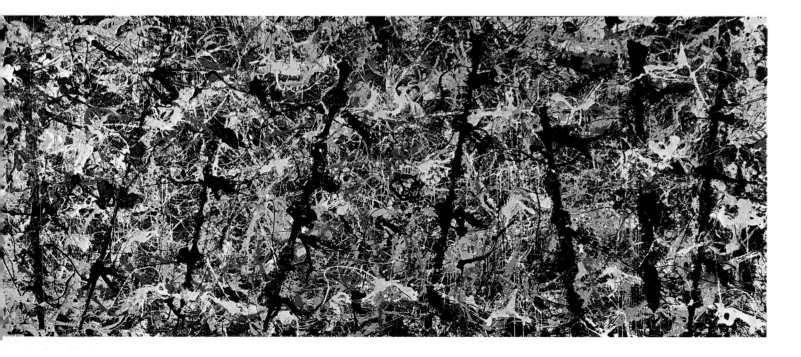

lating stripes play tricks on the eye and the mind by their alternate compliance and aggression. They range in visibility from strident vividness to a subliminal subtlety that produces wavering afterimages. Their optical vibrancy subverts the idea of a structured, geometric partition of space, thus replacing Cubist compositional strategy with a single-image, or field, Gestalt. The powerful and absorbing visual drama has been aptly characterized by the critic Robert Rosenblum as "the abstract sublime," referring to the sense of being engulfed by a color field which becomes almost numbing to the ego. Yet, Newman's sources, like Pollock's, are momentary and, despite his insistent geometric structure, take account of the spectator's psychological absorption in the large expanse of color form and the special effort required of him to perceive the work as a stable totality.

The stern rigor of form, mechanical handling of surface, and problematic optical character of Newman's painting can now be seen as forerunners of the "antisensibility" painting of a whole school of younger abstract painters today; they also anticipated the bright, unmodulated surfaces of Pop Art. Something of the same calculated insensitivity, directed to a higher artistic purpose, was also apparent in the paintings of Clyfford Still (b. 1904), who preferred biomorphic, rather than geometric, forms. His monumental areas of homogeneous hue, whether bright or somber, his determination to dispense with Cubist structuring and linearity, defined the tendency which Clement Greenberg later termed post-painterly abstraction. Some younger artists seemed able to combine both gestural and color-field abstraction. The dripped, liquid paint applications of Sam Francis (b. 1923) owed something to the controlled accidents of Pollock's open drip technique; but, in his early style, when Francis massed his congested and dribbled kidney shapes in consistent curtains of luminous darkness, relieved by the marginal activity of brilliant touches, his main debt was clearly to Still.

The reduction of chromatic expression to near invisibility occurred in the early 1950s even more dramatically in the black canvases of Ad Reinhardt (1913—1967). His segmented, compositional grids were so dark and even in emphasis

pl. 418

pl. 417

pl. 422

Clyfford Still. *Painting*. 1951. Oil on canvas, 7'10"×10". The Museum of Modern Art, New York. Blanchette Rockfeller Fund. 418

Sam Francis. *Shining Black*. 1958. Oil on canvas, 79⅜×53⅛". The Solomon R. Guggenheim Museum, New York. 417

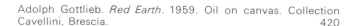

Mark Rothko. *Red, White, and Brown*. 1957. Oil on canvas,
99⅜×81⅝". Kunstmuseum, Basel. Gift of the Swiss National
Insurance Society. 419

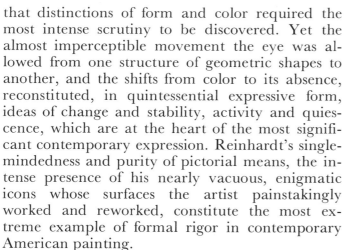

Adolph Gottlieb. *Red Earth*. 1959. Oil on canvas. Collection
Cavellini, Brescia. 420

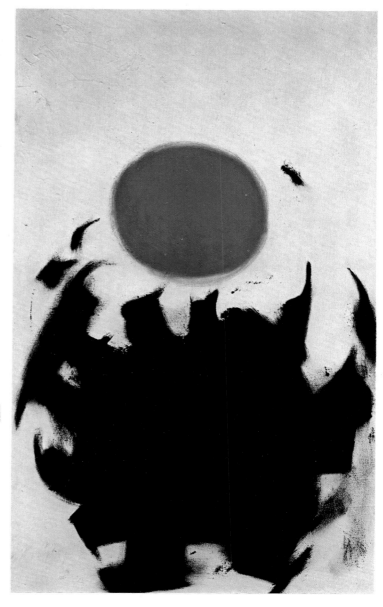

that distinctions of form and color required the most intense scrutiny to be discovered. Yet the almost imperceptible movement the eye was allowed from one structure of geometric shapes to another, and the shifts from color to its absence, reconstituted, in quintessential expressive form, ideas of change and stability, activity and quiescence, which are at the heart of the most significant contemporary expression. Reinhardt's single-mindedness and purity of pictorial means, the intense presence of his nearly vacuous, enigmatic icons whose surfaces the artist painstakingly worked and reworked, constitute the most extreme example of formal rigor in contemporary American painting.

The division among the Abstract Expressionists between an art of energy and impassivity, of impulse and color sensation, was recognized and acknowledged in the 1950s by many critics, including Meyer Schapiro, who lectured on the new painters in 1956 in London. His remarks were published in a revealing article in *The Listener*. There he contrasted Pollock's restless complexity and the relatively inert and bare painting of Rothko, Still, and Newman. "Each," he wrote,

"seeks an absolute in which the receptive viewer can lose himself, the one in compulsive movement, the other in all-pervading, as if internalized, sensation of a dominant color. The result in both is a painted world with a powerful immediate impact."[1] The significance and the influence of the less dramatic, obviously less Existential painters like Rothko, Still, and Newman were limited by the extraordinary widespread impact of de Kooning on second-generation American artists. Only in the 1960s, when the momentum of Action Painting began to be exhausted and a younger generation with a more objective esthetic viewpoint emerged, did the search begin for a different set of antecedents. pl. 419

Robert Motherwell provides an interesting exception to the either/or pattern of gestural and non-gestural field painting among the Abstract Expressionists. Over the past decade he has visually associated himself with the field paintings of Newman and Rothko to a surprising degree, rather than with the more emotive, gestural style of Abstract Expressionism, to which he originally gave such strong impetus. He can legitimately be placed in the broad and eclectic tendency of field

273

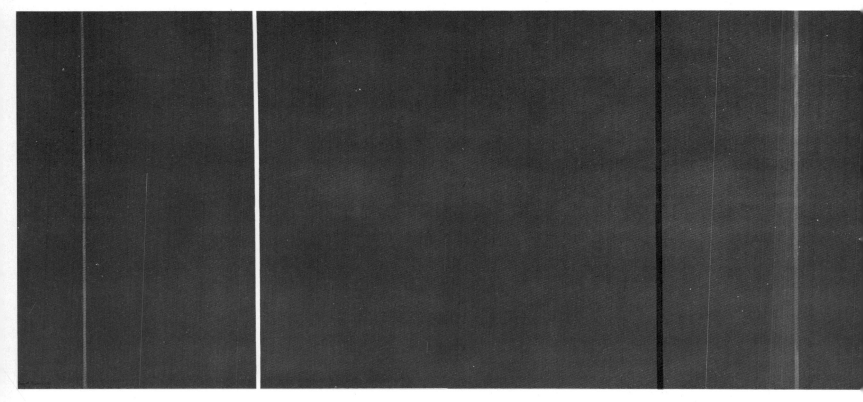

Barnett Newman. *Vir Heroicus Sublimis*. 1950–51. Oil on canvas, 95⅜″×17′9¼″. The Museum of Modern Art, New York. Gift of Mr. and Mrs. Ben Heller. 421

Ad Reinhardt. *Painting*. 1956. Oil on canvas, 80¼×43⅛″. Yale University Art Gallery, New Haven. 422

painting, in relation to his Open series as well as to some of his monumental collages, which work against a monochrome color ground and read as a single image. Yet contradictions persist as a result of his inextinguishable romanticism. pl. 424

Throughout his career, Motherwell's acute intellectual and historical sensibilities have impelled him to identify his paintings with feeling and with personal events in his life, under the literary influence of French Surrealism and the Symbolist poets and, in painting, through contact with Picasso and Miró. From his Spanish Elegy series which mourned the defeat of Spanish Republican forces, to his *Je t'Aime* paintings and collages, celebrating moments in his personal life, he has regarded his painting as a form of confession as well as a plastic expression within the modernist mainstream. He has gone so far as to describe his art as "anguish (and often a kind of madness)," adding that "Nothing is more difficult than expressing human experience authentically."[2] Even the bare, reductive color planes and the apparently programmatic formal interest of the Open series carry symbolic meanings. The artist intends them as a visual statement about the idea of openness in philosophical and historical terms as well as in terms of direct sensuous expression. pl. 423

The period after World War II produced a major breakthrough in American sculpture com-

274

parable to Action Painting, which shared many of its stylistic characteristics and expressive power. By the mid-1940s an idiom of fluid metal construction emerged as the dominant tendency among advanced American sculptors. Adopting from Surrealism its addiction to accident and spontaneity, the new welder-sculptors built open forms in a variety of techniques that combined improvisation and new kinds of metal alloy surfaces, while some vestiges of the formal ideals of modern Constructivist tradition remained evident, too. Although symbolic references to violence and elements of fantasy appeared frequently, as they had in the paintings of de Kooning and Pollock, the mood of sculpture was perhaps less extreme. It embraced a range of effects, including anti-Expressionist and quietist styles, in contrast to the familiar agitation of Action Painting. One notable example, Ibram Lassaw (b. 1913), welded intricate cage constructions in the early 1950s which created an atmosphere of detached and luminous serenity, opposed to the more familiar stereotypes of Existential anguish found in postwar vanguard art.

Seymour Lipton (b. 1903) established in his works a relationship between organic natural form—dramatizing the life processes—and the dynamics of the creative act. Theodore Roszak and Herbert Ferber (b. 1906) invented new sculptural symbols reminiscent of clutching tree roots or an imaginary crown of thorns, but the anguished character of their imagery was less distracting than that of their European counterparts, neutralized by its spatial and structural coherence. These artists and David Hare and Reuben Nakian, among others, provided a liberating les-

son for the younger generation that artistic self-definition could be achieved in the process of making spontaneous and improvisatory sculptural form.

The leading innovator in American sculpture, and perhaps the most original and capacious twentieth-century American sculptor, was David Smith (1906—1965). During the 1940s, he worked in a coarse, perhaps contradictory idiom, incorporating predatory animal imagery, "found" machine parts, and structural elements of the Constructivist tradition. Aside from his insistent originality and experimentation in a variety of styles, David Smith set himself apart from his American contemporaries in sculpture by a persistent respect for strict forms derived from Constructivism, and by his almost exclusive use of the more obdurate materials of iron and steel. These characteristics contrasted with the prevailing anti-formal tendencies in metal sculpture and the widespread pictorial character of sculptural forms which tended to lose their identity and functioned mainly as metaphors of the expressive potencies of the material means.

pl. 427

The intellectual control and the ruthless process of formal reduction and distillation progressively more evident in his art produced, in the 1960s, a group of assured masterpieces. From 1961 until his death, Smith created his magnificent large-scale Cubi series of open-form, but volumetric, structures reminiscent of Cubist sculpture. Despite their decidedly constructed character and geometric order, the Cubi sculptures remain surprisingly varied in formal ensemble. They were illusionistic in their preoccupation with light reflected on their burnished and wire-brushed surfaces. Smith's

pl. 426

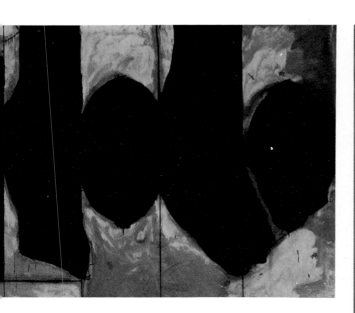

Robert Motherwell. *Elegy to the Spanish Republic No. 128*. 1974. Acrylic on canvas, 8×10'. Collection the artist, Greenwich, Conn. 423

Robert Motherwell. *Blueness of Blue*. February 1974. Acrylic on canvas, 72×84". Collection the artist, Greenwich, Conn. 424

Isamu Noguchi. *Cube*. 1967. Steel with painted aluminum plates and stainless steel ribs, 28' h. (cube 16×16×16'). Collection 140 Broadway Company, New York. 425

David Smith. *Cubi II*. 1962. Stainless steel, 10'10" × 36¾" × 24¾". Knoedler Contemporary Art, New York.
426

stainless-steel constructions introduced a new rigor of form into contemporary sculpture, coinciding roughly with the more objective innovations in the painting of Rothko, Newman, and Reinhardt. The inflated scale, open forms, spatial torsions, and, above all, highly reductive means of so-called primary structures, which emerged as a movement in New York after Smith's death, were predicted by the radical style of his Cubi series.

While sculptors using welded metals dominated the American scene in the 1950s, there was also much vigorous creative work with more traditional materials. The Japanese-American Isamu Noguchi (b. 1904), at one time an assistant to Brancusi, first worked in a variety of polished stones that demonstrated a suave and fluent mastery of abstract idioms. With strong Surrealist overtones, he later deftly created interlocking systems of flattened biomorphic forms derived from Arp and Miró in stone and bronze. He has more recently proved himself a masterful constructor of large-scale, outdoor sculpture designed for public spaces, working in the current Minimalist style made familiar by such metal fabricators as the Lippincott factory in North Haven, Connecticut.

pl. 425

A rare figure in the first postwar generation of sculptors was Joseph Cornell (1903—1972). Beginning in the 1930s, he made refined and fanciful box constructions which belong to the highest level of contemporary American creation. His work combined the structural austerities of Constructivism with the fantastic imagery of Surrealism, and utilized subtle painting and collage

pl. 428

276

David Smith. *Structure 41*. 1957. Rusted steel, 33×24½×11". Collection Mrs. Berthe Kolin. 427

Joseph Cornell. *Soap Bubble Set*. 1936. Glass case with map, goblet, egg, pipe, head, and 4 boxes; case 14¼×15¾". Wadsworth Atheneum, Hartford. Henry and Walter Keney Fund. 428

Louise Nelson. *Sky Cathedral—Moon Garden Plus One*. 1957–60. Black painted wood, 9'1"×10'2"×19". Collection Arnold and Milly Glimcher, New York. 429

techniques. His boxes are unique in our art for their combination—at poetic intensity—of precious sentiment, bizarre imagery, and stern formal rectitude. At one time they may have seemed too private and confined in sensibility to occupy the mainstream of American art, and were regarded as little more than highly personal and quixotic diaries. Cornell, however, is now universally admired, and his constructions have become honored forerunners, particularly of Louise Nevelson's "junk" assemblages and Jasper Johns's targets with anatomical casts mounted above them.

pl. 429

pl. 410

Louise Nevelson (b. 1900) belongs to the generation of David Smith and the welder-sculptors by age, but in spirit she has stronger affinities with the environmental art of the late 1950s, which replaced the egocentric romanticism of the Abstract Expressionists with a more factual view of the artistic process. Nevelson's walls contain myriad commonplace objects in stacked and interconnected boxes and crates. Newel posts, finials, parts of balustrades, chair slats and barrel staves, bowling pins and rough-cut wood blocks, sprayed in a uniform white, black, or gold, are some of the components which she cunningly sets in the shallow recesses of her additive, Cubist constructions. For all their small-scale intricacy of design units, the ingenuity of formal relation, and the dazzling variation of shape, her walls achieve both a powerfully unified impact and liberating possibili-

Larry Rivers. *Washington cross-
ing the Delaware*. 1953. Oil on
canvas, 6'11⅜"×9'3⅜". The Mu-
seum of Modern Art, New York.
430

ties of expansion. They operate forcefully on the
spectator, and bring his own spatial environment
into a fresh relationship with the imaginative real-
ity of art.

At the same moment in time as the appearance
of Nevelson's walls, the critical artistic issue they
posed was also raised by an important exhibition
staged at the Museum of Modern Art by William
Seitz called The Art of Assemblage. In his cata-
logue Seitz remarked: "The current wave of assem-
blage ... marks a change from a subjective, fluid-
ly abstract art towards a revised association with
environment. The method of juxtaposition is an
appropriate vehicle for feelings of disenchantment
with the slick international idiom that loosely ar-
ticulated abstraction has tended to become, and
the social values that this situation reflects."[3] The
most decisive evidence of a new environmental
spirit, embodied in the phenomenon of assem-
blage and in the sculptures of Louise Nevelson,
came subsequently from the paintings and "com-
bines" of painting surfaces and attached objects,
first in the work of Robert Rauschenberg and
Jasper Johns, and then in the broad vernacular
style of Pop Art.

About 1952, at almost the same moment that
de Kooning began his controversial Woman
series, Larry Rivers (b. 1923), known at first as a
second-generation de Kooning follower, had
begun to reappraise the pictorial cliché with his
pl. 430 controversial work *Washington Crossing the Dela-
ware*. This large salon-type painting was inspired
by American folklore and by the popular academ-
ic painting of the nineteenth century by Leutze
which every schoolchild knows. With its appear-
ance began a shift in general outlook that made
278 formerly scorned and banal themes admissible in

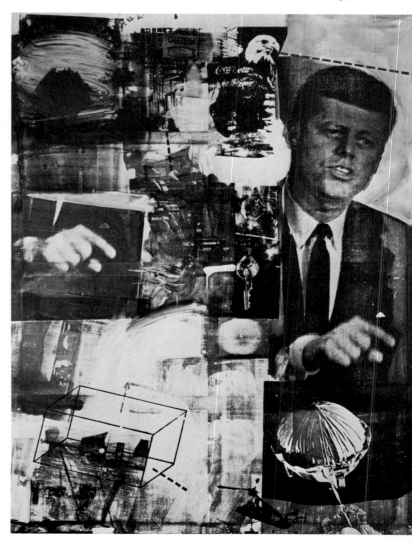

John Chamberlain. *Toy*. 1961. Welded auto parts and plastic, 48×38×31″. The Art Institute of Chicago. 432

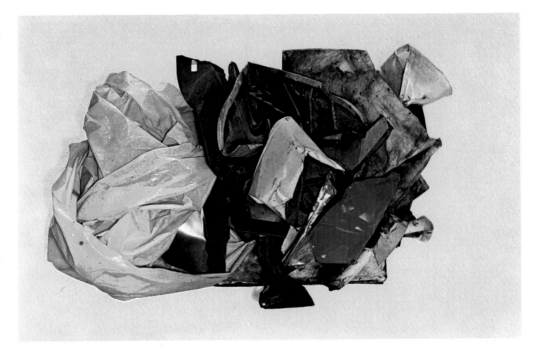

Edward Kienholz. *The State Hospital*. 1964–66. Cast plaster and fiber glass figures, hospital beds, bedpan, hospital table, goldfish bowls, live goldfish, lighted neon tubing, steel hardware, wood, paint, 8×12×10′ overall. Moderna Museet, Stockholm. 433

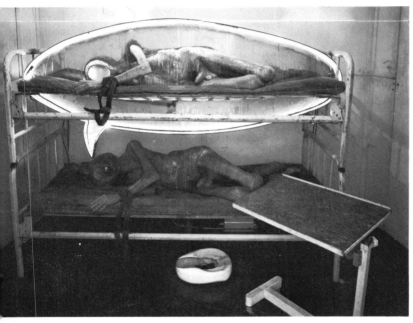

matter. The blatant use of subesthetic materials called into question the hierarchy of distinctions between the fine arts and extra-artistic materials drawn from the urban refuse heap. Junk art of this character gathered momentum in the late 1950s, and in the 1960s it was given added emphasis in the conglomerates of rusting boiler and machine parts of Richard Stankiewicz's sculpture, the surfaces of splintered wood and plastic of Robert Mallary, and the crushed and shaped auto bodies of John Chamberlain (b. 1927). Allan Kaprow (b. 1927), an early prophet and advocate of literal experience in art proposed "a quite clear-headed decision to abandon craftsmanship and permanence," and "the use of obviously perishable media such as newspaper, string, adhesive tape, growing grass, or real food," so that "no one can mistake the fact that the work will pass into dust or garbage quickly."[4]

pl. 432
pl. 441

The transformation of assemblage, which utilized anti-art materials, into an expansive environmental art with theatrical content was a dramatic feature of the mordant and memorable tableaux of Edward Kienholz (b. 1927). His vicious allegories can be viewed as the grotesque Gothic-realist countercurrent to the mindless California fascination with a world of hot rods, baroque car designs, high-polish craftsmanship, and other evidences of a shallow, ersatz visual culture. Kienholz's brutal visual anecdotes belong to an American moralizing tradition and comment on such topics as the abortion underground of the time, patriotism, eroticism, and even psychic disintegration, often with an almost unbearable literalism, as in the searing *State Hospital*.

pl. 433

The junk materials that Kienholz, Rauschenberg, and many others incorporated into their works not only posed questions about the nature of the art object, but made the advent of Pop Art almost inevitable by assimilating to art the social context of urban experience and mass culture. Rauschenberg's anti-art program broke through

"high" art. A new vernacular imagery drawn from popular sources and from nostalgic Americans began to establish itself as a controversial new current, in sharp opposition to the subjective preoccupations and idealism of the period's still dominant Action Painting.

Robert Rauschenberg (b. 1925) treated the banal themes Rivers introduced with even more formal radicalism outside the tradition of figurative realism; the results virtually transformed the values and the look of American painting in a few brief years. In the mid-1950s, Rauschenberg had begun to counter de Kooning's free brushstroke by loading his paintings with rags and tatters of cloth, reproductions, fragments of the comic strip, and other collaged elements of waste and discarded materials, Dadaist in their anti-art intensity. His packed surfaces were worked over with paint in the characteristic spontaneous gestural language of Action Painting, but their painterly expressiveness enjoyed reduced prerogatives in the context of an artistic structure choked with alien

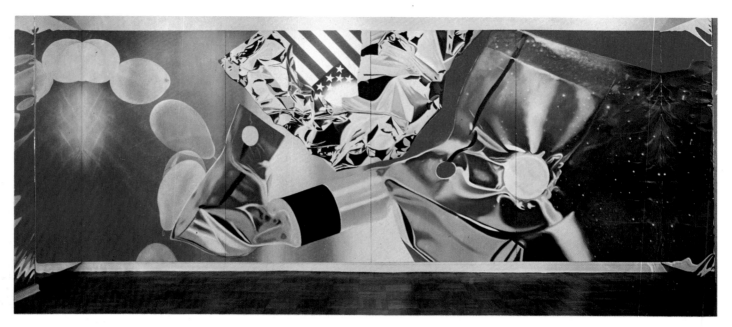

James Rosenquist. *Flamingo Capsule*. 1970. Oil on canvas with alumized mylar, 9½×23". Leo Castelli Gallery, New York. 434

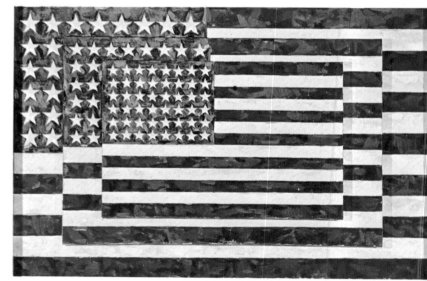

Jasper Johns. *Three Flags*. 1958. Encaustic on canvas-raised canvases, 30⅜×45½×5⅛". Collection Mr. and Mrs. Burton Tremaine, Meriden, Conn. 435

Tom Wesselmann. *Long Delayed Nude*. 1967–75. Oil on canvas, 67¾"×8'5½". Collection Dieter Brusberg, Germany. Photograph courtesy Sidney Janis Gallery, New York. 436

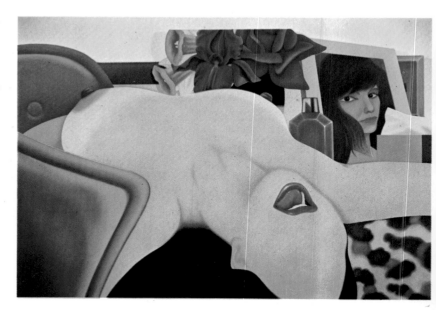

traditional disdain for the image-world of popular culture, and such common artifacts of daily life as Coke bottles, stuffed animals, rubber tires, and miscellaneous deteriorating debris suddenly became legitimized in the art context, by force of his pioneering example. Unlike the poetic objects of the Surrealists, his debris was not calculated to shock by its incongruity; junk was used, instead, in an optimistic and matter-of-fact spirit. If commentary critical of society was meant by its use it was on an elementary and unspecific level and referred to nothing more than the life cycle of objects in our culture and their rapid decline into waste as the flow of new goods pushed them aside.

The innovations of Jasper Johns (b. 1930) have had an even more far-reaching and immediate influence on the radical art of the 1960s. His historic paintings of flags and targets, first exhibited in 1958, and the subsequent maps, numbers, rule and circle devices, and other themes created new forms of representation, utilizing commonplace imagery. The numerous American flags, in particular, demonstrated the startling possibilities of dealing with the commonplace by remaking a devalued visual cliché into a refreshing source of visual elaboration at the highest artistic level. In Johns's two separate versions of the target, fragmentary painted casts of body parts and a repeated partial mask of the face were set in a series of open boxes over a centered bull's-eye. The sober formality of his hypnotic bull's-eye and the subdued human associations of his casts created a powerful interplay of thwarted alternatives between objective and subjective realms. One expected to be able to decode private messages from secret regions of the psyche, but they are effaced in "impersonality" in the received and sanctified modern fashion.

Pop Art made its American debut in 1962 with the one-man shows of Roy Lichtenstein, James Rosenquist, Andy Warhol, Tom Wesselmann

pl. 435

pl. 410

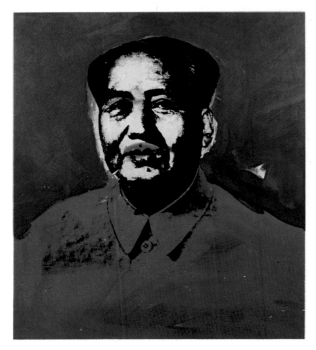

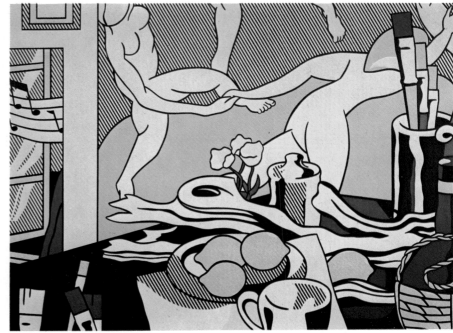

Andy Wahrhol. *Mao 6*. 1973. Acrylic and silkscreen on canvas, 50×42″. Ace Gallery, Venice, Calif. 437

Roy Lichtenstein. *Artist's Studio, The Dance*. 1974. Oil and magna on canvas, 96″×10′8″. Collection Mr. and Mrs. S. I. Newhouse, New York. 438

pl. 436 (b. 1931), and Robert Indiana. An offending shock was experienced by many artists and almost all critics confronted by an imagery that seemed scarcely to transform its sources in the newspaper comic strip (Lichtenstein), the billboard (Rosenquist), repeating or isolated commercial brand symbols (Warhol), montage in strong relief of food products (Wesselmann). The more obviously esthetic intention of the lettered signs and directional symbols of Robert Indiana (b. 1928) was found only slightly more acceptable, since he, too, took over explicit and routine commercial or industrial imagery, road signs, and mechanical type faces. By monumentally dilating a billboard detail, James Rosenquist (b. 1933) discovered pl. 434 iconic possibilities in the commercial advertising image and created confusing, alternative readings of his compartmented paintings. They relate both to the ambiguous legibility of contemporary abstraction and to the deliberate confusions of different realities by the Surrealists.

pl. 438 Roy Lichtenstein (b. 1923) decelerated the cartoon image by enlargement. By conspicuously overstating the Ben Day screen dots as part of his form, he compels our attention to medium and process as a significant content of his banal imagery. His work is about art and style despite its extremely mechanical and predictable look. Another kind of distancing effect was achieved by Lichtenstein in his choice of somewhat out-of-date comics for his early subjects. Modern life speeds up the sense of time's passage and makes us more sharply aware of changing styles and the obsessional interest of the general public with change and novelty through the communications media. These intuitions are at the heart of much Pop Art. The mass media have become a collective vehicle for instant history making, contracting time and

space into a blurry, continuous present, so that even the recent past seems as remote as events of ancient archaeology.

Andy Warhol (b. 1930) presents repeated images of car crashes, movie stars, and soup cans snatched from the march of news events, the daily unfolding of the celebrity pageant in the press and pl. 437 magazines, or the life cycle of processed articles and food. The iconic gravity of his imagery arrests on canvas the accelerated transience of advertising or topical banalities. He has also constructed food and soap cartons of painted wood, and stacked them to imitate a supermarket storeroom. These objects exist artistically by a nuance of contradiction between the actual product and its simulation and by the artist's fine calculation of his audience's differing responses to each.

Nothing actually happens in Warhol's art in the sense of conventional story-telling. Its point is, at least in part, to confront us with boredom as an issue, rather than to elicit specific responses to a subject matter neutralized by a remorselessly mechanical presentation. His cool and detached stance effectively thwarts any sense of emotional involvement or identification. Despite the iconography of blankness and impassivity, Warhol operates in the area of public myth and parable. He may even be considered a modern history painter, since his dominant imagery and visual ironies are inextricably linked with the conditions of mass urban culture.

Because he affects an antinarrative approach, using his canvas surface much like his film as a random and continuous medium in the spirit of *cinéma vérité*, visual facts are perceived as arbitrary and isolated moments rather than as an observed series of particular events. One of his important subjects is the reproduction process itself, the 281

Claes Oldenburg. *Alphabet, Good Humor*. 1974–75. Fiber glass and bronze, 11'10"×68"×28". Collection Michael Crichton.

439

Jim Dine. *Hatchet with Two Palettes, State No. 2.* 1963. Oil on canvas with wood and metal, 72×54×12". The Harry N. Abrams Family Collection, New York.

440

coarse scrim of halftone dots that mediate his images in the photomechanical silkscreen device. The handmade original painting, with all its sacrosanct historical and ceremonial associations, has been renounced in favor of commercial reproduction, whose ubiquity assures the subjects' swift decline into nostalgic clichés.

Jim Dine (b. 1935) occupies a unique position among the artists loosely associated with Pop Art. His paintings with object attachments, and his environments, have a brute physical presence that rebukes the indirection and muted poetic sentiment of Jasper Johns. Dine has extended the paradoxical play between literal experience and illusionistic representation by regenerating, with a rivaling skill, the painterly direction of Action Painting, and then assimilating it to a wide repertory of objects rich in human association of personal use or admired strength. His household furniture, room environments, bathroom cabinets, furniture, tools, palettes, and robes are meant to pl. 440 be enjoyed for their expressive power within the formal scheme of his construction as well as for personal or muted psychological association.

In a manner related to that of Dine and Johns, Marisol (b. 1930) mixes sculptural and drawing modes, and enjoys the interaction of literal objects and pictorial illusion in her ensembles of lifesize mannequins and *tableaux vivants*. Marisol's theatrical figure groups often utilize self-portraiture and pl. 442 autobiography, but in rather arbitrary or hallucinated images strangely dissociated from feeling. Other subjects of her magical, figurative art include American folk-art prototypes, the hipster world, and caustic caricatures of politicians and art-world figures.

Claes Oldenburg (b. 1929) is perhaps the most inventive of the Pop artists, and he has had a wide influence on all manner of art expressions and ideas in contemporary art. He was educated to Abstract Expressionism but broke with that movement about 1959, opening paths to a variety of new concepts, including Pop Art. With Allan Kaprow, Jim Dine, Robert Whitman, and Red

Allan Kaprow. "Car Wash," part of *Household*, a Happening at Cornell University, Ithaca, N.Y., September 1964. 441

Marisol. *The Party*. 1965–66. 15 figures in mixed mediums, 9'11"×15'8"×16'. Collection Mrs. Robert Mayer, Winnetka, Ill. 442

George Segal. *Picasso's Chair*. 1973. Plaster, wood, cloth, rubber, and string, 78"×60"×8'6". Collection Dr. Milton D. Ratner, New York. 443

Grooms, he invented the Happening, which extended Action Painting into a form of spontaneous, Expressionist theater. But he is best known for the gigantic ersatz food in painted canvas and plaster which he evolved after 1960. The surfaces of these bloated facsimiles of the lunch and drugstore counter were at first freely handled in the splatter-and-splash technique of Action Painting but the reference to their real-life models was clear and inescapable. A repeated emphasis on foodstuffs seemed to draw on the preoccupation of advertising with the infantile oral obsessions of the American mass audience.

In recent years, Oldenburg's objects have included such works as a series of soft telephones, toasters, typewriters, fans, automobiles that look freshly manufactured, slick, and grossly opulent instead of overripe or decayed, and a number of pl. 439 monumental hard sculptures. They enter into the context of art newly minted, vinyl-covered, before it has been caught up in the consumer cycle from use to junk. But these creations remain as outrageous as ever, in their immensity of scale and in their contradiction of the normal properties of the things they dissemble. Since 1965, Oldenburg has also been designing and drawing, with great elegance and wit, imaginary urban monuments—a toilet ball for the Thames, a teddy bear for Central Park, a mammoth block of cement for a downtown street intersection, among others. These visionary inventions are grafts of the fantasies of childhood on an urban environment whose dehumanization, overcrowding, and apparently hopeless problems of litter, traffic congestion, crime, and pollution resist rational solution. The irrationality of the man-made environment, with its threat to human survival, makes Oldenburg's visual gibes seem humane and plausible by comparison.

The dehumanizing impact of our surroundings supports the uncanny and moving sculpture of George Segal (b. 1924). His dramatic and theatrical art defies conventional distinctions between sculpture and painting, object and environment. Segal's human images often seem a vulgar intrusion on a brightly lit, artificial urban landscape that has only a marginal place for man. His ghostly human replicas are pieced together from castings of friends who have been patient enough to leave their impressions in plaster. Anesthetized, they exist as objects exist. Their most vivid identities and energies are esthetic; since they are denied the energy and outlet of effective action, they serve the gratuitous life of the work of art, much as Oldenburg's dispossessed and poetically suspended objects do. The acute sense of alienation at the heart of Segal's environmental sculpture has produced other variations on the human figure in the context of contemporary urban life, of poetic intensity and power. pl. 443

The paintings of Richard Lindner (b. 1901) translate the gaudy parade of the New York street into an intense drama of compulsive imagery and abstract patterning. Perverse and erotic imagery pl. 444 of this genre has broken to the surface in American art with a bruising explicitness, just as it has in literature, sanctioned by the prurience of so much commercial advertising. Forbidden subject matter of the past has now become a commonplace which artists choose neither to ignore nor idealize but to adapt to their own expressive purposes.

Richard Lindner. *Hello.* 1966. Oil on canvas, 70×60". The Harry N. Abrams Family Collection, New York. 444

Philip Pearlstein. *Male and Female Models on Cast-Iron Bed.* 1974. Oil on canvas, 60×72". Collection Mr. and Mrs. Edmund Pillsbury, New Haven. 445

Alfred Leslie. *The Killing of Frank O'Hara.* 1975. Oil on canvas, 9×6'. Allan Frumkin Gallery, New York. 446

Chuck Close. *Keith*. 1969–70. Acrylic on canvas, 9×7'. Bykert Gallery, New York. 447

Ralph Goings. *Donut Shop*. 1975. Oil on canvas, 44×62". Collection Mr. and Mrs. Joseph Rotman, Toronto. 448

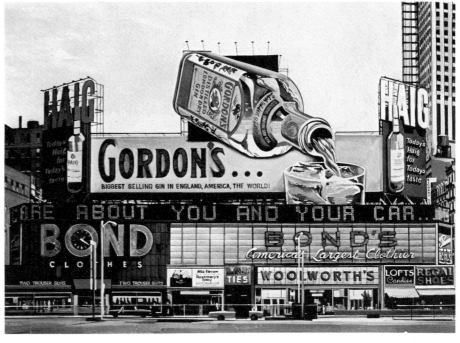

Richard Estes. *Gordon's Gin*. 1968. Oil on masonite, 25×32½". Private collection, France. 449

No longer a faithful mirror of the world of popular culture, Pop Art lost momentum as a group style after 1965. It was always much more than shallow representation of commercial imagery or the comic strip, as its detractors insisted. The Pop artists include at least two major innovators in American art: Oldenburg and Lichtenstein. Their work has transcended the expressive assumptions of the movement which formed them, and the original assumptions of Pop Art are no longer adequate to describe their wide range of invention and formal mastery.

The attitudes of irony and wit established by Pop Art and its exploration of commonplace subject matter have been an influence in the rise of new forms of figurative art in recent years. This new realism in painting and sculpture depends on photographic sources and commercial advertising for its imagery, but it has made a *trompe l'œil* illusionism viable once again without going to the

lengths of fantastic invention or satirical commentary often associated with Pop Art. Photographic reduction was already implied by the simplified visual definitions of art-world personalities who were among the favorite subject matter of Alex Katz in the late 1950s. In the 1960s, an intense fidelity to photographic models and an equally insistent formal structuring identified photographic realism, or post-Pop realism, as an art pushed to extremes. The powerful nude studies of Philip Pearlstein (b. 1924) are harsh, deliberately ugly, anti-idealistic in their anatomical elaboration, and brutally explicit in their sexuality. The abrupt, angular croppings of his figures add a further tension to his compositions. In a more painterly manner, Alfred Leslie (b. 1927) creates monumental figure portraits in vast enlargement as if thereby to oppress the viewer with their bulk. Chuck Close (b. 1940) pitilessly magnifies closeups of literally photographed heads transposed on

pl. 445

pl. 446

pl. 447

John Kacere. *Naija III*. 1975. Oil on canvas, 50×80". O.K. Harris Gallery, New York. 450

Duane Hanson. *Tourists*. 1970. Fiber glass and polychromed polyester, 64×65×47". Collection Saul Steinberg. 451

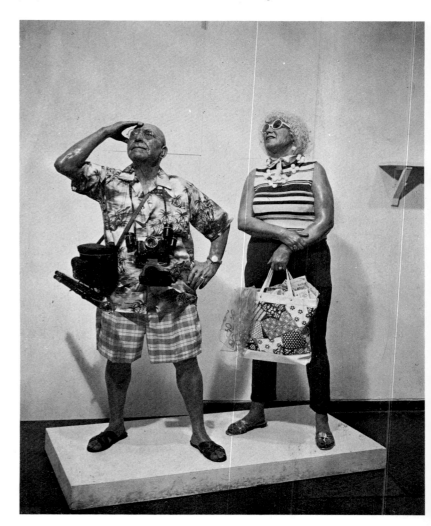

canvas from an opaque projector, which tend to lose recognizability and credibility at close quarters.

So intense may be the effort to capture the look, tone, and feel of the photograph that one realist, Malcolm Morley, actually painted his early works upside down, in order to deny the image its importance and to concentrate on abstract elements of the painted surface. Richard Estes (b. 1936) also began to forge novel expressive truths from the photographic image in the 1960s, concentrating on glistening vitrines of shopping centers or upon pl. 449 theater marquees with a passion ironically contradicted by the dispassionate manner of his meticulous rendering. Ralph Goings (b. 1928) presents the familiar world of motor vehicles, pickup trucks, and trailers, often parked outside the ubiquitous hamburger stand. The newness of his objects and their high polish are transplanted into an equally resplendent visual surface. His visual pl. 448 ironies stem from the emptiness and obviousness of a familiar subject matter, which in no way resembles the glamorous automobiles that appear sleekly and invitingly on billboards or in the color pages of advertising print media. The subject matter is essentially uninteresting, but the artist is totally obsessed by the play of reflective surfaces and the problematic character of even a commonplace subject as a source of magical illusion.

If these images do not resemble the highly charged sexual symbols of the billboards, there are nonetheless artists among the new realists who openly use eroticism to comment on American culture and artistic tradition. John Kacere (b. 1920) monumentalizes the lower torso of the female form, recently with a fetishistic attention to pl. 450 undergarments, in the glossy, smooth, and exaggerated voluptuous style of color photographs found in "girlie" magazines. Yet his work also refers to the odalisques of Ingres and the re-
286 strained sensuality of French idealistic painting of

Helen Frankenthaler. *Giant Step*. 1975. Acrylic on canvas, 7'9"×13'3". Private collection, New York. 452

pl. 451

the neoclassical period or, at least, to salon confections. The results are a complex amalgam of parody and grave, totally noncommercial figure painting respectful of the great tradition; and the latter focus finally subdues the distracting eroticism of his work.

It was perhaps inevitable that the obsession with visual facts through the photographic medium should open up the way for similar sculptural experiment. In the work of Duane Hanson (b. 1925) humanity is born as real and bizarrely unreal as the inanimate subject matter of related painting, and his figures closely resemble those in Mme Tussaud's waxworks, or the stuffed robots of Disney World's Hall of Presidents, with their accurate mimicry of human gesture. The fascination with duplications of reality, and particularly the human form in life-size, convincing replicas, is an age-old obsession. But today, when originals and reproductions are no longer so easily distinguishable, owing to the impact of media and the extremes to which consumers are manipulated by advertising ploys, sinister overtones are added to these counterfeit three-dimensional likenesses and to the artist's traditional deceptions and illusions. Clearly, there are irrational visual and intellectual crosscurrents at work in new realism, operating in a complex tension with the ironist qualities of both contemporary abstraction and Pop Art rather than in association with traditional realism. Even the soft-focus lyricism of the contemporary nudes of John Clem Clarke (b. 1927), which are posed in re-enactments of classical mythological themes, comments wittily on both the new sexual freedom and the irrelevance of traditional iconography.

While new realism and Pop Art were clearly rather extreme reactions to Abstract Expressionism, the new post-painterly abstraction emerging in the late 1950s and early 1960s was, at least in part, a continuation of certain of its important aspects. A new line of color-stain painting, clearly opposed to de Kooning's opulent, loaded brushstrokes, made its appearance. It seemed to evolve through Sam Francis, or perhaps Helen Frankenthaler, to Morris Louis, and it then took a more rigorous geometric form in the work of Kenneth Noland. There was also evident an increasing interest among a large group of artists in symmetry, clear definition of shape, immaculate surface, and formal order, all of which opposed the freewheeling invention, spontaneity, amorphous forms, and general messiness admired by the gestural Action painters. Soon the term hard-edge became current and popular. It was used to describe such artists as Ellsworth Kelly, whose decisive development had taken place, interestingly enough, in Paris rather than in New York, removed entirely from the American experience of Action Painting. Other artists like Leon Polk Smith, Alexander Liberman, and Al Held made a loose group, or constellation, of related precisionists.

pl. 452

These tendencies, however, did not identify themselves with the traditions of geometric abstraction, or with Constructivist examples based upon Mondrian and Malevich. The new American abstraction incorporated psychological ambiguity within its formal order and embodied the scale and energy associated with Action Painting. In place of the drama of personal creativity, or the kinesthetic engagement with medium, important new issues appeared in painting. The young-

Kenneth Noland. *Ticking West*. 1975. Acrylic on canvas, 7'8"×17'8". Collection the artist. Photograph courtesy Andre Emmerich Gallery, New York. 453

Morris Louis. *Pillar of Fire*. 1961. Plastic and paint on canvas, 92×47⅝". The Harry N. Abrams Family Collection, New York. 454

er artists made Conceptualism and a depersonalized objectivity their decisive and controlling ideas. The work of Newman and Reinhardt, from the quietist branch of Action Painting, gained a new prestige. Newman provided a point of departure for color-field painting with romantic overtones, while Reinhardt sanctioned, or directly influenced, a more self-contained, conventionalized, and repetitive or serial art in which sensuous color and atmosphere played a marginal role.

Although Newman and Reinhardt had been painting either large color fields of saturated hue or monochrome canvases in modular, or serial, repetitive formats for some time, chromatic abstraction became a widespread trend only in the late 1950s. Beginning with her abstracted landscape *Mountains and Sea*, which was probably influenced by Rothko's dye technique of color application, and Pollock's black stain paintings of 1951 on unsized canvas, Helen Frankenthaler (b. 1928) pointed to a new direction in American art with her lyrical abstractions. By pouring and running thinned paint washes down the canvas, Frankenthaler blurred and transformed the directional energies and brushstrokes of Action Painting. Paint was perceived as phenomenon rather than gesture, with far less personal accentuation of mark or stroke, and a new set of formal alternatives almost immediately opened up to the artist.

By age and origin Morris Louis (1912—1962) should be associated with the great innovating generation of Pollock and Rothko, with whom he shares many formal characteristics. But his main impact has been felt in the past two decades, and his patent anonymity of style and optical dynamics helped to release new energies among a younger group of artists. In his first mature work of pl. 454 1954, Louis flowed thin films of acrylic pigment on unsized canvas to form faint, muted color shapes vaguely reminiscent of Action Painting, but less active or aggressive. The even consistency and transparency of his diaphanous color shapes,

their slowed velocities and relatively indeterminate flow—defining edges were formed by the natural process of drying rather than by any expressive inflection of the hand—paralyzed the urgent expressiveness of Action Painting.

Louis's veils and overlapped washes of thin color led, in due course, to the structural rigor of the work of Kenneth Noland (b. 1924)—targets, chevrons, diagonals, and other emblem forms. pl. 453 There was an evident progression from a lyrical art to a new iconic form, away from accident and profusion of means to symmetry, codification of gesture, and economy. Noland's work shows more intellectual rigor than did Louis's paintings, which were attuned to sensation for its own sake. Noland's forms and signs are clearly defined, simple, almost banal, and they expand to the limits of his field, creating an alternating current of focus and dispersion; there is concentration within the emblem form, and yet a peripheral sense of color expansion beyond the framing rectangle.

Ellsworth Kelly (b. 1923) created hard-edge forms that were scrupulously clean of any detail and surface irregularity that might betray the individual hand. Where chance or irregularity was pl. 455 once equated with personal authenticity, by the 1960s formal decorum became the artist's marked preference, and it acquired unforeseen possibilities. Kelly managed a variety of inventions and new levels of sensuousness within his strict forms. Figure and field each became tangible realities, and the simplest configurations, in heroic scale, carried a dramatic impact without surrendering visual complexity. In their shaped canvases, Kelly, Charles Hinman, and Frank Stella in America, Richard Smith in England, and many others created an international mode of painting in three dimensions which also opposed the Expressionist art of the Action Painters. The shaped canvas emphasized the ambiguities between the pictorial and the structural, between visual illu-

Ellsworth Kelly. *Blue Green*. 1968. Oil on canvas, 2 panels, 7'7"×7'7" overall. Private collection, New York. 455

Robert Ryman. *Standard* (one of 12 panels). 1967. Enamel on cold rolled steel, each panel, 48×48". Collection Giuseppe Panza, Milan. Photograph courtesy Jon Weber Gallery, New York.
456

Jules Olitski. *Green Goes Around*. 1967. Acrylic on canvas, 60½×89½". Collection Mr. and Mrs. Arnold Ginsburg, New York.
457

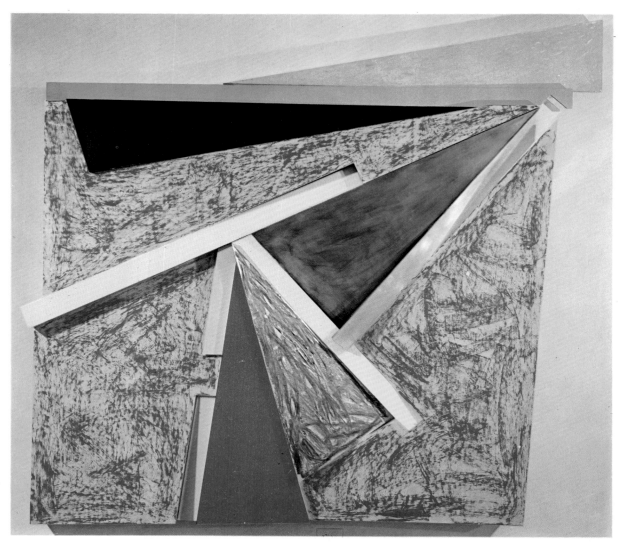

Frank Stella. *Morra da Uiuva I*. 1975. Lacquer and oil on aluminum, 8'4"×7'8". Collection Dorothy and Richard Sherwood, Los Angeles.
458

sion and three-dimensional object. The contoured stretcher provided one kind of definition, and the painted forms on the surface made another image and visual metaphor. Stella's shaped canvases were created in various permutations and series, sometimes with alternate color schemes. His impassive and simplistic compositions stressed a purposeful blankness of mind, and hence gave further meaning to the idea of the painting as object.

Another kind of monochrome painting and polychrome sculpture in one intense hue has been introduced in the past decade by Robert Mangold, John McCracken, Robert Ryman, and Brice Marden, who pushed on beyond even the marginal illusionism of Klein and Reinhardt. Mangold's tinted, shiny Masonite boards in eccentric shapes with ruled, subdivided interior circle segments gave the painting surface the mirrorlike opaqueness and finish of commercial products. John McCracken's gleaming lacquered slabs of vivid color hovered ambiguously between pictorialism and object status. Ryman's dryly brushed, whitened surfaces permitted the rough texture of the linen canvas to assert itself physically at its unpainted, irregular edges, thus also calling attention to its object character.

As another indication of the new spirit of literalism in progressive abstract painting, Ryman

and other leading figures of the new generation work on unconventional surfaces such as steel and aluminum and use acrylics, matte enamel, and other materials to emphasize the importance of tangible surface. Robert Ryman (b. 1930) is one of the most influential painters of early middle age, and his keen awareness of medium, support—whether metal, paper, or canvas—and brushstroke, and his consistent use of monochromes, usually white, reflect a new and fruitful preoccupation with the given physical conditions and internal syntax of painting. The result is an *œuvre* that at first looks programmed and ideological in the narrowness of its controlling ideas, yet manages to emerge as a highly nuanced and optically rewarding exercise in sensibility.

Brice Marden (b. 1938) also accepts the condition of flatness of the canvas support, on which he works in a combined wax and oil medium, with muted colors, usually, close to asphalt and putty in hue. Since his stretchers are massive in depth and streaked with visible, brushy paint built up to a palpable materiality, the effect locates the picture plane off the wall, as a wall-like surface in its own right. In *Fourth Figure*, the first of a recent series using primary colors in equal-size, stacked rectangles, Marden abandoned his resistant and somber tones for a more aggressive chromatic

pl. 456

scale. Like his earlier work, however, the new program seemed designed to test familiar ideas of meaning and appearance. His consistent preoccupation both with surface and with a quietly but firmly modulated expressiveness produces its own unique, identifiable quality. Marden's independent and formally rigorous, yet intuitive, drawings of ambiguous spatial grids are integrated into his painting concepts and procedures. In both modes an exquisite tension is maintained between program and execution, theory and sensibility. Many of the finest artists of the 1970s have conferred upon drawing a new role, which mediates between painting's dual character as corporeal object and spatial diagram.

The more romantic color-field painting of the decade of the '60s on the other hand, seemed impelled to divest itself of object status and to dematerialize the pictorial means. The large spray paintings of Jules Olitski (b. 1922) made their particular impact by diffusing the luminous effect of color so that both the rectangular boundaries of the frame and the material substance of the paint seem almost incidental to the perceived intensities of continuous color sensation. In the early paintings of Larry Poons (b. 1937), vibrating, elliptical dots on saturated color fields, with their resonating light halations, created a new mode of communicating almost disembodied optical energies. The shift in emphasis from the visible, material data of creative action to the perceptual experience itself also legitimized new medium explorations.

Perhaps the most decisive impulse in creating the influential new genre of literal painting-objects came from Frank Stella (b. 1935). Beginning with his black pinstripe paintings of 1958—60, continuing more recently in his protractor patterns of segmented arcs in vivid color, and in his constructed reliefs, he has managed to reverse the roles of geometry and Bauhaus design principles. His early black paintings opened up new expressive possibilities which have helped force a fundamental change in artistic outlook. Stella's subsequent series paintings and permutations of V's, parallelograms, rhomboids, hexagons, and circle fragments have constantly de-emphasized traditional composition by repetition and standardization of shape, thus transferring emphasis to the holistic experience of the painting as a single image and as an object. The particular kinds of opacities and redundancies which make his surfaces and patterns look so predictable and impassive have, in fact, helped generate original and influential contemporary forms in the realm of three-dimensional constructions perhaps even more than in the pictorial medium.

Stella's painting is more that of a structurist than a post-painterly abstractionist. His concern has been consistently not so much with color or pictorial illusion as with painting as an object, as a thing of literal and denotative meaning which exists in its own right, and is entirely self-referring. In the late 1960s, the tenor of the arts, despite elaborate rationalizations of subjective esthetic positions, was protest, an engagement with real, rather than ivory-tower, issues. For younger artists of that period, sculpture seemed a more attractive alternative for its superior reality, its object quality—a condition which only a few painters of the same period, Stella notably among them, were able to fully realize. It was from his example, and from the noncompositional field approach to painting found before him in the work of Pollock, Rothko, Newman, and Reinhardt, rather than from the abstract welded sculpture of the 1950s, that the new and influential art in three dimensions of the 1960s arose.

pl. 457

pl. 459

pl. 458

Frank Stella. *Quathlamba*. 1964. Metallic powder in polymer emulsion on canvas, 77″×13′7″. Private collection, New York. 459

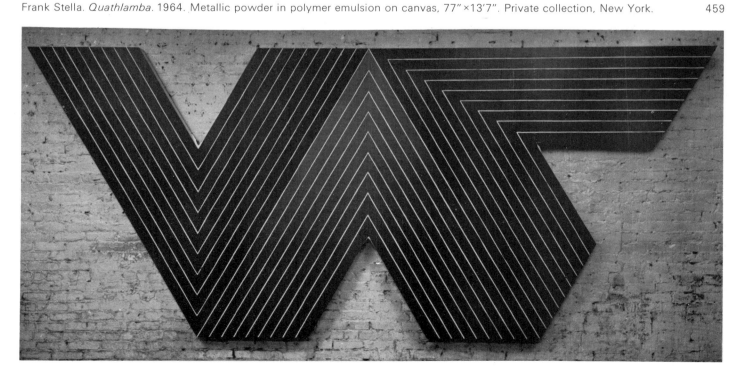

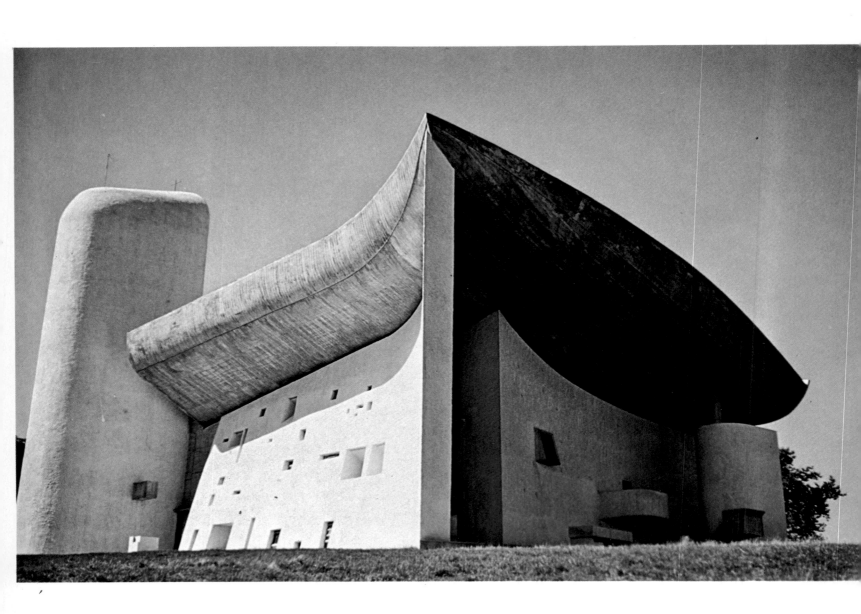

THE DIFFUSION OF THE NEW ARCHITECTURE: 1954-1975

This second postwar period did not generate anything in architecture like the previous wave of Utopian idealism either in theories or in projects, let alone in actual constructions. There was no urgent search for new beginnings but, instead, a wary effort to follow closely in the tracks of the avant-garde of the 1920s and 1930s. This time the slate was not wiped clean. There were no dramatic appearances of radical personalities or organizations, no vanguard effort, no sweepingly comprehensive manifestoes for the rejuvenation of design. Characteristically, about the most significant event of the period was the widespread infiltration by the masters and disciples of the new architecture of established architectural schools, which had, for the most part, remained bastions of academicism.

Caution and, significantly, a kind of narcissism prevailed. One new architectural figure to emerge at this time, Philip Johnson (b. 1906), may not have been exactly typical, but his background and inclinations were indicative of the times. Coming from the ranks of criticism to become a student of Gropius's and Breuer's at Harvard, he evolved into a devoted follower and sympathetic biographer of Mies van der Rohe. For the first decade of his career as a designer, ending in the mid-1950s, he built houses and other small buildings that were, if anything, more Miesian than those by Mies himself. On a conceptual level, Johnson's renowned Glass House, the nucleus of his country seat in New Canaan, Connecticut, 1949, is as representative of these new tendencies as Le Corbusier's Villa Savoye was of the formal innovations of an earlier era. Johnson's dwelling was essentially a sophisticated emulation of an idea originating with Mies, enriched by historical references to earlier events in the modernist tradition, whereas Le Corbusier's house, while based upon Cubist-inspired spatial inventions, had been created with a will to break new ground rather than merely refine and consolidate a volatile esthetic into

pl. 461

something fixed and constant. The modernist impulse was, in the late 1940s and 1950s, being harnessed into a traditional pattern, being reduced to yet one more historical style.

The Utopian urgency of post-World War I architecture, whose social and cultural idealism had originally justified its austere geometries and innovative planning, was now replaced by the limited goal of creating precise, beautiful contemporary forms for their own sakes, as *style*. Goals and horizons contracted, and the modern idiom became introverted and, finally, even fashionable. Some of these compact, handsome architectural forms of the past quarter century, such as Johnson's Glass House or Mies's more monumental, more recent, National Gallery, Berlin, 1962—68, a glass house of templelike proportion and configuration, are already anachronisms, even though they manage to look smartly contemporary. In their careful refinement of proportion and execution they even succeed in eclipsing those earlier modern buildings that were their sources.

pl. 462

This narrowing of focus on the part of one older master and the most important of his disciples was contemporary with an opposing phenomenon, best represented in the work of Le Corbusier, notably in his chapel of Notre-Dame du Haut, Ronchamp, 1950—54, and in several explosive designs built during the succeeding years. The stunning surprise of the prowlike shape of the chapel at Ronchamp overwhelmed and confused its beholders at first, but, once mastered, its forms seemed to follow logically from the less constrained nature of his projects of the 1930s, especially those urban schemes where curves replaced right angles. Thus, in the late works of two great leaders, the once-unified modern tradition had been abruptly sundered. Yet the new works of both preserved a single point in common: the creation of distinct autographic images, sometimes private and personal in meaning. These images, seductively photographed and handsomely published, formed a tempting, irresistible, yet dangerous, challenge for others to emulate. At first, Le Corbusier was admired but avoided, as his works seemed to be, in effect, a secret voyage, and Mies was turned to as the source for a more recognizably public architecture. Later, as architects

pl. 460

Le Corbusier. Chapel of Notre-Dame du Haut, Ronchamp. 1950–54.

460

293

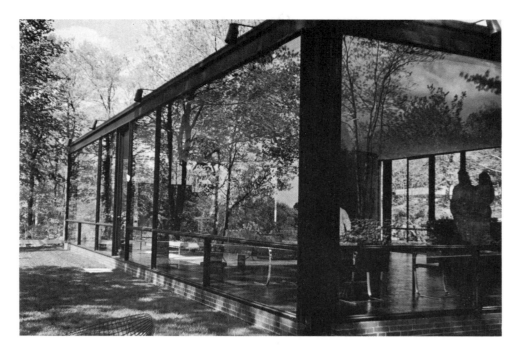

Philip Johnson. Glass House, New Canaan, Conn. 1949. 461

Ludwig Mies van der Rohe. National Gallery, Berlin. 1962–68. 462

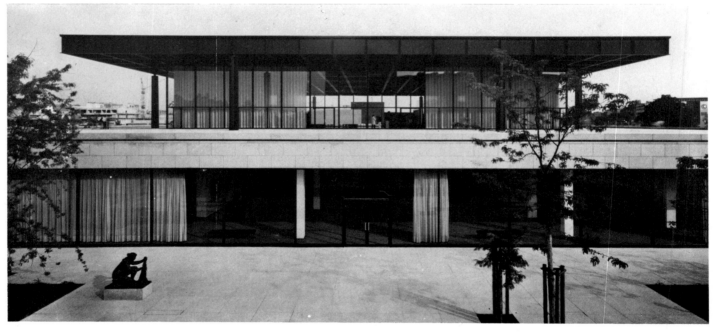

became bored or disenchanted with the possibilities of these Spartan forms, some of the epigones began to follow Le Corbusier. Only a hardy few could find distinctive ways of their own.

Thus arose a new species of form-making, the creation of a personal style, which became the goal of many ambitious architects. Whereas, formerly, a major goal of the new architecture had been to replace individual expression with an averaged-out universal mode, the prominent, admired modernist architects of the past quarter century have taken the opposite direction. Whether imitating, adapting, or transforming some aspect of the International Style heritage, a prime goal of new designers has been to establish their distinctive stamps, generally to the applause of critics on the lookout for architects whose personal expression just might equal the creative heroics so often, if too enthusiastically, ascribed to the more lionized contemporary painters and sculptors. A number of present-day architects have been bene-

ficiaries of a cult of personality, an exaggerated adulation that has its origins in the homage rendered to the persons of Wright, Mies, Gropius, and Le Corbusier by teachers, students, and writers in the years immediately after 1945. This is the one common theme of our period, and it compares perversely with the impersonal, altruistic idealism inherent in the original work of these remarkable pioneers. It is difficult to imagine a greater paradox, a more complete about-face.

Hand in hand with this individualization, in which architectural personalities are commented upon in the press in a tone not unlike that enjoyed by professional athletes or pop musicians—though in appropriately sedate language—comes its exact opposite: corporate design anonymity. Curiously, this phenomenon, especially characteristic of American practice, though now widespread throughout Europe, is partly the outgrowth of one important theoretical aspect of the International Style. These architectural firms, whose office or-

ganizations rival, in rationalized structure, those of their gigantic corporate patrons, have carried on those earlier ideals of cooperation and teamwork that were notable in the theory and practice of the Bauhaus and implicit in the ideals of De Stijl and Purism. Indeed, many of the realities of contemporary design depend upon this type of business organization, with its natural bent for inhibiting original, personal expression.

The legacy of the original International Style has been internationalized in a most uneven way, in part being incorporated into certain national or regional traditions, as in the United States and Latin America, while simultaneously serving as a force breaking down these provincial barriers. The International Style became, by the 1950s, an architectural koine, a common jargon employed by high and low alike everywhere, for the most diverse purposes, often to the despair of critics who rightly deplored the disappearance of local traditions. This lowering of the International Style heritage into a vulgar street language naturally produced reactions, countermovements, revisionist modernisms, and the like. It also produced a complex situation whereby one significant part of the profession continued to practice an entrenched manner of commercial modernism, working from and within the Miesian mold; a second, more venturesome, explored the plastic freedom contributed by the late works of Le Corbusier; while a third, a "nongroup," developed patterns of its own, at variance with some or all of the now-historical categories of early twentieth-century architecture.

Representing the first group is the highly regarded firm of Skidmore, Owings and Merrill, archetype of the large American architectural office, producing a corporate-styled, standardized product of great repute. Among the many who, with greater and greater frequency after 1960, opted for the Corbusian plastic tradition would be Kenzo Tange and Paul Rudolph. Of the independent-minded, the most renowned is Louis I. Kahn; but that collection of free spirits would include many others with little in common, save perhaps a disenchantment with Bauhaus esthetics, such as the Archigram group of England and those who are not precisely architects, for example, the engineer Frei Otto or the self-styled universalist R. Buckminster Fuller. Alvar Aalto also stands apart, following a personal line of growth away from the International Style that is not easily typed. Sometime around 1960, these various trends and possibilities became equal in their modernity though they remained vastly unequal in terms of their established bases, their patronage, and their potential for academic or critical recognition. An eclecticism both simultaneous and polymorphous resulted, a range of possibilities that included the jet-set commercial and industrial architecture of seamless glass containers, the sturdy neo-Corbusian masses of a Boston City Hall, the rugged shapes and spaces of Kahn, the inflatable structures, the lightweight

geodesic domes, and the even more perishable edifices made from the detritus of the auto-consumer civilization.

Architecture in the late twentieth century has been likened, for purposes of historical analysis, to the situation that prevailed in European architecture during the late sixteenth century, the period of the Late Renaissance and Mannerism, two simultaneous historical phenomena that are intertwined in a baffling ballet of interrelations and contradictions. Indeed, there are analogies of more than passing importance between a collection of architects from that period—Sebastiano Serlio, Giulio Romano, Jacopo Sansovino, Andrea Palladio, Philibert Delorme, and Michelangelo—and the major figures of today. These were all designers much concerned with style and its sources, preoccupied with scholarship and history, interested in both the canonically correct proportion and the bizarre effect for expressive ends, and concerned with the establishment of their own distinctive reputations. Historically, it was a period of shifting political authority, with the rapid rise and fall of power centers across Europe. However, the complexity and contradiction (to borrow the phrase from the influential book of 1966 by Robert Venturi) of late twentieth-century architecture is of a vastly different scale and involves values that are infinitely more permissive than the humanistic ones that prevailed four centuries ago, formal values that are not answerable to any political, social, or even intellectual system. Architecture today exists in an ideological void without precedent, one which does not even find a counterpart in the other visual arts or in literature.

In surveying the history of the 1920s, it was possible to single out a certain few pivotal men and movements. The significant achievements were in their hands, and what was created on the periphery of the new architecture is clearly recognizable for just that. However, the expansion of the International Style brought about both its popularization and its breakdown as a coherent movement, partly through growth and evolution, partly through a kind of corruption in which the forms, but not the theories, were taken over by the profession. Thus it is much more difficult to separate today's vanguard from today's establishment modernism in many cases. Moreover, even before considering the accomplishments of the younger generation, which took an unexpectedly long time to find itself, it must be stressed that the late styles of the old masters diverged rather than converged, contributing to a chaotic situation.

The iconic buildings of the 1950s, such as Ronchamp, the Glass House, the Guggenheim Museum, and a few others, were by those very ancient. Mies's Seagram Building, New York, 1954—58, designed in collaboration with Philip Johnson, was the most important of these for the simplified shape that the new towered city would take. It was not the first built of Mies's simple, rectangular glass shafts with proportionally exact metal detailing and vertical I-beams used exter-

pl. 460
pl. 461, 307

pl. 464

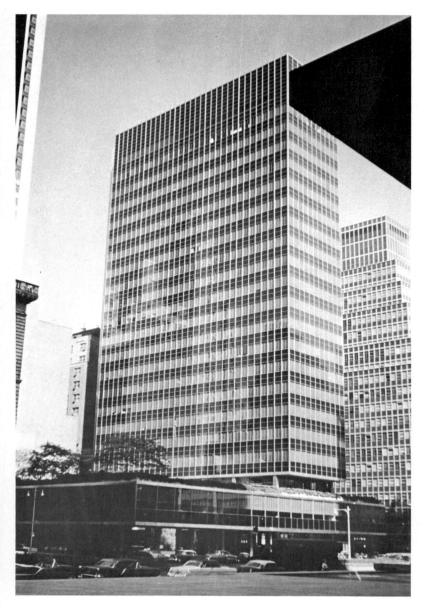

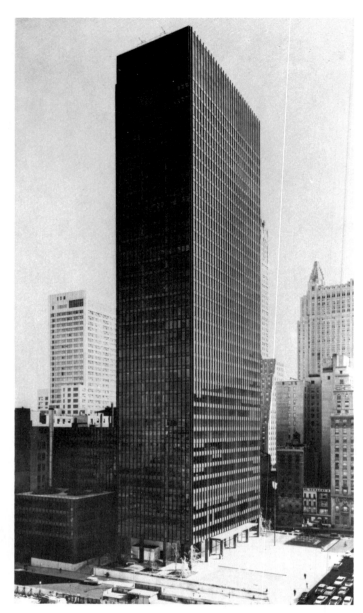

Skidmore, Owings and Merrill. Lever House, New York. 1950—52.
463

Ludwig Mies van der Rohe and Philip Johnson. Seagram Building, New York. 1954—58.
464

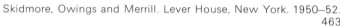

nally as if they were classical pilasters, but it was the most beautiful. Mies's collapsing of complex 1920s abstract geometry into one main form is not completely carried through here, but the effect is close (some lower forms cluster inconspicuously at the rear and sides). The architect made something timeless and universal out of a newly popular, yet thirty-year-old, idiom, providing a paradigm for subsequent urban high-rise design that has not, in the succeeding two decades, worn out its welcome with patrons, developers, and a certain coterie of architects. It has, however, become a building type largely ignored of late by much of the architectural intelligentsia and even, on occasion, ridiculed in the critical press. Stylistically, it is quite out of line with the gestural, Abstract Expressionist painting then at the peak of its creative and popular success, though it should not be forgotten that Mies's esthetic accords perfectly with the contemporary, square paintings of squares of Josef Albers.

Mies's Seagram Building was a triumph of reduction. It eliminated the complex, interlocking geometry of flux characteristic of his earlier designs, and especially characteristic of the Barcelona Pavilion, where form actually became content in an ideal structure. Also, it eliminated the familiar formal and decorative features of the American skyscraper as it had evolved in its special way during the 1920s and 1930s: it suppressed the set-back silhouette and the turret or tapered spire at the summit and transformed the vertical strip window into the vertically accented glass wall. Modern style here joined the new building type in a seamless unity. When finished in 1956, Seagram was situated in an old, but not antiquated, urban environment featuring brick-clad structures of moderate height, detailed for the most part in a subdued Renaissance manner. The only exception was the glass-slab Lever House, 1950—52, by Skidmore, Owings and Merrill, diagonally across the avenue, actually the first "Miesian"

296

pl. 463

building in the city—a reminder of how often followers were able to get the concepts of the pioneer architects built first. Almost before Seagram's completion, a glass-architecture fever spread up and down the avenue, and within a few years a city of crystal blocks had been thrown up, a dismal parody of the dreams of Bruno Taut, whose extravagant visions of a glass architecture were a world removed from such superficial, simpleminded applications.

Mies's hermetic way with the new tradition was the likely one to evoke wide public support, a certain critical acclaim, and, most important, a generous, well-heeled clientele who felt secure with this respectable-looking, yet clearly contemporary, type. There is no historical precedent for the international success of this sheer tower, with its restrained, calculated modifications of proportion, size, tinting, and surface relief, and its technique of assemblage. True, there has been an increasing variety in exterior treatment apparent over the past few years, a definite tendency to reduce the amount of glass surface or obscure it with facades designed in greater relief with a mas-

sive structural grid projecting in front of the curtain wall. There are also increasingly frequent modifications away from the rectangular box shape, substituting polygonal or curved profiles for the four-square, and this solution is especially popular in Europe. The Pirelli Building, Milan, 1956—59, a pioneer European skyscraper by Gio Ponti (b. 1891) in collaboration with the engineer Pier Luigi Nervi (b. 1891), was the prototype of this nonrectangular shape, with slightly bowed glass curtain walls on the long flanks terminated at both ends by distinctive prow-shaped stair towers.

pl. 465

Space does not permit more than a trifling sample of these new skyscrapers. Skidmore, Owings and Merrill, with offices in several cities, are the most accomplished masters of this architecture, derived, and even debased, from Mies. Distinguished, if rather cautious and unoriginal, in design yet often breath-taking in the scale of parts or of the whole, their works succeed through the use of a narrow range of luxurious-looking materials. Their most remarkable achievements have been two towers of the past decade in Chica-

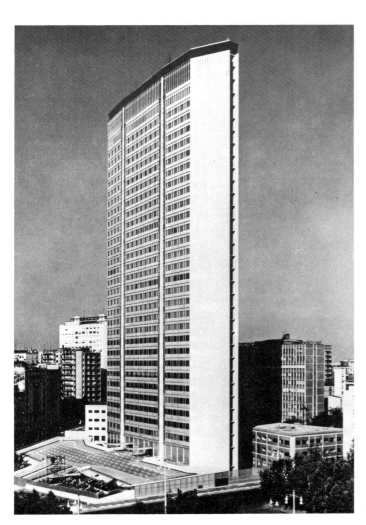

Gio Ponti and Pier Luigi Nervi. Pirelli Building, Milan. 1956—59.
465

Skidmore, Owings and Merrill. John Hancock Center, Chicago.
1966—69
466

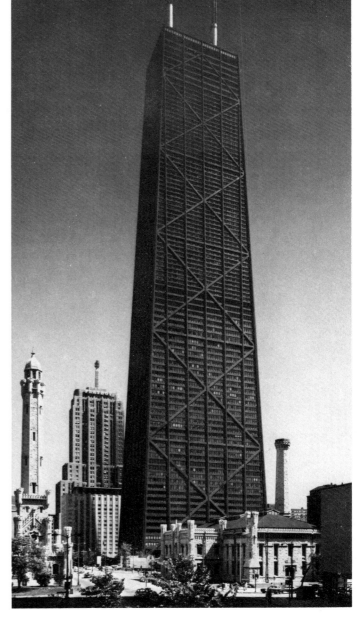

Minoru Yamasaki. World Trade Center, New York. Airview. 1965–. Photograph July 1973. 467

Défense District, outside Paris. Commercial plaza and office towers. 468

pl. 466 go, the John Hancock Center, 1966—69, with inclined walls and diagonal steel bracing, and the Sears Roebuck Tower, a design that re-introduces the old set-back form in what is, for the moment, the tallest building in the world. Local boosters would point out that these aspiring forms are but the most recent in a long line of tall office buildings in that Midwestern metropolis, but these behemoths are a far cry from the early skyscrapers of Sullivan and his contemporaries—many of which are now being demolished or threatened by their ambitious, outscaled successors. In the same pl. 467 vein are the two towers of the New York World Trade Center, a project conceived in the mid-1960s, but in 1976, still incomplete, by Minoru Yamasaki (b. 1912), a prominent, fashionable designer, whose work is indicative of how easily this genre of building can become a matter of packaging and external design, even when a major new structural concept featuring a load-bearing wall is introduced. These cracker-box forms have dwarfed the skyline of Manhattan in a way in which no other buildings have before, and seem more alien to their neighborhood and to the entire metropolis than any other imaginable forms. That they, along with many other recent urban towers, have provoked a surfeit of commercial office space and a depression in the building industry is only the least of the social problems generated by these colossi.

Europe has been a victim of this plague to a somewhat different degree. The tallest building there, the Tour Montparnasse, Paris, completed in 1973 after long years of planning and construc-

tion, is not quite 700 feet high, about half that of the tallest American building. However, since the historic building horizon was lower and, in fact, was not seriously pierced by skyscrapers until well after mid-century, the mutation seems even more deplorable there. However, criticism of such drastic changes in the more sacrosanct historic skyline of these older urban centers should be tempered by reminders of the early hostile criticism of such now-recognized innovative masterpieces as the Eiffel Tower, and of the drastic urban surgery practiced on Paris by Baron Haussmann more than a century ago. Fortunately for Paris, a large part of the new skyscraper development has been concentrated in an area to the west of the capital proper, the Défense quarter, an integrally planned pl. 468 commercial city incorporating mass housing as a secondary feature. It forms its own center apart, though alas not quite invisible, from the historic nucleus of Paris. Its tall buildings are clever variations on the international commercial norms of the 1970s, with more unusual geometries and surfaces than might be expected. Although there are generous terraced spaces just above ground level, these seem haphazard and often bleakly overscaled. Altogether, it appears as a tarted-up Radiant City, although lacking in the plastic intensity and planning coherence of a Le Corbusier.

London has met the skyscraper in a rather different way. The worst that can be said is that the builders and architects of the 1960s have accomplished something that eluded the efforts of the German bombing of 1940: the leveling of the historic skyline of the city. The dome of Saint Paul's,

pl. 469

the towers of Parliament, not to mention the spires of Wren's churches, have all been dwarfed and obscured by the random distribution of new tall buildings, forms that have been dispersed rather than concentrated in particular districts. Nonetheless, many bombed-out sites have at long last been built over; and it should not be forgotten that a city like London, no less than in the equally special cases of Paris, New York, or Chicago, is a living entity, not an exclusively historic monument, and that growth within as well as without the historic center is inevitable. London's skyscrapers are an undistinguished lot, especially by comparison with the high standard of British architecture in other areas—more impressive, in a somewhat ghoulish way to be sure, in the ensemble as seen from the dome of St. Paul's or from the several bridges spanning the Thames than in the individual buildings.

It is impossible, even when considering only formal and stylistic matters, to remain insensitive to the questionable social role played by these omnipresent towers, alienated objects in the midst of our contemporary metropolis, where they exist presumably as architectural demonstrations of contemporary society's power and efficacy. These sheer forms create a destructive visual tension between the old and the new. This vicious confrontation was not foreseen in the initial vision of the Radiant City, and it remains unclear whether the major flaw lies in the concept of the Cartesian skyscraper itself or in the superficial adaptation of a grand scheme in fragments rather than the entire plan. Also, it did not improve matters to have employed a design formula bowdlerized from an earlier generation of modernists in the first place. One thing is certain: there has been too little large-scale, architecturally determined planning and too much concern for short-term financial rewards, manipulation of private land values, speculation, and increases in the tax base. Predictably, there has been little concern for genuine social amenity and livability in nearly all gigantic building enterprises. One strains to find a convincing major exception to this rule.

Given the pernicious social consequences of so much recent architecture, inspired closely or at a distance by the half-century-old visual images of Le Corbusier, Mies, and their generation, the temptation is to blame them for these present failures. This is to fix responsibility in the wrong place and to ignore not only the idealistic content of the original Radiant City or the true Miesian tower but also the logically thought-out details and refinements as well. Focusing upon an inherently commercial building type does Mies's reputation a disservice: his Berlin National Gallery, mentioned above as one of the perplexing yet characteristic anachronisms of more recent modern design, is a splendid formal example of late modern, a demonstration of his epithet "less is more," and a space that exists more for its own sake than for its contents. His is a structure that is as much a cenotaph to architectural ideals as is Wright's very different Guggenheim Museum. Buildings of this sort, abstract demonstrations of space and structure, remain as necessary monuments in an age that gives short shrift to the grand gesture. The templelike image and the elegance of the Berlin National Gallery's structural joinery demand comparison with Mies's house projects of a quarter century before and especially with the Farnsworth House, Plano, Illinois, 1946—50. Careful analysis of the means of support and of

pl. 462

pl. 307

London skyline, with dome of St. Paul's and Barbican towers.

469

Alvar Aalto. Cultural Center, Helsinki. Exterior detail. 1955–58 470

Le Corbusier. Unité d'Habitation, Marseilles. 1947–52. 471

the specific relation between horizontal and vertical lines in each building shows a surprising variety of solutions for an architect who, in matters of volume and space, seems to aim for the most elementary standard.

Twenty years ago, it seemed as if the Miesian mode would form the permanent substance of a contemporary vernacular, and, to a degree, it has become an establishment idiom. However, the quality and the motivating spirit of this commercial vernacular have become increasingly depressing. At the same time, the more recent works of Le Corbusier were becoming better known and discussed. Simultaneously, his earlier works in the more simple, Purist idiom were being reappraised, and these laconic designs were found to contain still other elements that could serve the further advancement of the new architecture. A quarter century ago it was generally felt that in comparison to the clear, direct message of Mies's formalist architecture, Le Corbusier's efforts were too personal, complex, and exclusive to serve as useful models. In those days one admired Le Corbusier's formal manipulation and ceaseless invention but followed Mies's example, or possibly that of some regional contemporary mode; *or* one established a distinctly personal alternative, as was notably the case with Aalto. His career, from the 1950s to the 1970s, resulted in numerous buildings, public and private, that generally stand aloof from either the simplifying or the elaborating strains of new design. Irregular, even picturesque, shapes and masses dominate his work, but the very informality of his buildings, such as the Helsinki Cultural Center, a meeting hall for several labor unions and for concerts of 1955—58, or the church near Imatra, 1956—58, defies comparison with the more urgent, passionate rhetoric of Le Corbusier. Moreover, the gentility of his style and detailing is a world removed from the overwrought and sometimes misplaced precisionism of the Mies imitators or the strained, sculptural images and studied facade effects of other architects of this period.

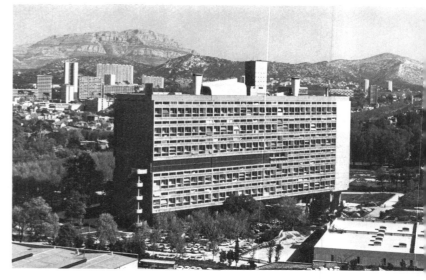

Ironically, other alternatives, exemplified variously during the 1950s and 1960s by the works of such otherwise unrelated architects as Philip Johnson, Eero Saarinen, and Louis I. Kahn, were sufficiently revisionist to merit such epithets as neotraditional or counterrevolutionary, though these labels are too blunt and gross to accurately describe a complex, even confused, phenomenon. These designers freely indicated their skepticism of each other's work, and their interests diverged widely, as did their clientele. They sought to establish separate identities for themselves and for their generation in the face of the idolatrous acclaim showered upon the older masters, especially Le Corbusier, who continued to pose an active threat to everyone, young and old, until his death in 1965.

Le Corbusier's late works, neither numerous nor located in frequented or easily accessible places, are a unique resource. In them the principles of the free plan and free facade expand into free form—a sculptural instinct previously held back by the planar fixation of the International Style. Each of his later buildings makes specific formal gestures toward the landscape, revealing an attachment for nature that his earlier works.

pl. 470

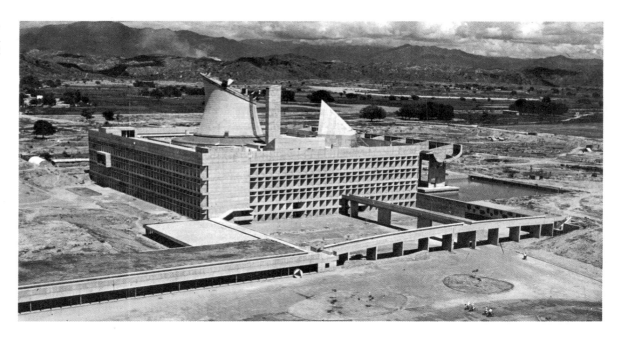

many of them urban, did not suggest. His early city schemes were tabletop exercises, but, by about 1930, in sketches and in detailed plans for Algiers, Rio de Janeiro, São Paulo, and Buenos Aires, he had shown an interest in transforming the Cartesian skyscraper into curving, ribbonlike slabs expressive of the topography of the site. Indeed, it is something of a jolt to realize that Le Corbusier never built a true skyscraper, that the form taken by his postwar mass housing was that of a tall slab that was invariably greater in length than in height. Marseilles, the first and richest Unité d'Habitation, 1947—52, was seventeen stories high, but its greater length gives a sense of horizontality that somewhat conceals its height. Here the architect first employed *le béton brut*, rough concrete left as the actual surface, untreated or unrendered to make a smooth face throughout the building, a technique that would be imitated and adapted widely later—today still the standard alternative to the shiny, clear, manufactured look of the contemporary urban tower. This rough concrete gave a sense of the accidental, introduced an ironic feeling of handicrafts in the product of a partly industrialized building technique in which common labor plays a larger role than does specialized craftsmanship.

pl. 471

The plans of Marseilles, featuring duplex apartments with balconies on each facade to insure cross ventilation, have been much discussed but little imitated; in fact, their unique layouts evolved from an economical reduction of the Citrohan scheme but incorporated ideas that had appeared in Soviet housing projects in the 1920s. On the roof terrace, the architect provided recreational facilities and simultaneously indulged in romantic sculptural fantasy. The ventilation stack was shaped into a tapered funnel form, various levels with stairs and ramps were introduced, and freely shaped concrete forms were molded as a children's play structure, which, in fact, echoed in miniature the ridge of mountains on the distant horizon. Art, or rather architecture imitating

nature, was a challenge that the architect could not resist, and in 1950 he would be designing an entire building, the chapel of Notre-Dame du Haut, as a free form echoing the contours of nature in a way utterly foreign to the traditions of European architecture—though Wright had, from time to time, sought something akin to this effect in his more advantageously placed houses, but in a rather more functional way. At Ronchamp, Le Corbusier sought to meet nature as an equal, creating a gestural form uniquely destined to the Place—a site on top of a domed hill that had been a Christian sanctuary for centuries and before that, perhaps, an acropolis for pagan cults antedating the Roman advent in Gaul.

pl. 460

This church, architecturally more an evocation of older rites and mysteries than a Christian sanctuary, is loaded with memories, allusions to forms of indescribable antiquity, and a profundity of expression in the use of mere architectural forms that reaches the explicit poignancy of the representational arts. It is not even easy to describe the building mass, so apparently free is its geometry of curves and angles. An aggressive prow greets the pilgrim as he mounts the hill; from this initial climax the forms subside, their curves leading one around and finally within, where all is dark, subdued, the curving lines now falling rather than rising. The curve of the concrete shell vault may suggest the shape of an airplane wing fragment, yet the massive vault seen from the exterior overhanging its massive supporting walls resembles the megalithic funerary architecture of millennia before. Nothing could seem less modern, at least in the futuristic or even machine-age sense, yet its expressive primitivism is so elementary that its creator could rightly be called the noble savage of the new architecture. His primitivism here was, however, no sentimental Rousseauian device but a means of probing the essence of architecture as no one before had done.

Ronchamp seemed to be an architecture without issue; no other architect was equipped,

301

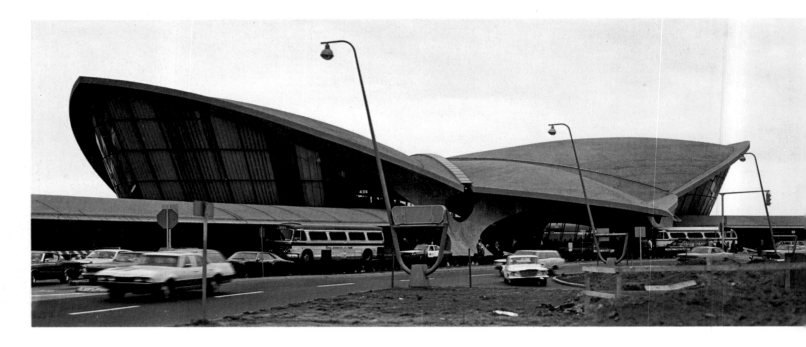

technically or morally, to carry out anything remotely in its class, and yet its hard-to-grasp liberties, its apparent yet illusive freedom from the exacting rigors of more familiar modern shapes beckoned, and several prominent architects of the late 1950s could not resist. The results were, at best, equivocal. Other architects, in admiration but also despair, were prompted by Ronchamp to turn back again to a study of Le Corbusier's earlier work, finding there a more useful and even inexhaustible text upon which to found their own work. Since the mid-1950s, no other architect has so occupied the minds of architects and critics, as much as an irritant as an idol but also an inexhaustible source for ideas and motifs of infinite variety.

Like so many modernist monuments of the 1950s, Ronchamp is built of paradoxes and inversions; it literally turns the rational idealism and the formal rectitude of the International Style inside out. The same is true of Le Corbusier's capitol at Chandigarh, projected from 1950, the ensemble never actually completed. The impressively scaled monumentality of the High Court, pl. 472 1955, and the Assembly, 1962, both with amply proportioned porticos, is an original, contemporary conception that achieves a degree of grandeur commensurate with that of the Beaux-Arts tradition, which the modern movement had originally sought to dethrone. The powerfully sculpted, virtually inimitable, forms of Chandigarh are some small consolation for the even vaster, unexecuted Palace of the Soviets project, a vision so different in conception that it seems not only to belong to another day, but to be the work of a totally different artist.

Unlike the great styles of the past, the Doric or the Gothic, the nature of modern monuments is their Promethean audacity. They remain solitary, defiant creative gestures in a kind of intransigence that, besides being detrimental to orderly development, is a disturbing inversion of another manifest principle, or characteristic, of contemporary

design: the need and desire to create uniform building types that can serve at least the partial industrialization of the traditional building crafts. Of the architects of the century's middle years, none is perhaps more representative of the Pyrrhic effort to rival the older masters than Eero Saarinen (1910—1961), the son of Eliel Saarinen. The younger Saarinen's background was, by the standards of the day, traditionalist, in spite of the fact (or perhaps because of it) that his father was a major pioneer of the early years of this century. While the forms of Eero Saarinen's architecture after 1950 are unmistakably modern, his style is randomly eclectic, the result, he maintained, of searching out a special, appropriate, distinctive style for each building job. Often his designs were inventive, sometimes imitative of something familiar; in all cases, the buildings seem strained, restless, and insecure. Above all else, his monuments should be regarded as neotraditional; that is to say, he made use of modernisms in his designs as a Beaux-Arts architect of the nineteenth century might adapt, manipulate, transform, or even reinvent motifs from the Roman-Renaissance tradition.

Interestingly, Saarinen's best work comprises two concrete airport structures, the TWA Terminal at Kennedy International Airport, New York, pl. 473 1956—62, and Washington's Dulles International Airport Terminal, 1958—62, the one expressionistic and the other neomonumental. Moreover, pl. 475 both are different from the simple, boxy geometries of his earlier General Motors Technical Center, Warren, Michigan—loosely Miesian in layout—or the tentative, much-criticized formalism of his domed Kresge Auditorium at MIT, Cambridge. Schematically the outline of a bird-in-flight, TWA resembles, among other things, an Art Nouveau brooch or perhaps a pre-1918 sketch by Erich Mendelsohn, but the most pungent association was surely made by two inadvertently overheard German-speaking travelers who waxed eloquent over this concrete Fledermaus!

Philip Johnson. New Wing, Boston
Public Library. 1972. 474

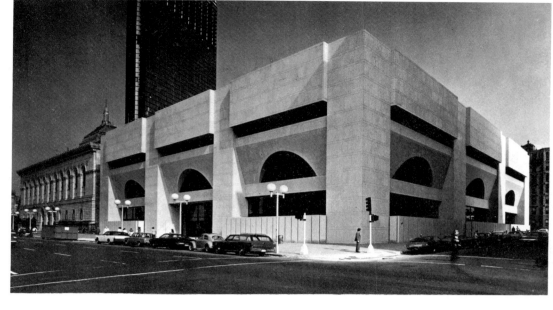

Eero Saarinen. TWA Terminal,
◁ John F. Kennedy International
Airport, New York. 1956–62.
 473

Eero Saarinen. Terminal, John Foster
Dulles International Airport, Wash-
ington, D.C. 1958–62. 475

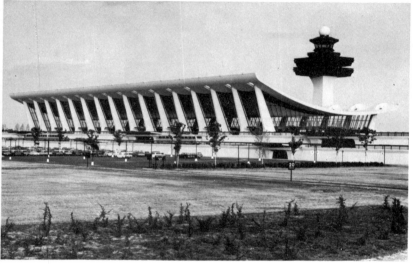

Saarinen was, of course, inspired by aerodynamics for these winglike canopy shells, wishing to anticipate, through architectural form, the exhilaration of flight—a somewhat naive romantic literalism quite inappropriate to the ungainly giant jets whose forms are in fact much tamer. Many years earlier, Le Corbusier had suggested that airplanes be studied by architects, not as a source of formal ideas, but, rather, as an example of a new, distinct form resulting from the direct, hardheaded solution to a difficult functional problem. Saarinen's stylish manipulation of these forms would seem to blunder right by Le Corbusier's admonitions without the faintest comprehension of the principle involved. Even more insensitive to the core of modernist doctrine is the structural inefficiency of the seemingly thin concrete shells; they were shaped rather arbitrarily with care for the admittedly effective spatial flow, but, as a result, the engineers had no choice but to build a thick concrete canopy with much reinforced steel, further adding to weight in order to make the idea stand.

Dulles is a much larger, more grandiose project, with outthrust piers holding a tension vault in place high above massive terrace structures. Again, flight is suggested through the rising con-

tours of the building, and, again, the profile of the building might just possibly be an adaptation of a Mendelsohn sketch. However, in its scale and with its rather formal portico, Saarinen's Dulles seeks to compete with the "facades" at Chandigarh, though they are too calculated to make a comparable impact. Saarinen was in the habit of studying the design of his buildings through the use of elaborate models, a praiseworthy effort to avoid spatial miscalculations. Ironically, many of his constructed works look just like that, like enlarged models, often ill-detailed and often with incoherent scale relationships. Still, his monumental forms are vastly superior to many contemporary efforts that strive for rhetorical effect.

Philip Johnson is a more impeccable formalist, a gadfly, by turns ironical, cynical, and generous. A coauthor of the book that effectively christened the International Style in 1932, he began a creative career only after World War II and, as we have seen, was, for a decade, not only an orthodox Miesian but one of those who gave the idea, albeit fleetingly, that this mode of glass, brick, and steel might become the permanent style of the century. Johnson is also a serious admirer of the works of Wright and Le Corbusier and even sought to transform some of Wright's motifs into his work, but without serious result. Another object of his admiration was the nineteenth-century romantic-classic architecture of Karl Friedrich von Schinkel, likewise venerated by Mies. This kind of modular classicizing design was behind his change of style in the late 1950s, a neotraditionalism added to his previous "revival" or continuation of Mies—though there were other forces at work as well. Though his wit and intelligence sometimes deserted him in occasional lapses in taste, usually confined to details, Johnson was probably the only architect among many—Edward Durell Stone, to name one—to work successfully in a new academic mode without creating a style of solecisms plucked randomly from the new architecture and

from historical tradition. Johnson's Sheldon Art Gallery, Lincoln, Nebraska, 1963, is a model of this sort of gem-box design; his new wing for the Boston Public Library, 1972, is a most striking instance of applying formalist principles adapted from the classical or classicizing styles to a contemporary design idiom that is mostly free of eclectic overtones.

pl. 474

The most conspicuous, even imitated, large-scale instance of this neotraditionalist architecture is Lincoln Center, New York, 1962—68, where Johnson was the architect of the New York State Theater, 1964, the building to the left of the major facade of the Metropolitan Opera, which dominates the stiff, symmetrical layout. Wallace Harrison, who previously contributed to Rockefeller Center and was the executing architect of the United Nations Buildings, 1950, where Le Corbusier had been a consultant, served as project coordinator for Lincoln Center as well as architect of the Opera, while his partner Max Abramovitz was architect of the Philharmonic (Avery Fisher) Hall, with the design of the Beaumont Theater placed in the hands of Eero Saarinen. Johnson's New York State Theater, on the interior, offers a vast open gallery space of true grandeur, an effect regrettably vitiated by the cheesy detailing of the gallery balustrades, a miscalculation altogether out of character for that architect. It would be pointless to belabor too much the design weaknesses of Harrison's Opera and Abramovitz's Hall: they aspire to the monumental but fall flat perhaps through naïveté, presuming an unsophisticated public and also displaying their rather superficial grasp of historical phenomena. The

pl. 476

plaza spaces are potentially stately in proportion, but often rather petty detailing and unimaginative planting cancel out the intended effect.

On the other end of the formalist, neotraditional spectrum of monumental architecture is the Sydney Opera House, completed 1973, one of the more dramatic architectural forms of our time but also a painful and even scandalous design. The competition project, more or less faithfully executed for the exterior, was the work of the Danish architect Jørn Utzon (b. 1918), though he resigned in outrage midway through construction. The scheme, hardly more than a sketch when it was selected (at the urging of Eero Saarinen, it is reported), was another overblowing of a concept by Erich Mendelsohn, a series of sail-like concrete canopy vaults set on a terrace dramatically sited on a promontory overlooking the harbor. Unfortunately, the architect had conceived the curvature of his shells without reference to the possibilities of construction, and the engineers, Ove Arup and Partners, were hard-pressed to build the form in anything like the architect's vision. Moreover, the curved shells were acoustically pointless and performing spaces had to be built whole within the monument. Taken together with the more prosaic, four-square, articulated elements of Lincoln Center, we can again see the confusing range of formal possibility inherent in our architecture.

pl. 477

Louis I. Kahn (1901—1974), the most original and incisive architect of the century after Wright, Le Corbusier, and Mies by dint of his unique traditionalism within the late modernist ambient, belongs with this group of revisionist architects whose work is in partial reaction to the formal

Lincoln Center for the Performing Arts, New York. Airview. 1962–68. 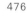476

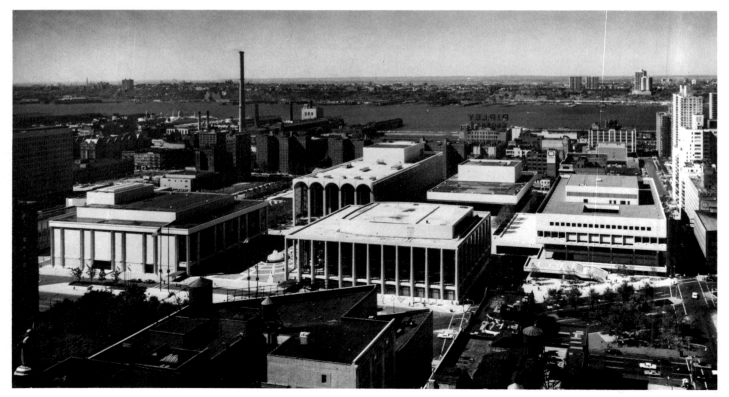

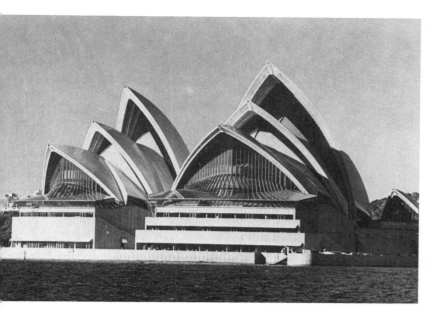

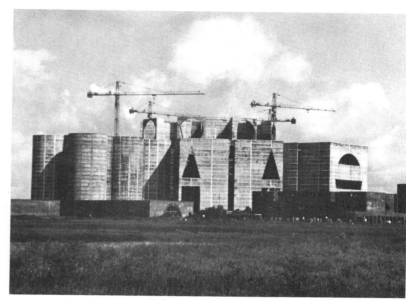

Jørn Utzon. Opera House, Sydney, Australia. 1973. 477

Louis I. Kahn. National Assembly Complex, Dacca (now Bangladesh). 1963–? Photograph July 1975. 478

dynamics and idealistic rationalism of the International Style. However, Kahn's traditionalism is less superficial, less motivated by a simple desire to be different or to prettify and make more publicly acceptable the harsher realities of the original radical style. Kahn's traditionalism is more inward, a personal assimilation of architectural forms as he found them, analogous to Le Corbusier's absorption of historical and vernacular forms, a gathering of resources and materials that would gradually, slowly, even painfully, be released toward the end of his life in a series of sturdy, unfamiliar forms. Unlike the neotraditionalism of his contemporaries, Kahn's architecture was neither easy nor popular. Like Wright, Le Corbusier, and even Mies, he was the solitary artist, tragic even, facing material and professional adversity out of his lack of conformity. He won an enormous following among students in the 1950s, and it is possible that his early success as a stimulating design critic helped release his own creative forces that so long lacked a means for expression.

A number of his works before the late 1950s are tentative, as if the architect were searching for some quality or effect that had not yet appeared in the principles or practice of the new architecture. After a reluctant acceptance and use of some of the standard formulas of post-International Style composition, in the final two decades of his career he fairly consistently rejected this language and created forms out of his own resources of study and reflection that are among the most autonomous of our time. Though admired by the intelligentsia, Kahn's work was not taken up as an alternate mode, was not successful except with unusual or especially perceptive, patient clients, and has not as yet formed a school of disciples even among his ardent admirers. At the beginning of his career, when few of his buildings had been completed, his method of composition and rather

personal language about the building process were widely commented upon. Indeed, some of his early works, such as the tentative, pivotal Yale Art Gallery, 1951—54, with the combination of a rather drab, conventionally Miesian exterior shell of brick and glass hiding an interior with a distinctive ceiling plan and structure in reinforced concrete, a honeycomb of tetrahedral voids, were rather mistakenly claimed by partisans of an unrelated contemporary movement, New Brutalism, as an example of their principles. Beginning about 1960, a new creative confidence appeared; from that point on until his death fourteen years later, each of his works added something vital and crucial to his evolving style. At a time when the new architecture had grown fat with success, Kahn's work was a refreshing, primitive, archaistic throwback, out of step with the commercial demands of the times and most effectively rejecting the immediate heritage of modernism's heroic years.

Kahn's geometry is as elementary as that of the International Style, but there would be no confusing the two. Made of clusters of cylinders and squat towers, with walls often as forbidding as a medieval fortress, his buildings sit directly on the ground, giving an effect of powerful tactile masses alien even to the late works of Le Corbusier. Significantly, one of Kahn's major works, the capitol at Dacca, Bangladesh, begun 1963, is an ensemble pl. 478 of public buildings for a Third-World nation, one more reminder of the apartness of modern architecture from its roots in Western culture. Significantly, just as Le Corbusier's object-buildings appear as sculptured forms set in a landscape, analogous to the practices of ancient Greece, Kahn's architecture offers substantial analogies with ancient Rome. His buildings are inward-oriented, aspiring toward vaulted spaces even when the ceiling could well have been a flat plane. Inside and out the eye is riveted by heavy-seeming 305

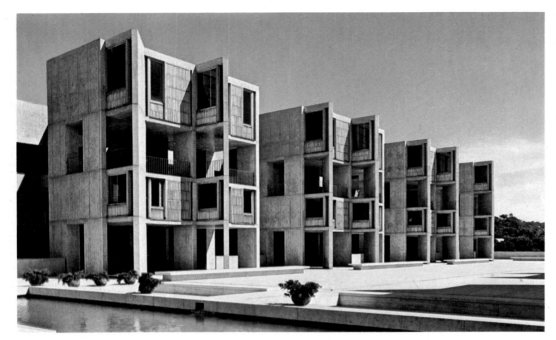

planes and masses illusively suggestive of the constructive bulk of Roman piers and vaults. Moreover, there is more than a hint of the star-shaped, snowflake patterns of Beaux-Arts planning in Kahn's layouts. These geometries appeared first tentatively and then, by 1960, more explicitly in his work, as he recognized his instinctive antipathy to the free plan of Le Corbusier, the open, continuous spaces of Mies, and the complex asymmetries of De Stijl.

Kahn's work thus represents a revisionist esthetic, one more paradox in a history that seems to defy coherence through its innumerable inversions, reversals, and contradictions. However, there is simultaneously an integrative role in Kahn's work: his distinctive brand of modernism, one appropriately monumental in its applications, makes viable once again certain procedures and even forms (though not details) of the academic heritage, making even clearer the importance of the Richardsons and the Wagners in the prehistory of the new architecture. By implication, Kahn's example also brings into historical perspective the

pl. 479, 480 work of the American Beaux-Arts-trained architects of the 1920s and 1930s, skyscraper designers who flirted with the modern idiom while remaining glued to their earlier ideals of dense monumental form. In effect, certain formal aspirations of Taut, Le Corbusier, and Ferriss seem to run together in the subterranean regions of Kahn's design thinking, and further compounding this syncretism are a number of parallels between Kahn's work and that of the early Wright. This is in no way the result of conscious borrowing or adapting; Kahn's roots are not those of an eclectic like Saarinen or of a historian-architect like Johnson, though all are beholden to tradition, indeed to two traditions, one of the twentieth century, the other of all that went before. Kahn's uniqueness is that he did not choose to perceive a difference between the two, whereas everyone else, for equally valid reasons, did.

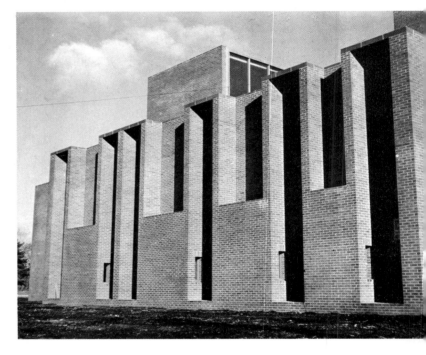

In his will to comprehend the wholeness of architecture Kahn joins Le Corbusier, and, for this reason, it is important to study his Dacca with Chandigarh. The differences are those of personality and of profound oppositions in the modernist tradition, an isolated heritage that has yet to establish itself as an integral part of contemporary culture. If Kahn's work represents one of the last mighty statements of a formalist, monumental esthetic—and there would be many who would maintain the opposite—then it is ironic that his achievement is also admired by many who proport to represent alternate positions.

If Kahn, Johnson, and Saarinen can all, for various reasons, be called neotraditionalists, there is reason to dub as neomodern a very diverse, stylistically heterogeneous, group of more recent designers. These architects span more than a generation and include, among others, Oscar Nie-

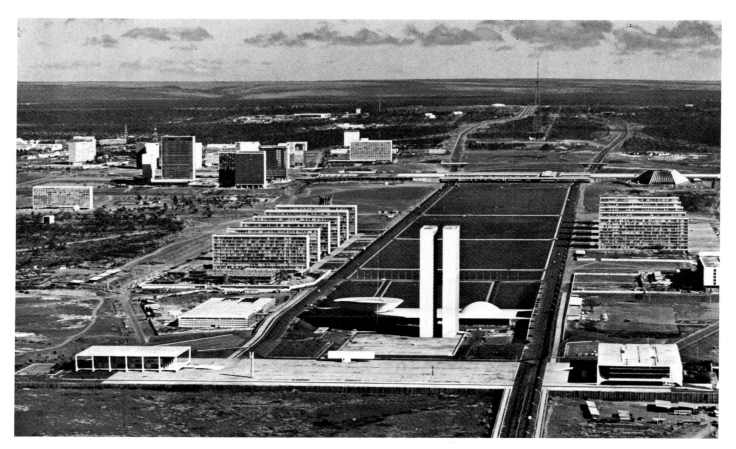

Lúcio Costa and Oscar Niemeyer. Brasilia. Airview. 1950–60. 481

meyer (b. 1901), Kenzo Tange (b. 1913), Paul Rudolph (b. 1918), James Stirling (b. 1926), and Richard Meier (b. 1934). In one way or another, they have been influenced by Le Corbusier, but given the many-sided aspects of his work, this can mean many things. Blending the master's concepts to their distinctive national heritages, their own well-formed impressions of recent history, their individual predilections, and the nature of the commissions that have come their way, they have produced extraordinarily individual styles. Outwardly their work seems eclectic, but this is deceptive. Rather than borrow surface elements from earlier designers, the neomoderns have bored deeper, examining the motivations for the new architecture and even censuring it for its failure to live up to advertised goals. Indeed, these architects have sought to perpetuate the revolution of the 1920s, not to revive it. So, if one speaks of the eclecticism of Rudolph or Stirling, it is a matter of philosophy and design and not a simple surface borrowing of formal device or a hubristic gesture.

Oscar Niemeyer is one of the more perplexing phenomena of the modern movement. While he was the earliest of Le Corbusier's gifted disciples, his work has proved with time to have been the least satisfactory. Yet this does not diminish Niemeyer's historical importance, for his apparent shortcomings have clearly indicated specific vulnerabilities inherent in the new architecture, especially its refractoriness when it comes to imitation or development forms passed from master to disciple. In the case of the Johnson-Mies van der Rohe relationship, the style was passed with deceptive ease, Johnson making it look much easier than it probably was. In the case of Niemeyer, the transplant was subject to a gradual deterioration. A hybrid of Le Corbusier's architecture had been created in Brazil by 1950, but the offshoot was not rugged. Part of the problem was Niemeyer's graphic virtuosity; the buildings often seemed not to develop, in real scale, the suggested, implied promises of the sketch. Indeed, Niemeyer, like all Latin American architects, found his work compromised by shoddy building procedures and by unstable, and then repressive, political regimes. Brasilia, the new capital city in the hinterland, built to a general plan of Lúcio Costa, another pioneer of the new architecture in Latin America, and with its official capitol buildings by Niemeyer, is one of the most telling indictments of the new architecture. Political reality decreed that it had to be designed and built in great haste, which accounts for many of the shortcomings. Niemeyer's concept for the capitol proper, two tall skyscrapers flanked by two low saucer domes, one inverted, containing the legislative branch, was a fairly straight adaptation from the earliest Radiant City sketches. So, before all else, the architect failed to realize he was working with an outmoded, largely irrelevant model. And finally, it becomes clear that in the capitol buildings as well as the courts and the executive mansion, Niemeyer has settled for simplistic formal concepts, tentative enrichments of the architecture of the heroic age, lacking in urgency and, if anything,

pl. 481

307

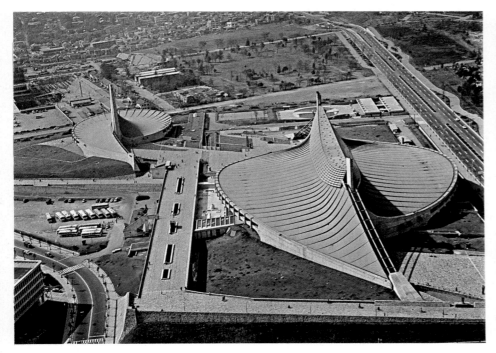

Kenzo Tange. Olympic Arenas, Tokyo. Airview.
1961—64. 482

Kenzo Tange. Town Hall, Kurashiki, Japan. Airview.
1958—60. 483

Kiyonori Kitutake. Civic Center, Miyakonojo, Japan.
1965—66. 484

rather precious and pretty, in the spirit of the fashionable American architecture of the late 1950s.

Kenzo Tange's early works are pale exercises in the international idiom and hardly prepare one for the originality of his concrete architecture beginning in the late 1950s. His robust constructive details, rugged surfaces, and striking forms were a welcome relief to the pervasive wanness of the modernist clichés then popular in the West; and the passage of two decades has not blunted the effect of such works as the Kagawa Prefecture, Takamatsu, 1955—58, or the Kurashiki Town Hall, 1958—60. Both contain minor solecisms and are jolting impositions upon the scale and materials of traditional Japanese architecture and towns. However, Tange's monumentality is free of the vulgarity of the commercial Western architecture then proliferating in Japan, an indication of the simultaneous high and low roads taken by modern architecture in its colonization of distant parts. Less obviously dependent upon the formulas of Le Corbusier's late style than others were, Tange draws upon certain elements of traditional indigenous composition, such as pronounced horizontal constructive elements and emphatically

pl. 483

varied surface textures, but has transformed these beyond casual recognition. His work of this period is eclectic in its use of elements from two cultures to make a distinctive architecture, one more Western than not.

Tange's subsequent work, which has included remarkable urban schemes for Tokyo and for the earthquake-ravaged Yugoslavian city of Skopje, has evolved along original lines that have taken him far beyond his sources in Le Corbusier. His urban schemes grow out of the Corbusian projects of the 1930s and later and are even more grandiose visions of a Radiant City. These urban schemes form an important, if symbolic or fictive, element in the contemporary tradition, and ultimately they will probably be as indicative of our day as were the unbuilt designs of Leonardo da Vinci, Boullée, and Ledoux of theirs. Hypothetical architecture is frequently dismissed by practitioners with unimpeachably radical, modernist credentials, but such speculation and experimentation—the testing of the frontiers and limits of planning and design—are, if anything, presently increasing in frequency and importance.

Tange's work has in fact been influenced by one of the more recent experimental, Utopian groups,

the Metabolists, established in 1960, one of whose members is Kyonori Kikutake. In 1964, Tange joined this group, whose ideas about urbanism and architecture revolve around a conviction that buildings should not be static but mutable, susceptible of transformation, addition, and amputation without compromise of the design as a whole. This updated futurism, akin to the sentiments of other radical groups of the 1960s, most notably Archigram in London, remains a kind of nirvana, though the ideal has given rise to certain forms in the recent works of Kikutake, Tange, and others which, although actually permanently anchored, give an illusion of movement. The tentlike, suspended structures by Tange for the Tokyo Olympics, 1961—64, and the accordionlike profile of Kikutake's Miyakonojo Civic Center, 1965—66, are instances of this trend, which has now led the major Japanese architects to the creation of distinctive, original buildings that continue to draw upon elements of their unique national tradition.

pl. 482

pl. 484

Of the American architects of the 1960s who instituted a re-evaluation of the formal and spatial elements of the earlier modernist tradition, Paul Rudolph is by far the most important. His early work manifested some of the uncertainty of the postwar decade, but by the early 1960s he had worked out a rich, virtually Baroque concrete style, less obviously dependent upon Le Corbusier than contemporary work in Japan but, rather, a more calculated mode influenced by the multiple strands of earlier radical architecture, including even certain images stemming from Wright. However, his distinctive, striated, brutal concrete surfaces invariably demand the closest comparison with the raw, *brut* concrete of Le Corbusier. The older architect had obtained his surfaces by allowing the imprint of the rough, crude formwork to remain uncovered; Rudolph secured his effect by more calculated means, deliberately roughening the surface or by employing a concrete block with

a rough, tubular form imbedded in the surface, which then textured the entire wall surface. Such effects were a deliberate reaction to the smooth, shiny exteriors of much American building of the day, and they were not immediately welcomed. Indeed, raw concrete still remains a material of dubious repute and respectability, even today, decades after its first appearance.

Rudolph's personal distillation of various sources into his characteristic mode came in the Yale University Art and Architecture Building, 1958—64, a work of considerable controversy in spite of, or perhaps even because of, its powerful external image and complex interior spaces, which, to many, seemed self-indulgent. Worse, some serious functional flaws that were not corrected exacerbated the building's notoriety. There was a deep antimonumental sentiment flowing at the time of its completion; feelings among students that questioned the very utility and relevance of architecture and its educational system were rife, and Rudolph had just produced the quintessential elite monument, devoid, to many eyes, of social responsibility or human values. During the student upheavals of the late 1960s, the building came to symbolize all that was felt to be unresponsive and negative in modern design, and, subsequently, a fire of mysterious origin gutted part of the interior in the spring of 1969, still one more curse on a curiously ill-starred structure. In spite of these calamities, the building survived, though with extensive alterations, and Rudolph has gone on to demonstrate the viability of his stylistic convictions in a series of dramatic projects, including one for mass housing along the New York waterfront that in its complex, cubic articulation of dwelling units was a notable relief to the customary shapes of commercial high-rise construction.

pl. 485

Of his actual buildings, one of the most typical is the campus of Southeastern Massachusetts

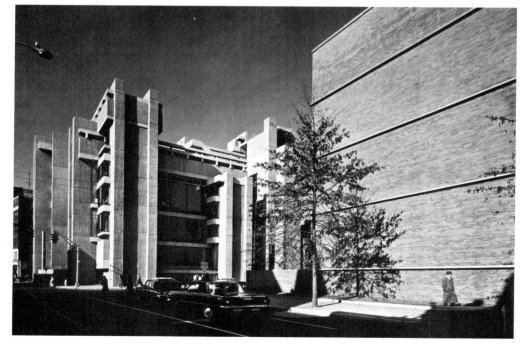

Paul Rudolph. Art and Architecture Building, Yale University, New Haven, Conn. 1958–64. 485

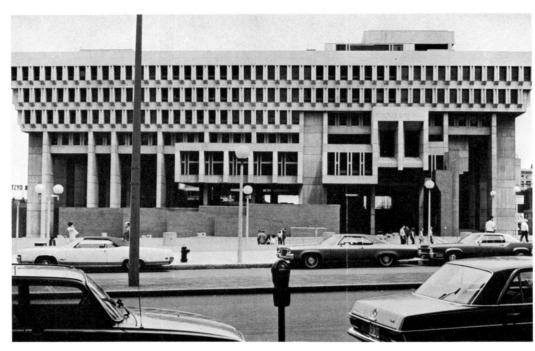

University, North Dartmouth, begun in 1963, a complex that is dramatic in ensemble and detail, even though Rudolph was relieved of his role as designer for a period of time during construction. Here the architect's skill at picturesque composition linking the buildings to each other and to the landscaped exterior spaces is manifest. With vast overhanging bays dominating the exterior, Rudolph establishes a characteristic, monumental silhouette employing a time-hallowed formula out of the International Style, but with a constructive sculptural emphasis that is distinctively his. The major interior spaces—complex galleried stair halls serving as lounges—are further indications of his inventiveness. Indeed, this characteristic architecture of concrete beams and slabs with sheets of glass and walls of concrete block is presently being imitated on a large scale by many of the successful commercial firms in the United States, especially in buildings for educational institutions or governmental authorities. The popular breakthrough for this rugged, sculpturesque style came with the construction of the new Boston City Hall, 1964–69, from a competition-winning project of 1962 by Kallmann, McKinnell and Knowles, a design that owed its characteristic top-heavy shape to a Le Corbusier design of the period, the Monastery of La Tourette, near Lyons. Of course, all of these adaptations of the older architect's imagery have tended to reduce his impulsive forms into more calculated, rationalized, and systematic forms—yet, ironically, this does not seem to distract from the expressive effectiveness of the derivative buildings. Such extravagant-seeming contemporary monuments contrast with the shallow, servile orthodoxy of the standard urban office or apartment tower. Both types have now evolved well away from their prototypes, and both architectural trends in the United States now seem to enjoy an entrenched status.

pl. 486

As we have seen, American architecture was drastically Europeanized about 1950, not by sudden infusion of new designers and new ideas from the Continent but, rather, by a spontaneous adoption of limited aspects of an older modernism. Now, a quarter century later, a reverse flow has been accomplished, and European architecture now seems to have become Americanized, at least in its more public manifestations. In this interval, English architecture has enjoyed a very special role, and many of its architects have played the parts of gadflies in the development of recent architecture. Its architectural culture seems more profound; its magazines maintain a high level of literacy, perceptiveness, and critical and historical insight. Moreover, its writers and correspondents have been eager and willing to engage in controversy and to expand their intellectual horizons beyond the conventional limits of architecture and urbanism. Significantly, for nearly two decades English designers have been earnestly sought out as visiting critics and lecturers in American schools, creating a vast movement of ideas across the Atlantic.

English architects were initially Americanized not through architectural channels but through a much broader and deeper curiosity concerning American culture as a whole. New Brutalism, the rallying cry that could not decide whether it was an ethic or an esthetic, was, in fact, nurtured by the same set of circumstances and many of the same sources that were simultaneously giving birth to Pop in British painting and graphics. The Americanophile attitudes current in England in the pre-Beatles era were highly skeptical of mainstream American modernism in architecture but were fascinated by the products of industry, especially the recent advances in auto and appliance design that Britain and the Continent had missed because of the dismal years of economic stagna-

tion following the war. They also followed the contents of slick magazines—ads as much as photo and text copy—and were influenced by the seamier pulp trash, "girlie" magazines, and the like. The New Brutalists were interested in overturning the rather polite modernism of postwar English architecture, and they were not interested in its slick American counterpart. Instinctively, they went for the vulgar, tough forms and were tempted by any kind of model that had a low degree of finish, and, if it had a lowly function to begin with, all the better. Intransigence and iconoclastic attitudes were more important for the New Brutalists than buildings themselves or even a coherent theory. Their effective tactics were a little those of a street gang, which, as it grew up, became a bit pompous, losing its original fresh, brash quality. They bequeathed several important features to British architecture as it came to be practiced in the 1960s: a knowledge and love of the heroic tradition of modernism dating from the 1920s, something they discovered only rather late in their passage, and a continuing love of architectural polemic and exciting adversary journalism unlike that of any other country.

The first of these predilections has given us a series of architects, of whom James Stirling is by far the most dramatic example—his work seeming to rejoin the innovating architecture of the 1920s across a twenty-year design vacuum—and a group of boisterous Utopians, the experimental architects of Archigram, Peter Cook, Dennis Crampton, Warren Chalk, Ron Herron, David Greene, and Michael Webb, a rock-grouplike formation of young architects who published an occasional underground magazine that soon gained international renown. In effect, Archigram took over the graphics of the Pop movement and fed them into Utopian projects that were the belated post-World War II explosion of imaginative architecture.

In the midst of this turmoil, Stirling, who had been practicing in partnership with James Gowan since the mid-1950s, produced a building, the Engineering Laboratories, Leicester University, 1959—63, which achieved instant international recognition as a landmark design. In the early 1950s, Stirling briefly had been in the Brutalist group, but his own interests, not seriously different perhaps, led him apart from the others. He had mixed feelings about the new, rough, less precise forms of Le Corbusier and a greater admiration for the exactness and planar character of the early work; he admired architecture of the nineteenth-century functional, industrial tradition: docks, warehouses, breweries, factories, and the like; and he had a particular passion for glass as a constructive material—not in any way out of step with twentieth-century traditions but, in any case, a new glass architecture, expanding the various concepts of Taut, Mies, Johnson, and the American high-rise architects. Stirling's architecture is very much that of an intellectual but very different in tone and intensity from the *intellectualisms*

pl. 487

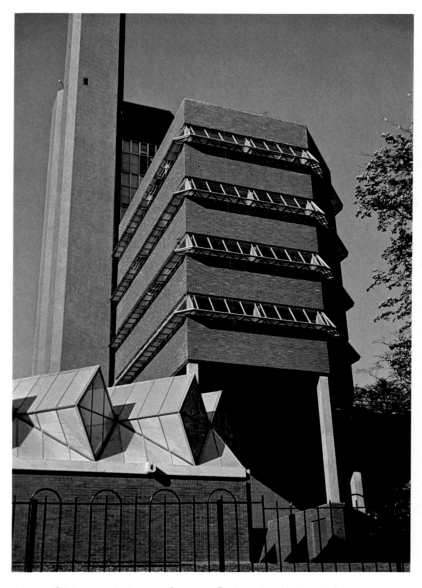

James Stirling and James Gowan. Engineering Laboratories, Leicester University, England. 1959–63. 487

of Philip Johnson. It is calculated in its organization and relation of parts—an inversion of the apparent spontaneity of Le Corbusier—full of difficult, expressive junctures, and the exact opposite of the more seamless designs of his established contemporaries who sought to draw everything together in an inexorable whole. Stirling's work may be complex, but it is not gratuitously complicated, and Leicester is an example of the clearly articulated working together of a multifunctioned structure. In its red brick, tile, metal, glass, and exposed concrete, various incompatible strands of the modern and protomodern tradition are spun together. Leicester is an integrative monument, implying a much greater possibility of unity in contemporary design than has appeared in decades, and this combination comes about without compromise in a building that also contains a powerful, iconic image.

If Stirling is a neomodern, he is also, if with a certain irony, a neo-Victorian, an artist of a Balzacian appetite when it comes to appreciating earlier styles. At the same time, he possesses prodigious powers of invention, and his subsequent

311

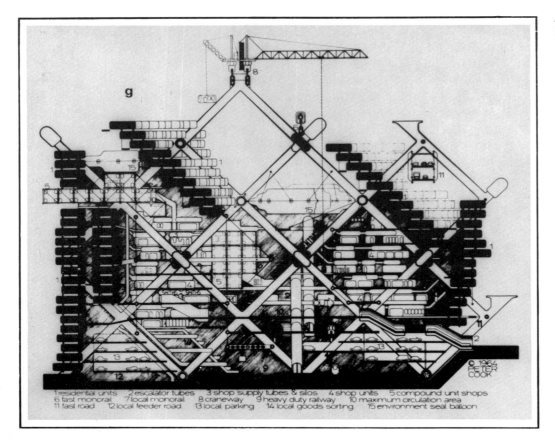

1 residential units 2 escalator tubes 3 shop supply tubes & silos 4 shop units 5 compound unit shops
6 fast monorail 7 local monorail 8 craneway 9 heavy duty railway 10 maximum circulation area
11 fast road 12 local feeder road 13 local parking 14 local goods sorting 15 environment seal balloon

work demonstrates that Leicester was not a momentary burning flame. The same materials, building technology, and imagery were used in buildings at Cambridge and Oxford; and at St. Andrews University, Scotland, he built a group of student residences using a precast concrete technology, the individual elements bearing a diagonal herringbone pattern that gives a texture as uniquely personal to Stirling's work as were the striations to Rudolph's concrete surfaces. Along with Kahn, Stirling is perhaps the most conspicuous inventor of new forms in the architecture of the last twenty-five years. Moreover, his work is admired by critics of many colors.

Although Stirling's work was beholden to many facets of earlier architecture, his flexings of form were in line with that youth movement Archigram, which could find little else in contemporary architecture to admire. Archigram developed images out of science fiction and related comics, and was willing to engage in an experimental, futurist architectural design at the expense of actual building. Crusaders and missionaries, its members lectured and taught everywhere, organized conferences of counterculture architects, and continued to publish. Their activity was closely linked to the various radical and youth activities of the pl. 488 1960s; their "plug-in" architecture was that of the turned-on, swinging London generation, English Pop painters, Carnaby Street fashions, and the pop music movement, which drew together such unlikely strands as American rhythm-and-blues and British turn-of-the-century music-hall into such novel hybrids as the Rolling Stones and the Beatles and, ultimately, such failed Utopian enter-

prises as Apple. Its forms were drawn from space

technology and futuristic speculation; ranging from hardware to software, it was capable of several varieties of anti-architecture, dwelling bubbles, walking cities, and other fantasies.

Godfather of Archigram and guru of the counterculture designers, alternative-architecture protagonists, and Utopian hopefuls of all sorts is the American Richard Buckminster Fuller (b. 1895), a man for whom an adequate professional title has yet to be invented. He is the proponent of a comprehensive design science, recently known as the World Game. Best known as the inventor of the geodesic dome, an approximate sphere made up of a rigid assembly of three-dimensional triangles and related forms, he has spent his career in seeking ways to make technology work to maximum efficiency in order to improve the human environment, and this vast effort has brought him into close relationship with the history and practice of architecture. Another Leonardesque figure in his universality of interests, he might better be compared with Euclid, Aristotle, Archimedes, and a slew of medieval scholastics than to any architects or artists, past or present. Delighting in his maverick role, he is that necessary generalist in an age of specialization and information explosions. His influence upon contemporary architecture has been more invisible than visible. Although the inventor of several ideas for industrialized dwellings, building components, and the like, it has been his ideas that have counted the most. Nonetheless, his most characteristic form, the geodesic dome—one of the most spectacular being the one built as the United States Pavilion at Expo' 67, Montreal—is pl. 489 worth special mention in a text primarily devoted to built forms.

The dome is, of course one of the most ancient of architectural forms, taking on sacred and cosmic meanings from remote antiquity and being re-employed in the Renaissance as the only proper capstone of the ideal building. Of twentieth-century builders who have employed this form, only one besides Fuller, and an engineer at that, Pier Luigi Nervi, has used it with grace and conviction in our time, as can be seen in his concrete arena for the Rome Olympic Games, 1956—57. Fuller's domes tend to have very special applications—as exhibition pavilions, as conservatories, as shelters for fragile electronic radar equipment, and even decoratively as nonenclosing space-frames. For the rest, his principles have been adopted by the counterculture—by the publishers of *Domebook* and *The Whole Earth Catalog*—as dwellings for those moving out and away from the rigors and horrors of late machine-age cities and their suburbs. The geodesic dome has proved an ideal, and perhaps even practical, house type for alternate living in remote areas, as a do-it-yourself architecture which also, through its distinctive form, is symbolic of a rejection of many contemporary values. Fuller's notions concerning the complete integration of energy and natural resources to construct a livable world form one of the most convincing of Utopian visions, one that just might be realizable. Remarkably, his appeal is to a wide, otherwise incompatible, audience embracing the angry cultural dropout, the anxious architectural student, the suburban homesteader, and even certain autocrats of the Third World. However, Fuller's ideas have had little or no response from the architectural profession as a whole, where the habits and traditions of generations have permitted a stylistic revolution in the twentieth century but have not been able to tolerate so sweeping a change in patterns of thought and technique as is implied in the theories of the inventor of the geodesic dome. The notion of living in a domical house, or of covering our cities with colossal mileswide domes, as Fuller proposed for New York, 1960, in order to regulate and improve the urban microclimate, strikes us initially as eccentric and then as preposterous, impractical, even fanatical, mad. Yet there is a more immediate, menacing madness in the form of our city as it is presently constituted: an organism in precipitous physical and social decline, in spite of, and most

pl. 491

pl. 490

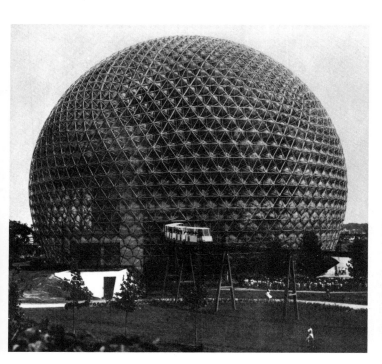

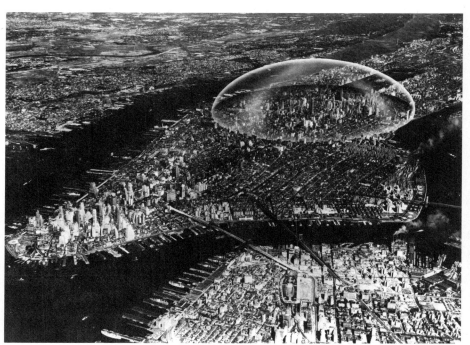

Richard Buckminster Fuller. United States Pavilion, Expo' 67, Montreal. 489

Richard Buckminster Fuller. Project for a Manhattan Dome. 1960. 490

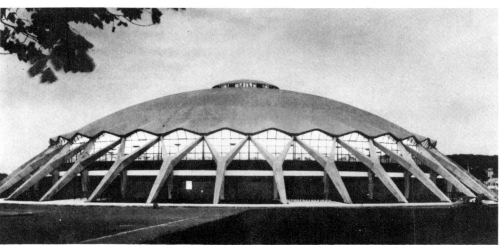

Pier Luigi Nervi and Annibale Vitellozzi. Olympic Sports Hall, Rome. 1956–57. 491

313

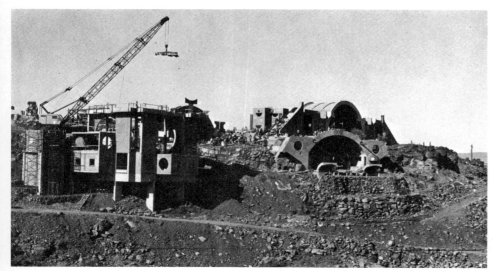

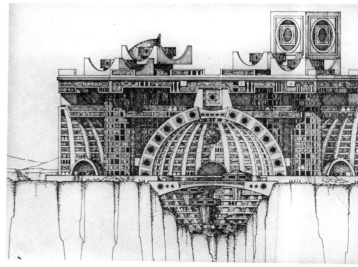

Paolo Soleri. "Arcosanti," a prototype Arcology for 3,000 people, under construction near Cosanti, Ariz., since 1970. 492

Paolo Soleri. "Arcosanti." Elevation. 493

likely because of, the vast resources that have been squandered in building motivated by speculation rather than planning.

Under such harrowing circumstances, it seems almost inconceivable that an architect of the late twentieth century would actually venture into the design and building of a comprehensive settlement that might serve as an urban alternative, but this is exactly the goal of the Italian-born architect Paolo Soleri (b. 1919), who has been active in the American Southwest for some three decades. After working with Wright at Taliesin West, he struck out on his own, building a partially subterranean desert house with movable dome in 1950. During the next decade, he experimented with concrete forms at his own studio and residence at Scottsdale, Arizona, and simultaneously developed schemes for vast megastructures, which first took the form of sculpturesque models for bridges of no particular function and then developed into numerous sketches for mesa cities. Working in isolation and in a landscape still offering vast wilderness, he developed a theory of high-density settlements, cities contained within one vast building of expressive structure and form. These arcologies

(architecture/ecology) were published in 1969 in a book, *Arcology: The City in the Image of Man*, and, simultaneously, his drawings and models were exhibited in museums in New York and elsewhere, eliciting great admiration. However, this seemed to be but one more endeavor destined to remain fantastic, exhibition-hall architecture—dream cities whose idea alone somehow would have to be sufficient to relieve the pressures and frustrations of real-city life.

Whereas Wright's prescription for remedying urban congestion was the decentralization of Broadacre City, Soleri's remedy is to meet congestion face to face with a scheme for even greater density, thus insuring the protection or, if necessary, the reclamation of the landscape as open space. Though his formal means of expression are totally different, the conceptual underpinnings of his vision are virtually identical to those of the Radiant City: high population concentration to allow for landscape to intervene between the buildings. Soleri's forms are futuristic, suggestive of the lunar and planetary cities of science fiction, with their complex, closed mechanical life-support systems; but they also owe something to such ar-

pl. 492, 4

Moshe Safdi. Habitat, Expo' 67, Montreal. 494

cane sources as the endless, theatrical, spatial fantasies of Piranesi and to the cliff dwellings and other remains of pre-Columbian Indian cultures. Nor are Soleri's visions mere fantasies; for the past few years he has been engaged in the construction of an arcology on a site near Prescott, Arizona.

Other architects were engaged in work on megastructures in the 1960s, among them Paul Rudolph, whose projects constitute some of his most important works. The Israeli architect Moshe Safdi (b. 1938), naturally drawn to the problem of human collectives through his upbringing on a kibbutz, was the author of Habitat, a megastructure-like apartment complex, which was carried out as a housing exhibit for Montreal's Expo'67. Overambitious ideas concerning the prefabrication of the individually articulated dwelling units—stacked above, not directly on top of each other in order to insure private open deck space for each unit—secured only a qualified success for this scheme, and a more efficiently structured Habitat project for New York did not elicit the support necessary for construction. Safdi's ideas for clearly articulated multiple dwellings are less idiosyncratic than Soleri's; they are meant to meld into the fabric of the existing city rather than replace it outright, and the geometry of Habitat is more recognizably a part of the modern idiom's formal mainstream. On a scale paralleling that of Soleri's arcology is Yona Friedman's Spatial City scheme, which proposes a megastructural space-frame platform erected over the roofs of the city of Paris, providing a three-dimensional building terrain, or hive, for new dwelling units, which sacrifices a minimum of existing structures to make way for supports, elevators, and the necessary service conduits. The likelihood of this sublime idea finding its way into even partial realization in the foreseeable future is remote, and this is indicative of the increasing split now occurring in present-day architectural design between imagination and reality. Today's architectural visions, which, among other things, are proposals meant to provide a substitute or remedy for the ills of the present urban fabric, seem beyond the reach of the now-limited resources of an increasingly demoralized contemporary civilization. Such vast schemes as London's Barbican or Paris's Défense quarter seem to be the limit of constructive possibility so far as contemporary urban planning is concerned. Shiny and new as they may be, they are only the belated, tawdry realizations of earlier, outmoded hopes for the revitalization of the contemporary city. Much the same can be said of the less controlled, more anarchic spread of the skyscraper in Lower Manhattan and of the towers now rising from Stockholm to Milan, in Albany, Chicago, Atlanta, Houston, and San Francisco.

Partially filling the gap between the vast and seemingly unrealizable schemes of much avant-garde, experimental architecture of the 1960s and 1970s and the formula-based commercialism of actual building have been the ideas and rare constructions of Robert Venturi (b. 1925), one of the

Las Vegas "Strip." Airview. 495

most original contributors of the past two decades. Nominally an offshoot of the so-called Philadelphia school, a group that took its inspiration from the teaching and works of Louis Kahn, Venturi's architecture has actually veered off in an ironic, antiformalist direction. He has been the champion of the ordinary in a period that has yearned after the fanciful, the protagonist of a rather homely, plain style of building in a period that has seen the larger firms turn out increasingly artful and clever designs. The term antimodern is not inappropriate to describe many of Venturi's innovative ideas, which have attracted wide support over the past decade as well as substantial controversy, but it only describes the negative side of his contribution, concealing the fact that he, like certain innovators of the early twentieth century, wants to get back to some simple essentials of design. Historically, Venturi might be likened to Adolf Loos: he has been a scourge in the flank of post-International Style esthetics in much the same way in which Loos was the enemy of *fin-de-siècle* Art Nouveau decorative excrescences. Venturi's condemnation of the mindless repetition of certain modernist clichés does not lead to the form-fetching results of Archigram or even of Stirling or Rudolph but, rather, to an architecture of calculated naiveté based upon vernacular building types astutely seasoned with stylish, sometimes witty, formal and even remotely historical details. The resulting idiom has something of the flavor of contemporary Pop Art, and the forms are sometimes similar to those of recent abstract painting, especially the shaped canvases of Frank Stella.

Venturi's contribution to the contemporary architectural debate is not limited to his own laconic buildings, which regrettably remain few in number, but extends to his interest in the most common, vulgar kinds of architecture spawned by the automobile civilization. His publication *Learning* 315

Robert Venturi. Venturi House (now owned by Mr. and Mrs. Thomas Hughes), Chestnut Hill, Pa. 1962.　　497

Charles Moore. Condominiums, Sea Ranch, Calif. 1964–66.　496

from Las Vegas, 1972, prepared in collaboration with Denise Scott-Brown and Stephen Izenour, is one of the major documents of the past decade. Venturi has fostered an esthetic that seems to offer a new morality, one which asks architects to abandon certain of their pretenses in the creation of form. In particular, he has singled out Rudolph for special criticism and even denunciation in his writings, claiming that a gestural architecture with so strong an imprint of modern style is in fact alien to the life and experience of those for whom it is built. Venturi has correctly perceived that, for the most part, the contemporary architectural tradition has not penetrated very deeply into the collective sensibilities and awarenesses of modern man. His realism in facing up to the the banal misappropriation of new forms in hyped-up merchandising architecture, most sublimely seen in pl. 495　the now-famous casinos and hotels of Las Vegas, with their towering signs and extensive parking lots often overwhelming the actual buildings, is a striking breakthrough, expanding the range of modernist esthetics. Nonetheless, if this is one architecture that Venturi admires, it is not what he himself designs or builds. His domestic projects pl. 497　have a calm, patrician elegance that belies their vulgar sources in contemporary tract or ranch-house architecture; his restating of the ordinary Levittown motif is "complex and contradictory," with offhand references to various cultures and more than a passing reference to the shingled cottages of American resorts and suburbs of the late nineteenth-century.

One of Venturi's roles has been to show the way toward a defusing of the tensions that have grown up and continue between progressive architecture and its intended public. It is thus all the more regrettable that Venturi's contribution is so little known outside the architectural world where its natural audience would seem to reside, and dou-

bly so since he has isolated himself from a considerable segment of progressive design by attacking certain of his peers, while extending ironic admiration to some disreputable, if vulgarly fascinating, species of modern design, Venturi has thus laid grounds for serious misunderstandings and has sounded an unnecessarily divisive note in the midst of the architectural vanguard.

Venturi's populism and realism is strongly seconded by the work of Charles Moore (b. 1925), another strong-minded, original architect who early developed a skepticism for the forms and myths of the heroic modernist tradition. Basically a product of the San Francisco Bay school of designers who had preserved an admiration for the rustic, Romantic architecture of Bernard Maybeck and the Greene brothers during the 1930s when the International Style was being introduced in southern California, Moore has been strengthened, rather than limited, by this rather independent heritage. The builder of several rough-finished houses in the 1960s, and of the Sea Ranch Condominiums 1964—66, in the partner-　pl. 496 ship of Moore, Lyndon, Turnbull and Whitaker, he became chairman of the Department of Architecture at Yale in 1964, succeeding Paul Rudolph. It would be hard to imagine a more drastic change. Though by no means an architect who eschews order or form, Moore was not merely skeptical of the sculptural efflorescence of the post-International Style designers but considered that line of development to be irresponsible. Although he has been somewhat reluctant to commit himself to a program of any sort (indeed, his permissive instincts were an outstanding virtue when at the helm of an architectural school during the iconoclastic, disturbed late 1960s), it is clear from his work that he is as antimodern in his forms as is Venturi, "modern" being here understood as a commitment to the images of the 1920s and their

lineal descendents down to the present day. Yet his houses are among the most original designs to have appeared in fifty years, and they presage even more variations and reactions to even the healthier lines of neomodernist architecture. His plans and shapes are as busy, varied, and contradictory as the altogether different ones of James Stirling, but they seem to aim closer to a populist vernacular in spirit, along the lines of the works and ideals of Venturi.

It would be strange, indeed, if this antimodern trend were not accompanied by a parallel movement with an almost diametrically opposed intention, namely the virtual revival of the forms of the 1920s, not for nostalgic or sentimental reasons but for hardheaded analytical ones. The houses of the past decade by the self-styled New York school, consisting of Richard Meier, Peter Eisenman, Michael Graves, Charles Gwathmey, and John Hejduk, are a reincarnation of Purism, although in their justificatory writings it goes under another name. All strive for elementary geometry in their works, but this does not become a least common denominator, but, rather, the base for distinct personal expression in their work. Theoretically explained by semiotics and other fashionable intellectual pastimes, their intricate, mannered compositions are reminiscent of the well-publicized revival of Palladianism in the eighteenth-century English architecture of Lord Burlington and his school. The houses of the New York school are aristocratic, if indeed that word has any contemporary meaning, refined, cultured, and supersophisticated. Certain of the accomplished fantasies of the 1920s—the roof terrace, see-through forms, and the like—all modernist elements that have never been integrated into the vernacular houses of our day, are here willfully brought back and underscored.

The designs of the New York school are but the last of the contradictions to appear in the complex narrative of recent architecture. About the only thing that can be said for certain is that they will not be the last. By the late 1930s it was possible for a number of historians to have written satisfactory accounts of the new architecture, which, if they were not always exhaustive or free of partisanship, were nonetheless adequately representative of recent events. Until the early 1950s, the same would have been the case. While it would have been an overstatement to say that there was but one modern architecture in those days, it at least seemed as if the differences were less important than the common issues and allegiances. Over the last twenty-five years, this singularity was first frayed and then thoroughly unraveled. The new architecture is no longer new, and indeed exists only as one of several inventive or radical alternatives. In the meantime, the forms of the earlier modern masters have been rounded off, simplified, and vulgarized into the Pop building culture of every country in the world. A once-youthful movement has passed through its middle age with the normal toll of beliefs and convictions, and, from all indications, it will henceforth have to share the limelight with a number of new contenders. It will go on, but changed now out of easy recognition.

pl. 498

Richard Meier. Weinstein House. Old Westbury, N.Y. 1971.

498

THE DEMATERIALIZED OBJECT: ART OF TECHNOLOGY, ENVIRONMENT AND IDEA

In the late 1960s, art in America and throughout the world began to expand its range of possibilities to unforeseen limits. The ideas of a more flexible art seemed broad enough to include vast Earthworks projects, literally covering miles of the Nevada desert, videotape events, a series of photographs of parking lots or cornflakes scattered in an open urban area. Art could be a computerized drawing of a nude, or a web of laser beams covering three city blocks. It could be grease, dirt, leaves, or ice blocks melting on a gallery floor, inert gas released in the landscape. It could be an artist engaging in sexual activity under floorboards on which the spectators walk, to the amplified sounds of heavy breathing, or it could be imperceptible art, involving merely verbal statements and print. All of these kinds of art, whether modestly understated or spectacular and challenging, have their stylistic labels—Land Art, Conceptual Art, performance art, body art, process art. What unites them is their dematerialized character, and the drastic change has been recognized under numerous serviceable rubrics, among them post-object art and post-studio art.

The change in the character of the work of art and in the way we regard its ultimate value is paralleled by the change in the structure of the art world. With the flowering of Conceptual Art and related contemporary movements, art today has become global, since it requires so little time or energy to transport entire exhibitions of statements by the artist, videotapes, photographs, and the like anywhere in the world. Non-object art is thoroughly international in character. About 1967, in fact, it sprang up independently in several countries at the same time. It not only needs no exhibition center, since it can exist simultaneously in various places, but most of its artists are extremely articulate and need not await critical approval to sanction or make the work exportable, especially since so much of the work is already translated into a verbal medium.

With the growing distaste for the object, there have arisen new ideas of art patronage, collecting, and support. A new breed of art dealer has appeared who prefers to function between the artist and the public more as a source of information than as merchant, or purveyor of objects. The Earthworks and many of the other projects they commission, and re-create after the fact through photographic exhibitions, are essentially uncollectible. Certainly there is no place for them in the traditional museum. The new avant-garde, its dealers and patrons, have all reacted violently to the commercialism of the art world of the 1960s, when Op and Pop Art were fashionable overnight successes and Jackson Pollock's paintings began to fetch hundreds of thousands of dollars. It was in this atmosphere of inflated prices and falsified values that the Conceptual artist Joseph Kosuth demanded that art no longer be considered, or treated as a commodity, but find support in society as a self-justifying act of inquiry of intrinsic value to the human spirit and to our scheme of civilized values. While this sort of idealism and protest on the part of the avant-garde is not uncommon, only in recent years has it been confirmed by the radical change in the nature of the artwork itself.

Conceptual and environmental art developed directly from structurist and Minimal sculpture of the 1960s. By the close of that decade, a remarkable variety of new sculpture and three-dimensional forms challenged the dominance of painting. Sculpture had so extended traditional definitions of medium that it could, with validity, be discussed as dust, literature, accident, nature, scientific illustration, theater, dance, or pedagogy. Increasingly, the articulated volumes or the physical presence traditionally associated with the sculpture object was abandoned. Instead, it came to be regarded as a non-object: a process in time, a performance, an idea, or an action rather than an articulated and tangible physical structure.

The rapidity of artistic change in the 1960s was unusual even in a period accustomed to the swift dispersal of outmoded styles into inglorious obsolescence. The accelerated pace of innovation may have reflected the sense, at large, of social despair and an impotence about solving critical human

Chryssa. *Ampersand III*. 1965. Neon lights in Plexiglas, 30¼" h. The Harry N. Abrams Family Collection, New York. 499

and environmental problems. There were wide-spread doubts about society's capacity to survive in the increasingly poisoned atmosphere of planet earth, and this new mood of global pessimism on our environmental prospects most likely contributed to artistic innovation and the uninhibited risk taking apparent on all sides.

Among the major sculpture groupings in the first years of the 1960s were assemblage and its extension in environmental sculpture in the work of Louise Nevelson, Edward Kienholz, John Chamberlain, and others. Later, one of the most impressive younger talents identified with junk sculpture, who also made a transition to more purified and reductive structurist modes, was Mark di Suvero (b. 1933). He created hulking, open forms in rough-hewn planks, beams, and steel rods, balanced precariously in asymmetrical compositions. Di Suvero inserted objects—chairs, buckets, chains, hoops—brute and untransformed, into daring systems of equilibrium with minimal alterations in their original physical character. His sculptures later expanded in scale so that their impact was architectural. The sense of extreme gesture and effort links him to the past, but his formal sophistication anticipates the new sculpture of an anti-Expressionist stance.

pl. 500

In the middle of the decade, an original stylistic synthesis emerged: Minimal Art. Although the term can legitimately describe examples of the shaped canvas, monochrome painting, and a drastically simplified, "cool" abstract pictorial art, it was identified most dramatically with the severely geometric structures that attained general public

Dan Flavin. *A Primary Structure*. 1964. Red, yellow, and blue fluorescent lights, 2×4′. Collection the artist. 501

recognition in the exhibition Primary Structures, organized at New York's Jewish Museum in the spring of 1966. The exhibition, in fact, demonstrated a new common sensibility and carried the weight of a visual manifesto for the emerging new esthetic viewpoint.

The museum exhibition had been preceded by a number of influential one-man shows in New York by Don Judd (b. 1928), Robert Morris (b. 1931), and Dan Flavin (b. 1933) which already provided abundant evidence that a new type of easily perceived, yet mentally complex, geometric form—symmetrical, boxlike, set out in modular units, unadorned—had begun to comprise a new collective style. Walter de Maria and Morris made what could be described as Minimal Art as early as 1961, some years before the term itself was invented. Tony Smith's first polyhedrons in painted plywood mock-ups preceded even these primitive ventures, although he was as unknown to the young structurists as they were unfamiliar to him. The new reductive, impersonal trend in sculpture appeared officially in the first museum show devoted to art of this character, the Black, White and Gray exhibition organized by Sam Wagstaff at the Wadsworth Atheneum in Hartford. That was followed in early 1965 by the exhibition Shape and Structure, assembled at the Tibor de Nagy Gallery in New York by Frank Stella and Henry Geldzahler. Then, at the Jewish Museum the following year, Judd's standardized, repeated, boxy galvanized iron and aluminum permutations in colorful motorcycle paint, Morris's identical L-shaped volumes in gray-painted plywood, and Bladen's heroic and personal drama of untitled, thrice-repeated rectangular volumes in black-painted plywood and metal were singled out by critics as the enigmatic ciphers of a new

pl. 501

Mark di Suvero. *For Lady Day*. 1968–69. Steel, 54×40×35′. Park Forest South Cultural Foundation, Ill. Gift of Lewis Manilow. 500

Bernard Rosenthal. *5 in 1*. 1974. Weathering steel, 30' h. Police Plaza, New York. Collection The City of New York. 502

Larry Bell. Untitled. 1969. Vacuum-plated, mineral-coated glass with metal binding, 20×20×20". Pace Gallery, New York. 503

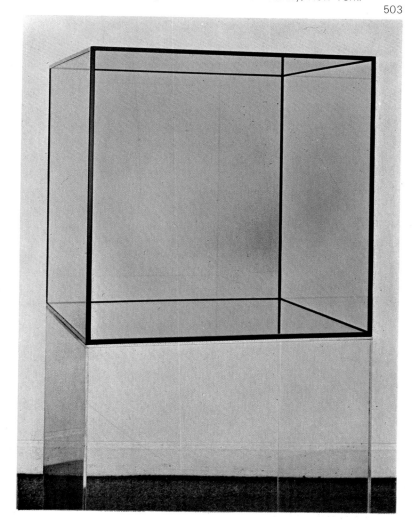

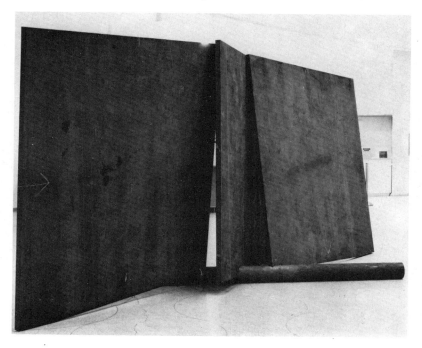

Richard Serra. *Moe*. 1971. Hot rolled steel, 8×20×12'. Collection Leonard Monheim, Aachen, Germany. 504

artistic movement. The suppression of the hand of the artist, since most of the forms displayed were fabricated in industrial shops from the artist's specifications, the addiction to architectural scale, and the impassive character of the structures all contributed to an impression of heroic scale, a deliberate vacuous content, and a certain hermeticism.

The best early rationale for Minimalism, with its rejection of pictorial illusionism and trust in real space, came from one of its leading exponents, Judd, who wrote some prescient art criticism in the 1960s pinpointing the esthetic issues involved. Describing his own practice, he wrote: "Three dimensions are real space. That gets rid of the problem of illusionism and of literal space, space in and around marks and colors—which is riddance of one of the most salient and most objectionable relics of European art. The several limits of painting are no longer present. A work can be as powerful as it can be thought to be. Actual space is intrinsically more powerful and specific than paint on a flat surface."[1]

It was quite clear that the new, anonymous structurist art engaged the most forceful new talents in America and Europe. Exciting possibilities of invention were dramatically opened up, ranging from the spatial power of Robert Grosvenor's immense, cantilevered beams; the compact monumental Cor-Ten steel disks, poised in precarious equilibrium, of Bernard Rosenthal (b. 1914); to the precious refinement of the more intimately scaled transparent boxes in fragile coated optical glass of Larry Bell (b. 1939). Like any genuine new movement worthy of the name, structurist sculpture offered its own set of prece-

pl. 502

pl. 503

321

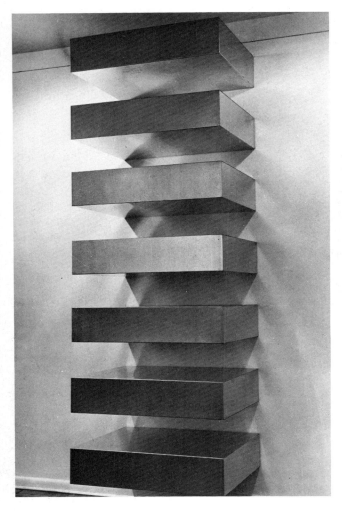

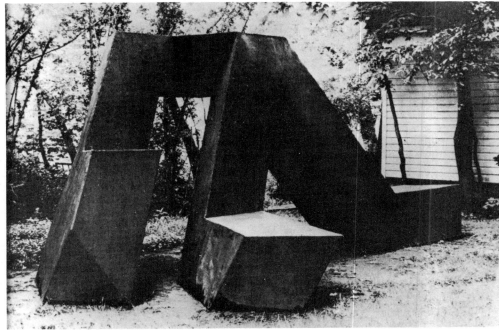

Tony Smith. *Willy*. 1962. Full-scale, painted plywood mock-up for steel sculpture, 7'8"×18'×12'. 506

Don Judd. Untitled. 1965. Galvanized iron, 11'3" h.; 7 boxes, each 9×40×31", at 9" intervals. Collection Henry Geldzahler, New York. 505

dents: the classical simplicities of the architect-sculptor Tony Smith, the monumental Cubi series of David Smith, and the elegant polychrome forms of the Englishman Anthony Caro.

Perhaps the most important pioneer of the new sensibility in America was Tony Smith (b. 1912), a member in good standing of the Abstract Expressionist community, though best known in his early years as a visionary architect and occasional painter. He did not make his first modular steel sculptures until 1962, but their impassive physical bulk and intense romantic presence almost instantly erased the frivolous illusionism of the recent sculpture and decisively established new pl. 506 directions for three-dimensional construction. Tony Smith evolved a sculptural program based on rather complicated organic geometry, derived from many sources, including Frank Lloyd Wright, an interest in topology and crystallography, the language inventions and puns of James Joyce, and some novel ideas about architectural sculpture. Smith wished to create new monuments which could coexist with such modern landmarks as massive oil tanks, smokestacks, airport runways, parking lots, and other constructions on a vast scale in the industrial landscape. Like his friend Barnett Newman, he felt disdain for prestigious historic painting and sculpture and preferred the colossal architectural schemes of an-322 tiquity, from the pyramids to Machu Picchu. (He

and Newman had conceived of rudimentary "earthworks" projects in correspondence and private journal entries two decades before the movement was initiated in America, inspired by the Indian mounds they observed in Ohio and the Midwest.) At some point, the ruined grandeur of ancient civilizations made contact with the man-made structures of the modern industrial world, and a new kind of monumental sculpture was born.

Besides Tony Smith and the more ambiguous Anthony Caro, the two leading Minimalist sculptors were Don Judd and Robert Morris. By the mid-1960s, Judd was fabricating metal forms either of a blocky, unitary character or in modular, repetitive serial schemes, reflecting, to some pl. 505 degree, the influential anti-Cubist compositions of Frank Stella. Though Judd often used neutral, unadorned industrial surfaces, in more recent years he has experimented with a new kind of sensuousness based on fluorescent commercial colors. The asceticism of these elementary boxlike forms was countered by the play of homogeneous colored surfaces as Judd continued to explore a wide range of seductive expressive possibilities in new industrial materials, techniques, and chroma. The use of such varied materials as aluminum, cold-rolled steel, galvanized iron, and brass gives his different sculptural objects a sensuous fullness to match their formal rigor.

Morris's approach to three-dimensional form was far more cerebral. By the mid-1960s he, too, worked in structures devoid of detail and basic geometric shape, and obsessive in their emphasis on wholeness. However, he also showed a sense of irony and a game-playing cunning closer in spirit to Duchamp than to the historical, formal Purists. His first one-man show in New York in 1963 consisted of lead and Sculpmetal reliefs with imagery clearly referring to Duchamp and Johns. But, that same year he also held a show of bland geometric forms in gray-painted plywood which reflected the paradoxical mental processes of the composer John Cage, a friend of Morris's who probably influenced the striking shift in visual esthetics as much as any single figure. At this time, Cage was quoted in an aphorism that summarized the Minimalist inspiration and its ironic vacuous effects: "I have nothing to say, and I am saying it." After 1965, Morris's work became more eclectic, but he remained unfailingly innovative in his modular sculpture, experiments with soft materials and random pilings of antiform and process art, Earthworks, steam environments, and other brilliantly original and daring projects in ecology, communications, and information systems.

By the end of the 1960s, an even more radical concept became an increasingly dominant feature of three-dimensional art forms, and that was the idea of executing sculpture *in situ*, as situational and therefore impermanent structures designed to function outside the studio environment. Carl Andre (b. 1935) was the first artist to use the term post-studio sculpture to rationalize what Robert Morris, Dan Flavin, and he had begun to do to break down conventional rationales linking the artist and his work to the studio. The identification of the art activity with an indoor or an environmental outdoor site, and with a nonvisual,

pl. 507

pl. 509

pl. 508

Robert Morris. Untitled. 1965. Gray painted fiber glass, 2×16'. Collection the artist, New York. 507

Carl Andre. *Twelfth Copper Corner.* 1975. Copper, 78 plates, each 0.5×50×50 cm; overall, 0.5×600×600 cm. Sperone Westwater Fischer Gallery, New York. 508

Robert Morris. Untitled (steam piece). 1967–73. Environmental structure: steam outlets at 4 corners of 25×25' square; steam occupies available space. Collection University of Washington, Bellingham. 509

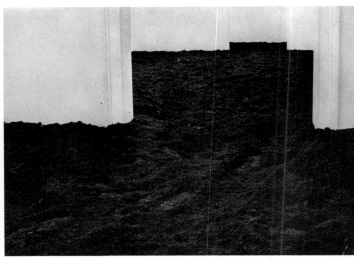

Walter de Maria. *50 M³*. 1968. 1,600 cu. ft. of earth. Installation view, Heiner Friedrich Gallery, Munich. 511

Michael Heizer. *Isolated Mass/Circumflex*. September 1968. One of a series of 9 Earthworks executed in Massacre Dry Lake, Nev. 510

conceptual idea, became decisive when artists succeeded in freeing themselves from the limitations of the studio mentality.

The emphasis by Morris, Andre, and Flavin on location, and their indifference to the fine-art character of their materials, found a logical, if surprising, extension in the efforts of the young, idealistic avant-garde who reacted violently to the commercialism of the art world in the late 1960s with Earthworks, or Land Art. Many of the creators of Earthworks, among them Morris, de Maria, and Robert Smithson (1928—1973), had begun their mature careers by making Minimal sculpture in which the discrete object became increasingly sublimated by reason of serial emphasis or the geometric stereotyping of individual forms. The revived interest in deserts, mountains, geological strata, and primitive states of nature not only betrayed a certain romanticism but could also be rationalized in terms of the social conditions of a world in uneasy transition.

Michael Heizer (b. 1944), a leading Earthworks artist, put it this way: "The position of art as malleable barter-exchange item falters as the cumulative economic structure gluts. The museums and collections are stuffed, the floors are sagging, but real space still exists."[2] There were plentiful precedents for working with land in traditions dating back to the Egyptian pyramids, ziggurats, Stonehenge (with which Andre said he had felt kinship on a visit in 1954), American Indian sand painting (an influence on Pollock) and burial mounds (which Newman and Tony Smith admired), and Zen rock gardens, not to mention Gutzon Borglum's presidential heads on Mount Rushmore. Perhaps even more important, as Willoughby Sharp pointed out in the catalogue

foreword for his pioneering 1969 Earth Art exhibition at Cornell, there were even closer examples that directly influenced the American avant-garde, and he cited Duchamp's use of his *Large Glass*, the pebbles in Pollock's 1950 painting on glass, and Rauschenberg's so-called Nature Paintings of 1953. The first (unexecuted) Earthworks proposal of the 1960s was made by Walter de Maria (b. 1935) in his wry Art Yard proposal of 1961, which began: "I have been thinking about an art yard I would like to build. It would be sort of a big hole in the ground. Actually, it wouldn't be a hole to begin with. That would have to be dug. The digging of the hole would be part of the art. Luxurious stands would have to be made for the art lovers and spectators to sit in."[3]

Land Art also belonged to the general social phenomenon of protest in the 1960s that expressed concern at many levels for the world's threatened ecology. This radical art form tried to revive a more meaningful interaction between man and nature, and to remind us dramatically and rightfully of the natural order of reality and man's indissoluble bonds with nature. A psychoanalyst recently made perhaps the most meaningful, if obvious, commentary on this grandiose artistic phenomenon: "The works of these innovators are an attempt to be as big as the life we live today, the life of immensity and boundless geography. But it's also the manifestation of a desire to escape the city that is eating us alive, and perhaps a farewell to space and earth while there are still some left."[4]

As photographs and other documentary post-factum evidence of the event came into increasing use with Earthworks, it became clear that a dialogue existed between conception, or idea, and the

pl. 513

pl. 510

pl. 511

actualization of the project in the landscape. The New York dealer John Gibson, who represented the Earthworks artists, aptly described one of the Nevada desert schemes of Dennis Oppenheim (b. 1938) as a kind of "visionary sculpture," and himself in this promotional function as an "idea broker." Land Art began to sublimate into a kind of cerebral memory art along the lines of the program which the English artist Richard Long (b. 1945) announced in his carefully explicit title and then dutifully executed: *Walking a Straight Line for Ten Miles, SW England, Shooting Every Half Mile. Out. Back.* The shooting in question was done every half mile as programmed, with a camera aimed down at the ground. The visual record not only became artistic proof of the activity but often seemed to replace the live project as significant visual commentary.

pl. 516

To an extraordinary degree, the last years of the 1960s saw idea rather than physical mass or visual definition become the controlling feature of art. Sol LeWitt (b. 1928) described the idea as "the machine that makes the work." The artist's aim, he wrote, is "not to instruct the viewer, but to give him information. Whether the viewer understands this information is incidental to the artist."[5] The object became the visual residue or end product of a highly calculated and rationalized action. Much of the traditional satisfaction with sensuous form and structured composition was

pl. 512

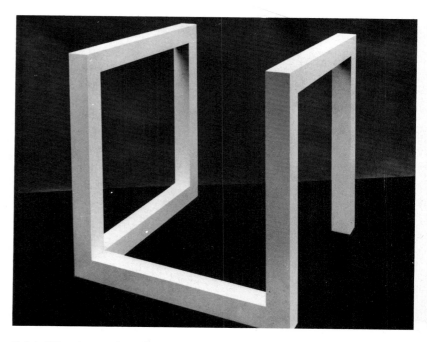

Sol LeWitt. *Incomplete Open Cube 8/20*. 1974. Baked enamel on aluminum, 42 × 42 × 42". John Weber Gallery, New York. 512

Robert Smithson. *Spiral Jetty*. 1970. Rock, salt crystals, earth, algae; coil length, 1,500'. Great Salt Lake, Utah. 513

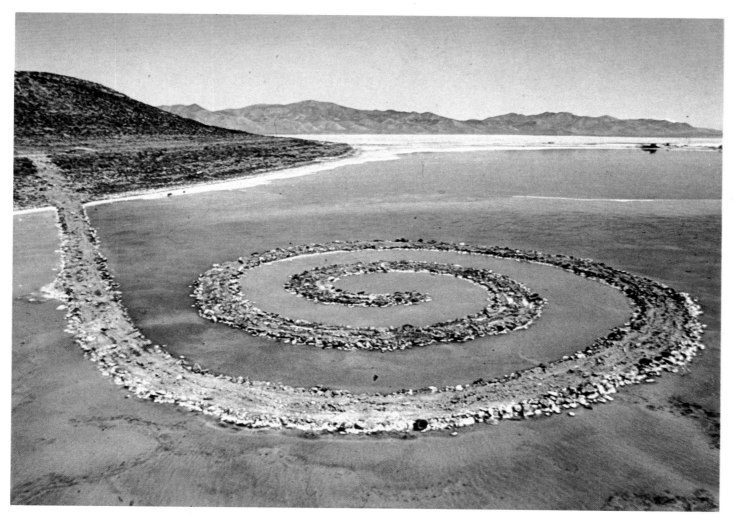

replaced by the pleasure of almost blindly working out an intellectual problem. Despite value placed on cerebral process, the character of the end product remained "intuitive," however, in LeWitt's words.

Conceptual Art flourished not only in the realm of ideas but also in actions, especially in performances of a theatrical nature which involved the artist's awareness of his own body as topography or an instrument for the ritual enactment of primitive feelings. In dramatic pantomine and a narrative of body manipulations, transmitted by video tape to TV screen, Bruce Nauman (b. 1941) Keith Sonnier, Vito Acconci (b. 1940), and many other artists envisioned themselves as solitary performers. They seemed almost indifferent to the public audience, willfully cut off from it like Beck-

pl. 514
pl. 515

ett or Ionesco characters acting out their private alienation and suffering in a new kind of soliloquy, or through the most elementary contact with their own physical existence. As the critic Michael Kirby put it: "In the new art form . . . the 'thing' has moved inside the body so to speak. The actions of the person himself become the object of his own attention." [6]

In Europe, developments in Conceptual Art and performance art took place simultaneously. Indeed, for the first time in the early 1970s, it was no longer possible to consider New York as the pre-eminent art center, since Conceptual Art extended the possibilities of expression beyond the range of narrow nationalist interests. In England, Richard Long's chaotic natural order or rock patterns and arrangements of growing and uprooted

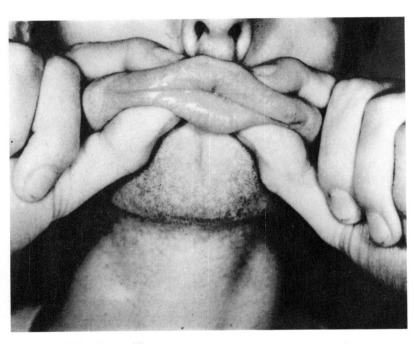

Bruce Nauman. *Studies for Hologram.* 1970. Silkscreen, 26 × 26". Leo Castelli Gallery, New York. 514

Dennis Oppenheim. *Attempt to Raise Hell.* 1975. Construction with bell and mixed mediums. John Gibson Gallery, New York.
516

Vito Acconci. *Conversions I (Light, Reflection, Self-Control.)* August 1971. Still from 48 min. Super-8 film, black and white.
515

Jan Dibbets.. *Sea-Horizon, 0–135 Degrees.* Two sets of 10 color photographs on aluminum; each set 19¾×16′5″. Collection the artist, Amsterdam. 517

pl. 519

pl. 517

pl. 518

bushes commented eloquently on the attenuations of artistic will in a more conceptualized Land Art. He evoked a fresh and humbling sense of nature's sweep and grandeur. The patterns of geometricized camera views of sea and sky of Jan Dibbets (b. 1941) make a haunting reference, in the unlikely medium of the Instamatic camera, to a fellow countryman's similar obsession with nature and abstraction—Mondrian's Plus-and-Minus drawings series. Among the more memorable recent examples of performance art in Europe was the sensational "performance" tableau at the international Documenta 5 exhibition in Kassel, Germany, in 1972 by Vettor Pisani (b. 1938), where the artist chained his naked wife by the throat to the ceiling of a virtually empty room, next to a ticking clock. The artist periodically got up from a morose squatting position to paint dabs of white paint on his model's ankle. Vito Acconci's pieces have involved more explicit mutilations of his own body, and sexual activities beyond mere voyeurism. Ralph Ortiz, Hermann Nitsch,

Vettor Pisani. *All the Words from the Silence of Duchamp to the Noise of Beuys.* 1973. 518

Richard Long. *Bolivia.* 1972.

519

Joseph Beuys. *Eurasia*, a Happening in Copenhagen, 1966. 520

and Günter Brus have designed violent public events, including ritual defecations and elaborate sadomasochistic torture machines, usually with women as their degraded victims. The theatrical character of much contemporary performance art evolves from the Happenings of the late 1950s of Oldenburg, Dine, Whitman, and others, and from new ideas about the actual theater transmitted by Antonin Artaud, who remarked, in words apropos of contemporary and future developments in the visual arts: "Instead of continuing to rely upon texts considered definitive and sacred, it is essential to put an end to the subjugation of the theater to the text, and to recover the notion of a kind of unique language half-way between gesture and thought."[7]

Another source of the unsettling sadomasochistic imagery which made its appearance in art of the late 1960s, besides the ritual "Theater of Cruelty," were violent public events such as the interminable Viet-Nam conflict, still dominating the TV screen. The more repelling Bodyworks and performances also seemed related to the feats of physical endurance and the experience of physical pain and discomfort that began with some of Yves Klein's performances and continued in the

tortured imagery of one of Europe's most influential innovators, Joseph Beuys (b. 1921). The antiform tendency in America, in reaction to the pristine geometries of Minimalism, probably derived from Beuys's experiments in the 1950s with animal fat, set down in unsymmetrical piles in the corners of empty rooms, and the artist's act of wrapping himself in rolls of felt with a dead hare. In one of his major so-called actions, enigmatically entitled *How to Explain Paintings to a Dead Hare* (1965), Beuys sat talking to a dead hare he held in his arms, his face covered with gold leaf. His ritualistic dramas have magical and primitivist connotations, and strong overtones of mysticism. Like Julian Beck's Living Theater, they are ritualized enactments of feelings of protest, and they often contain elements of social, sexual, and, recently, political drama of a provocative nature that invites self-examination. Much so-called process art, which utilizes random and subesthetic materials, derives from Beuys's example.

pl. 520

The interest in a new kind of material object—shabby, soft, vulnerable looking, dispersive, and spatially unsubstantial—received increased emphasis in America in the late 1960s. In 1968, Robert Morris organized a show at the Leo Castelli Gallery's warehouse space which established new kinds of interaction between process, materials, and duration in time. Writing of the new antiform esthetic, Morris declared: "Random piling, loose stacking, handling, give passing form to the material. Chance is accepted and indeterminacy is implied."[8] Painting began to approximate some of these unusual effects and values. Richard Tuttle's unframed, dyed, nailed-up pieces of cloth and the stapled wall hangings of Robert Ryman seemed to comment on painting as an "anxious object," making it more object than framed pictorial enclosure of illusionistic space. Dorothea Rockburne brilliantly straddled ideas of process, logical structure related to the formal rigors of Minimalism, and the wall hanging as

pl. 521

pl. 504

Installation view of group exhibition, 9 at Leo Castelli, Leo Castelli Warehouse, New York, 1968. 521

Bill Beckley. *De Kooning's Stove.* 1975. Color photograph mounted on board, 24×40". John Gibson Gallery, New York. 522

Dorothea Rockburne. *Levelling.* 1970. Oil on paper and chipboard, 72×81½". Collection the artist. Photograph courtesy John Weber Gallery, New York. 523

pl. 523 nondescript object in her highly refined and personal inventions.

The development from the art object to idea art was thus inconsistent, or at least full of contradictions. Order and disorder, random and systemic effects, privacy and a legible public imagery couched in the traditional language of geometric abstraction, competed for the ascendancy, as did the idea of decorative art object and dematerialized ends in art. In idea art, there was increasingly evident a strong strain of subjectivism which ran a gamut from language play, in whimsical verbal constructs, to a parodistic mockery of introspection approaching vaudeville slapstick. While a great body of Conceptual Art is solemn and even grimly humorless in its exploration of contemporary linguistic problems and esoteric philosophy, there is a countertendency of wildly comical impulse. The performance artist oscillates between the role of a clown and a grave professor dispensing obscure philosophical propositions in a mood of Jarryesque farce. As examples of the absurdist mood, there are William Wegman's performance pieces, Lawrence Weiner's ironic propositions, the "story art" of Peter Hutchinson (b. 1930), and such bits of whimsy as the following formulation by Robert Barry, offered as a serious artistic commentary:

All the things I know
But of which I am not
At the moment thinking –
1:36 PM, June 1969.[9]

No matter how intrinsically negligible such proposals may at first glance seem, they do pose an intellectual challenge which cannot be readily discounted. They cause us to reconsider our assumptions about the nature of artistic work, its ultimate value, and even the act of perception.

Story art is the phrase adopted by the dealer John Gibson to characterize a recent offshoot of Conceptual Art which mixes verbal and visual means, but discards the structurist and philosophical pretensions of the more solemn Conceptualists in favor of less intellectually rigorous forms of observation and autobiographical fantasy. Instead of using theoretical ideas, verbal constructs, and photographic documentation to challenge the traditional, sensuous concerns of painting and sculpture, story artists as different as Hutchinson, John Baldessari, Dennis Oppenheim, and more recently, Roger Welch and Bill Beckley (b. 1946), among others, pl. 522 have made their mixed means a vehicle for quixotic personal perceptions. An indication of the more hedonistic aspects of this development has been the new emphasis on glossy color photography rather than black-and-white visual material.

So arresting are some of Beckley's sumptuous color images, which he laboriously processes himself, that they re-establish affiliations with illusionistic painting. Photography is no longer a deliberately impoverished medium for routine information gathering. In Beckley's case the photo images combine with abutting blocks of type that recount apparently trivial events. But the guileless style of the verbal narration betrays strange *double entendres* and operates on a number of levels of personal and formal meaning. As narrative, story art plays a role today rather like that of Pop Art when it emerged in the early 1960s. Against the background of formalist abstraction and the ideological narrowness of Conceptual Art, it embraces a wider spectrum of real and imaginary life situations. In the words of one of its practitioners, James Collins, the current variation on traditional realism offers us "a humanizing gesture of some significance."

For the most part, however, Conceptual Art presented itself in intellectually demanding and

329

analytical forms, rather than as a kind of comical body of self-revelation. Its often maddening privatism contains elements of frustration, and comments obliquely on a mass society which has learned to detest and fear strong forms of individualism. Political, cultural, and intellectual nonconformity pose a threat to current escapist illusions. The contemptible "team spirit" and the faceless "plastic men," in Rebecca West's telling phrase, that accounted for the Watergate fiasco have in recent years made the passive, mindless anti-individualist tendency of contemporary mass society frighteningly apparent. In a world whose capacity for self-deception seems unlimited and whose moral values are coming unstuck, the ironies and even the infantile truancy of Conceptual Art allow us to feel more hopeful about our condition of freedom than do the most accomplished decorative wall paintings or conventional sculptural objects of the past.

The dematerialization of the traditional art object evident in Conceptual Art, and in performance art, found a parallel in another type of environmental art which perhaps even more dramatically captured popular imagination in recent years: the new union of art and technology. Vast areas of artistic expression have been assimilated to science and engineering, and artists have boldly experimented with such materials as synthetics or plastics and even embarked on the most complex imaginable collaborations with teams of technicians, working side by side with them in the laboratory. The first solid evidence of the artist's gravitation to science came before the public with the invention of so-called Op Art in the 1960s, light art, the revival of motion sculpture, and intermedia experiments utilizing electronic technology.

Op Art "arrived" in America with an immediate and astounding success at its public debut in William Seitz's The Responsive Eye exhibition held at the Museum of Modern Art in 1965. Yet, Op Art seemed a passing fad which exhausted its own artistic invention almost at the very moment it aroused the greatest public enthusiasm. Because of its scientism, its focus on such perceptual phenomena as reversible figure-ground relationships, and an imagery that often resembled nothing so much as an optician's test cards, the movement commanded less respect in the United States than in Europe. The antecedents of Op Art in Constructivist and kinetic traditions were remote from postwar American art. American artists who pursued its methods were quite different from their European counterparts. The powerful kinesthetic responses generated by the infinitely complex and cunning color systems of Victor Vasarely were more intellectually rigorous than the intuitive, clumsy structures of Josef Albers, who may legitimately be assigned priorities in the invention of Op Art.

In advance of Vasarely, he created, during the early 1930s, a new, dynamic perceptual type of painting which took an unprecedented account of the complex individual responsiveness to visual stimuli and the wealth of emotive content buried in visual experience. After 1949, he repetitively, almost compulsively, did the same thing superlatively well, and that was paint nests of color squares in different dominant hues and sizes and identical modular formats. His celebrated Homage to the Square theme was also perhaps the first unequivocal example of serial composition in American art. It occupied him exclusively as a compositional structure for over two decades and has no match for constancy of purpose, incorruptibility, and sheer obsessiveness except, perhaps, Mondrian's famous grid.

Although Albers's influence as a teacher was considerable and he counted among his students such outstanding contemporary artists as Robert Rauschenberg and Kenneth Noland, perhaps only one, Richard Anusciewicz, has seriously, and profitably, pursued his investigations of the "interaction of colors" and perceptual ambiguities. For a variety of artistic and cultural reasons, optical art did not excite the American imagination deeply or for long. In the development of American art of the 1960s it played primarily a catalytic role, leading to new forms of collaboration with industry in esoteric technological form, and establishing new connections between optical and kinetic phenomena and art on an environmental scale.

A number of motion sculptors activated material forms with such rapid movement that they created an optical imagery and effect of disembodied energies. Perhaps the most remarkable

Len Lye. *Fountain II*. 1959. Steel, motorized, 89" h. Howard Wise Collection, New York. 524

pl. 524

has been New Zealand-born Len Lye (b. 1901). His Tangible Motion Sculptures *Fountain II* and *Flip and 2 Twisters* were, in essence, programmed machines constructed of exquisitely fine metal components of stainless steel; in motion, they created dematerialized tongues of light and a flickering radiance. George Rickey (b. 1907) has created attenuated stainless-steel blade forms, egg-beater "space churns," and pairs of quartets of rectangular, uniform volumes that move gently, driven slowly by air currents, but their reflective, burnished surfaces also appear to melt away in

pl. 525

motion. Their sense of weightlessness and immateriality derives from the monumental scale, light play, and rhythmic control of movement that Rickey has mastered so admirably in recent years.

In the changes that rapidly overtook art in the 1960s, Lye was more characteristic of new developments than the more conservative Rickey. The pervasiveness of environmental art systems, whether in kinetic, luminist, or filmic form, soon became more sophisticated than anything the original Constructivists or Bauhaus experimentalists might have fantasied. The new visual and mass communications media, as Marshall McLuhàn pointed out in *Understanding Media*, have restructured our normal perceptual patterns, which are rapidly being superseded by a multisense involvement in a total field reality, such as the light and sound shows of the middle of the decade.

The twentieth-century pioneer in interpreting music visually was the American Thomas Wilfred. Starting in May 1905 "with a cigar box, a small incandescent lamp, and some pieces of glass," Wilfred developed a new artistic medium of large scale, totally abstract, and independent of music that created flowing, variegated light compositions which he called Lumia. For some time his pioneering *Lumia Suite* played as a curiosity at the Museum of Modern Art in New York, producing mildly euphoric "light ballets" that anticipated the optical experiments and the psychedelic art of the 1960s. There had, of course, been other authoritative precedents for electrified art, such as Moholy-Nagy's *Light-Space Modulator* of 1922–30, around which a luminist tradition might have been built. However, it took a combination of McLuhanism and the new cult of technology in the 1960s—which included the interest in the retinal dynamics of perception in Op Art—to create the necessary climate in America for widespread experiments in a variety of light mediums.

Chryssa (b. 1933) was the first American artist to use emitted electric light and neon rather than projected or screened light. Her imagery was also unique, since its sources were the lettered commercial signs of the urban environment, especially her preferred subjects—the neon signs of Times Square. Her best known lightbox series contained delicate neon variations on the letters W and A

pl. 499

and the ampersand, aligned in refulgent, parallel banks. The repeating effect of the letters produced resonating light impulses which had the effect of

George Rickey. *Two Lines Oblique.* 1967–68. Stainless steel, 25' h. Collection the artist. Photograph courtesy Staempfli Gallery, New York. 525

pulsations or waves even though there was no actual oscillation. The kinetic effect took place in the eye of the beholder. In Europe, Martial Raysse used neon to illustrate Pop imagery directly, in his own picturesque, vernacular style. Many artists in America and Europe, later identified with an antiform tendency, employed light as an incidental element, among them Dan Flavin, Robert Morris, Bruce Nauman, and Keith Sonnier.

In his book *Beyond Modern Sculpture*, Jack Burnham describes the artistic metamorphosis taking place as an evolution "from the direct shaping of matter to a concern for organizing quantities of energy and information."[10] Our total environmental sense today has little to do with the old folklore about the advantages or menace of machine culture. Machine-age art forms were officially recognized as superseded in 1968 by the collective works of a new group of artist-engineers who exhibited together for the first time at a Museum of Modern Art show in New York significantly entitled The Machine as Seen at the End of the Mechanical Age. Headed by Billy Klüver of

Lucas Samaras. Untitled. 1973–74. Photo-transformation: Ekta-chrome, 3×3″. Collection Arnold and Milly Glimpcher, New York.
526

the Bell Laboratories, the group sought to bridge the gap between modern science and art through the exchange of information and the creation of opportunities for joint experiment. They called their collaboration Experiments in Art and Technology (EAT). The new development, dramatized through a competition sponsored within the Museum show, had actually begun two years earlier, with a series of brilliant performance spectacles organized by Klüver, Rauschenberg, dancers Yvonne Rainer, Alex Hay, and Steve Paxton, and the composer John Cage, among others. *Nine Evenings: Theater and Engineering* was presented in the fall of 1966 at the 69th Regiment Armory on Twenty-sixth Street in New York, the same one that had once held the Armory Show. There, participating artists and engineers invented a remote-control dance piece, self-performing musical machines, and infrared-ray television cameras which managed to reveal and transmit onto an enormously magnified video screen images of members of the audience performing simple activities on cue in the dark. With the success of *Nine Evenings*, EAT was established and the flowering of environmental and mixed media art in the United States assured.

John Cage was the guru of the new environmentalism, for his electronic music had been intimately involved with technology since the 1940s. He had already composed music with radios, amplifiers, oscillators, contact microphones, and even sounds picked up from outer space. One of the memorable performances at *Nine Evenings* was the piece entitled *Bandoneon* on which David Tudor collaborated with Cage. They left an ensemble of programmed and responsive audio circuits, mov-

ing loudspeakers, television images, and lights to make their own random music when activated by the audience, thus creating one of America's first autonomous artistic machines. Such works-of-art-cum-robots were later developed by innumerable American visual artists who acquired familiarity with sophisticated electronic technology, transistors, and microcircuitry. James Seawright created sculptures whose movements, electronic sounds, and light projections were generated by a visible circuitry that became part of the work's esthetic. He has described these autonomous machines as "sculpture that happens also to be a machine." Howard Jones also created lights and reflected surfaces which the spectator activated both intentionally and unknowingly. Electronic technology made responsive environments and complex machines of this kind, set in motion by external environmental stimuli, possible for the first time. Nicolas Schöffer's kinetic sculpture was programmed by spectator movements, and some of the early experiments of GRAV in Europe provided the environmental models in the plastic arts for the American experiments

Modern historical precedents for environmental art of this kind were various, and sometimes even conflicting. Influential sources included the loose arrangements of collage materials in Schwitters's *Merzbau* environments and El Lissitsky's Constructivist *Proun* Rooms, which he called "the junction from architecture to painting." Closer at hand, Claes Oldenburg's *The Store* in 1961 recreated the interior of a Lower East Side store as an ironic commentary on derelict commercial culture. Allan Kaprow, the inventor of Happenings, had been drawn to Jackson Pollock's paintings as sources of energy that expanded the individual creator's private world into an activated space, engaging the spectator at new psychic and perceptual levels.

But the idea of an electronically energized environment, rather than one dependent on hand-made, dispersive collage works, had to wait until the mid-1960s to flower. The environmental art that then emerged contained a multitude of sensory phenomena—visual, aural, kinetic, and sometimes olfactory. Many of the most theatrical environments were essentially light shows, or entertainments, which tried to build an overload of sight and sound designed to disorient the senses, like a drug experience. A standard example were the euphoric light environments contrived by USCO (US Company of Garnerville), with flashing slide projections, pulsating strobe lights, Mylar sheets, and other devices which created heightened sensations and finally total immersion in an all-enveloping active field of pulsating sight and sound. A torrent of slide projections accompanied by high-decibel rock music made Andy Warhol's *Balloon Farm, Exploding Plastic Inevitable* and the Electric Circus among the most popular ventures in multimedia of the 1960s. With visual imagery changing too rapidly to be followed coherently, and ear-splitting musical sound, the

spectator experienced a sense of identity loss within the irresistibly energized room enclosure.

The character of artistic environments began to change markedly at the end of the decade. In 1968, the same year in which The Machine exhibition was shown at the Museum of Modern Art, Robert Whitman created a work at the Jewish Museum called *Pond* which did not invite, but rather, discouraged, spectator participation with its assortment of carefully positioned mirrors, strobe lights, slide projectors, and a solemn voice intoning over a loudspeaker a series of banal words, which could also be seen flashing across screens. The experience was mystifying and tended to turn the spectator off, directing him inward rather than outside himself into a visual-auditory paroxysm of sight and sound.

This type of gentle narcissism, later to be amplified in different ways by the self-obsessed, erotic Polaroid imagery of Lucas Samaras (b. 1936) and the energetic, more violent Bodyworks of Acconci and Nauman, attenuated the environmental impulse. The Pulsa collaborative, a group of seven artists from Oxford, Connecticut, created extensive zones of sound, pulsating light, and heat out of doors, on golf courses and at the Museum of

pl. 526

pl. 527

Modern Art garden in 1970. Pulsa's activities depended on chance stimuli in the environment interacting reciprocally with computer programming, and were responsive to such factors as human presence, traffic, and weather conditions. These latter environments showed a new concern not so much with immediate performance or even esthetics as with the entire ecology, rural and urban, and with the underlying rhythms of society itself.

The contemporary artist's interest in technology has inevitably led to ambitious and expensive collaborations within the industrial corporate structure. Art-conscious corporations have expanded the variety of types of assistance offered artists, which range from advice on materials to elaborate programs involving residence for creative individuals within industry. New synthetic materials have also significantly expanded the possibilities of expression in painting and sculpture. The widespread use of such synthetics as acrylics, urethanes, and polyester resins brought the significant changes in the art product as a direct result of contemporary industrial research. Ron Davis painstakingly constructs his own acrylic reliefs, and like many West Coast artists, he has discovered new sources of sensuous surface from products of the esoteric space industries of his region and from the familiar Detroit assembly line. He echoed the sentiment of many contemporary artists when he proclaimed the discovery that a new Chevrolet motor car was more perfect than most of the art of his time. The hybrid figures of Ernest Trova (b. 1927), which combine esoteric apparatuses and blandly generalized human figures in gleaming metals, are perhaps the most notable contemporary examples, in sculpture, of space-age imagery and technology, transcending even the cold perfection of Detroit esthetics.

pl. 528

The more ambitious collaborations between artists and industry on a grand scale have been imaginative and bold, even though the new alliance has rarely been completely successful. The EAT group managed to obtain considerable

Pulsa Group. *Golf Course Work.* Environment photographed in New Haven, 1969. 527

Ernest Trova. Study, Falling Man (Carman). 1966. Polished silicone bronze and enamel, 72 × 28 × 20″. Pace Gallery, New York. 528

333

pl. 529

financial backing from a sponsor for its ambitious Pepsi-Cola Pavilion at the Osaka World's Fair of 1970. A structure in the shape of a geodesic dome was built to house, among other attractions, the world's largest spherical mirror and a full-blown water cloud suspended in midair.

One of the most interesting and philosophically satisfying investigations of industrial technology was provided by the Software exhibition at the Jewish Museum, organized by Jack Burnham. There were, admittedly, a number of serious malfunctions in some of the most engrossing pieces, such as the MIT architecture group's *Seek*, a project in which a computer moved toy blocks around in interaction with an unpredictable and agitated team of gerbils who inhabited the man-made and constantly shifting environment. The exhibition made its point dramatically and communicated a fresh artistic concept. Exhibits were presented as a means of handling and relaying information and establishing patterns of environmental interaction within a systems structure rather than as a set of autonomous art objects. It signaled a movement, according to the formulation of curator Jack Burnham, away from art objects and toward artistic "concerns with natural and man-made systems, processes, ecological relationships, and the philosophic involvement of Conceptual Art.

All of these interests," he noted in his catalogue, "deal with art which is transactional; they deal with underlying structures of communication or energy instead of abstract appearances."[11]

A profound shift in attitude has inspired the continuing flow of innovation by some of the most fertile minds in American and European art in the 1970s. The new conceptions of art as idea and action, as information rather than a product, and even as a general state of awareness have proven their viability. One of the firm assumptions underlying the most adventurous art of the contemporary period is rooted in the rejection of the *status quo* not only in art but in emotions and politics. Like the Post-Impressionists, and like many of the revolutionary manifestations of twentieth-century art movements, the succession of dominant trends of the 1960s and 1970s, from Minimal Art to environmental systems and Conceptualism, are motivated by an ingrained experimentalism endemic to modern art. The restless tendency to push ideas as far as possible, expanding the frontiers of artistic experience and individual consciousness, is still responsible for creating the most significant artistic work of today, as it was nearly a hundred years ago when Cézanne, Seurat, Gauguin, and van Gogh rejected the observation of natural reality for an art of ideas.

Pepsi-Cola Pavilion, Expo' 70, Osaka, Japan. Exterior. Artificial fog by EAT, sculpture by Robert Breer.

529

NOTES

POST-IMPRESSIONISM:
THE LANGUAGE OF STRUCTURE

1. Ambroise Vollard, *Renoir: An intimate Record*, trans. Harold L. Van Doren and Randolph T. Weaver. New York, Alfred A. Knopf, 1925, p. 118.

2. John Rewald, *Georges Seurat*. New York, George Wittenborn, 1943, p. 62.

3. Ibid., pp. 61—62.

4. Cited in John Rewald, *The History of Impressionism*. Rev. ed. New York, Museum of Modern Art, 1961, p. 526.

5. Cited in Sam Hunter, *Modern French Painting: 1855—1956*. New York, Dell, 1956, p. 75.

6. John Rewald, ed., with the assistance of Lucien Pissarro, *Camille Pissarro: Letters to His Son Lucien*. New York, Pantheon Books, 1943, p. 158, letter of Apr. 1, 1891.

7. John Rewald, ed., *Paul Cézanne: Letters*. London, Bruno Cassirer, 1941, p. 239, letter of July 25, 1904.

8. Ibid., p. 251, letter of Oct. 23, 1905.

9. Ibid., p. 157.

10. Rewald, *Pissarro: Letters*, pp. 275—276, letter of Nov. 21, 1895.

SYMBOLIST PAINTING
AND ART NOUVEAU

1. Jean Moréas, "Le Symbolisme," *Figaro Littéraire* (Paris), Sept. 18, 1886.

2. Ibid.

3. Gustave Kahn, "Réponse des Symbolistes," *L'Événement* (Paris), Sept. 28, 1886.

4. Robert Ross, ed., *The First Collected Edition of the Works of Oscar Wilde 1908—1922*. Reprint: London, Dawsons of Pall Mall, 1969, vol. "Intentions and the Soul of Man," pp. 53—54.

5. Cited in Philippe Jullian, *Dreamers of Decadence: Symbolist Painters of the 1890s*. New York, Praeger, 1971, p. 34.

6. Ibid., p. 204.

7. Cited in ibid., pp. 40—41.

8. Charles Baudelaire, *The Flowers of Evil*, "Bile and the Ideal XXVI," ed. Marthiel and Jackson Mathews. New York, New Directions, 1955, p. 34.

9. Georges Lafenestre, "Salon de 1873," *Gazette des Beaux-Arts* (Paris), June 1873; as cited in Alan Bowness, ed., *French Symbolist Painters*. London, Arts Council of Great Britain, 1972, p. 105.

10. Maurice Malingue, ed., *Lettres de Gauguin à Sa Femme et Ses Amis*. Paris, Bernard Grasset, 1946, pp. 299—301, letter no. 174, July 1901.

11. Émile Bernard, *Charles Baudelaire*. Brussels, n.d., p. 45.

12. Odilon Redon, *A Soi-même: Journal (1867—1915)*. Paris, Floury, 1922, and Corti, 1961, pp. 25—29; cited in Herschel B. Chipp, ed., *Theories of Modern Art: A Source Book by Artists and Critics*. Berkeley and Los Angeles, University of California Press, 1968, p. 119.

13. Philippe Jullian, *The Symbolists*. London, Phaidon Press, 1973, p. 44.

14. Cited in Jullian, *Dreamers*, p. 144.

15. Malingue, *Lettres de Gauguin*, p. 287, letter no. 170; English trans. in John Rewald, ed., *Paul Gauguin: Letters to Ambroise Vollard and André Fontainas*. San Francisco, Grabhorn Press, 1943, p. 22.

16. Ross, *Collected Works of Oscar Wilde*, vol. "The Portrait of Dorian Gray," pp. x—xi.

17. Cited in Robert Goldwater, *Paul Gauguin*. New York, Harry N. Abrams, [1957], p. 82.

18. Quoted in Jean de Rotonchamp, *Paul Gauguin: 1848—1903*. Paris, Editions G. Crès, 1925, p. 243.

19. Cited in Goldwater, *Gauguin*, p. 80.

20. Ruth Pielkovo, trans., *The Letters of Paul Gauguin to Georges Daniel de Monfreid*. New York, Dodd, Mead, 1922, p. 95.

21. Goldwater, *Gauguin*, p. 144.

22. Ibid., p. 158.

23. J. van Gogh-Bonger and V. W. van Gogh, eds. and trans., *The Complete Letters of Vincent van Gogh*. Greenwich, Conn., New York Graphic Society, 1958, vol. 3, p. 6, letter no. 520 (to Theo), Arles, n.d. (c. Aug. 1888).

24. Ibid., p. 30, letter no. 534, Arles, early Sept. 1888.

25. Ibid., letter no. 564, Arles, Dec. 1888.

26. Ibid., p. 28, letter no. 533, and p. 31, letter no. 534.

27. Ibid., letter no. 531, Arles, early Sept. 1888.

28. Frederick B. Deknatel, *Edvard Munch*. New York, Museum of Modern Art, 1950, p. 18.

29. As quoted in Douglas Cooper, *Henri de Toulouse-Lautrec*. New York, Harry N. Abrams, 1956, p. 24.

30. Fritz Schmalenbach, *Jugendstil*. Würzburg, 1935, pp. 31—32; as cited in Peter Selz, *German Expressionist Painting*. Berkeley and Los Angeles, University of California Press, 1957, p. 56.

31. Henry van de Velde, *Déblaiement d'Art*. Brussels, 1894, p. 18.

32. Walter Crane, *The Claims of Decorative Art*. Boston and New York, Houghton, Mifflin, 1892, p. 93.

TRADITION AND INNOVATION
IN ARCHITECTURE: 1880-1914

1. Leonardo Benevolo, *History of Modern Architecture*. Vol. 2. Cambridge, 1971, pp. 396—397, quoting from the original text of Sant'Elia's Futurist manifesto.

EARLY MODERN SCULPTURE: RODIN TO BRANCUSI

1. Albert E. Elsen, *Origins of Modern Sculpture: Pioneers and Premises*. New York, George Braziller, 1974, p. 5.

2. Jean Selz, *Modern Sculpture: Origins and Evolution*. New York, George Braziller, 1963, p. 72.

3. Rainer Maria Rilke, *Auguste Rodin*, trans. Jessie Lemont and Hans Trausil. New York, Fine Editions Press, 1945, p. 18.

4. Ibid., p. 11.

5. Auguste Rodin, *Art*, trans. from the French of Paul Gsell by Mrs. Romilly. New York, Fedden, Hodder and Stoughton, 1912, p. 166.

6. Auguste Rodin, *On Art and Artists*, trans. Dorothy Dudley. New York, Philosophical Library, 1957, pp. 103—104.

7. Albert E. Elsen, *Rodin*. New York, Museum of Modern Art, 1963, p. 101.

8. The article, signed "X," appeared in *Journal* (Paris), May 12, 1898.

9. Quoted in George Heard Hamilton, *Painting and Sculpture in Europe: 1880—1940*. Baltimore, Penguin Books, 1967, p. 153.

10. Quoted in Carola Giedion-Welcker, *Contemporary Sculpture: An Evolution in Volume and Space*. New York, George Wittenborn, 1960, p. 24.

11. Elsen, *Origin of Modern Sculpture*, p. 25.

12. As cited in *Henri Matisse Retrospective 1966*. Los Angeles, UCLA Art Council and Art Galleries, 1966, texts by Jean Leymarie, Herbert Read, William S. Lieberman, p. 20.

13. Charles Blanc, *Grammaire des Arts du Dessin: Architecture, Sculpture, Peinture*. Rev. ed. Paris, 1880, p. 14.

14. Quoted by Paul Morand in his preface to the catalogue of the artist's first one-man exhibition at the Brummer Gallery, New York, Nov. 17—Dec. 17, 1926.

15. Ionel Jianou, *Brancusi*. New York, Tudor, 1963, p. 67.

16. *Barbara Hepworth: Carving and Drawings*, intro. Herbert Read. London, Lund Humphries, 1952, facing pl. 16.

EXPRESSIONISM

1. Herwarth Walden, "Kunst und Leben," *Der Sturm* (Munich), vol. 10, 1919, p. 2.

2. Paul Ferdinand Schmidt, "Die Expressionisten," *Der Sturm* (Munich), vol. 2, 1912, p. 734.

3. Gustav Schiefler, *Edvard Munch Graphische Kunst*. Dresden, Ernst Arnold, 1923, p. 2.

4. Henri Matisse, "Notes d'un Peintre," *La Grande Revue* (Paris), Dec. 25, 1908; English trans. Margaret Scolari in Alfred H. Barr, Jr., *Matisse: His Art and His Public*. New York, Museum of Modern Art, 1951, p. 119.

5. Ibid., p. 120.

6. In Georges Duthuit, *The Fauvist Painters* (Documents of Modern Art II). New York, Wittenborn, Schultz, 1950, pp. 27—28.

7. Cited in Marcel Raymond, *From Baudelaire to Surrealism*. New York, Wittenborn, Schultz, 1949, p. 58.

8. Ibid., p. 59.

9. Barr, *Matisse*, p. 122.

10. Duthuit, *Fauvist Painters*, p. 26.

11. Barr, *Matisse*, pp. 63—64.

12. Ibid., p. 78.

13. Ibid., p. 120.

14. Ibid., p. 136.

15. Wilhelm Worringer, *Form in Gothic*, ed. and trans. Herbert Read. London, G. P. Putnam, 1927, ch. X, pp. 71—76.

16. In Emil Nolde, *Jahre der Kämpfe*. Berlin, Rembrandt Verlag, 1934, pp. 90—91, letter of Feb. 4, 1906.

17. Ernst Ludwig Kirchner, *Künstlergruppe Brücke Manifesto*, 1906; as cited in Peter Selz, *German Expressionist Painting*. Berkeley and Los Angeles, University of California Press, 1957, p. 95.

18. In Selz, *German Expressionist Painting*, p. 344 n. 22.

19. In Herschel B. Chipp, ed., *Theories of Modern Art: A Source Book by Artists and Critics*. Berkeley and Los Angeles, University of California Press, 1968, p. 182, letter of Apr. 12, 1915.

20. Maurice Malingue, ed., *Lettres de Gauguin à Sa Femme et à Ses Amis*. Paris, Bernard Grasset, 1946, pp. 287—288, letter no. 170; English trans. in John Rewald, ed., *Paul Gauguin: Letters to Ambroise Vollard and André Fontainas*. San Francisco, Grabhorn Press, 1943, p. 22.

21. Wassily Kandinsky, *Concerning the Spiritual in Art*, trans. Michael Sadleir (Documents of Modern Art V). New York, Wittenborn, Schultz, 1947, p. 77.

22. *Wassily Kandinsky Memorial*, trans. Boris Berg. New York, Guggenheim Foundation, 1945, p. 54.

23. Ibid., p. 61.

24. In Klaus Lankheit, *Franz Marc*. Berlin, Konrad Lemmer, 1950, p. 18.

25. Franz Marc, *Briefe, Aufzeichnungen und Aphorismen*. Vol. 1. Berlin, Paul Cassirer, 1926.

26. Paul Klee, *Schöpferische Konfession (Creative Credo)*, ed. Kasimir Edschmid. Berlin, Erich Reiss, 1926; trans. in Norbert Guterman, *The Inward Vision: Watercolors, Drawings and Writings by Paul Klee*. New York, Harry N. Abrams, 1959.

27. Ibid., p. 5.

28. Cited in Chipp, *Theories*, p. 186.

29. Otto Benesch, *Egon Schiele as a Draughtsman*. Vienna, State Printing Office of Austria, 1950, p. 5.

30. Cited in Selz, *German Expressionist Painting*, p. 165.

31. Ibid., p. 340 n. 18.

32. "Call to Socialism," *An Alle Künstler* (Berlin), 1919; manifesto in pamphlet mentioned in Selz, *German Expressionist Painting*, p. 313.

33. In a lecture, *Meine Theorie in der Malerei (On My Painting)*, at the New Burlington Gallery, London, July 21, 1938; English trans. Bucholz Gallery, New York, 1941; as cited in Chipp, *Theories*, p. 188.

34. G. F. Hartlaub, *Die Graphik des Expressionismus in Deutschland*. Stuttgart, 1947, p. 24; as cited in Selz, *German Expressionist Painting*, p. 81.

CUBISM AND ABSTRACT AKT

1. Rainer Maria Rilke, *Duino Elegies*, trans. J. B. Leishman and Stephen Spender. London, Hogarth Press, 1939, p. 55.

2. See William S. Rubin, *Picasso in the Collection of The Museum of Modern Art*. New York, Museum of Modern Art, 1972, p. 196 n. 6.

3. Cited in Herschel B. Chipp, ed., *Theories of Modern Art: A Source Book by Artists and Critics*. Berkeley and Los Angeles, University of California Press, 1968, p. 205—206 n. 2.

4. Max Kozloff, *Cubism/Futurism*. New York, Charterhouse, 1973, p. 13.

5. Guillaume Apollinaire, *Les Peintres Cubistes: Méditations Esthétiques*. Paris, Figuière, 1913; English trans. Lionel Abel, *The Cubist Painters: Aesthetic Meditations*. New York, George Wittenborn, 1944; as cited in Chipp, *Theories*, p. 231.

6. Alfred H. Barr, Jr., *Picasso: Fifty Years of His Art*. New York, Museum of Modern Art, 1946, p. 80.

7. Julio González, "Picasso Sculpteur," *Cahiers d'Art* (Paris), vol. 11, no. 6—7, 1936, pp. 189—191.

8. *L'Esprit Nouveau* (Paris), no. 5, Feb. 1921, pp. 533—534; English trans. Douglas Cooper in Daniel-Henry Kahnweiler, *Juan Gris: His Life and Work*. London, Lund Humphries, 1947, p. 138.

9. Cited in Marcel Raymond, *From Baudelaire to Surrealism*. New York, Wittenborn, Schultz, 1949, p. 217.

10. Filippo Tommaso Marinetti, ["Initial Manifesto of Futurism"], *Le Figaro* (Paris), Feb. 20, 1909; first English trans. under Marinetti's direction in *Poesia*, Apr.—June 1909; reprinted in catalogue for exhibition at Sackville Gallery, London, March 1912; as cited in Chipp, *Theories*, p. 286.

11. *Technical Manifesto of Futurist Painting*, Milan, April 11, 1910; English trans. under Marinetti's direction reprinted in catalogue for exhibition at Sackville Gallery, London, Mar. 1912; as cited in Chipp, *Theories*, p. 292.

12. Ibid., pp. 292—293.

13. Umberto Boccioni, *Technical Manifesto of Futurist Sculpture*, Apr. 11, 1912; English trans. Richard Chase from Marinetti, ed., *Manifesti del Futurismo*; cited in Joshua C. Taylor, *Futurism*. New York, Museum of Modern Art, 1961.

14. In ["Initial Manifesto of Futurism"]; cited in Taylor, *Futurism*.

15. Kasimir Malevich, *The Non-Objective World*, trans. Howard Dearstyne. Chicago, Theobald, 1959; as cited in Chipp, *Theories*, p. 341.

16. Ibid., p. 342.

17. Naum Gabo and Antoine Pevsner, *The Realist Manifesto*, Moscow, Aug. 5, 1920; as cited in Chipp, *Theories*, p. 328.

18. Ibid., p. 329.

19. Piet Mondrian, *Plastic Art and Pure Plastic Art, 1937, and Other Essays, 1941—1943* (Documents of Modern Art I). New York, Wittenborn, Schultz, 1945; cited in Robert L. Herbert, ed., *Modern Artists on Art*, Englewood Cliffs, N.J., Prentice-Hall, 1964, p. 126.

20. Ibid., p. 130.

DADA AND SURREALISM

1. Cited in William S. Rubin, *Dada and Surrealist Art*. New York, Harry N. Abrams, 1969, p. 127.

2. Ibid.

3. André Breton, *L'Art Magique*. Paris, Formes et Reflets, 1957, pp. 36—37.

4. Rubin, *Dada and Surrealist Art*, p. 145.

5. James Johnson Sweeney in *Marc Chagall*. New York, Museum of Modern Art, 1946, p. 7.

6. In a lecture of 1934, "What Is Surrealism?" André Breton describes Dali's art as "a new affirmation, accompanied by formal proofs, of the *omnipotence of desire*, which has remained, since the beginnings, surrealism's sole act of faith. At the point where surrealism has taken up the problem, its only guide has been Rimbaud's sibylline pronouncement: 'I say that one must be a *seer*, one must make oneself a seer.' As you know, this was Rimbaud's only means of reaching 'the unknown.' Surrealism can flatter itself today that it has discovered and rendered practicable many other ways leading to the unknown." Cited in Herschel B. Chipp, ed., *Theories of Modern Art: A Source Book by Artists and Critics*. Berkeley and Los Angeles, University of California Press, 1968, p. 416.

7. Guillaume Apollinaire, "Le Vernissage du Salon d'Automne," *L'Intransigeant* (Paris), Nov. 16, 1913; cited in James Thrall Soby, *Giorgio de Chirico*. New York, Museum of Modern Art, 1955, pp. 244—250.

8. George Heard Hamilton, *Painting and Sculpture in Europe: 1880—1940*. Baltimore, Penguin Books, 1967, p. 260.

9. Hugo Ball, diary entry of Aug. 5, 1916, cited in ibid., p. 240.

10. [Jean] Hans Arp, *On My Way: Poetry and Essays, 1912—1947*. New York, Wittenborn, Schultz, 1948, p. 39.

11. Ibid., p. 48.

12. Ibid., p. 77.

13. *Museum of Modern Art Bulletin* (New York), vol. 13, nos. 4—5, 1946, p. 20.

14. Ibid., p. 21.

15. Francis Picabia in *Jésus-Christ Rastaquouère*. Paris, 1920, p. 44.

16. Marcel Duchamp, statement made at "The Art of Assemblage: A Symposium," Museum of Modern Art, New York, Oct. 9, 1961.

17. Ibid.

18. André Breton, "Phare de la Mariée," *Minotaure* (Paris), no. 6, 1935, p. 246; also in André Breton, *Le Surréalisme et la Peinture*. 3rd rev. ed. Paris, Gallimard, 1966; English translation in *View* (New York), vol. 5, Mar. 1945.

19. Kenneth Coults-Smith, *Dada*. London, Studio Vista, 1976, p. 82.

20. Max Ernst, *Beyond Painting and Other Writings by the Artist and His Friends*. New York, Wittenborn, Schultz, 1948, p. 13.

21. Max Ernst, "An Informal Life of M. E. (as told by himself to a young friend)," in William S. Lieberman, ed., *Max Ernst*, New York, Museum of Modern Art, 1961, pp. 11—12.

22. Cited in Georges Hugnet, "Dada," in Alfred H. Barr, Jr., ed., *Fantastic Art, Dada, Surrealism*, and rev. ed. New York, Museum of Modern Art, 1937, p. 30.

23. Cited by J. H. Matthews, *An Introduction to Surrealism*. University Park, Pennsylvania State University Press, 1965, p. 49.

24. André Breton, *Manifeste du Surréalisme*, 1924, in Richard Seaver and Helen R. Lane, trans., *Manifestoes of Surrealism*. Ann Arbor, University of Michigan Press, 1972, p. 14.

25. Ibid., p. 26.

26. James Johnson Sweeney, "Joan Miró: Comment and Interview," *Partisan Review* (New York), vol. 15, no. 2, Feb. 1948, p. 209.

27. Breton, *Le Surréalisme et la peinture*, p. 70.

28. Ibid., p. 145.

29. Ibid., pp. 133—134.

30. "L'Ane Pourri," *Le Surréalisme au Service de la Révolution* (Paris), vol. 1, no. 1, 1930, p. 9.

31. Breton, *Le Surréalisme et la Peinture*, p. 46.

32. Artist's statement, dated 1957, in *Magritte*. Chicago, William and Noma Copley Foundation, n.d., p. 6.

33. Cited in William S. Lieberman, ed., *Modern Masters: Manet to Matisse*. New York, Museum of Modern Art, 1975, p. 198.

34. Benjamin Peret, *Anthologie des Mythes, Légendes et Contes Populaires d'Amérique*. Paris, Albin Michel, 1960, p. 31.

35. Trans. by Lucy R. Lippard, ed., *Surrealists on Art*, Englewood Cliffs, N.J., Prentice-Hall, 1970, p. 53.

36. Ibid.

37. Ibid., p. 54 n. 1.

38. Ibid., p. 51.

39. Cited in Marcel Jean, *The History of Surrealist Painting*. New York, Grove Press, 1960, p. 228.

40. *Minotaure* (Paris), no. 3—4, Dec. 1933, p. 46; English trans. in *Alberto Giacometti*. New York, Museum of Modern Art, 1965, p. 44.

41. Cited in Carola Giedion-Welcker, *Jean Arp*. New York, Harry N. Abrams, 1957, p. xxvii.

42. Francis V. O'Connor, *Jackson Pollock*, ed. Irene Gordon. New York, Museum of Modern Art, 1967, pp. 32—33.

43. Irving Sandler, *The Triumph of American Painting: A History of Abstract Expressionism.* New York, Praeger, 1970, p. 41.

44. Albert Camus, *The Rebel*, trans. Anthony Bower. New York, Alfred A. Knopf, 1967, p. 91.

THE SHAPING OF A NEW ARCHITECTURE: 1818-1940

1. Bruno Taut, in exhibition leaflet, Berlin, Arbeitsrat für Kunst, 1919; trans. and quoted in Ulrich Conrads, *Programs and Manifestoes on 20th-Century Architecture.* Cambridge, Mass., MIT Press, 1970, p. 47.

2. Piet Mondrian, "The Realization of Neo-Plasticism in the Distant Future and in Architecture Today," *De Stijl*, 1922; quoted in H. L. C. Jaffe, *De Stijl.* London, 1970, p. 169.

3. Theo van Doesburg and Cornelis van Eesteren, "Commentary on Manifesto V: Towards Collective Building," *De Stijl*, 1923; in Conrads, *Programs and Manifestoes*, p. 67.

4. Walter Gropius, in exhibition leaflet, Berlin, Arbeitsrat für Kunst, 1919; in Conrads, *Programs and Manifestoes*, p. 46.

5. Walter Gropius, "Programme of the Staatliches Bauhaus in Weimar," 1919; in Conrads, *Programs and Manifestoes*, p. 49.

6. Walter Gropius, "Principles of Bauhaus Production," Dessau, 1926; in Conrads, *Programs and Manifestoes*, pp. 95—96.

7. Le Corbusier, *Towards a New Architecture*, trans. Frederick Etchells. 1st English ed. London, 1927, pp. 69—70.

ART BETWEEN THE WARS

1. Henri Matisse, "Notes d'un Peintre," *La Grande Revue* (Paris), Dec. 25, 1908; English trans. Margaret Scolari in Alfred H. Barr, Jr., *Matisse: His Art and His Public.* New York, Museum of Modern Art, 1951, p. 122.

2. Alfred H. Barr, Jr., *Picasso: Fifty Years of His Art.* New York, Museum of Modern Art, 1946, pp. 270—271.

3. James Johnson Sweeney, "Joan Miró: Comment and Interview," *Partisan Review* (New York), vol. 15, no. 2, Feb. 1948, p. 210.

4. Ibid.

5. Ibid., p. 211.

6. Henry Hope in *Braque.* New York, Museum of Modern Art, 1949, p. 91.

7. Andrew Carnduff Ritchie, "Julio González," *Museum of Modern Art Bulletin* (New York), vol. 23, nos. 1—2, 1955—56, p. 42.

8. *The Listener* (London), vol. 18, no. 449, Aug. 18, 1937, p. 339.

9. Cited by George Heard Hamilton, *Painting and Sculpture in Europe: 1880—1940.* Baltimore, Penguin Books, 1967, p. 204.

10. Cited by Nan R. Piene in exhibition catalogue, *László Moholy-Nagy's Light-Space Modulator.* New York, Howard Wise Gallery, Oct. 23, 1970.

11. Sam Hunter and John Jacobus, *American Art of the 20th Century.* New York, Harry N. Abrams, 1973, p. 114.

12. Quoted in *Stuart Davis.* New York, American Artists Group, 1954, n.p.

13. *Stuart Davis.* Minneapolis, Walker Art Center, 1957.

14. Stuart Davis, "What About Modern Art and Democracy, With Special Reference to George Biddle's Proposals?" *Harpers*, Dec. 1943; reprinted in Diane Kelder, ed., *Stuart Davis.* New York, Praeger, 1971, pp. 131—132.

POSTWAR EUROPEAN ART

1. C. Doelman, "Karel Appel: L'Aventure de la Sensation Extasiée," *Quadrum 3*, 1956, p. 44.

2. *Alberto Giacometti.* New York, Pierre Matisse Gallery, 1948, intro. Jean-Paul Sartre, p. 6.

3. Jean Dubuffet in *Exhibition of Paintings Executed in 1950 and 1951 by Jean Dubuffet.* New York, Pierre Matisse Gallery, Feb.—Mar. 1952, n.p.

4. John Ashbery in introduction to *New Realists.* New York, Sidney Janis, Oct. 31—Dec. 2, 1962, n.p.

5. Mario Amaya, *Pop as Art.* London, Studio Vista, 1965, p. 33.

6. Martin Friedman in *London: The New Scene.* Minneapolis, Walker Art Center, Feb. 6—Mar. 14, 1965, p. 37.

7. In Marcel Joray, ed., *Vasarely.* Vol. I. Neuchâtel, Éditions du Griffon, 1965, p. 36.

THE AMERICAN CONTRIBUTION FROM ACTION PAINTING TO MINIMAL ART

1. Meyer Schapiro, "The Younger American Painters of Today," *The Listener* (London), vol. 60, no. 1404, Jan. 26, 1956.

2. Robert Motherwell, in an interview with Irmeline Lebeer in *Chroniques de L'Art Vivant*, no. 22, July—Aug. 1971; English trans. in exhibition flyer, Minneapolis, Walker Art Center, 1972.

3. William C. Seitz, *The Art of Assemblage.* New York, Museum of Modern Art, 1961, p. 87.

4. Cited in ibid.; from an unpublished manuscript by Allan Kaprow, "Paintings, Environments and Happenings," Old Bridge, New Jersey, 1960, p. 12A.

THE DEMATIERALIZED OBJECT: ART OF TECHNOLOGY ENVIRONMENT AND IDEA

1. Donald Judd, "Specific Objects," in *Arts Yearbook 8: Contemporary Sculpture.* New York, 1965, p. 78.

2. Dave Hickey, "Earthscapes, Landworks and Oze," *Art in America* (New York), vol. 59, no. 5, Sept.—Oct. 1971, p. 44.

3. Sam Hunter and John Jacobus, *American Art of the 20th Century.* New York, Harry N. Abrams, 1973, p. 449.

4. Dr. Lawrence Hatterer, quoted in David L. Shirey, "Impossible Art: What It Is," *Art in America* (New York), vol. 57, May—June 1969, p. 34.

5. Sol Lewitt, "Paragraphs on Conceptual Art," *Artforum* (Los Angeles), vol. 5, June 1967, p. 80.

6. Michael Kirby, *The Art of Time: Essays on the Avant-Garde.* New York, E. P. Dutton, 1972, p. 155.

7. Antonin Artaud, "The Theater of Cruelty (First Manifesto)," in *The Theater and Its Double.* New York, Grove Press, 1958, p. 89.

8. Robert Morris, "Anti-Form," *Artforum* (Los Angeles), vol. 6, Apr. 1968, p. 35.

9. Lucy R. Lippard, *Changing: Essays in Art Criticism.* New York, E. P. Dutton, 1971, p. 297.

10. Jack Burnham, *Beyond Modern Sculpture: The Effects of Science and Technology on the Sculpture of This Century.* New York, George Braziller, 1968, p. 369.

11. Jack Burnham, "Notes on Art and Information Processing," in *Software.* New York, Jewish Museum, Sept. 16—Nov. 8, 1970, pp. 10—11.

ACKNOWLEDGEMENTS

We would like to acknowledge, with deep gratitude, the valuable contribution of our collaborators on this project:

General Editor: Harriet Schoenholz Bee
Text and picture research: Jillian Slonim
Layout: Max Thommen
Production Supervision: Tim Chilvers and Charles Riesen
Copyeditor and proofreader: Eliza Woodward
Coordinator: Jeanne Gross

In addition, we should like to extend our appreciation to the various museums and collectors who kindly allowed us to reproduce works in their possession. In this regard, particular thanks are extended to Sharon Mechling and Rita Myers at the Museum of Modern Art in New York City, from which so many remarkable works have come. A large proportion of the works reproduced here are drawn from illustrations used in the encyclopaedic work "L'Arte Moderna" published by Fratelli Fabbri Editori of Milan. We should like to particularly express our great admiration for the courageous initiative and insight of Dino Fabbri and the late Renata Negri who created this encyclopaedia with Franco Russoli, director of the Brera Museum in Milan.

Finally, we should like to thank the members of the Fabbri staff who today continue the splendid initiative of their founders, and were extremely helpful in assembling and producing the book. Especially helpful were Diana Benusiglio, Grazia Canale and Mirella Calvi.

BIBLIOGRAPHY

PART ONE

PAINTING AND SCULPTURE

Selected by William S. Feldman

I. GENERAL REFERENCES

1. American Abstract Artists (eds.). *The World of Abstract Art*. New York: George Wittenborn, 1957.

2. *The Armory Show: International Exhibition of Modern Art, 1913*. Introduction by Bernard Karpel. 3 vols. New York: Arno Press, 1972.

3. Arnason, H. H. *History of Modern Art: Painting, Sculpture, Architecture*. New York: Harry N. Abrams, 1968.

4. Arnheim, Rudolf. *Art and Visual Perception*. Berkeley and Los Angeles: University of California Press, 1954.

5. *Art Since Mid-Century: The New Internationalism*. 2 vols. Foreword by Jean Leymarie. Vol. 1, *Abstract Art*; vol. 2, *Figurative Art*. Greenwich, Conn.: New York Graphic Society, 1971.

6. *Art since 1945*. Essays by Carlo Argan, Marcel Brion, Will Grohmann, J. P. Hodin, Sam Hunter, Herbert Read, and others. London: Thames and Hudson, 1958.

7. Barr, Alfred H., Jr. (ed.). *Masters of Modern Art*. Survey of the Museum's collection. New York: Museum of Modern Art, 1954.

8. Battcock, Gregory (ed.). *The New Art: A Critical Anthology*. New York: E. P. Dutton, 1966.

9. Baur, John I. H. *Revolution and Tradition in Modern American Art*. Cambridge, Mass.: Harvard University Press, 1951.

10. Burnham, Jack. *The Structure of Art*. New York: George Braziller, 1970.

11. Calas, Nicolas, and Calas, Elena. *Icons and Images of the Sixties*. New York: E. P. Dutton, 1971.

12. Chipp, Herschel B. (ed.). *Theories of Modern Art: A Source Book by Artists and Critics*. Berkeley and Los Angeles: University of California Press, 1968.

13. Friedman, Martin L. *School of Paris, 1959: The Internationals*. Foreword by H. H. Arnason. Minneapolis: Walker Art Center, 1959.

14. Gauss, Charles Edward. *The Aesthetic Theories of French Artists, 1855 to the Present*. Baltimore: Johns Hopkins Press, 1949.

15. Gerdts, William H. *The Great American Nude: A History in Art*. Issued for exhibition at the New York Cultural Center. New York: Praeger, 1974.

16. Goldwater, Robert. *Primitivism in Modern Art*. Rev. ed. New York: Vintage Books, 1967.

17. Hamilton, George Heard. *Painting and Sculpture in Europe: 1880–1940*. Baltimore: Penguin Books, 1967.

18. Herbert, Robert L. (ed.). *Modern Artists on Art*. Englewood Cliffs, N. J.: Prentice-Hall, 1964.

19. Hofmann, Werner. *The Earthly Paradise: Art in the Nineteenth Century*. New York: George Braziller, 1961.

20. Hunter, Sam. *Modern American Painting and Sculpture*. New York: Dell, 1959.

21. Hunter, Sam, and Jacobus, John. *American Art of the 20th Century*. New York: Harry N. Abrams, 1973.

22. Janis, Sidney. *Abstract and Surrealist Art in America*. New York: Reynal, 1944.

23. Kirby, Michael. *The Art of Time: Essays on the Avant-Garde*. New York: E. P. Dutton, 1972.

24. Kramer, Hilton. *The Age of the Avant-Garde: An Art Chronicle of 1956–1972*. New York: Farrar, Straus and Giroux, 1973.

25. Lerner, A. (ed.). *The Hirshhorn Museum and Sculpture Garden, Smithsonian Institution*. Includes essays by Dore Ashton, John Baur, Milton Brown, Alfred Frankenstein, Linda Nochlin, and Irving Sandler. New York: Harry N. Abrams, 1974.

26. Mogelon, Alex, and Laliberté, Norman. *Art in Boxes*. New York: Van Nostrand, Reinhold, 1974.

27. Motherwell, Robert, and Reinhardt, Ad (eds.). *Modern Artists in America, No. 1*. New York: Wittenborn, Schultz, 1951.

28. Mulas, Ugo, and Solomon, Alan. *New York: The New Art Scene*. New York: Holt, Rinehart and Winston, 1967.

29. Myers, Bernard S., and Myers, Shirley D. (eds.). *Dictionary of 20th Century Art*. New York: McGraw-Hill, 1974.

30. Nemser, Cindy. *Art Talk: Conversations with 12 Women Artists*. New York: Charles Scribner's, 1975.

31. *New Art Around the World: Painting and Sculpture*. Essays by Alan Bowness, Sam Hunter, and others. New York: Harry N. Abrams, 1966.

32. New York, Whitney Museum of American Art. *American Art of Our Century*. 1961. Essays by John I. H. Baur and Lloyd Goodrich.

33. O'Connor, Francis V. *Art for the Millions: Essays from the 1930's by Artists and Administrators of the WPA Federal Art Project*. Boston: New York Graphic Society, 1975.

34. Plagens, Peter. *Sunshine Muse: Contemporary Art on the West Coast*. New York: Praeger, 1974.

35. Read, Herbert. *The Philosophy of Modern Art*. London: Faber and Faber, 1952.

36. Richardson, Anthony, and Stangos, Nikos. *Concepts of Modern Art*. New York: Harper and Row, 1974.

37. Ritchie, Andrew Carnduff. *Abstract Painting and Sculpture in America*. New York: Museum of Modern Art, 1951.

38. Rose, Barbara. *American Art Since 1900: A Critical History*. New York: Praeger, 1967.

39. Rose, Barbara. *Readings in American Art Since 1900: A Documentary Survey*. New York: Praeger, 1968.

40. Selz, Peter. *New Images of Man*. New York: Museum of Modern Art, 1959.

41. Stein, Gertrude. *The Autobiography of Alice B. Toklas*. New York: Vintage Books, 1960. Original edition: New York, Random House, 1933.

42. Wilmington, Delaware Art Museum, *Avant-Garde Painting and Sculpture in America*. Essays by William Homer and others. 1975.

43. Worringer, Wilhelm. *Abstraction and Empathy: A Contribution to the Psychology of Style*. New York: International Universities Press, 1953.

II. PAINTING

44. Baigell, Matthew. *The American Scene: American Painting of the 1930s*. New York: Praeger, 1974.

45. Ballo, Guido. *Modern Italian Painting from Futurism to the Present Day*. New York: Praeger, 1958.

46. Barr, Alfred H., Jr. *What Is Modern Painting?* New York: Museum of Modern Art, 1956.

47. Brown, Milton W. *American Painting from the Armory Show to the Depression*. Princeton, N. J.: Princeton University Press, 1955.

48. Geldzahler, Henry. *American Painting in the 20th Century*. Catalogue of the Museum's collection. New York: Metropolitan Museum of Art, 1965.

49. Haftmann, Werner. *Painting in the Twentieth Century*. 2 vols. New York: Praeger, 1965.

50. Hess, Thomas. *Abstract Painting: Background and American Phase*. New York: Viking, 1951.

51. Hunter, Sam. *Modern French Painting: 1855–1956*. New York: Dell, 1956.

52. Lake, Carlton, and Maillard, Robert (eds.). *Dictionary of Modern Painting*. New York: Tudor, 1955.

53. Lieberman, William S. (ed.). *Modern Masters: Manet to Matisse*. New York: Museum of Modern Art, 1975.

54. Raynal, Maurice, and others. *History of Modern Painting*. 3 vols. Vol. 1, *From Baudelaire to Bonnard*; vol. 2, *Matisse, Munch, Rouault, Fauvism, Expressionism*; vol. 3, *From Picasso to Surrealism*. Geneva: Skira, 1949–50.

55. Read, Herbert. *A Concise History of Modern Painting*. New York: Praeger, 1959.

56. Ritchie, Andrew Carnduff. *Masters of British Painting. 1800–1950*. New York, Museum of Modern Art. 1956.

57. Rosenblum, Robert. *Modern Painting and the Northern Romantic Tradition: Friedrich to Rothko*. New York: Harper and Row, 1975.

58. Seuphor, Michel. *Dictionary of Abstract Painting*. New York: Paris Book Center, 1957.

59. Soby, James Thrall. *After Picasso*. Hartford, Conn.: Mitchell; and New York: Dodd, Mead, 1935.

60. Sweeney, James [Johnson]. *Plastic Redirections in Twentieth-Century Painting*. Chicago: University of Chicago Press, 1934.

III. SCULPTURE

61. Andersen, Wayne. *American Sculpture in Process: 1930–1970*. Boston: New York Graphic Society, 1975.

62. Arnason, H. H., and Guerrero, Pedro. *Alexander Calder*. New York: Van Nostrand, 1966.

63. Ashton, Dore. *Modern American Sculpture*. New York: Harry N. Abrams, 1968.

64. Bowness, Alan. *Modern Sculpture*. New York: E. P. Dutton; and London: Studio Vista, 1965.

65. Burnham, Jack. *Beyond Modern Sculpture: The Effects of Science and Technology on the Sculpture of This Century*. New York: George Braziller, 1968.

66. Elsen, Albert E. *Origins of Modern Sculpture: Pioneers and Premises*. New York: George Braziller, 1974.

67. Elsen, Albert E. *The Partial Figure in Modern Sculpture from Rodin to 1969*. Baltimore: Baltimore Museum of Art, 1969.

68. Elsen, Albert E. *Rodin*. New York: Museum of Modern Art, 1963.

69. Elsen, Albert [E]. *The Sculpture of Henri Matisse*. New York: Harry N. Abrams, 1972.

70. Geist, Sidney. *Brancusi: A Study of the Sculpture*. New York: Grossman, 1968.

71. Giedion-Welcker, Carola. *Constantin Brancusi*. New York: George Braziller, 1959.

72. Giedion-Welcker, Carola. *Contemporary Sculpture: An Evolution in Volume and Space*. New York: George Wittenborn, 1960.

73. Goldwater, Robert. *What Is Modern Sculpture?* New York: Museum of Modern Art, 1969.

74. Gray, Cleve (ed.). *David Smith by David Smith*. New York: Holt, Rinehart and Winston, 1968.

75. Hohl, Reinhold. *Alberto Giacometti*. New York: Harry N. Abrams, 1971.

76. James, Philip (ed.). *Henry Moore on Sculpture*. New York: Viking, 1971.

77. Licht, Fred. *Sculpture: 19th and 20th Centuries*. Greenwich, Conn.: New York Graphic Society, 1967.

78. Maillard, Robert (ed.). *New Dictionary of Modern Sculpture*. New York: Tudor, 1971.

79. New York, Museum of Modern Art. *Alberto Giacometti*. 1965. Introduction by Peter Selz; statement by the artist.

80. New York, Solomon R. Guggenheim Museum. *Alexander Calder*. 1964. Introduction by Thomas Messer.

81. Penrose, Roland. *The Sculpture of Picasso*. New York: Museum of Modern Art, 1967.

82. Read, Herbert. *The Art of Sculpture*. New York: Pantheon Books, 1956.

83. Read, Herbert. *A Concise History of Modern Sculpture*. New York: Praeger, 1971.

84. Ritchie, Andrew Carnduff. *Sculpture of the Twentieth Century*. New York: Museum of Modern Art, 1952.

85. Selz, Jean. *Modern Sculpture: Origins and Evolution*. New York: George Braziller, 1963.

86. Seuphor, Michel. *The Sculpture of This Century*. New York: George Braziller, 1960.

87. Trier, Eduard. *Form and Space: Sculpture of the Twentieth Century*. Rev. ed. New York: Praeger, 1968.

88. Tucker, William. *Early Modern Sculpture: Rodin, Degas, Matisse, Brancusi, Picasso, González*. New York: Oxford University Press, 1974.

89. Valentiner, Wilhelm R. *Origins of Modern Sculpture*. New York: George Wittenborn, 1946.

IV. MOVEMENTS

Post-Impressionism and Neo-Impressionism

90. Andersen, Wayne. *Gauguin's Paradise Lost*. New York: Viking, 1971.

91. Cooper, Douglas. *Henri de Toulouse-Lautrec*. New York: Harry N. Abrams, 1956.

92. Fry, Roger. *Cézanne: A Study of His Development*. New York: Macmillan; and London: Woolf, 1927.

93. Gauguin, Paul. *Intimate Journals*. Preface by Emil Gauguin. Bloomington: Indiana University Press, 1958.

94. Goldwater, Robert. *Paul Gauguin*. New York: Harry N. Abrams, [1957].

95. Goldwater, Robert. "Some Aspects of the Development of Seurat's Style." *Art Bulletin*, vol. 23, June 1941, pp. 117–30.

96. Goldwater, Robert. "Symbolic Form: Symbolic Content." In *Problems of the 19th and 20th Centuries. Acts of the XX International Congress of the History of Art*, vol. 4. Princeton, N. J.: Princeton University Press, 1963, pp. 111–121.

97. Hammacher, Abraham Marie. *Genius and Disaster: The Ten Creative Years of Vincent van Gogh*. New York: Harry N. Abrams, 1968.

98. Herbert, Robert L. *Neo-Impressionism*. New York: Solomon R. Guggenheim Museum, 1968.

99. Homer, William. *Seurat and the Science of Painting*. Cambridge, Mass.: M.I.T. Press, 1964.

100. Hunter, Sam. *Henri de Toulouse-Lautrec*. New York: Harry N. Abrams, 1953.

101. Løvgren, Sven. *The Genesis of Modernism: Seurat, Gauguin, Van Gogh and French Symbolism in the 1880's*. Stockholm: Almquist and Wiksell, 1959.

102. Nochlin, Linda (ed.). *Impressionism and Post-Impressionism, 1874–1904: Sources and Documents*. Englewood Cliffs, N. J.: Prentice-Hall, 1966.

103. Rewald, John. *The History of Impressionism*. Rev. ed. New York: Museum of Modern Art, 1961. 4th rev. ed., 1973.

104. Rewald, John. *Post-Impressionism from Van Gogh to Gauguin*. 2nd ed. New York: Museum of Modern Art, 1962.

105. Rewald, John (ed.). *Paul Cézanne: Letters*. London: Bruno Cassirer, 1941.

106. Rookmaaker, H. R. *Synthetist Art Theories: Genesis and Nature of the Ideas on Art of Gauguin and His Circle*. Amsterdam: Swets and Zeitlinger, 1959.

107. Roskill, Mark. *Van Gogh, Gauguin and the Impressionist Circle*. Greenwich, Conn.: New York Graphic Society, 1970.

108. Schapiro, Meyer. *Paul Cézanne*. 3rd ed. New York: Harry N. Abrams, 1965.

109. Schapiro, Meyer. "Seurat and 'La Grande Jatte.'" *Columbia Review*, vol. 17, 1935, pp. 9–16.

110. Schapiro, Meyer. *Vincent van Gogh*. New York: Harry N. Abrams, 1950.

111. Van Gogh-Bonger, J., and van Gogh, W. V. (eds. and trans.). *The Complete Letters of Vincent van Gogh*. 3 vols. Greenwich, Conn.: New York Graphic Society, 1958.

112. Venturi, Lionello. *Impressionists and Symbolists*. New York: Charles Scribner's, 1950.

The Nabis, Symbolism, and Art Nouveau

113. Amaya, Mario. *Art Nouveau*. New York: E. P. Dutton; and London: Studio Vista, 1966.

114. Baudelaire, Charles. *The Flowers of Evil*. Edited by Marthiel and Jackson Mathews. New York: New Directions, 1955.

115. Cassou, Jean; Langui, Emil; and Pevsner, Nikolaus. *Gateway to the Twentieth Century*. New York: McGraw-Hill, 1962.

116. Chassé, Charles. *The Nabis and Their Period*. New York: Praeger, 1969.

117. Deknatel, Frederick B. *Edvard Munch*. New York: Museum of Modern Art, 1950.

118. Jullian, Philippe. *Dreamers of Decadence: Symbolist Painters of the 1890s*. New York: Praeger, 1974.

119. Kaplan, Julius. *Gustave Moreau*. Los Angeles: Los Angeles County Museum of Art; and Greenwich, Conn.: New York Graphic Society, 1974.

120. Lehmann, A. G. *The Symbolist Aesthetic in France, 1885–1895*. Folcroft, Pa.: Folcroft Press, 1950.

121. London, Hayward Gallery. *French Symbolist Painters: Moreau, Puvis de Chavannes, Redon, and Their Followers*. 1972. Introduction by Philippe Jullian; essay by Alan Bowness.

122. Lucie-Smith, Edward. *Symbolist Art*. New York: Praeger, 1972.

123. Madsen, Stephan Tschudi. *Sources of Art Nouveau*. New York: George Wittenborn, 1956.

124. Milner, John. *Symbolists and Decadents*. New York: E. P. Dutton; and London: Studio Vista, 1971.

125. New York, Museum of Modern Art. *Odilon Redon, Gustave Moreau, Rodolphe Bresdin.* 1961. Essays by Dove Ashton, Henry Joachim, and John Rewald.

126. Pevsner, Nikolaus. *Art Nouveau in Britain.* London: Arts Council of Great Britain, 1965.

127. Powell, Nicolas. *The Sacred Spring: The Arts in Vienna, 1898–1918.* Greenwich, Conn.: New York Graphic Society, 1974.

128. Praz, Mario. *The Romantic Agony.* 2nd ed. London: Oxford University Press, 1970.

129. Reade, Brian. *Aubrey Beardsley.* New York: Viking, 1967.

130. Rheims, Maurice. *The Flowering of Art Nouveau.* New York: Harry N. Abrams, 1966.

131. Schmutzler, Robert. *Art Nouveau.* New York: Harry N. Abrams, 1964.

132. Selz, Peter, and Constantine, Mildred (eds.). *Art Nouveau: Art and Design at the Turn of the Century.* New York: Museum of Modern Art, 1959.

133. Toronto, Art Gallery of Ontario. *The Sacred and Profane in Symbolist Art.* 1972.

Fauvism

134. Barr, Alfred H., Jr. *Matisse: His Art and His Public.* New York: Museum of Modern Art, 1951. Reprinted 1974.

135. Crespelle, Jean-Paul. *The Fauves.* Greenwich, Conn.: New York Graphic Society, 1962.

136. Diehl, Gaston. *The Fauves.* New York: Harry N. Abrams, 1975.

137. Duthuit, Georges. *The Fauvist Painters* (Documents of Modern Art II). New York: Wittenborn, Schultz, 1950.

138. Jacobus, John. *Henri Matisse.* New York: Harry N. Abrams, 1973.

139. Lieberman, William S. *Matisse, 50 Years of His Graphic Art.* New York: George Braziller, 1956.

140. Muller, Joseph-Émile. *Fauvism.* New York: Praeger, 1967.

141. New York, Museum of Modern Art. *Les Fauves.* 1952. Introduction by John Rewald.

142. New York, Museum of Modern Art. *The "Wild Beasts": Fauvism and Its Affinities.* 1976. Exhibition organized by John Elderfield.

Expressionism

143. Buchheim, Lothar-Günther. *The Graphic Art of German Expressionism.* New York: Universe Books, 1960.

144. Fischer, Friedhelm. *Max Beckmann.* London: Phaidon, 1973.

145. Grohmann, Will. *Expressionists.* New York: Harry N. Abrams, 1957.

146. Grohmann, Will. *Wassily Kandinsky: Life and Work.* New York: Harry N. Abrams, 1958.

147. Kandinsky, Wassily. *Concerning the Spiritual in Art* (Documents of Modern Art V). Translated and with an introduction by Michael Sadleir. New York: Wittenborn, Schultz, 1947.

148. Lankheit, Claus (ed.). *The Blaue Reiter Almanac. Edited by Wassily Kandinsky and Franz Marc.* New York: Viking, 1974.

149. Myers, Bernard S. *The German Expressionists: A Generation in Revolt.* New York: Praeger, 1957.

150. Miesel, Victor H. *Voices of German Expressionism.* Englewood Cliffs, N.J.: Prentice-Hall, 1970.

151. New York, Leonard Hutton Galleries. *Der Blaue Reiter.* 1963. Essay by Peter Selz.

152. New York, Museum of Modern Art. *Max Beckmann.* 1964. Essays by Harold Joachim, P. T. Rathbone, and Peter Selz.

153. Raabe, Paul (ed.) *The Era of German Expressionism.* New York: Viking, 1974.

154. Selz, Peter. *German Expressionist Painting.* Berkeley and Los Angeles: University of California Press, 1957.

155. Willet, John. *Expressionism.* New York: *McGraw-Hill, 1970.*

156. Worringer, Wilhelm. *Form in Gothic.* Edited and translated by Herbert Read. London: G. P. Putnam, 1927; and New York: Schocken, 1964.

157. Zigrosser, Carl. *The Expressionists: A Survey of Their Graphic Art.* New York: Universe Books, 1957.

Cubism and Collage

158. Apollinaire, Guillaume. *The Cubist Painters.* Translated by Lionel Abel. New York: George Wittenborn, 1944.

159. Barr, Alfred H., Jr. *Cubism and Abstract Art.* New York: Museum of Modern Art, 1936. Reprinted 1974.

160. Barr, Alfred H., Jr. *Picasso: Fifty Years of His Art.* New York: Museum of Modern Art, 1946. Reprinted 1966.

161. Cooper, Douglas. *The Cubist Epoch.* Los Angeles: Los Angeles County Museum of Art, 1970.

162. Fry, Edward. *Cubism.* New York: Praeger, 1966.

163. Gleizes, Albert, and Metzinger, Jean. *Cubism.* London: Unwin, 1913.

164. Gray, Christopher. *Cubist Aesthetic Theories.* Baltimore: Johns Hopkins Press, 1953.

165. Golding, John. *Cubism: A History and an Analysis, 1907–1914.* New York: George Wittenborn, 1959.

166. Hope, Henry. *Braque.* New York: Museum of Modern Art, 1949.

167. Janis, Harriet, and Blesh, Rudi. *Collage.* Philadelphia: Chilton, 1962.

168. Kahnweiler, Daniel-Henry, and Crémieux, Francis. *My Galleries and Painters.* New York: Viking, 1971.

169. Kozloff, Max. *Cubism/Futurism.* New York: Charterhouse, 1973.

170. Ozenfant, Amédée. *Foundations of Modern Art.* New ed. New York: Dover, 1952.

171. Penrose, Roland, and Golding, John (eds.). *Picasso in Retrospect.* Includes essays by D.-H. Kahnweiler, Robert Rosenblum, and others. New York: Praeger, 1973.

172. Richardson, John. *G. Braque.* Greenwich, Conn.: New York Graphic Society, 1961.

173. Rosenblum, Robert. *Cubism and Twentieth-Century Art.* New York: Harry N Abrams, 1961.

174. Rosenblum, Robert. "Picasso and the Typography of Cubism." In *Picasso in Retrospect.* Edited by Roland Penrose and John Golding. New York: Praeger, 1973, pp. 49–75.

175. Rubin, William S. *Picasso in the Collection of The Museum of Modern Art.* New York: Museum of Modern Art, 1972.

176. Steinberg, Leo. "The Philosophical Brothel." *Art News,* vol. 71, September 1972, pp. 20–29; October 1972, pp. 38–47. On Picasso's *Demoiselles d'Avignon.*

177. Wescher, Herta. *Collage.* New York: Harry N. Abrams, 1968.

Futurism

178. Apollonio, Umbro (ed.). *Futurist Manifestoes.* New York: Viking, 1973.

79. Martin, Marianne. *Futurist Art and Theory, 1909–1915.* Oxford: Clarendon Press, 1968.

180. New York, Solomon R. Guggenheim Museum. *Futurism: A Modern Focus.* 1973. Essay by Marianne Martin.

181. Taylor, Joshua C. *Futurism.* New York: Museum of Modern Art, 1961.

Constructivism

182. Arp, [Jean] Hans, and Lissitzky, El. *The Isms of Art.* Zurich: 1925. Reprint: New York, Arno Press, 1968.

183. Bann, Stephen (ed.). *The Tradition of Constructivism.* New York: Viking, 1974.

184. *Circle: International Survey of Constructive Art.* Edited by J. L. Martin, Ben Nicholson, Naum Gabo. London: Faber and Faber, 1937. Reprint: New York, Praeger, 1971.

185. Gabo, Naum, and Pevsner, Antoine. *The Realist Manifesto.* Moscow, August 5, 1920. Reproduced and translated in *Gabo: Constructions, Sculpture, Drawings, Engravings.* London: Lund Humphries, 1951.

186. Gray, Camilla. *The Great Experiment: Russian Art 1863–1922.* New York: Harry N. Abrams, 1962.

187. Malevich, Kasimir. *The Non-Objective World.* Translated by Howard Deastyrne. Chicago: Theobald, 1959.

188. New York, Leonard Hutton Galleries. *Russian Avant-Garde, 1908–1922.* 1971. Introduction by John E. Bowlt and S. Frederick Starr.

189. Rickey, George. *Constructivism: Origins and Evolution.* New York: George Braziller, 1967.

190. *Studio International* [periodical]. Vol. 171, April 1966. Special issue: *Naum Gabo and the Constructivist Tradition.* Includes "Realist Manifesto," "Naum Gabo Talks About His Work," essays by D. Thompson, A. Hill, and J. Ernest.

De Stijl and Geometric Abstraction

191. Barr, Alfred H., Jr. *De Stijl, 1917–1928.* New York: Museum of Modern Art, 1961.

192. Dallas, Museum of Fine Arts. *Geometric Abstraction: 1926–1942.* 1972. Essays by John Elderfield and Michel Seuphor.

193. Doesburg, Theo van. *Principles of Neo-Plastic Art.* Greenwich, Conn.: New York Graphic Society, 1968.

194. Jaffé, Hans L. C. *De Stijl.* New York: Harry N. Abrams, 1968.

195. Jaffé, Hans. *Piet Mondrian.* New York: Harry N. Abrams, 1970.

196. London, Annely Juda Fina Art. *The Non-Objective World, 1914–1955.* 1973. Essays by Margit Staber and Gerhard Weber. Exhibition also shown at the Art Museum, University of Texas at Austin.

197. Mondrian, Piet. *Plastic Art And Pure Plastic Art, 1937, and Other Essays, 1941–1943* (Documents of Modern Art I). New York: Wittenborn, Schultz, 1945.

Bauhaus

198. Albers, Josef. *Interaction of Color.* 2 vols. New Haven and London: Yale University Press, 1963.

199. Bayer, Herbert; Gropius, Walter; and Gropius, Ise (eds.). *Bauhaus, 1919–1928.* New York: Museum of Modern Art, 1938. Reprinted 1972.

200. Chicago, Illinois Institute of Technology. *50 Year Bauhaus.* 1969. English translation of exhibition catalogue published by the Wurttembergischer Kunstverein, Stuttgart, 1968. Includes essays, statements by artists, extensive documentation.

201. Franciscono, Marcel. *Walter Gropius and the Creation of the Bauhaus in Weimar: The Ideals and Artistic Theories of Its Founding Years.* Urbana, Ill.: University of Illinois Press, 1971.

202. Grohmann, Will (ed.). *Painters of the Bauhaus.* London: Marlborough Fine Art Ltd., 1962.

203. Haftmann, Werner. *The Mind and Work of Paul Klee.* New York: Praeger, 1954.

204. Itten, Johannes. *Design and Form: The Basic Course at the Bauhaus.* New York: Reinhold, 1964.

205. Klee, Paul. *The Thinking Eye: The Notebooks of Paul Klee.* Edited by Jürg Spiller. New York: George Wittenborn, 1961.

206. Moholy-Nagy, László. *Vision in Motion.* Chicago: Theobald, 1947.

207. Pevsner, Nikolaus. *Pioneers of the Modern Movement.* London: Faber and Faber, 1936. Rev. ed.: *Pioneers of Modern Design from William Morris to Walter Gropius.* Harmondsworth, Penguin, 1960; reprinted 1964.

208. Spies, Werner, *Josef Albers.* New York: Harry N. Abrams, 1962.

209. Wingler, Hans Maria. *Bauhaus: Weimar, Dessau, Berlin, Chicago.* Cambridge, Mass.: MIT Press, 1969.

Dada and Surrealism

210. Arp, [Jean] Hans. *On My Way: Poetry and Essays, 1912–1947.* New York: Wittenborn, Schultz, 1948.

211. *Artforum* [periodical]. Vol. 5, September 1966. Special issue: *Surrealism.* Includes articles by Nicolas Calas, Max Kozloff, Lucy R. Lippard, Robert Rosenblum, William S. Rubin, and others.

212. Balakian, Anna. *Surrealism: The Road to the Absolute.* Rev. and enl. ed. New York: E. P. Dutton, 1970.

213. Ball, Hugo. *Flight Beyond Time: A Dada Diary.* Edited by John Elderfield. New York: Viking, 1974.

214. Barr, Alfred H., Jr. (ed.). *Fantastic Art, Dada, Surrealism.* 2nd rev. ed. Includes essays by Georges Hugnet. New York: Museum of Modern Art, 1937.

215. Breton, André. *Manifestoes of Surrealism.* Translated by Richard Seaver and Helen R. Lane. Ann Arbor: University of Michigan Press, 1972.

216. Breton, André. *Surrealism and Painting.* Translated by Simon Watson Taylor. London: MacDonald, 1972.

217. Breton, André. *What Is Surrealism?* London: Faber and Faber, 1936.

218. Camfield, William. *Francis Picabia.* New York: Solomon R. Guggenheim Museum, 1970.

219. Dali, Salvador. *The Secret Life of Salvador Dali.* New York: Dial Press, 1942.

220. D'Harnoncourt, Anne, and McShine, Kynaston. *Marcel Duchamp.* Exhibition organized by the Philadelphia Museum of Art and the Museum of Modern Art, New York. Greenwich, Conn.: New York Graphic Society, 1973.

221. Dupin, Jacques. *Joan Miró: His Life and Work.* Includes catalogue raisonné. New York: Harry N. Abrams, 1962.

222. Ernst, Max. *Beyond Painting and Other Writings by the Artist and His Friends.* New York: Wittenborn, Schultz, 1948.

223. Gablik, Suzi. *Magritte.* Greenwich, Conn.: New York Graphic Society, 1973.

224. Gaunt, William. *The Surrealists.* New York: G. P. Putnam's Sons, 1972.

225. Giedion-Welcker, Carola. *Jean Arp.* New York: Harry N. Abrams, 1957.

226. Goldwater, Robert. *Space and Dream.* New York: Walker, 1967.

227. Greenberg, Clement. *Joan Miró.* New York: Quadrangle Press, 1948.

228. Huelsenbeck, Richard. *Memoirs of a Dada Drummer.* Edited by Hans J. Kleinschmidt. New York: Viking, 1974.

229. Lippard, Lucy R. (ed.). *Dadaists on Art.* Englewood Cliffs, .J.: Prentice-Hall, 1971.

230. Lippard, Lucy R. (ed.). *Surrealists on Art.* Englewood Cliffs, N. J.: Prentice-Hall, 1970.

231. Motherwell, Robert. *The Dada Painters and Poets: An Anthology.* New York: George Wittenborn, 1951.

232. Nadeau, Maurice. *The History of Surrealism.* New York: Macmillan, 1965.

233. New York, Museum of Modern Art. *André Masson.* 1976. Essays by Caroline Lanchner and William S. Rubin.

234. Richter, Hans. *Dada: Art and Anti-Art.* New York: Harry N. Abrams, 1970.

235. Rubin, William S. *Dada, Surrealism, and Their Heritage.* New York: Museum of Modern Art, 1968.

236. Rubin, William S. *Dada and Surrealist Art.* New York: Harry N. Abrams, 1967.

237. Russell, John. *Max Ernst: Life and Work.* New York: Harry N. Abrams, 1967.

238. Schneede, Uwe M. *Surrealism.* New York: Harry N. Abrams, 1974.

239. Schwarz, Arturo. *Marcel Duchamp.* New York: Harry N. Abrams, 1975.

240. Schwarz, Arturo. *New York Dada: Duchamp, Man Ray, Picabia.* Munich: Prestel-Verlag, 1973.

241. Šmejkal, František. *Surrealist Drawings.* London: Octopus, 1974.

242. Soby, James Thrall. *Giorgio de Chirico.* Revised and enlarged version of the author's *The Early Chirico.* New York: Museum of Modern Art, 1955. Reprinted 1966.

243. Soby, James Thrall. *Salvador Dali.* 2nd. rev. ed. New York: Museum of Modern Art, 1946. Originally published 1942.

244. Soby, James Thrall. *Yves Tanguy.* New York: Museum of Modern Art, 1955.

245. Waldberg, Patrick. *René Magritte.* Brussels: André de Rache, 1965.

246. Waldberg, Patrick. *Surrealism.* New York: McGraw-Hill, 1965.

247. Waldman, Diane. *Max Ernst: A Retrospective.* New York: Solomon R. Guggenheim Museum, 1975.

Abstract Expressionism

248. *Artforum* [periodical]. Vol. 4, September 1965. Special issue: *The New York School.* Includes articles by Lawrence Alloway, Michael Fried, Philip Leider, Irving Sandler, and Sidney Tillim; interviews with Dzubas, Matta, and Motherwell.

249. Ashton, Dore. *The New York School: A Cultural Reckoning.* New York: Viking, 1973.

250. Fried, Michael. *Morris Louis.* New York: Harry N. Abrams, 1970.

251. Geldzahler, Henry (ed.). *New York Painting and Sculpture: 1940–1970.* Includes reprints of H. Rosenberg, "The American Action Painters"; R. Rosenblum, "The Abstract Sublime"; C. Greenberg, "After Abstract Expressionism"; W. S. Rubin, "Arshile Gorky, Surrealism, and the New American Painting." New York: Metropolitan Museum of Art, 1969.

252. Goldwater, Robert. "Reflections on the New York School." *Quadrum 8,* 1960, pp. 17–36.

253. Greenberg, Clement. *Hofmann.* Paris: Éditions Georges Fall, 1961.

254. Greenberg, Clement. "The Present Prospects of American Painting and Sculpture." *Horizon* (London), no. 93–94, October 1947, pp. 20–30.

255. Hess, Thomas B. *Barnett Newman.* New York: Museum of Modern Art, 1971.

256. Hess, Thomas B. *Willem de Kooning.* New York: Museum of Modern Art, 1968.

257. Hunter, Sam. *Hans Hofmann.* New York: Harry N. Abrams, 1963.

258. *It Is* [periodical]. Nos. 1–5, 1958–1965 (New York). A magazine of abstract art edited by P. G. Pavia.

259. O'Connor, Francis V. *Jackson Pollock.* Edited by Irene Gordon. Includes transcript of interview with the artist. New York; Museum of Modern Art, 1967.

260. O'Hara, Frank. *Robert Motherwell.* Includes selected writings by the artist. New York: Museum of Modern Art, 1965.

261. New York, Museum of Modern Art. *The New American Painting.* 1959. Introduction by René D'Harnoncourt and Alfred H. Barr, Jr.

262. New York, Solomon R. Guggenheim Museum. *American Abstract Expressionists and Imagists.* 1961. Introduction by H. H. Arnason.

263. Ragon, Michel. "The Cobra Group and Lyrical Expressionism." *Cimaise,* no. 59, May–June 1962, pp. 26–45.

264. Robertson, Bryan. *Jackson Pollock.* New York: Harry N. Abrams, 1960.

265. Rose, Barbara. "Abstract Illusionism." *Artforum,* vol. 6, October 1967, pp. 33–37.

266. Rose, Barbara. *Helen Frankenthaler*. New York: Harry H. Abrams, 1971.

267. Rosenberg, Harold. *Arshile Gorky: The Man, the Time, the Idea*. New York: Horizon Press, 1962.

268. Rosenberg, Harold. *De Kooning*. New York: Harry N. Abrams, 1974.

269. Rosenberg, Harold. *The Tradition of the New*. New York: Horizon Press, 1959.

270. Rubin, William S. "Jackson Pollock and the Modern Tradition." *Artforum* (4 parts), vol. 5, February 1967, pp. 14–22; March 1967, pp. 28–37; April 1967, pp. 18–31; May 1967, pp. 28–33.

271. Sandler, Irving. *The Triumph of American Painting: A History of Abstract Expressionism*. New York: Praeger, 1970.

272. Schapiro, Meyer. "The Liberating Quality of Avant-Garde Art." *Art News*, vol. 56, Summer 1957, pp. 36–42.

273. Schwabacher, Ethel. *Arshile Gorky*. Introduction by Meyer Schapiro. New York: Macmillan, 1957.

274. Tuchman, Maurice (ed.). *The New York School: The First Generation. Paintings of the 1940s and 1950s.* Includes statements by the artists and critics. Los Angeles: Los Angeles County Museum of Art, 1967.

Pop Art, Assemblage, and Happenings

275. Alloway, Lawrence. *American Pop Art*. New York: Collier Books and Whitney Museum of American Art, 1974.

276. Amaya, Mario. *Pop Art . . . and After*. New York: Viking, 1965. Also issued as *Pop as Art*. London: Studio Vista, 1965.

277. Compton, Michael. *Pop Art*. New York and London: Hamlyn, 1970.

278. Forge, Andrew. *Robert Rauschenberg*. New York: Harry N. Abrams, 1969.

279. Kaprow, Allan. *Assemblage, Environments, and Happenings*. New York: Harry N. Abrams, 1966.

280. Kirby, Michael. *Happenings: An Illustrated Anthology*. New York, E. P. Dutton, 1965.

281. Kulturmann, Udo. *The New Sculpture: Environments and Assemblages*. London: Thames and Hudson, 1968.

282. Lippard, Lucy R. (ed.). *Pop Art*. Includes essays by Lawrence Alloway, Nicolas Calas, and Nancy Marmer. New York: Praeger, 1966.

283. London, Institute of Contemporary Art. *Man, Machine, and Motion*. 1955. Essays by Lawrence Gowing and Richard Hamilton.

284. New York, Martha Jackson Gallery. *New Forms—New Media I*. 1960. Essays by Lawrence Alloway and Allan Kaprow.

285. New York, Sidney Janis Gallery. *New Realists*. 1962. Introduction by John Ashbery.

286. Oldenburg, Claes. *Store Days*. New York: Something Else Press, 1967.

287. Rose, Barbara. *Claes Oldenburg*. New York: Museum of Modern Art, 1970.

288. Russell, John, and Gablik, Suzi. *Pop Art Redefined*. New York: Praeger, 1969.

289. Seitz, William C. *The Art of Assemblage*. New York: Museum of Modern Art, 1961.

290. Steinberg, Leo. *Jasper Johns*. New York: George Wittenborn, 1963.

291. Swenson, G. R. "What Is Pop Art?: Answers from 8 Painters." *Art News* (two parts), vol. 62, November 1963, pp. 24–27, 60–63; February 1964, pp. 40–43, 66–67.

292. Waldman, Diane. *Roy Lichtenstein*. New York: Harry N. Abrams, 1971.

293. Warhol, Andrew. *The Philosophy of Andy Warhol (From A to B and Back Again)*. New York: Harcourt, Brace, Jovanovich, 1975.

New Realism

294. *Art in America* [periodical]. Vol. 60, November 1972, pp. 58–107. Special issue: *Photo-Realism*. Includes William C. Seitz, "The Real and the Artificial"; J. Mashek, "Verist Sculpture"; interviews with artists.

295. Battcock, Gregory (ed.). *Super Realism: A Critical Anthology*. New York: E. P. Dutton, 1975.

296. Chase, Linda. *Hyperrealism*. New York: Rizzoli, 1975.

297. Kultermann, Udo. *New Realism*. Greenwich, Conn.: New York Graphic Society, 1972.

298. Milwaukee, Milwaukee Art Center. *Directions 2: Aspects of a New Realism*. 1969. Essays by Tracy Atkinson and John L. Taylor.

299. Monte, James K. *22 Realists*. New York: Whitney Museum of American Art, 1970.

300. New York, American Federation of Arts. *The Realist Revival*. 1972. Exhibition held at the New York Cultural Center and elsewhere. Essay by Scott Burton.

301. New York, Solomon R. Guggenheim Museum. *The Photographic Image*. 1966. Introduction by Lawrence Alloway.

302. Tillim, Sidney. "A Variety of Realisms." *Artforum*, vol. 7, Summer 1969, pp. 42–47.

Minimal Art

303. *Artforum* [periodical]. Vol. 5, Summer 1967, pp. 6–92. Special issue: *American Sculpture*. Essays by Wayne Anderson, Michael Fried, Max Kozloff, Philip Leider, James Monte, Robert Morris, Barbara Rose, Robert Smithson, and Sidney Tillim.

304. Battcock, Gregory (ed.). *Minimal Art: A Critical Anthology*. New York: E. P. Dutton, 1968.

305. Coplans, John. *Serial Imagery*. Exhibition held at Pasadena Art Museum. Greenwich, Conn.: New York Graphic Society, 1968.

306. Fried, Michael. *Kenneth Noland*. New York: Jewish Museum, 1965.

307. Fried, Michael. *Three American Painters: Kenneth Noland, Jules Olitski, Frank Stella*. Cambridge, Mass.: Fogg Art Museum, 1965.

308. Goosen, Eugene C. *The Art of the Real*. New York: Museum of Modern Art, 1968.

309. Judd, Don[ald]. "Black, White, and Gray." *Arts Magazine*, vol. 38, March 1964, pp. 36–38.

310. Judd, Donald. "Specific Objects." In *Arts Yearbook 8: Contemporary Sculpture*. New York, 1965, pp. 74–82.

311. Los Angeles, Los Angeles County Museum. *American Sculpture of the Sixties*. 1967. Essays by Lawrence Alloway, John Coplans, Clement Greenberg, Max Kozloff, Lucy R. Lippart, James Monte, Barbara Rose, and others.

312. Los Angeles, Los Angeles County Museum. *Post-Painterly Abstraction*. 1964. Essay by Clement Greenberg.

313. McShine, Kynaston. *Primary Structures: Younger American and British Sculptors*. New York: Jewish Museum, 1966.

314. Morris, Robert. "Notes on Sculpture." *Artforum* (4 parts), vol. 4, February 1966, pp. 42–44; vol. 5, October 1966, pp. 20–23; vol. 5, Summer 1967, pp. 24–29; vol. 7, April 1969, pp. 50–54.

315. New York, Solomon R. Guggenheim Museum. *Systematic Painting*. 1966. Essay by Lawrence Alloway.

316. Reinhardt, Ad. *Art-As-Art: The Selected Writings of Ad Reinhardt*. Edited and with an introduction by Barbara Rose. New York: Viking, 1974.

317. Rosenblum, Robert. *Frank Stella*. Baltimore: Penguin Books, 1970.

318. Rubin, William. "Younger American Painters." *Art International*, vol. 4, January 1960, pp. 24–31.

319. Smith, Brydon (ed.). *Donald Judd*. Includes introduction by Roberta Smith; catalogue raisonné. Ottawa: National Gallery of Canada, 1975.

Conceptual Art

320. Battock, Gregory (ed.). *Idea Art: A Critical Anthology*. New York: E. P. Dutton, 1973.

321. Bern, Kunsthalle. *When Attitudes Become Form: Works, Concepts, Processes, Situations, Information*. 1969. Exhibition organized by Harald Szeeman; essays by Scott Burton, Gregoire Müller, and Tommaso Trini.

322. Burnham, Jack. *Great Western Salt Works: Essays on the Meaning of Post-Formalist Art*. New York: George Braziller, 1974.

323. Ithaca, N.Y., Cornell University. Andrew Dickson White Museum of Art. *Earth*. 1969. Essays by William C. Lipke, and Willoughby Sharp.

324. Lewitt, Sol. "Paragraphs on Conceptual Art." *Artforum*, vol. 5, June 1967, pp. 79–83.

325. Lippard, Lucy R. (ed.). *Six Years: The Dematerialization of the Art Object from 1966 to 1972*. New York: Praeger, 1973.

326. McShine, Kynaston. *Information*. New York: Museum of Modern Art, 1970.

327. Meyer, Ursula. *Conceptual Art*. New York: E. P. Dutton, 1972.

328. New York, New York Cultural Center. *Conceptual Art and Conceptual Aspects*. 1970. Essays and statements by Terry Atkinson, Donald Karshan, Joseph Kosuth, and others.

329. New York, Whitney Museum of American Art. *Anti-Illusion: Procedures/Materials*. 1969. Essays by James Monte and Marcia Tucker.

330. Pincus-Witten, Robert. *Against Order: Chance and Art*. Philadelphia: Institute of Contemporary Art, 1970.

331. Sharp, Willoughby. *Air Art*. New York: Kineticism Press, 1968.

332. Smithson, Robert. "A Sedimentation of the Mind: Earth Proposals." *Artforum*, vol. 7, September 1968, pp. 49–50.

333. Vries, Gerd de. *On Art: Artists' Writings on the Changed Notion of Art After 1965*. Cologne: M. DuMont Schauberg, 1974.

Op, Kinetic, and Technological Art

334. Barrett, Cyril. *Op Art*. New York: Viking, 1970.

335. Burnham, Jack. "Problems in Criticism IX: Art and Technology." *Artforum*, vol. 9, January 1971, pp. 40–45.

336. Compton, Michael. *Optical and Kinetic Art*. London: Tate Gallery, 1967.

337. Davis, Douglas. *Art and the Future*. New York: Praeger, 1973.

338. Hansen, Al. *A Primer of Happenings and Time/Space Art*. New York: Something Else Press, 1965.

339. Higgens, Dick. *The Computer and the Arts*. New York: Abyss Publications, 1970.

340. Hultén, K.G. Pontus. *The Machine as Seen at the End of the Mechanical Age*. New York: Museum of Modern Art, 1968.

341. Kepes, Gyorgy. *The New Landscape in Art and Science*. Chicago: Paul Theobald, 1956.

342. Kepes, Gyorgy (ed.). *The Nature and Art of Motion*. New York: George Braziller, 1965.

343. Lippart, Lucy R. *Focus on Light*. Trenton, N.J.: New Jersey State Museum, 1967.

344. London, Institute of Contemporary Art. *Man, Machine and Motion*. 1955. Essays by Lawrence Gowing and Richard Hamilton.

345. McLuhan, Marshall. *The Mechanical Bride*. Boston: Beacon Press, 1967.

346. Mumford, Lewis. *The Myth of the Machine: The Pentagon of Power*. New York: Harcourt, Brace, 1970.

347. New York, Jewish Museum. *Software*. September 16–November 8, 1970. Introduction by Karl Katz; essays by Jack Burnham and Theodore Nelson.

348. New York. Jewish Museum. *Two Kinetic Sculptors: Nicolas Schöffer and Jean Tinguely*. 1965. Essays by Jean Cassou, Sam Hunter and K.G. Pontus Hultén; statement by Schöffer.

349. Piene, Nan R. "Light Art." *Art in America*, vol. 55, May–June 1967, pp. 24–47.

350. Popper, Frank. *Origins and Development of Kinetic Art*. Greenwich, Conn.: New York Graphic Society, 1968.

351. Reichardt, Jasia (ed.). *Cybernetic Serendipity: The Computer and the Arts*. New York: Praeger, 1968.

352. Seitz, William. *The Responsive Eye*. New York: Museum of Modern Art, 1965.

353. Selz, Peter (ed.). *Directions in Kinetic Sculpture*. Includes an introduction by George Rickey and statements by the artists. Berkeley: University of California Art Museum, 1966.

354. Sharp, Willoughby (ed.). *Kineticism*. New York: Kineticism Press, 1968.

355. Shirey, David L. "Impossible Art: What It Is." *Art in America*, vol. 57, May–June 1969, pp. 32–47.

356. Spies, Werner. *Victor Vasarely*. New York: Harry N. Abrams, 1971.

357. Tompkins, Calvin. *The Bride and the Bachelors: The Heretical Courtship in Modern Art*. New York: Viking, 1965.

V. CRITICS AND CRITICISM

358. Apollinaire, Guillaume. *Apollinaire on Art: Essays and Reviews, 1902–1918*. Edited by Leroy C. Breunig. New York: Viking, 1972.

359. Baudelaire, Charles. *The Mirror of Art: Critical Studies*. Garden City, N.Y.: Doubleday, 1956.

360. Calas, Nicolas. *Art in the Age of Risk and Other Essays*. New York: E. P. Dutton, 1968.

361. Fry, Roger. *Vision and Design*. Rev. ed. Harmondsworth: Penguin Books, 1961.

362. Greenberg, Clement. *Art and Culture: Critical Essays*. Boston: Beacon Press, 1965.

363. Hodin, Joseph P. *The Dilemma of Being Modern: Essays of Art and Literature*. London: Routledge and Kegan Paul, 1956.

364. Huymans. J.-K. *Against Nature*. Harmondsworth: Penguin Books, 1959.

365. Kozloff, Max. *Renderings: Critical Essays on a Century of Modern Art*. New York: Simon and Schuster, 1968.

366. Lippard. Lucy R. *Changing: Essays in Art Criticism*. New York: E. P. Dutton, 1971.

367. O'Hara, Frank. *Art Chronicles, 1954–1966*. New York: George Braziller, 1975.

368. Read, Herbert. *The Meaning of Art*. London: Penguin Books, 1949.

369. Rosenberg, Harold. *The Anxious Object: Art Today and Its Audience*. New York: Horizon Press, 1964.

370. Schapiro, Meyer. "The Nature of Abstract Art." *Marxist Quaterly*, no. 1 January–March 1937, pp. 77–98.

371. Soby, James T[hrall]. *Modern Art and the New Past*. Norman: University of Oklahoma Press, 1957.

372. Sontag, Susan. *Against Interpretation*. New York: Farrar, Straus and Giroux, 1966.

373. Steinberg, Leo. *Other Criteria: Confrontations with Twentieth-Century Art*. New York and London: Oxford University Press, 1972.

PART TWO

ARCHITECTURE

Selected by John Jacobus

374. Banham, Reyner. *Age of the Masters: A personal View of Modern Architecture*. New York: Harper and Row, 1975.

375. Banham, Reyner. *The Architecture of the Well-Tempered Environment*. Chicago: University of Chicago Press, 1969.

376. Banham, Reyner. *Theory and Design in the First Machine Age*. New York: Praeger, 1960.

377. Benevolo, Leonardo. *History of Modern Architecture*. 2 vols. Cambridge, Mass.: MIT Press, 1971.

378. Blake, Peter. *God's Own Junkyard*. New York: Holt, Rinehart and Winston, 1964.

379. Blake, Peter. *The Master Builders*. New York: Alfred A. Knopf, 1960.

380. Blaser, Werner. *Mies van der Rohe: The Art of Structure*. New York: Praeger, 1965. Rev. ed., 1972.

381. Boesiger, Willy. *Le Corbusier, 1910–1960*. New York: George Wittenborn. 1960.

382. Boesiger, Willy (ed.). *Le Corbusier and Pierre Jeanneret: Œuvre Complète*. 8 vols. Zurich: 1930–70.

383. Brown, Theodore M. *The Work of G. Rietveld, Architect*. Utrecht: A.W. Bruna, 1958.

384. Collins, Peter. *Changing Ideals in Modern Architecture*. Montreal: McGill University Press, 1967.

385. Collins, Peter. *Concrete: The Vision of a New Architecture. A Study of Auguste Perret and His Precursors*. New York: Horizon Press, 1959.

386. Condit. Carl W. *The Chicago School of Architecture*. Chicago: University of Chicago Press, 1964.

387. Conrads, Ulrich (ed.). *Programs and Manifestoes on 20th-Century Architecture*. Cambridge, Mass.: MIT Press, 1970.

388. Conrads, Ulrich, and Sperlich, Hans G. *The Architecture of Fantasy: Utopian Building and Planning in Modern Times.* Translated by C. and G. Collins. New York: Praeger, 1962.

389. Cook, Peter. *Experimental Architecture.* New York: Universe Books, 1970.

390. Cook Peter (ed.). *Archigram.* New York: Praeger, 1973.

391. Copplestone, Trewin (ed.). *World Architecture.* Includes chapter on modern architecture by John Jacobus. New York: McGraw-Hill, 1963.

392. Drexler, Arthur. *The Drawings of Frank Lloyd Wright.* New York: Museum of Modern Art, 1962.

393. Drexler, Arthur. *Ludwig Mies van der Rohe.* New York: George Braziller, 1960.

394. *Five Architects: Eisenman, Graves, Gwathmey, Hejduk, Meier.* New York: Oxford, 1975.

395. Fitch, James M[arston]. *American Building.* 2 vols. 2nd rev. and enl. ed. Boston: Houghton Mifflin, 1966–72.

396. Fitch, James Marston. *Walter Gropius.* New York: George Braziller, 1960.

397. Fleig, Karl (ed.). *Alvar Aalto.* New York: Georges Wittenborn, 1963.

398. Fuller, R. Buckminster. *Nine Chains to the Moon.* Philadelphia and New York: Lippincott, 1938.

399. Fuller, R. Buckminster. *Operating Manual for Spaceship Earth.* Carbondale: Southern Illinois University Press, 1969.

400. Giedion, Siegfried. *Mechanization Takes Command.* New York: Oxford, 1948.

401. Giedion, Siegfried. *Space, Time and Architecture: The Growth of a New Tradition.* Cambridge, Mass.: Harvard University Press, 1941. 5th rev. and enl. ed., 1967.

402. Giedion, Siegfried. *Walter Gropius: Work and Teamwork.* New York: Reinhold, 1954.

403. Giurgola, Romaldo, and Mehta, Jaimini. *Louis I. Kahn.* Boulder, Colo.: Westview Press, 1975.

404. Gropius, Walter. *Scope of Total Architecture.* New York: Harper, 1955.

405. Gutheim, Frederick. *Alvar Aalto.* New York: George Braziller, 1960.

406. Hamlin, Talbot (ed.). *Forms and Functions of Twentieth-Century Architecture.* 4 vols. New York: Columbia University Press, 1952.

407. Hitchcock, Henry-Russell. *The Architecture of H. H. Richardson and His Times.* Rev. ed. Hamden, Conn.: Archon Books, 1961.

408. Hitchcock, Henry-Russell. *Architecture: Nineteenth and Twentieth Centuries.* Harmondsworth and Baltimore: Penguin Books, 1958, 1963, 1968.

409. Hitchcock, Henry-Russell. *Gaudí.* New York: Museum of Modern Art, 1957.

410. Hitchcock, Henry-Russell. *In the Nature of Materials.* New York: Duell, Sloan and Pearce, 1942.

411. Hitchcock, Henry-Russell. *Modern Architecture: Romanticism and Reintegration.* New York: Payson and Clark, 1929; and New York: AMS Press, 1972.

412. Hitchcock, Henry-Russell, and Johnson, Philip. *The International Style: Architecture Since 1922.* New York: W. W. Norton, 1932. Reprinted 1966.

413. Jacobus, John. *Philip Johnson.* New York: George Braziller, 1962.

414. Jacobus, John. *Twentieth-Century Architecture: The Middle Years, 1940–1965.* New York: Praeger, 1966.

415. Jencks, Charles. *Architecture 2000: Predictions and Methods.* New York: Praeger, 1971.

416. Jencks, Charles. *Modern Movements in Architecture.* Garden City, N.Y.: Doubleday, 1963.

417. Jencks, Charles, and Baird, George (eds.). *Meaning in Architecture.* New York: George Braziller, 1969.

418. Joedicke, Jürgen. *Architecture Since 1945: Sources and Directions.* New York: Praeger, 1969.

419. Johnson, Philip C. *Mies van der Rohe.* 2nd rev. ed. New York: Museum of Modern Art, 1953.

420. Jordy, William H. *American Buildings and Their Architects.* Vols. 3 and 4. Garden City, N.Y.: Doubleday, 1970–72.

421. Kaufmann, Edgar, Jr. (ed.). *The Rise of an American Architecture.* Includes essays by Henry-Russell Hitchcock, Albert Fein, Winston Weisman, and Vincent Scully. New York: Praeger, 1970.

422. Kultermann, Udo. *New Directions in African Architecture.* Translated by John Maass. New York: George Braziller, 1969.

423. Kultermann, Udo. *New Japanese Architecture.* Rev. ed. New York: Praeger, 1967.

424. Kultermann, Udo (ed.). *Kenzo Tange: 1946–1969.* New York: Praeger, 1970.

425. Le Corbusier. *Creation Is a Patient Search.* Translated by James C. Palmes; introduction by Maurice Jardot. New York: Praeger, 1960.

426. Le Corbusier. *Towards a New Architecture.* Translated by Frederick Etchells. London, 1927; and New York: Praeger, 1970.

427. Martinell y Brunet, César. *Gaudí, His Life, His Theories, His Work.* Edited by George R. Collins. Cambridge, Mass.: MIT Press, 1975.

428. McHale, John. *R. Buckminster Fuller.* New York: George Braziller, 1962.

429. Mumford, Lewis. *Roots of Contemporary American Architecture.* New York: Reinhold, 1952.

430. Nervi, Pier Luigi. *Buildings, Projects, Structures 1953–1963.* Translated by Giuseppe Nicoletti. New York: Praeger, 1963.

431. Neutra, Richard. *Life and Human Habitat.* Stuttgart: Koch, 1956.

432. New York, Museum of Modern Art. *Modern Architecture: International Exhibition.* 1932. Essays by Alfred H. Barr, Jr., Henry-Russell Hitchcock, and Philip Johnson.

433. Norbert-Schulz, Christian. *Existence, Space and Architecture.* New York: Praeger, 1971.

434. *Notebooks and Drawings of Louis I. Kahn.* Philadelphia: Falcon Press, 1962.

435. Pehnt, Wolfang. *Expressionist Architecture.* New York: Praeger, 1973.

436. Pehnt, Wolfgang (ed.). *Encyclopedia of Modern Architecture.* New York: Harry N. Abrams, 1964.

437. Pevsner, Nikolaus. *The Sources of Modern Architecture and Design.* New York: Praeger, 1968.

438. Richards, J. M. *An Introduction to Modern Architecture.* Harmondsworth: Penguin Books, 1940. Rev. eds.: New York, Penguin Books, 1947; Baltimore, Penguin Books, 1962.

439. Roth, Alfred (ed.). *The New Architecture.* Zurich: Girsberger, 1940.

440. Saarinen, Aline B. (ed.). *Eero Saarinen on His Work.* New Haven and London: Yale University Press, 1962. Rev. ed., 1968.

441. Safdie, Moshe. *Beyond Habitat.* Edited by John Kettle. Cambridge, Mass.: MIT Press, 1970.

442. Scully, Vincent. *American Architecture and Urbanism: A Historical Essay.* New York: Praeger, 1969.

443. Scully, Vincent. *Frank Lloyd Wright.* New York: George Braziller, 1960.

444. Scully, Vincent. *Louis Kahn.* New York: George Braziller, 1962.

445. Scully, Vincent. *Modern Architecture: The Architecture of Democracy.* New York: George Braziller, 1961. Rev. ed., 1974.

446. Scully, Vincent. *The Shingle Style: Architectural Theory and Design from Richardson to the Origins of Wright.* New Haven: Yale University Press, 1955.

447. Scully, Vincent. *The Shingle Style Today, or The Historian's Revenge.* New York: George Braziller, 1974.

448. Sharp, Dennis. *Modern Architecture and Expression.* New York: George Braziller, 1966.

449. Sharp, Dennis. *Sources of Modern Architecture: A Bibliography.* Facsimile of Architectural Association (London) Paper 2. New York: George Wittenborn, 1967.

450. Sharp, Dennis. *A Visual History of Twentieth-Century Architecture.* Greenwich, Conn.: New York Graphic Society, 1972.

451. Singelenberg, Pieter. *H. P. Berlage, Idea and Style.* Utrecht: 1972.

452. Smith, G.E.K. *The New Architecture of Europe: An Illustrated Guidebook and Appraisal.* Cleveland and New York: World, 1961.

453. Stern, Robert A. M. *New Directions in American Architecture.* New York: George Braziller, 1969.

454. Stirling, James. *Buildings and Projects 1950–1974.* Introduction by John Jacobus. New York: Oxford, 1975.

455. Sullivan, Louis H. *The Autobiography of an Idea.* Foreword by Claude Bragdon. New York: American Institute of Architects, 1924.

456. Sullivan, Louis [H]. *Kindergarten Chats.* Lawrence, Kans.: Scarab Fraternity Press, 1934; and New York: Wittenborn, Schultz, 1947.

457. Taut, Bruno. *Modern Architecture.* London: The Studio, 1929.

458. Venturi, Robert. *Complexity and Contradiction in Architecture.* Museum of Modern Art Papers on Architecture 1. Introduction by Vincent Scully. New York: Museum of Modern Art, 1966.

459. Venturi, Robert; Scott Brown, Denise; and Izenour, Steven. *Learning from Las Vegas.* Cambridge, Mass.: MIT Press, 1972.

460. Webb, Michael. *Architecture in Britain Today.* London: Country Life, 1969.

461. Whittick, Arnold. *Eric Mendelsohn.* 3rd ed. London: Leonard Hill, 1965.

462. Whittick, Arnold. *European Architecture in the Twentieth Century.* 2 vols. London: Crosby Lockwood, 1950–53.

463. Wiebenson, Dora. *Tony Garnier: The Cité Industrielle.* New York: George Braziller, 1969.

464. Wright, Frank Lloyd. *In the Cause of Architecture: Essays by Frank Lloyd Wright for Architecural Record.* Edited by Frederick Gutheim. New York: Architectural Record, 1975.

465. Zevi, Bruno. *Towards an Organic Architecture.* London: Faber and Faber, 1950.

INDEX